NINETEENTH CENTURY ART A CRITICAL HISTORY

NINETEENTH A CRITICAL

Third edition. With 496 illustrations, 193 in colour

CENTURY ART HISTORY

THOMAS CROW

BRIAN LUKACHER

LINDA NOCHLIN

DAVID L. PHILLIPS

FRANCES K. POHL

In the captions to the illustrations, measurements are in inches (centimetres in parenthesis), height before width, unless otherwise indicated.

Any copy of this book issued by the publisher as a paperback is sold subject to the condition that it shall not by way of trade or otherwise be lent, resold, hired out or otherwise circulated without the publisher's prior consent in any form of binding or cover other than that in which it is published and without a similar condition including these words being imposed on a subsequent purchaser.

First published in the United Kingdom in 1994 by Thames & Hudson Ltd, 181A High Holborn, London WCIV 7QX

www.thamesandhudson.com

© 1994, 2002 and 2007 Thames & Hudson Ltd, London

Third edition 2007

All Rights Reserved. No part of this publication may be reproduced or transmitted in any form or by any means, electronic or mechanical, including photocopy, recording or any other information storage and retrieval system, without prior permission in writing from the publisher.

British Library Cataloguing-in-Publication Data A catalogue record for this book is available from the British Library

> ISBN-13: 978-0-500-28683-8 ISBN-10: 0-500-28683-3

Printed and bound in Slovenia by MKT Print d.d.

Short Loan Collection

CONTENTS

Introduction: Critical Art and History 7

CLASSICISM AND ROMANTICISM

1 THOMAS CROW Patriotism and Virtue: David to the Young Ingres 18
 2 THOMAS CROW Classicism in Crisis: Gros to Delacroix 55

3 The Tensions of Enlightenment: Gova 82

4 BRIAN LUKACHER Visionary History Painting: Blake and His Contemporaries 102

5 BRIAN LUKACHER Nature and History in English Romantic Landscape Painting 119

6 BRIAN LUKACHER Landscape Art and Romantic Nationalism in Germany and America 143

7 Brian Lukacher Architecture Unshackled, 1790–1851 160

NEW WORLD FRONTIERS

8 Frances K. Pohl Old World, New World: The Encounter of Cultures on the American Frontier 180

9 FRANCES K. POHL Black and White in America 199

REALISM AND NATURALISM

10 The Generation of 1830 and the Crisis in the Public Sphere 224
11 The Rhetoric of Realism: Courbet and the Origins of the Avant-Garde 242
12 DAVID LLEWELLYN PHILLIPS Photography, Modernity, and Art 265
13 The Decline of History Painting: Germany, Italy, and France 293

MODERN ART AND LIFE

14 Architecture and Design in the Age of Industry 310

15 Manet and the Impressionists 332

16 LINDA NOCHLIN Issues of Gender in Cassatt and Eakins 349

17 Mass Culture and Utopia: Seurat and Neoimpressionism 368

18 The Appeal of Modern Art: Toulouse-Lautrec 382

19 Abstraction and Populism: Van Gogh 390

20 Symbolism and the Dialectics of Retreat 406

21 The Failure and Success of Cézanne 440

Chronology 454
Select Bibliography 465
List of Illustrations 469
Index 475

0.1 Gustave Courbet Portrait of Baudelaire, ca. 1848. Oil on canvas, 207/8 × 24 (53 × 61). Detail

INTRODUCTION: CRITICAL ART AND HISTORY

THE FIRST MODERN
CENTURY

THE ART, ARCHITECTURE AND DESIGN DISCUSSED IN THIS BOOK was made in **L** Europe and North America during a period of rapid and profound social and political modernization. The close of that epoch, now more than a hundred years distant, did not, of course, end the drama. In fact, far from slowing down, the dynamic of change begun in the nineteenth century was accelerated in the twentieth. Soon the terms "imperialism," "assembly line," "mass culture," and "total war" entered the modern European and American lexicons, supplanting an earlier vocabulary that included "nation," "industry," "popular," and "revolution." Yet if actions and words were shifting their arenas and changing their meanings, the basic facts of crisis and everlasting uncertainty remained the same. Indeed, even more than before, Karl Marx's Shakespearian-sounding phrase from the Communist Manifesto—"all that is solid melts into air"-summed up the experience of vast multitudes of people awed and displaced by modern forces of social and economic change. If nineteenth-century history and culture remain compelling today, it may be because the twentieth century—and now the early twenty-first—witnessed still greater and more rapid political and cultural transformations. We thus look backward with mixed feelings of nostalgia and recognition, anxiety and familiarity, anger and longing. The first task before us, therefore, is to put the nineteenth century succinctly in its place.

In Western Europe, the end of the eighteenth century marked the final dissolution of feudalism—a primarily agricultural and rigidly hierarchical productive and social order that had survived for seven hundred years. In the place of feudalism, there now arose a modern capitalist and bourgeois economic and social edifice. (The situation in Eastern Europe was somewhat different: there feudalism was intensified in the early modern period, and only disappeared *de facto* from Russia after the 1917 Revolution.) This epochal reconfiguration of economy and society—long in coming but no less dramatic in the end for its gradual preparation—was marked by outbreaks of violence and insurrection. Populations long oppressed sought the freedoms promised in liberal doctrines; communities long isolated—like the Ornans depicted by the French Realist Gustave Courbet—were brought into conformity by centralized nation-states.

Beginning in 1776, and continuing for a generation, wars of colonial independence—inspired by Enlightenment principles of political consent and social contract—were waged and won in North and South America, Mexico, and the Caribbean. These victories in turn rebounded in the core nations of Europe, accelerating already existing demands for social justice, economic equality, and political enfranchisement. Across Europe and the Americas, absolutist monarchies fell or were toppled, to be replaced by dictatorships, constitutional monarchies, and republics.

By the middle of the nineteenth century, the social and political upheaval that had begun with the bloody dispatch of the French Bourbon monarchs in 1793 (the event that appears in retrospect as the exclamation point at the end of the feudal sentence) was becoming more democratic, inclusive, and organized. In 1848, the increasingly self-cognizant working classes of France, Germany, Austria, Italy, and England rose up in arms (or in the latter case formed a mass political and protest movement) to combat the vestigial aristocratic, and the new bourgeois, elites who maintained economic and political dominance. A decade and a half later, the slave plantation system of agriculture in the southern United States was overturned by black women and men motivated by the sting of the lash, and by whites driven in some cases by moral outrage and in others by economic calculation. In addition, the efforts of women to achieve emancipation began to rival in intensity the ongoing class and racial struggles.

But the "age of Revolution," and the succeeding "age of capital," as the historian Eric Hobsbawm called them, were not only periods of noble or elite retreat and retrenchment. The nineteenth century also inaugurated the age of imperialism—an epoch when the nation-states of Europe and the United States began to organize and coordinate their economies in order to exploit their own populations more productively, and to seize the raw materials, labor, and markets of the rest of the globe more efficiently. Democratic, revolutionary successes were often quickly reversed: emancipation and enfranchisement were rolled back with startling rapidity, and whole populations—generally darker skinned and most often living in the Southern Hemisphere—were brought into subjection. In the United States, the genocide of Native Americans reached its apogee by 1890 (the year of the Wounded Knee Massacre), even while large numbers of new European and Asian immigrants—often themselves displaced by pogroms of one kind or another—arrived at Atlantic and Pacific harbors. Lynch law, white supremacy, and Jim Crow (the popular name for the U.S. system of racial segregation) also reached their pinnacle in the 1890's. Emergent ideologies of racism and Eurocentrism—along with legions of missionaries, bureaucrats, diplomats, police, vigilantes, soldiers, and sailors—were marshaled to support this reactionary enterprise. The occasional artist too was enlisted in the effort, though in the case of Paul Gauguin in French Polynesia, with decidedly mixed results.

During the last quarter of the nineteenth century, violence, political struggle, social change, and periodic crisis seemed entrenched in the West. Though no major wars raged, present and future prospects were unclear and unsettled: many artists and writers described their time as an age of "transition," a period of "decadence" or a "penultimate age," implying that the approaching millennium would bring sweeping changes to an unstable or even degenerate world. Economic cycles of boom and bust followed close upon each other; new agricultural and industrial technologies for better and worse transformed countryside and city alike; and as the twentieth century dawned, the restlessness and overt and underlying violence that had characterized the former century was fully internationalized. The cyclical economic decline from 1873 to 1895 temporarily disrupted cooperation between the big political powers, and by the eve of World War I (1914), nearly the entire non-European world was divided up into colonies for the benefit of a half-dozen Northern and Western imperialist nations. Yet imperialism notably failed to secure either peace or generalized prosperity; rather, it generated its own antinomies. World wars between the imperialist nations were fought; broad (though fragile) alliances were forged among oppressed European and non-European peoples; and metropolitan bourgeois culture itself was on the point of being dethroned. The twentieth century was by far the most bloody and destructive in human history, and scholars are remiss if they do not investigate the first modern century in the sanguinary light cast by the second.

ART AND EMANCIPATION, ART AND REACTION

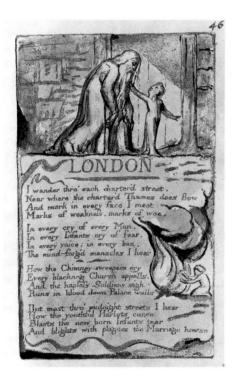

0.2 WILLIAM BLAKE Songs of Experience, Plate 46: "London," ca. 1794. From hand-printed book, $4\frac{3}{4} \times 2\frac{5}{8}$ (11.3 × 6.8)

The nineteenth century in Europe and the United States was punctuated at its beginning, middle, and end by revolutions—political, industrial, and cultural—and by the less violent struggles of workers, women, and indigenous peoples for freedom and equality. It was also an age of economic modernization and political consolidation among the major political and economic powers—a gathering of imperial strength and speed in advance of new drives for global domination in the twentieth and twenty-first centuries. The visual arts of the epoch were also indelibly marked by restiveness, change, modernization, rebelliousness, and the re-imposition of authority; they too were shaped and figured by the irruption of classes and interests formerly excluded from the domain of national culture, and by efforts to vanquish this insurgency. (The insight into links between the ethics, politics, and economic life of a society and its art, we shall soon see, was itself a signal achievement of the age.) No longer the reliably pliant vehicle of entrenched elites, art was often now the contradictory, unpredictable, and critical voice of diverse individuals, subcultures, and interest groups. For the first time in European history, painting and sculpture, as well as the new reproductive media (lithography, wood engraving, and photography), were available as instruments of democracy as well as of domination. Even architecture and design, the social arts par excellence, and the ones most dependent upon the patronage of the wealthy, the entrenched and the powerful, were regularly employed to satisfy the practical and ideological needs of subordinate or dissident classes and class-factions. Apartment blocks, union halls, train stations, department stores and libraries—as well as wallpapers, textiles, glassware and metalwork—now served multiple, and often antagonistic masters.

The democratization of art—that is, the emancipation of artists from the controlling institutions of church and state—and resistance to capitalist modernization were phenomena that could be observed at the very beginning of the nineteenth century. The prints, drawings, and paintings of the English William Blake and the Spanish Francisco Goya, for example, offer clear instances of the critical attention of artists to the cultural and political crises and realignments of the moment. Each man was responsive, first of all, to his own conscience and his own talent. In Blake's illustrated poetic books such as America (1793) and Europe (1794), and in the unpublished The French Revolution (1791), he celebrated the figures of the Abbé Sieyès (French author of What is the Third Estate) and Thomas Paine (American writer of Common Sense) and lamented the failure of his native country to embrace the revolutionary upwellings in the United States and France. And in "London" from Songs of Experience (ca. 1794), he described the combined tyrannies of commercial property, state religion, and cold, merciless reason—"I wander thro' each chartered street,/Near where the chartered Thames does flow . . . /In every voice: in every ban,/The mind-forged manacles I hear." Blake's ingenuous illumination for the poem, which depicts an aged and enfeebled figure of London led by the beard by a small child, recalls similar images of innocence, experience, and inversion of morality—in J.-L. David's painting Belisarius Begging Alms (1781), and at the conclusion of J.-J. Rousseau's Discourse on Inequality (1755): "For it is manifestly contrary to the laws of nature, however defined, that a child should govern an old man, that an imbecile should lead a wise man, and that a handful of people should gorge themselves with superfluities while the hungry multitude goes in want of necessities." Blake was every bit as revolutionary a figure as David and Rousseau, but far more distrustful of the power and institutions of the state than either the Jacobin artist or the peripatetic philosophe. He believed that ordinary men and women—drawn together by will, love, benevolence, and sexual desire—could be the instruments of millenarian transformation.

In Francisco Goya's series of etchings, the *Caprichos* (1799), he condemned the prevailing ignorance and prejudice of the Spanish monarchy and clergy, espoused tolerance, and preached economic and political reform. "You who cannot" (*Caprichos 42*),

. 2

1 1

0.2

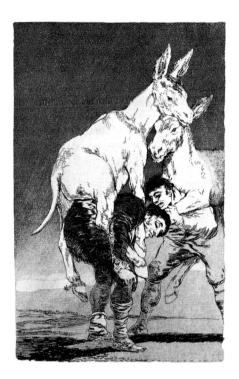

0.3 FRANCISCO GOYA Caprichos 42: "Tu que no puedes" ("You who cannot"), 1796-7. Etching and burnished aquatint, $83/8 \times 57/8 (21.4 \times 15)$

is the caption for a print that depicts two laborers, bent over and with eyes closed, 0.3 carrying asses on their backs. The men are being crushed by their burdens, but they are not yet ready to set them down and right the injustice. Less certain than Blake that simple artisans and workmen could combine to topple kings, but also less distrustful of reason and enlightenment. Gova asserted his own right and responsibility. In his words, to "censure human errors and vices... and at the same time exercise [his] imagination." Goya saw himself as a reformer, guided by reason and the zeal for independence; Blake regarded himself as a prophet whose trumpet blasts could help bring down the walls of a corrupt, modern Jericho. But despite these and many other differences, Goya and Blake also had much in common: they each found ways to embody revolution in the technique and forms as well as the subjects of their art. Each represented the political and social crises of their day in the language of solar and Manichean metaphors: Light erases Darkness, Day combats Night, God confronts Satan, Master opposes Slave, Orc (Blake's personification of desire) battles Urizen (his figure of oppressive reason), Truth (Goya's preferred allegory) strives to vanquish Ignorance. Perhaps most remarkable of all, however, is the fact that Blake and Goya represent their themes and protagonists dialectically; that is, they describe them as various and mutable. Neither light nor dark, reason nor unreason, neither God nor the devil are singular and eternal; like the dawning modern age itself, they are multiple and protean, contingent upon the political and social perspectives of the spectator and upon fast-changing historical events.

Blake and Goya were surely exceptional, among nineteenth-century artists, for their intellectual independence and political perspicacity. Yet even reactionary figures, such as the arch-Classicist J.-A.-D. Ingres, often manifested so active and perceptive an engagement with the facts of modernization and social change, that their art too must be called critical. Ingres's The Apotheosis of Homer (1827), for example, appears to represent Classicism as a timeless canon of physical beauty and formal perfection passed down, generation to generation, from archaic Greece, through the Christian Middle Ages, to modern, enlightened France. Yet a closer examination of the picture suggests that it represents at the same time the cultural and ethical divide then increasingly felt to exist between the antique past and the modern present.

Exhibited in 1827 at the Salon Carré of the Louvre palace (the most prestigious venue in Paris for the display of works of art), the *Apotheosis* depicts the blind Homer, enthroned before an Ionic temple and crowned with laurel by a winged Victory (or Fame). At his feet, in postures that recall the figures of Day and Night from Michelangelo's Tomb of Giuliano de' Medici, are seated allegorical representations of the *Iliad* (beside a sword) and the *Odyssey* (with an oar resting on her lap). To Homer's immediate right are the three great tragedians Aeschylus, Sophocles, and Euripides, and to his left the poet Pindar (offering the lyre) and the sculptor Phidias (with left arm extended, holding a mallet). Ranged around and below these Greeks are other ancient and modern luminaries indebted to Homer: Apelles leads Raphael by the hand, Virgil guides Dante, Molière (holding the mask of drama) stands beside Racine, and Shakespeare accompanies Poussin (in the left foreground, pointing to Homer). Omitted from the picture, but everywhere implicit, is Ingres (he included himself in a preliminary version), who as recent Academician and proud recipient of the Légion d'honneur, saw himself as the honored heir to Poussin, Raphael, and, especially, the Greeks. In 1818 the artist proclaimed: "In matters of Art, I have not changed. Age and reflection have, I hope, strengthened my taste, without diminishing its ardor. I still worship Raphael, his century, and above all the divine Greeks." For Ingres, therefore, ancient Greece represented both the childhood of Europe—the origin of a European classical culture that flourished from the fourteenth through nineteenth centuriesand the full swell of a maturity that could never be superseded.

Commissioned for the ceiling of the newly decorated room of Egyptian antiquities in the Louvre, *The Apotheosis of Homer* proclaims Classicism an indisputable canon guaranteeing a stable cultural foundation for the present. The painting suggests that present French and European culture is the culmination of a continuous line of development beginning in archaic Greece, and passing through the Roman empire, the Christian Middle Ages, the Renaissance, the time of Louis XIV, and the present age of Charles X. The painter and critic Etienne Delécluze described the static and retrospective aspects of the *Apotheosis* in his Salon review for the 1828 *Journal des débats* when he praised Ingres for dispensing with the pretension of artistic originality in his painting and instead graciously accepting the formal "archetypes" provided by all the great personages he represents. Delécluze writes:

The individual originality of these men is incontestable, but what placed them beyond all comparisons were the era and circumstances under which they lived. Homer found himself at the ideal point for giving life to mythological traditions; Dante for fixing the poetic theology born in the fifth century; Shakespeare for transfusing the ideas of the south into northern brains; Phidias for clothing symbolic idols with man's image; and Michelangelo for *incarnating* the Middle Ages. But once all these great combinations have been fashioned and fixed, all that can be done is to modify the archetypes indefinitely.

This subtle crafting and modification of the Classical corpus of "archetypes," according to Delécluze, was Ingres's achievement. Yet this was clearly an achievement more of a negative than of a positive kind: it involved the erasure of historic and artistic difference and dissonance and the substitution of a bland and conflict-free Classicism. Banished from the Classical tradition in Ingres's painting are the irrational pessimism of Euripides, the devastating loneliness of Dante (as he leaves behind his guide Virgil on the threshold of Paradise), the alienation of Hamlet, and the stunning anticlassicism of the aged Michelangelo; what remains is only costume, cliché, and hollow splendor. In thus purging from the Classical past and present all that gave it complexity and vitality, Ingres's *Apotheosis* comes to resemble an attack upon, more than an homage to, the legacy of Homer, and it should not surprise us that most critics of the painting found it objectionable. "Is this," they must have asked themselves, "all that remains of Classicism, the prized institutionalized system of artistic training and moral instruction?"

Indeed, if we now look again at the *Apotheosis of Homer*, we notice how much more it resembles a crude pastiche than an ideal paradigm of Classicism. Figures are ranked in rigid bands echoing the horizontal and vertical steps in the foreground and columns in the background; they hold hands but fail to interact or engage the viewer, despite the grotesquely abbreviated *repoussoirs* in the extreme foreground. Can there be any other explanation for the flatness, awkwardness, and stiltedness of the picture than that Ingres was recording—poignantly, reluctantly, perhaps even helplessly— the breakdown in the authority of the Classical tradition in the modern world?

Delécluze himself half understood the problematical nature of the *Apotheosis* when he described its painter's technique as "submitting less to the laws of linear perspective than to laws of a perspective that one could call *chronological* . . . in giving more relief to the modern figures and gradually weakening his colors as he reaches the semifantasy figures of Orpheus and Linus, who are on the furthest plane of the picture." In the hands of Ingres, the ancient world is one of blindness, shadows, and loss; the great monuments of Greek antiquity are destroyed—the Athena Parthenos, the Colossus, the entire *oeuvre* of Apelles—and there are no comparable modern works to take their place. Indeed, the further you enter the modern world, as the art historian Norman

7.4

Bryson has written, elaborating Delécluze, "the more the nobility and generality of countenance evident in such figures as Phidias and Apelles gives way to the ironical peering and sardonic expressions, at their nadir in the busy scribbling and sarcastic 'smile of reason' of Voltaire [at the lower right corner]." Bryson's word for this representation of absence or loss is "desire," but the passivity of the term seems to me somewhat misleading: I am more persuaded that what is at work is an active, restless, and critical intelligence. Ingres saw and felt (however much he may have lamented) the weakness and vulnerability of the Classicism of his day and could not avoid depicting it. At about the same time, the French architects Etienne-Louis Boullée and Claude-Nicolas Ledoux also recognized and expressed in their buildings and monuments the arbitrariness of the signs of the prevailing language of classicism, producing what their contemporary, the English architect George Dance the Younger, called an "architecture unshackled" (see Chapter 7). Precisely such a knowledge of cultural crisis and change—featured in the art of conservatives such as Ingres as much as in the work of radicals such as Blake, Goya and Ledoux —is the distinguishing trait of the most salient art and design of the nineteenth century. This is the art I am calling critical. It is an art that does not merely describe a surface appearance, but exposes the design and form of an historical, social, and ideological edifice—what the early nineteenth-century philosopher Hegel in his Logic (1813) called "an objective universal" or a "concrete totality." (This concept of totality was given greater historical and class specificity in the writings of the twentieth-century philosopher and critic Georg Lukacs.) In this way, the art and design of a Blake, Gova, Ledoux or Ingres at the beginning of the century, or a Van Gogh, Toulouse-Lautrec or Horta at the end, may be seen as generating its own interpretations: it provides its own frames of reference and highlights the salient modes of social and material life by means of which its forms, lines, and colors may be understood. Van Gogh described the awkward meeting of city and country in a series of small paintings of Montmartre made in 1887; at about the same time, Toulouse-Lautrec summarized in a number of paintings and posters the nascent struggle over urban popular culture. His Ambassadeurs, Aristide Bruant (1892) depicts a proletarian idol in the process of becoming a modern celebrity. Victor Horta in his Maison du Peuple conceived and built a headquarters for the Belgian Workers' party whose forms summarized at once the imperatives of heart and head—will and intelligence—needed to drive any popular movement for social and political justice. Critical art, in short, provides its own theory, and the critical art historian needs only to follow where it leads.

THE NINETEENTH-CENTURY ORIGINS OF CRITICAL ART HISTORY In the nineteenth century, scholars and critics for the first time divined and theorized the interconnections between seeing and knowing, and between vision and society. Marx, Ruskin, Baudelaire, Morris, Mallarmé and a number of other authors and critics, explored the links between art, perception, and history. The most complete and widely influential discussion of the question is found in the writings of Marx. In his *Economic and Philosophic Manuscripts* of 1844 he wrote that the transformation of the alien, objective world into a subjective world of consoling "human reality" depends upon the state of development of the human senses:

Just as music alone awakens in people the sense of music, and just as the most beautiful music has no sense for the unmusical ear . . . for this reason the senses of the social person are other than those of the non-social person. Only through the objectively unfolded richness of people's essential being is the richness of subjective human sensibility (a musical ear, an eye for beauty of form . . .) either cultivated or brought into being. For not only the five senses but also the so-called mental senses—the practical senses (will, love, etc.)—in a word, human sense—the

humanness of the senses—come to be by virtue of humanized nature. The forming of the five senses is a labor of the entire history of the world down to the present.

Marx's point is that while humans by virtue of their nature as humans have senses and perceptions, these are rude and unformed in the absence of their specific development and cultivation, which only occurs historically and in community with their fellows. Moreover, all the senses are differently developed according to the nature of the particular society in which the person lives: a capitalist society in which the sense of having dominates is clearly different in its sensual or perceptual capacities from a forager, horticultural, feudal or communist society which does not subscribe to the same concept of private property. And finally, Marx stands his argument about the impact of society upon the human senses on its feet by arguing that the cultivation of the senses—whether in the form of art, music or literature—in its turn plays a significant role in the historical unfolding of a society. Giving material form to our sensual instincts or capacities, both theoretically and practically, "is required," he writes, "to make people's sense human, as well as to create the human sense corresponding to the entire wealth of human and natural substance."

A similar formulation of the link between history and material culture—or between art and society—was independently achieved less than a decade after Marx by the moral philosopher and esthetician John Ruskin. An important figure in the revival of architecture and the arts in mid-century Britain and in its medieval revivalism, Ruskin wrote in his essay "On the Nature of Gothic and the Function of the Workman therein" (1853), "The art of any country is the exponent of its social and political virtues. The art or general productive and formative energy of any country, is an exact exponent of its ethical life. You can have a noble art only from noble persons, associated under laws fitted to their time and circumstances." In Saint Mark's Rest (1884), he further observed that critics and spectators of works of art needed to understand and synthesize all the characteristic, expressive forms of a given epoch. He wrote that: "Great nations write their autobiographies in three manuscripts—the book of their deeds, the book of their words, and the book of their art. Not one of these books can be understood unless we read the two others; but of the three, the only quite trustworthy one is the last. . . . Art is always instinctive . . . [and we can understand it] at a glance (when we have learned to read)."

Ruskin's art history and criticism is accordingly finely tuned to the subtlest formal and historical nuances of the works of architecture, painting or sculpture that fall beneath his gaze. His analysis of the painter J. M. W. Turner's images of the sea, for example, proceeds from a consideration of fragmented, vaporous or liquid paint surfaces, to a discussion of geological, meteorological, and moral truths. His examination of The Fighting Temeraire (1839) and Rain, Steam, and Speed—The Great Western Railway (1844) highlights the "cold deadly shadows" of the one, and the dynamic of 5.20 historical "progress and decline" in the other. The basis of these combined esthetic and ethical opinions is Ruskin's appreciation of art as a form of labor; like Marx, he believed that creative and productive work is one of the defining activities of humans, and that to deny the one is to degrade the other. Ruskin's insight was later summarized in a sentence by his student, the author, designer, and political activist William Morris: "Yet the essence of what Ruskin then taught us was simple enough, like all great discoveries. It was really nothing more recondite than this, that the art of any epoch must of necessity be the expression of its social life, and that the social life of the Middle Ages allowed the workman freedom of individual expression, which on the other hand our social life forbids him."

At about the same time that Marx, a German, was composing his notebooks addressing the historical character of the senses, and the Englishman Ruskin was

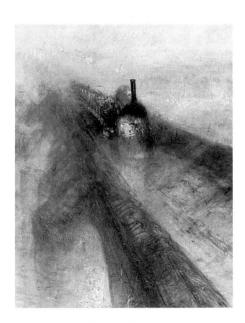

0.4 JOSEPH MALLORD WILLIAM TURNER Rain, Steam, and Speed-The Great Western Railway, 1844. Detail of Plate 5.20

publishing his radical view that every age had its own unique vision and art which corresponded to its peculiar ethical and social life, a French poet and journalist was suggesting many of the same things. It was Charles Baudelaire who provocatively argued that artists and writers be resolutely of their own time; it was also he who established the model of the critic who is profoundly and passionately engaged with his subject and his epoch. Jettisoning any notion of Classical "archetypes," as found for example in Delécluze, and setting the tone for future critical encomiums to modernity, he wrote at the conclusion of his review of the 1845 Paris Salon exhibition: "The true painter we're looking for will be the one who can snatch from the life of today its epic quality, and make us feel how great and poetic we are in our cravats and our patent-leather boots. Next year let's hope that the true seekers may grant us the extraordinary delight of celebrating the advent of the *new*!"

With this essay, and others that followed, Baudelaire, as well as later nineteenthcentury critical thinkers and writers such as Morris and Stéphane Mallarmé, discovered that vision itself, as well as the artistic forms that are its sensual embodiment, is not given for all time—as the arch Classicists believed—but is contingent upon a host of changing historical and ideological factors. The "ideological" nature of seeing has a very contemporary sound to it, but in fact this concept too is a product of nineteenth-century thought, as the critic Raymond Williams and others have argued. By "ideology" is meant here the characteristic bodies of knowledge, belief, imagery, and expression that are created by a particular social class at a given moment in history. Ideologies arise largely unbeknownst to their subjects as a set of workaday assumptions or commonsense notions about the world. They provide their possessors with a coherent image of their lived relation to social reality, and thus may be an effective (because surreptitious) instrument for the domination of one class or group by another. Ideologies both follow from economic and political power, and are a tool for achieving that control. "The ideas of the ruling class," wrote Karl Marx and Friedrich Engels (the first to theorize ideology), "are in every epoch the ruling ideas." The mid-twentiethcentury political theorist Louis Althusser offered a brief but compelling example of one of the ideologies that arose at the dawn of the nineteenth century but which is still vital to class stability today:

[According to] the ideology of *freedom*, the bourgeoisie lives in a direct fashion its relation to its conditions of existence: that is to say, it comprehends its real relation (to the laws of a liberal capitalist economy), but *incorporates* it into an imaginary relation (the idea that all people are free, including "free" workers).

By this example of the way in which the ideology of freedom masks the severely circumscribed liberties of workers in a liberal capitalist economy, it can be seen that ideology *per se* is powerful precisely because it is both an imaginary representation of social and material relations and an actual lived relation to reality. Ideologies are thus like mimetic works of art in their dualism of illusory and real; they represent reality in a conventional and an historically contingent fashion. Modern art and scholarship are critical precisely to the degree that they interrogate or expose the ideological circumstances of dominant forces of political and economic modernization and consequent cultural modernity.

A CRITICAL SURVEY OF NINETEENTH-CENTURY ART

Taking their cue from contemporary artists and critics themselves, the authors of this book intend to consider nineteenth-century art critically—that is, to travel freely between the formal surface and the social-historical depth of works of art, architecture and design, and pay considerable attention to the space in-between. As a result, chapters include longer and more detailed examinations of individual artworks and careers

than is usually the case in books that survey nineteenth-century art. Without that close attention, the actual critical purchase of works of art on the social and material relations of their moment would be invisible. Artists, like everyone else, are human agents—they make their own history, though not under circumstances of their own choosing, in isolation from their fellows, nor apart from the ultimately controlling authority of nature. The devotion of whole chapters to Goya, Van Gogh, Seurat, Toulouse-Lautrec, and Cézanne, and large blocks of text to David, Courbet, Cassatt, Eakins and William Morris, is thus intended both to highlight the historical constraints these artists faced, and to expose the surprising extent of their artistic and ideological self-emancipation. Their critical purchase on modernity is exceptional and demands close attention.

The combined social-historical and monographic perspective taken in this book is found in many scholarly books devoted to individual artists and movements, but it has generally not been used in surveys of nineteenth-century art. The authors of most earlier survey texts, beginning with Julius Meier-Graefe (1904), Richard Muther (1907) and Léonce Bénédite (1910), and extending to Robert Rosenblum/H. W. Janson (1984) and Lorenz Eitner (1988), were empiricists in the sense that they based their research methods upon the model of investigations in the natural sciences. They proceeded by induction, collecting art historical data—artists' names and biographies, anecdotes, titles of artworks, genres and subjects, key dates, stylistic developments, and the documented responses of patrons, critics, and the public—and then assembled them into "long chains of deductive reasoning," in the words of empiricism's parent, Descartes, in the confidence that "there can be nothing so remote that we cannot reach it, nor so recondite that we cannot reach it, nor so recondite that we cannot discover it." Fritz Novotny's idiosyncratic volume for the Pelican History of Art (1960) generally conforms to this model. Although he frames his chronological survey (1780–1880) with references to the "spiritualization" of art in the hands of Immanuel Kant and Cézanne (in this he recalls Meier-Graefe), he nevertheless speaks of his own approach in purely scientific terms. For Novotny, scholarly (scientific) method and subject matter are perfectly merged, since he sees the nineteenth century as "defined [by] the study of the external appearance of nature. [It is] the century of Naturalism." John Rewald's History of Impressionism (1946; 4th revised edition, 1973)—though an indispensable survey of the events and personalities that belong to that movement—is similarly hampered by absence of consideration for the larger social and material forces that give meaning to the facts. Thus, in his introduction, Rewald approvingly cites the words of the nineteenth-century French political historian Fustel de Coulanges: "History is not an art, it is pure science. . . . Like all science, it consists in stating the facts, in analyzing them, in drawing them together and in bringing out their connections. The historian's only skill should consist in deducing from the documents all that is in them and in adding nothing they do not contain."

Naive empiricism, however, can only provide, in the words of the twentieth-century philosopher Max Horkheimer, "a sum-total of facts [which] is there and must be accepted," instead of the conscious and unconscious "activities of society as a whole." For the critical art historian interested in holism, a scientific approach functions as a kind of sieve which holds back from view the large social, economic, and political forces shaping and defining art production, while permitting, and obsessing about, only the formal, biographical, and patronage factors to pass before the scholarly gaze. Some recent surveys of nineteenth-century and modern art, to be sure, have taken a broader and more synthetic approach to their subjects.

In the introduction to Robert Rosenblum and H. W. Janson's *Nineteenth-Century* Art (1984; English edition Art of the Nineteenth Century), Rosenblum rejects "the purist tyranny of abstract and absolutist systems," insisting that "art historians should

be as flexible, various, and comprehensive as possible in their approaches, and be willing to consider anything from the history of technology to the abiding mysteries of genius and psychology as potentially illuminating their ever more vast subject." True to their words, Rosenblum and Janson are more inclusive than their predecessors in their near encyclopedic attention to diverse artists outside the established canon and in their wide-ranging discussions of the many sources and documents of art history. Among the relevant themes for study cited in his introduction, Rosenblum lists the Bible, opera, ballet, tuberculosis, syphilis, prostitution, and photography. Yet, however open-minded these authors are, their overall goal and achievement is similar to that of survey authors that came before: it is to construct a more or less unified art historical mechanism that functions noiselessly and without friction, and in which modern contradiction and superfluity—as well as totality—is as nearly as possible eliminated.

Rosenblum and Janson's signal achievement—notable as well in Petra ten-Doesschate Chu's Nineteen-Century European Art (2003)—was to have cogently discussed a considerable amount of Salon and academic art in addition to nowcanonized modern, and to have extended their purview well beyond France. They generally abstained, however, from making critical judgments, or from trying to identify the links between artworks and their ambient social or political contexts or networks. In his Modern Art, 1851–1929: Capitalism and Representation (1999), Richard R. Brettell is far more responsive to the insights of recent scholars and critics from outside art history. Eschewing biography and chronology and de-emphasizing the "movementbased history of modern art," Brettell offers a challenging collage of art historical themes, methods, contexts, and forms. His book takes seriously the Marxian aphorism, cited earlier, about the volatility of formerly solid traditions and institutions, and interrogates a very large number and range of works created from between 1851 (the year of the Crystal Palace Exhibition in London) and 1929 (the year of the public opening of the Museum of Modern Art in New York City and the stock market crash.) Unlike the art historian T. J. Clark, whose elegiac Farewell to an Idea-Episodes in the History of Modernism (1999) interrogates just a handful of paradigmatic works across nearly two centuries, Brettell recognizes that socio-economic modernization, cultural modernity, and modern art occurred in many different places and took many, varied forms.

In his ambitious and highly achieved series of books devoted to the *Social History of Modern Art* (1988–), Albert Boime has sought to include "the 'Salieris' [as opposed to the Mozarts] of the art world, the so-called mediocrities who have been ranked according to what only can be considered an arbitrary and even capricious standard." The statement, however, purports to a breadth that cannot possibly be achieved, even by so capacious and adroit a scholar as Boime: if the entirety of an epoch's cultural production is equally worthy of study, how can the project ever have boundaries? How can the writer avoid the historicist nightmare of simply re-presenting the entirety of the historical record—unchanged, undistilled, and endless? In addition, Boime would abjure the responsibility to which the art historian, of all scholars, must attend: the discrimination of major from minor, primary from secondary, instrumental from incidental, and critical from accommodating.

But by this relative indifference to formal quality, the social historian of art is guilty of throwing out the baby with the bathwater. By dismissing judgments of artistic and formal significance as merely "arbitrary" and "capricious," Boime is reverting to the empiricist (or neopositivist) position of dichotomizing content (seen as primary) from form (secondary). Boime himself undercuts this view in his introduction to the first volume of A Social History of Modern Art when he describes visual art as "essentially a language of signs that transmits ideas." Since all languages are social constructions, the formal language of art too must be imbued with social content. Far from merely reproducing pre-existing ideas, then, artistic form is an essential determinant of just

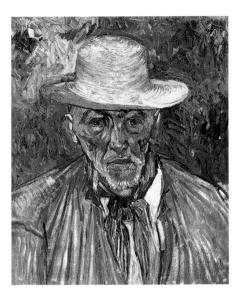

0.5 VINCENT VAN GOGH Portrait of a Peasant (Patience Escalier), 1888. Oil on canvas, $25^{3/8} \times 21^{1/2} (64.5 \times 54.6)$

what is expressed, and thereby plays a formative material role in the evolution of society and history. No mere obedient servant (even less, passive mirror) of ideology, artworks are one instrument with which humanity makes and remakes itself. In this way, formally innovative works of visual art may in fact be judged more significant than conservative ones because they played a greater role in bringing about (or, at least, compellingly addressing) historical change.

To many late nineteenth-century spectators in Paris, London, Berlin, Brussels, Chicago, and elsewhere, the innovative, modern art, architecture and design examined in this book was in fact an affront to dominant ideas and institutions. It was seen as a challenge to ruling ideas about hierarchy and value, and as the forward, cultural wedge of insurgent classes and communities. Modern art and design—which was, to be sure, only a subset of all the art created during a century of modernization—was often exhibited at popular venues: rented halls, pavilions, tents, expositions, artists' studios, bars, restaurants, and circuses. It was promoted by an intimate community of artists, designers, critics, and patrons, and seemed to represent at once longings for a past age when manufacture was artisanal not industrial, and dreams of a future time when craft labor would be voluntary, not forced by motives of need or profit. Modern painters, sculptors and designer, in addition, sought to establish closer connections between their works and the new, mass public than was possible at official venues, and to stave off the challenge posed by the new reproductive media that seemed to foreclose imagination and invention. These modern artists accepted as a matter of course what artists at the beginning of the century had struggled to achieve—freedom of thought and action—and tried to make their works an instrument for critical reflection and sometimes even for social change. This last especially proved chimerical, but the ambition—and the names Courbet, Van Gogh, Seurat, Morris and Toulouse-Lautrec are apposite here—reveals one more sense in which much nineteenth-century art may be called critical: to reckon with totality as did Goya and Ingres is one definition of critical; to attempt to change the world through art, as did Courbet and Van Gogh with 0.5 depictions of proletarian labor and peasants, is another.

This survey does not, however, focus only on modernist works. It includes for example, discussions of late Federal Period and antebellum painting and sculpture in the United States, Georgian and early Victorian English landscape etchings and engravings, Native American ledger art, and photography. In all cases, however, the art and material culture under review is seen to engage many of the same contentious political and artistic questions concerning modernization that arose in the first modern century but that still reverberate in our own; these issues include the value of local versus national, and popular versus elite cultures, industrialization versus environmental preservation, the question of the existence of a "canon" of great authors and artists, and concerns with the artistic representation of sexuality, social class, gender, and race. Nineteenth-century artists, like artists today, also confronted the emergence of new techniques for the mass-reproduction and distribution of their works, and the vexing question of the politics of public exhibition and museum display. In addition, artists were engaged with the forms and imagery of mass and non-European culture for example, with cartoons and caricatures, broadsides and posters, magazine illustration and advertisements, and with Native American, Oceanic and African art forms.

An insistence on the commonalities between art issues past and present may appear overstated, but the constellations are compelling. Indeed, we believe that if our texts stimulate consideration of contemporary issues concerning power, modernization, and the representation of class, race, and gender, they will have in fact succeeded in engaging more fully a nineteenth-century art in which there emerged a new historical and critical understanding of society and culture which we share today.

CLASSICISM AND ROMANTICISM

1

PATRIOTISM AND VIRTUE: DAVID TO THE YOUNG INGRES

THOMAS CROW

THE CULT OF CIVIC VIRTUE

N 1781, NO ONE IN FRANCE HAD THE SLIGHTEST IDEA **1** that a revolution would begin before the decade was out, an upheaval of every social institution which would not spare the traditional fine arts. But artists were ready in advance to overturn old norms and customs of art-making. Over the next eight years, the French public would confront a novel idea of the artist's vocation: no longer the dutiful servant of the state and the church who defines success in terms of official favor, the new-model artist (invariably assumed to be male) vaunts his independence from the dictates of royal patrons and postures of conformity; he speaks over the heads of insiders and bureaucrats to make contact with the large audience who thronged the spaces of the public exhibitions, the so-called Salons, which took place in the old palace of the Louvre every two years. By virtue of this appeal, the perceived character of this audience begins to change. Where it had been a floating and passive crowd, it becomes the embodiment of active public opinion, a palpable force with a role—even a dominant one—in determining the success of painting or sculpture.

This new common ground between artist and audience can be defined by two terms: patriotism and virtue. To understand them, however, it is necessary to reconstruct their specific power and use in the period. Patriotism did not carry the chauvinistic overtones which encumber the word today; nor did virtue connote a priggish or self-satisfied private morality. Devotion to the nation, to *la patrie*, represented a universalized allegiance to one's fellow citizens and to the idea of the general welfare, usually at odds with obedience to the dictates of the state and accepted social custom. The duty of the artist was to set an example of individual emancipation, to break free, at least subjectively, from government patrons who represented only a self-seeking minority. Nor was one's art to

be slavishly adjusted to the contingent habits and costume of one's country; to mirror one's compatriots as one found them would be merely to reproduce and endorse all the defects of an unequal society. An ideal was therefore required, and the republics of ancient Greece and Rome were called on to provide a counter-example to a corrupt present. An artist who could live up to these demands would thereby demonstrate a civic virtue worthy of comparison with the self-denying heroes of antiquity.

The philosophical and political debates of the 1760's and '70's had separated the inheritance of Classical antiquity from its normal role of providing symbols of authority and rule. In the previous century, Louis XIV had customarily been likened both to Alexander the Great and the sun god Apollo; Classicism was a catalog of pomp and magnificence. But in these years approaching the Revolution, Classical culture was more likely to call to mind a toughened citizensoldier or a stoic philosopher living in voluntary poverty with whom an ordinary Frenchman with some education might identify. The very words patriotism and virtue summed up this change.

This growing gap between the Classical tradition and the needs of the ruling order created a new space in which painters could operate. The artist who recognized this first and exploited it with the greatest power was Jacques-Louis David (1748–1825). In 1781, he was 33 years old, still considered a young and relatively untried artist. He had undergone the lengthy and laborious training required of any ambitious aspiring painter, which included years of long sessions devoted to drawing from prints, then from plaster casts of ancient sculpture, and finally from the live model. This sequence of study elevated the inheritance of Classical art over the direct evidence of living nature, which the young student could only approach once he had thoroughly absorbed an

idealizing abstraction. All of David's formal artistic education took place within the Royal Academy of Painting and Sculpture, which had been established under Louis XIV to organize and perpetuate a clear hierarchy of ambition and honor among artists. Only those painters capable of producing complex narrative compositions on Classical themes ('history paintings' as they were called) could aspire to the highest rewards that the state could offer.

The culmination of a successful youthful career, which David reached at the age of 26, was the Rome Prize. This gave the winner a scholarship period, lasting three years or longer, at the French Academy in Rome. There the best young artists were given their final induction into the great tradition, now surrounded at first hand by the remains of ancient art and the exemplary classicizing art of the Italian Renaissance. David had extended his stay for nearly six years, and when he returned in 1781 he seemed more than ready to take his place in the normal succession of history painters, one whose first loyalty would be to the established traditions of the Academy and its duty to embellish the aura of the monarchy.

His first painting for the Salon, however, began to probe the potential of traditionally Classical subject matter to exploit the new dissenting constructions of patriotism. He produced a large canvas on the theme of the blind Belisarius begging for alms. This character was the actual Roman general largely responsible for the Emperor Justinian's extensive conquests. According to legend, Belisarius became the victim of jealous intrigue at court. Falsely believing him guilty of treason, the Emperor ordered that he be blinded and dispossessed. In David's painting, an old soldier who had served in his victorious campaigns recognizes the fallen leader in his pitifully dependent condition. The painting amplifies this veteran's shock of recognition through the contrast between the magnificent triumphal arch, redolent of glory and rule, with the fall from glory enacted in a beggar's abject acceptance of charity from a passing woman.

The theme of Belisarius was not just any item from the catalog of ancient virtue. The writer Jean-François Marmontel had published a novel with that title in 1767, in which the exiled general is made to deliver lengthy monologues denouncing the social evils that his creator believed were eroding the vitality of the French state: official religious intolerance, a parasitical nobility, the reign of luxury over civic virtue, and the domination of favoritism over merit. Eventually, the sanity of his message induces the mighty again to seek his counsel: Justinian himself comes in secret, in the company of his heir Tiberius, to listen to his once and everfaithful general, who can no longer see him.

This hopeful parable of the ruler coming to his senses was not ungrounded in political reality. Marmontel's embattled novel had attracted the support of certain embattled state officials who believed that reform was necessary in order to put the French monarchy back on secure social foundations. The character of Belisarius thus provided David with a means to put his feet in two camps at once: both that of dissenting patriots outside the corridors of power and that of a small group of reforming bureaucrats who were themselves isolated and on the defensive within the government. David needed to appeal to this latter group, as it happened to include the administrator responsible for the Academy and the visual arts. David obligingly put his stress on emotions of pity and sentimental regret, his hero's miscry and its contrast with an exalted former state constituting a mute appeal for a renewal of lapsed royal benevolence—and nothing more incendiary.

A CALL TO ORDER

The success of the *Belisarius* with both camps demonstrated how the Salon exhibitions, with their free and open access to everyone, could put vivid images of the virtue of the ancients into public circulation. The reduction of a complex story to a few figures and eloquently simple gestures was itself viewed as a reproach to the profusion of subsidiary figures and ornament in older academic art, which seemed more about the vanity of display than the communication of moral truth. In terms of David's career, it had the effect of securing the first of a regular succession of state commissions for large-scale narrative paintings: he had arrived as a history painter.

With that arrival came a large number of students attracted by his synthesis of daring political allusion with impeccable command of the Classical tradition. While aspiring artists received their formal training in drawing at the Academy, they acquired their practical instruction in making paintings in the studio of an individual master. David had served his apprenticeship with the most rigorous Classicist of the older generation, Joseph-Marie Vien. With his own students, he took devotion to the example of the ancients beyond strictly artistic concerns to include the philosophical and practical organization of studio life as a whole. In contrast to the authoritarian hierarchy observed by other masters, David encouraged a far more open, egalitarian atmosphere. At a time when most young artists abandoned formal education in their early 'teens, he laid down the requirement that all of his students know Latin and thus have independent access to Classical learning. His studio, rather than the hidebound Academy, would provide their primary locus of intellectual discussion and moral identity. Together they began to act on the belief that modern French artists could behave as had the artists of the Greeks, who (so it was argued) were granted creative liberty and thus were inspired to express the ideals of their communities in perfected physical form.

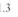

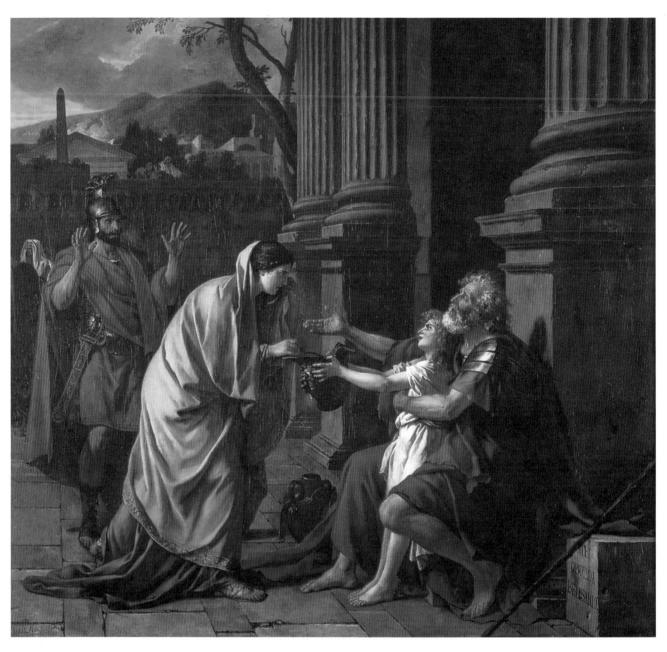

1.1 JACQUES-LOUIS DAVID Belisarius Begging Alms, 1781. Oil on canvas, 9'51/8 × 10'27/8 (287.3 × 312.1)

In a short time, David's studio began to preempt the functions of the Academy. When his most favored apprentice, Jean-Germain Drouais (1763-88), came to compete for the Rome Prize in 1784, both master and pupil treated the result as a foregone conclusion. When Drouais was predictably successful, they effectively declared themselves independent of the state by financing the journey from their own resources. The bond between them was so tight that David accompanied him to Rome and remained for nearly a year. Two other students also made the trip, so that something of the same close-knit studio environment could be transferred to Italy.

During his time in Rome, he completed, with Drouais's assiduous assistance, the work that would give him his breakthrough to dominance over French painting for the rest of his long life: The Oath of the Horatii Between the Hands of 1.3 Their Father (1785). His subject matter came indirectly from the seventeenth-century tragedy *Horace* by Pierre Corneille, a touchstone of Classical drama known by any educated French person in the way that Hamlet or Macbeth would be known in the English-speaking world. The narrative of the play concerns the triplet champions of early Rome, summoned to settle the war with neighboring Alba by combat with that

1.2 JACQUES-LOUIS DAVID The Oath of the Horatii Between the Hands of Their Father, 1785. Oil on canvas, 10'97/8 × 13'111/4 (329.9 × 424.8)

city's champions, their own cousins, the likewise triplet Curiatii. In the tangled ties of kinship that gave Corneille his tragic material, the wife of the youngest Horatius, the only warrior of the six to survive, was sister to the Curiatii, while his own sister, Camilla, was betrothed to one of his victims. She became one in her turn when Horatius finds her mourning her beloved and kills her on the spot.

As fixed in a surviving preparatory drawing, the subject which had been assigned David was the father of the clan successfully defending his son before the Roman people for the latter crime. This is a free adaptation of Corneille's final scene, where the elder Horatius pleads for his son's pardon before the king of Rome. But the final composition does not depict the event described in his commission. The defense of the murderous victor is forgotten; the new subject is a pledge by the three sons to triumph or die for the honor of Rome, an

event imagined by the artist to have occurred before the fateful combat (this oath appears nowhere in the play or in any of Corneille's ancient sources). In order to equal the visual impact of any other painting in the Salon, he enlarged without permission the previously agreed dimensions of the canvas by fifty percent.

Thus David was also taking over responsibility for setting the scale and subjects for his paintings, despite their being paid for by the state. This went hand in hand with calculated defiance at the level of style. His invention of the oath-taking allowed him to distill the complexities of the story into a striking unity, an almost primitively elemental configuration of bodies. It would demonstrate how much strength history painting could gain from an austerity of means that seemed at one with the stoicism of these early Romans. At the same time, David took advantage of the inherent problem faced by

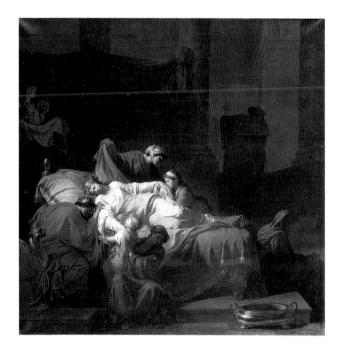

1.3 PIERRE PEYRON The Death of Alcestis, 1785. Oil on canvas, $10'8 \times 10'6 (327 \times 325)$

history painters in communicating to the Salon audience from the heights of the room (all large canvases were hung near the distant ceiling, as can be seen in contemporary engravings). Like no one else's painting, it would beam its narrative across the spaces of the crammed exhibition, and leave its starkly calligraphic configuration of male bodies as a permanent image in the memory of its viewers.

The abrupt transitions and dialectical sharpness of the new painting, its austere and declamatory voice, stood in pointed contrast to the intricately embellished pictorial rhetoric of his academic colleagues. An example would be The Death of Alcestis, shown in the same Salon by his principal rival Pierre Peyron (1744–1814), whose theme, taken from the drama of Euripides, is a wife's self-sacrifice so that her husband might live. David's innovations made Peyron's compactly interwoven grouping of figures, emerging from a darkened, softening atmosphere, seem a thing of the past, too subtle and selfinvolved to make an impact in the civic arena. That David retained a similar mode of composition in his self-contained group of female figures, but exclusively there, made the contrast all the more emphatic.

David's withdrawal from Paris and his gathering of the independent forces of his studio helped strengthen his resolve to overturn the accepted conventions of narrative in painting. The impact of the painting is inseparable from its violations of his audience's habitual expectations as to how such a scene should be organized. It implicitly rejected the developed compositional skills of generations of academic painters. To press all of the figures into the same foreground plane, to join the male and female groups with no mediating transitions or mutual recognition between them, to offer no release into deep space beyond the starkly symmetrical colonnade—by every contemporary standard, these were all daring and dissonant simplifications.

It was through this rhetoric of style that David's painting spoke most forcefully to feelings of patriotic discontent with the established cultural order. In the eyes of its admirers, its harsh notes and impatience with compositional subtleties elevated the mind and moved private emotions away from center stage; the pride and inflexibility of the early Romans, so foreign to modern mores and so telling a reproach to them, had come alive on canvas.

THE ENTERPRISE OF WOMEN

The initiatives of David and his group depended on a large and secure level of state subsidy for history painting, the sheer scale of which left room for dissenting gestures. Such support had been in place for no longer than a decade. Previously official sponsorship of the highest genre had been more often a matter of lip service rather than actual funds; artists relied on income from private commissions for portraits and decorative works. From 1775 onwards, however, the ambitious male talents of the new generation were drawn into the production of highminded (and usually mediocre) public paintings, and this left a vacuum in the other genres of art. Almost instantly a cohort of talented women came to the fore. The year 1783 saw the admission of two women to the Academy (there were places for only four)—Adélaïde Labille-Guiard (1749–1803) 1.6 and Elisabeth-Louise Vigée-Lebrun (1755–1842). In terms of 1.4 both quality and patronage at the highest levels, they would go on to dominate portraiture during this final decade of the Old Régime—including portraits of the royal family, which were virtually equivalent in status to Classical history paintings.

The latter artist, 28 years old at the time of her reception, had the easier path to recognition. Her father, Louis Vigée, had been a portraitist and teacher in the lesser Academy of St. Luke (the survivor of the old artists' guild). By the age of 15, her precocious talent was attracting well-born and wealthy clients, and in 1779 she sealed what would be a continuing relationship with the young Queen Marie-Antoinette. She married a successful art dealer, J.-B.-P. Lebrun, and conducted herself as a significant figure in society, presiding over her own soirées and attracting regulars from the upper spheres of Parisian culture and state administration. The reigning tone was one of elegant simplicity on antique models.

Vigée-Lebrun and David maintained a wary social relationship; the latter's education and style made him a natural

colleague, but his patriotic commitments occasionally caused him to recoil from her cozy alliance with the royal house. Her portraits indeed served as a medium for the incorporation of certain Enlightenment attitudes into the style and selfimage of the ruling elite. She moved the genre away from conventional attitudes and costume intended to convey rank and station, toward a cultivated disdain for affectation and a corresponding emphasis on individual feeling. Her selfportrait with her daughter (1789) set a kind of standard in this new pursuit of innocent candor. In it she defines herself in terms other than those of her energetic professional prowess. The clothes are simple and unpretentious; they belong to no precise social location but serve to suggest an imaginative community of grace and feeling; the natural freshness of skin is at one with the natural spontaneity of the embrace.

The compression and intertwining of the two figures into a compact oval at the same time represents a survival of one of the favorite devices of Rococo decorative artists from the early decades of the century: a familiar old form is made to perform a new duty. And Vigée-Lebrun's version of the natural is characterized throughout by a reassuring consistency and absence of the unexpected. Having already demonstrated that sort of reliable performance early in her career, she was handed one of the most important and most delicate public commissions of the 1780's.

This was not a didactic history painting, but a state portrait of the Queen with her children. By the middle years of the decade, Marie-Antoinette had become a focus for popular resentment against state policies and the government's endless crisis of indebtedness. A tide of published political dissent took delighted advantage of her reputation for unprincipled extravagance and scandalous public behavior, particularly in the company of her rakish and reactionary brother-in-law, the Comte d'Artois. Vigée-Lebrun's portrait displays the traditional pomp of regal portraiture, provided by the setting in the Versailles Palace with the magnificence of the Hall of Mirrors visible to the left. The Queen's pose is properly upright, and the artist has arranged the group into the solid pyramid ordained by the most sanctified academic teaching. That seriousness of bearing and self-presentation was crucial in the intended effect of the painting, in that the King's foreign wife was widely seen to have distracted the amiably simple monarch from his paternal devotion to the nation.

The portrait's stress on her role as mother was meant to answer further charges that she had failed in her conjugal duties. The studied precariousness of the baby's seat in her lap, flanked by gestures of loving emotion from the older children, was designed to show the Queen as not only having grown into her role as mother to the royal heirs but as being a

good mother in the natural, nurturing manner celebrated by the eighteenth-century cult of sensibility. It was no fault of the artist's competence in rendering this balancing act that the state, out of fear of a negative public response, withheld the portrait from the official opening of the Salon of 1787. Any positive benefit was annulled in the general ridicule, and the empty space in the hanging was quickly equated with the looming fiscal deficit. Vigée-Lebrun herself left France at the first outbreak of the Revolution and found an eager clientele at princely courts throughout Europe.

The career of Labille-Guiard followed a substantially different course from that of her more luminous rival, and it demonstrates the widening options that opened up (albeit grudgingly and briefly) to women artists during this decade. She was six years older and had received her most important training from a history painter, F.-A. Vincent, rather than a specialist in the portrait genre. She achieved a rank not unlike Vigée-Lebrun's, in 1785 becoming portraitist to Mesdames, the King's unmarried aunts, but her sense of vocation displayed a greater intellectual and professional gravity.

This she projected with confidence and conviction in the self-portrait which she submitted to the Salon of 1785. At 1.6 over six feet in height, the canvas presents her on a queenly scale of her own. Instead of any comforting domesticity, she

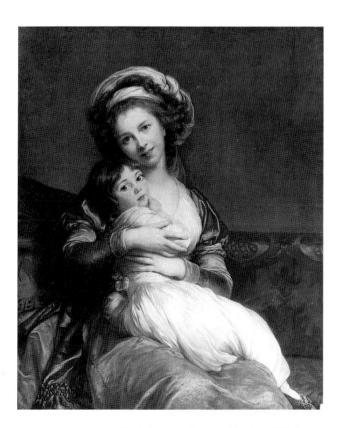

1.4 ELISABETH-LOUISE VIGÉE-LEBRUN Portrait of the Artist With Her Daughter, 1789. Oil on canvas, $41\frac{3}{8} \times 33$ (105 × 84)

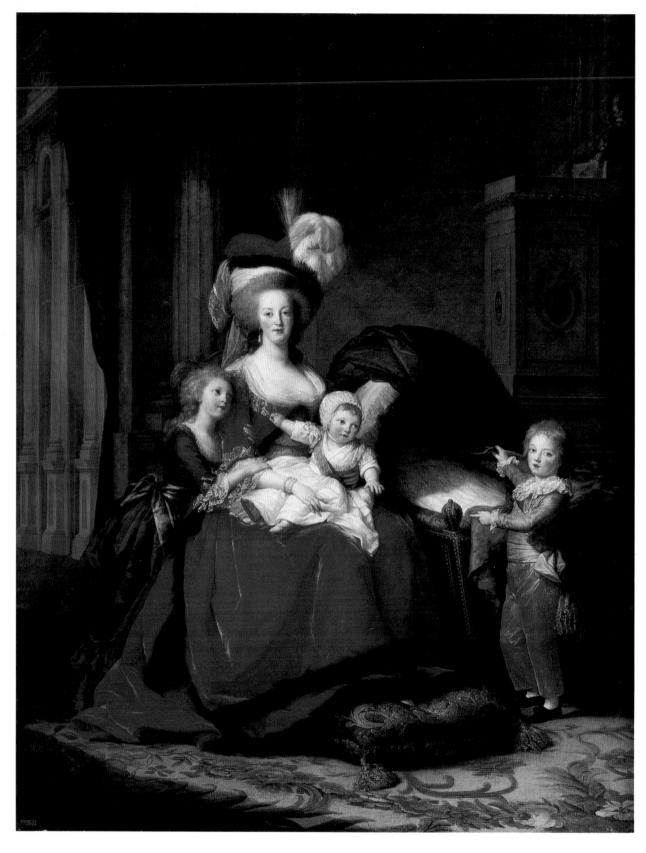

 $\textbf{1.4 Elisabeth-Louise Vigée-Lebrun} \ \textit{Marie-Antoinette With Her Children}, \ \textbf{1787}. \ \ Oil \ on \ canvas, \ 9'1/4 \times 84\% \ (275 \times 215)$

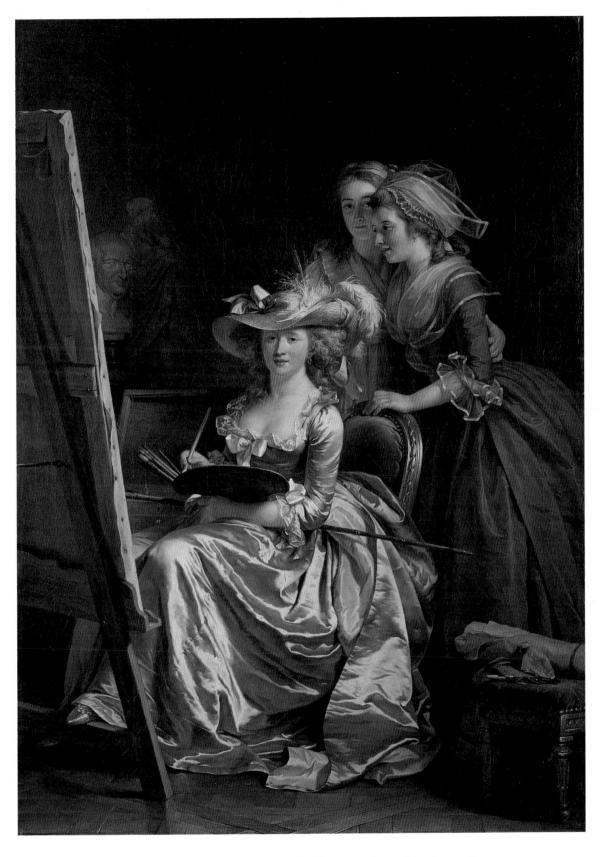

 $\textbf{1.6 Ad\'ela\"ide Labille-Guiard} \hspace{0.2cm} \textit{Self-Portrait With Two Pupils}, \hspace{0.1cm} \textbf{1785}. \hspace{0.2cm} \textbf{Oil on canvas}, \hspace{0.1cm} \textbf{83} \times \textbf{59}^{1/2} \hspace{0.1cm} \textbf{(210.8} \times \textbf{151.1)}$

adver-tises herself as already a teacher and master of her genre: two attentive students hover behind her chair. The setting is unabashedly a place of work, as the prosaic stretcher bars and tacked canvas make plain. A sculpted bust of her father in the severe Roman mode (from an actual work by Pajou) looks on, but no living male intrudes on the studio's enterprise. This would have been a point of some importance to the artist, since both she and Vigée-Lebrun were subject to the slander that men had actually produced their paintings, a back-handed but galling tribute from a sexist culture. Labille-Guiard's link to Vincent remained intimate—they would marry in 1790—so she was especially vulnerable to this reflex suspicion. The finery of her dress and hat, perhaps incongruous to modern-day eyes, would have been deemed an expected and correct outward sign of status and accomplishment. At the same time she encourages a worthy simplicity in the dress of her students.

This self-portrait stands as a reminder that enlightened pedagogy as a feature of the artist's new intellectual independence was not necessarily limited to the erudite pursuits of male Classicists. Labille-Guiard herself took a sympathetic part in the coming Revolution and painted one of the few known portraits of Robespierre.

THE CIRCLE OF MEN

After his return from Rome, David was some time in reorganizing the collective work in his own studio. A combination of injury, illness, and indecision prevented him from making a start on an equivalent successor to the *Horatii*, though he had a royal commission in hand. In the end, he capitalized on new friendships in order to keep his name before the public at a lower cost to his time and resources but with little or no lessening of impact.

Early in 1786, a wealthy young jurist named Trudaine de la Sablière, a scion of one of the country's most distinguished families of royal administrators, presented himself as the patron of David's *Socrates at the Moment of Grasping the Hemlock* (1787). He paid more than handsomely for the honor of commissioning it: 7000 livres to begin with, according to one report, augmented to 10,000 livres in the end as an

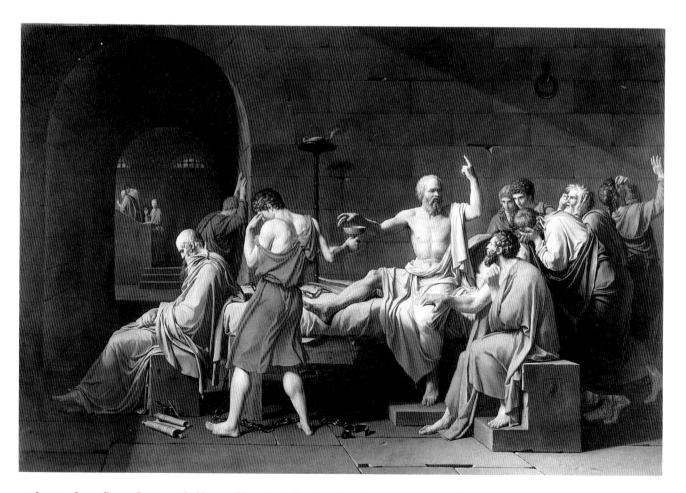

1.7 JACQUES-LOUIS DAVID Socrates at the Moment of Grasping the Hemlock, 1787. Oil on canvas, 511/8 × 771/8 (129.9 × 195.9)

1.8 Jean-Germain Drouais The Dying Athlete, 1785. Oil on canvas, $49\frac{1}{4} \times 71\frac{3}{4}$ (125 × 182)

expression of his delight with the results (this for a cabinetsized picture when the state was paying only 6000 livres for a full-scale historical canvas like the *Horatii*).

The story comes from the writings of Plato, who had been a student of the martyred philosopher, and more recently from a retelling of the suicide by the French *philosophe* Denis Diderot. Despite its stark prison-setting and theme of self-sacrifice, the *Socrates* calls into question the tendency to classify all of David's history paintings of the 1780's under the heading of an austere and militant virtue. His formal choices were made within a rhetorical conception of painting, one in which style was less the mark of an artist's unique personality and more a considered adjustment to the demands of the subject matter and the occasion. This smaller canvas, offered as an emblem of personal friendship, called for a more harmonious and interwoven compositional order.

In philosophical terms, it is a more complex theme than the tale of the *Horatii*, emblematizing subtle constitutional and moral questions in place of Corneille's broadly brushed nationalist legend. It catches the ambivalence Trudaine

would display toward any expansion of the principle of free expression to incorporate popular participation in political life (he would go to the guillotine in 1794 for that reluctance). The suicide of Socrates is the result of a prior and more fundamental renunciation of political action under conditions of democratic sovereignty: from the moment of his indictment forward, he accepts without resistance the judgment of the democratic assembly the better to reject the legitimacy of the authority behind it. What more fitting purchaser to have than the man who would go on to translate the American *Federalist Papers* into French, including James Madison's strictures against unrestrained factions and the potential "tyranny of the majority" in democratic legislatures?

The treatment of the male body is also changed from the strained austerity of the *Horatii* in a way that corresponds to masculine bonds in Greek society and in Platonic thought. The figure of the anonymous cupbearer—in its scale, placement, color, and sensual attractiveness—functions as a balancing element of the composition equal in weight to the figure of Socrates himself, a Ganymede assisting at the

1.9 Jean-Germain Drouais Marius at Minturnae, 1786. Oil on canvas, $9' \times 12'2$ (274.3 \times 370.8)

passage to immortality. In Plato's account of the suicide, the jailor bearing the poison is only a minor, anonymous presence, but this prominence given to the physical for its own sake evokes another facet of Plato, one in which the contemplation of the beautiful male body is enlisted for the purposes of enlightenment. The speeches of the participants in Plato's Symposium describe the contemplation of the beautiful male adolescent by the mature citizen as a potential means to lead the mind upward from the realm of the sensual to an understanding of universal good. Though Socrates is allowed his "philosophical" refusal of the sexual seductiveness of Alcibiades, there is a great deal of humorous carousing and delicious reminiscence of erotic feeling on the part of the wealthy Athenians present. And in the end the sexual abstinence of Socrates is meaningful only because of the palpable desire stimulated by the proximity of the beautiful male beloved. In David's painting, Socrates reaches for the cup and for the boy in the same gesture.

Later, in his monumental history painting *Leonidas at Thermopylae* (1814), David would put on display his under-

standing of the central place held by same-sex *eros* in the warrior culture of ancient Greece. The *Socrates* likewise is meant to be a Greek painting, not a Roman one, imbued with a sophisticated scholar's appreciation of "Greek love." Trudaine was the center of a circle famous for both its intellectual sophistication and its lavish entertainments; it was a milieu in which the serious pursuit of political wisdom was bound up with the cultivation of a lightly carried erudition amid multiple temptations of the table and the bed. David plainly enjoyed the attention of this company, and his painting is a tribute to and document of one ideal of leisured, disinterested masculine fellowship, which had many points in common with Plato's. And the beauty of the *Socrates* is how many of these points it manages to touch within such a compactly legible image.

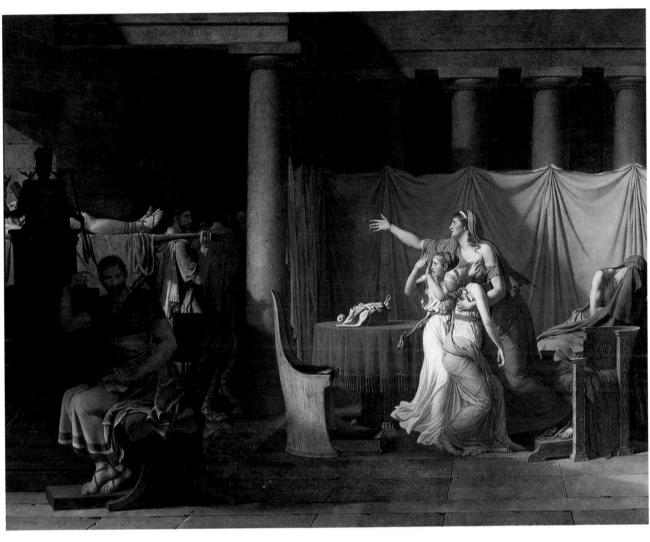

1.10 JACQUES-LOUIS DAVID Lictors Returning to Brutus the Bodies of His Sons, 1789. Oil on canvas, 10'71/8 × 13'101/8 (322.9 × 422)

A VIOLENT PATRIMONY

Despite the distractions of such erudite and worldly company, David's most important bonds remained the working relationships of the studio. A new arrival, the twenty-year-old Anne-Louis Girodet (1767–1824), painted a number of the background figures in the *Socrates*, and other talented students were in the wings. But David's aspirations for his group—and for many observers the hope of French painting—were centered on the distant Drouais, who was engaged in his own struggle to assert his independence against the constraints imposed by the French authorities in Rome. In practical terms, however, a lone student isolated in a foreign environment was dependent on the Academy, and his earliest Roman painting conformed to the first of its requirements: a painted study of the male nude to be submitted to the judgment of the academic

elders back in Paris. Barred by entrenched authority from devoting his talents to the highest genre of narrative historical painting, he set about elevating this obligation to the same exalted plane.

Drouais's *Dying Athlete*, completed in 1785, transformed the balanced studio pose on which it is based into a tense internal drama. As depicted, the wound is all but invisible, but the entire body is organized to mark the spasm of pain that energizes the figure. Although the body as a whole seems fully drawn out along its continuous lower contour, it is in fact twisted unnaturally at the center along a harshly incised transition. Its languid extension is violated at the center of the torso in a contraction that reads as an involuntary one of pain. The raking light further throws that area into shadow so that the body is divided by zones of light and dark as well as by its disposition in space. The light is the zone of control; despite the wrenching pain, the warrior's reaction to it is

limited to the dark zone; he resists and contains it so thoroughly that the overall composure of his figure is undisturbed. The effort it costs the warrior is registered in the contrast of the supporting right hand with the left. What had been no more than the model's fatiguing effort to maintain the pose, becomes an inner determination to hold the body upright to the end, to refuse collapse into unconsciousness.

This is the mark of the hero, and it is meant to enlarge the aura of heroism beyond exploits of the fictional warrior to take in the suffering artist's achievement as well. After Drouais, it would become a pattern for young artists to use the single male figure as a primary focus for their early ambitions and self-definition as artists. They would develop its potential as a carrier of complex meaning far beyond anything their elders had attempted at the same stage of life. But Drouais was also impatient to test himself directly against his master's example. With David's encouragement, he worked in secret, neglecting his obligatory student work in order to throw himself into a project beyond his years and station, one plainly intended for the public arena of Paris.

The subject which they chose together was a moment in the life of Gaius Marius, a general and consul of the late Roman Republic. This episode comes in fact from the decline of Marius' career into corruption and tyranny. Under a sentence of death by the Roman Senate, he faces down his executioner by the sheer force of his presence; in the next moment the soldier drops his sword and flees. The malign side of the "hero" is not, however, immediately apparent, resembling as he does the severe but benevolent patriarch of the *Horatii*. Its minimalist pairing of two soldierly male characters extended David's Corneillian esthetic—the dialectical sharpness, abrupt transitions, self-aggrandizing utterance, and singleminded stress on pride and inflexibility in the mores of ancient Rome—to a degree that eliminated even David's small allowances for prevailing taste.

But the Marius (1786) at the same time reveals something of the tense emotional and psychological interplay between the two artists. It is figured most of all in the cloak with which the young soldier shields his face, which Drouais uses as a device to turn his painting diametrically against its model in the Horatii. The theme of the latter painting was one of solidarity between the generations, the authority of the father passing to his sons along with the swords: David's heroes were engaged in rapt attention to the tense point of contact between them, and the vision of the spectator was vicariously engaged with the same intensity. But when that same spectator puts himself or herself in the place of either protagonist in the Marius, the effect is blindness and isolation. The deceptively noble face of Marius was one that Drouais refused to contemplate; he put an abyss, a cancellation of vision, between that implacable visage and himself.

This simultaneous affirmation and denial, vision and blindness, left unresolved at the heart of the painting, and all the visible signs of the strain involved in controlling the refractory materials that went into its making, worked in the end to its advantage. Despite its moral ambiguities, the impression it conveys of a bristling, barely contained energy could readily be understood as the sign of virtue condemned to perpetual struggle in an unjust society. When the Marius was put on display in the Drouais family home in the early spring of 1787, public response was wildly enthusiastic. The painting was capable of creating the excitement of a Salon triumph without the necessity of a Salon. Thomas Jefferson joined the stream of spectators and came away overwhelmed by the experience: "It fixed me like a statue a quarter of an hour, or half an hour, I do not know which, for I lost all ideas of time, even the consciousness of my existence." The intensity of the painting, which is in large part a result of its unresolvable contradictions of meaning, temporarily banished rational reflection from at least one spectator otherwise eminently capable of it.

Drouais never had the opportunity to overcome this anxiety of influence in a comparable painting, nor could he fulfill the hopes of his Parisian admirers. Early in 1788 he died of smallpox while still in Rome. His death at the age of 26 was widely ascribed to his zealous overwork in pursuit of ideal artistic virtue; David was inconsolable. Those unrealized expectations and the circumstances of his death were romanticized into legend that had a powerful effect on several generations of young artists who followed him. Like him, they would want success early and on terms guaranteed not by training and experience but by special inner qualities which set the artist apart from the routine existence and dulled perceptions of others. It would henceforth be the burden of the modern artist perpetually to be called on to demonstrate that exalted state.

TRAGEDY AND THE REPUBLIC OF EQUALS

There was an unintended coincidence between David's grief over the loss of a virtual son and the theme of the painting he was preparing for the Salon of 1789, and this surely made his engagement with the subject even more intense. In his Lictors 1.10 Returning to Brutus the Bodies of His Sons, the hero is the founder of the Roman Republic, Junius Brutus (namesake of Caesar's assassin), as he might have received the beheaded corpses of his two male heirs, executed at his own order for treason against the new political order. It was through the blood ties of their mother, who was related to the expelled king, that the two sons had been enlisted in the plot to restore

1.11 JEAN-BAPTISTE REGNAULT Lamentation of Christ, 1789. Oil on canvas, $13'11\frac{3}{8} \times 91\frac{3}{4} (425 \times 233)$

the monarchy. Under the law that Brutus had himself brought into being, a sentence of death was mandatory, and the law obliged him to deliver it and to witness the execution.

1.12

Like the *Horatii*, the painting concerns the rigor of a father who must contemplate the sacrifice of his male offspring for the good of the country. But where their end in the former is heroic, here it is ignominious. And David exploits an even starker syntax of disassociation in order to call the categories of male heroism into question. The immobile central actor vacates the center of the composition and sits in a shadowy corner; other key elements of the action are likewise scattered to the sides of the canvas, most conspicuously the griefstricken female nurse at the far right. One great gap occupies the center; across it, the opposition between male and female, between clenched angularity and supple, curvilinear form, verges on disassociation. Meaningful connections are made not so much in the actions and expressions depicted, but rather in the mind of the viewer, which is activated by the gaps and silences between separate and distinct elements. The formal dismemberment of both composition and surface becomes not only means but metaphor, for the dismemberment of Brutus' sons is the unseen event which defines all of the living figures, and the dismemberment of the family unit—glossed over in the *Horatii*—is its consequence.

By virtue of its disruptions of normative order in technique and composition, the painting can be decidedly ambivalent about the costs of the hero's political resolve. The grieving women as a group (who alone catch the light), the unheard protest of Brutus' wife (whose outstretched hand stabilizes the entire composition), are treated with as much if not greater sympathy. The painting allows room for both halves of the Greek historian Plutarch's famous judgment on his action, that it "cannot be sufficiently condemned or sufficiently praised," that Brutus' character was at one and the same time "that of a god and that of a savage beast," which is to say, simultaneously above and below the human community. It encompasses a truly tragic recognition that the social body can come into being only by means of a temporary transgression of the condition of humanity itself; and as the existence of society violates the continuum of nature, so nature will have its revenge.

David's *Brutus* may be the closest the art of painting has ever come to rendering tragedy in its own, pictorial terms

1.12 ANNE-LOUIS GIRODET *Pietà*, 1789. Oil on canvas, $11' \times 92^{1/2}$ (335 \times 235)

1.13 ANNE-LOUIS GIRODET The Sleep of Endymion, 1791. Oil on canvas, 1938 × 24½ (49 × 62)

rather than merely illustrating those of the stage. At the same time, however, it questions one of the fundamental assumptions of tragic drama going back to Aristotle: that great passions are the property of the well-born. The nurse, isolated at the far edge of the composition in her own private world of sorrow, is the chief formal and thematic counterweight to Brutus himself. The tension visible in her jawline, neck, and shoulder, the lean and austere grandeur invested in her body, oppose the smooth, uninflected rendering of Brutus' wife, making the response of the noble matron seem somehow histrionic and inadequate by comparison.

The power of that figure becomes even more striking in the light of evidence that it was not painted by David but by a new recruit to the studio, François Gérard (1770–1837). Likewise, as crucial a detail as the head of Brutus may have been painted by Girodet. In any event, the two young painters had been drawn into an intimate collaboration parallel to that between

David and Drouais on the *Horatii*. It is today an old-fashioned expression to refer to the students or followers of an artist as constituting a "school." But it is important to restore the basic meaning of the word in this instance: no less than the circle of Trudaine, David's studio had become a place of collective learning and experiment within the Classical tradition, but with the added pressure and risk of a high-stakes project to be accomplished and tested in public. And the practical character of their interaction generated a different kind of art, an interrogation of the idea of civic virtue which is a world away from the comfortable philosophical pieties of the *Socrates*.

These were lessons to which Girodet in particular was attending—the concentration of bodily eloquence within contours of a compact geometric simplicity, the evocation of inexpressible sorrow and loss through absence and a drastic reduction of pictorial incident. Through his aristocratic

FIGURES OF REVOLUTIONARY VIRTUE

family he gained a commission, unusual for such a young artist, to paint a large-scale work (111/2 feet in height) on the subject of the Virgin with the dead Christ. In so doing, he was responding to the other major event of the 1789 exhibition, which had seen something of a revival (temporary of course) in large-scale religious painting. Twenty-one canvases, more than half of those in the "historical" category, had been commissioned by the state or by various church bodies on Christian subjects. A Lamentation of Christ by Jean-Baptiste Regnault, a state commission intended for the main altar of the chapel at Fontainebleau, received the largest share of attention before the late arrival of the Brutus. Enthusiastic admirers in the press found much to praise in the contrast between the shadowed background with its suggestive mystery and the vividness of the foreground group of figures with its startling juxtapositions of color and unsettling naturalism in the treatment of Christ's body.

1.12

Girodet's painting was on a directly analogous subject and was almost as large. His conception both pays homage to Regnault, his master's rival, and challenges him in the Davidian terms of austere rhetorical grandeur. The shift in subject from the public scene of deposition and lamentation to the private mourning of the Virgin allows him to reduce the elements of the story to a laconic minimum. Like Drouais's Marius, it plays its two highlighted figures, marked by vividly saturated hues, against a large field of indistinct gloom penetrated by a narrow beam of illumination. For both fledgling history painters, this device allowed them to avoid the complications that come with a large complement of figures and at the same time gain the instant sense of gravity and profundity conveyed by darkness and isolation. Even more than Regnault, he has forsworn obvious Christian symbols; there are virtually none in the painting. The accessories are Classical or natural: shroud, sarcophagus, cavern, dawn. Girodet has fused the bodies of Virgin and Christ into one continuous outline, a union of life and death expressed in basic bodily terms. And the open expression of sorrow in Regnault's Virgin is transformed into a veiled inclination of the head, the eyes in shadow, the neck conforming to an oppressive horizontal line, in a direct echo of the veiled form of Brutus' grieving servant.

But for all of the painting's indebtedness to rhetorical ideas present in the *Brutus*, the moody gloom and quiet of Girodet's *Pietà* represented a marked departure from what anyone would have expected of the Davidian group. It was a precocious and risky painting, particularly in its effective manipulation of a vast area of virtually featureless painted surface, and was as impressive in its way as Drouais's *Marius* had been. In a Classical manner, Girodet boldly carves his signature in a fictive inscription at the foot of the sarcophagus, proudly appending his age of 22.

The curtailment of religious painting was but one effect of the changes in the French art world set off by the taking of the Bastille in 1789. David and the painters in his circle were sympathetically engaged with the Revolution from the start, but decisive changes in their art were slow in coming. Reformminded artists in Paris put their initial energies into a drive for egalitarian reorganization of the Academy, including open access to the Salons. The first important artistic innovation would take place in Italy rather than France, generated out of the momentum established in David's studio in 1789.

Girodet, having won his Rome Prize, left Paris in 1790 determined to extend the independent identity he had staked out in his *Pietà*. In order to live up to the ideal of precocious genius, he had to contend not only with David's powerful influence on him, but with Drouais's example as well. The intransigent attitude he displayed in Rome, his expressions of contempt for the Academy and its teaching, followed the path laid down by his late colleague. And like Drouais, he had to manifest that resistance while meeting the requirement that he paint the male nude. How then was he to imitate Drouais's example of independence and his transformation of the academic nude into an emblem of that independence without falling into a dependent imitation of his predecessor?

He found his subject in a realm of mythology far removed from the vigilantly martial world of David's and Drouais's Roman heroes. His painting, completed in 1791, depicts Endymion, the beautiful boy with whom the moon goddess Selene fell into desperate infatuation. In some accounts she put him into perpetual sleep so that he would always be available to her nocturnal visits. Girodet has rendered her as immaterial moonlight, whose passage through the overhanging branches is facilitated by a smiling figure with the combined traits of Eros and Zephyr.

He stated repeatedly, in letters written during and immediately after his work on the picture, that this was to be a work owing absolutely nothing to David's example and that he would spare no effort necessary to achieve this independence. It is difficult to cite a prior instance in which that very modern form of youthful rebellion is expressed so vividly and insistently by an artist. And he evolved its form through what amounts to a systematic reversal of almost every one of the salient traits of Drouais's prototype in the Dying Athlete. The athlete had been tense, maximally alert, disfigured, and suffering, yet ready with his weapons. Endymion, by contrast, is drained of tension, never conscious, physically flawless, and in a perpetual state of bliss, with weapons discarded in the foreground. The hard daylight delineated the body of the athlete with an unnatural clarity; the soft moonlight envelops the body of Endymion with a diffuse but entirely natural obscurity.

.13

1.8

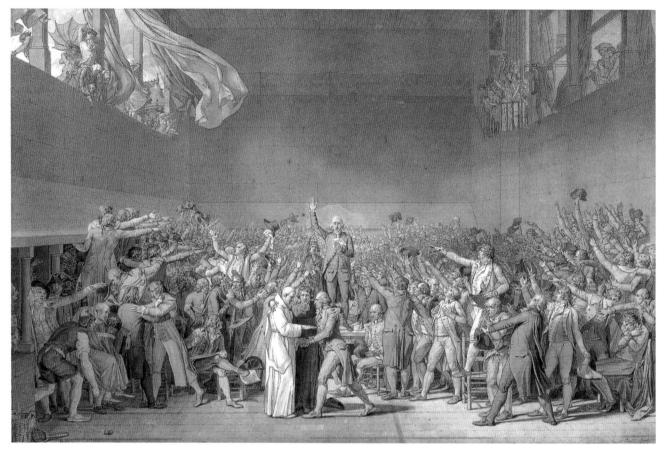

1.14 JACQUES-LOUIS DAVID The Oath of the Tennis Court, 1791. Pen, bistre wash, and white highlights on paper, 26 × 413/8 (66 × 105)

More than Girodet realized, his painting reached beyond the Brutus back to the philosophical world of David's Socrates. Its apparent androgyny is more precisely the narrowing of a total ideal of human beauty into an exclusively male realm, a move which pays homage not only to the homoerotic bias of ancient Greek culture but also to the bonds of exclusively masculine fellowship within the studio itself. Girodet had set out to prove that the internal complexity of potential appropriate to the hero could be articulated even without Drouais's intercutting between the poles of grandeur and beauty, that it could be accommodated entirely within the latter category. The result is a body that is removed from life yet never decays; that is subject to perpetual repetitions of sensual pleasure yet is never exhausted by them; that is trained like an athlete of antiquity for war yet remains forever untouched by violence, knowing death only in the midst of ecstatic animation of the nerves, muscles, blood, and skin.

As he was completing the *Endymion*, Girodet was also becoming an active participant in the Revolutionary process. He would go on to lead Republican artists in violent clashes with the Vatican. So it is difficult to draw obvious connections between political and esthetic commitments. The younger

artist's preoccupation with ideal mythology markedly contrasts with David's simultaneous immersion of his art into the flow of living history back in Paris. In 1791, in the first Salon of the Revolution, his master showed a highly finished drawing which predicted a new kind of history painting. This was the *Oath of the Tennis Court*, celebrating the moment during the Estates General of 1789 when the delegates of the Third Estate pledged themselves to remain in permanent assembly until they had achieved a constitution: they would "die rather than disperse until France was free." To capture the moment David conceived a vastly multiplied oath of the Horatii, which now bound the assembled representatives of the nation to a new foundation of civic order.

The source of the commission was not the state, but an unofficial political body, the "Society of the Friends of the Constitution," more commonly known, after the old monastery in which it held its meetings, as the Jacobins. Its commission to the artist was organized as an expression of the national will: the gargantuan final picture, with life-size foreground figures, was to be paid for by three thousand subscribers, who would receive a print of the image. The canvas was to hang in the National Assembly itself, to hold

before the nation's legislators both the foundation of their authority and an ideal model of the general will in operation.

Both act and image hark back to the antique models of patriotic fervor and self-sacrifice which David had figured so vividly in his earlier work. But this literal bonding of art and the primal moment of Revolutionary public life proved to be less a way forward than a cul-de-sac for history painting. The lesson of David's experience is that when the artist forsakes the distance of metaphor, the actual public sphere will perpetually escape representation. This was the fate of the Tennis Court project. To finish it would have required an impossibly stable political consensus. After the King tried to flee France to join the external enemies of the Revolution, the Jacobins split into antagonist monarchist and republican factions (the more radical group retaining the name); the dream of accord emblematized in the Oath of the Tennis Court had vanished. Amid the growing factional struggles, perpetual economic crisis, and panic induced by military attacks on France, today's hero was likely to become tomorrow's traitor.

This process of historical change would not stand still to accommodate the atemporal and time-consuming medium of painting. By 1792 David had all but abandoned his canvas with only a few of the central figures sketched in the nude. His pupil Gérard won a state competition with a similar project to memorialize the effective moment of the monarchy's downfall, *August 10*, 1792, but likewise never moved to the stage of working it up on canvas.

FIGURES OF REVOLUTIONARY DEATH

The vicissitudes of these projects were part of a general upheaval affecting virtually every aspect of conceiving, making, and viewing art. Both the practical and esthetic ambitions of painters and sculptors had been formed for generations within stable governing institutions that took responsibility for training, advancement, housing, and—for the most favored artists—assuring a livelihood. That tradition

1.15 JACQUES-LOUIS DAVID Marat at His Last Breath, 1793. Oil on canvas, $63\frac{3}{4} \times 49\frac{1}{8}$ (160.7 × 124.8)

1.16 ANATOLE DEVOSGE after JACQUES-LOUIS DAVID The Death of Lepelletier de Saint-Fargeau, 1793. Pencil on paper, $18^{1/2} \times 15^{3/4} (46.7 \times 40)$

and those institutions were suddenly overturned, and by 1792 a new Republican government was instructing young artists to despise everything for which the old order had stood. The church, long a source of patronage, was under siege. A puritanical austerity in private life was encouraged and increasingly enforced as a sign of civic virtue, while a succession of revolutionary regimes asked artists to invent forms for philosophical and ideological messages wholly new to public art. Unfortunately, those regimes lacked the will and money to pay for what they required, and artists were forced back on their own resources in the midst of a shattered economy.

Some artists and craftworkers found employment in a novel and enormous enterprise of symbol-making: the creation of the great Revolutionary festivals, with their myriad floats, costumes, temporary architecture, and sculptural props. David, as he was drawn into the radical political leadership, took on the role of supervising this entire apparatus as the organization of political pageants and ceremonies turned into a year-round industry. But he would eventually return to painting at the behest of his political allies, and in doing so came to affirm the value of his pupil Girodet's concentration on the eloquent male body.

Early in 1793, following the King's execution, a royalist soldier had murdered a deputy, Lepelletier de Saint-Fargeau, who had voted for the death sentence. David was called upon to paint a memorial to the political martyr and produced a rather conventional image of the Classical hero on his 1.16 deathbed reminiscent of his own fallen *Hector* from 1783 (and gave over most of the actual painting to Gérard). That summer another, more incendiary assassination took place. The extreme populist writer and deputy Jean-Paul Marat was attacked in his bath by a counter-Revolutionary zealot named Charlotte Corday. Marat was the hero of the organized sansculottes, the movement of artisans and workers in the poor neighborhoods of the city. A major symbolic tribute was required, and David again was summoned to produce a painting to stand in for the lost martyr. But the Revolutionary leadership, of which the artist was a part, was worried about the demands of the popular movement and its propensity to spontaneous violence. The Terror was about to begin, but in their view terror had to be strictly controlled from above.

David put that ambivalence into paint. In his Marat at His 1.15 Last Breath, the martyr is the saintly "Friend of the People." The papers on the edge of his rude writing stand show that he had been dispatching some money to a soldier's widow when surprised by his killer (whose own false letter requesting an audience he still holds). His nudity could be read as both a metaphorical and actual mark of heroic stature, in that he typically carried on his duties through the pain of an excruciating skin disease, which he could soothe only by immersion in a medicinal bath. While the subject's passion for equality and fraternity is plain, he is past all action and the image is meant to console its viewer far more than incite him or her to a rage for vengeance.

Marat's pose, the instruments of violence, the inscriptions, the plain wood of the upright box, the insistently perpendicular compositional order, all conjure up Christ's sacrifice without leaving the factual realm of secular history. For guidance in this delicate task, he called on the absent Girodet's experiment in religious painting from 1790, in which his pupil had already diminished overt Christian trappings in favor of atmosphere and the body's own eloquence. Amid numerous borrowings, the most obvious sign of David's reliance on Girodet's *Pietà* is the tracing of the contour along the head and shoulders of the Virgin into the line of the sarcophagus; in a startling transposition, this has become almost precisely the line of Marat's head and body as it emerges above the bath the key division of the composition between a lower zone full of incident and an upper zone of shadowy, meditative stillness.

For the third of his Revolutionary martyr portraits, the Death of Bara (1793), David returned to the Classical canon to 1.17 imagine a boy-victim of the counter-Revolution as an unblemished, eerily beautiful ephebe, suffering but without visible wounds, dreaming more than dving, near to but not

1.17 JACQUES-LOUIS DAVID The Death of Bara, 1793. Oil on canvas, $46\frac{1}{2} \times 61$ (118 × 155)

within the fury of combat. The regard of the artist, with which we are invited to identify, appears to have scandalously little to do with civic virtue or battlefield heroism, despite the charge to the painter. The sensuality of the body seems to go beyond a youthful beauty appropriate to its age and innocence, and commentators have assumed with near unanimity that the painting suffers from an overbalancing from public to private preoccupations.

But his response first of all must be understood in terms of the special circumstances of the 1793 commission. The young Joseph Bara, who had actually died in ambiguous circumstances, was a contrived martyr. How was David to move from the celebration of mature victims—Lepelletier and Marat—who were significant historical actors, known personally to the artist, to the representation of an unknown boy? How was he to ennoble what was at best a trivially unlucky act of bravado? How was he to find a fresh form for the abstract stereotypes of outraged innocence and the sacrifice of youth with which he was forced to work, following Robespierre's unreal dictum that "the French alone have thirteen-year-old heroes?"

Once again, when faced with a demanding and unconventional assignment, he looked to the work of his students. In this instance, he was responding to the nude academic study as transformed by his own followers, the late Drouais and Girodet in particular. In their hands, it had become a

privileged emblem of virtue and self-sacrifice in youth, and their vision of physical perfection carried with it a statement of anti-authoritarian originality in style and conception.

If David had needed a vivid reminder of this potential, he received one in the summer of 1793 when Girodet's *Endymion* was finally seen, to great success, in the Paris Salon. His pupil's inspired interplay of conceptual oppositions in the realm of abstract and ageless beauty would have corresponded to the difficult combination of ideas, and conditions bound up in the Bara commission. It had made concrete the longstanding ideological association between the physical perfection achieved by the ancients and their free society of equal, active citizens. Though this is not to say that the translation was entirely successful or that the *Bara* could be said to have functioned as a legible icon of utopian virtue. In fact one can see in it a collapse of this intimate dialogue within the inherited rhetorical codes of Classical art.

Certain aspects of the painting have undeniable power: the nervous scumbling applied simultaneously to the body and its setting continued David's recent ventures into extreme gestural freedom in the remarkable Revolutionary-period portraits of Madame Chalgrin and Madame Pastoret. Here it permitted him to appropriate, by means of a maximally porous rather than maximally sealed technique, Girodet's atmospheric unity of figure and ground. But when it came to

the suppression of the genitals—imperative in view of the mandate that David represent outraged innocence—the result was less happy. The overall illumination and blond light deprived David of Girodet's device of veiling shadow; his response was to take the boy's body and break it in two, simultaneously to figure its suffering and to downplay its sex. The body is twisted unnaturally at its center, subjected to a wrenching discontinuity, which marks the body's violation, the bayonet wound to the midsection that killed the boy. This device, along with the shadowed abdomen, directly recalls the abrupt inner displacement of Drouais's *Athlete*, which David superimposed over the undisturbed imaginary wholeness of the *Endymion*. Much of the strangeness of the image is derived from the clash of these two incompatible bodies in one.

LEAVING TERROR BEHIND

There was no opportunity for a public response to David's *Bara* because Robespierre's government was overturned in the summer of 1794, one day before the scheduled festival in honor of the child-martyr. This Thermidorian Reaction (so-called because of the month in the Revolutionary calendar in which it took place), ended the period of radical change, and republican France entered a five-year phase of indecisive collegial government. David, as a close associate of the fallen Jacobin leader, had narrowly escaped the same sentence of death. As it was, he was sent to prison and remained in confinement for more than a year. Gaining his full freedom late in 1795, David soon recovered his lost position and large teaching studio, but his circle would no longer be the dominant nexus of practise it had been before Thermidor.

Without David to provide a center, the various components that had gone into the collective work of the old studio split apart. Without the critical spirit of the 1780's or the political commitment of the early '90's, these dispersed elements came to express narrower, more obvious and usually more conservative interests. In the Salon of 1795, the first under the new order, the great consensus success was a new *Belisarius* by Gérard. This painting (now lost) harked back to the pathetic qualities of David's own version of 1781, but exaggerated that pathos by imagining that the blind outcast's young guide had been killed by a snake; Belisarius is left without aid, carrying the boy's corpse through a deserted wilderness.

Gérard was painting for the Salon because he, and all of his generation of young artists, had seen their career interrupted by war in Europe. The French Academy in Rome had been sacked by pious Romans early in 1793 (Girodet had narrowly escaped the scene with his life) and had remained closed ever since. The Revolutionary reforms of the exhibition system meant that painters who would normally have been continu-

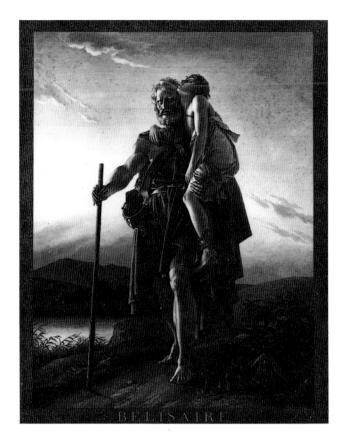

1.18 after François Gérard *Belisarius*, 1795. Engraving, $18\frac{3}{8} \times 13\frac{1}{2}$ (46.5 × 34.5)

ing their studies in Italy were free to make precocious careers in Paris. The ineffectual efforts of the government to sustain a program of public commissions meant that the artist's professional survival depended upon early public recognition.

This state of affairs encouraged a volatile, speculative approach to subject matter and style. The success of Gérard's *Belisarius* encouraged a number of young artists to produce their own similar elderly victims. As that success was seen as a matter of emotional effect rather than reflection on history and virtue, the identity of the outcast could be altered at will. Fulchran-Jean Harriet gave the theme a turn into the landscape sublime in 1796, offering an *Oedipus at Colonus* in which Belisarius' dead guide is replaced by an unconscious Antigone. Despite its source in the tragedy of Sophocles, the harsh, windswept environment is unrelieved by the presence of Theseus (the hero of the Athenian polis) or any other sign of the blinded exile's final reconciliation with civic culture.

In David's *Brutus*, the sorrow of any individual actor is only one element in a larger complex of causes and effects addressed to the viewer's active understanding; emotional responses are elicited—and deepened—through cognitive apprehension of the inevitability of that suffering. In these paintings of the 1790's, by contrast, individual pain and loss

38 · PATRIOTISM AND VIRTUE

1.1

are isolated and exploited for sheer intensity of effect. This cult of emotion savored for its own sake revealed its compatibility with the politics of reaction in the painting that enjoyed the most enthusiastic response in the 1799 Salon. Pierre-Narcisse Guérin (1774–1833), seven years younger than Girodet, was the first artist of the period to come to prominence who had not studied with David. He had received his training in Regnault's studio and won the Rome Prize in 1797. Still unable to travel to Italy, he set to work on a Return of Belisarius to his Family for the Salon. The subject corresponds exactly to a passage in Marmontel's Enlightenment novel, the same text on which David had drawn for his public debut in 1781. But Guérin went further than had Gérard in suppressing the earnestly political implications of his source, to the point of effacing the identity of Belisarius altogether. After the painting had been completed, he altered the identity of his hero by the simple measure of restoring his sight and inventing a new name and personal history out of whole cloth.

Now the subject was one Marcus Sextus, proscribed by the dictator Sulla during the civil wars of the late Roman Republic. After the fall of his persecutor, he returns home to find his wife dead and family shattered. Public response to this fable in 1799 was overwhelming; crowds surrounded it;

1.19 FULCHRAN-JEAN HARRIET Oedipus at Colonus, 1796. Oil on canvas, $61\frac{1}{2} \times 52\frac{3}{8}$ (156 × 133)

1.20 Pierre-Narcisse Guérin The Return of Marcus Sextus, 1799. Oil on canvas, $85\frac{1}{2} \times 95\frac{1}{2} (217 \times 243)$

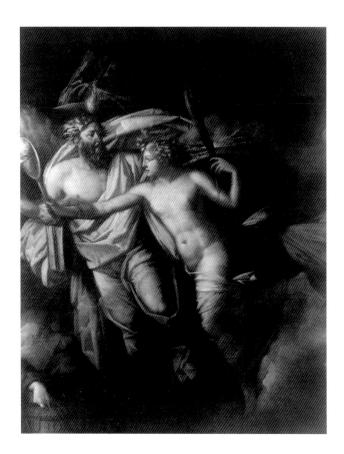

visitors attached poems to its frame; art students decorated it with laurel garlands. The allegory was patent to everyone: for Sulla, read Robespierre; for Marcus Sextus, read the moderate émigrés who had fled the Revolution but were beginning to return under the more lenient and conciliatory regime that came after Thermidor. In order that nothing cloud that meaning, the artist avoided choosing a hero whose complex character and fate would be well-known from literature and artistic precedent. Here there were no troubling ambiguities; the concept was simple and designed for a predictable effect. In stylistic terms, Guérin's painting was a recycling of David's signature devices from the previous decade (David was heard to say that Guérin "had been listening outside my door"), with something of a Girodet-style nocturne thrown in for melancholy effect. But in moral and intellectual terms, it was a violation of what had been the most deeply held beliefs within David's circle about the responsibility of history painting to interrogate and translate the complex inherited specifics of its themes.

1.21 (left) Philippe-Auguste Hennequin Allegory of August 10, 1799. Oil on canvas, $88\% \times 68\%$ (224 × 175). Detail

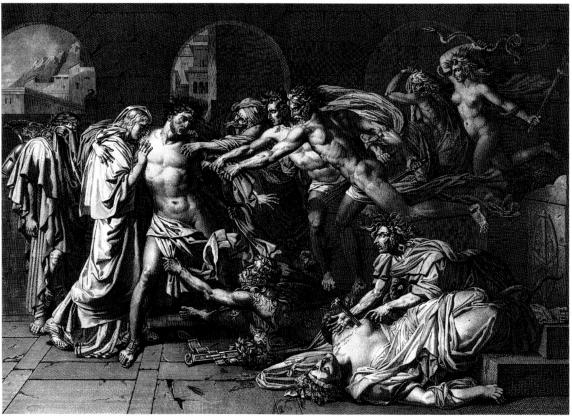

1.22 after Philippe-Auguste Hennequin The Remorse of Orestes, 1800. Engraving, 15\% × 22\/4 (39 × 56.5)

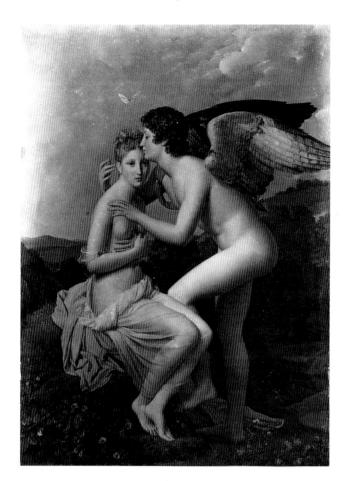

1.23 FRANÇOIS GÉRARD Cupid and Psyche, 1798. Oil on canvas, $73^{1/4} \times 52 (186 \times 132)$

1.21

But to see the Directory period as leading to a simple victory of reaction would be misleading, despite Guérin's conspicuous triumph. Even in that Salon, the jury awarded the first medal to Philippe-Auguste Hennequin (1762–1833), an unreconstructed Jacobin, for his massive Allegory of August 10. This canvas (now sadly mutilated) memorialized the insurrection which brought about the final overthrow of the monarchy as "The Triumph of the French People," and transferred the symbolic language of the Revolutionary festivals into the medium of painting. That artist went on to have a similar success in 1800 with his Remorse of Orestes, a mythological narrative that was an equally transparent allegory of the persecutions suffered by those still loyal to the patriotic cause.

Hennequin, who was of Drouais's generation, had remained something of an outsider throughout his career. After a brief, unhappy time in David's studio, he made his own way to Rome, was caught up in the Revolution in Lyon, and was imprisoned in 1795 for his part in the ultra-leftist "Conspiracy of Equals" led by Gracchus Babeuf. Only on his release in 1797 did he begin his career as an exhibiting artist in

the Paris Salon. Both of his prize-winning canvases demonstrated that his lovalty to a learned Classicism as the natural expression of popular democracy was as dogged as his Iacobinism. At the same time his irregular training manifests itself in a naive awkwardness in drawing and a tendency toward labored handling and an undisciplined accumulation of figures and incidents. In the densely packed, agitated composition of the Orestes, the technical shortcomings worked much more to his advantage in conveying the terrifying impasse of its hero. Orestes suffers the torments of the Furies because he has fulfilled his divine obligation to avenge the murder of his father; in that his mother was the murderer, he has nevertheless committed a crime abhorrent to the human community. As an allegory of the persecutions suffered by the followers of Babeuf (and by leftist democrats in general), it uses the complexity of its tragic source in a way that contrasts with Guérin's avoidance of any known referent that might complicate his message. Hennequin makes his complaint, to be sure, but shares with his viewer a recognition that necessity never removes the moral stigma of murder.

That Hennequin could enjoy success with such defiance of political orthodoxy-and even normal standards of competence—is a sign of the disarray and fragmentation that characterized culture in this period. Any previous honors an artist might have received could not guarantee continued recognition and support. Intense competition brought about splits between former close friends such as Girodet and Gérard. The former's arduous return from Italy—plagued by delays, malaria, and dangers from enemies of France consumed more than two years. Finally reaching Paris in 1795, he found himself unable to capitalize on the high reputation that his Endymion had prepared for him. Wealthy 1.13 speculators and military contractors were now in a position to command and direct the work of artists for whom little public support was forthcoming. There was as a result a corresponding license in matters of painterly style that rendered moot the freedom and individual distinction that Girodet had struggled so hard to attain within official structures. In fact, the cultivation of originality had largely passed from the culture of art into the fashions of an extravagant, youth-conscious, and apolitical elite. Gérard proved himself far more adaptable in recording the carefully constructed images of its leading figures, as in his portrait of Madame Récamier (1805). The style was for dress and coiffure after the antique, but this was Classicism exploited for its elegant simplicity and flattering eroticism, not for its association with civic virtue.

Public life was marked by a willed forgetting of the rigors and austerities of Robespierre's Republic of Virtue. The resentful Girodet was forced to witness the superficial appearance of his *Endymion* establish a corresponding fashion

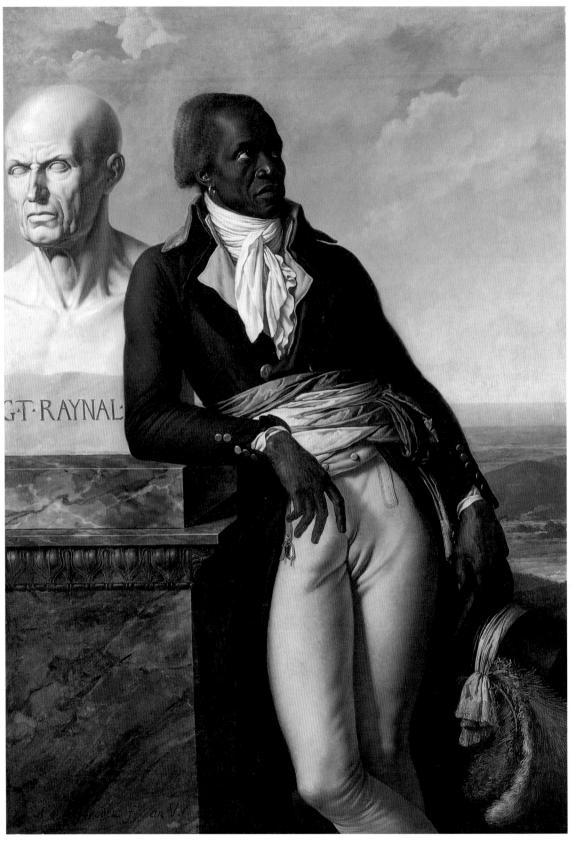

1.24 Anne-Louis Girodet Portrait of Jean-Baptiste Belley, 1797. Oil on canvas, 63×45 (160 × 114.3)

in history painting. His rival Gérard led the way in capturing the Endymion's sealed envelope of flesh and delivering it to a strain of precious eroticism that sought a place beyond the vicissitudes of political orthodoxy. The latter's Cupid and Psyche was the center of attention in the Salon of 1798. Its landscape setting is outside of time; the bodies exhibit the immunity to temporal corruption appropriate to mythical beings. The innocent Psyche is about to feel the first kiss of an invisible Cupid, and the erudite viewer is meant to take pleasure in this metaphysical conceit, while the frozen stillness and all of the hovering on the edge of physical contact and of awakening carnal desire amount to a heightening of the sexual tension inherent in the subject.

Girodet's contribution to the same exhibition clashed with his old companion's recourse to mythological refinement. In perhaps the last of the great Revolutionary portraits, fully comparable to David's Marat, he depicted Jean-Baptiste 1.15 Belley, representative to the French National Assembly from 1.24 the colony of Saint-Dominique (present-day Haiti). It would be better to say that this is a double portrait contrasting the living and the dead, the African and the European, the force of action and the force of ideas. Belley leans against a splendid commemorative bust of Abbé Raynal, the great Enlightenment advocate of political reform, which the artist has imaginatively erected on a hilltop of the Caribbean island. Raynal's liberationist ideas and his arguments against colonial exploitation had prepared the ground for Belley's decisive intervention in the Assembly in 1794, when he won approval for the abolition of slavery in the colonies and full citizenship for blacks.

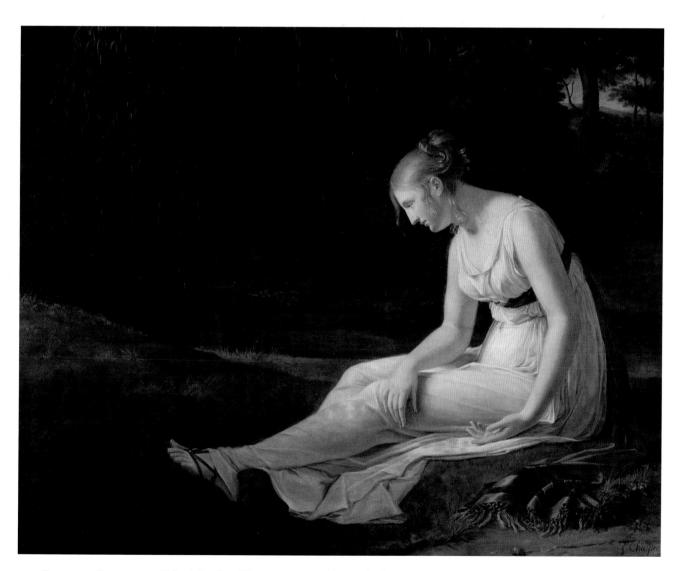

1.25 Constance Charpentier Melancholy, 1801. Oil on canvas, 52×66 (132 × 167.6)

The Belley painting celebrates a heroic triumph of Enlightenment ideas and the principle of equality. The rhetorical antitheses of the paired portraits raise its ambitions to the intellectual and moral standing of history painting. But unlike the Marat, Girodct's work was a willful, individual exercise, and a lonely one. It found no echo even within the reconstituted studio of David. There the shift away from contemporary history had taken an even more exaggerated turn toward an archaizing Classical culture and the simplified graphic conventions of Greek vase painting, Pompeiian frescos, and early Renaissance art. The graphic innovations of the English sculptor and draftsman John Flaxman (1755– 1826) were a crucial instrument in the separation of the Classical tradition from political and moral reflection on the present. That artist's illustrations of Homer's *Iliad* and *Odyssey*, produced for Roman patrons during the 1790's, were distinguished by an austere reduction of pictorial description to the play of contour and twodimensional pattern. Neither he nor his English sponsors saw Classicism as bound up with the recovery of republican liberties in the present; his imagery belongs to a realm before history even begins. And the admirers of the abstract intelligence of his designs tended to view all subsequent compromise with empirical experience as a corruption of the pure origins of the tradition.

1.26

Gérard showed conspicuous attention to this esthetic current in the Cupid and Psyche. Constance Charpentier (1767–1849) was one emergent artist who was able to take its potential further. She, along with a number of other women, had taken advantage of a Revolutionary loosening of the rules in artistic instruction to develop skills in the allegorical realm of history painting. In the past, they would have been barred from the study of the model and so from academic training. Before 1789, David had unsuccessfully fought against that restriction, but in the new environment, Charpentier had been able to study with him and with Gérard, establishing herself as a regular exhibitor in the Salon. In a work entitled Melancholy, which met with an enthusiastic public reception 1.25 in 1801, she found a striking way to translate Flaxman's graphic linearism into painting. She accomplished this by building the work out of two opposed conventions of illusion and by a manifest inconsistency of illumination. The single, dejected female figure, garbed in a simple Greek gown, is saturated with light to the point that internal modelling and details are suppressed. The startling and unreal contrast with the darkly atmospheric forest setting concentrates all of the pictorial stress onto the contours of the figure. That boundary between light and dark is the passage which effects an ingenious reconciliation between a subjective poetics of ambiguity and the control of Classical rationalism (bringing up to date the Enlightenment equation between nature and the forms of ancient art). As a viewer, one is given the vague background in which to indulge in reverie oneself; at the same time the figure provides a surrogate with which one can identify, but less as a full-bodied presence than as an interruption in the field of dreaming. It bends physical form toward signifying the essentially mental condition of melancholic reverie.

In the same year, a painting appeared from one of the new male Davidians, The Death of Hyacinth in the Arms of Apollo by Jean Broc (ca. 1780–ca. 1850), which likewise manipulated light to suppress plasticity in pictorial illusion. Its mythic source, best known from the Latin poet Ovid, recounts the jealousy of the wind Zephyr: filled with unrequited passion for Apollo's boy lover, he causes the god's discus to swerve and kill the beautiful Hyacinth. Broc's concentration on ideal adolescent nudity continued what Gérard had begun three

1.26 JOHN FLAXMAN, "The Fight for the Body of Patroclus," from Illustrations to Homer's "Iliad," 1793. Engraving, $6\frac{5}{8} \times 13 (16.8 \times 33.6)$

1.23 years earlier in the *Cupid and Psyche*, and he adopts the same low viewpoint that reduces the background to simple bands of meadow and sky in a poetic never-never land. But the backlighting has the effect of reducing even further the weight and surface texture of flesh: the edges of the bodies are drawn with light rather than the dark tones that normally indicate the recession and disappearance of three-dimensional form.

This is a device already exploited by Girodet in the figure of Zephyr who hovers over Endymion; Broc went further by making it the governing logic of his entire composition. It gave him the means to solve the same conceptual problem faced by Charpentier, that is, how to make the obdurately empirical medium of oil painting approximate the elemental simplicity of the decoration on Greek ceramics or of Flaxman's drawings. The rippling sequence of fingers on Apollo's right hand, joined to the faces of the lovers in double profile, is a passage of conspicuous virtuosity in this regard. In terms of the painting's theme, reversal as a formal procedure underscored a frankness in celebrating the reversal of normative heterosexuality. It transforms the Platonism of David's *Socrates*—that same-sex desire among males is a path to mental concentration and knowledge of abstract truth—into its own anti-naturalistic visual idiom.

The proponents of these ideas formed something of a self-contained sect within the studio (variously called the

1.27 JEAN BROC. The Death of Hyacinth in the Arms of Apollo, 1801. Oil on canvas, $70 \times 49^{1/2}$ (177.8 × 125.7)

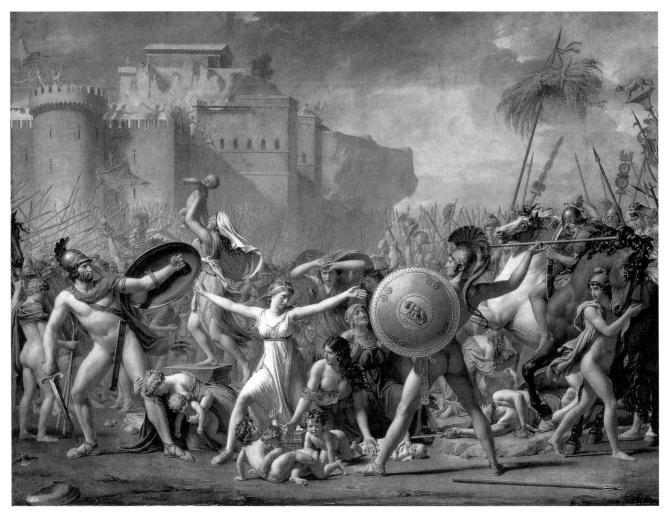

1.28 JACQUES-LOUIS DAVID The Intervention of the Sabine Women, 1799. Oil on canvas, 12'8 × 17'4/4 (386 × 520)

Primitives, Meditators, or the Bearded Ones) and did not share in the sort of collaboration and trust enjoyed by the first generation of pupils. Their cultivation of virtue was an inwardly directed and exclusive affair. David, on the other hand, never wavered from his commitment to public art and a public role for the artist; even while in prison he was preparing sketches for his next great history painting. But at the same time he was as attentive as Gérard had been to the ideological force of this newly purified, Hellenic Classicism.

The result was a massive canvas, completed in 1799, the *Intervention of the Sabine Women*. It was very much David's intention that this subject be distinguished from the better-known rape of the Sabines, famously depicted by Poussin and Rubens among countless others. That prior event was the beginning of the narrative trajectory which David captured near its end. The early Romans, a rough and exclusively male lot, needed women in order to perpetuate their community; to this end they employed a ruse to steal the wives of their

neighbors. It is three years before the Sabine men are able to mount a successful counter-attack, and in that time marriages have been established between the Romans and their captives and a new generation has been born. As the two armies meet and their respective leaders—Romulus for the Romans and Tatius for the Sabines—prepare for single combat, the women throw themselves into the midst of battle, pleading for reconciliation between the two states. At the center is Hersilia, wife of Romulus himself.

In a pointed reversal of the value system which governs the *Horatii* and *Brutus*, the existence of irreconcilably divided loyalties here guarantees a happy ending. The *Sabines* was conceived at David's most desperate hour as a bid for rehabilitation, and it was designed for maximum public appeal. He saturated the scene with screams, shouts, and confusion, making the spectator's experience approximate that of spectacular melodrama. In place of tragic parsimony of incident, the composition offers profusion of detailed illus-

1.28

tration and tempts one's attention toward a deep landscape setting. The most sentimentally affecting element of the story, the children deliberately placed in harm's way, stare directly out at the spectator.

All of this finally is in keeping with the premeditated message of the painting and its essentially strategic conception: none of the copious incident and detail serves to alter the conclusion one is to draw from Hersilia's plea for peace between Romulus and Tatius. The message of harmony is given in advance; everything else in the composition is there as illustration of its necessity. In its most radical phase, the new French Republic had come to be personified as a woman; Hersilia is that personification resurrected as an ideal mother of healing and nurturing, clad all in white.

The suspended conflict appears all the more as a suspension of history itself by virtue of David's startling decision to depict his warriors in the nude. While this was believed to conform to an ancient Greek practise, it had no historical pertinence to a Roman subject. But he took the step, late in the compositional development of the painting, to appropriate the idealizing Hellenism being promoted by his students. The design of the principal triad of figures could be a vignette from Flaxman. The effect of its paradoxical delicacy and formalized balance is to remove the memory of actual conflict and violence to a safer realm of myth.

David's mode of exhibiting the painting achieved a further gathering of power to himself. His response to the lack of state

1.29 JACQUES-LOUIS DAVID Napoleon at the St. Bernard Pass, 1800. Oil on canvas, $8'10^{5/8} \times 7'7^{1/4}$ (270.8 \times 231.8)

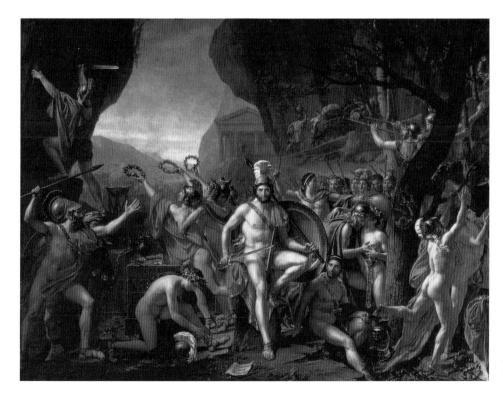

1.30 JACQUES-LOUIS DAVID Leonidas at Thermopylae, 1814. Oil on canvas, 12'11³/₄ × 17'5 (395.6 × 530.9)

funds for the support of art was to ignore the Salon of 1799 altogether and arrange an independent showing of the work in his own space, charging an admission fee to every visitor. Owing to this isolation and personal control over its display, David for the first time was able to present one of his largescale paintings at eve-level rather than at the top of a crowded Salon hanging. He further exploited these new circumstances by placing a standing mirror opposite the painting. The spectators were invited to use the reflection in order to achieve a distanced, totalizing view of the narrative; at the same time they would see themselves as participants in the action behind them. This is the first of more than one trick he would later play with mirrors in his private exhibitions in an effort to mystify and spectacularize the act of viewing. Having designed a work that maximized the potential for such effects and that reinforced rather than tested the beliefs of its audience, he made the next logical move in financially speculating on the successful appeal of his strategies. He was handsomely repaid for his effort: the painting stayed on view for five years and financed the purchase of a substantial country house and land. The entrepreneurial artist of the nineteenth century was well and truly launched.

THE SUBLIME OF AUTHORITARIANISM

A month before the opening of David's exhibition of the Sabines in the last month of 1799, the constitutional government had fallen in the coup of 18 Brumaire. Emerging

1.31 FRANÇOIS GÉRARD Ossian, 1801. Oil on canvas, 725/8 × 761/2 (184.5×194.5)

1.32 ANNE-LOUIS GIRODET Ossian Receiving the Napoleonic Officers into *Valhalla*, 1802. Oil on canvas, $37 \times 73^{1/2}$ (93.9 × 186.7)

as leader of a new regime was the charismatic young general Napoleon Bonaparte. Careful at this point to preserve republican forms, his faction came up with the title of First Consul; it evoked the chief executive office of the Roman Republic, one first occupied by Brutus. Napoleon was no stranger to David: he had visited the artist's studio in 1797 and given a mighty impression as an exemplar of martial virtue. On assuming power, he made an immediate effort to bind David to the new government as its official painter. The first successful product of that alliance was the portrait (1800) of 1.29 the general, calmly seated on a rearing charger, crossing the Alps over the St. Bernard Pass. The actual crossing was a more prosaic affair on the back of a donkey, but plainly the rhetorical requirements of leadership were to prevail over accuracy: carved in the stone are the names of Hannibal and Charlemagne, who had followed the same route to Italian conquests. The setting of natural sublimity of course does more than serve historical commemoration: as in Harriet's Oedipus, the wild terrain and turbulent weather are meant to 1.19 lend action and drama of an irrational kind to the sheer presence of the main actor.

At the same time, however, the wind-blown cloak and broken clouds remain superficial effects laid over an obdurately stable and Classical substructure. Even the perilous slopes and shafts of light arrange themselves in a rigid X-shaped armature which fixes Napoleon firmly in his seat. Soon the republican painter discovered that his deeper moral

1.34 (above) JACQUES-LOUIS DAVID and FRANÇOIS GÉRARD Aeneas Carrying Anchises From the Ruins of Troy, late 1790's. Engraving, 95% × 61% (24.5 × 15.5)

1.33 (*left*) Anne-Louis Girodet *The Deluge*, 1806. Oil on canvas, $14'1\sqrt[3]{4} \times 11'2\sqrt[4]{4} (431 \times 341)$

and artistic preoccupations were at odds with the Bonapartist vision of public art. By 1802, David had begun work on a major new historical canvas. The subject was Leonidas at Thermopylae, the hero being the leader of that small band of Spartans who held off the entire Persian army at a narrow pass, but at the cost of every Greek soldier. He chose the moment of reflection and preparation before the battle, and continued the pre-Revolutionary line of ancient leaders who sacrificed everything for virtue and the welfare of the community. Napoleon, on seeing the picture in preparation, dismissed the entire idea as a painting of losers. David suspended work on the Leonidas for a decade and soon was diverted into the wearying and esthetically thankless task of glorifying the new Emperor's rite of coronation in 1804. The outcome was an overbearingly enormous canvas enumerating every dignitary present at the pompous ceremony in Notre-Dame (and though he made a study of the arrogant self-

crowning itself, David ended by shifting his moment away from any suggestion of usurpation to the aftermath when the freshly Imperial Bonaparte turned to crown his consort Josephine).

This was painting as duty, and it was performed as such. It returns to a conception of rhetorical elevation as copious magnificence in the accumulation of ornaments and witnesses to glory. But much Napoleonic painting was conceived without this sort of clear brief. As political legitimacy devolved into the charisma of one man, painters were presented with a qualitatively new situation. Although he was convinced that art mattered, the ruler himself could not be exactly sure of what he wanted until he saw it. His identity and self-image—general to statesman, Consul to Emperor—were continually subject to change. Artists' initiatives were bound to take on a speculative character, and speculation could as easily turn out wrong as right.

1.30

Gérard, typically, was first to take advantage of the Consul's known enthusiasm for the *Ossian* poems. These were claimed as the rediscovered epic cycle of an ancient Celtic bard of that name, though they had actually been produced a half-century earlier by the Scottish writer James Macpherson. Because invented to eighteenth-century requirements, true believers could take the Ossianic as more pure and primitive even than the poetry of archaic Greece, and the primitifs of David's studio put them on a level with the works of Homer and Hesiod. Even those who doubted the announced provenance of the verse appreciated it precisely for its modernity: its evocations of a dark and primal northern world inhabited by heroes and spirits corresponded to a growing cult of subjectivity and irrationalism. In a painting destined for Bonaparte's country retreat at Malmaison, Gérard makes his Ossian a blind and bereft old man, conjuring from his lyre the memories of lost parents and children, who surround him as ghostly spirits in a moonlit miasma. With the wild setting, eerie nocturnal lighting, and subject matter of fevered imaginings in an elderly survivor, Gérard distilled the developments of the 1790's into a cloudy fantasy unconstrained by Classical logic or structure.

1.31

Girodet had a good claim to being the most experimental painter in his generation, and his rivalry with Gérard was intense. He seized on the First Consul's decorating plans for Malmaison as a chance to rehabilitate his career as a history painter, seeking at the same time to surpass his old friend and studio-mate in the Ossianic stakes. Not content with replicating the other-worldly setting and mood of the poems, he sought to incorporate Napoleon's contemporary concerns into the invented mythology. In his 1802 painting, French commanders, killed in recent campaigns, arrive in a Valhalla presided over by the blind Celtic bard and packed to the breaking point with ghosts and spirits. The upper zone is dominated by elements of overt allegory after Hennequin (if more suavely handled) in the floating personification of republican liberty and the victory of a Gallic cock over an Austrian eagle. These are only the beginning of a catalog of allegorical correspondences to persons and recent political events, ingeniously conceived but nearly impossible to decipher without the guidance of a detailed inventory. In a further burst of conspicuous invention, Girodet conceived the entire atmosphere and lighting of the scene according to his understanding of electric luminosity, using recent discoveries of science as a spectacularly vivid equivalent to the afterlife.

All of Girodet's prodigious natural ability was on show in the painting, which deploys the resources of illusionism to construct a dense tissue of physical impossibilities. The packed accumulation of figures is relieved by a translucent delicacy in their rendering: "figures of crystal," in the words of David, who praised his old pupil's originality to his face, but dismissed it to others as outlandish and undisciplined. Contemporary evidence suggests that Gérard's more straightforward illustration of strictly Ossianic themes found greater favor both in public and with the First Consul. Two former adherents of the Davidian *primitifs*, the twin brothers Franque, would later adopt the same arrangement as a formula to depict Napoleon himself being beckoned by spirits in a dream to return from Egypt in 1799 and save France by assuming power.

The setback may well have been beneficial to Girodet in that he turned away for a time from political subject matter and from appeals to the ruler's immediate interests. For the Salon of 1806, he prepared an immense *Deluge*, a terrifying 1.33 emotional drama in a turbulent and darkly primitive world. In contrast to his *Ossian Receiving the Napoleonic Officers into Valhalla*, he reduced the drama to a configuration of elemental simplicity and unmistakable meaning. This subject,

1.35 JEAN-AUGUSTE-DOMINIQUE INGRES Napoleon on the Imperial Throne, 1806. Oil on canvas, 8'8% × 63 (265.7 × 160)

50 · PATRIOTISM AND VIRTUE

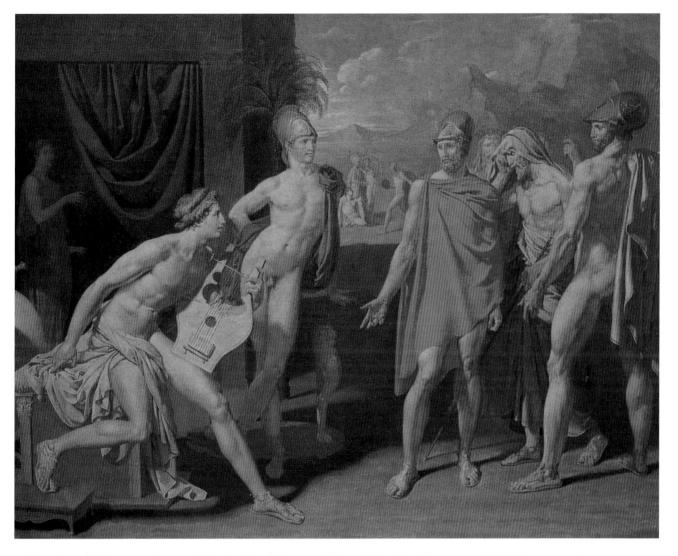

1.36 JEAN-AUGUSTE-DOMINIQUE INGRES The Ambassadors of Agamemnon Visiting Achilles, 1801. Oil on canvas, 431/4×61 (109.9×154.9)

centered on the burden of a strong young father, struggling to support a parent, a spouse, and a child simultaneously, had become a popular one in the immediately preceding period. Regnault had shown a small canvas on the subject alongside his *Lamentation* in 1789; there the man carries his father on his back and is therefore unable to seize hold of his wife and son as the current sweeps them away. Contemporary viewers were prepared to overlook the curiously sluggish current, and it became one of his most popular works: he eventually painted several replicas to meet demand from collectors. Not for the first time, of course, Girodet took cues from the success of this artist and pushed the same material toward a more extreme and ambitious statement.

Regnault's conception of the scene, in that it stresses the emotion of irretrievable loss, fits within the category of sentimental subjects, and its compact dimensions are those of a cabinet picture. Girodet, by contrast, wanted to maximize both the drama and the physical impact of terror in a canvas of outsized, aggressively public scale. The size of his figures is grander than life. He stacked them vertically, which corresponds to the perilous fall along the cliff face and allows the canvas to tower over the spectator. So that the scene would conform to the requirements of high drama, he chose a moment when his central male figure has not yet lost his grip on the wife and child. The aged father has become the very embodiment of dead weight, already inert and corpse-like, clutching a futile bag of gold; he exerts monstrous strength from a withered body that seems beyond age. Thanks to this death grip of the past, the frail support of the vital younger generations is about to fail, and all the characters are poised on the brink of oblivion in the rushing torrent.

Consistent with his public ambition, Girodet took advantage of an established Classical prototype—the motif of the Trojan hero Aeneas carrying his father and leading his son

from the burning ruins of the city, precisely as rendered by Gérard for a series of printed illustrations to Virgil's Aeneid in the later 1790's (in which both he and David had also collaborated). But Girodet has reversed the meaning of the motif from one of filial devotion to one of fatal conflict of obligations. If one defines expressive dissonance in any art form in terms of departure from a settled sense of harmony, then this painting is maximally dissonant within the conventions of history painting. The artist has stretched the internal contrast of age and youth virtually to the breaking point—just as the man's arm is being pulled to its limits. The terrified expressions defy every Classical norm of composure, a quality heroic actors had been assumed always to exhibit even in extreme pain. Muscles bulge and tendons strain. An outsized, funereal cloak swirls in a freakish whirlwind.

1.34

To compare the Deluge to David's conception of the Spartan leader Leonidas is to see how thoroughly Girodet had seized and transformed the conventions of heroic nudity. For David, the hero gathers and contains his strength within himself in order to exert it at will; for Girodet, the hero, such as he remains, is a victim, his strength arrayed as a conduit across which uncontrollable, nonhuman forces exert themselves: among these is the sexual desire which binds him to his mate and to the next generation. The larger community, with its veneration of constraining authority and wealth, is a threat to his survival. But this is less a motif of youthful rebellion than a figure for the finality of human isolation. At this point Girodet had finally set his art against the rationalist, communitarian precepts of his formation in David's circle. This was recognized by conservatives in the fine-arts division of the Institute, the umbrella cultural organization under Napoleon's Empire, who despised the Jacobin associations that still clung to the Classical canon. In a competition to select the best works of art produced during the first decade of Bonapartist rule, the jury preferred the Deluge to David's Sabines.

DREAMS BEYOND HISTORY

In the same year that Girodet exhibited the Deluge, an artist of the next generation made his own dramatic bid for official favor. Repeating the former's own tactics in 1802, J.-A.-D. Ingres (1780–1867) sought to appeal directly to the self-regard of Napoleon and to distinguish himself from the competition by a conspicuous display of esthetic originality. The painting was Napoleon on the Imperial Throne (1806). In its conception, Ingres sought to actualize in esthetic terms the kind of pedigree which David had etched into the rock of the St. Bernard Pass, one extending back through the Emperor Charlemagne and the origins of Frankish kingship to Roman antiquity. As Bonaparte had clothed his usurpation of absolute power in ancient formalities, so Ingres proceeded to represent his body within pictorial conventions appropriate to ancient times. The painstaking precision of detail, which gives the symbolic accessories a weight equal to the man, was likened at the time to the manner of Flemish "primitives" like the Van Eycks. The hieratic frontal pose is arranged in the manner of Byzantine and early medieval ivory carvings of quasi-divine rulers. The Emperor's face is mask-like and displays a waxen pallor; the figure as a whole is imprisoned within a rigid geometry that finds its ultimate point of reference in ancient renderings of the colossal statue of Zeus, sculpted by Phidias from gold and ivory as the cult image at Olympia.

Ingres had been a pupil in David's studio during the late 1790's. His winning Rome Prize painting of 1801, The Ambassadors of Agamemnon Visiting Achilles, had displayed a striking command of the rhetorical distinctions basic to the Davidian project. At the beginning of the epic, the greatest warrior among the Greek army at Troy withdrew from the war after a petty argument with his commander. Both Achilles and his companion Patroclus display the languidly ephebic grace appropriate to noble bodies that have withdrawn from the fray and are therefore free to manifest the homoerotic attraction that binds them in comradeship. Patroclus, the transitional figure and the first to reenter the battle, playfully sports the helmet of Achilles, an anticipation of the disguise that will lead to his death at Hector's hands. The entreating warriors, driven by the Trojan forces to the very brink of defeat, display the hardened musculature and indented contours of bodies marked in strife. Such competition paintings had to be completed in a matter of weeks with no models or preparatory drawings permitted in the cell-like individual studios. As a consequence, few could stand up to exacting judgment; but Ingres's entry achieved a deservedly high reputation. Not only did it contend successfully with the authority of Flaxman's Homeric engravings, the English artist 1.26 himself saw and praised the result.

By the middle of the decade, Ingres had extended the rhetorical conception of form in a new direction: over the repertoire of body types derived from antique models, he imposed a set of distinctions derived from the historical change in artistic styles over time, including nonclassical ones. According to this logic, if one were treating subject matter from a particular period or evoking ideas associated with it, one would adopt the manner of its art. The pastiche of styles in his enthroned Napoleon was a demonstration of this approach. It did not find immediate favor, earning the young Ingres a stubborn reputation as an eccentric medieval revivalist. Bonaparte's negative reaction completed the parallel with Girodet in 1802: the Emperor found the naked

1.37 JEAN-AUGUSTE-DOMINIQUE INGRES Jupiter and Thetis, 1811. Oil on canvas, $11'45\% \times 8'5\% (347 \times 257.2)$

archaism of his claim on power embarrassing when projected with such scrupulous fidelity by the powers of art.

Conveniently this setback coincided with the reopening of the French Academy in Rome, and Ingres was able belatedly to take up the scholarship he had won five years before (and he contrived to remain in Italy for the next fifteen years). His first painting of the nude, to be sent back for inspection in Paris, extracted the Classical prototype from beneath the Bonapartist trappings and expanded it into an overwhelming totem of masculine power. The subject matter of his *Jupiter and Thetis* (1811) concerns the divine intervention that lay behind the desperate entreaties of the Greek warriors to the reluctant Achilles. The latter's divine mother is shown supplicating the chief of the gods to strengthen the Trojans and teach the Greeks a lesson for Agamemnon's high-handed mistreatment of her son. The jealous Juno looks on and plots her revenge.

1.37

The common source in the Olympian Zeus makes a pair of Ingres's enthroned Napoleon and his Jupiter. They illustrate

the double-sidedness of artists' subservience to an absolute authority. The dependent adoration of a dominant political figure easily transmutes itself into a personal fantasy of power and domination, and both are equally aspects of isolation and vulnerability. In this case, as so often, that domination is exercised over a woman, a diminutive figure who is turned into an impossibly sinuous and compliant emblem of submission. Ingres's imagination of untrameled strength, encouraged by the cult of the First Consul/Emperor, helped remove the rational constraints on the linear Classicism of the period. Because its approach to the human figure devalued inner substance in favor of pliable outline, it offered little resistance to the compulsions of private desires. The emphasis on silhouette in the figure of Thetis differs markedly from that achieved by Charpentier in her figure of Melancholy, in that it is not a product of the signifying structure of the painting as a whole; rather it proceeds from exaggeration and distortion, and the suppression of internal anatomy is just that, a

diminishing of the body's structural resistance to the artist's command.

Certainly Ingres's personal expansion of pictorial rhetoric into self-conscious archaism was an ingenious extension of the practises within which his education had taken place. But historical circumstances were such that, in contrast with David's sharpening of Classical rhetoric in the *Horatii*, 1.2 it did not trigger a new collective dialog. Nor could any painter have accomplished this. As individual artists became more detached and competitive, career patterns began to show the strains of maintaining an entire tradition by means of the frail emotional and intellectual resources of any single individual. Girodet's technical innovations in the Endymion had probably had the greatest individual impact on the art of the next decade, but his own art veered erratically and unpredictably between styles and themes. The baffled responses of his audience left him feeling bitter and misunderstood. Ingres, on the other hand, dealt with the erosion of community and stable benchmarks of Classical practise by refusing the very principle of development and change. He would obsessively return to favorite motifs and compositions, seizing any opportunity to try out small refinements in replicas and repetitions in other media. In one famous instance of this, he inserted the torso and head of his anonymous nude study of 1808, the so-called *Valpinçon Bather*, almost without alteration into the midst of his crowded *Turkish Bath*, painted more than fifty years later, by which time the context from which it took its meaning had changed enormously.

Girodet and Ingres were among the most committed Classicists of the early Empire, yet the art of both remains remarkable for its highly subjective and idiosyncratic character, its insistent revelation of the irreducible creative personality. That these are traits which have come to define Romanticism in art should be enough to underscore the point that the greater part of the Romantic legacy was in fact engendered within the project of later Classicism by artists who were determined to remain faithful to its traditions, indeed, who could not imagine a serious art outside of those traditions. Both artists cultivated an exactingly polished technique in finishing the surfaces of their paintings, building up glazes so as to banish as far as possible individual gestural imprints in the paint. A "licked" finish would become one of the clichés of conformist academicism later in the century, but in the cases of its two originators, their obsessiveness with a sealed surface reads as a holding action, a determined imposition of an impersonal discipline over the involuntary exposure of the self.

1.38 JEAN-AUGUSTE-DOMINIQUE INGRES *The Turkish Bath*, 1862. Oil on canvas, diameter 42½ (108)

CLASSICISM IN CRISIS: GROS TO DELACROIX

THOMAS CROW

FORCE OF ARMS

THE ROMANTIC STYLE IN THE USUAL SENSE OF THE **⊥** term—energetic brushwork, linear order giving way to the impact of color, elevation of contemporary and exotic subject matter to epic intensity—arrived in the first decade of the nineteenth century. But it was as much a product of the translations and distortions of the Classical inheritance as was the art of Girodet and Ingres. Its chief innovator, Antoine-Jean Gros (1771–1835), was likewise a student of David and loyal to Davidian values all of his life. The most distinctive achievements of his career were attained against that loyalty under the pressure of political contingencies.

In age Gros fits between Girodet and Ingres, and this had a decisive impact on his formation. Girodet had been among the last of the Old-Régime students to have at least the better part of the normal period of training in Rome. Ingres was able belatedly to enjoy his after the French Empire had consolidated control of Italy. Gros's time came just at the point when Rome was closed to the French in 1793. He did manage to travel to Italy, spending time in Florence and in Genoa while those cities remained friendly territory (in the latter, he spent time with a weary Girodet recuperating on his long journey back to France). There was plenty to see and absorb, but he was denied the crucial opportunity to hone his drawing in a supportive institutional environment amid the monuments of Rome. In order to remain safely in Italian territory for as long as he did he needed protection, and the Bonaparte brothers looked after him; for a time in the late 1790's, he held a noncombatant's post with the army that left him ample time to practise his art (from this Gros has latterly acquired an exaggerated reputation as a soldier-artist).

That myth of Gros's early life would, however, have followed naturally from the painting with which he established his reputation on returning to Paris in 1801. The new Consulate decided to undertake a program of large-scale painting glorifying the successes of the French army and to that end proposed a competition in 1801 for paintings to commemorate the victory of a small party of 500 French against massed Arab cavalry numbering 6000 at the Battle of Nazareth two years before. Gros's sketch, to the consternation 2.1 of many critics, took the prize. What they could not grasp was the absence of a clear center to the composition and to the depicted action. General Junot himself is well to the rear, shown in individual combat with a Mameluke horseman rather than in overall command of the operation. The entire composition is made up of such vignettes, the unifying principle of the painting coming from strong notes of color repeated at intervals and rhythmic interlacing of the episodes achieved through surface handling of the paint.

The absence of a more solid underlying structure was not simply Gros's choice; it proceeded in part from the government's lacking any precise account of the battle. In place of a coherent verbal overview, it provided some anecdotes of individual acts of bravery, more often by common soldiers than by officers. This sort of record conformed to a mode of celebrating French victories that had persisted from the more democratic phase of the Revolution: the success of republican arms was attributed to the commitment of the citizen soldier fighting out of patriotic devotion rather than coercion or greed. Within this propagandistic mode, Junot's valor would be equal to that of the anonymous soldiers in the foreground, and so Gros faithfully rendered it. He augmented these with two scenes of his own invention designed to proclaim a basic humanity and idealism underlying the French adventures abroad: a vignette of Arabs about to decapitate a helpless European was contrasted to one of a French soldier protecting a surrendering captive from being shot.

2.1 Antoine-Jean Gros The Battle of Nazareth, 1801. Oil on canvas, 531/4 × $76\frac{3}{4}$ (135 × 195)

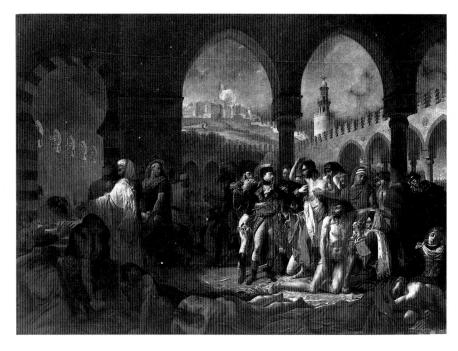

2.2 ANTOINE-JEAN GROS Napoleon in the Plague House at Jaffa, 1804. Oil on canvas, $17'5^{1/2} \times 23'7^{1/2} (532.1 \times 720)$

The inventive artistic solution he devised for knitting all of this together had the further effect of conveying, through rapid gestural notation and the liberation of color, an exciting sense of the fury and confusion of battle. It was important too that this novel category—heroic history painting of a contemporary event—not be confused with the meticulous description deployed by traditional painters of battles, an approach which had always placed their efforts among the lower genres. Had Gros more deeply internalized the routines of Classical drawing, he might well have lacked the necessary flexibility and improvisatory flair to deal with this complicated

brief. As it was, his success put him in a commanding position to respond to escalating demands for contemporary reportage in history painting.

The commission for a full-scale version of the Nazareth subject never in fact materialized. As it looked back to the Directory's citizen army ideal, it was out of step with the Bonapartist cult, according to which French victories were guaranteed by the charismatic command of one individual. Three years later Gros made good this discrepancy with Napoleon in the Plague House at Jaffa (1804). The conquest of 2.2 the Palestinian city was again the success of another general,

so this time there was no question of the painting dealing with the battle itself. Instead Gros exploited an outbreak of plague which spread from the city's Arab defenders to the victorious French. Bonaparte is shown fearlessly touching the sore of one of his suffering soldiers while his aide anxiously holds a handkerchief to his face. The ostensible subject matter is eminently rational: fear was thought to advance the spread of the disease, and the general is here by personal example attempting to arrest the idea of inevitable contagion and death. But the effect in the painting is irrational: the sick among the French seem almost to rise by magic to make contact with their leader. Dominating the foreground, by contrast, are the shadowed figures of those dead and dying deprived of that touch. The ordinary soldier is now powerless. To the extent that heroic nudity had been a bearer of republican ideals, Gros reversed its normal meanings in transforming it into a sign of dependent helplessness, nowhere more emphatically than in the grotesquely outsized soldier on his knees in the foreground, who looks away from his attentive Arab physician toward his diminutive, tightly clothed commander.

As in the *Battle of Nazareth*, Gros has exploited animated surface and punctuation with vivid color to convey the exotic locale and the horrific sensory impact of the plague house. A good deal more control was required, however, in that this painting was required to return to a traditionally hierarchical arrangement with the hero at its center. The contemporaneity of the scene, its unfamiliar aspect and profusion of picturesque detail should not obscure the fact that Gros met this challenge by appropriating a touchstone of the modern Classical tradition—David's *Brutus*.

1.10

The crucial device by which his teacher's painting articulated the irresolvable conflict between public duty and private devotion had been the great divide in the composition, the formal interruption that split the civic from the domestic sphere. The two were pried apart in such a way that enormous tension remained between them: the engaged viewer would find no settled position for his or her sympathies; the meaning of the work consisted in his or her mental reenactment of the conflict. Gros deployed his architecture and divided his figures in order to reproduce almost exactly David's compositional scheme. The Arab doctors at the left, with their desperate charges, occupy the same position as the grouping of Brutus with the procession bearing the corpses (down to a repetition of the litter-bearer's sidelong glance). Bonaparte and his men, bathed in light, correspondingly reproduce the clustering of Brutus' wife and daughters with their ascending pattern of bare limbs. And the delirious French soldier at the far right introduces a darker note of isolation and blindness directly analogous to David's (and Gérard's) grieving nurse.

But the utter transformation in the meaning and use of this

powerful scheme is the most revealing sign of the impact of absolutist priorities on history painting. There is no tension between the divided parts of Gros's composition; the viewer is not challenged by simultaneous appeals to two sides of his or her moral character. The split rather represents a reassuring division between European Enlightenment, in the person of the conqueror, and the darkness of the Oriental vanquished, who are inured to death and impassive in its presence. On the ruin of David's critical examination of republican virtue, Gros constructed an immutable division out of Christian eschatology, in which the radiant presence of Christ in Limbo is contrasted to an Arab Hell (the seated figure in the left-hand corner, the stand-in for Brutus, mimics representations of the cannibalistic Ugolino from Dante's Inferno). This conflation of conquest and redemption was all the more useful in view of the disturbing reports that the French, on Napoleon's order, had themselves visited a hellish massacre on the surviving, unarmed defenders of the city.

AN IMPERIAL ANTIQUITY

Ambitious painting under the empire has perhaps been misleadingly typified by such propagandistic and questionable glorifications of Napoleon. A comparative stability and freedom of movement on the Continent, which came in

2.3 ANTONIO CANOVA Perseus, 1801. Marble, height 865/8 (220)

2.4 Antonio Canova Pauline Borghese as Venus, 1808. Marble, length 79 (200.7)

2.5 ANTONIO CANOVA Magdalene, 1796. Marble, height 37 (94)

the wake of French conquests, allowed for more pacific developments as well. Patrons from across Europe competed for the talents of the French Classicists, and the most favored manner was the precious, mythological Classicism that had been incubated under the Directory.

One patron in particular, Giovanni Battista Sommariva, led this current of taste and thematic interest. After 1806, he was resident in Paris and known under various titles, including Marquis de Sommariva, though he had begun his career as a barber's assistant in northern Italy. Subsequently trained as a lawyer, he arrived in Milan in 1796 just at the moment when the victorious General Bonaparte had arrived and begun his organization of a French puppet republic in the region. The upstart lawyer astutely and unscrupulously negotiated a path through the shifting tides of war, retreating to France when fortune dictated. By the turn of the century, he was Napoleon's surrogate in Milan and in that capacity amassed an enormous fortune, a showplace villa on Lake Como, and a commensurate number of bitter enemies.

Even before his definitive fall from power, Sommariva was deliberately attempting to gain prestige and rehabilitate his unsavory *parvenu*'s reputation by enlightened patronage of art. His first instrument in this regard was the immensely influential sculptor Antonio Canova (1757–1822). This artist, of Venetian origin, had come to prominence in the same Roman milieu which supported Flaxman in the 1790's. As a

2.6 PIERRE-PAUL PRUD'HON *Crime Pursued* by *Vengeance and Justice*, 1808. Oil on canvas, $96 \times 9'7$ (244 × 292)

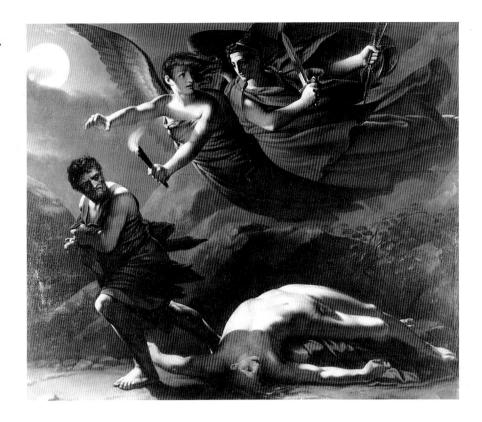

native-born Catholic, he was in line for the sort of commissions to which his English contemporary could never aspire. These included the monumental papal tombs that consolidated his position as the preeminent official sculptor of the age. His prestige had originally been established, however, with smaller compositions on Classical themes which manifest an esthetic analogous to the purified linearism of Flaxman's Homer. The Perseus (1801), a mid-career work, demonstrates his paradoxical ability to communicate a sculptural idea through the abstract element of line rather than through volume and mass. Viewed directly from the front or the rear, the high information-content conveyed by the indented profile contrasts with the comparatively lower level of articulation in the polished surface of the stone. This internal contrast allowed Canova to combine a strong intellectual clarity with subtle and luxurious refinement in his tactile values.

1.26

2.3

The combination came to appeal enormously to the Bonaparte family. The Emperor's sister, Princess Pauline Borghese, had been married into Italian nobility as part of their legitimation as the new pan-European dynasty. It was the client herself who requested that she be represented as Venus Victorious, and in his portrait (1808) Canova obligingly imagined her as simultaneously displaying the dignified pose of a patrician Roman matron and the careless nudity of a goddess for whom mortal opinion is nothing. In public, it would have been cause for scandal, but its intended audience

2.7 JEAN-BAPTISTE REGNAULT Liberty or Death, 1795. Oil on canvas, $23\% \times 19^{1/4}$ (60 \times 49)

2.8 PIERRE-PAUL PRUD'HON Psyche Carried by Zephyrs to Cupid's Domain, 1808. Oil on canvas, $76\frac{1}{4} \times 61\frac{1}{8} (195 \times 157)$

2.9 PIERRE-PAUL PRUD'HON Portrait of the Empress Josephine, 1805. Oil on canvas, $96\times70^{1/2}$ (244 \times 179)

was limited to those whose sophistication in such matters could be assumed. Only some guests of the Borghese family were conducted to see the work, their visits customarily taking place at night in the dramatic illumination and deep shadow of torchlight. Canova himself favored this same theatrical device in displaying his work to prospective clients. The fashion for nocturnal viewing by artificial light represented yet another avenue by which sculpture was assimilated to modes of illusion more characteristic of two-dimensional representation, but in this case the effect was further from Flaxman's linearism and closer to the chiaroscuro of Girodet's *Endymion*.

A group of Canovas formed the core of Sommariva's collection, and he gave similar dramatic emphasis to their display. These he housed first at his Italian villa, which he transformed into a shrine to classicizing art, then in an imposing Parisian townhouse, where they provided fresh stimulus to mythological fantasy art. His proudest possession among these was a single figure of the penitent Magdalen (1796), in which the sensuality of the revealed body is reclaimed for orthodox piety only by the artist's Classical economy of means. This particular sculpture—perhaps improbably to our eyes—was one of the most acclaimed works of art of the early nineteenth century. The novelist Stendhal was one of its most ardent admirers, and it brought its owner tremendous prestige. For its installation, Sommariva had a special shrine constructed where it was surrounded by violet furnishings and lit by a single alabaster lamp.

Canova's art made a direct impact on the work of the French artist Pierre-Paul Prud'hon (1758–1823) in his Crime Pursued by Vengeance and Justice (1808), an allegorical subject painted for the principal chamber of the Napoleonic criminal court. The fleeing figure is modeled after a sculpture by the Italian. The other elements come from a comparable repertoire: the airborne deities follow the pattern of one of Flaxman's outlines, and the nude male victim, divided by shadow and brilliant moonlight, is a flexed, upended tribute to Endymion. All of this the artist melded together in a general 1.13 twilight which underscores its message of menace, threat, and retribution. That effect was markedly different from the allegories of clarity and light which had characterized Republican official art. In that an exemplary effort in the earlier mode, Regnault's Liberty or Death, had been conceived at the height of the Terror, it could be argued that Prud'hon's conception exhibits a greater realism about state power. At the same time, however, it drains any vision of idealism and impartiality from the conduct of justice and replaces those standards with an imaginary regime marked by violent sensuality.

The Empire years represented a great rehabilitation for Prud'hon, who was older than Girodet and Gérard, a contemporary of Hennequin whose career had likewise followed an unorthodox and uneven pattern. Supported by a provincial fellowship in Rome, he had remained defiantly outside the Davidian circle and resisted its esthetic and rhetorical preoccupations. He developed a characteristic manner, highly individual for the times, which deemphasized dialectical clarity in favor of a calculatedly hazy merging of objects with their atmosphere (he painted first in monochrome, then introduced color in selected areas, overlaying the whole with a series of translucent glazes). As in the Rococo fantasies of Boucher in the previous century, this emphasis on surface lent itself to fantasies of freedom from the constraints of gravity.

Two such mythological subjects, both personifying the wind, were among the best-known of his paintings—Psyche Carried by Zephyrs to Cupid's Domain (also 1808) and the single Zephyr (1814), shown as a playful preadolescent momentarily suspended just above his reflection in a glassy pond. Both returned to themes made fashionable by the Davidians under the Directory, his unorthodox technique giving them a new currency, and both were commissioned by Sommariva. As with Canova, this collector was conspicuously signaling the affinity of his taste and of his person with the Bonaparte family, Prud'hon having painted portraits of the Emperor, the Empress, and Napoleon's son and heir, the ill-fated King of Rome, over the course of the Imperial period. His portrait of the Empress Josephine (1805), turns away from the pomp of her recent coronation (memorialized in the gargantuan canvas by David) to a contemplative pose among the woodland surroundings of her park at Malmaison. The strong illumination of the sitter, with its emphatic,

2.10 PIERRE-NARCISSE GUÉRIN Aurora and Cephalus, 1811. Oil on canvas, $8'4'/4 \times 73^{1/4}$ (254.5 × 186)

2.11 ANNE-LOUIS GIRODET *Atala at the Tomb*, 1808. Oil on canvas, 77½ × 8′6⅓s (197 × 260)

Other collectors, domestic and foreign, pursued the same artists and supported the same sensibility. Prince Yusupoff, a high Russian nobleman, commissioned Guérin in 1811 to paint a replica of a picture, *Aurora and Cephalus*, that the artist had supplied to Sommariva the year before, and a matching pendant on the subject of Iris and Morpheus as well. The pair,

2.12 ANNE-LOUIS GIRODET *Pygmalion and Galatea*, 1813–19. Oil on canvas, $99\% \times 115$ (253×292)

2.13 ANNE-LOUIS GIRODET *The Revolt at Cairo*, 1810. Oil on canvas, $11'8'/8 \times 16'47/8$ (356 × 500)

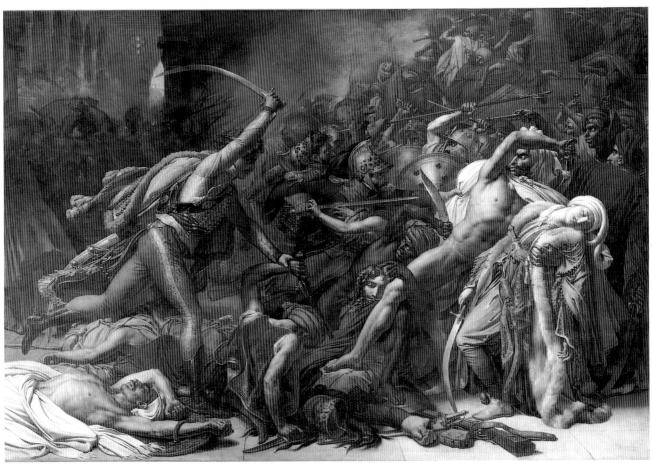

both of which show a beautifully unconscious mortal male subject to a goddess's infatuation, amount to an elaborate homage to the continuing authority of Girodet's *Endymion* under the culture of the Empire. The destination of the paintings demonstrates how completely Girodet's Revolutionary utopianism had been divorced from the image of human perfection with which it had been associated in the 1790's. Guérin's mechanical handling of the clouds and the celestial illumination shows the degree to which the singularity and daring of his model had been reduced to conformist formulae.

At this point, however, Girodet himself would have been the last to object to the embrace of his signature esthetic by such patrons. He had grown firmly and cantankerously conservative since the turn of the nineteenth century. From the time of his miscalculated Ossianic painting for Malmaison, he would go on avidly courting those in power. Sommariva had garnered wide public acclaim when he arranged for the inclusion of Canova's Magdalene in the Salon of 1808; for the same exhibition Girodet produced a painting which played on the sensibility so expertly orchestrated by the Italian collector. He drew his subject from the novel Atala by the neo-Catholic writer Châteaubriand, a phenomenally popular fantasy about Christian converts in America: the scene is the aftermath of the suicide by the violated heroine of the title, who has honored a Christian childhood pledge to preserve her virginity or die. His stilled and brooding treatment of this morbidly sensational subject, structured around the contrast between the ideal beauty of Atala and the exotic male physicality of her bereaved lover Chactas, made it the one unalloyed public success of Girodet's mature career. This may be precisely because it was far from his most original or inventive work.

Sommariva naturally courted him, but the result of their collaboration was probably the least happy of any of the collector's initiatives. In 1812 he commissioned Girodet to treat one of the central myths of artistic creation, the story of the sculptor Pygmalion who falls in love with his own creation and successfully entreats Aphrodite to bring the statue to life. True to his previous instincts, Girodet sought to introduce an effect of stunning originality which would go beyond all previous approaches to the subject: the marble statue would be captured at the precise instant when an electric spark of life coursed through previously inanimate matter.

The story itself recalls that of Endymion by means of a symmetrical reversal of its terms: there a divine being was smitten by love for a mortal and had both robbed him of consciousness and given him an unchanging, eternal beauty (like a work of art); in the Pygmalion myth a mortal is smitten by an image of undying beauty and brings about its divine transformation into mortal flesh and human awareness. As it happened, however, the fashioning of the painting entailed an

altogether unwelcome reversal of the sureness and facility that had graced his youthful masterpiece. Working largely at night under lamplight, isolated from daytime visitors, he was said to have entirely effaced the painting three times over a period of six years. Where the Endymion still carries extraordinary power by virtue of the seamless, uninflected surface of paint in which the illusion is embedded, the surface of the Pygmalion is clotted and uneven, bearing witness to indecision and obsessive, dissatisfied reworking (its protracted gestation surely lies behind Balzac's famous story of the Unknown Masterpiece of 1831, in which the fictional master Frenhofer futilely attempts to give the painted image of a woman the ultimate illusion of life, effacing a magnificent likeness through obsessively dissatisfied reworking). Girodet's concentration of the spectacular effects of metamorphosis came at the expense of any equivalent attention to the action, which remains stiff and insipid by comparison to all of his previous work. His failure to find adequate form for his subject turned its theme of the ultimate creative act into a bitterly ironic commentary on the artist's declining powers.

2.14 THÉODORE GÉRICAULT The Charging Light Cavalryman (chasseur), 1812. Oil on canvas, $11'5\frac{1}{2} \times 8'8\frac{1}{4}(349 \times 266)$

THE ARTIST HERO IN THE FACE OF EMPIRE

The implicit negative judgment contained in the failure of Giroder's *Pygmalion* was not of course on its maker alone. It summed up the condition of Classicism, once shared social metaphors had been withdrawn from the visual repertoire of antiquity. The artist himself, in the years just prior to beginning Sommariva's commission, had completed what was perhaps the most confident and inventive painting of his entire later career, the Revolt at Cairo, for the Salon of 1810. In it he found an appropriate object for the idiosyncratic skills which had betrayed him in the Ossian. The subject was an event of twelve years before, during the same Middle Eastern campaigns that had supplied Gros with his early subject matter. Girodet isolates one concentrated scene of quasianonymous struggle, choosing the moment when a rebellious Arab onslaught is just being turned. In the foreground, a single French officer appears single-handedly to be forcing back an insurgent phalanx of claustrophobic density. That imbalance conforms to the ethnocentric patriotism of Gros's Plague House at Jaffa, but Girodet's characterization of Arab resistance does not reproduce his colleague's ascription of resignation and passivity to the colonized. At the right side of the composition is a magnificently defined rebel whose stance precisely parallels that of the charging European. It is the Arab who exhibits heroic nudity, which allows exertion in extreme peril to be manifested sensually in every anatomical detail. What is more, this leader of resistance finds sufficient strength to support a fallen comrade.

Underneath the tumult of the action, one can make out the basic planar grid of Classical composition, and Girodet has answered the demands of a traditional painting of action where the hero must be tested against a worthy opponent—as much as he has answered the demands of propaganda. Without there being any known dissenting intentions on the part of the artist, that overriding allegiance to tradition upset the normal ethnic hierarchies of Napoleonic battle painting. The private, contemplative themes encouraged by new patrons like Sommariva represented by contrast a narrowed and comparatively impoverished version of the Classical tradition; for Girodet it meant having little to draw upon but a futile recollection of past youthful glory.

During the second decade of the nineteenth century, the most convincing revival of the larger ambitions of Davidian Classicism likewise came from the exploitation of marginal possibilities allowed within contemporary Imperial subject matter. Its author, Théodore Géricault (1791-1824), was an unconventional outsider in the increasingly professionalized ranks of younger artists. He has come down to us as the first great Romantic, and of his startling singularity as an artist and personality there can be no dispute. But singularity is itself a quality that must be put together from bits and pieces of already existing models. And the more one knows about the ambitious young artists who came immediately before him, the less idiosyncratic Géricault's impulses seem. One can begin to see him constructing his own autobiography, reenacting the myths of artistic individuality current in his own time. In an environment awash with mercenary temptations, he managed convincingly to revive the Revolutionary ideal of the independent, public-minded artist, impatient for glory and indifferent to merely monetary rewards.

Under the Empire, the biography of Drouais was increasingly taken to exemplify this ideal. His legend falsely condensed the objective circumstances of a precocious career into an enduring mythology of a miraculously singular talent sweeping all before it. And Géricault, who possessed similar financial and social advantages but none of Drouais's professional pedigree, formed his ambitions in the shape of that legend in 1812 and 1814. He believed in it to the point of rejecting any sustained application to learning his craft; during brief stints in the studios of Carle Vernet and Guérin, he attempted to substitute spontaneity and bravura for soundness in drawing and composition (to the point that he acquired the nickname of 'pastry cook' among his fellow students). Despite such uncertain preparation, he nonetheless chose to put his name before the public in 1812 with a heroic single figure, one that would manifest, in unexpected ways, ambitions for psychological and narrative complexity of a kind normally encountered in multifigured narrative machines.

At the age of 21 and using his own resources entirely, he prepared a canvas of monumental dimensions for the Salon of 1812. The Charging Light Cavalryman (chasseur) is both 2.14 portrait and battle painting: it differed from previous Imperial equestrian portraits in that its announced subject (Lieutenant Dieudonné) was unknown and effectively an anonymous individual; it differed from previous descriptions of French military heroics in its very Classical investment of heroism as a potential within an isolated figure. The development of his sketches passes a crucial point when the direction of the rearing horse is changed from leftward to rightward, while the gesture and attention of the rider, if not his seat, remain directed to the left as before. This uses the body, movement, and even the expression of the horse to convey an internal complication within the action and thoughts of the rider.

This is realized in the final painting with enormous assurance, but it should be recognized that the eloquence and complexity of his body is only implied, translated into external surface equivalents spread outwardly in two dimensions. An energetic and unfinished application of paint instills the excitement of the theme across the physical surface of the canvas. Every directional form leads one's attention away

2.15

from the torso of the figure, which lacks any effective volume, any capacity for action within itself. This necessitates perpetual distraction and displacement toward outthrust extremities, ornaments, and turbulent, luminous atmosphere.

It might be argued in reply that the elaborate modern uniform itself prevents exposure of the body and that the nature of the subject matter prevents anything approaching the expressive nudity of Classicism. But the rider's tight sleeves and breeches only reveal how two-dimensional and pattern-like Géricault's understanding of the figure remains, neither modeling nor contour conveying strength in the grip of his legs or the sweep of his sword arm. The signs of strength that work effectively are isolated ones displaced to the ends of limbs: the boot in the stirrup and the clenched fist around the reins. It comes as no surprise to learn that the painting was worked out largely through color sketches without preparatory drawing. Worries over drawing would probably have prevented the painting ever being realized at all.

Works of startling genius can come about through compensation for deficiencies and the overcoming of self-imposed difficulties. In this instance, the imbedded weakness in the work is an inescapable mark of the social on the singular identity of the artist, that is, the mark of those existing identities to which he must somehow answer if he is to complete his own. Because Géricault was not yet ready to match the example of a Drouais on its own terms, the heroic body that was its emblem is registered in the *Light Cavalryman* as an absence, a non-body which generates the painting's spectacular compensatory invention by its very unrepresentability.

The year 1814 saw the first fall of Napoleon from power in France and a temporary return of the Bourbons before their definitive restoration after Waterloo in 1815. It was decided that a Salon would hastily be held to mark the return of monarchist culture, but it had to be exceptionally open in order to obtain an adequate number of works. Géricault took advantage of the opportunity to double his representation in the exhibition by including the Light Cavalryman along with whatever new work he could prepare in time. Again his bid for renewed attention was a monumental single figure, The Wounded Heavy Cavalryman, which he plainly intended as a pendant to the earlier work. The object would be to deepen the effect of the new painting (and give the old an enhanced resonance and timeliness) by setting up a quasinarrative interplay of antithesis between them: light versus heavy, active versus passive, mounted versus earthbound, vigorous versus debilitated. Gravity rules in the second painting, in contrast to the first where the horse and its passenger had been connected to the earth by only one spindly, springing limb. The most obvious of these antitheses has always dominated commentary, that is, the one provided by Napoleon's

2.15 THÉODORE GÉRICAULT The Wounded Heavy Cavalryman (cuirassier), 1814. Oil on canvas, 11'9 × 9'7³/₄ (358 × 294)

intervening reversal of fortune in the snows of Russia. While Géricault doubtless made room for that reading, it was just one part of a grandly rhetorical construction of opposed qualities between the two paintings, and this had more to do with enlisting the modern single figure to do the sort of meaningful work normally reserved for the complex internal narratives of Classical history painting.

For purposes of balance between the paintings, the addition of a mount was necessary. And the soldier's need simultaneously to keep his feet and to maintain his grip on the animal in turn justifies the dramatic contrapposto of his pose. Much has been made of the horse's strange, occluded foreshortening—the result of a restricted format—as the painting's most serious failing. But this seems less serious than Géricault's failure to articulate the key areas of muscular exertion necessary to complete the action. And these again are passages where the costume permits the closest approach to the nude. The thighs of the figure are massive without their underlying structure being sufficiently defined; they cannot convey the strength required to keep those heels planted in the ground and the body braced against the descent and the horse's panicky movements. Worse is the flaccid, perfunctory shape of the right arm, which offers no discernible sense of how sufficient force is being applied to the grip on the bridle.

2.16 LOUIS HERSENT Louis XVI Distributing Alms to the Poor, 1817. Oil on canvas, 70 × 90 /4 (178 × 229)

2.17 PIERRE-NARCISSE GUÉRIN Henri de Rochejaquelein, 1817. Oil on canvas, 85×56 (216 × 142)

These failings of execution are overwhelmed in the end by extraordinary passages elsewhere, the daring expansiveness of the painting's conception, and its complex dialectic with its predecessor. Géricault's early proclivity for undertaking major Salon canvases at the last possible moment made their impact all the more startling but their conspicuous short-cuts unavoidable. The pressure and the ambitious scale gave him his schooling, painful though it was. Having been refused the honor of a state purchase of either canvas, he could do nothing but return them to his studio and later, unable to bear the sight of them, have them rolled and put away.

RETURN FROM THE WRECKAGE

In 1816, in the wake of this experience, Géricault made a concerted attempt to win the Rome Prize and retroactively acquire the traditional formation he had denied himself as a young student. After a predictable failure to gain the final round in the competition, he again fell back on his own resources, making the rounds of Florence, Rome, and Naples, throwing himself into a new discipline of Classical drawing and command of the nude.

On his return to Paris the following year, he felt himself ready to compete on the supreme level of multi-figured narrative. But the range of available options had altered considerably since his departure. The restoration of the Bourbon monarchy was by now firmly established, enforced by the allied armies of Europe. A correspondingly conven-

2.18 François Gérard Entry of Henri IV into Paris, 1817. Oil on canvas, 16'7% × 31'41/4 (510 × 958)

tional iconography of praise for royalty and the counter-Revolution was now in place. Among those who eagerly responded was Louis Hersent (1777–1860), a contemporary of Guérin's and likewise an ex-student of Regnault. This artist had early turned away from the Classicism of his training for more picturesque subject matter. To honor the new King, Louis XVIII, he turned to the sentimental mode of eighteenth-century genre painting to depict Louis XVI (older brother of the reigning monarch) distributing alms to the poor during the harsh winter of 1788. Conservative commentators waxed lyrically about the old King's habit of secretly performing such charitable acts in the neighborhood of Versailles and compared the figure in Hersent's maudlin composition to those of beneficent rulers of antiquity-Trajan, Titus, and Marcus Aurelius.

2.16

2.17

Géricault also saw the genre of the heroic single figure in battle preempted by the regime to celebrate the leaders of the ultra-Catholic and Royalist resistance to the Revolution in the Vendée region of the west of France. Some half-dozen artists were given these commissions in 1816. The enterprising Guérin was one of the first to complete his, a portrait of Henri de Rochejaquelein (1817), which he showed in the Salon of the following year. It is striking to see the ease with which Republican conventions of celebrating individual courage in the thick of battle were turned to opposite ends through the substitution of different iconographical props: the white flag of Royalism, the sacred heart pinned to the chest. This

particular Vendéen 'general' was the most aristocratic of the group, which included individuals who had been little more than opportunistic bandits. He had died in 1794, murdered according to his apologists—by duplicitous Republicans to whom he had offered clemency. Guérin lends to his pose and features the practised beauty and composure of the young Classical warrior, the better to underscore the themes of selfsacrifice and inborn nobility.

The ease with which such opportunistic transformations could be effected did as much as anything to drain the moral authority from the Davidian figural canon. Even for artists steeped in its tradition, other stylistic options were equally accessible. Gérard greeted the returning Bourbons with a vast historical canvas (1817) depicting the seventeenth-century 2.18 monarch Henry IV being met by the civic leaders of Paris in an atmosphere of popular celebration. Henry IV was the founder of the Bourbon dynasty, and even during the Revolution he had been held up as the virtuous monarch, solicitous of the welfare of the people, from whose example subsequent rulers had disastrously departed. His accession to the throne, symbolized in his acceptance by Paris, put an end to a terrible period of protracted civil war. Gérard's choice was thus in some ways more canny than Hersent's, in that the historical precedent was more exact and powerful, while it allowed the new regime to exploit a current of criticism once directed against the monarchy. He also exploited the possibilities of historicism, as opened up by Ingres, but without any of

the latter's tendency toward preciousness and esotericism. *The Entry of Henry IV* expertly recalls the teeming magnificence, the multiplied subsidiary characters, the rich costume, detail, and color of Peter Paul Rubens and other masters of pomp and circumstance from the founding age of Absolutism.

Gérard had renewed his longstanding rivalry with Girodet, each now vying to be named to the revived Old-Régime office of First Painter to the King. It was a contest in which the former easily prevailed, untroubled as he was by any concern to restore the authority of Classical form from within its core mythology. His Henry IV set a pattern for a stylistically eclectic approach to historical drama, emphasizing costume and spectacular effects, which a group of vounger artists would carry through the 1820's. It was this group (much less than Géricault or Eugène Delacroix) that contemporaries would designate as 'Romantics', and it included avowedly liberal painters like Ary Scheffer and Horace Vernet (1789-1863) as well as uncomplaining Royalists. The young Vernet, a friend of Géricault, would apply this approach to a celebration of the Imperial army's resistance to the Allies at the gates of Paris and the military successes of the Revolutionary forces (The City Gate at Clichy and The Battle of Jemappes, both 1822).

Vernet's studio became a social center for young, disaffected ex-officers and artists, bored and antagonistic to the Restoration (he himself painted a group portrait of the studio, full of in-jokes and putting the practise of art no higher than fencing and riding). Géricault found a natural home there, but he lacked its insouciance about artistic matters. Having begun as something of a dilettante in the acquisition of technical skills, he sought now, perhaps alone in his generation, to

reinvest formal values with the moral import they had carried under the Republic.

He now possessed a command of Classical drawing that was doubly remarkable in an artist who remained essentially self-taught. The question, given the depressing examples around him, was what kind of subject matter would carry his exalted ambition. His drawings from Rome demonstrate that his interest in pictorial action and drama easily carried over into a personal fascination with violence and victimization. Back in Paris, he was first attracted to newspaper accounts of the murder of a liberal official in the provinces, a certain Fualdès, which carried bizarre details of secret conspiracy, transvestism, and ritual murder. He took his meditations no further than a series of drawings, having subsequently found a subject in which horrific suffering was redeemed by far clearer public significance: the shipwreck in 1816 off the West African coast of the frigate *Medusa*.

In its essentials, the story of the survivors of the disaster would not have seemed a vehicle for Géricault's new ambitions for Classical grandeur. The incompetently commanded flagship of a small fleet had run aground in the notorious shallows of the Arguin bank. The commander of the vessel was a returned émigré aristocrat who had spurned the advice of the experienced naval officers under him. As the privileged commandeered the inadequate lifeboats, a large raft was lashed together from the masts and spars. Some 150 seamen and soldiers were forced to crowd together on this precarious, openwork platform; there was no room for them to do anything but stand and the structure was so overloaded that the water came to their waists.

2.21,

2.19

2.20 THÉODORE GÉRICAULT Severed Limbs, 1818. Oil on canvas, 20½ × 25½ (52 × 64)

As soon as the officers in the boats (which also carried the cruelly impatient governor of Senegal) realized that towing the raft was slowing their own progress to a crawl, they cut the line, leaving its occupants to their fate. The castaways were then struck from without by a storm and from within by a horrific episode of despairing delirium in which factions among the enlisted men violently attacked the officers with the intention of breaking up the raft and committing collective suicide. The latter killed and wounded large numbers of the mutineers. The fighting, along with accidental or voluntary surrender to the waves, reduced their number to less than thirty within six days of the abandonment.

2.21 THÉODORE GÉRICAULT Despair and Cannibalism on the Raft of the Medusa, 1818. Black pencil, brown ink, heightened with white gouache on beige paper, 11 × 15 (28 × 38)

The living soon began to eat the flesh of the corpses which remained on the raft. A group of the hardiest and most lucid, including the ship's surgeon Savigny, augmented this horror by organizing deliberate killings of those nearest death in order to stretch the pitiful provisions. Through these expedients, fifteen survived for another week. At virtually the last possible moment, an accidental pass by a search vessel brought the raft in sight, and the blackened, emaciated survivors were taken to the primitive French capital in Senegal. Five more died there; only ten were ever to reach France.

The details of the story only became known because a confidential report written by Savigny to explain his conduct

was leaked to the press by elements within government opposed to the Minister of the Marine, and particularly to his policy of excluding experienced Imperial officers from service. The wounded naval administration concentrated its revenge on the bearer of the news, who then went public with a book on the disaster (written with Corréard, another survivor more recently returned from Africa) to vindicate himself. Their cause found ready support in the circle around Vernet, where the same grievances toward the Restoration were keenly felt. Géricault's seizing on the subject combined an attraction to the events in themselves and a commitment to Savigny's and Corréard's account of their actions.

Their version of events was far from unchallengable, and both the governor of Senegal and the naval authorities had been quick to seize on the grim fact of cannibalism and Savigny's particular responsibility for the deliberate policy of murder which had allowed him and his confederates to survive (the lone woman on board, the canteen attendant, had suffered a broken thigh and was among those killed). Géricault famously immersed himself in every detail of the castaways' ordeal; he was said to have visited hospitals to see dying men at first hand and painted his eerily evocative studies of severed heads and limbs as a counterpart to the charnelhouse of dismembered bodies which the raft had become. He completed full compositional studies of the two episodes of greatest horror, the mayhem of the mutiny and the subsequent cannibalism. But in the end the demands of his artistic 2.21 ambition—to equal the clarified grandeur of Davidian historical painting on his own terms—exactly coincided with the moral vindication of the raft survivors. Compromising facts and events are sacrificed in the interests of a purified compact of common humanity, redeemed by suffering and achieving salvation through its own unaided powers. He chose the moment of the first, agonizing sighting of the rescue ship, 2.22 when no one knew if they had been seen in return and the group is galvanized into one last collective action in order to attract its attention; it is as if the dependent plague victims of Gros's Plague House at Jaffa had suddenly found the inner 2.2 resources to take over their own redemption.

It is crucial to recognize that the painting (1819) communicates its subject matter as an idea rather than anything resembling reportage. Were it remotely true to the facts, the bodies would be starved and disfigured by sun poisoning, sores and open wounds. Instead Géricault seized the opportunity to display all of the impressive command of the athletic male nude that he had achieved since departing for Rome and he could do this on a scale that was larger than life, a notoriously difficult challenge to draftsmanship. He added figures, including three blacks, to answer the needs of his composition. The unconscious youth, cradled in the arms of a

2.22 THÉODORE GÉRICAULT The Raft of the Medusa 1819. Oil on canvas, 16'1 × 23'6 (490.2 × 716.3)

middle-aged protector, is a beautiful Athenian ephebe out of Girodet, Broc, or Guérin. The finished painting is a complex hybrid of the hyper-traditional (a centralized pyramidal arrangement of nude figures) and the unexpected (building it on a pitching sea with a cast of contemporary, semianonymous victims). But perhaps its most startling paradox is the degree to which this grand narrative involving many figures continued at the same time in the same problematic of the isolated hero which had preoccupied the artist in his first public paintings.

His catastrophic indecision over the hanging of the painting in the Salon of 1819 was a direct manifestation of its double character: finding that the organizers had placed it low on the wall, he chose instead to have it elevated over the portal of the vast exhibition space in the Louvre. But even as he stayed to watch his painting being hoisted into position, he recognized that he had made a grievous error. The elevated position was the one he automatically felt to be appropriate for an imposing historical composition: the highest genre of painting was defined by expansiveness of effect and breadth of comprehension; its decorum normally demanded a certain distance of viewing so that its totality would be legible and local detail reduced to suitably subordinate importance. The bodies in the Raft are painted with all the imposing generality demanded by tradition, but Géricault and his friends were right to see the painting's force drain away as it was removed from an intimate proximity to the viewer. The direction of the artist's compositional decisions had been to push the figures forward into the viewer's presence, until bodies seem to spill out of pictorial space altogether. Without crucial details being immediately present, as they are today in its low hanging in the Louvre, contact with the drama was lost.

One such detail, which can stand for all, is the extended hand of the unconscious youth in the lower left. Like everything in the painting, it is twice as large as life; this has the effect of making it seem twice as close as one expects it to be, however near to the painting one stands. The paradox of the Raft is that its colossal size both creates and demands an intimacy of approach that is normally the province of an easel painting. The tender pathos of that open palm is so involving in its emotional invitation that, once it is accepted, any disinterested vantage point outside the composition disappears. The chain of mingled bodies, uniting the races of Europe and Africa, becomes the equivalent of one single body in a state of transformation; its internal quickening proceeds from the group of moribund figures at the left across and upward through rekindled alertness at the center onto the ecstatic vitality of the frantic signaling at the pinnacle of the group. The only figure which is obviously beyond reviving lies on an opposing diagonal to this unified movement, which distributes the physical and moral

awakening of one body over the variations of nineteen individuals. This collective body has a brain—the four cooler heads clustered around the mast-but its salvation is overwhelmingly an affair of nerves, sinews, and blood. In this way Géricault, in his production as a public artist, remained a painter of the heroic single figure. Through the Raft's inspired anomalies of theme and scale, he managed to recast historical drama in its terms, pushing painting to an extreme of gigantism in order to generate a paradoxical intimacy with one generalized, eloquent body.

PUNISHMENTS OF THE DAMNED

By the time the Raft went on display, the scandal had done its work: the captain had been disgraced, the governor and minister had been removed. A new law opened up military ranks to those who had served under the Empire: the King himself had recognized that exclusionary policies were harming the state. Géricault believed that his celebration of the catalyst for reform would be honored by state purchase. He failed in this aim, though the painting was in fact (contrary to legend) rated quite highly by the Academy and awarded a medal. Still, there was no possible private destination for such a work in France and his disappointment was profound.

Ill health, mental and physical, aggravated by horse-riding injuries would cause Géricault's early death in 1824 at the age of 33. Although he planned new historical compositions (now on openly liberal themes like the evils of the slave trade), his limited energies permitted work only on a more modest scale. But even here his innovations were immense, commensurate with those of his Salon painting. A sojourn in England, where he successfully showed the Raft in a paying exhibition, led to remarkable experiments in drawing and printmaking. Taking up the new medium of lithography, he produced prints for a wider market, documenting scenes of common life-labor, sports, disability and alcoholism, the destitute poor, a public hanging. And in his primary medium, he manifested similarly broad sympathies in five of the most remarkable exercises in portraiture ever painted.

These have come down to us as his "portraits of the 2.23 insane," and there may have been as many as ten of them. They were discovered almost a half century after the artist's death, and any original data concerning their motivation and purpose has been lost; all one knows of their dating is that they came after the Raft. There is some evidence that suggests Géricault underwent psychiatric treatment himself within advanced medical circles where new, humane forms of treatment had been pioneered. French psychiatry in this period had developed the modern therapeutic approach in which mental illness is seen as continuous with normal life;

one line of argument even presented the insane as a kind of modern aristocracy in whom the Revolution's democratic emancipation of individual thought and feeling had simply reached an insupportable extreme.

2.23

Géricault's surviving portraits display a sympathetic objectivity which is at least congruent with this new scientific attitude. According to late nineteenth-century testimony, each represents a particular psychological malady, 'a monomania' in contemporary parlance. Each sufferer is depicted according to the portrait conventions of the time, particularly the plain dignity in dress and technique which David had developed in

his portraits (and self-portraits) of the Revolutionary period. Géricault conveys the underlying texture of muscle, fat, and bone in each face with startling economy and with a mobile technique which he is able to vary to surprising effect from subject to subject.

For the viewer, each is an occasion for the simultaneous discovery of an individuated person and of the uncertain traces of impersonal, objective conditions; each prompts reflection on the degree to which knowledge of other selves always entails the unstable convergence of the two. In their way they answer the same demands for elevation and complication in the single figure which Géricault had pursued in his public art. Reversing the *Raft's* passage through the colossal to arrive at the intimate, each portrait begins within a confined and homely approach to one isolated figure but deploys its plain-spoken manufacture and modestly suspended judgment to prompt in the viewer mental events commensurate in scale with those elicited by the most sweeping narrative.

The paintings pursue one latent implication of the *Raft's* construction of heroism, that is, the heroic subject may not necessarily be an effective actor in the world; heroism may well be manifested in resistance to forces which overwhelm isolated and vulnerable individuals. One's approach to such subjects is through a simultaneous diagnosis of the threatening conditions and identification with the extreme states of mind induced by confrontation with a hostile external world. The most innovative project in historical painting of the 1820's, that of the young Eugène Delacroix (1798–1863), would move toward the latter of these two poles.

Géricault and Delacroix had between them something of the same tense combination of filiation and rivalry that had existed within the circle of David. The latter had lost his father in infancy and his mother in adolescence. He shared

2.23 (top) THÉODORE GÉRICAULT *Portrait of an Insane Man*, 1822–3. Oil on canvas, 24 × 19³/₄ (61.2 × 50.2)

2.24 THÉODORE GÉRICAULT Pity the Sorrows of the Poor Old Man, 1821. Lithograph, 12½ × 14¾ (31.7 × 37.6)

2.25

Géricault's background in the upper bourgeoisie (his legal father Charles had been an important diplomat) and also took his early training in Guérin's studio. The two became acquainted there in 1817, and Delacroix posed for one of the slumped boys in the left foreground of the *Raft*. When the older artist received a state commission for a Sacred Heart of Jesus, he surreptitiously passed it on to his grateful protégé. But the ambition of the younger very quickly surpassed such routine works. He pressed himself to complete a major painting for the Salon of 1822 in place of competing for the Grand Prix de Rome. The result was a strikingly original exercise on a literary theme, the *Bark of Dante and Virgil*, depicting the passage of the two poets across the marshes surrounding the fifth circle of hell.

His first Salon entry demonstrated that he would absorb his Italian culture outside the normal institutional channels. Where Géricault had only postponed his pilgrimage to Italy, Delacroix would forgo the passage that once had been deemed essential in the development of any ambitious painter (he would later travel to the exotic territory of North Africa, following French colonial expansion, as a kind of substitute). The considerable intellectual and technical demands of the highest genre had, nevertheless, to be met in other ways. His recourse to the *Divine Comedy* marks one solution: cultivation of the most advanced literary taste, which in this period was elevating alternative poetic traditions over the legacy of French Classicism: Dante, Shakespeare, Goethe, Byron over Racine and Voltaire. Delacroix would illustrate all of these foreign writers during the 1820's.

Searching for the means to make a painting of such literary sources, however, he turned to a more local and immediate mode: Géricault's Raft. Indeed almost all of his major work of this decade can be read as a meditation on one or another aspect of that work, which concentrated and filtered for him virtually the entire previous tradition of historical painting. In spite of Dante's description of passing over a calm and misty slough, Delacroix chose to show the vessel threatened by a turbulent sea. He exploits the *Inferno* to recall the predictable equation of the Medusa survivors' suffering and sins with the punishments of hell (as Géricault himself had quoted Dante's cannibalistic Ugolino in the vignette of the older man cradling the nude adolescent). The damned souls clinging to the bark call directly to mind the bodies on the fringe of the raft, and one exhibits a mindless, devouring hunger. On that platform of bodies, Delacroix has constructed a compositional pyramid capped by the poet's beckoning gesture toward a distant horizon.

If the painting lacks the *Raft's* movement into depth, this can perhaps be explained by the differences in stages of technical competence between the two artists. In its summary application of paint, compression of space, and emphasis of

surface pattern, Delacroix's *Dante and Virgil* exhibits some of the same traits as Géricault's *Charging Light Cavalryman*. Where confident command of drawing is lacking, there is a corresponding effort to compensate through emphasis on texture and the multiplication of arresting incidents and effects across the surface. Unlike his mentor, however, Delacroix would essentially remain at this stage and forge a consistent pictorial idiom out of it, one capable of organizing the most complex narrative structures.

In coming to understand this art, which has come down to us as the essence of Romanticism, it is important to see the ways in which Delacroix's practise represents the logical outcome of developments reaching back into the 1790's and beyond. Gérard and Guérin established the model of precocious Salon success when the Rome Academy was closed by war and the Revolutionary exhibitions removed the old restrictions on entry. Their ability to capitalize on that opportunity, dignified by the Davidian notion of the artist as self-creating exemplar of virtue, helped remove the old artisanal associations from an artistic career. This in turn made painting seem an attractive and feasible venture to a quasi-aristocratic amateur like the young Géricault. And as the normal routines of training and socialization played a minimal part in his development, the next step was to move permanently outside of the confining discipline embodied in the Rome Prize procedure, with its controlled stages of progress, humiliating submission to repeated judgment, and years of subservient conformity.

As Géricault had quickly recognized, there was a considerable price to be paid for such abstinence, but it was one Delacroix was willing to assume. The artist would have few learned routines on which to rely, a diminished fund of concrete knowledge once so patiently, even subliminally absorbed over vears of artistic exercise among the monuments of Italy. No ambitious painter could as yet forgo traditional demands for high erudition and elevation of thought, but these qualities would now depend upon the inevitably limited intellectual resources that any single individual could command. And there was a corresponding pressure for immediate results, and this meant rapid, cost-effective execution. The credentials of this new-model artist were not secured by any institution: they had to be tested and proven in every public outing. Each major painting was a speculative exercise in which it was imperative that public attention be seized with some effective combination of the familiar and the strikingly novel.

Delacroix's *Dante and Virgil* fulfilled nearly all of these requirements in a canvas of relatively modest dimensions. For the Salon of 1824, he moved to capitalize on its public success with a painting on a truly monumental scale, the *Massacre at Scio*. The subject comes from the recent events of the Greek war of independence from the Ottoman Turks, which had

2.25

2.26

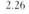

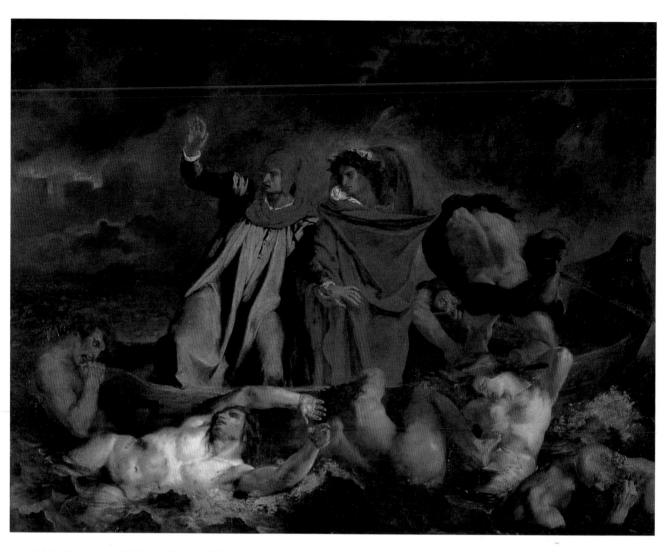

2.25 EUGÈNE DELACROIX The Bark of Dante and Virgil, 1822. Oil on canvas, 74 × 947/8 (188 × 241)

begun in 1821 and would go on through most of the decade. It was the struggle that was famously to enlist the English poet Byron, who perished at Missolonghi in that same year. The Greek cause provided a rallying point for disaffected liberals in France as well, who chafed against the repressive regime of Charles X but who lacked any effective avenues of resistance at home. As the government was constrained to follow the policy of the Holy Alliance in favor of the Turks, liberals were safely able to present themselves as defenders of core Western values against a brutal Oriental despotism.

Some two years before, the population of the island of Chios (the legendary birthplace of Homer and a seat of Hellenic learning) had been subjected to a brutal campaign of retaliatory terror, its towns razed, its inhabitants murdered or sent into slavery. As a subject it was of a piece with the Raft as well as with those unrealized projects of Géricault's later years, the victims of the slave trade and the prisoners of the Spanish Inquisition released by democratic insurgents in 1820. In the

year of his mentor's death, Delacroix paid him homage—and laid claim to his legacy—with his own crowded scene of collective martyrdom arranged into a canted pyramid of dead and suffering bodies set against the sea's sharp horizon.

The Massacre at Scio, however, made plain the difficulties 2.26 entailed in trying to build so directly on the Raft of the Medusa without bringing to the task the same degree of immersion in the subject and lengthy trial and error in achieving a final composition. The principal group rests awkwardly within the vertical format (over 13 feet high), in that Delacroix could not find a way to treat the large upper zone in more than a perfunctory, space-filling way. As the critics of the Salon noted with near unanimity, the painting lacks any focus of effective action, leaving one's attention divided by fragmented vignettes. Most of these, derived from generic iconographies of plague and disaster, do little to evoke the specific outrages of the Turks. One mounted warrior carries a naked woman into captivity and prepares to slay her male defender, but his

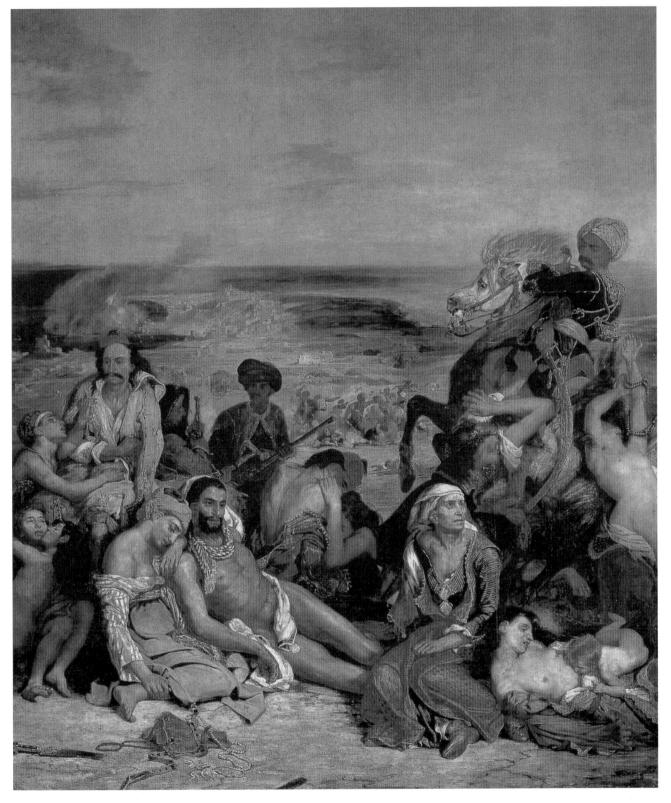

2.26 EUGÈNE DELACROIX The Massacre at Scio, 1824. Oil on canvas, $13'8\frac{1}{4} \times 11'7\frac{3}{8}$ (417.2 × 354)

haughty demeanor, splendid costume, and easy command of a spirited horse fascinate more than repel: this cavalryman seems an orientalized cousin of Géricault's flamboyant *chasseur*.

In its defense, it could be said that the confusions of the painting are the same confusions of philhellene sentiment in France of the period. The stock images to which Delacroix resorted were current in journalistic and literary responses to the massacres. Polemics in favor of the Greeks, along with fashion inspired by eastern Mediterranean dress, frequently digressed into admiring tributes to the beauty of the Turkish physique and costume. Delacroix and his friends simply did not know enough about the people and cause they were celebrating. In the manner of frustrated and disaffected liberals in many later times and places, they substituted imaginary identification with a distant colonial resistance for the struggle they were unable to pursue at home. The painting could not magically provide by itself the coherence lacking on the level of its uncertain political motivation.

SUICIDE OF THE DESPOT

2.24

2.27

The year of Delacroix's public setback over the *Massacre at Scio* was simultaneously one of belated vindication and Salon success for Ingres, returning from his long sojourn as an expatriate in Italy. He had labored for the previous four years over one large painting commissioned for the cathedral of his home city of Montauban. The subject combined a normal devotional motif, the Virgin and Christ child, with a piece of ultra-Royalist historicism, the vow of Louis XIII (which gives the painting its title). The monarch of the seventeenth century appears in the position normally occupied by an adoring saint. The vow in question was a dedication of the kingdom to the Virgin in an appeal for divine assistance in defeating the forces of the French Protestants.

The entire picture is in fact an extreme extension of Ingres's well-rehearsed historicist approach, executed with his customarily precise professionalism. Since 1820 he had spent most of his time in Florence, and the central religious motif is an undisguised pastiche of various versions of the motif by its High-Renaissance master, Raphael. As a result, the painting is an unstable concatenation of parts and degrees of fictionality. The Virgin and Child are ostensibly either a vision or an unseen divine presence, but the effect is a rather idolatrous one of a known work of art, a material representation, being addressed and adored. The parted curtains signify an earthly unveiling or the boundary of a theatrical stage set. Reversing the old relation between royal patron and artist, divine right is shown seeking its confirmation in the blessing of a painter's genius.

None of this stood in the way of the painting receiving the warmest official welcome. There is a painting by François-

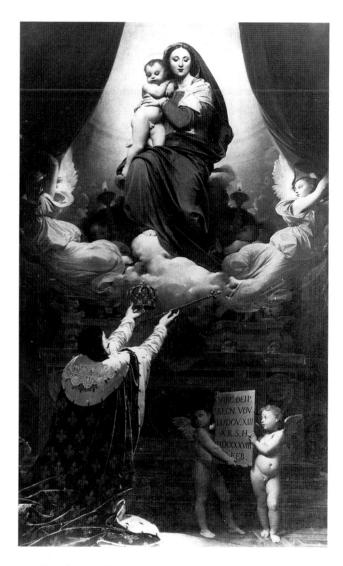

2.27 JEAN-AUGUSTE-DOMINIQUE INGRES The Vow of Louis XIII, 1824. Oil on canvas, $13'9\sqrt[3]{4} \times 8'8\sqrt[3]{6}$ (421 × 264.5)

Joseph Heim showing Charles X distributing prizes at the Salon of 1824: Ingres's Vow is tellingly placed directly above the figure of the King. As Gérard had understood with his Entry of Henry IV, the outward forms of the restored Bourbon dynasty, propped up by foreign powers, would necessarily be a theatrical show of past moments of glory. The artists who tried most assiduously to meet the needs of the regime in the end produced the most profound exposure of its shallowness and artificiality. Where Ingres had missed the mark with Napoleon, who believed that he had created a new synthesis of ancient and modern forms of state power, his instincts were precisely right for the Restoration. He moved on to his monumental allegory for the new royal museum, *The Apotheosis* of Homer, which famously fossilizes a rigid cultural genealogy leading back through the French Classicism of Louis XIV, High Renaissance, and Periclean Athens to reach its pure source in the archaic origins of Greek culture.

2.28

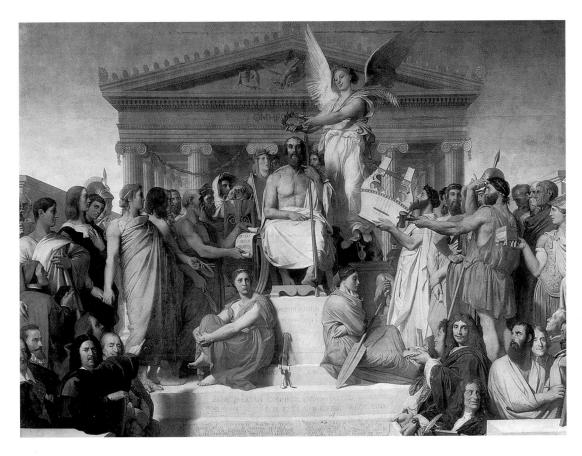

2.28 JEAN-AUGUSTE-DOMINIQUE INGRES The Apotheosis of Homer, 1827. Oil on canvas, 12'8 × 16'11 (386 × 515.6)

Commentators of the time, continuing the habits of Revolutionary esthetics, tried to place a frame of moral and political significance around artists' stylistic choices. One such construction has persisted into many present-day accounts, pitting the backward-looking conservatism of Ingres's manner against the liberating quality of Delacroix's gestural colorism. But the latter could just as easily be turned to the support of the prevailing social order. One of the great official successes of the Salon of 1827 was The Birth of Henry IV by Eugène Devéria (1805–65), in which royal pageantry is rendered with conspicuously open brushwork, high-keyed color, and profuse invention in its details. This work pushed to a conclusion the infantilization of royal power which Ingres had begun in 1817 with Henry IV Playing With His Children, a small cabinet picture executed in the delicate manner of a Flemish miniature.

2.29

2.30

Devéria's success, which brought a rain of prizes and commissions his way, made him for a time the recognized leader of the 'Romantic' school. This confirmed many Republicans in their view that rapid, gestural technique and

2.29 EUGÈNE DEVÉRIA *The Birth of Henri IV*, 1827. Oil on canvas, $15'10\frac{1}{2} \times 12'10\frac{3}{8} (484 \times 392)$

2.30 JEAN-AUGUSTE-DOMINIQUE INGRES Henri IV Playing With His Children, 1817. Oil on canvas, $39 \times 49^{1/4}(99.1 \times 125)$

the stress on color over line represented a craven, unpatriotic acceptance of English styles, in particular that of Thomas Lawrence. Romanticism for them was the signature style of the hated Holy Alliance and a betrayal of the glorious achievements of French painters under the Republic and Empire, which had paralleled the conquests of French arms

and elicited admiring imitation by artists across Europe. This was as strong a position as that which linked the new school with opposition to authority (as in the Greek struggle for independence), but it was fatally weakened by the absence of a commanding artistic personality to give it form. Ingres was a living refutation of any necessary connection between Repub-

2.31 EUGÈNE DELACROIX The Death of Sardanapalus, 1827. Oil on canvas, $12'11'/2 \times 16'3$ (395 \times 495)

licanism and Classicism. Even David himself, in exile in Brussels since 1815, devoted himself to portraits and esoteric exercises in Greek mythology. Much of the frustration of this camp came out in the emotional responses to Girodet's death in 1824. An enormous procession gathered for the burial, and Gros stepped forward in tears at the graveside to make an unscheduled apology for having abandoned the true path of correct drawing in favor of the shallow gratifications of color and splashy execution.

From the early 1820's on, Gros attempted to be true to his word, but his born-again devotion to firm contours and antique subjects could not quiet the claims that the Davidian manner was a straitjacket for any modern artist and that any such effort was doomed from the start. The belittling responses to his painting and his own growing feelings of failure ended with his suicide in 1835. Despair over the general artistic impasse of the late Restoration took on powerful imaginative form in the huge painting on the theme of suicide with which Delacroix challenged Ingres and Devéria in 1827—the *Death of Sardanapalus*.

In terms of official and critical responses, the challenge was decidedly unsuccessful. In terms of the artist's ability to render a teeming scene of death and destruction into a coherent statement, it nevertheless represented a great advance over the Massacre at Scio of three years before. The link to Byron remains, now in literary rather than biographical terms. The story of the last Assyrian king, committing suicide rather than submit to conquest, was the subject of Byron's verse poem of 1821, which was translated shortly thereafter and performed on stage in Paris. In taking up the theme, Delacroix increased his difficulties by a wholesale magnification of the story's nihilistic implications. Byron's hero is accompanied in death only by a favorite concubine who voluntarily accepts his fate. The painter returns to the ancient legends which portraved Sardanapalus as a licentious monster; he is shown indolently observing the execution of his orders that the destruction of his possessions and the women of his harem take place before his eyes as the massive pyre is set alight.

His assimilation of Géricault's model is this time secured through a diametric reversal of its meaning: at the peak of the canted pyramid is no longer a lowly black sailor reaching outward to save his companions; instead the occupant is an absolute ruler at the height of arrogance, looking inward to will the death of everyone in his vicinity. The painting's ambiguities of space, which externalize the riot and disorder in the mind of the architect of the scene, are brought into line by that strong underlying design (cover up the one visible corner of the bed and the composition collapses into the undisciplined hotchpotch its detractors said it was). The same could be said of the dispersion of

2.22

eye-catching incident across the entire surface and of the sustained intensity of hue, which artfully conflates blood with fire and enforces an overwhelming feeling of claustrophobic menace. The painting compels conviction through its abandonment of all compromise with the public values of the Davidian past or the Royalist present: the social compact implodes, and Delacroix comes into his own as a history painter.

In an essay published shortly afterwards, Delacroix wrote of a time in Michelangelo's early career when, so it was believed, neglect by patrons brought him close to giving up. Later in life, he would paint the sculptor in a state of idleness, surrounded by his past creations but with his chisel thrown to the studio floor, and he gave to his painted Michelangelo the traits and the pose he had earlier given to his Sardanapalus, making plain an understanding of the ruler's destructive despair as metaphor for the artist's condition.

His extravagant projection of futility in the Sardanapalus was played out most centrally through imaginary violence

2.32 EUGÈNE DELACROIX Greece on the Ruins of Missolonghi, 1827. Oil on canvas, 83% × 56 (213 × 142)

against women conceived entirely as objects of erotic possession. The regrettably automatic sexism of the time, which made such extreme fantasies acceptable, cannot be set aside. But as complete a statement as this painting was, it represented only a temporary swing in its maker's sense of 1.2, 10 possibility. Like David in his movement from *Horatii* to *Brutus*. Delacroix was capable of better, even within the masculinist assumptions he would never have questioned. In the same year (1827), he returned to the theme of the Greek struggle, but chose to condense his renewed expression of solidarity into one, monumental figure—an allegorical personification 2.32 of Greece standing at the site of Missolonghi (where Byron had died), mutely appealing for the help of the West. In 1826 the city had again been the object of a Turkish assault, one so overwhelming that its defenders blew up the walls, destroying it and themselves rather than surrender. This prompted a new wave of Western agitation for the Greek cause, and Delacroix completed the large canvas in only three months.

Missolonghi made lurid fantasies about ancient despots seem paltry by comparison. With *Greece*, he conceded that representation of such total carnage in the real world was beyond both his ken and the capacities of his art, so he sought another solution within the neglected resources of Western tradition. The turn to explicit allegory allowed him to reintegrate the body of the oriental woman as heroic emblem. As in Girodet's *Revolt at Cairo*, an anecdotal ascription of nakedness to an exotic victim—while retaining a potentially erotic appeal to some viewers, both male and female—cannot help conveying the connotations of moral superiority indelibly linked to the ideal nude. The disordered clothing, a conventional sign of distress, discloses the breast of an inviolable goddess; the male victim by contrast appears only as a stain of blood and a severed limb.

The terrible collective suicide which ended the siege of

For any French observer, such a figure would also have brought directly to mind "Marianne," the female symbol of the Republic adopted by the Jacobins in the immediate wake of Louis XVI's overthrow in 1792. This cast a partisan Republican light on the aspirations of the Greeks. The Ottoman forces appear only in a curiously flattened Egyptian soldier at some illegible distance to the rear. Haste may explain this lapse of convincing illusion, but it may well be a case of Delacroix experimenting with an overtly artificial, allegorical approach at the level of form, a way of building cognitive complexity into a painting that ran with rather than against the uncertainty of his draftsmanship. The two figures together, for all of their incongruity, forecast directly his response when upheaval at home in France ended the Restoration regime.

On July 28, 1830 discontent across the entire social spectrum with the reign of Charles X brought on violent

insurrection in the streets of Paris. That moment of revolt, which so vividly recalled the great "days" of the 1789 Revolution, was quickly left behind when the deposed King's cousin, Louis-Philippe, was installed at the head of what came to be called the July Monarchy. Delacroix did not finish his painting in honor of the revolt until 1831. He was no radical and would personally have had no argument with moderate constitutional monarchy. But the demands of his artistic allegiances and skills caused him to produce a painting, *The 28th of July: Liberty Leading the People*, quite at odds with the 2.3. comfortable status quo.

The first of these allegiances is of course the unrealized public potential of the *Raft of the Medusa*. *Liberty's* barricade, heaving up in the foreground, is the raft itself turned ninety degrees to the right so that the bodies tumble off its leading rather than its trailing edge. Géricault's sprawling barelegged corpse is shifted more or less intact from the lower right corner to the lower left, precisely marking the way he transposed his model. The straining pyramid of figures now pushes toward the viewer rather than toward a distant horizon.

The most pressing question would have been what to place at the peak of the rising. Géricault had selected a black man, bare to the waist, who could serve simultaneously as an emblem of the African locale and as a condensed personification of all oppression and every desire for emancipation from intolerable conditions. The anonymity of the figure, turned away from the viewer's regard, the magnificent description of the nude torso, along with its ethnic exoticism, made it a key device in universalizing the import of the subject. Delacroix turned to his immediately previous personification of the same urgent demands: a change in headgear to the Phrygian cap of the great Revolution (the mark of a freed slave in antiquity) and Greece becomes Marianne, emerged from the long darkness of royal tyranny to fight for France. In that she is a woman, she completes the whole of humanity; in that she can be nude, she represents a natural condition of humankind, suffocated by oppression but revealed again in revolt.

To some at the time, *Liberty* seemed to be merely a robust plebeian—sun-browned, barefoot, and careless of all modesty—who would naturally have leapt into the fray. She is indeed this character to a sufficient degree that she belongs with the surrounding sociological enumeration of male types engaged in the struggle, all ages and classes represented among the living and dead. She calls up certain colorful contemporary accounts of working-class women who rallied their compatriots on the barricades. If she were the least bit more idealized, more evidently a part of the order of symbol, the painting would revert to a curious juxtaposition of reportage with arbitrary allegorical accompaniment.

2.33 EUGÈNE DELACROIX The 28th of July: Liberty Leading the People, 1830. Oil on canvas, 8'61/8 × 10'8 (260 × 325.1)

But the body of *Liberty* hovers between actual physicality and a different kind of pictorial order altogether. Her leading arm is a dark silhouette deprived of persuasive foreshortening, defined by its difference from the white expanse of the tricolor flag behind; it exists as an interruption of the continuity of that abstract sign. Her head turns unnaturally to present a similarly flattened outline to the viewer. In a way that is directly reminiscent of inner transformation from mortal body to goddess in Canova's allegorical portrait of Pauline Borghese, the figure stands simultaneously as a sculptural presence and as a mental abstraction. Delacroix makes Woman the link between matter and understanding, the medium of passage from fact to meaning and back again. The discreet departures from a naturalistic norm are sufficient to impose a governing conceptual order on the disparate collection of bodies and actions surrounding her, that order carrying with it the ethic of purposeful civic virtue embedded in the legacy of Revolutionary Classicism. The imprint of that legacy may have been reduced to a trace, but that it could work so effectively is a sign of its continuing power. That the conceptual artifice of Classicism could function only when treated with such extreme discretion was just as clear a sign that it was at the point of being lost as a resource for art.

In fact, a crisis in Classicism was evident in other national cultures as well during the first quarter of the nineteenth century. In Spain and England (states in which the grip of antiquity had never been as powerful as in France), Francisco Goya and William Blake among others set different unifying myths against the legacy of Greece and Rome. In the case of Goya the chief rhetoric employed was *Majism*, a subcultural style and tradition derived from the Spanish *pueblo*; in the case of Blake it was chiliasm, borrowed from English radical and millenarian sects. These two artists' contributions to what appears to have been a widespread Western movement of cultural nonconformism and political insurgency—Romanticism—must now be considered in detail.

SUICIDE OF THE DESPOT - 81

THE TENSIONS OF ENLIGHTENMENT: GOYA

The work of francisco Goya (1746–1828) expresses most vividly the revolution in art that occurred during the three decades following the political upheavals of 1789. Goya was indeed the archetypical artist of his age, whose alternatively triumphant and tormented life and art reveal both the dizzying freedoms and brutal coerciveness inaugurated by Enlightenment and revolution. Shaken and divided by the conflicting demands of patrons, by loyalty to the Spanish elite and *pueblo* alike, and by the shattering of previously secure divisions between public art and private desires, Goya, it could be argued, was paradigmatic in ushering in the epoch called Romanticism, which was, some argue, the first cultural expression of the modern age.

Just as an examination of Goya's complex genius may therefore shed light on the cultural crises that marked his age and influenced our own, so a consideration of the political turmoil of Goya's Spain can illuminate aspects of his art and the new global order that then emerged. A critical history of Goya in his times must therefore include consideration of the artist's life as well as the following developments: nationalism, which arose as the justification for, and the defense against, Imperial war; guerilla armies, formed in Spain to fight the invading armies of Napoleon in the name of the nation; and the pueblo (the people) who emerged as significant actors in the drama of historical change and *modernization*. All of these phenomena are the product of the struggles between Napoleonic France and its southern neighbor. No artist other than Goya was so intimately involved in these complex worldhistorical matters; no other man or woman suffered and expressed them so intensely or so conspicuously, yet survived and, in a sense, transcended them.

An introduction to the psychological and historical complexity of Goya's life and art is provided by a glance at two self-portraits from his 1799 collection of satirical etchings and

aquatints called Los Caprichos (The Capriccios), an album of 80 prints originally conceived in 1797: Caprichos 1, 3.1 Frontispiece; and *Caprichos 43*, "El sueño de la razón produce 3.2 monstruos" ("The sleep of reason produces monsters"). The Frontispiece self-portrait reveals a cynical and disdainful artist, prosperous and wary, with doughy cheeks, puffy eyelids, and sharp eyes; he seems fully convinced of his own superiority and of the value of his many indictments of sin, stupidity, and corruption contained in the eighty ensuing plates. "The author's . . . intention," Goya wrote on the margin of a sheet containing a study for Caprichos 43, "is to banish harmful beliefs commonly held, and with this work of caprichos to perpetuate the solid testimony of truth." The Goya of Caprichos 1 is thus assertive, self-satisfied, and confidently up-to-date. He is *ilustrado* (enlightened) Goya, afrancesado (Francophile) Goya, and elitist Goya; he is no fool and will just as surely suffer none.

The Goya of "El sueño," however, is very different. Recalling the distraught Brutus in David's painting of 1789, 1.10 the artist here is melancholic and frightened, unstable and lacking confidence; he has suffered the breakdown of his own reason and, perhaps, expects others to experience the same. The atmosphere of Goya's print is dark with foreboding: resting his head and arms on a pedestal or work table, the artist is accompanied by a cat (predatory symbol of the night) near his left shoulder, and surrounded by a swarm of mocking owls (symbols of folly) and bats (symbols of ignorance). The diagonal of Goya's body and crossed legs point toward an overlarge lynx—another creature of the night—whose crossed paws mimic the posture and hands of the artist. Unlike him, however, the lynx will remain on vigilant guard against the monsters of greed and stupidity.

Placed at the beginning of the second part of the *Caprichos*, "El sueño" thus functions as a suitable introduction to a

82

3.1 FRANCISCO GOYA Caprichos 1: Frontispiece, 1799. Etching and aquatint, $8\% \times 6$ (21.9 × 15.2)

3.2 FRANCISCO GOYA Caprichos 43: "El sueño de la razón produce monstruos" ("The sleep of reason produces monsters"), 1799. Etching and aquatint, $8\frac{1}{2} \times 6$ (21.6 × 15.2)

number of plates which mock lust, folly, and ignorance in the form of witches and demons, such as Caprichos 68, "Linda maestra!" ("A fine teacher!"). Yet it is by no means clear that the cloud of monsters that darkens Goya's self-portrait is that of popular ignorance, soon to be dispersed by the artist's satiric pen and sunlit powers of reason. Just as likely is it that Goya is reflecting upon the distressing antipodes of his own mind and upon the janus-face of Enlightenment itself. For in fact, the very creation of art in an age of Reason entailed a dangerous flirtation with madness. More than any previous period in history, the Enlightenment was a time when artists questioned the received ideas of absolutist politics and hierarchized religion, embracing in their stead new subject matter painted in innovative new styles. Desiring, however, to maintain the former emotional impact and historical stature of their work, artists were now required to exercise to the utmost their powers of independent invention and imagination—in effect to draw their art directly from

their own psychic wellsprings. Where the violent or erotic narratives from ancient history and religion—the penitent Magdalen, the beheading of John the Baptist, the Bath of Diana, David with the head of Goliath—once served the purpose of safely channeling libidinal desire toward a socially sanctioned outlet, these same stories were now valued only insofar as they exposed the emotional depths of their human protagonists. Without the measured psychic release that these once revered narratives provided, the violence and eroticism that are part and parcel of the creative process (and which exist as the mirror of Enlightenment itself) were now liable to pour forth in a flood. The price to be paid for this artistic *genio* (genius), therefore, could be high indeed; in times of war, civic strife, or emotional distress, it could include madness. In the "Sleep of Reason," Gova announces that he is prepared to pay this price. Imagination, he claims, is wed to Nightmare; Science, he fears, resurrects Ignorance; Reason itself engenders Monsters. Goya's artistic vision in the

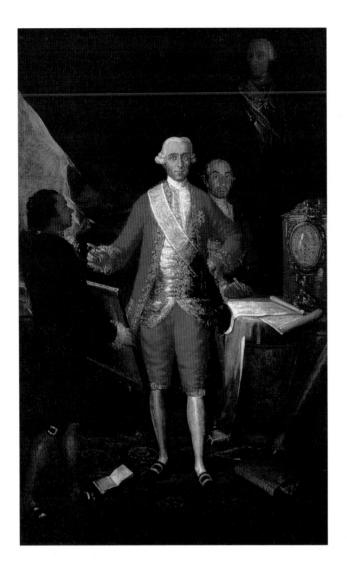

Caprichos and his subsequent art was dark, we shall discover, but prescient in its imagining of the modern century's union of Enlightenment and barbarism.

Gova was born near Saragossa in Aragón, Spain, some 75 miles from the French border; his father was a goldsmith and his mother a minor aristocrat. (These three facts of the artist's birth—proximity to enlightened France, and filial ties to both craftspersons and nobles—would fix the unique trajectory of his life and career.) After studying painting in Saragossa and Madrid, Goya traveled to Italy in 1770, remaining there for a little more than a year. His activities during this time are not fully known, though it is fairly certain that he spent at least several months in Rome, studying Classical statuary, as well as works by such Baroque masters as Domenichino and Reni. Back in Saragossa by mid-1771, Goya remained there (executing a few local religious commissions) until 1774, when he was summoned to Madrid by the Neoclassical painter Anton Raphaël Mengs to create designs for the Royal Tapestry Factory. For another two decades, Goya would continue to receive (what he increasingly saw as onerous) commissions for tapestry cartoons, while his career as a court portraitist and a religious painter blossomed. Among his important portraits from this time are Conde de Floridablanca 3.3 (1783) and The Family of the Infanta Don Luis (1784); both are bold and innovative. Each possesses a dramatic chiaroscuro and a surprising informality, recalling at once the lighting of Jacob Van Honthorst and the composition of William Hogarth. Another artistic influence must immediately be mentioned, however: it was clearly Velázquez who presided over Goya's art historical pantheon. Goya's inclusion of

3.3 FRANCISCO GOYA Conde de Floridablanca, 1783. Oil on canvas, $81\frac{1}{2} \times 42$ (207 × 106.7)

3.4 FRANCISCO GOYA Charles IV and His Family, 1801. Oil on canvas, $9'2\frac{1}{4} \times 11'\frac{1}{4} (280 \times 335.9)$

3.5 Francisco Goya The Family of the Duque de Osuna, 1788. Oil on canvas, $88\% \times 68\%$ (225.7 × 174)

himself in both of the above portraits—as well, of course, as in the later *Charles IV and His Family* (1801)—his embrace of spatial and compositional ambiguity, and most of all his psychological incisiveness, all remind us of Velázquez, the great master of the Spanish Baroque.

In recognition of Gova's talents as church and palace decorator and portraitist, he was appointed to the post of Pintor del Rev (Painter to the King) in 1786. Soon after, he painted The Family of the Duque de Osuna (1788), the very picture of the enlightened, noble Spanish family. Patron of the arts, sciences, and letters, president of the Madrid Economic Society, member of the Spanish Royal Academy and generous host of a tertulia (salon) attended by the most renowned artistic and intellectual ilustrados of Madrid, the Duque is seen posing informally beside the Duquesa and their children. Standing in an indeterminate space, he lists gently to one side, supported on his right by the back of his wife's carved-gilt armchair and balanced on his left by the hand of his eldest daughter. The obvious affective ties between the parents and children, and the fact that the two boys at the lower left are shown at play, reveal that the Duque and Duquesa were in fact advocates of the new French and Swiss pedagogical ideals which emphasized the special innocence of childhood and the important role of parents in the education of their children. The Osuna library is known to have contained the works of Rousseau, Voltaire, and the French Encyclopedists, and their friends included the satirist Ramón de la Cruz and the poet and dramatist Leandro Fernández Moratin, whose didactic works were thoroughly afrancesado, or French in inspiration. Indeed, the latter's mocking commentary on the proceedings of the 1610 witchcraft trial at Logroño (an important literary source for several works of Gova) was probably inspired by Voltaire's mockery of the Inquisition in Candide (1759).

By the end of the decade of the 1780's, the successful Gova was receiving more commissions than he could handle, including portraits for the new king, Charles IV, and his queen, María Luisa. He received as well additional tapestry and Church commissions, honors, titles, and wealth. After his appointment by Charles III to the post of Pintor del Rey, he proudly boasted to his friend Zapater, "Martin, boy, now I'm King's Painter with 15,000 reales!" Just three years later, in April 1789, he was promoted to the post of Pintor de Cámera (Court Painter) to Charles IV. In the following year he was elected to the Real Academia de Bellas Artes de San Carlos (Royal Academy of Fine Arts of San Carlos, one of the most progressive art academies in Europe) and made an honorary member of the prestigious and enlightened Real Sociedad Aragonesa (Royal Society of Aragon). Goya's rise to fame and fortune, spurred by his own vaulting ambition as well as by a talent that rivaled his much-admired Velázquez, seemed unending. His friendships with Floridablanca, the Osunas,

and with the newly influential Gaspar Melchor de Jovellanos (author of a report on Spanish agriculture that became a veritable handbook for liberal reformers), among others, seemed to ensure that the artist's horizons would remain forever cloudless. Yet at this very moment, Goya's career was disrupted by the storms of the French Revolution.

In Spain the shock of 1789 and its aftermath essentially halted the pace of Enlightenment that had been accelerating since the beginning of the reign of Charles III (1759–88). The aim of the Reform King and his Prime Ministers, beginning with the Marquis of Esquilache (1759–66), was to modernize a country whose power and worldwide influence had fallen far behind that of its European rivals to the north. The population of Spain would need to be expanded, agriculture and the economy revived according to the new free-trade and agronomic principles of the French physiocrats, cities cleansed and rebuilt, and the power of the Churchespecially its Holy Office of the Inquisition—curbed if not destroyed. Progress in each of these areas was often halting or slow; more than once the Holy Office aroused sufficient popular opposition to prevent important reforms. Yet despite these setbacks, and despite the extreme numerical inferiority of the *ilustrados* compared with the bloated population of the "useless classes" (nobility, clergy, and state bureaucracy), Enlightenment had made serious inroads in Spain by the time Charles III's reign ended: economic societies were formed, educational scholarships permitted ambitious students to study in France and England, and the proportion of the "unproductive classes" in the population was reduced by royal decrees and expropriations.

The extent of Spanish reform, however, like that of Bourbon France, was limited by royal dependence on the very classes whose power and wealth were to be curbed. The nobility and clergy were hardly likely to support modernizing themselves out of existence, and it is likely that Caroline reforms had reached their outer limits when the Revolution in France essentially put a stop to the whole enterprise. Reform, in any case, was one thing, revolution clearly another: even at its most farsighted, popular democracy had never been part of the Spanish Bourbon plan, nor the seizure of church properties, nor a Declaration of the Rights of Man and Citizen, nor the regicide. Each succeeding French revolutionary event or initiative caused the Spanish monarchy and nobility to recoil; by late 1792 it was clear that the Spanish Enlightenment would have to be postponed. The former flood-tide of French publications would now be dammed at the border, French residents of Spain would be silenced, Spanish students in France would become exiles, and the Jesuit order and Inquisition would once more be given their head, all in an effort to extinguish the spread of the revolutionary incendio.

Spanish foreign and domestic policy was now in turmoil as valued allies became enemies and enemies friends; the longstanding treaty with France was in shreds and a hasty (and temporary) marriage of convenience was made with England. In the midst of the scramble in 1792, the 25-year-old Emmanuel Godov—the King's favorite and the Queen's lover—was named First Secretary of State to the royal office. The king had chosen Godoy precisely for his youth and loyalty to the crown, but the selection shocked the conservative clergy as well as the enlightened reformers who saw in the appointment a return to the corruption and perversity that had marked the years of Spanish decadence. At the same time, the afrancesados were reeling from many other blows. Those ilustrados or luces (lights) who had once received royal support or sanction for their reformist ideas, now shrank from public view or switched sides. By early 1793, Spain and France were at war, and the afrancesados were torn between national loyalty and allegiance to the international torch of Enlightenment; Goya suffered in kind, and from 1792 to 1793 barely survived a grave illness which, when it was over, shook his confidence and mental stability and left him permanently deaf. For the next three decades Spain would be pitched forward and back in a torrent of revolution and reaction. international and civil war, military coups and popular insurgencies, and mad quests for a mythic national essence that could somehow give meaning to it all. Goya, born of the pueblo but now inextricably linked to the ilustrados, would witness and represent this paroxysm of national schizophrenia and violence.

As the *ilustrados* retreated in the face of attacks from church and crown, popular resentment toward new enlightened Spain began to gather strength as well. The luces had always been only a small fraction of a population that remained overwhelmingly poor and peasant; their proposals for "land reform" on the whole meant enclosure and capitalization of formerly common lands, and their ideas of democracy did not generally entail universal suffrage or radical redistribution of wealth. To the Spanish pueblo, therefore, the Enlightenment was largely an unwanted afrancesado affair that threatened to undermine the traditional and (marginally) sustaining life and culture that had been developed over the centuries. Thus an odd alliance was made between the pueblo and the forces of traditional conservatism—the crown, the clergy, and the entrenched civil servants—against the ilustrados who had sought to reform the organization of the state, its economy, and its educational system in the name of the very same *pueblo*. In Spain nationalism was at war with modernization.

The conservative union described above was inherently unstable (and the crises and violence it spawned would extend into the late twentieth century), but its effects were seen at all class levels and in all forms of cultural production. Thus, for

3.6 FRANCISCO GOYA Queen María Luisa Wearing a Mantilla, 1799. Oil on canvas, $82\frac{3}{4} \times 51\frac{1}{8}$ (210 × 130)

example, in the decade before and the two decades after the outbreak of war with France, there occurred a great revival of Spanish popular culture, with its theater of duende (ghosts or spirits), monsters and grotesques, and its legends of rebellious bandits, smugglers, bullfighters, and other picaro (rogue) types. Equally popular was the cult of the majas and majos. These proletarian aristocrats, or plebeian nobles, with their distinctive manners and dress, were quickly imitated by all strata of Spanish society, including the "true" aristocrats, who admired them for their presumed embodiment of the pure Castilian blood and spirit. Goya often depicted the hereditary nobility in the guise of majas and majos, including the artist's lover, the Duquesa de Alba, and the unknown model for the Naked and Clothed Majas (ca. 1798–1805), and 3.7, 8 even the Queen herself in Queen María Luisa Wearing a 3.6 Mantilla (1799). The French Ambassador to Spain, J. F. de Bourgoing, offered a vivid description of the majas and majos in his 1788 account of his travels on the peninsula:

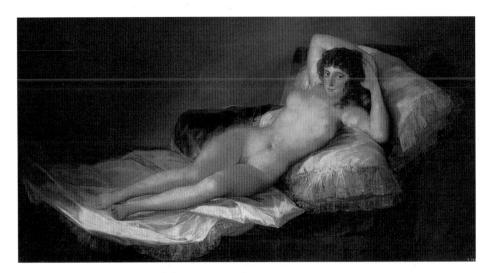

3.7 FRANCISCO GOYA Naked Maja, ca. 1798–1805. Oil on canvas, $37^{3/8} \times 74^{3/4}$ (94.9 \times 189.9)

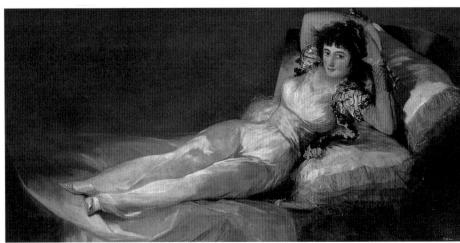

3.8 FRANCISCO GOYA

Clothed Maja, ca. 1798–1805.

Oil on canvas, 37³/₈ × 74³/₄
(94.9 × 189.9)

The Majos are beaux of the lower class, or rather bullies whose grave and frigid pomposity is announced by their whole exterior. . . . Their countenance, half concealed under a brown stiff bonnet, called Montera, bears the character of threatening severity, or of wrath, which seems to brave persons the most proper to awe them into respect, and which is not softened even in the presence of their mistress. . . . The Majas, on their parts . . . seem to make a study of effrontery. The licentiousness of their manners appears in their attitudes, actions and expressions; and when lewdness in their persons is clothed with every wanton form, all the epithets which admiration can inspire are lavished upon them. This is the disagreeable side of the picture. But if the spectator goes with a disposition, not very scrupulous, to the representations in which the Majas figure, when he becomes familiarized to manners very little conformable to the virtues of the sex, and the means of inspiring ours with favorable sentiments, he sees in each of them the most seducing priestess that ever presided at the altars of Venus. Their impudent affectation is no more than a poignant allurement, which introduces into the senses a delirium that the wisest can scarcely guard against, and which, if it inspires not love, at least promises much pleasure.

Bourgoing's focus upon the bewitching eroticism of *Majism* was a rehearsal for the racist and sexist ideology of Orientalism that would soon erupt across Romantic Europe. Just as significantly, it clearly reveals the degree to which the aristocracy of both France and Spain underestimated the democratic and insurgent potential of their nations' working-class subcultures. As the art historian Francis Klingender has observed:

Majism, the frivolous imitation of the real majas and majos by the smart set, is a symptom of the *encanaillement* [keeping of bad company] of the court aristocracy who would have been wiser to conceal their degradation. When on the edge of the abyss the aristocracy has a curious habit of destroying its moral defenses by toying with the ideology of the enemy. Blind to the implications of the bourgeois

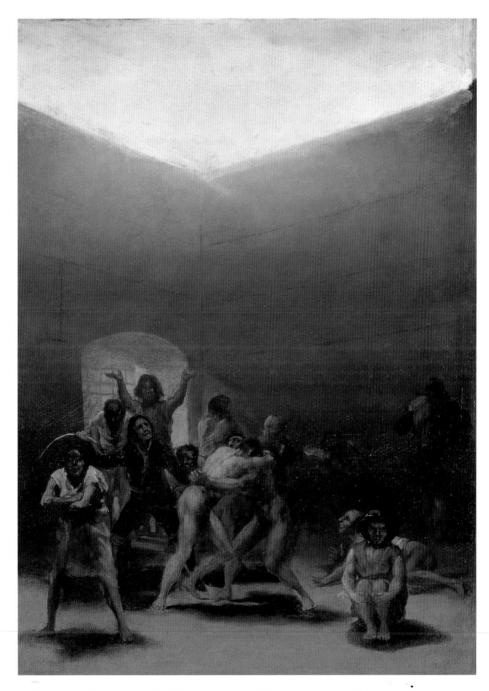

3.9 Francisco Goya Courtyard with Lunatics, 1793–4. Oil on canvas, $17\frac{1}{4} \times 12\frac{7}{8}$ (43.8 × 32.7)

cult of nature, the French nobility applauded the milkmaid fashion of Marie Antoinette, and the Spanish grandees were similarly heedless of the democratic roots of majism, when they perverted its moral freedom.

Soon, the *majas* and *majos* of Spain, the *sans-culottes* of France and the "free-born Englishmen" of Britain would wage *guerilla* wars (literally "little wars"), erect barricades or lead the clamor for a new democratic charter. *Majism* was thus among the first of the subcultural styles that would play a

powerful role in the drama of nineteenth-century culture and revolution and in the imaginations of the epoch's most talented artists. Like such later phenomena as "flaneurie" (see p. 333), *Majism* was a fashion of dress and a style of life, and however ultimately contradictory its political filiations, it helped organize people into collectives able to act (for a time) with a single purpose. For artists such as Goya, without fixed class identity, and increasingly without the economic or ideological security supplied by reliable religious and political patronage, subcultural style was a powerful attraction. Goya's

frequent representation of *Majism*, in his portraits as well as in his tapestry cartoons (*The Picnic*, ca. 1778), thus represents more than a simple keeping abreast of fashion; it indicates a political and psychological identification with groups and individuals who exist on the margins of the ruling society.

3.7, 8

Goya's Naked and Clothed Majas express more than the predominating aristocratic and exploitative vision of workingclass sexuality as a species of exoticism. Indeed, painted for Godoy, the two Majas positively trumpet the encanaillement that was the eventual undoing of the upstart Prime Minister and putative nobleman. By its peculiar anatomical geography, the Naked Maja especially, ironically celebrates that "perversion [of] its moral freedom," as Klingender termed it, which marked the aristocratic reception of Majism. The model for the painting is unknown, but her face possesses a uniqueness as pronounced as her body's ordinariness. In fact, the key to the picture's irony lies in this lack of fit between head and body, an absence marked by the vague treatment of neck, shoulders, and hair. With her pubic region located directly in the center of the painting, she is an expression of that perfect and vulgar metonymy that substitutes an organ for a complete human being. Like the women in paintings by François Boucher and J.-H. Fragonard, she is given over completely and shamelessly to spectatorial consumption. Yet unlike them, as André Malraux has written, "she calls attention to the least physiological aspects of her sex, her personality." In Goya's Naked Maja, the masculinist objectification of female sexuality, and its psychological antidote, has "progressed" as far as it ever would in the nineteenth century. Later in France Gustave Courbet, Edouard Manet, and Paul Cézanne would all look back in fright and admiration at Goya's achievement, finding there just that unique combination of physical and psychological, or real and allegorical, that expressed the temper of modern life and sexual exchange.

To claim to see irony, or at least allegory, in what appears to be an exercise in pornography may seem to be overreading, but it must be remembered that at the very moment these paintings were conceived, Goya was lampooning Godoy and the epicurean excesses of the nobility in his drawings in the Sanlúcar Album A and Madrid Album B (1796–7), as well as in the Caprichos. Ultimately, the question of Goya's intentions here, like the question of specific parodic intent in the famous portrait of Charles IV and His Family, is probably unknowable, both because of the lack of relevant documents on the subject and because of the inherent difficulty of ever fully discerning artistic intention itself. Some things, however, can be asserted with confidence: as the decade closed, and the new century dawned, Goya represented with increasing frequency the pueblo as well as the grotesque and marginal figures of Spanish popular culture—the *duende*, the witch, the monster, the donkey, and the majas and majos. As at once a man of the pueblo whose tastes ran to bullfighting and street festivals, and a man of the *ilustrados* eager, for example, to master and practise his French, Goya was clearly divided in his attitude toward refulgent nationalism (costumbrismo) and rationalism. Indeed, his shifting allegiance to both "popular" and enlightened Spain is compellingly revealed in an extraordinary sequence of works that begins with the Courtyard with 3.9 Lunatics (1793–4), includes The Witches' Sabbath (1797–8) 3.10 and the Caprichos, and culminates in the Executions of the 3.11-Third of May, 1808 (1814) and the Disasters of War. 3.17-

THE IMAGE OF THE *PUEBLO*: THE LATER ART OF FRANCISCO GOYA

Consideration of *Courtyard with Lunatics* must begin with an 3.9 account of Goya's nearly contemporaneous physical and mental breakdown. A few weeks after France's declaration of war on Spain in March 1793, Goya's illness was discussed in a letter between his friends Martínez and Zapater: "the noise in

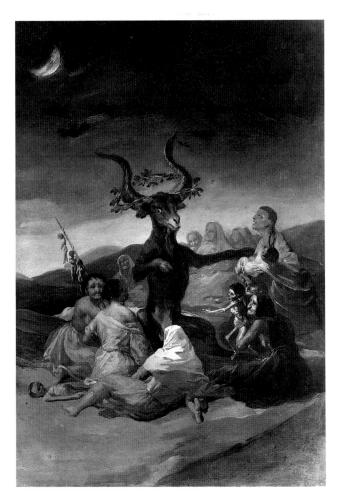

3.10 FRANCISCO GOYA *The Witches' Sabbath*, 1797–8. Oil on canvas, $17^{3/8} \times 12^{1/4} (44 \times 31)$

his head and the deafness have not improved, but his vision is much better and he is no longer suffering from the disorders that made him lose his balance." The exact nature of Gova's illness is unknown, but the conclusion that it was at least worsened by the virulent political environment seems unavoidable. Now in self-imposed exile in Cadiz, Gova gradually recovered sufficient strength to return to his work and to Madrid, and by January 1794 had nearly completed a set of eleven small pictures painted on tin. Intending to submit the works to judges of the Academia de San Fernando, Gova wrote to his friend at the Academia, Bernardo de Iriarte: "In order to distract my mind, mortified by reflection on my misfortunes, and in order to recoup some of the expenses they have occasioned, I executed a series of cabinet pictures in which I have managed to make observations that commissioned works ordinarily do not allow, and in which fantasy and invention have no place." These eleven pictures of "fantasy and invention" inaugurate Gova's second career.

The works that have so far been identified with this group, of which Courtyard with Lunatics is certainly one, mark a profound change in Goya's art. Dark, dramatic, sometimes terrifying, Gova's new vision seems a century removed from the still Rococo refinement and wit of the tapestry designs and portraits created only a few years earlier. No longer merely representing the world of popular carnival, fantasy or nightmare, Gova has discovered instead how to create pictorial equivalences of these realms. "It was the discovery," Malraux has written, "of the very meaning of style; and at the same time, of the peculiar strength of painting, of the power of a broken line or the bringing together of a red and a black over and above the demands of the object represented." Courtyard does not offer an operatic representation of madness, as we find in the Carceri (prisons) engravings of the Italian G. B. Piranesi, or a conversation-piece madness as we discover in Hogarth's engraving of "The Madhouse" for A Rake's Progress (both of which were probably seen by Goya in the collection of Martínez), but instead an imaginary and horrifying vision of the loneliness, fear, and anomie engendered by mental illness and social alienation. Occupying the foreground of a courtvard sealed off by heavy masonry blocks and an iron gate at the rear, a dozen "patients" and a single warden sit, stare, posture, implore, grimace, wrestle or discipline themselves. The top of the picture is evaporated by sunlight, rendering all the more monstrous the nightmarish scene below.

There can be little doubt that Gova intended his picture as an indictment of the widespread punitive treatment of insanity. Until the reforms instigated by E. J. Georget in France and Samuel Tuke in England in the late 1810's, the insane had generally been confined with criminals, the sick, and the indigent in vast warehouse asylums such as Salpêtrière in Paris, and the hospital of Bethlehem (Bedlam) in London. Inmates at these institutions usually received no treatment whatsoever, but were put in iron manacles or subjected to physical punishment and back-breaking labor. The purpose of this irrational-seeming generalized confinement was in equal parts economic and political. During periods when labor was in short supply, asylums provided a large ready pool of workers whose gross exploitation had the added advantage of depressing the salaries of those on the outside: during periods when labor was abundant, asylums absorbed great numbers of the unemployed, keeping them subdued and under watch. The political, or ideological, purpose of confinement is perhaps harder to pinpoint precisely, but the philosopher Michel Foucault has plausibly argued that it was intended for the chastisement of the "immorality of the unreasonable" and for fending off the revolutionary threat—represented by madness—of absolute political and personal freedom.

Indeed, to an enlightened generation that extolled the virtues of liberté, the reform of prisons and asylums was an essential goal. The subject was common in the writings of Beccaria, Voltaire, and Condorcet, among others, and was surely a frequent topic for discussion in the enlightened tertulia in which Gova moved. Condemnation of brutality toward prisoners—criminals and the insane—was explicitly the subject of a number of Goya's later paintings and drawings as well as the subject of works by the English artists Francis Wheatley and George Romney and the French Théodore Géricault. Goya's small painting, in which the light of reason above is shown exposing or disinfecting the brutality of prejudice below, thus seems fully consistent with afrancesado ideology. Yet like Caprichos 43, "The Sleep of Reason," there is in Courtyard with Lunatics an oppressive sense of foreboding and despair, especially in the standing and seated figures in the left and right foreground; there is also a sense of sadism, as if Goya and we were among those spectators at Bethlehem or Charenton who paid a penny or a sous for the privilege of watching the mad behave like animals in a menagerie the better to reassure us of our own reason. Goya was probably just such a witness at Saragossa, where he claimed in a letter to Iriarte to have watched the above performance. How uncertain of his own reason must Goya have been to watch such a scene! How he must have recoiled at his own pleasure to paint such a picture!

Gova's growing ambivalence toward Enlightenment and attraction to the dark Spain of popular culture and superstition is equally apparent in The Witches' Sabbath (1797–8) 3.10 and Caprichos 68, "A Fine Teacher!" Both are coarse, vulgar, and grotesque in subject and execution and thus a far cry from the refinement and wit that are the usual tokens of Enlightenment culture. Both are at once satires and

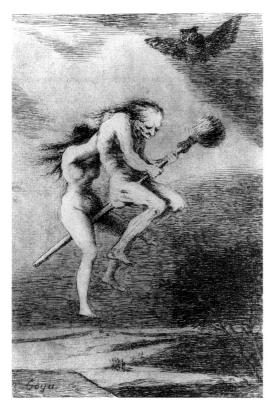

3.11 FRANCISCO GOYA Caprichos 68: "Linda maestra!" ("A fine teacher!"), 1799. Etching and aquatint, $83\% \times 5\%$ (21.3 × 15)

3.12 FRANCISCO GOYA *Caprichos 50*: "Los Chinchillas" ("The Chinchillas"), 1799. Etching and aquatint, $8\frac{1}{4} \times 5\frac{7}{8}$ (20.8 × 15.1)

3.13 FRANCISCO GOYA Caprichos 10: "El amor y la muerte" ("Love and Death"), 1799. Etching and aquatint, $8\frac{1}{2} \times 6$ (21.8 × 15.3)

3.14 FRANCISCO GOYA Caprichos 52: "Lo que puede un sastre!" ("What a tailor can achieve!"), 1799. Etching and aquatint, $8\frac{1}{2} \times 6$ (21.7 × 15.2)

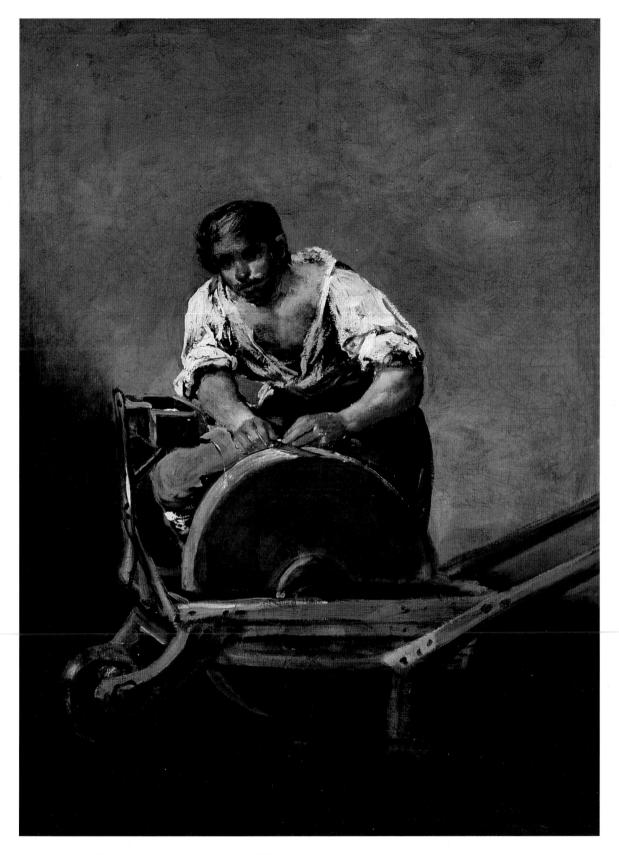

3.15 Francisco Goya *The Knife Grinder*, ca. 1808–12. Oil on canvas, $25\% \times 19\%$ (65 × 50)

celebrations of the new popular penchant for witchcraft and the licentiousness it betokened. The Witches' Sabbath is one of six paintings on the subject of witchcraft commissioned by the Duquesa de Osuna for the bedroom of her country house. In the center of the small canvas appears a seated he-goat or devil crowned with vine leaves. Encircled by young and old witches, he conducts his service with raised cloven hooves while receiving offerings of live children from the two witches on the right, and dead children from the witches on the left. The light from a crescent moon at the upper left casts a phosphorescent blue pall over the macabre landscape, while a half dozen circling bats are seen in silhouette. Gova's painting may have been derived from a discussion of witchcraft in Moratín's satiric account of the seventeenth-century auto da fé (execution of the judgment of the Inquisition) of Logroño, but numerous other popular sources were available. Particularly relevant here was the widespread and longstanding association of witchcraft with female sexual freedom, a tradition summarized by Moratín when he wrote: "The hegoat was a very respectable personality in Antiquity, and much esteemed by women for his fine prendas [jewels or endowments]." The beast's bountifulness is in fact revealed by his long horns and by the visual pun created by the agitated yellow shawl at his loins. Created during a brief interlude of relative self-confidence among the ilustrados, Goya's satirical painting indulges the artist's broad pueblo humor while also, perhaps, alluding to a decadent regime overseen by a cuckold for a king and a gigolo for a Prime Minister. Such self-assured wit and irony would become rare for Goya in the new century; it would gradually be replaced by helpless negation and gall.

The condemnation of sexual license and corruption apparent in The Witches' Sabbath and the five other paintings created in 1797-8 for the Duquesa de Osuna, becomes more rancorous and more complex in Los Caprichos. On February 6, 1799 there appeared the following notice in the *Diario* de Madrid, announcing the publication of a "collection of prints of extravagant subjects, invented and etched by Francisco Gova:"

The author is convinced that censuring human errors and vices—although it seems the preserve of oratory and poetry—may also be a worthy object of painting. As subjects appropriate to his work, he has selected from the multitude of stupidities and errors common to every civil society, and from the ordinary obfuscations and lies condoned by custom, ignorance or self interest, those he has deemed most fit to furnish material for ridicule, and at the same time to exercise the author's imagination.

Despite the artist's disclaimer, it is clear that these *Caprichos*, which went on sale on February 19 at the modest cost of 4 reales each, were specifically intended to ridicule the cupidity, licentiousness, and superstition of modern Spain and not simply "every civil society." Indeed, Goya's contemporaries embraced the work both as a kind of roman à clef, in which the ruling troika—Godoy, María Luisa, and the King—among others, were particularly lampooned, and as a broader indictment of official corruption, Majism, witchcraft, and a rampant Inquisition. The Duque and Duquesa de Osuna were smart to purchase four sets before publication; just two days after their appearance, the albums were withdrawn from sale, probably because of a threat from the Holy Office.

Los Caprichos, we have already seen, is at least superficially the product of ilustrado ideology. Caprichos 50, "Los Chin- 3.12 chillas" ("The Chinchillas," slang for "aristocrats"), depicts two figures being spoon-fed by a third. The two have closed eyes, padlocks over their ears and are wrapped in coats which resemble noble coats of arms; the reclining figure at the bottom clutches a rosary, while the one at the right grips a sword as he is fed by the middle figure with blindfold and donkey's ears. This latter jackass obtains his delicious gruel from the great two-handled cauldron in the center of the print. As with many of Goya's Caprichos, "The Chinchillas" is both allegorical and literary: in the former sense, it is awkward and unnaturalistic, recalling the plates in such iconographic encyclopedias as the famous Iconologia (1593) of Cesare Ripa; in the latter sense, it has an anecdotal character that suggests a larger narrative context. Indeed, the specific literary origin of Caprichos 50 is found in a popular comedy of manners by José de Cañizares that satirized the ignorance and pomposity of its noble protagonist, Lucas de Chinchilla. In his print, as in the play, Goya expresses the view that nobles who are preoccupied with their own aristocratic genealogy (symbolized by their oversized coats of arms) are blind (eyes closed) and deaf (ears padlocked) to understanding, accepting only the food of Ignorance (represented with blindfold and donkey ears). One contemporary explanation of "The Chinchillas" ran as follows: "Fools that pride themselves on their nobility surrender to indolence and superstition, and they seal off their understanding with padlocks whilst they are grossly fed by Ignorance." Despite its ready readability, however, Goya's image is not a straightforward allegory of the value of Enlightenment over Ignorance or aristocratic decadence; as with his Courtyard painting and "The Sleep of Reason," "Los Chinchillas" appears to embrace aspects of the very darkness and superstition it otherwise condemns: the disturbing face of Ignorance who wields his spoon like a dagger, the grotesquely pastiched bodies of the "nobles," and finally the oppressive weight created by the aquatinting of the upper half of the plate, all suggest the nightmare world of unreason—of the madhouse—more than the enlightened satiric theatre of Cañizares. In Goya's Caprichos, in other

words, it is often hard to determine whether the artist deplores or delights in his disturbing subject matter.

A similar ambiguity is apparent in an earlier print in the series, Caprichos 10, "El amor y la muerte" ("Love and Death") which ridicules the exaggerated pride and bravado of Majism. A mortally wounded majo, sword at his feet, collapses in the embrace of his lover. Their faces are pressed together in pain and anguish, as a dark cloud above seems poised to descend upon and envelop them; all the chivalric romance of dueling has been chilled in the cold night of death. Here, as elsewhere in the Caprichos, Gova ridicules the foolishness or self-destructiveness of the popular classes in a clear expression of ilustrado ideology. Yet it must at the same time be noted that however critical he is of them, it is the *pueblo*, and not the elites of Spain, that have now become Goya's preoccupation. Moreover, for all the bourgeois moralizing in "Love and Death," the man and woman are depicted with extraordinary sympathy and pathos. The same sympathy is found in Caprichos 42, "Tu que no puedes" ("You who cannot"), in which two members of the pueblo are burdened by asses perched on their back, and in Caprichos 52, "Lo que puede un sastre!" ("What a tailor can achieve!"), in which a pious crowd kneels in worship before a tree that is draped to resemble a cowled monk. This latter image mocks popular belief in miracles and witchcraft, but the focus is clearly on the reverence and awe of the kneeling woman in the foreground; it is her psychology that is compelling, just as it is the maja's expression of mourning in "Love and Death" that provides the image its drama and conviction. In the hands of Gova, the *pueblo* make their first heroic appearance in the visual record of European culture: they are not types, but individuals, and thus are not consistent, but contradictory, not passive but active—indeed at times revolutionary.

0.3

.14

Goya's embrace of the pueblo—suggested in the tapestry cartoons and witchcraft paintings but first clearly revealed by the Caprichos-soon after became a dominant theme in his art. This orientation, it must be acknowledged however, was the result of economic circumstance as well as political conviction and emotional temperament: after 1801, the artist's public and private sources of patronage began to dry up. Goya's close ties with the court were largely severed after the completion of the portrait of the family of Charles IV, perhaps because of dissatisfaction with the portrait, but more likely because of a renewed campaign against the *ilustrados*. The liberal prime minister Urquijo was deposed and jailed in 1801 at the same time that the great ilustrado Jovellanos himself was exiled and then imprisoned. Other shocks soon followed: in 1802 the Duquesa de Alba died suddenly, followed a year later by Goya's great friend Zapater. By 1805, Goya's distance from his former noble patrons was increased still further by virtue of his son's marriage into a prominent

family of Saragossa merchants, and by his own friendship with Leocadia Zorilla, an articulate and fierce opponent of absolutism who would later become Goya's companion. From this moment on, Goya depicted the Spanish bourgeoisie (a rare and threatened species in Spain), and increasingly the *pueblo*. In great canvases such as *The Water Carrier* and *The Knife Grinder* (ca. 1808–12), and especially in the almost innumerable drawings and prints, Goya portrayed proletarians, beggars, prisoners and their victimizers—the hereditary nobility, soldiers, and clergy. In the last two decades of his life, Goya would focus upon the *pueblo* while recording his private reflections and fears concerning the horror of the War of Spanish Independence (1808–14) and its destructive aftermath.

The Gova of the Disasters of War (ca. 1810–20), the Executions of the Third of May, 1808 (1814), and the "Black Paintings" (ca. 1820–23) is very different from the artist who once painted tapestry cartoons and portraits. Whereas the earlier artist was a public figure who recorded, however presciently, the appearance of the leading men and women of his time, the later artist was a private man who represented the unknown and unheralded pueblo; whereas the earlier painter drew upon an existing vocabulary of religious, political, and moral verities, the later painter had no such secure foundations; and finally, whereas the earlier Goya directed his art to an audience he knew and whose expectations he could predict, the later Goya painted, drew, and etched for no audience of whom he could be certain, or for one from which he had more reason to expect punishment than reward. Isolated and vulnerable, independent and experimental—it may be said, in short, that the later Goya experienced and represented the alienation which the Romantics and indeed all modern artists would both suffer and enjoy. For perhaps the first time in history, a major public artist-Goya had been designated First Court Painter in 1799—withdrew to the confines of his own insights and imagination in order to create an essentially private art intended to please or succor himself alone. When his art was exhibited, we shall see, it was largely ignored or disdained; Goya's greatest renown would be achieved after his death.

We have noted some of the political and cultural transformations that created the conditions for Goya's alienation—the conflict in Spain between Enlightenment and traditional culture, the ideological struggle among aristocratic, bourgeois, and popular classes over the question of national identity, or "Spanishness," the economic and political turmoil generated by the Revolution in France, and the slow demise of an artistic tradition based upon shared beliefs and standards of excellence. Yet, until 1808, Goya remained a more or less passive, more or less aloof, observer and recorder of this turmoil and these events. His art, we have seen, was

3.15

3.18–22 3.17

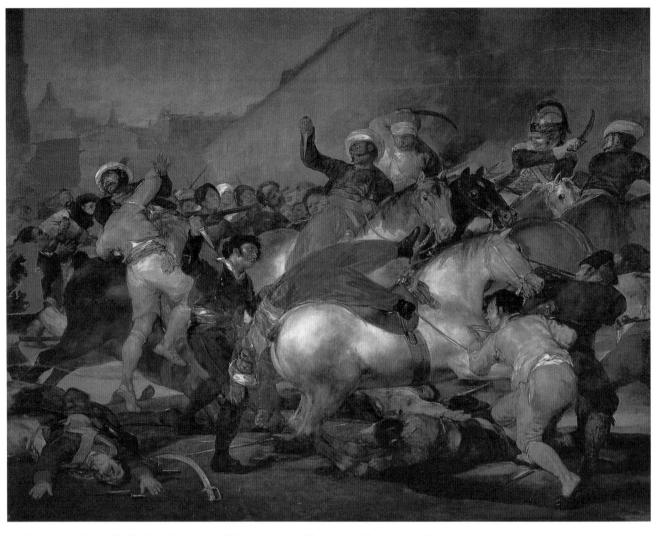

3.16 Francisco Goya The Uprising of the Second of May, 1808, 1814. Oil on canvas, 8'9 × 11'4'/8 (266.7 × 345.8)

insightful, complex, and perhaps even keenly dialectical, but it was still generally the dispassionate product of that cynical regard seen in the frontispiece self-portrait from the Caprichos. After 1808, however, the Gova of the arched brow and curled lip was no more; like David in France after 1792, or Courbet in 1870-71, Goya was now a participant in, and a victim of, the earthquake of war and revolution. The public artist and the private man could now no longer be separated.

In 1808, widespread revulsion for the corrupt court of Charles IV and especially for the intrigues of his minister Godoy, led to the abdication of the King and the crowning of his son, Ferdinand VII. In 1807 Napoleon, in pursuit of his policy of isolating England from the rest of Europe, had seized the opportunity to occupy the Iberian Peninsula and in May 1808 placed his brother Joseph Bonaparte on the throne of Spain. Appealing to ilustrado and pueblo alike, the new French monarch immediately proclaimed a policy of national regeneration, modernization, secularization, and Enlightenment. Distrustful, however, of such afrancesado reforms when put forward under successive Caroline regimes, the plebeians of Madrid and elsewhere were certainly not going to accept the dictates of the hated French invaders. Thus, on May 2 and 3, 1808, the *madrileños* rose up in arms against the French and their mercenaries in defense of Ferdinand VII and Spanish independence. Within days the uprising in the city was crushed, but the war had migrated across the countryside in a bloody and confused guerilla conflict that would last for six years until the surrender of Joseph Bonaparte and the restoration of the Spanish monarchy.

Goya's great Executions of the Third of May, 1808, like its 3.17 companion The Second of May, was paid for by the Crown and painted in 1814. It was intended as a testimonial to the courage and suffering of the Spanish pueblo. Amid a huddle

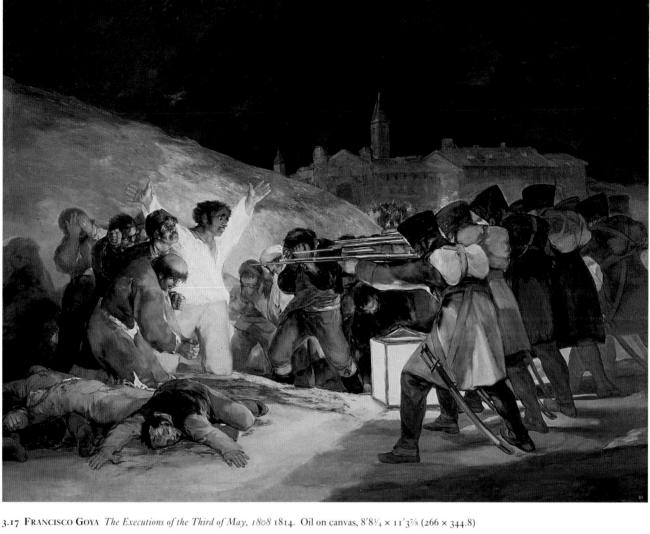

of people and bodies, a man in white with arms outstretched is faced by a phalanx of executioners. His eyes show fear and resignation as he awaits the same bloody end as befell those of the *pueblo* sprawled obscenely in the dirt in front of him. Although he has company, he is alone this night on the hill of Príncipe Pío on the outskirts of Madrid; like Christ on the hill of Golgotha, he bears the stigmata and is illuminated in death by an unearthly light. The colors and light in the picture are coarse and garish as Goya continues to experiment with "the very meaning of style," with the metaphorical relationship between, for example, paint and blood, darkness and fear, illumination and pathos. All of the artist's subtle skills of composition, coloring, and characterization are marshaled here in order to expose and consecrate the martyrdom of the *pueblo* at the hands of faceless and pitiless French centurions.

In evaluating the meaning of Goya's Executions, it must be remembered that it was painted in 1814 after the restoration of Ferdinand VII and the arrest, expulsion or imprisonment of the Spanish afrancesados and liberales, many of whom counted among the artist's friends. Goya himself had tried to flee Spain in 1812 and two years later was hauled before the restored Inquisition to explain his "obscene" Naked and Clothed Majas and to undergo a lengthy "purification." His request to the Council of Regency early in 1814 for an allowance to paint the Second and Third of May was therefore clearly an effort to get back in official good graces by painting pictures that could provide a dramatic justification for the recently concluded war, and sanction for the restored regime of Ferdinand. In order to regain his good name and position, Goya would represent the nightmarish chaos of the previous six years as a coherent battle of the pueblo against atheist invaders in the name of Church and King.

The story of the War of Spanish Independence was not, of course, so simple, but neither were Goya's pictures very

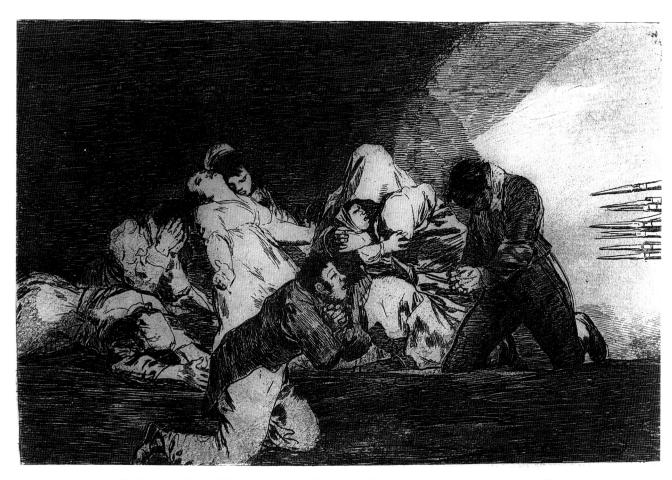

3.18 Francisco Goya The Disasters of War 26: "No se puede mirar" ("One can't look"), ca. 1810-20. Etching and lavis, 55/8 × 81/4 (14.4 × 21)

convincing as propaganda. The initial uprising of the *pueblo* was anti-elite as well as anti-imperialist, and the conflict became quickly fragmented and radicalized. Guerilla bands and juntas of "right" and "left" were formed in efforts either to repel "godless" liberales or to install a new secular and popular democratic constitution. A liberal constitution was indeed passed by a Cadiz government in exile in 1812, but in the context of national civil war, it had little significance or effect; it was quickly overturned when Ferdinand returned to power. Thus Goya's Executions of the Third of May, for all its realistic horror, was an effort to provide a mythic integrity to the Spanish war by exalting the heroism and sacrifice of the pueblo. In this function, it may be compared with David's Intervention of the Sabine Women, painted at the conclusion of another extended period of civil conflict and international war and likewise intended to unify an audience behind an undemocratic regime. Yet unlike David's, Goya's painting did not bring its author wealth and renewed acclaim. Goya's Executions was perhaps too frank in its representation of national sacrifice, too sincere in its pathos, too literal in its equivalence of flesh, blood, and paint. Indeed, the pueblo

3.17

themselves embodied the contradictoriness of Goya's enterprise: though they welcomed in 1814 the restoration of the rule of Church and Crown (chanting in the streets of Madrid, it is said, "Long live our chains!"), the same pueblo was often a source of profound social radicalization. Perhaps the pueblo and the war itself (like the U.S. war against Vietnam) were thus simply inconducive to heroic and propagandist representation. In any case, upon its completion, the picture was quickly secreted in the Prado basement, not to be seen or even acknowledged for two generations.

If The Executions of the Third of May, 1808 was Goya's public, righteously indignant response to French imperialism, the Disasters of War was his private, ambivalent response. 3.18-Drawn and engraved between 1810 and about 1820, these plates could not be published in Goya's lifetime due to their emotional intensity and political and moral ambiguity; except for a small number of artist's proofs, the Disasters only appeared in 1863, some thirty-five years after Goya's death. When they were conceived in 1808, however, they were intended, like the Executions, to be a public display of patriotism and nationalist zeal. Their genesis is as follows:

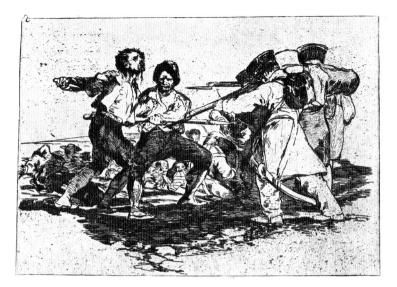

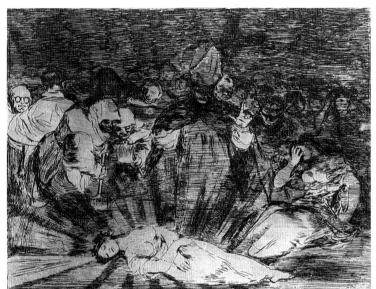

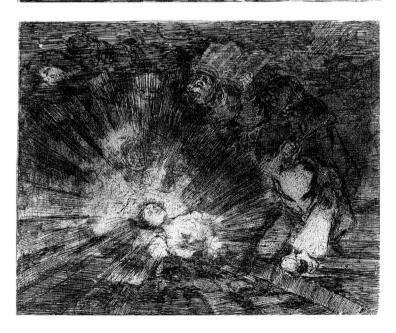

3.19 FRANCISCO GOYA *The Disasters of War 2*: "Con razón o sin ella" ("Whether right or wrong"), ca. 1810–20. Etching and lavis, 61/8 × 8 (15.5 × 20.5)

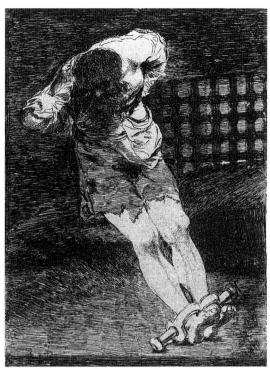

3.20 FRANCISCO GOYA *The Disasters of War 84:* "La seguridad de un reo no exige tormento" ("The custody of a criminal does not call for torture"), ca. 1810-20. Etching and burin, $4^{1/2} \times 3^{3/8} (11.5 \times 8.5)$

3.21 FRANCISCO GOYA The Disasters of War 79: "Murió la verdad" ("Truth is dead"), ca. 1810–20. Etching, $7 \times 8\%$ (17.5 \times 22)

3.22 FRANCISCO GOYA *The Disasters of War 80*: "Si resucitaría?" ("If she were to rise again?"), ca. 1810–20. Etching, 7 × 85% (17.5 × 22)

within months of the outbreak of hostilities, Goya was called upon by General Palafox to travel to his native Saragossa "to see and examine," the artist wrote, "the ruins of that city in order to illustrate the glories of its citizens, from which I cannot excuse myself as I am so much interested in the glory of my native land." Gova thus accepted the commission, made the hazardous journey to Saragossa, and began to make the oil sketches and drawings that served as preparation for the prints he called The Terrible results of the bloody war in Spain against Bonaparte. And other emphatic caprichos, but which are known today as the Disasters of War. Far from representing heroic resolve and singularity of purpose, however, these prints express revulsion at the horror and brutality of war. They expose the savagery of the pueblo as well as the French and condemn the Spain of the restoration as much as the regime of Bonaparte.

The 82 plates of *The Disasters* may be generally divided into three groups which depict: the victims and horrors of war (plates 2–47), famine, death, and burial (plates 48–64), and "caprichos enfáticos" (literally, "emphatic capriccios," plates 65-80), that is, nightmares and scenes of corrupt clerics, monsters, and grotesques. Most of The Disasters were completed by 1814, but a few, especially from the third group, were probably made during the period of monarchical reaction and Inquisitorial virulence after 1814 but before the liberal coup of 1820. Among the prints of the first group are Disasters 2, "Con razón o sin ella" ("Whether right or wrong") and Disasters 3, "Lo mismo" ("The same"), both of which, significantly, show the Spanish attacking the French with axes, pikes, knives, and even teeth. Disasters 26, "No se puede mirar" ("One can't look"), undoubtedly a model for The Executions of the Third of May, 1808, reverses the brutality and shows the French pitilessly slaughtering the pueblo; it also offers a particularly vivid example of Goya's use of brief captions both to illuminate and undermine the meaning of his images. Spanish men, women, and children are gathered in a cave in order to be shot. They beg, crawl, cover their faces, and turn their backs to the executioners at whom they cannot bear to look. Their killers are visible to us only by the ends of their rifle barrels and bayonets jutting in from the right margin; they cannot be seen. Are such horrors as these appropriate subjects for art, suitable vehicles for esthetic pleasure; should one look at them? "One can't look" and yet one must see the brutality and senselessness of war. Disasters 28 and 29 again reverse the polarity of horror and show the pueblo torturing and killing a single victim, a bourgeois who is probably also an afrancesado, and thus a "traitor" to Spain. And so the horrors compound in image after image shootings, stabbings, famine, rape, and death.

3.19

3.18

3.17

Among the plates from the final group of "caprichos 3.21, 22 enfáticos" are the bleak Disasters 79 and 80, "Murió la verdad"

("Truth is dead") and "Si resucitaría?" ("If she were to rise again?"). These depict the burial of a young woman (perhaps an allegory of the Constitution) by a rabble of grotesque clerics, and the same woman, unburied, perhaps in a state of decomposition. In the first print, her body emits strong beams of light, emblem of reason and truth; in the second, her light is dimmed along with her youth and beauty. Probably conceived in 1819, during the bleak nadir of the ilustrados and liberales, these plates express the pathos and alienation of one who has seen the collapse of Reason and vet who remains condemned forever to hope. The very last images that Gova intended for his Disasters (though not included in the posthumous edition of 1863), reveal a similarly poignant dialectic. They show chained and tortured prisoners, recalling the world of Courtyard with Lunatics and the Caprichos. Like these earlier works, Disaster 84, "The custody of a criminal does not call for torture," expresses the reforming zeal of the ilustrado; yet unlike them, there is no irony, or satire, or even the prayer of Enlightenment. The prisoner is slumped and manacled, crushed between the margins of this small plate as between prison walls. Gova undoubtedly saw or heard of such tortures during the period of Spanish guerilla war and French "counter insurgency" between 1810 and 1814. He would see or hear of them again in 1814–15, and again during the period of White Terror unleashed against popular radicalism and the liberales after the second restoration of Ferdinand in 1823-4. Fearing such a fate for himself, the aged artist left Spain for France in 1825 and died there, in relative peace, three years later. The reason Goya's despair was so great was that he had seen the barbarism of Enlightenment itself in the person of Napoleon as well as the defeat of Enlightenment by Spain.

The works of Goya's last decade are not uniformly bleak. They include several portraits, religious paintings, the robust and experimental Bordeaux Milkmaid (1825-7), and a small number of lithographs, a new medium for the artist. Most remarkable and perplexing, however, are the so-called "Black Paintings" created to decorate the walls of two rooms of his suburban Madrid residence, the Quinta del Sordo (Deaf Man's House) between 1820 and 1823. Painted during a brief constitutionalist interlude, these frescos (now transferred to canvas) cannot, however, be considered confident celebrations of revived truth and reason. They are primarily grotesque or macabre, and any allegorical or satiric content they may possess is extremely recondite, and was so to its earliest viewers. Saturn Devouring His Children and The Witches' Sabbath may, like the Caprichos, allude to the violence and superstition of the Inquisition, but now without the spirit of reform. Nightmarish and even lurid, these are private images, lacking public purpose, lacking even an audience apart from the artist himself, his son, his companion Leocadia, and the few surviving friends courageous enough to visit the home of

an ancient *ilustrado* reprobate. Given the dark emotional timbre of these fourteen paintings, the question must arise: is Gova any longer an artist of the Enlightenment?

The "Black Paintings", like the late Disasters, were created by Gova for himself during an epoch when reason slept. Disdaining public meanings, conventional forms, and scrutable iconography, Goya appears to have lost, or anyway abandoned, his reason in the "Black Paintings". They are painted with unprecedented boldness and breadth and are alternately sober and shrill in their coloration. Yet there is a logic to these and to the other, less disturbed late works of Goya, such as the Milkmaid or the many drawings of the French popular classes from *Album G* (1824–6). The historian Gwyn Williams detected it when he wrote: "As for the grotesque, the maniacal, the occult, the witchery, they are precisely the product of the sleep of human reason; they are human nightmares. That these monsters are human is, indeed, the point." Goya's very focus upon the grotesque is an expression of his continued fascination with ordinary people, with the Spanish pueblo, and (after 1825) with the French menu peuple in all its complexity. For Goya, as for other artists since Breugel, the grotesque and the popular define and occupy a world opposed to order, rationality, the ideal, and the aristocratic. Yet unlike the popular grotesques of earlier artists, Gova's are not decorative or picturesque. They are defined, we have seen, by their contradictoriness, that is by their combined brutality and nobility, their unreason and virtue, their blindness and vision; they offer the artist and the viewer no comforting homilies about lovalty or truth, but then, neither are they as frozen or static as the project of Enlightenment had become. Although they are primarily vehicles of a profound artistic pessimism and alienation, Goya's pueblo reveal a new direction in the history of art—a proclaimed unity of purpose and perspective among artists and the insane, the alienated, the dissident, and the popular. This perspective, belonging to the radical, the nonconformist and the socially or culturally marginal, was championed in France by Géricault and Delacroix; in England it would be represented principally by William Blake, to whom we shall now turn.

3.23 FRANCISCO GOYA Saturn Devouring His Children, ca. 1820. Mural transferred to canvas, $57\frac{1}{8} \times 32\frac{5}{8}$ (145 × 82.9)

· 4 ·

VISIONARY HISTORY PAINTING: BLAKE AND HIS CONTEMPORARIES

BRIAN LUKACHER

BLAKE'S REVOLUTION

W HILE DAVID AND GOYA WERE NEGOTIATING THE ideologies of Enlightenment, Revolution, and Empire during the course of their artistic careers, the English poet, printmaker, and painter William Blake (1757-1827) was producing a highly imaginative and hermetic art that was no less responsive to the impact of these same historical forces and events in Britain. Unlike his French and Spanish counterparts, however, Blake dwelt for the most part on the margins of artistic activity in his country, effectively cut off from the preeminent fine arts institutions and the most respected avenues of patronage in late Georgian London. If David and Goya took on celebrated and visible roles sometimes dangerously so-as their nations' premier artists during times of pronounced political and social upheaval, Blake's situation was quite different, as best summed up by his own admission, "I am hid." Blake's proclaimed devotion to creative and spiritual self-definition through mystical revelation, in opposition to any and all authoritarian standards (artistic, religious, or social), makes him exemplary of an alienated, countercultural Romanticism, a notion that certainly seems overburdened with later twentieth-century values and misconceptions but that is nevertheless borne out by the specific conditions of Blake's life and art. Undoubtedly, "Blake" has become a kind of cultural palimpsest for the social and psychological utopias of our own century: how else could he be claimed by some as a visionary, and conveniently heterogeneous, precursor to Karl Marx and Carl Jung? For our purposes, Blake's contribution to the visual arts around 1800 proves most vital to understanding the fate of history painting and the question of national cultural identity in English Romantic art.

To appreciate Blake's predicament as an artist "hidden"

from, and yet directly engaged with, the esthetics and politics of his day, our attention will be focused on his self-sponsored, one-man exhibition of 1809, an occasion that marked Blake's most decisive effort to solicit the attention of a public audience. Exhibiting sixteen of his "Poetical and Historical Inventions" at his brother's London residence (also the site of the family hosiery shop, an unusual art venue), Blake promoted his self-appointed calling as the artistic reformer of Britain in the midst of the Napoleonic Wars. In some verses written around the time of the exhibition, he imagined an angelic annunciation instructing him, "'Descend thou upon Earth/ Renew the Arts on Britain's Shore, / And France shall fall down & adore./ With Works of Art their Armies meet,/ And War shall sink beneath thy feet." Blake's pacifist hope for the political efficacy of his art was, paradoxically, cast as a nationalist appeal for patronage and recognition, something made clear in the published "Advertisement" and Descriptive Catalogue for his exhibition. Resentful that his art had been dismissed, if acknowledged at all, as little more than "a Madman's Scrawls" (his words), Blake looked forward to the eventual redemption of his artistic stature: an esoteric engraver who had struggled within an artisan subculture of radicals and mystics was ready to assume his position as an empowered history painter assuaging and redirecting the misguided energies of war-torn empires.

Blake's career began in the 1770's as an engraver of antiquarian and reproductive fine art prints, his lifelong work in commercial engraving serving as an intermittent source of income that did little to save him and his wife, Catherine Boucher, from abject poverty (friends and infrequent patrons would express their surprise at the physical squalor and economic deprivation of the Blakes' living conditions). Blake received brief instruction in life drawing at the recently established Royal Academy of Arts (chartered by King

George III in 1768) and submitted watercolors of historical and biblical subjects to the annual Academy exhibitions. Throughout his career, however, he would remain an adversarial outcast of the Academy, condemning its restrictive, and yet at times overly eclectic, pedagogy and exhibition policy, and especially its hypocritical failure to encourage a genuinely progressive English school of historical art. Blake's faith in the supremacy of history painting and, more generally, in idealist esthetics was nonetheless dependent on the propounded artistic principles of the Academy. Typically for Blake, indicting or negating a system of thought or an institution of power also entailed incorporating and redefining its values within the imaginative program of his own art and beliefs, whether it be the rational empiricism of Enlightenment philosophy, the self-contradicting authority of constitutional monarchy, or the emergence of industrial capitalism, all of which were to be the subject of scathing commentary in his pictures and writings.

It was during the early 1790's that Blake developed a unique approach to producing his illuminated books of poetry. Experimenting with the technique of relief etching, he printed the handwritten scripts of his poetic sagas graphically embellished with decorative, emblematic, and narrative motifs. The visual imagery, far from simply illustrating or supplementing the poetry, could simultaneously amplify and contradict the content of the verse, the dynamic between word and image often undermining epistemological assumptions about the very processes of reading, seeing, and interpreting. Figurative elements sometimes occupied separate plates or were integrated into the design of the text. The books of poetry were printed in small numbers and handcolored, often with Catherine Boucher responsible for the tinting. A medieval craft esthetic was thereby conflated with reproductive printing techniques, Blake seeking to reconcile the autographic singularity of his illuminations with their intended multiplication.

Blake's poetic books from this period can best be characterized as spiritual allegories of revolutionary politics. Creating their own mythic personifications of human desires, habits of mind, and world views, designated by primitivizing, onomatopoeic names such as Orc, Los, and Urizen, Blake's writings often seem like a strangely invented form of biblical science fiction, though the abiding influence of Miltonic and Ossianic verse is ever at hand. The demiurgic struggles recounted in his poetry appear to transpire in either a cosmic or cellular void, or, geographically speaking, in an English nation poised ominously on the brink of eschatological destruction. In lamenting and exhorting over the cycles of oppression and liberation and of persecution and resistance under which his mythic characters labor, Blake's "Giant forms," as he would call them, perform epic psychodramas of contemporary

history, centering on England's failure to embrace the revolutionary fervor of America and France. Blake was in frequent contact with the radical, intellectual circle of the publisher Joseph Johnson, which included the political and feminist republicans Thomas Paine and Mary Wollstonecraft. These associations, along with his social and professional roots in the urban artisan milieu that was the wellspring of English Jacobinism during the 1790's, affirm Blake's radical political credentials. His poetic books America (1793) and Europe (1794), both subtitled "A Prophecy," chart the travails of political liberty against the despotic, royalist authority of church and state, the contest clothed in seemingly obscure imagery of god-like powers battling over the soul of Albion (Blake's figure for the humanity of England). Blake's writings during the 1790's register with some urgency the emergence and repression of social and political protest among the English Jacobin movements that had found inspiration, and later disillusionment, in the French Revolution and the establishment of the Republic. With England's declaration of war against France in 1793, and with Prime Minister William Pitt's repressive policies against any organized expressions of social dissent, the country became increasingly embroiled in a climate of political paranoia, spurred on by invasion scares, grain shortages, and government censorship. As the decade closed, the rise of Napoleon ensured that the nationalism and militarism required for the defense of England would continue to preempt or suppress any calls for revolutionary reform. Much of Blake's art and poetry addresses the English Revolution that would never come to pass.

BODY POLITICS AND RELIGIOUS MYSTICISM

Blake's hopeful testimony to this nascent English revolutionary impulse is seen in one of his most renowned images, the color print known as Albion Rose (ca. 1794-5). The first 4.1 sketches for the human figure date back to around 1780, and it is thought that the concept of the picture commemorates Blake's experience of the Gordon Riots of that year—anti-Catholic and anticolonial war protests in London that ignited into widespread mob violence; Blake was among the crowd that stormed and burned Newgate Prison, an episode made famous in Dickens's historical novel Barnaby Rudge (1841). The youthful male nude of Albion seen alighting on a sloping summit gives us the essentials of Blake's visual language: the human figure employed as a corporeal sign of spiritual, intellectual, and political positions. The balletic, self-exalting presentation of the body in Albion Rose—derived, while also diverging, from Renaissance proportion diagrams of the Vitruvian Man, as well as from Neoclassical engravings of

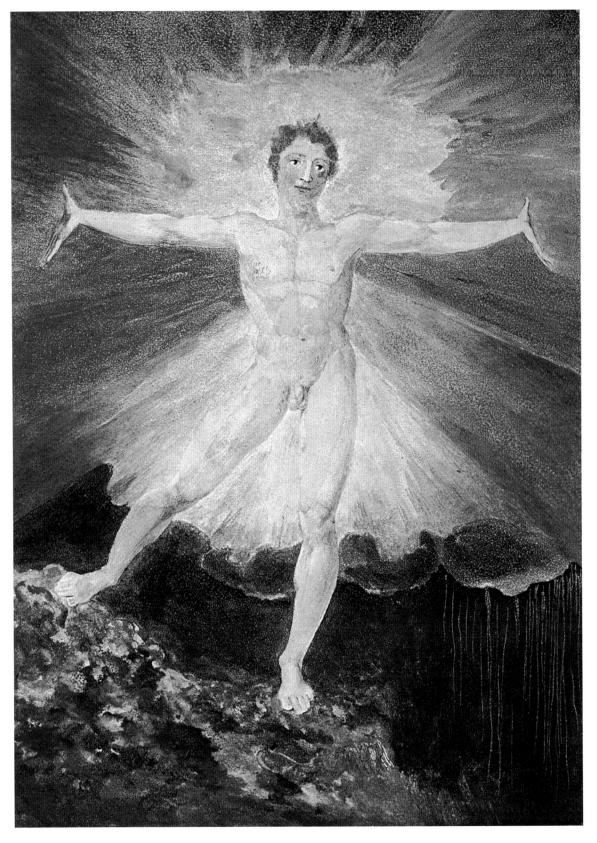

4.1 WILLIAM BLAKE Albion Rose, ca. 1794–5. Color print, with pen and watercolor, over line engraving, 105/8 × 77/8 (27.1 × 20.1)

sculptural antiquities excavated at Herculaneum—is complemented by the glorious burst of colored light that surrounds the figure. Arms extended and hair aflame, the body of Albion is posed in triumphant frontality. Blake attenuates and simplifies the anatomical structure of the human form, its modeling kept to a minimum with the contour lines strongly demarcating the figure within its prismatic aureole. This linear definition of the refulgent body is counterpointed to the mottled darkness of the hillside and the eclipsed black of night seen in the lower portion of the print. Although Blake espoused an unswerving Neoclassical purity of line in artistic execution, the coloristic explosions in his work-often signifying a perceptual and sensual materialism against which Blake declaimed—are vital to his pictorial designs and their dialectical play of esthetic (and implicitly ethical and metaphysical) contraries.

4.1

The figure of Albion is not simply a Neoclassical exercise in antique heroic nudity. Albion is nothing less than the body of England, obviously divested of the outward signs of social class and historical identity: refined vet elemental, chaste vet sexualized, and ennobling yet leveling, in a state of what Blake would call "Naked Beauty Displayed." Like most of Blake's nudes, Albion seems a knowing contradiction, a disembodied embodiment. He is of the flesh and plainly physical, but he also functions as an ethereal blueprint for some regenerated model of a utopian humanity, Christ-like and Apollonian all at once. In America (1793), Blake envisioned the infectious, liberating impact of the American Revolution on the British people, "Leprosy London's Spirit" cured and reawakened as "a naked multitude." Elsewhere in the poem, he writes of a dawning freedom: "The morning comes, the night decays . . . / Let the slave grinding at the mill run out into the field,/ Let him look up into the heavens and laugh in the bright air." This transition from oppressive darkness to revealed radiance, from imprisoned labor to pantheistic release, in turn recalls Paine's solar metaphor for political freedom in his The Rights of Man (1791): "But such is the irresistible nature of truth, that all it asks, and all it wants is the liberty of appearing. The sun needs no inscription to distinguish him from darkness." The self-illuminating figure of Albion, likewise, announces this resplendent visibility of liberty. Using the most canonical feature of Classical humanist art—the idealized nude—Blake fashioned a revolutionary icon, a pictorial entreaty for social and spiritual transformation; as he would implore his readers in the preface to his later poem Milton (1804–08), "Rouze up, O Young Men of the New Age!"

Much more common, however, in Blake's art of the 1790's was the imagery of subjugation and enslavement. In the solemn and tormented frontispiece to his poem *Visions of the Daughters of Albion* (1793), Blake delineates the constricted body language of mental and physical bondage. The female

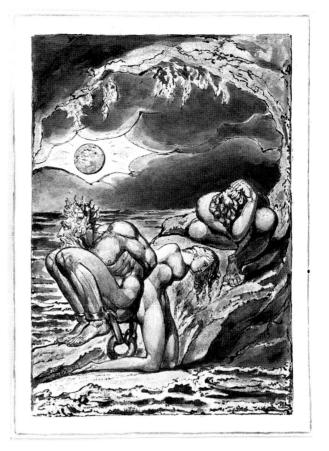

4.2 WILLIAM BLAKE Frontispiece to Visions of the Daughters of Albion, 1793. Relief etching, watercolor, $6\frac{5}{8} \times 4\frac{3}{4} (17 \times 12)$

protagonist of the poem, Oothoon, is seen manacled to her slave-master/rapist, while her jealous and inhibited lover cowers and withdraws into himself on the cavernous ledge above the enchained figures. The poem, broadly speaking, intertwines abolitionist and quasi-feminist arguments against sexual and economic exploitation, denouncing the trade in flesh that commodifies both "the swarthy children of the sun" and "the virgin joys of life." The social and moral perversion of freedom is translated, visually, by Blake into the physical constraints of his bound figures—these miniaturized variations on Michelangelesque nudes that typified his figurative style. The agonized subjection of the figures is conveyed not only through their poses and gestures—opposing, for example, the taut frenzy of the male with the bowed resignation of the female—but also through their formal definition, with the lineaments of their anatomies harshly and schematically rendered, their massive bodies contained and reduced to compact diagrams of human despair. In keeping with Blake's aversion to the conventions of pictorial illusionism, the bleak landscape setting in this design is expressively metaphoric, rather than objectively descriptive. The grotto entrance frames a disconsolate vista of sea, clouds, and darkened sun,

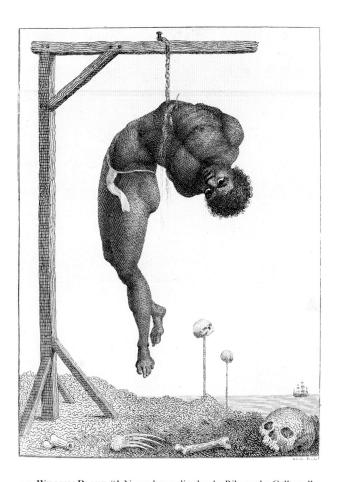

4.3 WILLIAM BLAKE "A Negro hung alive by the Ribs to the Gallows," from John G. Stedman's Narrative of a Five Years' Expedition against the Revolted Negroes of Surinam, in Guiana, on the Wild Coast of South America, 1796. Engraving, $7 \times 5^{3/8}$ (18 × 13.5)

the realm of nature treated as flat patterns of unnaturalistic color shades, resisting any logical sense of graduated spatial recession. This mental landscape inverts into a skull-like, anthropomorphic profile that only reinforces the malevolent plight of the incapacitated titans. Concurrent with these mythic abstractions of oppression were Blake's more documentary, engraved illustrations of the inhumane actuality of contemporary slavery that he prepared for Captain John Stedman's book entitled Narrative of a Five Years' Expedition against the Revolted Negroes of Surinam, in Guiana, on the Wild Coast of South America (1796). Based on Stedman's evewitness drawings that recorded the varieties of torture and punishment meted out to rebellious slaves by their colonial masters, Blake's engravings, like the one depicting a black man bound and hung by his torso to a gallows, are unflinching in their portrayal of the repressive violence connected with the traffic in slavery. The slaves are often shown, as in this plate, with expressions of stoic restraint, their quiet fortitude meant to elicit civilized compassion for their unendurable physical suffering, while also making them seem all the more

impervious—almost inhumanly so—to the brutal circumstances of their punishment. Suspended hopelessly between the grim skeletal remains of past victims and the distant slave ship visible in the harbor, the tortured slave is made to objectify the perpetuation of death that was necessarily synonymous with the perpetuation of slavery itself.

Blake's preoccupation with the conflicting powers of revolution and oppression was inseparable from his Christian religious mysticism. He embraced, assimilated, and critiqued eighteenth-century mystical systems with habitual regularity, ranging from the apocalyptic hermeneutics of the Swedish mystic Emmanuel Swedenborg to the Neoplatonic scholarship of the English mystic Thomas Taylor. Using selfinduced trances as a source of artistic inspiration, experimenting occasionally with an antinomian lifestyle as a way of recapturing prelapsarian bliss (William and Catherine had been espied nude, emulating Adam and Eve, in their cottage garden), and frequently entertaining visitations from the spirit world (often from his deceased brother and fellow artist Robert or from more celebrated guests like Dante and Milton), Blake had constant recourse to the otherworldly in his struggles against the prevailing structures of society and art. These nonconformist religious and mystical tendencies in his work and temperament make him all the more fascinating and compelling to some, and all the more irrelevant and trying to others.

With his art consistently cast in terms of "visions" and "prophecies," Blake was participating in a widespread millennial anxiety that swept through significant segments of English society during the closing decades of the eighteenth century. As the historian E. P. Thompson observed in analyzing the concomitant rise of religious enthusiasm and political radicalism that marked the English reaction to the French Revolution, "Chiliasm touched Blake with its breath; it walked abroad . . . among the Jacobins and Dissenters of artisan London." With the century perilously waning and with revolutionary events on the Continent inciting political and social discord within England, contemporary history appeared to promise the impending fulfillment of biblical, apocalyptic scenarios, especially in the collective imagination of the ever growing, religious nonconformist sects and their self-styled prophets. One such prophet, Richard Brothers, the "Prince of the Hebrews" who foretold the imminent collapse of all monarchies, along with the destruction of London, "the modern Babylon," was even arrested for seditious treason in 1795 and confined to a lunatic asylum where he drew up published plans for London's promised resurrection as the New Jerusalem, the influence of which may be detected on Blake's own later poetic epic Ferusalem, The Emanation of the Great Albion (1804–20). The proliferation of these chiliastic predictions of historical destruction and spiritual renewal

4.3

during this period was deeply symptomatic of both social disenchantment and political disenfranchisement, to which the increasingly obscurantist and prophetic quality of Blake's imagery bears striking witness. Those modern scholars most attuned to the social formation and historical specificity of Blake's work, particularly Jacob Bronowski and David Erdman, have noted that by 1800 Blake's imaginative religiosity brought with it a certain degree of political quietism that was in part necessitated by the conservative nationalism dominating social and political discourse in England.

BLAKE'S PUBLIC ART

As noted earlier, Blake's 1809 exhibition was to have signaled his galvanizing re-emergence from the obscurity of his early career. Although Blake's "Advertisement" and Descriptive Catalogue for the exhibition often evince a dutiful patriotism in his solicitous claims for public attention, Blake does not shy away from his more typically invective commentary on the suffering of art in "a corrupt state of Society." He referred to the works he exhibited as "Experiment Pictures," primarily because they were executed in tempera on canvas, a new medium for Blake that he also described as "fresco painting" and that he saw as a pointed challenge to what in his estimation was the commercial and esthetic vanity of oil painting (unfortunately, the surviving tempera pictures from the exhibition have themselves badly deteriorated). These experiment pictures were meant to serve as mere models for gargantuan frescos that Blake hoped would be commissioned by the government for the adornment of national monuments. Representative of these delusively ambitious frescos was the first picture listed in the catalog: The Spiritual Form of Nelson Guiding Leviathan, in whose wreathings are infolded the Nations of the Earth. Admiral Lord Nelson, the British naval commander who died at the Battle of Trafalgar in 1805, was certainly a topical and popular hero in the public consciousness during the Napoleonic Wars, and contemporary artists were quick to capitalize on the nationalist cultural craze for commemorative military monuments, most of which were endlessly planned and debated by governmental committees and in the art press, but were rarely ever built. Even before the death of Nelson, John Flaxman had proposed plans for an allegorical naval monument with an imposing statue of Britannia to be set within a sepulchral precinct on Greenwich Hill, dedicated to public commemoration in honor of England's naval triumphs against the French. The designs for this antique-inspired, megalomaniacal project—characteristic of Flaxman's severe and reductive graphic style that would prove so influential among European artists-were engraved by Blake in 1799. Flaxman's scheme reflected the Neoclassical

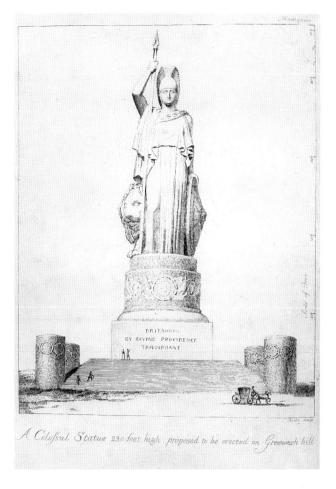

4.4 JOHN FLAXMAN, engraved by WILLIAM BLAKE Design for the monument to British naval victories with a statue of Britannia, 1799. Engraving, $8\frac{1}{4} \times 5\frac{1}{4}$ (21 × 14.6)

obsession with designing vast, memorializing public spaces where spectacles of national power could be celebrated in a modernized Greco-Roman ambience. Blake's own dream, ten years later, of having his modestly scaled pictures monumentalized and venerated as a public art of national import conformed to the prevalent cultural politics that called for the artistic aggrandizement of British contemporary history. Blake was hardly insensitive, however, to the compromising logic that would render the purposefulness of art entirely subservient to nationalist and imperialist causes; as he wrote in 1810, "Let us teach Buonaparte, & whomsoever it may concern, That it is not the Arts that follow and attend upon Empire, but Empire that attends upon & follows the Arts." In another draft of this statement, Blake would substitute "Englishmen" for "Buonaparte."

Blake's divided attitude toward the strained allegiance between art and empire is apparent in his allegorical interpretation of Nelson. As befits his "spiritual form," he is clothed only in a loincloth and a halo, the mortal hero now deified within a mandala-like pattern of highly abstracted rays

4.5 WILLIAM BLAKE The Spiritual Form of Nelson Guiding Leviathan, in whose wreathings are infolded the Nations of the Earth, 1809. Tempera on canvas, $30 \times 24^{5/8}$ (76.2 \times 62.5)

4.5 of light. The naval warrior's aloof and calm expression, and the almost automatistic ease with which he lassoes the interminable sea monster that encircles him, makes him seem divinely oblivious to the futile struggle of the women and men trapped within the serpentine coils (one figure with sword in hand, just beneath Nelson's left arm, is already caught in the dragon's maw). As a terrifying image of dominion and conquest, the picture is especially attentive to these dread casualties ("the Nations of the Earth") that have fallen under Nelson's imperial sway. At the base of the composition, the figure of an expired slave is prominently shown, liberated from the stranglehold of the sea serpent, but only to be left as a lifeless castaway on the narrow shore of freedom. The leviathan referred to in the picture's title alludes both to the biblical leviathan, a monstrous opponent to divine will, as well as to Thomas Hobbes's famous political trope for the corrupting power of the ship of state. As Nelson's beastly agent of war, the leviathan has, at very best,

ambivalent connotations for the maritime supremacy of Britain. Blake's Nelson harks back to his revolutionary prototype, the nude Albion; but in this later picture, the physical freedom of the human form is not so certain, the body of Nelson appearing much less taut and energetic, having now become more encumbered and restricted by its supernatural task. One must wonder whether Nelson guides the leviathan, or whether the sea creature guides, and perhaps even enslaves, the transcendent hero.

The artistic traits of Blake's picture—its claustrophobic anti-illusionism, its denatured and contorted treatment of the human body, and its overall fascination with heroic supernaturalism and ritualized violence—connect his work with the more innovative currents in recent English historical and poetical paintings. Blake saw his art as belonging to an abortive tradition of progressive history painting that, in his opinion, had already fallen victim to the purely commercial vicissitudes afflicting art patronage in England.

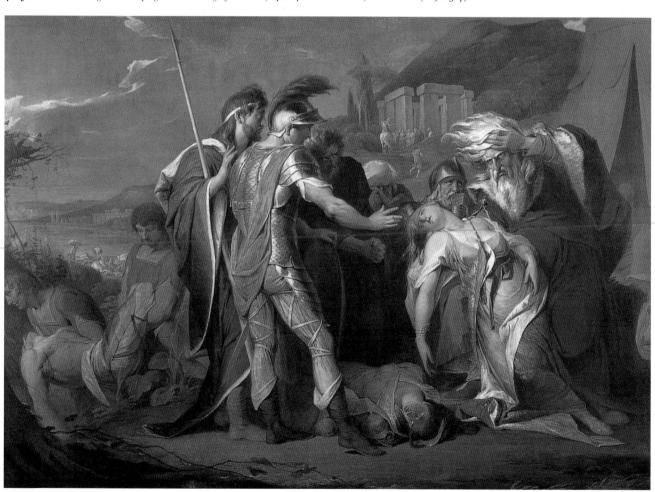

4.6

Foremost among Blake's contemporary artistic heroes was the 4.6, 7 Irish-born painter James Barry (1741-1806). Barry had received early encouragement and support from such prominent and influential men as the Conservative statesman and esthetician Edmund Burke and the founding President and leading portraitist of the Royal Academy, Sir Joshua Revnolds. Although Barry rose quickly through the ranks of the Academy to become its Professor of Painting in 1782, he carried on a rancorous crusade against the Royal Academy's, and by extension English society's and the state's, failure to promote "public taste" for history painting; in his view, private interest and social and political factionalism had destroyed the civic ideal of a truly public art representative of egalitarian values (he had even turned down an invitation to become America's national history painter). His hectoring criticism of the Royal Academy led to his expulsion in 1799. Although he found other institutional sponsorship that allowed him to pursue his ambitious painting cycles of historical and allegorical subjects, Barry's career ended in poverty and disillusionment, making him the unquestioned martyr to the lost cause of history painting in England—so much so that Blake planned to write "Barry, an Epic Poem."

4.7 JAMES BARRY Satan and His Legions Hurling Defiance Toward the Vault of Heaven, ca. 1792–4. Etching, black ink, 29½8 × 19½8 (74.6 × 50.4)

In his effort to promote a distinctly national school of history painting, Barry, along with other artists of the period, often turned to Shakespearean and Miltonic themes for inspiration. His King Lear Weeping Over the Body of Cordelia (1786 7) depicts a Shakespearean scene that was significantly censored and rewritten for late eighteenth-century stagings of the play: the grim pathos of Lear cradling the body of his only faithful daughter, with the corpses of the other conspiratorial daughters close at hand, was deemed too transgressive for Georgian theatre audiences. For Barry, the deranged fury of an aged king cursing over his internecine family implied political questions about the stability of monarchical power and its potentially irrational conflict of private and public passions. Lear and his male entourage of mourners dominate the foreground stage of Barry's picture, the monumental figures divulging a profound range of emotional reactions to the spectacle of their despairing king. Lear himself, with his windswept mane of white hair and prophet-like grandiloquence (critics of the day complained of his Semitic mien), would provide a figurative and psychological model for many of Blake's looming patriarchs and domineering gods, as well as for later artistic renditions of the Gaelic bard Ossian and his mythic heroes that were so popular among painters from David's atelier. The landscape background of Barry's composition, offering visual escape from the massive array of dramatis personae, is most notable for its inclusion of primitive Druid trilithon temples, evoking the ancient history and religious civilization of Britain. Barry's Lear was part of a commercial enterprise known as "the Shakespeare Gallery," a project underwritten by the London publisher and alderman John Boydell who had commissioned most of Britain's leading artists to paint Shakespearean episodes for public exhibition, the pictures later to be engraved in large stocks for public sale. Since history painting was not receiving direct encouragement through royal patronage, these speculative financial ventures submitted the future of British narrative art to the uncertain and variable forces of the marketplace.

Barry was also an accomplished printmaker whose illustrations of Miltonic subjects demonstrated, often better than in his paintings, a heroic figure style that had earned Blake's admiration. Barry's etching Satan and His Legions Hurling Defiance Toward the Vault of Heaven (ca. 1792–4) was most emphatically a visual essay in the sublime. Edmund Burke had formulated the esthetics of the sublime in a treatise from his student days, A Philosophical Inquiry into . . . the Sublime and the Beautiful (1756). Here the sublime was defined as a pleasure of terror, esthetically mediated of course, in which the imagination revels in thoughts of fear, privation, and subjection, all the while identifying with obverse conditions—states of sensory and psychological overstimulation and illusions of omnipotent power. For

Burke, Milton's Paradise Lost was the creative work that exemplified the sublime, particularly the passage in which the fallen Satan rises out of the fiery lake of Chaos to curse the heavens—the precise episode illustrated in Barry's etching. In fact, Barry's composition responds to Burke's stipulation in the *Inquiry* that only poetic, not pictorial, images could most compellingly inspire these sublime affections. Barry's Satan is seen rousing his warriors and directing their rebellious attention upward to the celestial realm, the eerie light from the infernal depths below creating rich patterns of chiaroscuro that accentuate the vigorous modeling of the figures. The visuality of the sublime is conceived by Barry as a masculine realm of physical strength in which the swelling and extended bodies of the fallen angels, congested along the precipice of a flaming abyss, strain to break through the very boundaries of the image. The insurgent theme of the Miltonic illustration operates on many levels: the pictorial assault on the poetic sublime, the radical Barry challenging the conservative Burke (and the entire artistic and social establishment for that matter), and the suppressed energies of political revolt finding an irresistible embodiment in the dark heroism of Satan. Burke himself had originally associated this scene from Milton with, in his words, "the ruin of monarchs, and the revolutions of kingdoms."

Along with Barry, it was the Swiss-born painter Henry Fuseli (1741–1825) with whom Blake most closely identified as a fellow, underappreciated artist whose excessive imagination seemed to contest, while also appealing to, the mercantile art culture of late eighteenth-century London. Fuseli's intellectual background was remarkable: he emerged from the literary and philosophical circles of the Sturm und Drang (storm and stress) movement in Zurich and Berlin; by 1770, he had translated Winckelmann's art historical writings on Greek art into English, consulted with and written a critical commentary on Rousseau and his moral philosophy, and finally turned to painting as a professional pursuit on the encouraging advice of Reynolds. After an eight-year Roman sojourn, Fuseli settled in England in 1780 where he established his dual career as a painter of occult, mythological, and poetical subjects and also as a prolific literary reviewer. Among his closest colleagues could be counted the influential theorist of physiognomic science J. C. Lavater, the Liverpool art collector, banker, and abolitionist William Roscoe, and the revolutionary feminist and political activist Mary Wollstonecraft (she had reportedly become infatuated with Fuseli and wanted him to join her on a tour of Republican France in 1792).

At once admired and scorned for his cynical libertinism he was renowned for his colorful blaspheming and overbearing manner—Fuseli enjoyed testing the limits of artistic decorum. His pictures consistently fix upon the human figure in extremis, as seen in the second version of his most celebrated

4.8 HENRY FUSELI The Nightmare, 1790. Oil on canvas, 30 × 247/8 (76×63)

and scandalous painting, The Nightmare (1790), a work that 4.8 visualized the disturbing torments of a sleeping woman. Drawing from traditional folklore about demonic visitations and the supernatural carnality of dreaming, as well as from eighteenth-century medical theories on the psychophysiology of human sleep, Fuseli depicted the nocturnal intrusion of a grimacing incubus and his electrified, spectral nightmare into a woman's bedchamber. The dreaming woman is shown supine and vulnerable, surmounted by the peculiarly fetallooking fiend that is meant to serve as a vengeful personification of her desires; the psychical disables the somatic, resulting in the occult rape fantasy of the female protagonist. It is of course more accurate to say that the fantasy is Fuseli's, the dreaming delirium of this implied sexual violation posited as internal to the feminine so as to mask the demonic projection of masculine desire: that is, under Fuseli's stage direction, the dreaming woman victimizes herself. As though part of a Sadean reenactment of a spooky Nativity scene, the virginal victim gives birth to the gnomic offspring of her libidinal impulses, the visual displacement of suggestive sexual imagery discernible in the vaginal parting of the curtains and in the phallic end of the bolster that supports the dreamer's body (the upper torso revealingly thrown back in poised abandon). Although the first version of The Nightmare (1781) may have employed this imagery of supernatural persecution in veiled allusion to the diminished status of

Britannia after the war with the American colonies and in the wake of the civil disorder of the Gordon Riots, Fuseli maintained a lifelong obsession with the feminine realm of dreams, and with what he referred to as (paraphrasing Shakespeare) "the undistinguished space of women's will." His famous aphoristic remark about having to endure "the epoch of viragos" betrays obvious misgivings about the progressive advocacy for women's rights in the Wollstonecraft circle. In his later private, graphic erotica from about 1810, however, Fuseli was prone to inverting the terms of sexual domination, the scenario in these drawings often involving a restrained Promethean male being sexually suffocated by a muscular grouping of ornately coiffed courtesans. The feminine is seemingly liberated from the oppressive breeding of dreams, but only to minister to the masochistic fantasies of the artist.

Fuseli's credo that "the forms of virtue are erect, the forms of pleasure undulate," can properly be taken as the guiding principle behind his more heroic species of history paintings. Blake's image of Nelson subduing a serpentine monster is in many ways a hieratic reworking of the conquering male nude that dominated Fuseli's forceful Diploma painting for the Royal Academy, Thor Battering the Midguard Serpent (1790). 4.1 Along with subjects from Milton and Shakespeare, Fuseli favored epic myths from Nordic legend and the Nibelungenlied—this new emphasis on the Northern European mythic canon in accordance with current speculations on the cultural geography of nations espoused by the German philosopher of history J. G. Herder (who had praised Fuseli in 1774 as "a genius like a mountain torrent"). Inspired by the strained and expressive exaggeration of human anatomies in late Michelangelo and in Giulio Romano, Fuseli's figure of Thor is most assuredly a concerted study in "erect virtue." With the masculine body shown flexed and towering (Fuseli was fond of low vantage points and drastic foreshortening), Thor remains highly sexualized in his supreme moment of physical exertion. His genitals at the center of the picture are barely kept from view by the shadow of his projecting leg; but this

4.9 HENRY FUSELI Symplegma (Man and Three Women), ca. 1810. Watercolor, $7\frac{1}{2} \times 9\frac{5}{8}$ (18.9 × 24.5)

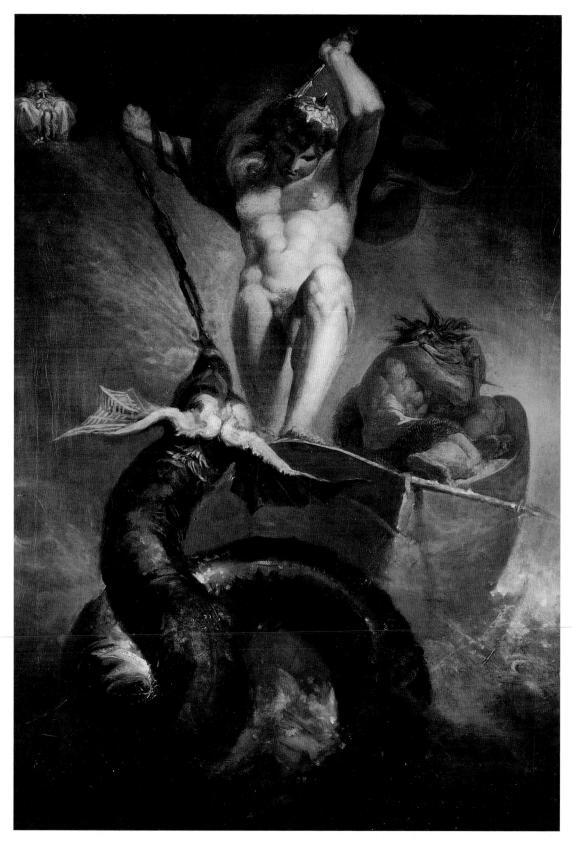

4.10 Henry Fusell Thor Battering the Midguard Serpent, 1790. Oil on canvas, $51\frac{1}{2} \times 36\frac{1}{4}(131 \times 92)$

pronounced swathe of shadow also connects his sex to the bloody head of the sea serpent that he has just snared from out of the misty waters. The subsidiary figures of the massive, aged boatman, shrinking away in fear, and the ancient god Wotan observing the struggle from on high—perched like a more feeble version of the incubus in the upper corner of the picture—only serve to swell the superhuman scale and fearless heroism of Thor. As a youthful deity with power over the elements of nature and the cultivation of land, Thor held more plebeian and popular associations than most of the more noble and venerable gods from the Eddic pantheon. In characterizing the revolutionary tremblings of Europe in late 1789, Fuseli almost seemed to be anticipating the visual impact of his figure of Thor, as when he wrote of "an age pregnant with the most gigantic efforts of character . . . whilst an unexampled vigour seems to vibrate from pole to pole through the human mind, and to challenge the general sympathy."

But Fuseli was generally reluctant to grant any direct social or moral function to modern English art, his own or anyone else's. In his role as Professor of Painting at the Royal Academy (a position he assumed in 1801), he asserted, with fierce candor, that the very existence of academies and public exhibitions "were and are symptoms of Art in distress and . . . the decay of Taste." His epic male figures exploding out of shadowy voids were insistent reminders of the absence of heroic grandeur in contemporary society and culture: futile challenges to what Fuseli derided as "that Micromania which infects the public taste" (by which he meant the diffuse esthetic interests of private patronage and commercial collecting habits that militated against the creation of "great works"). The Romantic poet and philosopher Samuel Taylor Coleridge came closest to recognizing the contradictory sexual politics and cultural pessimism of Fuseli's own great works when he judged them finally to be an art of "vigorous impotence."

PROPHECY AND PREHISTORY

Blake's more utopian effort to redeem contemporary society through his eternalizing icons of modern history like The Spiritual Form of Nelson ironically brought his art in close alliance with that most transient and unelevated type of visual culture, political caricature. Although Blake once chastised a prospective patron's artistic taste by remarking "I can perceive that your Eye is perverted by Caricature prints," the overwrought conjunction of modern history and cosmic allegory in many of his own pictures from the 1809 exhibition was not dissimilar to the teeming fantastical imagery produced during this period by the brilliant caricaturist James Gillray (1757–1815). Gillray received instruction in drawing at the Royal Academy and was well versed in both Old Master and contemporary art. By the 1790's he had become a prolific caricaturist for the Tory (conservative, royalist) Party, even though the vehemently anti-Jacobin themes of his prints did not reflect his own political beliefs. While Blake's 1809 exhibition was dismissed by a reviewer from the liberal journal The Examiner as the work of "an unfortunate lunatic," it was Gillray who actually spent his final years debilitated by insanity. In his crowded and complex etching Phaeton 4.1 Alarm'd! (1808), Gillray casts the Tory spokesman and propagandist George Canning as the new Phaeton, the "Sun of Anti-Jacobinism," coursing through the heavens above the war-torn earth (aflame and surmounted by a tiny Napoleon), his path beset by astrological personifications of his political opponents. The mythical, God-like defender of the Tory government is challenged by the monstrous clutter of Whig parliamentarians whose cartoonish portraits remain distinctly legible, even through their exceedingly grotesque armature. Blake's Nelson could easily claim Gillray's Canning as a fellow luminary from the nationalist firmament (the recently deceased Pitt, who is portrayed as the Tory father figure of Apollo in the lower left shadow of the Gillray print, was also given his "Spiritual Form" by Blake in a companion picture to the Nelson painting for the 1809 exhibit). Gillray's parodic and allusive appropriation of myth and allegory was an obvious strike against the pretense and hyperbole of history painting.

In mythologizing the daily politics of England, Gillray's prints often explicitly lampooned the imagery of high art at the Royal Academy, showing that the moral and esthetic exclusivity of history painting could be brought unceremoniously to the print culture of the streets. His Phaeton Alarm'd! knowingly refashioned the apocalyptic uproar of Benjamin West's The Destruction of the Old Beast and False Prophet, exhibited at the Royal Academy in 1804. West's painting belonged to an official commission for a series of religious history paintings that were to decorate the royal chapel at Windsor Castle. The ambitious project went awry when West, an American expatriate who succeeded Reynolds as President of the Royal Academy, fell out of royal favor, presumably because George III suspected him, and politicized factions within the Academy, of "democratick" sympathies. Many of the works from this planned cycle illustrated passages from the Book of Revelation, a point of contention with the King who criticized West's propensity for what he called "Bedlamite scenes from Revelations" (itself a revealing comment in the light of George III's own bouts of madness). West's apocalyptic spectacles nevertheless proved extremely popular with exhibition audiences in both London and Paris. In the religious painting cribbed by Gillray, West practised his own more typical style of academic eclecticism, the triumphant stampede of equestrian Christian warriors treated in gleaming, Neoclassical profile, while the vanquished armies

4.11 James Gillray *Phaeton Alarm'd!*, 1808. Engraving, 13 × 14½ (33 × 36.8)

4.12 Benjamin West The Destruction of the Old Beast and False Prophet, 1804. Oil on panel, $39 \times 56\frac{1}{2}(99 \times 143.5)$

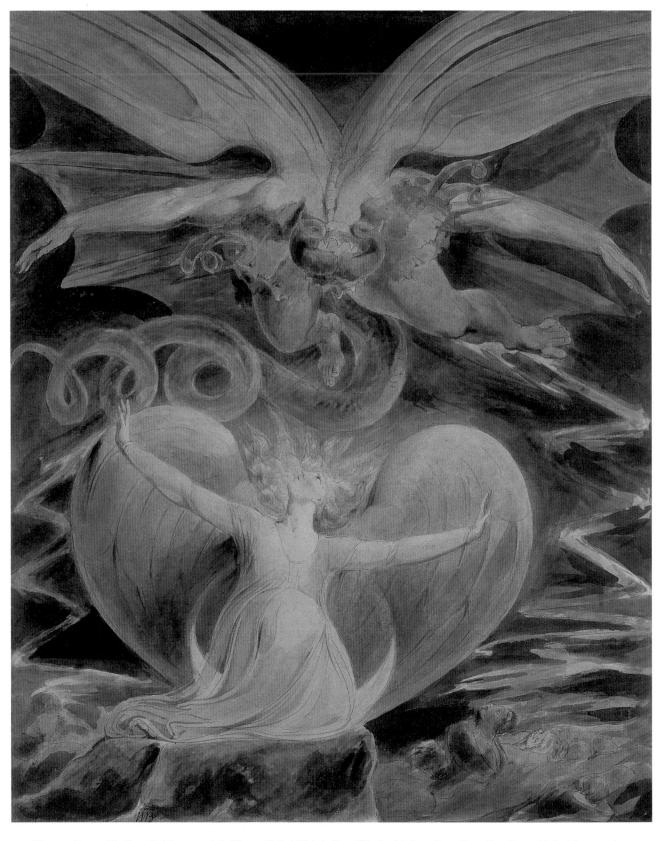

4.13 WILLIAM BLAKE The Great Red Dragon and the Woman Clothed With the Sun: "The Devil is Come Down," ca. 1805. Pen and ink with watercolor over graphite, $16\frac{1}{8} \times 13\frac{1}{4}$ (40.8 \times 33.7)

of the false prophets and the lionheaded demonic adversaries of God, seen retreating into tenebrous chasms and windswept clouds, are indebted to Rubens and the trappings of Baroque allegory. The appeal of West's pictures of this kind lay not in their learned artistic accomplishment, but rather in their contemporary historical and millenarian overtones: with the resumption of the Napoleonic Wars after the Treaty of Amiens and with the recent turning of the century, such apocalyptic paintings were redolent of widespread fears for the future survival of England and the fate of Europe.

Despite the dichotomy between the artistic careers of West (the professionally prominent academicist) and Blake (the insular engraver and poet), their art shared in the nationalist, religious fervor of these early years of the nineteenth century. While West was exhibiting his epic machines of biblical destruction, Blake was also illustrating the Book of Revelation for a group of scriptural paintings that had been commissioned by his only steady patron, Thomas Butts (a government munitions clerk whose politics and occupation were strikingly antithetical to those of Blake). Eschewing the yards of canvas and cast of thousands required by West, Blake's apocalyptic designs have a figurative conciseness, gestural eloquence, and compositional equipoise that allowed him to translate the religious mystery and copious allegory of the Book of Revelation into terse visual epigrams. These qualities are most evident in his stunning watercolor The Great Red Dragon and the Woman Clothed with the Sun: "The Devil is Come Down" (ca. 1805), a work that could also be described as an eschatological refrain of Fuseli's Nightmare. Roughly contemporary with Blake's spiritualization of Nelson for the 1809 exhibition was West's own project for a monumental painting of The Apotheosis of Nelson (1807), a design replete with architectural and sculptural surrounds that were to have made the entire ensemble into a secular altarpiece commemorating British maritime power and the religion of nationhood. Although West was most renowned for his grand-manner history paintings of contemporary events, especially death scenes of prominent military and political figures, here he invents a composite allegory in which Nelson's draped corpse is being conveyed heavenward by gigantic and mournful figures of Neptune, Britannia, and Victory. Ponderous, erudite, and reverential, the painting may be seen as the more official version of the visionary national artform that Blake was trying to expand upon with the 1809 exhibition.

Blake sought to legitimize the conception of his own works by comparing them not to the acclaimed, patriotic art of West but to, as he wrote in his Descriptive Catalogue, "compositions of a mythological cast, similar to those Apotheoses of Persian, Hindoo, and Egyptian Antiquity." Inspired by late eighteenth-century mythographic and antiquarian speculations on the origins of art and religion, Blake asserted that through

4.14 BENJAMIN WEST Design for The Apotheosis of Nelson, 1807. Oil on canvas, $39^{1/2} \times 29 (100.3 \times 73.8)$

his own mental travels ("taken in vision") he had seen the lost sacred art of the Jews that had adorned the palaces, temples, and city walls of the ancient world, and that these originary instances of public monumental sculpture and painting formed the basis for all subsequent artistic traditions, whether Greco-Roman or "Asiatick." The auratic and archaizing character of the Spiritual Form of Nelson was indebted to 4.5 eighteenth-century engravings of Indian antiquities, as seen, for example, in the illustrations of relief sculptures from the 4.15 Shiva Temple at Elephanta that appeared in Baron d'Hancarville's comparative study of ancient art and myth, Researches on the Origin, Spirit, and Progress of the Arts of Greece; . . . on the Antique Monuments of India, Persia, the Rest of Asia and Egypt (1785), a study which purported to reveal the primacy of sexual and occult symbolism to the cultural and mythic forms of earliest civilizations worldwide. Blake's catalog commentary also spoke of reviving mythological and recondite meaning in modern art and posited a syncretic theory of artistic tradition encompassing "the finest specimens of Ancient Sculpture and Painting and Architecture, Gothic, Grecian, Hindoo, and Egyptian." In preparing his later engraving (ca. 1820) of the *Laocoön*, Blake summarily rewrote the history of art by reattributing the Hellenistic sculpture—a

4.15 BARON D'HANCARVILLE Researches on the Origin, Spirit and Progress of the Arts of Greece; . . . on the Antique Monuments of India, Persia, the Rest of Asia and Egypt, volume 1, plate 10, 1785. Engraving, $6 \times 8 (15 \times 20.5)$

4.16 WILLIAM BLAKE Laocoön, ca. 1820. Engraving, 107/8 × 83/8 (25.5×21.2)

paradigmatic artwork that had been central to the German Enlightenment esthetic debates of Winckelmann and Lessing—as a copy of a lost original from the Temple of Solomon. With its array of inscribed mottos lamenting the corruption of art by war and money, this reproductive print of a fundamental piece of ancient statuary is transformed into a didactic proclamation about the divine origins and modern plight of art. Although Blake saw the panoply of ancient world art as unified by "a spiritual agency," it was one that remained tied to a Judeo-Christian origin. The antiquarian fantasy of incorporating all of world culture within a renewed English art of national grandeur cannot be divorced from the imperialist fantasy that is the subject of Blake's picture—the 4.5 transfigured Nelson (culled from both Shiva and Laocoon, 4.1 construed as both protective demi-god of Albion and militaristic Antichrist) enfolding the nations of the earth within its primordial serpent.

Mythic accounts of national origins and exotic dreams of colonial encounters were much in evidence at Blake's 1809 exhibition. Paintings (now lost) of "savage girls" aboard a missionary vessel and of the Sanskrit scholar Charles Wilkins among Indian Brahmins could be seen along with The Ancient Britons, a picture whose catalog entry included Blake's account of Druidic and Arthurian legend given as proof that Albion and the English nation had originally descended from the lost continent of Atlantis and from the lost tribe of Israel. The national identity of Blake's England could only be redeemed by virtue of its visionary prehistory and its colonizing future—the more conjectural, global, and syncretic, the better. Thus, while scorning the veristic and documentary demands of contemporary history painting, Blake would argue that "the history of all times and places is nothing else but improbabilities and impossibilities." Prefiguring the dilemma surrounding later manifestations of primitivism and mysticism in nineteenth-century art, Blake's work was at once critical of and constituted by its own historical experience, announcing itself as both powerless and transcendent, victimized and prophetic.

Writing a few months before his death, Blake acknowledged his own inability, or rather unwillingness, to participate fully in the creation of a nationalist culture. He commented yet again on the longstanding opposition of "Englishmen" to his standard of "Republican Art," an opposition that was not in the least overcome by the nationalist strains of his 1809 exhibition. Intent on disassociating himself from any illusion of social and cultural unanimity within England and from the generic defining of its national identity, Blake looked back over his lifetime and concluded: "since the French Revolution Englishmen are all Intermeasurable One by Another, Certainly a happy state of Agreement to which I for One do not Agree."

. 5 .

NATURE AND HISTORY IN ENGLISH ROMANTIC LANDSCAPE PAINTING

BRIAN LUKACHER

LANDSCAPE INSTINCTS AND THE PICTURESQUE

"THERE DOES NOT EXIST, AS FAR AS I KNOW, IN THE world a single example of a good historical picture; . . . the production of it is a task which the closing nineteenth century may propose to itself." This comment by John Ruskin, from the third volume of his treatise Modern Painters (1856), might easily be mistaken as being in the spirit of a lament. But the failure of history painting, and the dim possibility of its successful revival in the remaining decades of the century, was not an issue of overriding concern for Ruskin. As the most prolific and profound commentator on art and society during the Victorian epoch, Ruskin was both identifying and facilitating the eclipse of historical painting by landscape painting, in effect signaling one of the more important transformations in nineteenth century artistic practise. His monumental Modern Painters, whose five volumes spanned 1843 to 1860, was devoted to the study of what its author called "the landscape instinct," an instinct that Ruskin justifiably believed had come to prevail over modern cultural life and that had determined much of the character of the Romantic imagination earlier in the century, whether in literature or painting.

Although the raison d'être for *Modern Painters* was to put forth a passionate defense of the lifework of England's leading and most controversial landscape artist, J. M. W. Turner, the scope of Ruskin's study eventually encompassed not only an entire history of European landscape art but also an inquiry into the scientific and spiritual conditions of the human perception of nature, and of the primary interrelationship between natural environment and social development. Ruskin

took surprisingly little solace in his assertion that human sensitivity to landscape had reached its apogee in the nineteenth century. The predominance of this landscape instinct was to him symptomatic of the current degeneration of humanity, of what he described in his chapters "Of Modern Landscape" and "The Moral of Landscape" as "the present crisis of civilization." Responsible for the making of this crisis were Ruskin's bêtes noires of modern society: faithlessness bred by the scientific objectification of nature; untoward faith in the redemptive promise of technology and utilitarian reform; and moral insensibility brought on by excessive, material self-interest in an industrializing world. With space and time vanquished by such modern inventions as the railroad and the telegraph, the refuge humanity needed to find in the natural world was itself no longer guaranteed. In the nineteenth-century search for, and seeming conquest of, the landscape, Ruskin detected, in his words, "the elements of progress and decline being strangely mingled in the modern mind." Although his own merging of social criticism and landscape esthetics is frequently qualified as being an anxiously Victorian misreading of Romanticism, Ruskin recognized that the Romantic experience of nature (the landscape encounter as a presentiment for spiritual and psychological reflection) also had an inescapably social dimension, one in which the Romantic landscape could be revealed as an ideologically contested site of material progress and historical struggle.

In English art criticism, the national preference for landscape painting over history painting had been remarked upon well before the time of Ruskin's *Modern Painters*. Writing in 1807, an anonymous critic for *The Literary Panorama* applauded the emergent, native taste for landscape art, but in doing so, also felt compelled to make some

distinctions based on the academic hierarchy of the genres: "The landscape scenery of our island is distinguished by its own features, and these afford scope for the sublimest efforts of art. History Painting has not been the *forte* of this country. It is a branch of art not suddenly brought to perfection. Our artists seldom allow due time to their works; they seldom ripen them by perseverence and study. What their mental conceptions suggest they execute instantly; but instant execution is no friend to historical excellence." By inference, this writer argues that the genre of landscape painting was more conducive to the capricious, instantaneous habits of English artists, habits which were themselves due in part to the absence of an established academic tradition and to the commercial vagaries of artistic taste (both of these factors were often cited by art critics of the day as the chief inhibitions to the British cultivation of history painting). Landscape painting accommodated the impulsive mental freedom that is here deemed characteristic of artistic traits in England, while also allowing the country's painters to perform a public service by displaying the indigenous esthetic wealth of the national scenery.

Although this unsigned critic spoke of the English recovery of nature in terms of "the sublimest efforts of art," the most popular terminology for the esthetic claims of landscape at this time revolved around the notion of the picturesque. Made fashionable during the late eighteenth century by the published travelogs of the Reverend William Gilpin, the picturesque esthetic encouraged discerning tourists to evaluate and classify the scenic qualities of topographic locales according to pictorial modes of landscape painting. English scenery could be exoticized (and acculturated) in the eve and mind of the picturesque tourist by virtue of its passing resemblance to the seventeenth-century landscape art of Claude Lorrain and Salvator Rosa, the picturesque imagination often seeking to reconcile the contrasting styles and moods of these Italianate models (the pastoral serenity of the former with the rugged violence of the latter). The tourist well versed in the playful formalism and classifying criteria of the picturesque could take visual possession of a prospect and thereby entertain an illusory dominion over nature: the land transformed into a landscape through the refining and all-encompassing act of perception. As Gilpin advised his readers, "the province of the picturesque eye is to survey nature; not to anatomize matter. It throws its glances around in a broad-cast stile. It comprehends an extensive tract at each grand sweep."

From its initial project of cultivating the visual semantics of nature-seeking tourists (both from the landed gentry and the burgeoning middle classes), the picturesque esthetic soon became the subject of tireless polemical debate among art theorists, associationist philosophers, and landscape designers. With the Napoleonic Wars, the English countryside became

the locus of conflicting interests: on the one hand, there was an economic imperative for increasing agricultural yield through accelerated enclosure of common land and scientific agrarian reform, and on the other, a cultural imperative for promoting rural England as a picturesque landscape park of ever varying visual pleasure, particularly so since travel to the Continent had to be drastically curtailed during wartime. Gilpin and other landscape estheticians insisted that the picturesque vista had to be kept free of scenes of rural labor and industrial production—those very sources of economic growth and national strength on which England depended. The resistance of picturesque sightseeing and landscape design to the agrarian demands and social relations of the countryside was itself the subject of satirical comment, as witnessed in the novels of Jane Austen and the caricatures of Thomas Rowlandson. As late as 1834, the art critic Anna Jameson recounted her somewhat uncomfortable experience of trying to elicit the esthetic interests of "an independent English yeoman"; after describing the picturesque beauty of the surrounding landscape, her admiring remarks about the scenery met with this riposte from the farmer, "'Picturesque!' he repeated with some contempt; 'I don't know what you call picturesque, but I say, give me a soil, that when you turn it up, you have something for your pains." Judging from this anecdote, the cult of the picturesque, of such popular appeal precisely because it appeared to democratize the elitist cultural pretensions of landscape appreciation, could not overcome the social divisions of class, profession, and gender.

The picturesque, whether touching on the formalist connoisseurship of the landscape or on the social engineering of life within the landscape, was often restrictive in its task. Treatises on the picturesque invariably employed illustrative plates to demonstrate, through contrast and comparison, its modifying esthetic principles. In Gilpin's summa Three Essays: On Picturesque Beauty, On Picturesque Travel, and On 5.1, Sketching (1792), two landscape etchings are set opposite one another. The first shows a symmetrical, unmodulated composition, embodying the maternal, orderly protectiveness of nature that Burke had designated earlier in the century as "the beautiful." The second shows Gilpin's picturesque rearrangement of these primary landscape features: the terrain and foliage now seen with irregular outlines and variegated surfaces, a serpentine path directing the eve through the interlocking, receding passages of the scenery, and two shadowy figures plotted in the foreground—perhaps travelers in "pursuit of the object" (to quote Gilpin)—who are in turn echoed compositionally by the paired outcropping of ruins on the distant promontory above them. Here one finds the kind of permutational interplay between the natural and the artificial that was so central to arguments about the picturesque. As the literary historian Martin Price has observed, "The drama of

5.1 WILLIAM GILPIN Plate from Three Essays: On Picturesque Beauty. On Picturesque Travel, and On Sketching, 1792. $6^{1/8} \times 9 (15.5 \times 22.5)$

5.2 WILLIAM GILPIN Plate from Three Essays: On Picturesque Beauty, On Picturesque Travel, and On Sketching, 1792. $6^{1/8} \times 9 (15.5 \times 22.5)$

the picturesque is readily cast into the form of the energies of art wrestling with the materials of nature, or the alternative form of the genius of nature and time overcoming the upstart achievements of a fragile, but assertive art."

Within this picturesque contest between nature and art, and between land and landscape, the outward signs of social diversity were not particularly welcome. Even the most pragmatic and professionally active of picturesque landscape gardeners, Humphry Repton (1752-1818), was sometimes troubled by the unsightly impingements of rustic life in his own designs for estate parks and villages. More so than most landscape gardeners swept up by the picturesque tide, Repton attempted to reconcile the social and economic requirements of a property with its scenic potential; consequently, he spoke of "humanizing as well as animating beautiful scenery." Although his writings on the theory of landscape gardening often expressed disdain for the picturesque as a faddish weathervane of taste favored by "successful sons of commerce," Repton's proposals for the improvement of landed

estates rarely strayed far from a domesticated picturesque idiom. In preparing his garden designs for prospective clients, Repton would also utilize "before" and "after" scenes of the same landscape, his elaborate watercolor drawings equipped with flaps and overlays that would help dramatize the transformation of the view at hand. He made use of this device in the 1816 design for his own garden prospect in Hare 5.3, 4 Street, Essex. Repton amends the prosaic character of the village scene by distancing and obscuring its unseemly details. The village green, once a common for grazing livestock, is appropriated by Repton for his private garden preserve, its curving, hedged boundary replacing the rigid linearity of the fence along his property that had barely kept crippled vagrants at bay (the loitering figure in Repton's "before" improvement episode most probably identifiable as an indigent war veteran). Flowering shrubs and arboreal trestles protect the eye from the distractions of passing stagecoaches and local shopkeeping. The picturesque garden functions as a series of projecting screens that removes the social actuality of

5.3 HUMPHRY REPTON "View from my own cottage, in Essex" (before), 1816. $6\frac{3}{4} \times 9\frac{1}{2}$ (17 × 24)

5.4 HUMPHRY REPTON "View from my own cottage, in Essex" (after), 1816. $6\frac{3}{4} \times 9\frac{1}{2}$ (17 × 24)

village life from view. Even after eradicating these eyesores from his garden vista (one is tempted to say, "dehumanizing" rather than "humanizing" it), Repton could still write of an affection for "the cheerful village, the high road, and that constant moving scene which I would not exchange for any of the lonely parks I have improved for others."

RUINS AND CITIES

The late eighteenth-century vogue for the picturesque also encouraged many landscape artists, amateur and professional alike, to specialize in topographic watercolor painting, a medium that lent itself to both formulaic compositional techniques and innovative experiments in landscape sketching out-of-doors. For the most advanced landscape water-colorists of this period, the tenets of the picturesque were to be quickly mastered, and just as quickly superseded, a development that is best exemplified by the work of Thomas Girtin (1775–1802). Girtin's modest career began, typically enough for the landscape artists of his generation, in architectural drafting and in the coloring of topographic engravings of Gothic antiquities and country seats. During the mid-1790's, he was employed by Dr. Thomas Monro, a physician and an unscrupulous proprietor of lunatic asylums, who also oversaw

an informal landscape drawing academy that convened in his London townhouse. In 1799, Girtin was at the center of the Sketching Society, a group of watercolor painters who pursued not only picturesque motifs culled from tours of Wales and the Lake District, but also historical landscape subjects from Ossianic legend and other poetical sources. Censured by some for his republican political sympathies and dissolute lifestyle, Girtin was widely recognized at the time of his premature death as the most promising landscape painter of the English school. His watercolor of *Kirkstall Abbey* (1800) epitomizes the picturesque topography of ruins that pervaded much of the landscape imagery in the outpouring of prints and

drawings during this period. Girtin's vista strands the ruined abbey in the middle distance of a predominantly umber landscape, the jagged outline of the bleached architectural structure distinguished from the undulating sweep of the valley (the ruins remain cushioned somewhat within a darker copse of trees). Picturesque devices are evident in the formal correspondence between the cloud masses and the interspersed areas of foliage, and also in the serpentine path of the river that directs the excursion of the eye through the landscape. However, Girtin's watercolor diverges from accepted notions of the picturesque in its conspicuous inclusion of the mundane and unromantic aspects of rural life: rustic laborers

5.6 THOMAS GIRTIN *The Thames from Westminster to Somerset House*, sketch for the "Eidometropolis" or panorama of London, 1802. Watercolor, 95/8 × 21¹/₄ (24.4 × 54)

5.7 JOHN CONSTABLE Golding Constable's Flower Garden, 1815. Oil on canvas, $13 \times 20 (33 \times 50.8)$

5.8 JOHN CONSTABLE Golding Constable's Kitchen Garden, 1815. Oil on canvas, $13 \times 20 (33 \times 50.8)$

straggling along the muddy road in the foreground, with the cob and timber farm buildings (not conforming to the picturesque taste for quaintly ramshackle cottages) that only serve to accentuate, and even render more ironical, the faded grandeur connoted by the medieval ruins. In the distance, at the visible terminus of the river's winding, smoke is seen rising from the terrain, an indication of human labor operative within the landscape (whether it be from firing kilns or from the burning and clearing of brush). The landscape of rural utility at first may seem at odds with the landscape of antiquarian and philosophic meditation. But this apparent incongruity is more purposeful than not—the historical remnants of Britain's national past, rife with poetical and esthetic associations for the cultivated viewer, alongside the purely external traces (figures and buildings) of the workaday demands of rural Britain. The landscape is conceived as nostalgic and retrospective, as well as unreflectively present and productive.

Girtin also applied his considerable talents as an architectural draftsman and a landscapist to a relatively novel form of early nineteenth-century visual culture—the panorama. In 1802, his "Eidometropolis," a panoramic view of the London 5.6 cityscape, opened to great critical acclaim. Although panoramas, dioramas, and other kinds of mechanized scenic exhibits and light shows were initially received as exclusive entertainments of fashionable society, these visual spectacles became increasingly popular within the emergent urban mass culture of the period. Panoramas were often devoted to sensational kinds of subjects: dramatic scenes of terrifying natural phenomena (volcanos, waterfalls, and similarly uncontrollable

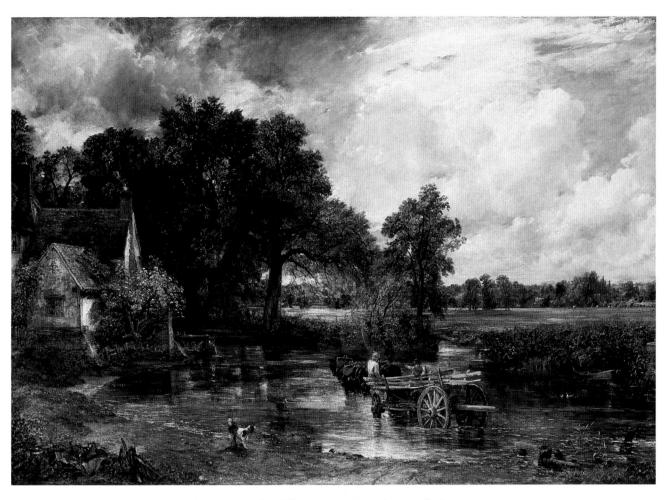

5.9 JOHN CONSTABLE The Hay Wain (Landscape: Noon), 1821. Oil on canvas, $51\frac{1}{4} \times 73$ (130.5 × 185.5)

sublimities) and of exotic places connected with the British Empire and its military conquests within an expanding global arena. Through the panoramic recreation of these elemental and remote landscapes, the city could, in a sense, contain and incorporate nature within its metropolitan domain. Interfusing the procedures of both science and art, and technology and culture (thereby adumbrating the later development of photography and cinema), the panorama and related visual media also remained fixed upon the specularity of the evergrowing metropolis. The modern city and its cosmopolitan populace required a naturalized and heightened vision of itself. As the early twentieth-century philosopher and critic Walter Benjamin remarked on the widespread appeal of the panoramic urban vista (paraphrasing an earlier discussion from Marx): "The city dweller, whose political superiority over the country is expressed in many ways in the course of the [nineteenth] century, attempts to introduce the countryside into the city. In the panoramas the city dilates to become landscape."

The "Eidometropolis" was primarily a river view of the city, with its circular survey of London following the

embankment of the Thames, the commercial artery signifying Britain's maritime prowess. Girtin's original oil painting, now lost, measured 108 feet in its circumference and was admired both for its wealth of topographic and anecdotal detail and its subtle observation of atmospheric effects. One of the surviving watercolor sketches for the panorama affords a view of the Adelphi Terrace (a prominent residential development where Girtin had worked at Dr. Monro's) and Somerset House (the site of the Royal Academy), landmarks attesting to the civic and cultural identity of late Georgian London. But the point of view taken from the south bank, visible in the left foreground, also encompasses the rapidly developing industrial quarters of the city, with its nearby clutter of foundries, breweries, and quays. Girtin's nuanced watercolor technique, especially in the complex overlapping of rooflines and fuming smoke and vapor as well as in the abbreviated calligraphy used to notate the passing skiffs and their wake on the Thames, worked effectively in capturing the breadth of the urban vista. Even in the finished panorama, where one would generally expect to find a highly delineated visual register, Girtin was credited with sustaining a more diffused, atmospheric style

that was deemed all the more appropriate to the urban/industrial landscape; as a contemporary reviewer wrote: "the view appears through a sort of misty medium arising from the fires of the forges, manufacturers, &c."

Girtin's dual engagement with picturesque scenes of rusticity and ruin and with the panoramic spectacle of the metropolis points to the almost indivisible relation of the countryside to the city in the social and cultural fashioning of nineteenth-century landscape esthetics. The seeming dichotomy of the rural and the urban in the pictorial and literary production of landscape imagery was perhaps more dialectical than oppositional. Nevertheless, the prevailing ideology of an urban perspective on the natural world, in which nature and the rural landscape are construed as a cultural resource offering moral respite from what one early-nineteenth century commentator called "the guilt and fever of a city life," would inform much of the artistically progressive, though often socially regressive, landscape painting of the century, from the British watercolor school to French Impressionism.

CONSTABLE'S RUSTIC NATURALISM

Writing from London in 1802, the aspiring landscape painter John Constable (1776–1837) would complain: "Panorama painting seems all the rage . . . [but] great principles are neither expected nor looked for in this mode of describing nature." Throughout his artistic career as the most innovative exponent of a rustic, naturalist landscape art, Constable was often troubled by the theorizing of "great principles" in painting. His many opinions on the function of landscape art (recorded in his voluminous correspondence and in a series of lectures he delivered late in his life) are in some ways most remarkable for their self-contradicting claims. On one hand, he could bluntly pronounce: "In such an age as this, painting should be understood, not looked on with blind wonder, nor considered only as a poetic aspiration, but as a pursuit, legitimate, scientific, mechanical." And on the other, he could wax poetic about his own attachment to his native landscape of the Stour Valley as being the very wellspring of his art (this is the most oft-quoted passage from Constable's writings): "Still I should paint my own places best; painting is but another word for feeling, and I associate 'my careless boyhood' with all that lies on the banks of the Stour; those scenes made me painter . . . I am fond of being an egotist in whatever relates to painting." Constable's landscape painting would seek to negotiate a rapprochement between the antipodes of science and sentiment, between a vision of nature that was objectifying and transparent and yet also subjective and solipsistic. Constable's art is most instructive and compelling because of its very effort to overcome any disparity between this positing of landscape as an apprehensible form of knowledge with undiluted truth content and also as an expressive recollection of a fantasized, autochthonous union of self and nature.

This admixture of observational detachment and personal investiture is often recognized as being fundamental to the achievement of Constable's landscape painting. From 1809 onward, Constable decided to restrict himself to a regional landscape art focused on the canals, fields, mills, and cottages surrounding and including his father's property near East Bergholt in Suffolk. If, in his decision to pursue an artistic career, Constable had resisted his familial obligations to take over the milling and farming business, he could at least repossess this patrimony, repeatedly, through representing it. The landscapes portrayed in his art were not simply disinterested objects of picturesque beauty redolent of a vaguely updated pastoralism. Instead, the lay of the land and the stretches of scenery were inscribed by memory and personal history, in which a socio-economic, and even psychological, identification with the landscape served as a virtual precondition for the artistic knowledge of "nature." Constable's self-imposed exile within the countryside of his father's property (an exile not abroad, but at home), and the optical and emotional alertness to the local particularity of that landscape, is best documented in his pair of small paintings from 1815 depicting his father's gardens, fields, and rural outbuildings. Painted from the upstairs window of the family house, Constable's site-specific orientation to the landscape and the sweeping embrace of the vista are indebted to the unprincipled principles of panorama painting that the artist had disparaged earlier during his student years in London. In the rural setting of this more personal landscape, the mere task of describing nature was redeemed and made pure, undemanding of any overarching esthetic formulae. Constable would often write, in self-heroizing terms, of his own dedicated search for a natural, incorrupt vision of landscape; disavowing artistic precedent and pronounced stylistic idiom, the painter advocated a guileless sincerity and dogged faithfulness in establishing an unmediated rapport with nature.

In the views rendered from his family's estate house, the illusion of this undeclamatory naturalness of vision was predicated in great part on the highly cultivated and controlled character of the agricultural landscape that was being described. With their attention to the patterning and demarcation of the agrarian property, these paintings maintain a casual orderliness in their presentation of the landscape: the parterres, hedgerows, fences, and paths that subdivide the diagonal wedges and the horizontal bands of the scenery attest to the proprietary pleasure taken in surveying and recording these prospects. Visually, the paintings reconcile acute clarity with atmospheric diffusion of detail; brushwork is at once

incredibly descriptive of specific landscape features and yet also broadly textured and summary in its indication of such motifs as livestock, windmills, and distant gates and rooflines. The irregular geometry of the landscape is set against the more transient, though no less closely observed, effects of atmosphere and light: the deepening shadows that lengthen across the well-kept lawns and gardens, and the amassing clouds that are captured with a meteorological precision and yet are also made to respond compositionally to the density and outline of the trees and foliage on the ground below. Conforming very much to a georgic conception of landscape, these pictures point to a contradiction that runs throughout Constable's art in its pictorial treatment of the human labor that was necessarily required to secure the productive balance and imagined harmony of nature and society celebrated and promoted in this kind of imagery; as the literary historian John Barrell has commented: "No painter offers us a more civilised landscape than Constable, but the existence of the men who have civilised it has for the most part to be inferred from the image of what their effort has achieved." These pictures of the family property are not without considerable human incident: harvesters, gardeners, and threshers are present, but only just. Reduced to distant highlights or chromatic accents within the landscape, the laborers are deftly integrated into the painted fabric of Constable's well-ordered vision of nature. Just as these figures are shown tending the property that is not theirs, Constable's landscape in turn tends to them, almost suppressing the human presence as a mere visual cipher amid the productivity of the natural world.

During the 1820's, Constable worked to create a monumental version of the naturalist landscape of a rural society that was legitimized, at least in the artist's mind, by its associative connections with his own past. Although his artistic inspiration lay in the Stour Valley, Constable's artistic career was centered in London. Intent on commanding greater respect from the Royal Academy and from those art critics who guardedly commended his art for its "portraiture" of nature, Constable began exhibiting large-scale pictures (the so-called "six-footers") of the agrarian and waterway landscapes of his home county of Suffolk. Ranging in mood and format from the epically placid The Hay Wain (Landscape: Noon) (1821) to the disquieting turbulence of Dedham Vale (1828), these exhibition landscapes sought to shore up an image of rural England during a period when social relations in the countryside were being strained by economic depression and civil unrest on the part of the agrarian working class. As much as Constable presumed to be unconcerned with the social actuality of the rural scene (the effects of nature were absorbing enough), his six-footers nevertheless betray an ambivalent awareness about the difficult task of sustaining some quasi-empirical mythology of rural England. Just before sending The Hay Wain to the Royal Academy exhibition Constable lamented, almost as if to anticipate and rationaliz the urban insensitivity to his Stour Valley landscapes. "Londoners, with all their ingenuity as artists, know nothing of the feelings of country life, the essence of landscape." The vivid optical immediacy of The Hay Wain implied an effort to render perception itself more unsullied and refreshed through its intensification of both the intangible atmospheric effects of light and shadow and the more palpable textures of moisture, plantlife, and earth. The painting's mood tends toward bucolic lassitude, seizing a moment of routine uneventfulness that is compromised somewhat by the activated paint surface of the landscape, especially in the glistening foliage, the tremulous reflections in the stream, and the thickening clouds (hence the appeal of Constable's facture to French Romantic painters and critics when this picture was shown in the Paris Salon of 1824). If The Hay Wain makes wonderful work of perceptual attentiveness, it shows rural labor as almost sluggishly and unselfconsciously performed. One wonders if the wagon stalled by Willy Lott's cottage (a neighboring resident of the Constables' property renowned for his having never ventured far from the environs of his shaded habitat) will ever emerge out of the watery mire and return to the sunlit harvest meadow glimpsed in the distance, where another wagon is seen already burdened with hay and ready to depart for the barn. This, then, is Constable's feeling for country life, where the inevitable cycle of rural labor becomes synonymous with habitual indolence, and where seeing and representing the landscape is made to seem more demanding than harvesting it.

CONSTABLE AND THE RUIN OF ENGLAND

The outbreaks of Luddite insurrection and rural arson in East Anglia, and the failing market prices during the post-Napoleonic War years that undermined the economic status of rural gentry like Constable's family, seem like unthinkably remote social nightmares when looking at The Hay Wain. Such was the function, whether consciously or unconsciously, of Constable's six-footers. The incommensurability between the landscape imagery and the social experience of the countryside can nevertheless be discerned in Constable's ambitious exhibition paintings of the 1820's. The tremendous 1828 exhibit of Dedham Vale (Constable referred to the picture as "perhaps my best") rehearses yet another of the artist's "native scenes" which he had first painted in 1802, this Wordsworthian recurrence of a familiar landscape over a temporal span of one's life indicative of the painter's more reflexive inquiry into his own comprehension of the natural world. With its Claudian proscenium of framing foliage and

5.10

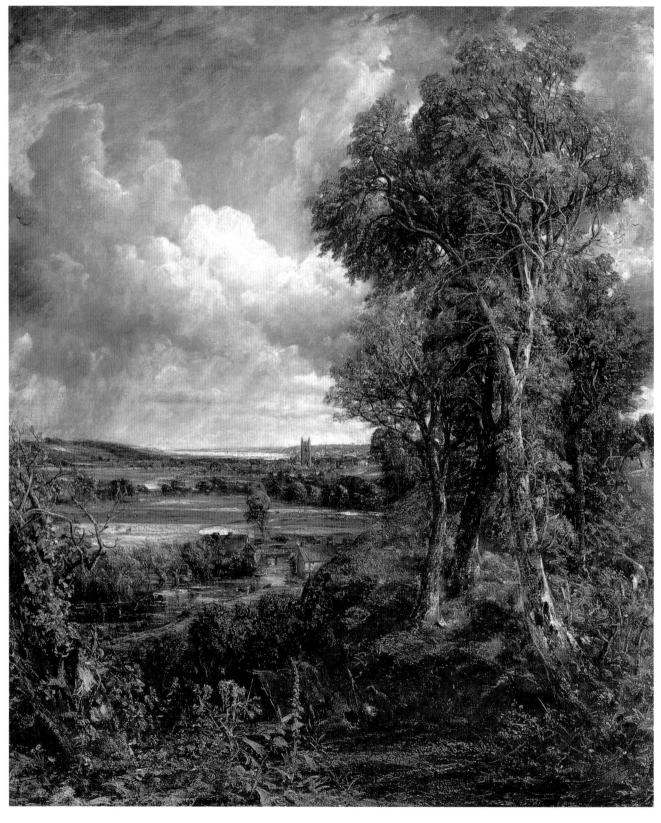

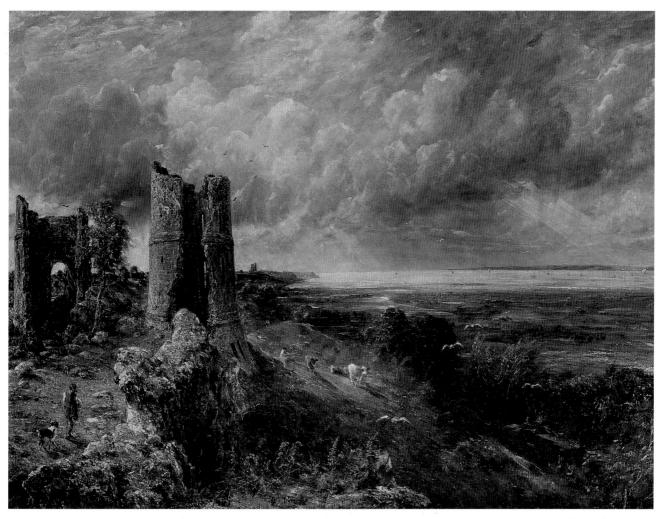

 $\textbf{5.11 JOHN CONSTABLE} \ \textit{Hadleigh Castle, Mouth of the Thames-Morning After a Stormy Night, 1829}. \ Oil on canvas, 48 \times 64 \% (122 \times 161.9)$

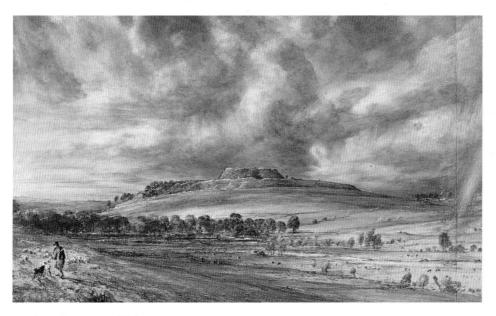

5.12 John Constable *Old Sarum*, 1832. Watercolor, 11 $\frac{7}{8} \times 19^{\frac{1}{8}}$ (30.1 × 48.6)

its serpentine river view measured out and broken at key recessional junctures by the topographic landmarks of mills, cottages, and bridge, and further on, of the church tower standing guard over the village, the painting tentatively retains many of the picturesque principles of design that Constable had hoped to disinherit through his development of an artless, unaffected naturalism. The moral and social iconography of the landscape, its cherishing vista of a faithful, hard-working agricultural community, is complicated by the foreground ridge of darkness wherein the figures of a vagrant mother and her child can be discerned, their makeshift encampment within the tangled thicket of trees and underbrush in poignant contrast to the well-tended vista of fields and village stretching off into the distant valley. Here is a rare instance in which Constable admits a scene of rural poverty into his landscape, albeit obscuring it within the shadowy recesses of the overgrown furrow. One might be led to think that this pathetic intrusion is meant to be overlooked, the eye diverted easily into the expansive valley beyond. But it is also hidden so as to be revealed. Reluctant to sentimentalize excessively over the ordeals of pauperism, Constable perhaps saw this foreground passage as a primitivist episode in the formation of rural England that finds its fulfillment or resolution in the unfolding landscape of the Stour Valley.

Later, in 1836, while lecturing on the history and theory of landscape painting, Constable recounted an anecdote that provides an interesting gloss on the problematic foreground of Dedham Vale. Describing a drawing he had made of a beautiful tree in Hampstead (he feminized the landscape motif as "this young lady"), Constable digressed: "some time afterwards, I saw, to my grief, that a wretched board had been nailed to her side, on which was written in large letters, 'All vagrants and beggars will be dealt with according to law.' The tree seemed to have felt the disgrace, for even then some of the top branches had withered . . . In another year one half became paralyzed, and not long after the other shared the same fate, and this beautiful creature was cut down to a stump, just high enough to hold the board." In Dedham Vale, the blasted and tortured tree to the left and the slender, though no less involuted, coulisse of trees on the right mimic and gesture in empathetic response to the "disgrace" of the figurative scene that they surround. Without literally bearing the cruel and demeaning signs of impoverished homelessness, the trees are made to suffer and feel for that which society cannot. Constable once admitted to loving trees more than people. And so his trees in Dedham Vale are burdened with a compassion for a human plight that the artist would otherwise seem predisposed to conceal or repress. Constable often spoke of equating nature with "moral feeling" and "moral awareness"; nature redresses, at least at the level of expressive sentiment and natural metaphor, the social ills of humanity, a strategy that conveniently insulates any moral conflict suggested by the presence of the vagrant figures from its more truly social origin.

The stylistic temper of *Dedham Vale* predicts the more foreboding and abstracting qualities of Constable's later art. The drastic mood-swing in Constable's work during the late 1820's toward a solemn and yet agitated expression of landscape is usually ascribed to his psychological despondency of mourning (his wife had died in late 1828), his ongoing professional estrangement from the artistic establishment (his belated election as a Royal Academician in 1829 did little to alleviate the resentment he felt toward the London artworld), and his social alienation from an agrarian setting that could no longer offer shelter from the divisive forces of political protest and class conflict (throughout the '20's Constable increasingly voiced unhappiness with the changing face of the social landscape of the countryside, culminating with his rare outburst of political paranoia over the national debate of the Great Reform Bill of 1831–2). The pretense to a descriptive naturalism gave way to a more urgently and vigorously executed painting style in which the effects of chiaroscuro and the tactile manipulation of pigment were both drastically deepened. Straying from the by now exhausted topography of the Stour Valley, the pictures broached more heroic and symbolic strains of ruin and storm imagery, as seen in the exhibition oil painting Hadleigh Castle, Mouth of the Thames—Morning After a Stormy Night (1829) and his watercolor Old Sarum (1832). Instead of the cultivated agrarian scenery that had dominated Constable's art, these works dwell on nature's blighting of human history, the ruined tower of Hadleigh Castle with its vertical wound of shadow answered by the diagonal shafts of sunlight flooding across the Thames estuary and the distant coastline. The sentinel-like ruin has its private and public connotations—a cathartic remnant of recollected desire and a feudal, and perhaps futile, reminder of an historical past when power and authority were more watchful and protective of England. Although the surface of the finished painting is not as anxiously marked as its large oil sketch, the animated rendering of forms, both inert and shifting in the moldering ruins and the scudding clouds, is taken to new extremes. In a letter of 1830, Constable even worried that his distinctive painting style had become too expressively mannered, "a species of self-worship," as he phrased it. The fluctuating visibility of nature in Hadleigh Castle conveys the mutable emotiveness of the picture, ranging from despairing to hopeful, from negational to exhilarated.

Similarly, the watercolor of *Old Sarum* speaks of both endurance and loss, the more programmatic aspect of the picture explicated in the accompanying text to the print in which Constable comments on the significant historical

5.11

3.12

3.12

associations of the vanished city: here, according to the artist, was the originary site of parliamentary law and feudal civil order, its monumental battlements reclaimed by the landscape only to serve eventually as the counterpastoral haunt of a solitary shepherd. Fearful of the assault on Tory Anglicanism signaled by the Reform Bill crisis and its democratizing mission for parliamentary reform, Constable sees the active ruination of the present-day government reflected in the abandoned ruin of the past. The desolate, twilit earthwork in Old Sarum—nature and history inextricably united—stands as a kind of retrospective prophecy of what can go wrong in even the most authoritative of times, its apt political contemporaneity recognized by the portraitist Thomas Lawrence, also President of the Royal Academy, who advised Constable to dedicate the plate to the House of Commons (the borough of Old Sarum was also notorious for the very political corruption that the Reform Bill proposed to remedy), an irony probably not appreciated by Constable during his time of political reaction. Toward the close of his career, Constable asserted that landscape was no longer only "the child of history"; his ruin images set out to elaborate this subsumption of history by landscape. The introspective, "egotistical" project of Constable's landscape painting, however, could not help but become implicated in and even disfigured by the fragmenting debates over the political and social destiny of nations.

VISIONARY LANDSCAPES OF PALMER AND MARTIN

For a far more exaggerated conception of the English Romantic landscape as an imaginative refuge from the social struggles of contemporary life, the work of Samuel Palmer (1805–81) is even more telling, though much less involving, than that of Constable. The son of a London antiquarian bookseller and Baptist lay preacher, Palmer fell under the influence of the elderly and neglected William Blake in 1823-24. Along with a small group of young, unknown watercolorists and engravers who declared themselves "the Ancients," Palmer lionized Blake and advanced his idea of art-making as mystical craft and spiritual vocation. Retreating to the village of Shoreham in Kent, this sect of artists transformed the specific locality of the countryside into otherworldly landscapes filtered through literary images of agrarian life from the Psalms and the Georgics of Virgil. Untrammeled by the naturalist scientism that Constable had pursued, Palmer subjected what he called "generic Nature" to an imaginative recasting; as he wrote, in a characteristically rapturous letter from Shoreham, of "midsummer scenes, as passed thro' the intense purifying separating transmuting heat of the soul's

infabulous alchymy." His compact tempera and watercolor panel A Hilly Scene (ca. 1826) is the outcome of one of these alchemical transmutations, the Shoreham landscape contracted into a prelapsarian vision of supernatural bounty that scorned the agricultural and technological improvements of modern farming. In Palmer's landscape, the dense harvest field threatens to overtake the cottages and village church; with its Gothic nave of framing trees and its symmetrical alignment of neatly quilted hillsides, the composition of nature adheres to a divine ordonnance that pretends to transcend mere human design. The sickle moon and evening star almost touch the nearby awning of foliage, the celestial realm magnified and brought close to earth. Although Blake was relatively uninterested in landscape painting (he once expressed admiration of some foliage sketches by Constable), the influence of his archaizing anti-illusionism is strongly felt in Palmer's Shoreham landscapes of the 1820's. The internal illumination of the tightly contoured landscape motifs, the opalescent and vibrant containment of every form, even the sexualized, anthropomorphic fecundity of the landscape—all show the imprint of Blake on Palmer's miniature abstractions of the natural world.

A landscape like A Hilly Scene is almost claustrophobic and exclusionist in its effect. Even though the beholder is invited to enter through the open gate to this Blakean "green and pleasant land," the path through the overscaled field of grain quickly narrows and is compressed by the suffocating richness of the landscape. While Palmer drew inspiration from Blake's visionary pastoralism, his own politics were closer to the self-interested conservatism of Constable than to the radical religious utopianism of his mentor. Just as Constable believed that the Reform Act would deliver governmental power to "the rabble and dregs of the people, and the devil's agents on earth," so Palmer, in an election pamphlet he wrote in 1832 addressing the recent rise of incendiary rural protest, warned of the political enfranchisement of "a crew of savages and a thoughtless rabble." If, in 1826, sequestered in Shoreham reading the scriptures, Palmer could write, "towards evening the dawning of some beautiful imaginings, and then some of those strong thoughts that push the mind ... on the right road to TRUTH," by 1832, the evenings were not so translucent and inspirational, as Palmer evoked the more ominous night vision of the reform movement: "Their optics are adapted to darkness. And it is now a very dark night in Europe. The radicals are elated." The concentrated fantasy of rural England secured by Palmer in paintings like A Hilly Scene would not endure much past the early 1830's; the atemporal and misleadingly benign landscapes that emerged from Palmer's condition of visionary blindness could no longer withstand the impact of the darker optic of social discord.

5.13 Samuel Palmer A Hilly Scene, ca. 1826. Watercolor, pen, and tempera, $8\frac{1}{8} \times 5\frac{1}{4}$ (20.6 × 13.3)

5.14 JOHN MARTIN The Fall of Ninevah, 1829. Mezzotint, 36 × 263/4 (91.4 × 68)

The regressive intimacy of Palmer's landscapes plainly sought to forestall the social dissidence of life and culture in early nineteenth-century England. The very antithesis to Palmer may be found in the work of the apocalyptic landscapist whose paintings and prints were an unavoidably popular sensation in post-Waterloo England, John Martin (1789-1854). Specializing in historical and poetical landscapes, most often of biblical and Miltonic scenes of cataclysm and destruction, Martin closed the gap between the high art of academic landscape painting and the popular culture of the theatrical nature spectacle. Highminded artists and critics saw his art as vulgar and unrespectable, William Hazlitt, for example, declaring that Martin's work, "has no notion of moral principles . . . [with] this craving after morbid affectation." Constable resentfully belittled Martin's enormous success, and the literary and fine arts press alternately judged his art to be the divine emanations of an untutored genius (Martin's training was as a coach and china painter) or the cheap tricks of a crowd-pleasing entrepreneur (his works were widely replicated both in prints and in dioramas and stage sets). Although the narrative content of his art was drawn from the ancient history of eastern empires

and the spiritual prehistory of humanity as described by Milton, Martin's images were nevertheless supremely modern in character, transposing the social and environmental crises of industrial Britain into primeval and antiquarian arenas of cultural fantasy. As the historian Jules Michelet noted in his journal after arriving in England in 1834, "Bentham, Malthus, and Martin are the true expression of Great Britain: the self-interest, the crowds, the stifling population." Both the appeal and the affront of Martin's art lay in its sublime sublimation of the impact of industrial capital and rampant urbanism into imagery of omnipotent and catastrophic acts of nature and divine justice visited upon long-vanished empires, as in his architectural extravaganza The Fall of Ninevah (1829), a mezzotint that Martin's deranged brother, Jonathan (incarcerated for an incendiary assault on York Minster), would knowingly rework as a vision of the conflagration of modern London. In Martin's popularizing historical landscapes, the tribulations of contemporary society (urban growth and its attendant problems of population and disease control as alluded to by Michelet) were displaced into the remotest epochs of sacred and natural history.

5.14

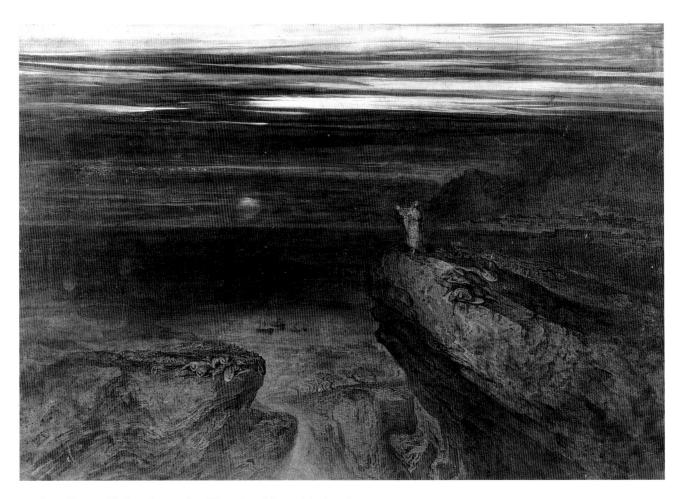

5.15 John Martin *The Last Man*, ca. 1832. Watercolor, $18\frac{3}{4} \times 27\frac{3}{4} (47.6 \times 74)$

One of Martin's more quiescent and reflective landscapes, though no less concerned with abject destruction at the edge of history, was his watercolor The Last Man (ca. 1832). Martin was responding to the literary vogue for this dystopian theme in Romantic poetry and fiction: Byron's "Darkness" (1816), Mary Shelley's novel The Last Man (1826), and Thomas Campbell's poem of the same title and date were his sources. Like latter-day science fiction that envisions the ravaging of the earth and civilization by plagues and ecological disasters, this early nineteenth-century topos of the last man bearing witness to the end of historical time and the death of nature played upon all of the social anxieties of the period. It also supplied the Romantic landscapist with the ne plus ultra in ruin imagery; the last man, after all, had the tragic pleasure of surveying global ruin, as Mary Shelley's protagonist explained: "Time and experience have placed me on a height from which I can comprehend the past as a whole, and in this way I must describe it . . . The vast annihilation that has swallowed all things—the voiceless solitude of the once busy earth, the lonely state of singleness which hems me in, and mellowing the lurid tints of past anguish with poetic hues, I am able to escape by perceiving and reflecting back the grouping and combined colouring of the past." Martin's watercolor also tints and glazes in this eerie combination of the lurid and the poetical: the miasmic streaks of color washed across the sky, obscuring the pallid sun and pressing down on the parched terrain, the atmosphere itself appearing like the strata of the earth. Deep shadows bleed back into the distance of the mountain and harbor view, the depopulated remains of the architectural landscape receding into the darkness. In the foreground, enormous rock spurs jut over the wasteland, broken by the flowing gorges in the terrain, suspending the viewer over what Campbell referred to in his "Last Man" poem as "the gulf of time." The abyssal depth of these chasms signifies a rupture in time, a visual trope for the proleptic accomplishment of the scene before us. The isolated figure of the last man on the promontory is vaguely Christ-like, though divested of any redemptive promise; he offers this glimpse into the future as a cautionary object of fateful instruction, addressing the viewer with a rhetorical gesture of lamentation. In the depiction of the prominent geological fragments, Martin suggests the petrified movement of earth history, the flow of time embedded in the landscape. Etched into the surface of the earth are waves of human corpses, their skeletal outlines already swept up into the geological current. The natural world services civilization for one last time, as the mass grave of human history.

Despite the fantastical nature of this and other pictures by Martin, the artist was also preoccupied with different branches of scientific inquiry, especially hydraulic engineering and paleontology. Martin invested the fortune amassed from the sale of prints after his epic landscapes and architectural vistas in utopian (and money-losing) schemes for renovating the Thames embankment in London, consolidating the city sewage system and purifying the water supply. These efforts in futuristic urban reform were counterbalanced by his work as an illustrator of natural history, particularly his imaginative reconstructions of extinct dinosaur species based on fossil remains. In The Last Man, the stilled waters and abandoned maritime city warn of the contemporary failure to solve the industrial/urban dilemmas of modern England. And when the viewer looks at the profile of projecting rockfaces in Martin's watercolor, the geology assumes a monstrous aspect, as though the gigantic mold of reptilian creatures can be seen reemerging at the end of human history. Prehistory reawakens underfoot at the closure of time, the first and the last bound together in this geological landscape of historical extinction.

TURNER'S MEANINGFUL OBSCURITY

Whether contrastively embodied in Constable's georgic naturalism or in Martin's science fantasy, Romantic landscape painting in England was being developed as an artform of historical reflection. No artist was more deeply involved in this enterprise of advancing the expressive and stylistic range of landscape painting than J. M. W. Turner (1775–1851), the chief rival to both Constable and Martin. Although it was the evangelical Ruskin who most enthusiastically defended and defined the significance of Turner's incomparable contribution to nineteenth-century landscape painting, something of the profound difficulty and internal contradictions of Turner's art are best summarized in an appreciation written by the French philosopher and art theorist Hippolyte Taine in 1862. He immediately alighted upon Turner's dual attachment to discursive meaning and disorienting sensation in his depiction of landscape, especially in the artist's late works:

By degree the sensation of the eye, the optical effect, appeared to Turner of secondary importance; the emotions and reveries of the speculative and reasoning brain obtained the empire over him. He felt a wish to paint gigantic and philosophic and humanitarian epics . . . His

works compose an extraordinary jumble, a wonderful litter in which shapes of every kind are buried. Place a man in a fog, in the midst of a storm, the sun in his eyes, and his head swimming, and depict if you can, his impressions upon canvas—these are the gloomy visions, the vagueness, the delirium of an imagination such as Turner's.

To elevate and make more complex the signifying and narrative possibilities of landscape painting, and yet also to arrive at a new artistic visuality that would transmit the heightened sensory experience of the Xux of nature: these two seemingly contrary impulses perpetually inform and challenge one another in Turner's art. Turner's landscapes are rarely explicit, in either outward description of natural eVect or didactic iconography. The ambiguity of perception and imagination is openly registered and experienced in his landscapes, an ambiguity that simultaneously makes visible and obscures the human instrumentality of the natural world that is so often at the center of his art. At all levels, Turner's art implies at once an alienating submission to and a prideful overcoming of the forces of nature: the landscape presents nature as a relentlessly animate power that threatens to subsume human purpose and yet that also reXects and determines the historical ambitions of society and civilization. Commenting on the larger social and epistemic shift that underlies Turner's atmospheric and energized vision of nature, his Wnest modern biographer, Jack Lindsay, has written: "The sense of deepened alienation from nature [in Turner] at the moment of increased mastery links in the social and economic spheres with the advent of the Wrst phases of industrialism and the mechanistic science which it needs, the Wrst phases of expropriation of the peasantry on a large scale, and the swelling of the cities with crowds of workless labourers."

Although his artistic career began as a topographic watercolorist in the same circle as Girtin, with whom he worked at Dr. Monro's, Turner soon after 1800 began to produce ambitious exhibition landscapes in oil that encompassed grandiose historical themes, ancient and modern. Unlike Constable, who pointedly tried to screen out art traditions from his evolving naturalist landscapes (excepting the work of those Dutch seventeenth-century painters whom he admiringly dubbed "a stay-at-home people"), Turner ranged far and wide across the history of art, carrying on painting competitions with the earlier landscape art of Claude, Rembrandt, Poussin, Watteau, Canaletto, and others. Rather than cultivating an imitative electicism, this study only strengthened the visual breadth and experimental adventurousness of his landscape painting. An indefatigable traveler with an encyclopedic interest in poetry and the sciences (from optics to geology), Turner constantly required the stimulation

5.16

of seeing the natural world under changing conditions, always bringing associative forms of knowledge to his interpretation of nature. Shunned by some patrons and members of the Royal Academy because of his lower-class Cockney manners, Turner nevertheless mancuvered through the academic and commercial art worlds with great success, garnering collectors from across the social and political spectrum, and merchandizing his art assiduously through his own private gallery and through the distribution of engraved reproductions.

Even as early as the period of the Napoleonic Wars, Turner's penchant for atmospheric obscurity, what Hazlitt described as "abstractions of aerial perspective," was inseparable from the thematic program of the landscape imagery he was treating. For his exhibition picture London (1809), Turner appended his own poetic passage to the title of the painting, the verses directing the spectator's attention away from the pastoral foreground, even beyond the Greenwich Naval Hospital in the middle distance, to the far-off cityscape crowned by the dome of St. Paul's. Emulating the eighteenthcentury nature poetry of James Thomson, the artist's literary tag brought a moralizing subtext to the painting: "Where burthen'd Thames reflects the crowded sail,/ Commercial care and busy toil prevail,/ Whose murky veil, aspiring to the skies,/ Obscures thy beauty, and thy form denies,/ Save where thy spires pierce the doubtful air, / As gleams of hope amidst a world of care." Although the landscape distances the urban turmoil of London, the poetry reminds the viewer of the churning life that is embroiled within the city's atmosphere spreading across the horizon. The relative calm that initially seems to pervade the mood of the painting is subverted by the poetic language with its invocation of doubt, toil, obscurity, and the denial of form, language that encapsulates the predominant themes and visual properties of so much of Turner's art. London is also a nationalist statement about the flourishing of the capital, its dynamic and yet grinding commercial life that proceeds apace even in the midst of wartime. The form-denying atmosphere of doubt introduced here in its modern urban incarnation would also reappear with far greater intensity as a natural cataclysm enveloping the illfated historical exploits of humanity. If Turner's London attests to the survival of England, his breakthrough historical landscape, Snow Storm: Hannibal and His Army Crossing the Alps (1812), is more decisively crisis-ridden about the future of the nation and a Napoleonic Europe. Obsessed throughout his life with the Punic Wars and the suggestive analogy he could sketch out between the vanished maritime empire of Carthage and the modern maritime empire of Britain, Turner here depicts the alpine passage of Hannibal's army into Italy, a legendary strategic invasion that nonetheless ended in defeat. In this instance, the Carthaginian invaders are more probably Napoleonic than John Bullish, though Turner was not anxious to restrict or delimit the contemporary allusiveness of the historic episode. Once again, his poetic adjunct to the picture, cited in his exhibition catalog as an extract from the painter's unfinished epic poem "The Fallacies of Hope," moralizes over the narrative scene of Hannibal's army plundering the alpine villages as they make their way to the plains of Italy where the military campaign will finally falter. This senseless surplus of human violence, most visible in the figurative action along the foreground ridge of the landscape, is answered by the natural violence of the elements that Turner has so grandly orchestrated. The signal devices of a sublime landscape style inaugurated here—the overcast and ominous sun disk, the parabolic gyres of atmosphere and light, and the visual continuity created between the cavernous, storm-torn sky and the massive reaches of alpine geology would recur throughout Turner's art. The painting's transgression of narrative and compositional legibility (reducing the heroic protagonist Hannibal to a speck atop a microscopic elephant barely visible on the far reaches of the valley floor, and creating a turbulent vacuum along the diagonal axis of the picture that basically evacuates the landscape of fixed, definable motifs) was noted by a bewildered Constable: "It is so ambiguous as to be scarcely intelligible in some parts (and those the principal), yet, as a whole, it is novel and affecting." The liberal journal of the period, *The Examiner*, went to the heart of the picture in observing, "the moral and physical elements are here in powerful unison." Perhaps so, but in having the crimes and hubris of human history assimilated into cyclical patterns of natural destruction, Turner absolves history of its possible moral lessons, as though to suggest that nature will always be there to sweep up after the tragic failure of human events.

TURNER'S LATER WORK

The convulsive turbulence of landscape and the moral and philosophical quandary about the meaning of history and progress would be fundamental to Turner's innovative art of the 1830's and '40's. As part of a series of watercolors for a set of engravings to be entitled Picturesque Views in England and Wales, Turner created some of his most probing landscapes of contemporary social observation. While encompassing many scenes of purely natural splendor, these watercolors also depicted detailed episodes from the political and economic life of the nation, at least as construed by Turner. The watercolor of Dudley, Worcestershire (ca. 1831-2) presents a nocturnal 5.18 view of a manufacturing town in the famous "Black Country," so-called because of its inordinate concentration of industrial activity and the resultant blighting of the surrounding landscape. In showing a canal approach to the manufacturing

5.16 Joseph Mallord William Turner $\it London,$ 1809. Oil on canvas, $35^{1/2} \times 47^{1/4}$ (90 × 120)

5.17 JOSEPH MALLORD WILLIAM TURNER Snow Storm: Hannibal and His Army Crossing the Alps, 1812. Oil on canvas, 57 × 93 (144.8 × 236.2)

heart of the community, with its array of blast furnaces, foundries, and steam boilers flanking the waterway into the town, Turner emphasizes both the production and distribution of industrial goods in modern England, while also alluding, not without irony, to his own earlier, Claudian harbor scenes of the rise and fall of the Carthaginian empire that he had exhibited as didactic historical landscapes in 1815 and 1817. Following in the tradition of late eighteenthcentury landscapists of industrial scenery whose work he admired, Joseph Wright of Derby and Philippe de Loutherbourg in particular, Turner has exploited the nocturnal drama of the incandescent factory landscape, in which the conflicting sources of artificial light seem to blaze forth with even greater intensity as if to overcome the quiet of the night that might otherwise be expected. With its broad washes of deep blue and luminous orange-red, Turner's watercolor sets up a chromatic opposition in the very temperature of color and the topographic features that these washes describe, the active fires of the architecture of industry set against the cool moisture of the night landscape, the crescent moon virtually resting on the crest of the hill above the restless town. The industrial landscape has transcended the diurnal cycles of nature, the economic demand for constant productivity separating the timetables of factory life from the temporal patterns of the natural world (travel books of the period often remarked on the ceaseless human activity in these night landscapes of the industrial districts and their almost otherworldly appearance).

To appreciate this modern landscape as an historical landscape, Turner silhouettes the castle and priory ruins and an adjacent church steeple on the hillside that embraces the industrial fury down below, the more vaporous and insubstantial outlines of these medieval antiquities foiled against

the incisive and massive skyline of kilns, boilers, and smokestacks (signifying, one could be led to speculate, the passing of a civil and spiritual order with the coming of progress, a social rhetoric of contrasting historic epochs that would be employed by Thomas Carlyle and A. W. N. Pugin in their invective critiques of modern industrial life during the 1830's). But Turner's view also suggests that within the modern jumble of the industrial setting one finds a living ruin, a manufacturing landscape that is both productive and destructive. This site of historical contrasts was keenly observed by the engineer and inventor James Nasmyth when he recalled his 1830 tour of Dudley, commenting on the condition of the castle ruin:

Now it is abandoned by its owners, and surrounded by the Black Country. It is undermined by collieries and even penetrated by a canal. The castle walls sometimes tremble when a blast occurs in the bowels of the mountain beneath. Their melancholy grandeur is rendered all the more impressive by the coal and iron works with which they are surrounded—the olden type of building confronting the modern . . . I sat down on the elevated part of the ruins, and looking down upon the extensive district, with its roaring and blazing furnaces, the smoke of which blackened the country as far as the eye could reach . . . and I thought of the price we pay for our vaunted supremacy in the manufacture of iron.

Without insisting on the conveyance of such sentiments, Turner's picture nevertheless elicits similar reflections. Admittedly, the artist has not stationed himself on the heights of the historical past, like Nasmyth and Martin's last man, but

5.18 JOSEPH MALLORD WILLIAM TURNER Dudley, Worcestershire, ca. 1831–2. Watercolor, $11 \times 16\frac{1}{2} (27.9 \times 41.9)$

138 · ENGLISH ROMANTIC LANDSCAPE PAINTING

positions himself and us within the present-day experience of industry. And for Turner, his own mode of vision was itself a by-product of this technological conception of nature and temporality, an activated visual field of historically transitional viewpoints and occluded atmospheres in which past and present contest one another.

The late marines and landscapes of Turner, culminating with such extraordinarily radical paintings as Slavers Throwing Overboard the Dead and Dying-Typhoon Coming On (1840) and Rain, Steam, and Speed-The Great Western Railway (1844), strained the discursive and visual boundaries of landscape painting. In these works the dichotomy between signification and sensation in Turner's art, as recognized by Taine, was most strongly tested. In Slavers, Turner's lifelong passion for nautical disaster and blood-red sunsets found its perfect expression in a near contemporary subject of moral outrage and social conscience. Inspired by a late eighteenthcentury account of a slave ship that jettisoned its ailing human cargo at sea for the purpose of collecting insurance money (slavers could collect insurance only on those slaves "lost at sea," not those that died from neglect and disease), Turner once more pits the callous inhumanity of humanity against the vengeful moral authority of nature. Although the abolitionist movement in England had already succeeded on the domestic front, the colonialist slave trade still flourished (British vessels would patrol their waters for Spanish and French slavers), while Chartist agitators began making pointed parallels between the exploitation of child labor in industrial England and the slave-supported plantation system in the tropics and the Americas.

In Turner's painting, the turbulent ocean is already littered with the manacled bodies of the victims of the slave trade, their hands straining above the sea swells, responded to only by diving gulls and monstrous schools of fish that prey upon the human flesh. In the right foreground waves, Turner draws attention to the torments of a female slave, the treatment of the figure's swelling breast and belly and extended leg meant to appeal to the social and sexual prerogative entertained by the London viewer over these hapless victims, no matter the appropriate guilt and compassion that the painting was also meant to inspire through the inclusion of such horrific details. Like the grotesque, leering fish gathered round to feed upon the body of the slave (critics would compare the figurative elements in Turner's art to the mutational caricatures of Grandville), the viewer can both relish and be repulsed by the spectacle of death enacted in this animalistic, sensualized ocean. Ruskin even evoked the swelling movement of the sea in the picture as being "like the lifting of its [the ocean's] bosom by deep-drawn breath after the torture of the storm"; he displaces repressed sexual horror onto the tormented, maternal sea, perhaps an appropriate rhetorical move since in Turner's painting the body of the sea, and its fierce aquatic progeny, consumes the rejected body of humanity. The upended leg of this slave is echoed formally by the bowsprit of the slave ship in the distant waves, the vessel driven toward the fury of the oncoming typhoon (the wedge of gray-blue foaming mist and the wall of cloud to the left of the ship). Lampooned mercilessly in the contemporary press with a kind of nervously outrageous humor, the picture would gain its more sympathetic and compelling reading from Ruskin. His prose picture of Turner's *Slavers*, in *Modern Painters* (1843), is justifiably famous for its passionate interleaving of form and content, as in this oft-quoted passage:

Purple and blue, the lurid shadows of the hollow breakers are cast upon the mist of night, which gathers cold and low, advancing like the shadow of death upon the guilty ship as it labours amidst the lightning of the sea, its thin masts written upon the sky in lines of blood, girded with condemnation in that fearful hue which signs the sky with horror, and mixes its flaming flood with the sunlight, and cast far along the desolate heave of the sepulchral waves, incarnadines the multitudinous sea.

Allegorizing as he goes, Ruskin invests each phase describing an element of Turner's seascape with meaning and moral inflection, not that he is very interested in expressing empathy for the disturbing human content of the picture. Blood, death, and guilt are finally part of nature as refracted through Turner's omniscient mastery of the seascape (and Ruskin's secondary mastery of those effects through language). The social and economic conditions that provided the theme of the painting are not Ruskin's real concern. He sees the desperate hands and limbs of the victims only through the gesturing of the waves and the mists, the slaves already dismembered and disembodied, haunting and enveloping the vessel as "ghastly shadow." To Ruskin, the blood-stained sun that splinters the sky and sea, thickening and staining the very pigment of the canvas, effectively takes up the slack for humanity, answering for its profit-driven amorality only with further violence, solemn and frenzied all at once. The retributive function of nature in Slavers has an almost nihilistic futility to it, an idea articulated as well in Turner's verse fragment appended to the picture's title, which closes with the hopeless question, "Hope, Hope, fallacious Hope!/ Where is thy market now?"

This ironical and disjunctive refusal to market hope, to locate fixed meanings or to find moral certitudes within the often destructive dialectic of nature and society, is also evident in Turner's greatest technological landscape, *Rain, Steam, and Speed.* Depicting an engineering wonder of the 1840's, Brunel's Great Western Railway, specifically one of the rail

5.20

5.19 JOSEPH MALLORD WILLIAM TURNER Slavers Throwing Overboard the Dead and Dying—Typhoon Coming On, 1840. Oil on canvas, 35% × 54% (91 × 138)

system's new bridges traversing the Thames Valley at Maidenhead, the painting establishes a series of antitheses and correspondences between nature and technology. The topography of the landscape is obscured by the unsettled weather of streaking sun and showers, the commanding form of the railway viaduct imposing its linear geometry upon the once picturesque terrain. With scumbled pigment on the front of its engine car, the train bears down upon its perspectival path with a manic velocity (or at least an illusion of such is given), the coaches of the train rendered as a compressed blur rapidly receding into the mist. Despite the expansiveness of the vista and the plunging spatial depth of the rail trestle, the painting still draws the eye to the surface of the canvas, to its rich textures of pigment with luminous transparencies set opposite deep passages of shadow. The steam engine that now propels this train through the swirling landscape may be taken as a technical model, maybe even a scientific allegory, of natural

power, in which fire, water, and mist are recombined to produce locomotive power. While the dark and pronounced forms of the railway isolate it from the fluctuating, atmospheric realm of nature, Turner's painting also shows how this blurring of sight, this animation of space and time, is the result of a new mode of perception facilitated by the motive and propulsive energy of the train. Through the visual metaphor of Turner's artistic medium, nature and machine are strangely analogized.

Within its sweeping effects of light and mist and the insistent dissolution of its forms, the picture veils small representational signs that call into question the historical status of the railway and its technology of travel. A rowboat is seen drifting in the river; a plowman is just visible to the right of the train bridge; and on the bridge itself, a coursing hare outdashes the oncoming train. These may appear to be like comic sleights of hand and eye; but in part because of their

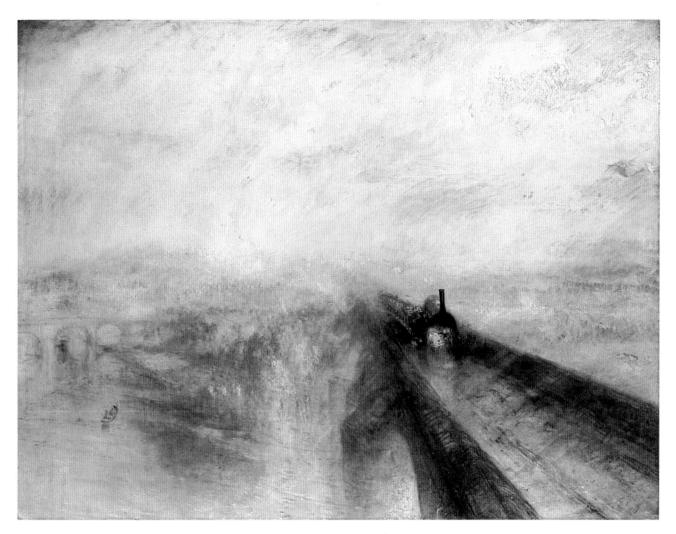

5.20 JOSEPH MALLORD WILLIAM TURNER Rain, Steam, and Speed—The Great Western Railway, 1844. Oil on canvas, 35% × 48 (91 × 122)

graphic fragility and visual tentativeness, these wry pictographs recollect the preindustrial human relations to the natural world, undisruptive and almost passing unnoticed within the technological landscape. Concerned with the mutable fabric of being and being seen, these stray signs reward the viewer with another fallacy of hope: that one should look all the more intently at the landscape when social and industrial change is about to overtake it.

Ruskin did not want to think about this painting; it only showed what a great artist could do with a degraded subject. The critic and novelist W. M. Thackeray, after humorously recommending that the spectator look quickly at the picture before the train vanishes, concluded, "The world has never

seen anything like this picture." The Impressionists later guaranteed that the world would see many more of its kind. Turner's *Rain, Steam, and Speed* remains a thoroughly Ruskinian painting in its exploration of the "landscape instinct" and the social imperatives that accompanied and formed it. The Romantic modernity of the picture resides in its contradictory accommodation of "progress and decline" (Ruskin's phrase) that was to be the most representative aspect of the nineteenth-century cultural effort to historicize nature and to socialize the landscape. As the twentieth-century critical theorist Theodor Adorno has observed, almost in an updated spirit of Ruskin's earlier social philosophy of landscape, "In every perception of nature there is actually present the whole of society."

. 6 .

LANDSCAPE ART AND ROMANTIC NATIONALISM IN GERMANY AND AMERICA

BRIAN LUKACHER

RUNGE'S NEW AGE

THE DISTINCTIVE CAPACITY OF LANDSCAPE PAINTING L to enfold contradictory ideologies about national and cultural identities during the first half of the nineteenth century was especially significant for the development of Romantic art in Germany and America. The promise of landscape painting as the defining genre of artistic renewal around 1800 was proclaimed most insistently by the German painter and art theorist Philipp Otto Runge (1777–1810). Writing in 1802 of the moribund condition of modern religious and historical art, Runge anticipated "the time . . . when a beautiful art could rise again, and it would be landscape painting." This rhetoric of regeneration and rebirth around the ideal of "Landschafterey" (as Runge coined it) spoke not only to the inner creative and spiritual life of the artist but also to the political dream of the national consolidation of the disparate German states. For Runge and his fellow German Romantics, landscape painting was the art of the future, through which a rejuvenated and unified German nation could express both its sense of heritage and its sense of destiny. Espousing a mystical pantheism that entailed an often ethereal and symbolic conception of nature, the German Romantics (artistic and literary) theorized their relation to the natural world in terms of rapturous, subjective reflection and yearning, unfulfilled self-expression. Simultaneously, the experience and representation of landscape for Runge and his compatriots also served as a nationalistic fulcrum of collective hope for political and spiritual unity, especially in the wake of the Napoleonic invasion of the German states that coincided with and profoundly affected the creation of some of the most important landscape paintings of the German Romantic movement.

It has often been observed that despite Runge's proselytizing about the virtues of landscape art, his own artistic practise revealed little conventional adherence to landscape painting. The majority of his art was figurative and rendered in a schematically linear style very reminiscent of the abstracted classicism of John Flaxman's illustrated work. Runge's first important commission was to produce illustrations for a new German edition of the Ossianic saga, which had enjoyed widespread popularity throughout Europe. When the poems of Ossian were first translated into German in 1768, the Sturm und Drang philosopher of history, J. G. Herder, acclaimed the primitive purity of the poetry, insisting that the modern reader could recover "the voice of nature" in the heroic tales of the ancient bard. Even more importantly, the epic verse of Ossian belonged to a uniquely Northern European cultural heritage.

Runge responded enthusiastically to the purported primitivism and evocative natural metaphors of Ossianic poetry. His 1804 outline drawing of Fingal with Raised Spear portrays Ossian's warrior father as a titanic figure who both dominates and embodies the world of nature. With his commanding stride, Fingal appears to dwarf the coastal landscape in the background, while deer are seen scattering across his path into the rugged ravines of the foreground. The emanating pattern of the sun disc behind the figure doubles as an emblematic shield for the hero—appropriately so, as Fingal's ferocity in battle is persistently compared to the searing beams of the sun throughout Ossian's account of his father's warring exploits. In its suggestion of the synchronicity of solar and superhuman heroic power, as well as its simplified and hieratic conjunction of figure and landscape, Runge's drawing of Fingal may well remind one of Blake's revolutionary

1.2€

0.2

4.1 icon Albion Rose. Although unaware of each other's work, Runge and Blake shared an affinity for mythopoeic theories of human culture, and both strove toward the discovery of a divinely communicative art that would combine the primeval and the apocalyptic.

For the duration of his brief career, cut short by an early death from consumption, Runge sought to realize his new conception of landscape painting through his ambitious project known as the Tageszeiten (Times of Day). This ensemble of designs presented an allegorical treatment of the temporal cycles of life that united the human and the natural, and the physical and the spiritual. Iconic arrangements of floral symbols and allegorical figures (primarily infants and maternal types) were characteristic of the Tageszeiten, as in the engraving of Night (1805), in which the botanical and figurative elements are orchestrated into a crisp diagram of mystical harmony. Runge had a Linnaean mastery of botany, but his obsession with floral motifs was at once metaphysical and sentimental. "People would see themselves and all their passions and feelings in all flowers and plants and in all natural phenomena," he wrote to the Romantic author Ludwig Tieck, while explaining his expanded view of landscape painting. He referred to "the arabesque" and "the hieroglyphic" in justifying the decorative interlace and semiotic complexity of the Tageszeiten.

The exhilarating pantheism of the *Tageszeiten* (which also permeates Runge's loquacious writing about art, nature, and humanity) distinguishes this pictorial essay on temporality from that of his near contemporary, the Danish-German artist Asmus Jakob Carstens (1754–98), whose brooding drawing of *Night and her Children* (1795) was representative of the most experimental neoclassical trends in Northern

6.1 ASMUS JAKOB CARSTENS Night and her Children, 1795. Chalk and pencil drawing, $29\% \times 38\% (74.5 \times 98.5)$

6.2 PHILIPP OTTO RUNGE *Fingal with Raised Spear*, 1804. Pen drawing, $15\frac{1}{2} \times 9\frac{1}{2} (39.5 \times 24.2)$

6.3 PHILIPP OTTO RUNGE *Night*, 1805. Engraving, $28\frac{3}{8} \times 18\frac{7}{8}$ (72 × 48)

European art during this period. Carstens was admired by the vounger generation of German Romantics for his intellectual depth and artistic independence. His work consisted primarily of a series of Michelangelesque designs of theogonic subjects inspired by the writings of Plato and Hesiod. Night and her Children is a solemn image of the goddess of darkness surrounded by her destructive, despairing progeny. The weighty figures, both physically and allegorically, have an epic restraint even as their scale and arrangement threaten to strain the very boundaries of the drawing. As opposed to the flourishing upward movement of Runge's later design of Night, Carstens's composition evokes a subterranean feeling of oppressiveness and confinement. Its eloquence and profundity point to a condition of exhaustion—the exhaustion of an encumbered classical sublimity that Runge was anxious to overcome with the turning of the new century.

Runge's *Tageszeiten* aspired instead to a transcendent condition of art in which nature and humanity were to be registered as divine signatures, to borrow from the terminology of the seventeenth-century theosophist Jakob Böhme, who

inspired the artist and whose ideas were being revived in the *Natur-philosophie* of the Dresden Romantic circle with whom Runge was affiliated. Color theory and the properties of light became increasingly important to Runge's art as he sought to translate the linear simplicity of the *Tageszeiten* into a more fully pictorial medium, which resulted in the small painted version of *Morning* (1808).

While retaining the schematic symmetry and inset frame with borders of the engraved prototypes, the painting captures the sensate mysticism of light and its colorful reflections in depicting this landscape of a dewy meadow at dawn. The floral motifs and plant life remain emblematic and sacral in their presentation, though they are now integrated into the world of perception and its transient optical effects, with the outline of the celestial blue-white lily, for example, seen fading by gradations into the tinted dawn light. The figures in *Morning* reveal Runge's effort to formulate a new syncretic iconography out of multiple traditions: Germanic fairy folklore for the floral sylphs and *geister* (spirits), pagan mythology for the reigning presence of Aurora, and the Christian faith

6.5 PHILIPP OTTO RUNGE The Downfall of the Fatherland, 1809. Pen drawing, $13^{7/8} \times 9^{1/4} (35.4 \times 23.6)$

for the infant Christ borne from the fecund earth. Mythical and religious fragments are recombined, although from Runge's writings it is clear that his worldview and belief system was fundamentally Christian.

However, *Morning* defied conventional sectarian religious values by incorporating a range of mystical and scientific theories about the workings of what Runge called "the boundless creation that fills the universe." In the borders of *Morning*, botanical and cosmological motifs commingle: the tendrils and bulbs of flowers are made to seem interchangeable with eclipsed sun discs and galactic spirals, a demonstration of the dual infinities operating within the divine manifestations of the natural world. Initially Runge thought of the *Tageszeiten* as a charming and elevated form of interior decoration—cosmic and floral wallpaper to ease the educated soul into pantheistic reverie. Later, however, he imagined the project as a comprehensive synaesthetic device that would transform society, declaring it "an abstract, painted, fantastical-musical

poem with choruses, a composition with all three arts brought together, for which the art of architecture would have to realize a custom-made edifice." This musical temple of art devoted to, as Runge wrote in a letter to Goethe, "the firm belief in a certain spiritual union in all of the elements," anticipated the Wagnerian and Symbolist theory of the *Gesamtkunstwerk* (the total or complete work of art), through which the soul of the German nation would be brought into a state of exaltation.

The Tageszeiten as an artistic instrument for realizing national and spiritual union remained, of course, a visionary unexecuted scheme. Runge's highly conjectural theories of landscape painting and his natural philosophical esthetics inhibited the actual production and quality of his art. He often acknowledged the fancifully outlandish aspect of his own art theories and in doing so displayed an acute awareness of the destructive historical forces that made his dreams of a new landscape art all the more remote and unachievable. Runge nevertheless responded to the Napoleonic invasion of the Prussian and Swedish states with a powerful patriotic lament that was in stark contrast to the elated mysticism of the Tageszeiten: the 1809 drawing unambiguously entitled The Downfall of the Fatherland. Commissioned by Friedrich Perthes, Runge's patron and an important publisher for German Romantic literary circles, this illustration was designated to adorn the cover of a nationalist journal, The Fatherland Museum, but was suppressed as a consequence of the French occupation against which it was protesting. Here a peasant mother cultivates the land seeded with the corpse of her husband recently lost to war and invasion; a cupid has been reduced to an earthbound field-hand mournfully guiding the plow. An arbor of passion flowers and medieval arms with a Janus head trophy embellishes the border of the print. The style and medium of the proposed engraving was meant to evoke what Runge called "altdeutsch Kunst" (old German art), by which he meant the German tradition of late medieval and early Renaissance art that culminated in the work of Dürer. This illustration was to have had a distinctly national character both in terms of its political allegory and its visual idiom. Although the impasse or non-fulfillment of Runge's artistic mission may safely be ascribed to biographical and historical circumstance, it was Goethe who recognized that within Runge's radical re-definition of landscape art one could discern a saliently tragic paradox at the heart of the Romantic generation. As he remarked a year after Runge's death, with respect to the Tageszeiten, "It wants to embrace everything, and so loses itself in the elemental . . . if you stand on the brink of the abyss, you must either die or go mad; there is no grace."

The establishment of a self-consciously national character in German art during the Napoleonic Wars was most fundamental to a secessionist group of artists from the Vienna Academy of Fine Arts, known as the Lukasbund, or the Brethren of St. Luke. Spearheaded by two artists, Franz Pforr (1788–1812) and Friedrich Overbeck (1789–1869), this confraternity of artistic souls named their movement after the patron saint of the artists' guild during the medieval period, which is indicative of the profound nostalgia for the Middle Ages that permeated the artistic and social ideals of the Lukasbund. Pforr and Overbeck had been deeply impressed by the romanticized accounts of Dürer and Raphael in Wilhelm Wackenroder's preposterously titled book, The Heartfelt Effusions of an Art Loving Monk (1797), a volume that encouraged young artists to pursue a cloistered life of virtuous simplicity and to recover the spiritual and esthetic purity of "primitive" fifteenth-century painting, which was construed as belonging to the last phase of medieval culture. This concern with the purification of art and spirit and the return to a national Düreresque style was also evident, as we have seen, in Runge, despite his frequent warnings against the naïve emulation of past styles that are found in his opinions on art. Runge, too, had been inspired by Wackenroder's mixture of mystical nature-worship and national chauvinism. "Art should be named the flower of human feeling . . . rising from earth's various areas to heaven," Wackenroder wrote, as if predicting the iconography of the Tageszeiten. But some areas of the earth were plainly superior to others, as he exclaimed about the unique genius of Dürer: ". . . fate has bestowed to German soil a truly national painter."

The Lukasbund rejected modern, urbane notions of the artistic profession and its institutions and instead pursued a communal lifestyle in which the creation of art was at once an act of daily craft and of priestly devotion. Their vision of history was drastically selective, as Pforr complained that after the Middle Ages one found only "the grosser fruits of knowledge, prosperity, and property." The Enlightenment and the French Revolution might as well not have happened, judging from the intellectual persuasion of their writings. In 1809, the Lukasbund removed themselves to Rome, going from their French-occupied homeland to another part of the Napoleonic Empire, where they were granted permission to take up residence in a derelict monastery. The countercultural spirit of this anti-materialistic sect that sought to fuse art and life was recalled in the 1850's by the Italian art theorist Pietro Selvatico: "The guardians of the status quo laughed at the sight of these poor foreign pilgrims wandering through Rome, who, after having religiously gathered at the remnants of forgotten Christian art, retreated to an abandoned convent where they ate like anchorites and posed for each other as they had no means to pay for a model. Because of their long wavy hair, which they wore to their shoulders in the German fashion, they were derisively called *Nazarenes*."

Like Runge, Pforr's youthful experimentation as the leader of the Lukasbund was cut short by an early death in 1812, which brought the founding and most radical period of the movement to a sudden end. The self-fashioned archaism and transcriptive simplicity of the Lukasbund style is well represented by Pforr's Roman drawing The Virgin and the Demon (1810). Its linear precision and graphic subtlety betrayed two tendencies: to draw from nature in a nonformulaic technique while also simulating the detailed idiom of late fifteenth-century German and Italian prints. The drawing's subject matter of an equestrian maiden and knight vanquishing evil with demure reticence and chivalric composure is symptomatic of the chaste and yet fanciful idealism that Pforr associated with the medieval past. "My inclination tends towards the Middle Ages, when the dignity of man was still fully apparent," Pforr wrote, adding, "The spirit of these times is so beautiful and little used by artists. The fantastical is often interwoven with the real, seldom without a moral, and all is pervaded by a contemplative atmosphere."

Stranded in the disenchanted and unstable world of the nineteenth century, Pforr nursed an escapist vision of the Middle Ages in which the feudal and ecclesiastical authority of that epoch went unquestioned. His picture Count Rudolph of Hapsburg and the Priest (1809–10), inspired by a popular historical ballad of Friedrich Schiller, celebrated the unerring wisdom of the nobility in the Middle Ages and the subservience of worldly power to the spiritual mission of the Catholic church. In this poetical history painting, Count Rudolph, a progenitor of the Hapsburg dynasty, interrupts his hunting excursion to aid a priest whose journey on foot to a dying man's bedside has been made all the more difficult by having to ford a river. The aristocrat has dismounted to offer his horse to the priest while their two young assistants look on with expressions of humility and wonder at this gracious and serendipitous meeting between the representatives of court and church. Even the horse bows its head in meekness and respect.

The dominant palette of grays and greens emphasizes the characteristically German feature of the twilit forest land-scape setting. The figures are brought into a unified frontal plane that is compositionally integrated with this landscape backdrop (notice, for example, how the slope of the cliff on the left is continued by the outstretched arm of the page holding the lance and also how the head of Rudolph is seamlessly aligned with the tree trunk positioned somewhat awkwardly behind him in the center of the canvas). This

. .

6.8

planemetric treatment of space is anti-illusionistic as if to demonstrate the folk-like artlessness of the Lukasbund style. The medievalizing impulse for the Lukasbund was not satisfied merely by the period trappings of costume and narrative. Instead, an earlier mode of seeing and representing the world is repossessed or revisited, an act of historical imagination that sought to recover the perceptual purity of a time before, as Pforr put it, "our eyes were spoiled."

In crafting their utopian fictions of the medieval past, the Lukasbund pointedly turned away from the historical trials of their own epoch and even their own immediate environment. Overbeck's Portrait of Franz Pforr (1810) is a late Gothic/ early Flemish fantasy that bears little evidence of the lived Roman experiences of the Lukasbund. Overbeck presents the youthful figure of Pforr within a trompe l'oeil medieval window that opens up onto a domestic Gothic loggia, which in turn affords a partial view of a charming Northern European townscape. The artist is accompanied by an illproportioned cat (an animal often associated in emblem books with sight and vision) and by a devoted wife and Christian muse who is seen sewing while studiously attending to her bible lectern. Pforr wrote of craving a lifestyle in which a tranquil domesticity would naturally support and complement his artistic pursuits, and so Overbeck set about to visualize Pforr's idyll in this fanciful portrait. The porcelain brittleness and sharp contours of the figures and their environment once again functioned as signs of a national style. Even the colors of Pforr's blouse echoed those of the Prussian flag. The heimlich (familiar, redolent of home) mood of this painting, and its vision of the past as present, yields, however, to an eerie sense of pristine detachment and magical unreality. Overbeck includes in the window frame a symbolic motif of faith surmounting death—the cross atop a skull, a device that Pforr had designed as a logo for the Lukasbund that would, indeed, soon be stricken by mortality. Overbeck was devastated by Pforr's death in 1812, but a year later he converted to Catholicism and established himself as the preeminent mural and fresco painter of epic religious subjects in nineteenth-century Rome.

The Lukasbund exemplified the primary concepts of German romanticism that had been expostulated by Goethe and Hegel during this period: the indivisibility of form and meaning in the arts, the expression of national character, and the nostalgic reverence for the medieval past. But both Goethe and Hegel grew suspicious of revivalist impulses in art movements such as the Lukasbund. Regressing into quaint religiosity and historical fantasy was deemed anathema to the romantic spirit and imaginative freedom of the artist, as Hegel cautioned: "It is no help to the artist to adopt . . . past world-views, to propose to root himself firmly in one of these ways of looking at things, e.g. to turn Roman Catholic as in

6.6 Franz Pforr The Virgin and the Demon, 1810. Pencil drawing (destroyed)

6.7 FRIEDRICH OVERBECK Portrait of Franz Pforr, 1810. Oil on canvas, $24\frac{3}{8} \times 18\frac{1}{2}$ (62 × 47)

6.8 Franz Peorr *Count Rudolph of Hapsburg* and the Priest, 1809–10. Oil on canvas, $17^{7/8} \times 21^{1/2}$ (45.5 × 54.5)

6.9 Caspar David Friedrich Monk by the Sea, 1809–10. Oil on canvas, $43\frac{1}{4} \times 67\frac{3}{8}$ (110 × 171)

6.10 CASPAR DAVID FRIEDRICH Abbey in the Oak Forest, 1809-10. Oil on canvas, $39\frac{1}{2} \times 67\frac{3}{2}$ (100.4 × 171)

6.11 CASPAR DAVID FRIEDRICH Large Enclosure near Dresden, 1832. Oil on canvas, 2878 × 403/8 (73.5 × 102.5)

6.10

recent times many have done for art's sake." The landscapist Caspar David Friedrich, whose work will be examined next, was much more prosaic and decisive in expressing his distaste for the arch primitivism of the Lukasbund. As he claimed: "What our ancestors did in childlike simplicity, we cannot do against our better knowledge. When grownups shit in the living room like infants, to prove their innocence and lack of guile, people will neither be convinced nor pleased."

FRIEDRICH AND THE MEDIATION OF LANDSCAPE

In 1810, Caspar David Friedrich (1774–1840) exhibited a landscape painting entitled Monk by the Sea at the Berlin Academy that startled and mystified its audience. One may say that, like the Lukasbund, Friedrich strove for the purification of art while avoiding the primitivist reversion to period styles that he and some of his contemporaries had denounced. Monk by the Sea was strikingly modern in its reductive pictorial means and in its disquieting ambiguity of sentiment and meaning. The painting announced what would become a hallmark of Friedrich's art: the subject of the isolated figure in the landscape, which implied a probing metaphysical reflection on the relation between humanity and the natural world. Although more outwardly descriptive of the natural world than those of Runge, Friedrich's landscapes also sought to go beyond the materiality of nature and to treat the topographic features of landscape in transcendent or immanent terms. As Friedrich commented on the theory of landscape: "Art stands as the mediator between nature and humanity. The original is too great and too sublime for the multitude to grasp." For Friedrich, this central task of "mediation" (a concept primary to the philosophical esthetics of the Jena Romantics) in the artistic rendering of nature inevitably led to the disturbing recognition of an unbridgeable gulf between nature and art, as well as that between mind and spirit, and even between subject and object. Friedrich's landscapes are often most compelling because of their knowingly acute failure to make visible a pure metaphysics of nature. With Monk by the Sea the effort to discover the numinous within nature, only to find absence and separation, was radically visualized.

Monk by the Sea did not come easily to its artist. The painting was altered a number of times before it assumed its austere final state. A heeling ship was removed from the coastal vista and the crepuscular lighting was adjusted. Despite its paucity of topographic features, the landscape was site specific and recognized as a portrayal of a stretch of coastline along the Isle of Rügen in the Baltic—a popular tourist spot that was often rendered in engravings and

panoramas during this period. In reducing the foreground strip of beach and the prospect of the sea to narrow bands stranded in the lower quadrant of the composition, Friedrich allowed an atmospheric void to subsume the canvas with only the geometry of the frame to delimit the dull monotony of the twilit sky. The diminutive figure of the Capuchin monk provides the only vertical accent in the picture. Scholars have detected in this figure the features of Friedrich himself while also associating the monk with the theologian and poet G. L. Kosegarten, a patron and colleague of Runge and Friedrich who was renowned for his outdoor "shore sermons" on Rügen. In reviewing the painting for a Berlin literary journal, the manic depressive poet Heinrich von Kleist noted "the truly Ossianic or Kosegarten effect" of Friedrich's picture, while likening the desolate landscape to the biblical apocalypse. Kleist was equally disturbed by the strange sensory assault of the landscape and the disorienting effect of its anti-picturesque composition: "when one studies it, it feels as if one's eyelids have been cut away."

Monk by the Sea had a symbolic pendant in the painting Abbey in the Oak Forest (1809–10). Like Runge, Friedrich often executed and exhibited his landscapes in thematically unified ensembles. In this picture one witnesses a funeral procession of monks amid a snow-covered graveyard, the earthbound religious ritual shrouded in a broad band of fog (the viewer perhaps led to assume that the brooding monk along the shore has now found peace in death). Only the ruined Gothic portal and the gesturing oaks ascend above the gloom into the atmospheric ellipse of twilit sky. Conforming to mimetic and organic theories of the origins of the Gothic style put forth by Goethe, Hegel, and others during this period, Friedrich's painting establishes a parallel between the religious edifice and the natural architecture of the heroic oaks, both types of monuments rooted to Germanic soil. The broken tracery of the Gothic window also echoes the crescent moon faintly visible in the sky above. The remnants of religious faith are thus reflected in the forms of nature, as though to offer spiritual solace from the ravages of temporal decay that otherwise come to determine the estranged mood of the painting. Unlike Monk by the Sea, with its scumbled, indefinite emptiness, Abbey in the Oak Forest is painted with an unerring linearity and its composition evinces stasis and the arrest of time. Friedrich was often attracted to the imagery of tombs, barrows, and commemorative monuments—his was more often than not a landscape of interment around which the atmosphere of mourning hung heavy. What was being interred, and mourned, was not only the corpse of, in this case, a brethren monk, but religion itself, with the sanctuary of God fallen into ruin. The funereal tone of Abbey in the Oak Forest also mourned the fading hope for a redeemed German nation: Friedrich was anxiously despondent, more so than

usual in light of his melancholy temperament, over the French occupation. And in later years his political disillusionment only worsened with respect to the suppression of liberal democracy in Germany after the fall of Napoleon.

The morbid romanticism of Friedrich's art circa 1810 elicited the attention and support of romantic literati and royal patrons alike. By the 1820's, however, his philosophically charged and searchingly introspective landscape paintings began to fall out of favor. While he maintained his commitment to what he called "the spiritual eye" and the allegorical intonations of landscape, Friedrich's later art was ostensibly more descriptive in manner and less tortured in mood. In his later landscapes depicting the outskirts of Dresden, Large Enclosure near Dresden (1832) and Hill and Ploughed Field near Dresden (1824-8), the topography is no longer bleakly sepulchral but rather has a benign and familiar aspect. Friedrich's preference for dawn and dusk—times of day in which nature and consciousness undergo subtle shifts in reflectivity—is sustained in these paintings. The landscapes show evidence of rural and urban life, but a contemplative calm prevails, in part a consequence of the notable absence of human figures. The flight of crows connects the foreground countryside to the distant cityscape in the latter picture, while the former contains an unmanned sailboat run aground with wind in its sail. These unobtrusive details allude to sentiments of neglect and futility that may be tellingly self-referential for the artist. The ritual of meditation before nature, which in Friedrich's art was usually dramatized through the inclusion of the figure in the landscape, is here incorporated into the very compositional and perceptual structure of these pictures. The curvilinear patterns of the terrain serve as projections of the viewer's scopic embrace of the landscapes: Nature has become a field of vision that contracts and dilates from a measurable topographic parcel to a

6.12 CASPAR DAVID FRIEDRICH Hill and Ploughed Field near Dresden, 1824–8. Oil on canvas, 8¾ × 12 (22.2 × 30.4)

global and even cosmic expanse. In *Large Enclosure*, the muddy bed of the river and its reservoir take on the appearance of continental landmasses and oceans as if observed from an omniscient perspective above the earth. Between these two pictures, Friedrich's disembodied viewer yearns to secure an unobstructed view of Dresden as a celestial city at dawn, and is elevated to an ocular satellite that transforms a swampy passage of land at twilight into a quietly breathtaking *Weltlandschaft* (world landscape).

Friedrich's approach to landscape art was profoundly deliberative and ruminative. The careful symmetry, linear precision, and recurrent and restrictive color schemes of his landscapes spoke of his discerning mastery of the natural world within an esthetic system, thereby demonstrating his mediation of nature and what lay beyond its external semblance as understood and conveyed through the acts of seeing and painting. But this calculated mastery of landscape ceded to metaphysical perplexity over the intersecting realms of the natural and the spiritual. The French sculptor David d'Angers famously remarked that Friedrich seized on "the tragedy of landscape," alluding to the reverential submission and unfulfilled transcendence of humanity before nature that was hauntingly suggested by Friedrich's art. In refusing to submit to the rising demands of a naturalist esthetic in nineteenth-century landscape painting, Friedrich treated the natural world as an otherworldly cipher that simultaneously inspired and confounded the claims of empirical knowledge and philosophical reflection.

PROGRESS AND ITS DISCONTENTS: THOMAS COLE AND THE AMERICAN LANDSCAPE

In American art of the late eighteenth and early nineteenth centuries, landscape painting superceded the traditions of history painting without much of a struggle. To American patrons and audiences, grand manner painting was deemed tainted by European associations of refined luxury, gross sensuality, and Catholic idolatry. The London studio of the expatriate American artist Benjamin West provided sanctuary for young American students who chose to venture into the often unrewarding (artistically and financially) field of history painting. Modern historical art executed in the name of patriotism also had its practitioners in the United States, though the feckless politics of such commissions tended to jeopardize the careers of artists who wished to memorialize the history of the young republic in paint. Many commentators from this period observed that the American nation held little interest in cultivating a sense of historical consciousness, and even less of historical conscience. As a character in James Fenimore

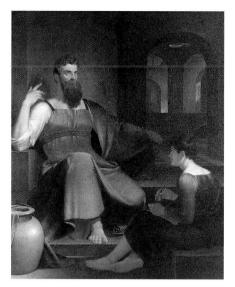

6.13 JOHN VANDERLYN Marius Amidst the Ruins of Carthage, 1807. Oil on canvas, 87 × 68% (221 × 173)

6.14 WASHINGTON ALLSTON Jeremiah Dictating His Prophecy of the Destruction of Jerusalem to Baruch the Scribe, 1820. Oil on canvas, 893/8 × 743/4 (227 × 189.9)

Cooper's novel *Home as Found* (1838) boasted, "in the way of history, one meets with but few incumbrances in this country. A nation is much to be pitied that is weighed down by the past in this manner, since its industry and enterprise are constantly impeded by obstacles that grow out of its recollections."

In 1814, two of America's most promising history painters, John Vanderlyn (1775–1852) and Washington Allston (1779–1843), were living and painting abroad: Vanderlyn in Paris and Allston in London. Both were planning for their eventual return to America in the hopes of establishing their elevated pursuit of history painting. Writing to Allston, Vanderlyn complained of the commercial transience of the work of art in modern exhibition culture. "It is almost inconceivable," he wrote, "how differently mankind see[s] in works of art particularly, and to what extent mode and fashion or prejudice regulates public taste, that this should be the case with respect to the capricious forms of a bonnet or a hat &c one can easily conceive, but that in the production of the pencil . . . they should differ so widely proves that mankind does not love and respect truth equally." The history painter's appeal to higher moral and esthetic truths in the absence of public consensus about the social mission of art led to frustration and disappointment for high-minded painters such as Allston and Vanderlyn. Although both found patronage and encouragement from prominent contemporaries (Vanderlyn from Napoleon and American Vice-President Aaron Burr, and Allston from Samuel Taylor Coleridge and elite Federalist Boston families), their careers as history painters in the United States were checkered at best.

The strained mixture of imperiousness and ponderousness found in both Vanderlyn's Marius Amidst the Ruins of Carthage (1807) and Allston's Jeremiah Dictating His Prophecy of the Destruction of Jerusalem to Baruch the Scribe (1820) appealed only to the most cultivated and Europeanized

of American tastes. Both paintings aspired toward Michelangelesque grandeur, but their exceedingly static compositions and their dour narrative subjects (a fallen classical warrior harboring revenge fantasies and an imprisoned Old Testament prophet foretelling the Babylonian sacking of Jerusalem) betray an ossified approach to the possibilities of figurative historical art. The strongest passages in these paintings are auxiliary compositional elements: the twilit landscape of ruins in the Vanderlyn and the atmospheric architectural vista (similar to contemporary domed interiors designed by John Soane and Benjamin Latrobe) in the Allston. Not surprisingly, Vanderlyn and Allston supplemented their practise of historical art by painting natural scenery, from panoramas to poetical landscapes.

The enterprising, expansionist culture of America was more receptive to landscape art, especially as its national identity was predicated in large part on the myth of the North American wilderness and its prospective settlement. William Cullen Bryant, the New York poet and promoter of the fine arts, asserted that the moral and religious authority of his country sprang from the incomparable beauty of its natural scenery. More pointedly, the social and economic growth of the United States was in direct relation to the unparalleled natural resources of its hitherto untouched landscapes. As an editorialist for The Knickerbocker wrote in 1835, "What an extent of territory we have yet to people. Our range of forest offers a home to the oppressed. The landscape has been bountiful in her gifts. Metallic ores abound in our mountains and beds of coals have opened their veins to our view, as if in anticipation of the immense destruction which future generations may effect in the pathless landscape." The byline of this editorial was "The Downfall of Nations," though the writer's comments suggest uncertainty as to whether this imminent sacrifice of nature would contribute to the rise or the decline of America.

6.13 6.14

The emergent school of landscape artists in the Hudson River Valley, centered around the English-born Thomas Cole (1801–48), often promulgated these cultural myths about the futurity of the nation and the primeval vastness of its wilderness. In his topographic landscape paintings of the Hudson Valley and the Catskill Mountains from the 1820's, Cole set out to develop the paradoxical notion of a wilderness esthetic in American landscape painting. His View of the Round-Top in the Catskill Mountains (1827) is dominated by the looming, shadowy form of the dramatic mountain range blanketed with dense forests, intimating an unspoiled stretch of landscape. The narrow foreground plateau of the picture is occupied by expressively frail and withered trees and the distinctive outcropping of a geological ruin. Although meant to signify a savage and untamed domain of nature, this area of the landscape also has manifold historical associations: it is distinctly patterned after the Italian landscape painting style of Salvator Rosa, thereby imparting a European artistic pedigree to the American topography. The altar-like formation of the

geology also alludes to the sanctified status of America as a new "Promised Land," a national landscape of Christian fulfillment. The biblical providence of the North American landscape, however, implies the eclipse of an indigenous Indian culture, and thus, this curious earth sculpture may also have been recognized as an Indian antiquity. Beginning with Thomas Jefferson, American antiquarians and natural historians were fascinated by the geological features and ancient lore of Indian tumuli and ritual stones. Even when exalting the incorrupt wilderness of the American landscape, Cole makes reference to the intersection of past and future civilizations. Beyond the sublime obscurity of the mountain range in this painting, the undulating ribbon of the Hudson River is visible in the distance, sunlit and with vessels on its calm waters. The ambivalent treatment of this scenery (beautiful and sublime, remote and accessible), along with the popular identification of Cole's art with this region, attests to the commercial and tourist appreciation of a changing landscape that could no longer sustain its own reputed status as a truly wilderness setting.

6.15 THOMAS COLE View of the Round-Top in the Catskill Mountains, 1827. Oil on canvas, 184 × 254 (47.6 × 64.1)

Cole's political anxiety over the populism of Jacksonian democracy and its expansionist rhetoric of unlimited national growth became increasingly apparent in the 1830's, both in his art and his writings. After a trip to Europe, Cole pursued what he called "a higher style of landscape," by which he meant historical and allegorical landscape painting in emulation of the contemporary pictures of Turner and Martin. Cole, too, wished to create a programmatic ensemble of landscapes that addressed philosophical and historical concerns that exceeded the limits of descriptive landscape art, and so in 1836 he completed his five-painting cycle entitled *The Course* of Empire for his New York City patron Luman Reed, a successful business man of the kind Cole often derided in his letters as "dollar-godded utilitarians." Despite-or more likely because of—his astute mercantilism, Reed showed exceptional patience in entertaining Cole's overweening ambition as an historical landscapist.

Charting the rise and fall of a civilization through five "states" within the same imaginary landscape setting, The Course of Empire interwove the temporal cycles of human and natural history. The series traced the barbaric hunting and gathering phase of earliest humanity through its pastoral, cultivated state and into civilization's seeming apogee as a Greco-Roman style empire of lavish splendor, succeeded,

predictably enough, by a scene of the once-flourishing architectural vista swept up in war and violence. The concluding picture of the cycle entitled *Desolation* envisioned 6. nature's inevitable reclamation of the landscape, the frailty of human culture epitomized by the vine-infested Corinthian column and the litter of marble that lies at its base. Even the pale moon with its less rigid column of reflected light shimmering in the stilled harbor seems to reprove the monumental remnants of civilization. Although intended to be a nocturne, the landscape retains a brilliant variety of color and animated brushwork, suggestive of the restorative power of nature in its quiet and gradual eclipse of human history. Influenced by cyclical theories of history popularized in a Jacobin treatise on the corruption of civilization and religion, Comte de Volney's widely-read The Ruins of Empire (1791), and also influenced by philosophical ruin meditations in Byronic verse, Cole's final painting of the series may be interpreted as an image not of melancholic despair, but of renewed promise.

The contemporary relevance of The Course of Empire was clarified by Cole's 1836 lecture published as "Essay on American Scenery." Here Cole distinguished the historical associations of European landscapes from those of America, which were praised for both their wild and Edenic aspects. Although free of "vestiges of antiquity," the American

6.16 THOMAS COLE The Course of Empire: Desolation, 1836. Oil on canvas, 391/4 × 631/4 (99.7 × 160.7)

6.17 ASHER B. DURAND Landscape, Progress, 1853. Oil on canvas, 48 × 72 (121.9 × 182.9)

landscape was fraught with anticipatory significance—of histories yet to unfold. And therein lies Cole's cause for concern. The Course of Empire implies that the cyclical pattern of history is a curse of European civilization that America could perhaps manage to forego. But in his "Essay," Cole lamented that the American landscape had already become susceptible to another pattern of desolation and destruction: "The most noble scenes are made desolate with a wantonness and barbarism scarcely credible in a civilized nation . . . desecrated by what is called improvement." The utilitarian domination of nature that was essential for American prosperity and growth is here decried by Cole for its uncivilized and degenerate character. Regretful over the widespread settlement of the wilderness and the spreading railway lines, he was nonetheless resigned that "such is the road society has to travel."

Cole's successors in American landscape painting openly contended with the visible signs and historical impact of technological progress and the ideology of Manifest Destiny, which gave theological and nationalistic sanction to the "civilizing" of the North American continent. Asher B. Durand (1796–1886), a friend and colleague of Cole, extolled the vanishing wilderness ("spared from the pollutions of civilization," he noted) while also painting an epic landscape entitled *Landscape*, *Progress (Advance of Civilization)* (1853) for the railway financier Charles Gould. This picture promotes a technological pastoralism, in which the broad prospect of an imaginary Hudson River landscape plays host

to the modern improvements that Cole had earlier disparaged: railway viaducts, telegraph poles, steamships, and new communities are safely nestled within the sweeping panorama of the glorious morning landscape. Viewed from a foreground precipice with blasted trees (and a back-lit Claudian coulisse thrown in for good measure), the landscape is observed by two Indians who look on, obviously not as the beneficiaries of American progress that the painting wishes to celebrate, but rather as its few surviving victims. These Indian figures are, quite literally, history, looking with wonder at the future that promises their extinction. Interestingly, the beholder's point of view is aligned with that of the Indians, so as to bring an alienated cultural perspective to this otherwise optimistic spectacle of national power and its imagined integration within the natural order. Durand's picture collapses the temporal stages of Cole's Course of Empire into a modern parable of technological determinism and nationalist selfassurance. As a contemporary reviewer exclaimed about the painting: "It tells an American story out of American facts, portrayed with true American feeling."

The finest technological landscape painting in nineteenth-century American art was George Inness's *The Lackamanna Valley* (1857). Recently returned from Italy and France, Inness (1825–94) produced a series of topographic landscapes for the Delaware, Lackawanna, and Western Railroad Companies, including one that recorded the newly built roundhouse on the outskirts of Scranton, Pennsylvania, a

6.18

6.21 GEORGE INNESS *The Lackawanna Valley*, 1857. Oil on canvas, $33^{7/8} \times 50^{1/4}$ (86 × 127.5)

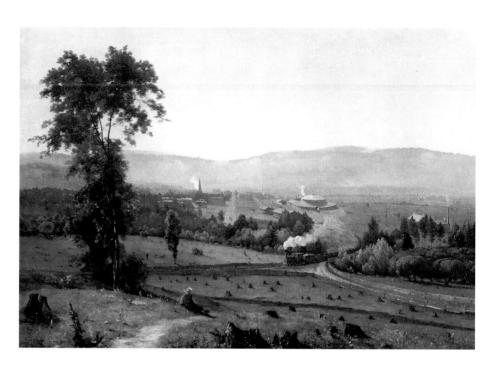

burgeoning mining town. Although similar to Durand's Progress, with its elevated viewpoint overlooking a morning landscape that yields to the arrival of the railroad, Inness's picture also has a visual immediacy and a fresh notational style influenced by the Barbizon school, whose work the artist had admired during his travels abroad. In the flowing horizontal massing of landscape elements and in its atmospheric vibrancy, this picture dispenses in large measure with the scenographic idiom of Hudson River School landscape painting. The perceptual liveliness of Inness's style is well-attuned to the confident faith in the technological improvements that the picture brightly announces. While Cole would have found only moral disgrace in the field of tree stumps along the sloping foreground of Lackawanna Valley, Inness brings a placid acceptance to his treatment of a landscape that is primed and ready for the assumption of the railroad. The reclining rustic figure in this foreground area of the picture is also made to seem unperturbed by the prospect of a gleaming roundhouse disgorging locomotives out onto the serpentine rail lines that reconfigure the natural scenery. Inness has created a kind of corporate landscape that harmonizes the rural and the industrial. Progress is not an historical passage, his painting wishes to assure the beholder: it is merely an endless morning.

TO SILENCE OR TO REVEAL NATURE'S ALLEGORY

For those mid-nineteenth-century American landscape painters classified as luminists (a modern art historical nomenclature), the natural world did not have to serve as a theater of historical change and national self-definition. John Kensett (1818-72) and Fitz Hugh Lane (1804-65) had their professional origins in printmaking and their art retained an adherence to a limner tradition in technique and style. Designated "luminists" because of the becalmed suffusion of light and reflection in their landscape art, Kensett and Lane often preferred painting on a smaller scale than had Cole and Durand, and the localities of their landscapes were more regionally focused and divested of the pressing national connotations of a wilderness esthetic. Lane's modest career and the selection of his landscape motifs restricted him to the harbors and coves of the Massachusetts and Maine coastlines. His professional insularity probably contributed to the subdued though concentrated intensity of his landscape art. In the case of Kensett, his early career involved close affiliations with the Hudson River School (he traveled to Europe with Durand in the 1840's) and his professional life was centered in New York City, where he enjoyed considerable prominence. During the 1860's, however, his art assumed a slightly formal hermeticism in its delineation of the natural beauty of the Adirondack scenery and the New England coast to which he often returned during summer painting excursions for inspiration.

Instead of the dramatic amplification of landscape imagery found in the Hudson River School, the art of Lane and Kensett dwelt on quiescent scenery relatively devoid of human incident. This minimizing of narrative content in their landscapes belied the subtle compositional control that they exerted over their pictures. Lane's Brace's Rock, Brace's Cove (1864) and Kensett's Lake George (1869) are both fixed on the preternatural tranquility of nature. The luminist landscape tends to say everything and nothing at once. These pictures are highly descriptive of the regional landscapes being surveyed—the topographic features and the surfaces of the natural world are meticulously differentiated without recourse to striking color contrasts or sparkling atmospheric flourishes. The land masses (whether thin, dark jetties or majestic mountains) form asymmetrical planes that punctuate the limpid expanses of water and sky. The play of reflections in these pictures has a lingering tangibility that intensifies the almost trance-like stillness of the compositions. Certainly the topography of Lane's depopulated cove appears forlorn and even banal in comparison to the scenic grandeur of the tourist stomping ground in Kensett's picture. But in both, the presentation of the natural world resists either picturesque or sublime enhancement. Human points of reference are not entirely suppressed: the dilapidated fishing boat in the foreground of Lane's painting and the canoeist in the middle distance of Kensett's remind one of the human encounter with the stunning indifference of nature.

Scholars of American art have proposed that there are affinities between American transcendentalist philosophy and the luminist vision of landscape. In both the writings of Ralph Waldo Emerson and the pictures of Fitz Hugh Lane, art historian Barbara Novak has argued, the focused observation of concrete specificities in the natural world facilitates a selfless union of the human mind with the spirit of the universe—a translucent exchange whereby the observer seizes on the externality of nature to discern the higher consciousness or divine agent that is both within and without. There is little historical evidence to support the ascription of a transcendentalist doctrine to the art of Lane and other luminists, though certainly Lane's remarkable ability to impart an alien beauty to the familiar forms of nature in his paintings strongly suggests a sensitivity to the metaphysical overtones of landscape art. In general, the luminist conception of landscape painting eschewed programmatic intentions. The prevailing cultural imperative to invest landscape with nationalistic import or religious-philosophic truth is largely repudiated in their work, which perhaps accounts for the aura of remoteness and detachment that is one of the hallmarks of luminist landscape art.

The nationalist rhetoric of American landscape art nevertheless continued to flourish throughout the nineteenth century. Frederic Edwin Church (1826–1900), the most prominent and accomplished of Cole's students, specialized in epic, exhibition-scale landscapes that were calculated to represent the inexorable bond between nation and nature in

America. Uniting a scientific naturalism and the pictorial theatricality of the sublime, Church's Twilight in the Wilderness (1860) was received as a quintessentially American landscape painting, in which the identity of the artist was thought to have merged with the will and spirit of a divine nature. While assiduously maintaining a clear-eyed empiricism in its description of atmosphere, foliage, and mountainous prospect, Church brings a sanctimonious awe to the presentation of nature. Critics of the day were divided over whether a numinous hush or an apocalyptic turbulence pervaded the landscape. As in luminist pictures, there is a contemplative extension of the act of observation in this painting, but the atmospheric drama of scarlet-tinged clouds, eerily reflected in the centrally receding river, activates the perspective and propels the eye into the far reaches of the vista and its glowing band of fading sunlight. Responding to the pristine surface and seamless naturalism of the painting, one contemporary reviewer noted "an absence of any signs of mood or manner." But as a loyal student of Cole, Church was committed to an allegorical conception of landscape painting, without resorting to the outmoded historical and poetical guises of a romantic landscape tradition. At first glance, Twilight in the Wilderness appears bereft of figurative and emblematic conceits. But Church does include a cruciform assemblage of branches poised at the end of a blasted tree trunk in the left foreground, the shape silhouetted against the reflective body of water. Divine providence both guards over and threatens the security of the breathtaking wilderness landscape. As if to invite the prepositional slippage in the painting's title, twilight of the wilderness, the landscape, at once transfixed and in dynamic flux, subverts the national mythology and religious promise of a wilderness esthetic that was its raison d'être.

Wishing to expand the geographic and natural historical scope of his landscape art, Church turned to tropical South American topography for the subjects of his monumental pictures, which were often staged and exhibited as exotic illusionistic displays intended to transport the spectator to paradisiacal and marvelous locales. The artist's increasingly global conception of nature was inspired in part by Alexander Humboldt's modestly titled natural history compendium Cosmos (1845–9), a book which also contained the first historical survey of landscape painting. Humboldt's treatise catalogued the infinite permutations of natural phenomena, while also proposing that a divine typology of natural order could be found within the manifold and variable conditions of the heavens and the earth. The South American landscapes of Church similarly embraced a panoply of scientific particularities out of which could be divined the providential operations of what Humboldt called "the Great Picture of Nature." Church's tremendous volcanic landscape

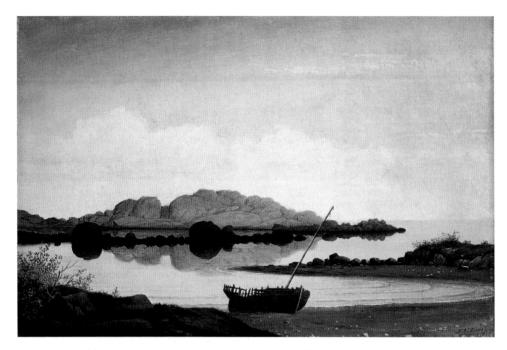

6.19 FITZ HUGH LANE *Brace's Rock, Brace's Cove*, 1864. Oil on canvas, 10 × 15 (25.4 × 38.1)

6.20 JOHN FREDERICK KENSETT *Lake George*, 1869. Oil on canvas, 44 × 66½ (111.7 × 168.9)

6.22 Cotopaxi (1862) contained an encyclopedic variety of natural elements within one tableau: the erupting volcano opposite a setting sun over a glassy lake, and dense jungle passages adjacent to torrential cascades and steep palisades. Despite the panoramic sweep of the vista, the eye gravitates toward the painting's vertical accents, seen, for example, in the explosive plume of sulfurous smoke that is answered by the cleansing waterfall beneath. Although ostensibly drawn from observations on the artist's recent travels in Ecuador, the imagery and compositional devices of Cotopaxi—the dynamic interplay of the geological and the celestial and the evacuated foreground space that leaves the beholder suspended over a void—owe more to the catastrophic landscapes of John Martin than to any on-site scientific investigations.

The diversified landscape of *Cotopaxi* invited an equally diverse range of interpretations. Its landscape was characterized as being both prelapsarian and eschatological. Church's

scientific and artistic embrace of South America served to extend the hemispheric ambitions of the doctrine of Manifest Destiny, as if to suggest that the American conquest of the wilderness required ever new horizons and even more primeval terrain. The landscape's symbolic contest between light and darkness, between purifying illumination and suffocating fumes, also alluded quite pointedly to the national conflict of the American Civil War. The destructive and transforming power of a remote volcanic landscape was thereby rendered more historical than natural historical. The christological sign formed by the pattern of blood-red sunlight, as first recognized by contemporary reviewers, took this landscape closer to the realms of religious vision and national allegory. The scientific naturalism of Church's landscapes could not be disassociated from the cultural and political resonance of the imagery of nature during this unprecedented period of historical uncertainty in the United States.

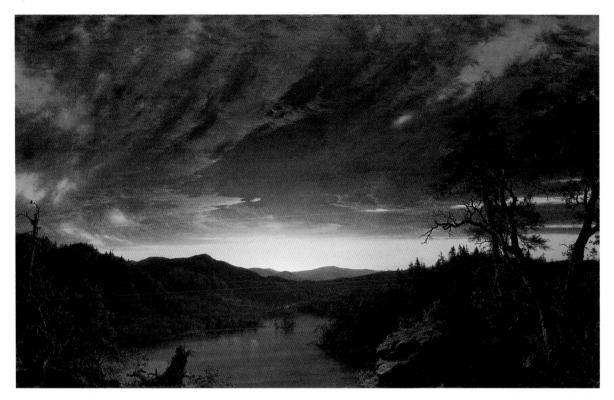

6.21 Frederic Edwin Church Twilight in the Wilderness, 1860. Oil on canvas, 40 × 64 (101.5 × 162.6)

6.22 Frederic Edwin Church Cotopaxi, 1862. Oil on canvas, 48×85 (121.9 × 215.9)

. 7 .

ARCHITECTURE UNSHACKLED, 1790–1851

BRIAN LUKACHER

A MODERN ENLIGHTENMENT

TN 1804, THE ENGLISH ARCHITECT GEORGE DANCE the Younger (1741–1825) passed an evening in conversation with the poet and metaphysician Samuel Taylor Coleridge, the art collector Sir George Beaumont, and other eminent guests. Nature, imagination, and apparitions were among the topics discussed. Dance, who later noted that he found the evening especially fatiguing, chimed in with some wide-ranging reflections on the question of architectural invention in modern times; his comments were recorded in the diary of another guest: "He [Dance] derided the prejudice of limiting Designs in Architecture within certain rules, which in fact though held out as laws had never been satisfactorily explained ... in his opinion Architecture unshackled would afford the greatest genius the greatest opportunities of producing the most powerful efforts of the human mind." The prevailing norms and principles of architectural design were not at all authoritative, Dance asserted, but rather were arbitrary and unproven. Moreover, architecture's innate adherence to a Classical tradition had to be overcome if its expansive potential was to be realized. Dance did not clarify what an architecture unshackled would look like. And it is unclear whether the powerful efforts of the human mind to which he referred dealt only with the realm of artistic invention or with the larger ambitions of an emerging commercial society and nation-state that was Great Britain. Despite the informality of Dance's remarks, they astutely announce the transformation of Western architectural practices and theories during the early nineteenth century, a period when the vast knowledge of a new scientific archaeology and a global multiplicity of past historical styles challenged and inspired architects; and when revolutions in social need and new technologies of living, especially in the realm of industry and

transportation, demanded architectural solutions that would eventually erode the authority of the Classical tradition.

Through the lens of twentieth-century architectural modernism, the architecture unshackled of 1800 is prophetic and predictive. Some of Dance's own experimental drawings, for example, show him defying the conventions of spatial enclosure and anticipating a modern "open plan" in a monumental domed interior. In a sheet from the early 1790s, either for the Bank of England or a mausoleum interior, the design departs entirely from ancient Roman and Byzantine prototypes in its seamless continuity of spatial containment and structural support. The piers are treated as pliant curving extensions of the hemisphere above, transforming the hallowed Classical paradigm of a pantheon into an elliptically arched globe that vitiates the tectonics of masonry support and pendentive vaulting. In a similar vein, Dance's follower Sir John Soane (1753–1837) created a proto-Bauhaus hanging glass curtain wall in a design for the side conservatory at his suburban Pitzhanger Manor in 1806-10. Without a semblance of traditional ornament, the geometric glazed screen comprises a modernist grid appended to the dressed stone and brick elevation of a Georgian Neoclassical villa. The German architect Friedrich Gilly (1772-1800), who proposed replanning an entrance plaza into Berlin as an epic Athenian agora, sketched a series of designs in the late 1790s for a monument to Frederick II, King of Prussia, reduced to massively denuded post and lintel elements that seem at once neolithic and space age. And finally the late eighteenth-century design for a Royal Library by the French architect and educator Etienne-Louis Boullée (1728-99) relied on the ancient prototypes of Roman thermal architecture, but its implied infinitude of scale and the redundant simplification of its Classical elements (the endless Ionic colonnades and the visual repetition of the coffered panels in its dramatically

7.1 GEORGE DANCE THE YOUNGER Preliminary design for an identified domed building (detail), ca. 1791

7.2 SIR JOHN SOANE Unexecuted design for alterations to the conservatory at Pitzhanger Manor (detail), 1806–10

7.3 FRIEDRICH GILLY Design for a monument to Frederick II, 1795-9

receding barrel vault) suggest a radical passage from Antiquity to futurity. As the critical theorist Walter Benjamin commented, "Boullée's conception of a library looks like a train station." All these examples of an architecture unshackled from around 1800 are of course graphic speculations—designs and proposals that were not realized, except to the degree to which they adumbrated the future development of architectural modernism.

These paper projects are admittedly exceptional rather than typical of the period. And Dance, Soane, Gilly, and Boullée undoubtedly thought of themselves as inheritors of the Greco-Roman tradition of monumental architecture. But their daring (and occasional) willingness to unburden themselves of this Classical pedigree—itself sanctioned by Enlightenment architectural proscriptions—foretold a modernism that would not be fully realized until the supremacy of an age of industry and mass production a century later. The purification of the Classical language of architecture had been at the center of the tendentious *Essay on Architecture* (1753) by the Jesuit *philosophe* Marc-Antoine Laugier (1710–69). Like Voltaire and Rousseau, Laugier equated ornamental refinement and the ostentatious blandishments of civilization with decadence and corruption. Translated into architectural terms, this meant that engaged columns, blind

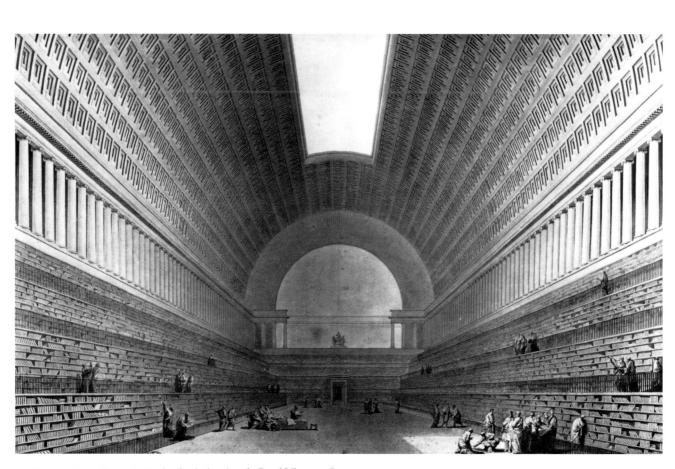

7.4 ETIENNE-LOUIS BOULLÉE Design for the interior of a Royal Library, 1784

arches, and compound orders ("an architecture in relief," as Laugier denounced it) were to be censured, as they marked a later Roman dilution of the pure Greek temple model, whose structural integrity and free-standing columns were distilled from the primal architectural shelter of earliest humanity. In what was to become the most renowned architectural illustration of the eighteenth century, the 1755 frontispiece to the second edition of Laugier's firebrand essay depicted an architectural muse pointing to the natural model of architecture. This proto-temple of the primeval forest was a tonic antidote to the convoluted inventions of the effete, courtly Rococo style. Laugier incorporates and contests Classically based architectural theory (from Vitruvius to Scamozzi), though his recommendations for the reform of modern architecture were not as radically regressive and reductive as the frontispiece would lead one to believe.

Architects throughout Europe debated Laugier's *reductio* ad absurdum of architectural origins. Some of his recommendations, such as encouraging a hybrid Greco–Gothic synthesis in ecclesiastical architecture and suggesting that urban planning should receive inspiration from the new picturesque trends in garden design, had tangible influence on the most advanced design trends throughout Europe. The

church of Ste. Geneviève in Paris by Jacques-Germain Soufflot (1713-80), whose design process and period of construction spanned the years 1756-90, is most often cited as a partial realization of Laugier's theoretical ideas. Its Greek cross plan is demarcated within by the continuous trabeation (upright supports and entablature) of giant Corinthian orders along the nave and aisles, bringing a Classical lucidity and elegance to the monumental interior space. The building referenced recent archaeological knowledge: the so-called Temple of the Sun at Baalbek (in what is now Lebanon), measured, drawn, and published by Robert Wood in 1755, provided the model for the Corinthian order on the interior and also on the entrance portico. The stolid and primitivizing Doric order was found in the crypt below, after Soufflot's own archaeological drawings of the Doric temples at Paestum from his earlier Italian sojourn. Despite these erudite antique allusions (along with the inspiring prototypes of St. Peter's in Rome and St. Paul's in London), Ste. Geneviève's interior sequence of saucer domes and transverse side-aisle sail vaults assume a strikingly Gothic air; the vaulting systems barely seem to impinge on their majestic post-and-lintel base. The aisles and nave were originally illuminated by a flanking row of windows on the side elevations, but in 1790-91 when the

church was converted into the Republican Pantheon or Temple of Great Men, these windows were blocked in, thus compromising the atmospheric Gothic effects of transparency and the thinning of the exterior masonry walls that Soufflot had originally intended. In accordance with Laugier's prospectus, this innovative ecclesiastical design applied the spatial and structural principles of the Gothic (absent its specific stylistic properties) to the archaeologically inspired and rational forms of Classical building.

Laugier had noted, "there are sensible people who maintain that the fine arts are the ruin of a state." Central to his architectural theory was the Enlightenment project of promoting a culture of moderation that prized clarity of purpose and a restrained nobility of expression. In his extended analysis of *bienséance* (or the appropriateness of architectural design and its degree of decoration to a building's function

7.5 MARC-ANTOINE LAUGIER Frontispiece to the second edition of the Essay on Architecture, 1755

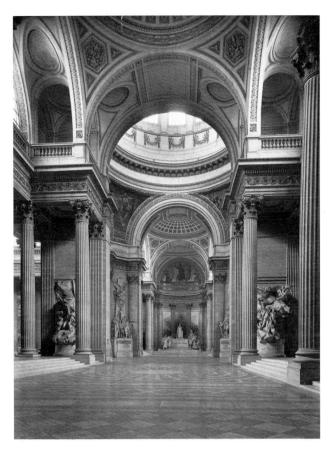

7.6 JACQUES-GERMAIN SOUFFLOT Interior of Ste. Geneviève (the Pantheon), Paris, 1756–90

and program), Laugier seemed the paramount voice of reason. But in turning his attention to architectural types that were truly social institutions (hospitals and almshouses), he summarily pronounced, "Buildings that house the poor must retain something of poverty." Such were the limits of architectural reform for a liberal *philosophe* disinclined to accept the radical egalitarian implications of the Enlightenment.

THE NEW ARCHITECTURE OF SOCIAL INSTITUTIONS

From the late eighteenth century onward, however, architects and social reformers increasingly addressed the pressing needs of an emergent modern industrial society in housing and caring for the impoverished, the ill, and the criminally inclined. Laugier's interdiction against "misplaced splendor" in these non-elite social forms of architecture did not go unnoticed. But despite the economic restrictions and class prejudices that insured the Classical orders would not be wasted on the collective residences of the poor, the professional architect nonetheless felt compelled to master a complex range of engineering, scientific, and even moral

principles that were unique to designing institutional building types of the late Enlightenment. The poststructuralist philosopher Michel Foucault famously characterized this as an architecture of surveillance and classification that sought to delineate and police the boundaries between privilege and restriction, normalcy and deviancy, and social inclusion and social exclusion for the modern period. This meta-historical critique broadly condemned as bad faith or mere ideology the intentions of social philanthropists and official bureaucrats to ameliorate society's ills. The sordid conditions of public hygiene and the welfare of the indigent that accompanied urban growth and industrialization were, however, tangible enough to produce more than simply ideological shadow play. The late Enlightenment effort to respond to these new reformist challenges is seen in the proposal of 1785 by Bernard Poyet (1742-1829) for a monumental hospital of the Hôtel Dieu on the Île des Cygnes in Paris. A fire in 1772 had destroyed the decrepit and overcrowded warren of the former hospital opposite Notre Dame. The complicated requirements of high-density occupation, medical segregation of patients by type of affliction and social class, efficient circulation of those attending to the ill, and the overall salubriousness of the supply of water and air (its ingestion as well as its evacuation), were all to be managed through the legible concentric geometry and spatial compartmentalization of model plans of this kind. On the one hand, the wheel-like self-containment of the design was patterned after Renaissance ideal cities and fortresses; on the other, it was a mechanical diagram that predicted the replicable efficiency and dehumanizing uniformity of industrial design in the coming centuries. The elevation facing the Seine was distinguished by a heavily rusticated waterway entry, while the sweeping and repeated lines of the arched fenestration (on axis with the radial spokes of the communal corridors of the wards) were to bring much-needed light and air into the hulking brick and masonry structure. Wedge-shaped courtyards spaced between the wards also gave relief within. The

7.7

hospital was meant to seem somewhat forbidding in its barely inflected treatment of the exterior façade, in essence an Enlightenment version of the Roman Colosseum dedicated however to the maintenance of life rather than its orchestrated demise. At the circular hub was a spacious courtyard with a Neoclassical chapel—an austere version of the Temple of the Sibyl at Tivoli that was to remain within eyeshot of the ill and dying who were evenly and rationally distributed within the annular system of this architectural machine.

This Enlightenment belief in the power of architecture to bring calculated order, collective hygiene, and rhetorical clarity to the social body and its environment also informed the ambitious utopian proposals of Claude-Nicolas Ledoux (1736–1806). Although Ledoux enjoyed patronage from the Parisian elite of the ancien régime with commissions for elegant townhouses or hôtels, his most significant work fell into the category of utilitarian architecture, specifically, the design of imposingly aggressive toll gates that ringed the outskirts of Paris, and the creation of a model factory complex for the Royal Salt Works at Arc-et-Senans in 1774-8. The latter was arranged as a hemicyclical amphitheater with the central pavilions and director's quarters rendered in a brutal mannerist style of exaggerated rustication and elemental Doric porticoes, while the factory buildings borrowed from vernacular idioms of regional Franche-Comté farms and mills, though severely stripped down and regularized. Ledoux was imprisoned during the Terror and afterward never regained his footing as a practicing architect. But in 1804, he published a treatise with the ambitiously telling title of Architecture considered in relation to art, morals, and legislation, in which he laid out his elaborate proposals for Chaux. This ideal community was envisioned as a physiocratic utopia—a paternalistic commune that united agricultural and industrial modes and relations of production. The loquacious and intellectually pretentious text was accompanied by visually captivating engravings that accentuated the reductive geometries of the buildings sited in quasi-sublime landscapes.

7.7 BERNARD POYET Design for the Hôtel-Dieu hospital on the Ile des Cygnes, Paris, from C.-P. Coquéau and Bernard Poyet, Mémoire sur la necessité de transférer et reconstruire l'Hôtel-Dieu à Paris, 1785

Ledoux argued that the architectural structures in this model community would both metaphorically and literally express the occupation of its inhabitants/laborers through the bold use of abstract stereometric forms and transparent signs: thus, the water engineer dwells in a cylindrical conduit through which the river itself pours, the wood gatherer resides in a rustic ziggurat of stacked timber, and so on architecture parlante, or speaking architecture, as later critics would deem it. Every aspect of life, from sexual initiation to the acquisition of intellectual and skilled knowledge, to all legal and economic transactions, had its discrete, temple-like, "speaking" structure. Ledoux was confident that the bare surfaces and emphatic outlines of these simplified buildings would stimulate and even determine the productive capacities of the workforce. As he boasted in his treatise, "Let my city and the character of its edifices, like their nature, serve to propagate and purify moral customs ... man indicates his needs, often badly; the architect rectifies them." The consti-

7.8 CLAUDE-NICOLAS LEDOUX Royal Saltworks at Arc-et-Senans, 1774-8

tution of the community and its architectural character were made indissoluble. The perpetually edified citizen of Chaux would come to possess only a subjectivity that was architecturally mediated. But even here, the prospect for human conflict and the anticipated need for national security and military power were acknowledged: the final plate from Ledoux's treatise is an exhilarating and terrifying aerial view of a cannon manufactory, the industrial workshop comprised 7.9 of a quadrangle of massive pyramids expelling fiery exhaust, interconnected by elongated masonry sheds that could contain armaments and laborers in quantities that seem to defy even utopian logic. The decade and a half of the Napoleonic Wars, however, confirmed the dark logic of Ledoux's proposal.

Like most architectural utopias ("correcting society on the drawing board," to paraphrase the art historian Meyer Schapiro), Ledoux's was true to its Enlightenment heritage, being at once idyllically primitivist and overbearingly futur-

7.9 CLAUDE-NICOLAS LEDOUX Design for a cannon manufactory in the ideal city of Chaux, from Architecture considered in relation to art, morals, and legislation I, 1804

7.10 Cherry Hill, Pennsylvania, Eastern State Penitentiary, by John Haviland, 1825-36

ist. It was ostensibly devoted to the liberating cult of Nature and Reason and yet it also postulated an anonymously state-controlled society in which all possibility of human freedom is subsumed by architectural instrumentality. As will be seen in Chapter 14, a generation of architects and planners from the mid-nineteenth century forward, including the industrial town-planners Titus Salt and J.-P. Godin and the garden city designer Ebenezer Howard, would reconsider Ledoux's effort to unite the family, civil society, and the power of the state in idealized and comprehensive urban/architectural schemes.

The new architecture of social reform during the early nineteenth century was less audacious than the hypothetical projects of Ledoux. But the intimidating language of architectural mass and the reliance on radial geometry and spatial containment held firm. The much heralded design by John Haviland (1792–1852) for the Eastern State Penitentiary on Cherry Hill, just outside of Philadelphia, Pennsylvania, incorporated the most progressive techniques of penal reform. Built between 1825 and 1836, the structure concretized a generation's worth of social and moral speculation about the capacity of the prison to bring humane treatment and stern improvement to its convicts through model design. The English born Haviland was familiar with John Howard's harrowing State of the Prisons in England and Wales (1780) that had inaugurated the international movement to improve the conditions of incarceration. The architectural writer James Elmes, who was Haviland's teacher, had also made studies of penal and judicial architecture in the British Isles. Most important was the 1791–2 proposal by the utilitarian philosopher Jeremy Bentham (1748–1832) for the Panopticon, a

theoretical prison in which a web of cells would be systematically distributed around a central observation tower that would serve both functionally and symbolically as society's omniscient and omnipresent eye of judgment. The Eastern State Penitentiary was a decidedly Benthamite exercise in prison reform, as it had a central pavilion and two-story tower with seven one-story cell-blocks radiating out from this core rotunda. The plan ensured the solitary confinement of the prisoner, with one cell and small yard for each inmate. There were no communal spaces; rudimentary flush toilets were provided in every cell, a modern convenience unheard of in respectable residences at the time. This unvielding doctrine of penal isolation grew in part out of local Quaker religious and legal tradition, which dictated that the criminal should be subjected to the Quietist compunctions of conscience rather than corporal punishment or enforced labor. As Alexis de Tocqueville summarized this moral premise after visiting the newly completed prison, "The trials of solitude lead him [the convict] through reflection to remorse." The only symbolic or imagistic trapping of the penitentiary was on the façade of its quadrangular stockade, which had a castellated feudal style replete with battered walls and portcullis on its entry block and corner towers. A contemporary newspaper editorial noted its "grave, severe, and awful character." Because of this and the novel penal functionalism of its incisive geometric plan and the underlying theory of instilling contrition in the collective mind of its convicts, the building quickly became a tourist attraction and renowned object of official inspection for foreign dignitaries and would-be social engineers.

The panoptic formula permeated, in modified form, the planning of all kinds of nineteenth-century institutions, from

7.10

mental asylums to utopian communes and educational colleges (building types not as disparate in program as one might think). One step up from the reformed prison was the British workhouse, a social institution that emerged in the 1820s and 1830s. The financial burden of parish relief for the poor had steadily increased from the eighteenth century into the early Victorian period, largely as a consequence of expanding enclosure laws that limited the accessibility of common agricultural land to the peasantry and the subsistence-wage economy spawned by industrialization. Respectable society suspected that the destitute were taking advantage of government relief and petitioned for parliamentary reform of the Poor Law, which occurred in 1834. One solution was the establishment of parish or county workhouses, where the indigent would have to register as virtual inmates to reside there and perform routine labor under strict supervision. The Rev. J. T. Becher (1770-1848) of Nottinghamshire was in the vanguard of this reform movement, and the workhouse of Southwell, designed and planned by him in 1824-6 before the passage of the Poor Law, with the assistance of the architect and contractor William Nicholson, embodied the draconian techniques of effecting social change through architectural organization. An extensive three-story structure constructed from local red brick with broad timber floors, the Southwell workhouse consists of three building blocks around an octagonal courtyard. The central core was the governor's residence from which the institution was administered, its distinction made evident on the exterior façade by a blind relief arch and a pedimented neo-Palladian projecting entrance bay; the rear elevation onto the interior courtyard commanded views of the daily workings of the compound (exercise yards, laundry and carpentry sheds, etc.). The flanking blocks housed 160 people, segregated between the east and west wings by gender (children and the infirm were sequestered to the rear of the estate). Further

segregation was made through the ascription of moral qualities to the residents (hearty/weak, devout/impious, deserving/undeserving). These discriminations and chastisements by the governor threatened to destroy traditional family bonds among the poor, and were in fact intended to do so. The harsh regime of the workhouses was meant to impel the destitute to find employment beyond government relief at any cost, and thereby lessen their financial dependency on the community. The most revealing architectural signifier of the Southwell workhouse is the declarative, weighty dressed stone segmental arch that monotonously surmounts every window. It denotes protection and strength, but also promises burden and demands submission.

ARCHITECTURE AND THE GOTHIC IMAGINATION

The liberation of architectural style in European design during the early nineteenth century transpired not surprisingly within the more socially privileged and politically unmoored contexts of elite residences, fashionable dwellings, garden fabriques, and funereal monuments. Picturesque eclecticism began to eclipse the Greco-Roman hegemony. The charming, or alternately spectacular, relation of a house to its landscape setting, the eclectic breadth of its historical character, the compositional play of asymmetry and striking angles of vision both within and without: these were the new criteria for pattern books of designs for ornamental cottages and artistic villas that flourished in England, America, and Continental Europe. The architectural critic Colin Rowe has written of this tendency toward formal anarchy and stylistic relativism: "Liberalized in his sympathies and enfranchised of time, the architect was now heir to all the ages, and for him not only the whole of nature, but the whole of history had become present—and available."

7.11 Southwell, Nottinghamshire, workhouse, by J. T. Becher and William Nicholson, 1824-6

7.12 KARL FRIEDRICH SCHINKEL Design for a mausoleum and memorial chapel for Queen Luise of Prussia, 1810

For the German principalities, an equally patriotic symbolism of political resistance to the Napoleonic occupation and the myth of a unified national ancestry became enmeshed with the cultural appeal of the Gothic. The brilliant architect, scenographer, and panorama painter Karl Friedrich Schinkel (1781–1841) proposed a mausoleum and memorial chapel in 1810 after the death of his patron Queen Luise of Prussia that was to have been a numinous Gothic temple recessed within a crepuscular sylvan landscape. Its palm-leaved ribbed vaults, slender piers crowned with angels, and crystalline lighting conveyed the gravity-defying qualities of the Gothic style. In a polemical description that accompanied the exhibited design, Schinkel proclaimed the death of antique Classicism for modern times, arguing that the spiritual and political needs of Prussia required the reclamation of the Gothic. The eternal and the infinite were not to be attained through the finite tectonics of Classicism. No matter, for upon royal decree, the mausoleum was eventually constructed as a compact Doric temple. Prussia's King Friedrich Wilhelm III had espoused a liberal commitment to an enlightened constitutional monarchy and the politics of cultural nationalism. Prussia's resounding defeat at the hands of Napoleon encouraged the insurgent association of the Gothic with national liberation. But after the expulsion of the French and the remapping of Europe at the Congress of Vienna, the Prussian King's program of political reform was eclipsed by the traditional policy of autocratic rule. Thereafter Schinkel's utopian vision of Berlin as a royal capital city retained a glacial Classical air, with the notable exception of some muscular Rundbogenstil (round-arch or Romanesque style) designs.

The religious authority of the medieval age remained in question during this period, as picturesque travelogue writers tended to disparage the monastic and ecclesiastical ruins of the Gothic past (of pre-Reformation England and northern Europe) as "former nurseries of superstition, bigotry, and ignorance." The tremendous spatial effects and ornamental richness of the Gothic were salvaged in the name of nationalist historicism, romantic metaphysics, and picturesque composition. When one of the leading avatars of art-collecting and esthetic opinion-making in England decided to commission a monumental residence that also served as an opulently themed art gallery, it was the Gothic style that prevailed. William Beckford (1760-1844), an outcast gay pseudo-aristocrat whose wealth came from West Indian sugar plantations and who had authored the orientalist occult novella *Vathek* (1782), oversaw the creation of Fonthill Abbey between 1792 and 1812 with the stylistically flexible architect James Wyatt (1746–1813) responsible for the design. The

7.13 Fonthill Abbey, Wiltshire, by James Wyatt, begun 1792. Watercolor by Charles Wild, ca. 1799

7.14 Fonthill Abbey, Wiltshire, by James Wyatt, 1792-1812: view from St Michael's Gallery across the Octagon into King Edward's Gallery. After Charles Wild, from John Rutter, Delineations of Fonthill and its Abbey 1823

structure housed Beckford's extensive art and book collection, his learned and yet sumptuous passion for acquisitiveness matched by a megalomaniacal taste for architectural extravagance. Here was "House Gothic" run riot, as Fonthill drew on monastic, collegiate, and ecclesiastical models with both archaeological expertise and an eye for outright spectacle. This "Cathedral of Art" was one of parodic sacrilegious excess, with Beckford deploying the Catholic trappings of spiritual splendor for his own private empire of the senses. All the furnishings were meticulously customized in a medieval décor to accentuate the dizzying vistas of the long corridors and processional axes of the building. Fonthill Abbey became a modish landmark of ritual pilgrimage for Regency society. But not for very long. The specter of financial ruin forced Beckford to sell his visionary sanctuary in 1822. Three years later its 226-foot-high central spire collapsed, transforming it into an instant ruin, but one vainly bereft of picturesque age value and cultural nostalgia.

The domestication of Gothic proved conveniently migratory. In the United States, where the "Englishness" of the Gothic Revival would seem untenable with respect to its historical or political associations, the cult of the picturesque and the demand for modest though stylish villas nevertheless made the Gothic a fashionably acceptable option. A. J. Davis (1803–92) and A. J. Downing (1815–52) designed and promoted through their treatises and pattern books their picturesque cottages and diminutive Gothic mansions throughout New England and the Hudson River Valley. Davis's design for Knoll in Tarrytown, New York, of 1838 is 7.15 the finest example of this American adaptation of picturesque irregularity, with its advantageously scenic situation on a bluff above the Hudson and its asymmetrically composed verandah framing a Gothic entrance tower that facilitated a romantic continuum between interior and exterior. The cruciform plan is compact and functional without compromising the historical costume of castellated and Tudor ornaments

and moldings that characterize the interior décor with custom-designed Gothicizing furniture by Davis. In their many publications, Davis and Downing addressed the appropriateness of the picturesque Gothic to the commonsense ambitions and yet sprightly imaginations of the American gentleman. "The proper pride of republicans" that Davis praised was not the delirious and ostentatious egoism of Beckford. Downing even warned his prospective clients that "unless there is something of the castle in the man," one should seek to express the qualities of individuality and feeling through one's home with due modesty, though without resorting to the sterile grandeur of the Greek Revival. The American ideology of the picturesque dwelling was often equivocal and socially malleable in its message: it connoted both baronial standing above the commonplace and honest domestic virtue of hardworking selfadvancement. It was both a cultural bulwark against the tremendous economic and national expansionism of the Jacksonian period and a boastful manifestation of that very unchecked growth. Not wanting to seem too puritanical about his masculinized version of the picturesque and its uniquely American conjunction of self-restraint and impulsiveness, Downing enthusiastically asserted, "Men whose aspirations never leave them at rest—men whose ambition and energy will give them no peace within the mere bounds of rationality, these are the men for picturesque villas."

7.15 A. J. DAVIS West (rear) façade and two plans for Knoll, Tarrytown, New York, 1838. Watercolor

CHANGING URBAN LANDSCAPES

Despite this ascendancy of the picturesque Gothic in domestic design, the Classical façade continued to dominate the new public and civic architecture in capital cities during the early nineteenth century. The architectural landscape of London, regarded as the "metropolis of the world" because of its rapacious industrial and commercial growth, posed extraordinary challenges to architects who valiantly wished to maintain an antique decorum in the face of unceasing urban development and social change. Sir John Soane's career-long engagement as the architect to the Bank of England in the City of London bears notable witness to this predicament. From 1788 until 1833, Soane planned and built an epic though loosely connected sequence of miraculously top-lit rotundas and magisterial courtvards that comprised the three-acre bank complex. The exterior elevations employed authoritative Classical forms with broad outlines in partial relief of Roman triumphal arches applied to rusticated and scored walls. The most elaborate design statement that Soane made on the street façade of the Bank of England occurred at the so-called Tivoli Corner, designed and built in 1803-5. Soane adapted the circular Temple of Vesta at Tivoli and sliced it in half to turn the corner with unexpected drama on this otherwise drab juncture of the City on the bank's rear northwest end. He was hopeful that an ambitious urban renovation proposed by his mentor Dance for a new grand residential street from Finsbury Square to the north would ceremoniously terminate at his Tivoli Corner (the plan was unfortunately never developed). Soane's ingenious transposition of an ancient tholos (circular temple) with an enriched Corinthian order onto a commercial streetscape was made even more grandiose by its high attic story. Here the architect compiled flanking pavilions with cinerary urns and acroteria (plinths with sculptural motifs and ornamental blossoms) that framed a mausoleum-like centerpiece. Contemporary critics often reviled Soane's architecture for its sepulchral chock-a-block means of composition, judging it as morbidly improvised and gloomily inappropriate to the active life of a modern metropolis. Despite this criticism, the varied skyline and effulgent burst of architectural projection at Soane's Tivoli Corner, especially as recorded in this stunning perspective drawing by his draftsman Joseph Gandy, stood as a nationalist proclamation of England's (hoped for) financial and military supremacy during the Anglo-French Wars.

Soane's rival and colleague in determining the urban fabric of modern London was John Nash (1752–1835), whose comprehensive plans for the New Street and Marylebone Park, later called Regent Street and Regent's Park (1812–26), were the most ambitious undertaken in any European city at the time. Nash was the favorite architect of the Prince Regent and

7.17

7.16

7.16

7.16 (above) London, Tivoli Corner, Bank of England, by Sir John Soane. Watercolor by Joseph Michael Gandy, 1803

7.17 (*right*) London, Consols Transfer Office, Bank of England, by Sir John Soane, 1798–9

CHANGING URBAN LANDSCAPES - 171

future George IV, and he possessed a keen entrepreneurial instinct, which was needed especially in navigating through the economic and political exigencies of his urban proposal: the creation of a grand artery from the Prince's Carlton House on the Mall northwest through Piccadilly and to Oxford Street, and from there to the new suburban developments at Regent's Park. These improvements were practical and cosmetic, and, somewhere in between, social as well. Nash wrote that the objective of his scheme was to provide "a boundary between the Streets and Squares occupied by the Nobility and Gentry, and the narrow streets and meaner houses occupied by mechanics and the trading part of the

community." In actuality, the length of Regent Street, at a final cost of £1,500,000, generated greater commercial circulation and thereby a more porous relation between socially diverse neighborhoods. As a riposte to Napoleon's arcaded Rue de Rivoli in Paris designed by Percier and Fontaine at the height of the Empire, Nash laid out a sweeping Roman Doric colonnade, known as the Quadrant, where the new street diverged from Piccadilly toward Oxford Circus. The picturesque taste for serpentine movement and its play of optical and mental stimulation was vividly fulfilled within an urban context. The two-story-high colonnade was rendered in cast iron, a material the architect had innovatively employed

7.18 London, the Quadrant, Regent Street, by John Nash, 1819–20; on the right, the County Fire Office by Robert Abraham. Engraving after T. H. Shepherd

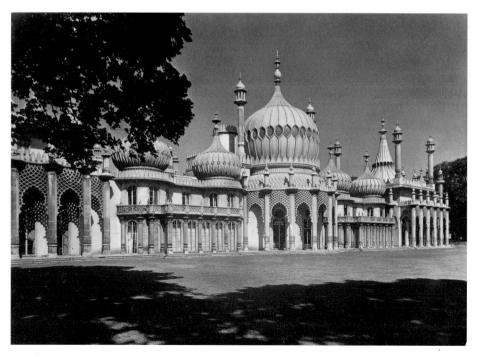

7.19 Brighton, the Royal Pavilion, by John Nash, remodeling begun 1816

before in private estates. Stylistic chameleon that he was, Nash experimented with cast-iron columns, balconies, and brackets at his earlier Gothic design for Corsham House and for the remodeling of the Prince Regent's Royal Pavilion in Brighton, an adventurously exotic and frivolous essay in "Hindoo" revival architecture that marked the outer edges of a picturesque colonial style. The Quadrant looked wonderful as an urban vista, but its utility within the life of the city was troubled and short-lived. Irrespective of the Quadrant's bounding Classical facade, the shopkeepers renting within complained of poor lighting and ventilation; eventually the covered promenades gave unintended shelter to prostitutes and orphans. The rusty colonnade was dismantled by 1848.

The commercial life of the nineteenth-century city demanded constantly changing architectural forms in which ossified historical idioms and new building technologies were strangely conjoined. The Parisian arcades of the Restoration and the July Monarchy were much-frequented emporia of luxury goods and scenes of fashionable self-display. These enclosed shopping corridors established an intermediate zone between the privacy of interior domestic space and the jostling dynamism of the public street. The Galerie Colbert designed by Jacques Billaud in 1826-8 had as its historical model an Early Christian basilica enlivened with Pompeian polychrome and fitted with a glazed pitched roof. Cantilevered wooden pediments divided the bays of this latticed glass roof aligned with the arcaded gallery beneath. The impressive rotunda with its glass dome was supported by cast-iron wall rings and ribbed braces. From the inside, the dome's structural support was painted to resemble tent poles and ropes, with an illusionistic panel of decorated canvas above the drum to heighten the

feeling of transparency and airiness. In the nearby Palais Royal, a district long renowned for its brothels, cafés, and gaming rooms, the Galerie d'Orléans, designed by P.-F.-L. 7.20 Fontaine (1762–1853) and built during the tumultuous years surrounding the 1830 Revolution, had an even more dramatic combination of traditional architecture and industrial castiron/glass construction. Framed on a cross-axis by Doric peristyles, the arcade was the most expansive of its kind, the lightness of the vaulted conservatory roof enhanced at the gallery level by mirror-paneled pilasters and gaslight globes on cast-iron brackets. In 1830, an amazed tourist reported, "The splendor and magnificence cannot be described ... I saw it vesterday evening for the first time with its gas illumination like sunlight. It is a large enchanted chamber." The Galerie d'Orléans gentrified the area immediately and replaced the socially dissolute cavalcade of urban physiologies with more a respectable clientele in search of an emergent, glittering consumer culture. But as with most urban commercial spaces devoted to bourgeois vending and modish entertainment, the enchantment was far from everlasting. By the 1840s, this arcade and its array of boutiques and cafés had lost its stylish appeal and by the 1890s it was largely abandoned. In his novel La Peau de chagrin (1831), Balzac employed the transient urban landscape of the Palais Royal to symbolize the modern Parisian's unquenchable thirst for fleeting fashion and material spectacle, all the while recognizing that, "our century stands laughing in the midst of ruins."

7.20 Paris, Galerie d'Orléans, by P.-F.-L. Fontaine, 1829. Lithograph after J.-B. Arnout, from Paris et ses souvenirs

FAITH OR TECHNOLOGY

Picturesque eclecticism and its proclaimed freedom of style had brought with it a devaluation of architectural significance. Urban commercial life and new industries facilitated the creation of innovative building technologies that threw into question the constructive relevance of historical models from the past. These impasses lay at the center of a trenchantly polemical treatise that galvanized early Victorian architectural debates: Contrasts, or a parallel between the architecture of the 15th and 19th centuries by A. W. N. Pugin (1812-52), first published in 1836 with a much expanded edition in 1841. Pugin was a Gothic Revival architect with a key difference: he was a devout Catholic for whom the architecture of pre-Reformation Britain embodied not merely a historical style but a spiritual and social authority that he believed had been tragically and systematically dispelled from contemporary life. Inveighing against "chains of paganism" and "academies of mixed styles" that had held sway over English culture since the sixteenth-century Dissolution (the dismantling of Catholic religious and educational institutions during the reign of Henry VIII and after), Pugin disparaged more than the architectural taste of the time. His vituperative prose came from a deeper mistrust of modern society itself. The didactic illustrations gave credence to the treatise's title and were far more powerful than his verbal arguments. Each plate represented antithetical architectural designs or views of the medieval past and the Victorian present. "Catholic town in 1440" was a glorious medieval skyline of parish church towers, feudal battlements, and cathedral spires, whereas "The same town in 1840" shows a blighted urban-industrial skyline of kilns, jails, and "socialist halls of science." In another "contrast," an "Ancient Poor House" is presented as a well-ordered monastic enclave that affords solemn funeral rites to its "poor brother," while its modern counterpart is a grim panoptic workhouse that consigns its deceased inmates to the anatomist's table. Pugin's illustrations were as much a sociological indictment of the Victorian age as a commentary on architectural style. The Gothic past is construed as a historical golden age to which society must return in order to enjoy a shared spiritual and architectural salvation. In meditating on the debasement of the architecture of modern churches, Pugin declared, "They are erected by men who ponder between a mortgage, a railroad, or a chapel."

One wonders, though, whether Pugin's dogmatic invocation of an archaeologically and spiritually correct Gothic structure was any more or less helpful for architects than Laugier's primitivist cabin. What future lay in either of these doctrinaire models of the past? Pugin adhered to his own brand of functionalism or what he called "fitness." In the building that he considered his finest achievement, the

THE SAME TOWN HAVE A 1762 Z. No. distinguis Barrier Grant J. DON 18 1849.

Of Palaster Sawer Hall in 1762 Z. No. distinguis Barrier Barrier Grant J. E. Mar Wolfe, J. Linck Robe, A. Linck de Son. J. San Wolfe Edition of College and May 7. Li Theory Chief C. E. Sayar Chief. F. Brazzario Chief. D. No. Chard. E. No. Chard. E. No. Chard. E. No. Chard. E. Sayar Chief. Sayar Chief. Sayar Chief. Sayar Chief. Edited San Charles Sayar Chief. Sayar Chief

Untipolis folius in H-IO.

2. Nationals in the SML is passed they distribute a thing is the SML and it is been a single state of the SML in passed in the SML in the

7.21 A. W. N. PUGIN The same town in 1840 and 1440, from the second edition of *Contrasts*, 1841. The modern town has a radial prison in the foreground (cf. 7.10)

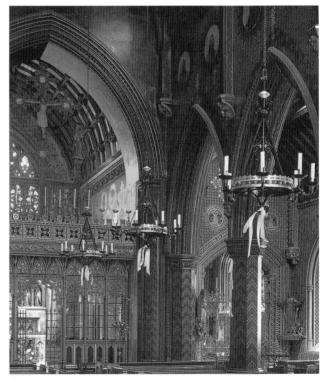

7.22 Cheadle, Derbyshire, St. Giles, by A. W. N. Pugin, 1841-7

Church of St. Giles, Cheadle (1841–7), the exterior massing was designed to connote the liturgical functions and ceremonial spaces of Catholic ritual conducted within. Even its kaleidoscopic pattern of interior decoration, which serves as a virtual compendium of regional idioms and craft media of medieval ornament, was keyed to the structural and sacramental form of the building. Cardinal John Newman, the leader of the Oxford (or Tractarian) Movement that advocated a new Anglican Catholicism, was moved to declare, "The new Cheadle Church is the most splendid building I ever saw. It is coloured inside every inch in the most sumptuous way." Pugin's architectural ethos remained a faith-based affair—to enjoy the diapered and polychromed surfaces of St. Giles as anything other than a manifestation of "the most mystical feeling and chaste execution" was to be in error and without grace.

Pugin's religiosity did not prohibit his practical consideration of secular and civic building types. His interior treatment of the new Palace of Westminster in London, designed and built between 1835 and 1868, entailed thousands of drawings for every decorative device, furnishing, and object in this most historically and politically symbolic of buildings in the British capital. He also provided designs for details on the exterior, and for the famous tower containing the clock known as "Big Ben." The overall elevations and plan were designed by Charles Barry (1795–1860), who brought a late Gothic Perpendicular and Tudor idiom to this controversial commission that sounded the death knell for the Classical as a national style. The British seat of government was given a defining Gothic skyline, though Pugin criticized the roughly symmetrical massing and axial interior distribution of the building with the famous rebuke, "All Grecian, Sir, Tudor details on a classic body." His detailing of the interior was ceremoniously opulent and materially resplendent. The throne and canopy in the House of Lords is a gilt oak paneled and enameled Gothic fantasy with its intricate multiplication of

7.23

7.23 London, Palace of Westminster, throne and canopy in the House of Lords, by A. W. N. Pugin

7.24 London, Palace of Westminster, by Sir Charles Barry and A. W. N. Pugin, 1835–56. The "Big Ben" tower is at the far right

foliated traceries, ogee arches, and filigree pinnacles. Symbolic figures of the orders of knighthood, heraldic shields, and dynastic attributes affirm the medieval symbolism of the royal heritage. The ornate splendor of the canopied throne was in inverse relation to the diminishing authority of the monarchy in the actual governing of the nation as the nineteenth century progressed. The chamber's over-laden ornament and exquisite expenditure of craftsmanship once again evinced Pugin's abiding sense of historical nostalgia—a longing for a chivalric and royal age that was more than merely vestigial and ritualistic in quality.

Toward the close of his career, which would end in frustration and madness, Pugin had been working on models for a utilitarian architecture of industrial workshops and railway stations. But his influence in this realm of modern building was to be seen only after his death, especially in the opulent High Victorian Gothic design of George Gilbert Scott (1811-78) for the Midland Grand Hotel, St. Pancras (1867-74). Its polychrome masonry, variety of pointed arches culled from German, French, and Italian models, and ornate medieval painted décor are thoroughly integrated with iron construction in a multifaceted building whose program encapsulated the contemporary experience of cos-mopolitan travel and the tyranny of the commercial schedule. Scott's towered and castellated hotel, attached to the front of the railway station by W. H. Barlow (1812-1902), sought to reconcile the schismatic worldviews of Pugin's contrasts, reaching back to an age of faith while embracing the new era of industry. In Paris, the Franco-German architect Jacques-Ignace Hittorf (1792-1867) retained a Beaux-Arts Classical orientation in his ambitious redesigning of the Gare du Nord terminus in 1857–66. In accord with the imperial pretensions of Napoleon III, the entrance façade was a triumphal arch with expansive lunette glazing, giant paired pilasters, and caryatids and statues on the roofline (personifying the cities rendered accessible by rail). This epic masonry façade predicted the tripartite nave and side aisle disposition of the railway shed and platforms inside, fitted with cast-iron struts and polychrome slender columns. Rhetorical monumentality and lucid functionalism were effectively fused in Hittorf's station, which became a majestic Parisian landmark of the Second Empire. Later its imperial grandiloquence was deemed tragically misplaced, the Swiss historian Jacob Burckhardt, for example, judging it as "one of the most frightful architectural infamies of our century."

It has been said that the train station was the cathedral of the nineteenth century (the French romantic writer Théophile Gautier had marveled at these "cathedrals of the new humanity"). But the Victorian art critic and archi tectural theorist John Ruskin (1819-1900) was most decisive on this question: "The Crystal palace is the metropolitan cathedral of the century." Built to house the "Great Exhibition of the Works of Industry of all Nations" of 1851, the Crystal Palace (so christened by one of the tart pencils at Punch magazine) was a modern monument of quintessential contradiction: materialistic and ineffable, chauvinistic and internationalist, standardized and transcendent. It was to have been a temporary, serviceable structure made to mechanical order; in this respect it was the engineering prototype for exposition and world's fair buildings that followed for the next century and a half (see Chapter 14). True to the epoch's faith in utility, positivism, and progress, the Crystal Palace was if anything a cathedral of statistics: it occupied 18 acres of Hyde Park; its length was its date,

1,851 feet; it was constructed, or more properly speaking, assembled in 6 months' time from over 10,000 prefabricated parts (glass panes, cast-iron hollow columns, wrought-iron girders, and wooden roof frames and floorboards); during the final week of its 1851 venue the daily attendance was over 100,000 people, which was also the approximate number of manufactured products, machines, decorative objects, industrial samples, scientific specimens, historical relics, and more on display from Britain, the European nations, and their colonies.

The designer of the Crystal Palace, Joseph Paxton (1803–65), had built the great greenhouse at Chatsworth before winning this career-defining competition against 240 other design entries. His primary goal was to create an unprecedented effect of transparency while still securing a vast exhibition space and accommodating the crowds of visitors. The artifice of engineering, industry and science was made to seem coextensive with the natural world that it dominated. An enormous, venerable elm tree on the site was even contained within the high sweep of the palace's arched transept. The girders were painted in primary colors that interacted optically with the changing weather conditions and the quality of light, as recorded in popular

chromolithographic views of the interior. Contemporary accounts by journalists and travel writers maintained that despite the mechanical repetition of the building's constituent parts the Crystal Palace induced intimations of infinitude that defied rational and perceptual comprehension. The erection of the building, which emulated the factory system on its construction site, was observed by the landscape painter J. M. W. Turner (whose own late work seized on similar effects of dissolution and disembodiment through atmospheric haze and refracted light); he wrote in a letter shortly before his death, "The Crystal Palace has assumed its wonted shape and size ... like a Giant."

Prince Albert, the royal sponsor of the Great Exhibition, had announced the gargantuan scope of this undertaking: "None will doubt that we are living in a most remarkable period of transition, laboring toward that great aim indicated everywhere in history: the union of the human race." Other social and political observers were skeptical of this universalizing claim that the peoples, products, and nations of the world could be brought to a meaningful concentration through such spectacles. Thomas Carlyle was greatly exercised throughout the six-month run of the Great Exhibition, ridiculing the structure as "the glass soap bubble" and "the

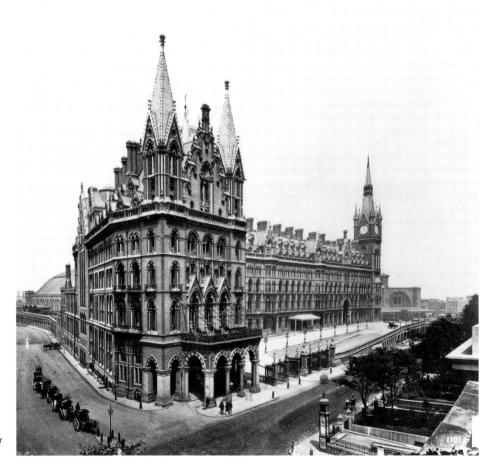

7.25 London, St. Pancras station and hotel: the train-shed, by W. H. Barlow, 1868–9, is visible at the far left, beyond the former Midland Grand Hotel, by Sir George Gilbert Scott, 1868–76

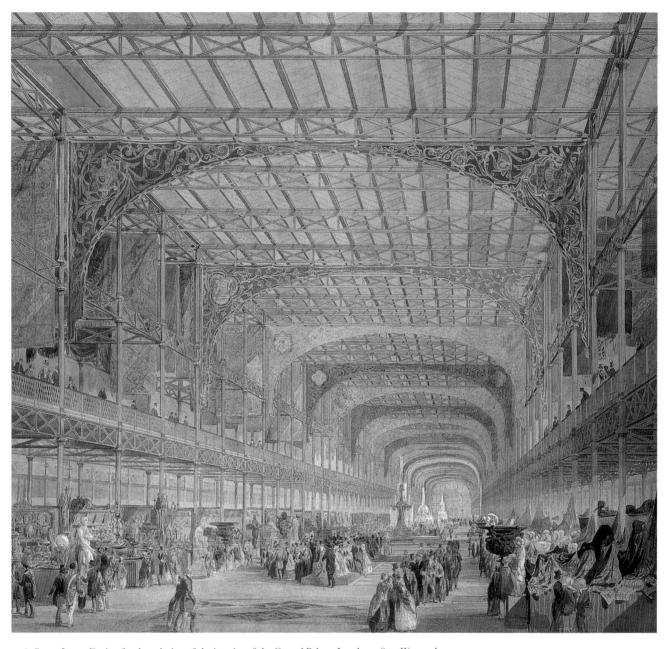

7.26 Owen Jones Design for the coloring of the interior of the Crystal Palace, London, 1850. Watercolor

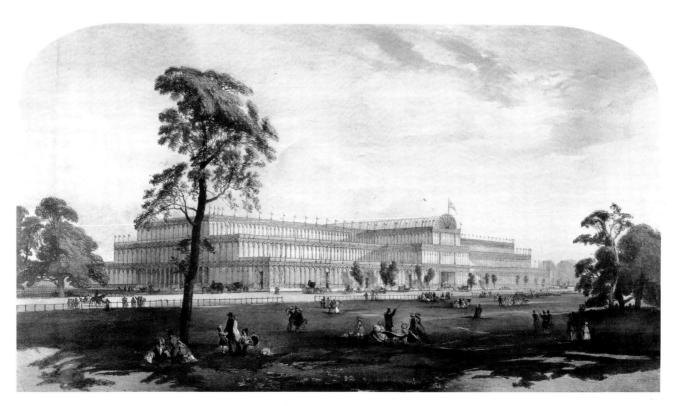

7.27 London, Crystal Palace, by Joseph Paxton, 1850-51. Engraving

gigantic birdcage." He commented less on the nature of the displays and their glorification of industry than on the sociology of the crowd's reception of these sights. The English public, Carlyle believed, was being reduced to "gawkers" and "saunterers"—a passive society blissfully unconscious of the anonymous labor and ratiocinated harnessing of power that such an enterprise required. Pugin of course condemned the Crystal Palace, but nevertheless saw fit to exhibit some of his liturgical and decorative designs in its Medieval Court.

Ruskin was perhaps most tormented by the Great Exhibition and its celebrated venue. His architectural treatises *The Seven Lamps of Architecture* (1849) and *The Stones of Venice* (1851–3) are centered on two fundamental arguments: for architecture to be beautiful and meaningful it must bear the material traces of the individual acts of labor of those who fashioned it, and it must bear, with the help of nature, the scars of history and heritage. These criteria were becoming increasingly difficult, most likely impossible, to sustain. He consoled himself with the thought that the Crystal Palace should not be considered as architecture at all. Prefabrication

and the erasure of the vicissitudes of manual skill, the geometric regularity of form, the magical inversion of interior and exterior, the transformation of science and industry into commodities of national veneration, and the incorporation of non-Western cultures within cosmopolitan spaces of exhibition; all these facets of modern architecture and society belonged to a present and a future that Ruskin could not bear to imagine. Whether or not George Dance would have seen the Crystal Palace as an architecture unshackled lies beyond conjecture. It was an architecture that exploded the traditional boundaries of historical style and set into motion a principle of technological determinism that collapsed the distinctions between art and industry, and between architecture and engineering. As Ruskin characterized the Great Exhibition and others that imitated it, "Nations indeed stand up with no other feeling than one of triumph, freed from the paralysis of precedent and the entanglement of memory." This was a powerful truth that later generations of architects and builders would long have to consider: the liberating dependency of modernity on forgetfulness.

NEW WORLD FRONTIERS

. 8 .

OLD WORLD, NEW WORLD: THE ENCOUNTER OF CULTURES ON THE AMERICAN FRONTIER

FRANCES K. POHL

THE BUCKSKIN JACKET AND THE PARKER PEN

In 1941 THE ANTHROPOLOGIST CLAUDE LÉVI-STRAUSS described a particular encounter in the American room of the New York Public Library: "There, under its neo-classical arcades and between walls paneled with old oak, I sat near an Indian in a feather headdress and a beaded buckskin jacket—who was taking notes with a Parker pen." Lévi-Strauss marveled at these unexpected juxtapositions—the feather headdress and the Neoclassical arcades, the beaded buckskin jacket and the Parker pen, the French anthropologist and the Native American researcher. Earlier in the century the U.S. photographer Edward Curtis responded to similar juxtapositions in a different manner. He retouched his images of tribal peoples in order to remove such "impurities" as suspenders, parasols, and alarm clocks.

The juxtapositions outlined by Lévi-Strauss and brushed away by Curtis have been an integral part of the daily experiences and cultural representations of those who have inhabited the North American continent since the arrival of European settlers in the sixteenth century. To ignore these juxtapositions or brush them away results in a deceptively static and one-sided view of the encounters between these European settlers and the indigenous populations, a view that most often presents Native Americans as having been systematically conquered and their cultures subsequently preserved in a "pristine" state in the museums and private collections of Euro-Americans. While conquering and controlling the indigenous peoples of North America was certainly a central component of the European agenda in the New World, this conquest was never complete. Native

peoples and their cultures continued to exist, to adapt and change, and exert their own influences on the Europeans who came to subdue and record them (the two processes often went hand in hand).

The complexities of these juxtapositions, these encounters between the Old World and the New, need to be kept in mind when looking at nineteenth-century U.S. art. The U.S. in the nineteenth century was not a homogeneous society, but neither was it a collection of separate entities embodying the pristine cultures of Native America, Africa, England, Ireland, Italy, Spain, or China. The anthropologist Eric Wolf has argued that "the world of humankind constitutes a manifold, a totality of interconnected processes." This chapter will investigate certain aspects of this totality of interconnected processes as they manifested themselves in nineteenth-century pictorial representations of encounters between Native Americans and Europeans.

The following pages contain only a few examples of the thousands of such images that appeared in the nineteenth century. The questions raised in these pages, however, can be applied to the larger body of images and can lead to a greater awareness of the central role they played—and continue to play today—in the formation of popular concepts of the U.S. and its peoples. Most of the works in this chapter do not depict "violent" encounters—U.S. soldiers shooting or stabbing Native Americans or vice versa. Rather, I have focused on portraits of Native Americans by white artists or scenes of Native Americans in their villages or in classrooms in order to show that these seemingly non-violent encounters also have a coercive aspect to them, that they reveal a social system that relies on pictorial representations as well as physical force to control or subdue a people. The works by Native American

artists also show how Native Americans resisted the extinction of their culture, or its preservation only in museums as collections of static artifacts, by recording their own visions of their changing world.

The pictorial representations of Native Americans and Euro-Americans appeared in many forms-photographs, engravings, lithographs, drawings, paintings, and sculptures. They also appeared in many different places—the home (particularly in the form of popular magazines and sets of stereoscopic photographs), art galleries, community centers (which were often the sites for traveling exhibitions), business establishments, government archives, and public plazas. Just as it is a mistake to think that separate, pristine cultures existed side by side in the U.S. in the nineteenth century, so too is it a mistake to think that popular or commercial art and fine art occupied completely separate spheres. For example, while the venue for the display of each category of objects might differ (the art gallery versus the magazine page), those who worked for popular magazines often drew upon the conventions of fine art in composing their images while fine artists, in turn, often looked to popular culture for inspiration. Indeed, many artists who came into prominence in the fine art world in the U.S. over the century began their careers as commercial artists and often continued to create illustrations for popular magazines after their reputations as fine artists had been established. Some did so for financial reasons, others for political reasons, believing that the work of "fine artists" needed to be made more accessible to a larger, non-artworld audience in order to improve the esthetic and moral fiber of the nation. In addition, the meaning of a particular image depended upon where it appeared and who viewed it. For example, a painting may well have meant one thing when seen by an art critic hanging in a gallery and quite another when seen by a garment worker in engraved form in a magazine. Acknowledging the effect of venue and audience on the meaning of an image results in a fuller understanding of the wideranging and varied impact of pictorial representations in the nineteenth century.

THE MYTH OF THE FRONTIER

According to the historian Richard Slotkin, the oldest and most enduring national myth in the U.S. is the myth of the frontier. Since colonial times, this myth has underpinned the rhetoric of pioneering progress, world mission, and eternal battle against the forces of darkness and subversion. While it began in the materiality of frontier life, it continued long after people had ceased to live in frontier conditions. The historian Frederick Jackson Turner articulated the major elements of the myth of the frontier in an address in 1893 at the World's Columbian Exposition in Chicago. For Turner, the frontier—or the "West"—was synonymous with the U.S. itself. It was here where the successive meetings between savagery and civilization took place and were resolved and where citizens became sturdy and independent. Once the Pacific coast had been reached and the frontier had literally disappeared, it lived on for Turner in the character of the nation, in the ruggedness and inquisitiveness and aggressive individuality that marked the national spirit.

The frontier myth, according to Slotkin, endures to this day as a primary organizing principle of U.S. historical memory because it is able to encode the "lessons of history" in easily graspable stories or catchphrases; history is successfully disguised as archetype. The enemies of the U.S. become the "Indians," the noble or ignoble savages, while the U.S. military dons the persona of the cowboy. These "cowboy and Indian" stories appear throughout the mass media—movies, television, comic books, novels—and are acted out time and again by young children in playgrounds and backyards across the nation. Such is the power of this myth that challenges to its "truthfulness," which were particularly evident during 1992, the year marking the quincentenary of Columbus's arrival in the Americas in 1492, are often labeled "unAmerican." And vet such critical challenges must be undertaken in order to unravel the complex layers of meaning embedded in the tens of thousands of images of the frontier that were produced in the U.S. in the nineteenth century.

While Native Americans were constantly represented as actors on the frontier stage in the nineteenth century, they had earlier been used as the very embodiment of the frontier itself, of that wild land that needed to be tamed and made "productive." This geographic personification—the Native American as the New World—appeared most often in the form of the semi-naked "Indian Queen" with classicized features. This emblematic figure had been used since the arrival of Europeans in the New World to represent this world as a whole-North, Central, and South America-but she also briefly enjoyed the status of a national symbol in the U.S. in the late eighteenth century, when such symbols were being actively sought by the new nation. Such a representation can be found in Augustin Dupré's Diplomatic Medal (1790). Here 8.1 the figure of Mercury, the winged messenger representing Europe (the Old World), greets the female personification of the U.S., wearing a feathered headdress and skirt (the New World). She is seated beside packaged objects, toward which she gestures with her right hand. In her left hand she holds a horn filled with fruits which she extends toward Mercury. Thus, in exchange for manufactured goods from Europe, the newly formed United States of America would provide food and raw materials. In order more clearly to connect the packaged objects to the left of the female figure with Europe,

an anchor is placed in the foreground, which corresponds to the ship behind Mercury. And finally, in addition to the commemorative date on the lower portion of the coin—July 4, 1776—which marks this female figure as representing the U.S. rather than the New World as a whole, are the words above the figures—"To Peace and Commerce."

In the early years of the nineteenth century, this "Indian Queen" was replaced by a figure whose "Greekness" received greater emphasis, as in an anonymous engraving, "America," of 1804. The bared breasts and feathered skirt of the figure on the diplomatic medal are replaced by a simple gown reminiscent of the clothing worn by women in ancient Greece. Yet this figure also has a decidedly "contemporary" look to her. The Greek world was a major source for designers of female clothing in the early nineteenth century, particularly in France. "America" also wears an elaborate cloak elegantly draped across her shoulders, and against her left arm rests a long pole with a liberty cap on its top end, a reference to both the American Revolution of 1776 and the French Revolution of 1789. Indeed, one could almost imagine her attending a ball in Paris in honor of Napoleon Bonaparte, whose coronation as

8.2

8.1 (below) AUGUSTIN DUPRÉ The Diplomatic Medal, 1790. Bronze, diameter 25/8 (6.7)

8.2 (right) "America," anonymous engraving from The Four Continents, 1804. Engraving, $13\% \times 9\%$ (34.6 × 24.6)

8.3 (below, right) John Vanderlyn The Death of Jane McCrea, 1804. Oil on canvas, $32\frac{1}{2} \times 26\frac{1}{2}$ (82.5 \times 67.3)

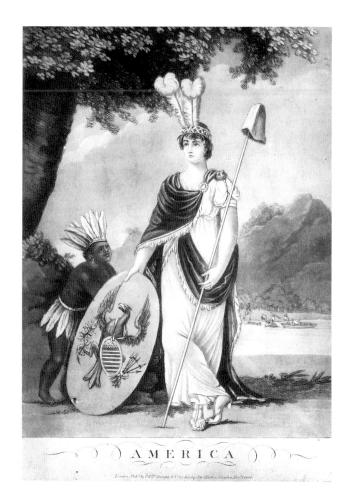

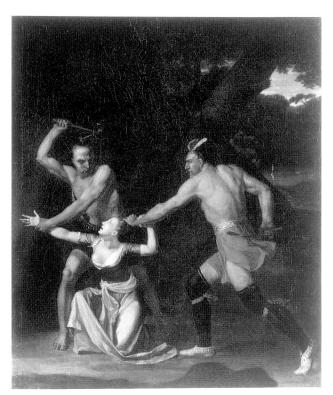

182 · OLD WORLD, NEW WORLD

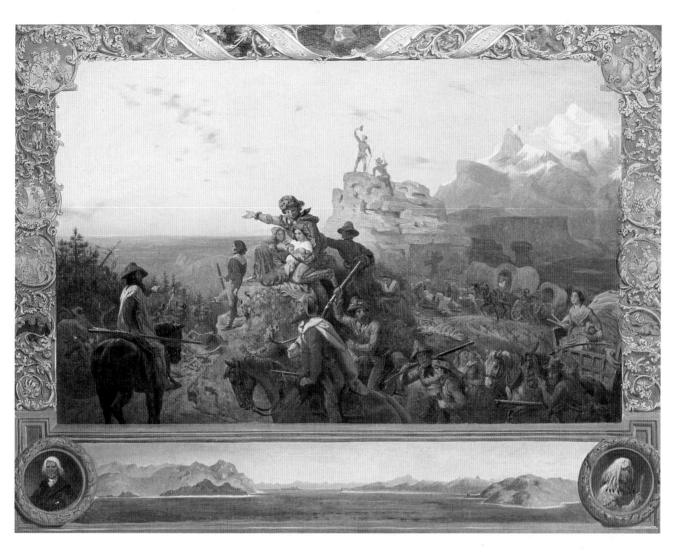

8.4 EMMANUEL LEUTZE Study for Westmard the Course of Empire Takes Its Way (Westmard Ho!), 1861. Oil on canvas, 331/4 × 433/6 (84.5 × 110.2)

Emperor the same year the engraving was produced brought an end, at least for the time being, to the political experiments in revolutionary republican rule brought on by the French Revolution.

While the title of the engraving might suggest that this female figure represents the New World as a whole, the liberty cap and the shield, on which is emblazoned the new U.S. symbol of the American eagle festooned with a medallion containing the stars and stripes of the new national flag, identify her as a representation of the United States of America. Her association with the indigenous peoples of the New World has also not totally disappeared. It remains in the form of the childlike figure with Native American features who accompanies her. It is this childlike figure who now wears the feathered headdress and skirt worn by the woman in the diplomatic medal. While the female figure in the engraving does retain two token feathers attached to her headband, they are much more elegant than those in the child's headdress.

According to the art historian Barbara Groseclose, this shift from a strong central character bearing Native American referents to an ancillary childlike Native figure parallels the enforced dependency of Native peoples on the U.S. federal government during the nineteenth century. Native physiognomy or clothing now refer to "condition, not geography race instead of place." This is borne out in the engraving by the placement of the native figure behind the shield and by the figure's adoring gaze in the direction of America. The subservience of this native figure is further evident if we compare the compositions of the Diplomatic Medal 8.1 and the engraving. The relationship between the U.S. and 8.2 Europe is presented in the medal as an exchange of gifts between equals. Mercury offers the gifts of the powers of Europe to the enthroned Indian Queen, who is both Old World (classicized features) and New World (feathered skirt and headdress). Both are presented within a horizontal composition as mutually interdependent. Both are shown

with heads in profile and frontal torsos; both are approximately the same size and on the same level; both are "dignified" by Classical referents. The New World is gendered female and is associated with the land or nature; the Old World is male and will transform the products of nature offered to it by the female figure into products of culture, manufactured goods.

8.2

The relationship articulated in the engraving between Euro-Americans and Native Americans—domestic relations as opposed to foreign relations—is one of subservience, not equality. The composition itself is hierarchical. The native figure is located at the base of a triangle whose apex is the head of America. The native figure is half the size of America and leans toward her, gazing upward, while she is erect and gazes off into the distance. The native figure is more closely associated with the land in terms of skin color and costume and is the compositional counterpart of the moose-hunting scene to the right of America (the place occupied by the ship in the medal—again, domestic production versus foreign trade). The native figure is also not clearly gendered; s/he is a child, to be protected by Mother America and by the shield of Euro-American governance.

The decreasing presence of Native Americans as central emblematic representations of the U.S. parallels the increasing classicization of national symbols, and of narrative pictorial representations in general, in the early nineteenth century when national spokespeople promoted the U.S. as a new Greek democracy or Roman republic. In another work of 1804, John Vanderlyn's (1775–1852) painting The Death of Jane McCrea, the classicizing elements appear in the physiques and poses of the two Mohawk warriors, who are about to scalp the young colonist Jane McCrea. It was commissioned by Joel Barlow, President Jefferson's envoy to France, who had commemorated the event in his anti-British epic poem The Columbiad. The painting is meant to illustrate an incident that allegedly occurred during the American Revolution, when many Mohawks were hired by the British to help defeat the rebellious colonists, rather than constitute, like the engraving "America," an emblematic representation of the nation as a whole. Yet the blond Jane McCrea can also be read as a symbol, this time of colonial women and of the nation at large, for one justification for the decimation of the Native population was the threat they posed to colonial women and, thus, to the nation's future.

The use of colonial women in this way—as symbols of colonial vulnerability—is particularly evident in narratives documenting the captivity of Europeans among Native Americans which first appeared in written form at the end of the seventeenth century, and in engravings and paintings like Vanderlyn's in the late eighteenth century. By the beginning of the nineteenth century, the captivity narratives which

received the most attention were those in which the captor was a Native American man or men and the captive a European woman. These narratives cannot, of course, be read simply as records of the general historical practise of captivity in the seventeenth and eighteenth centuries. They give little indication, for example, that Native American men, women, and children formed the largest body of captives on the British Colonial frontier or that such native captives were treated as cruelly as were those white captives depicted in whiteauthored captivity narratives. Indeed, the Native American woman who received the greatest attention in art and literature, the early seventeenth-century Powhatan Pocahontas, was presented most often not as a captive (which she was), but as a symbol of the Christian salvation of Native American "savages" and the legitimacy of colonial appropriation of Native land through her various roles as John Smith's savior, the mediator between her people and the colonists at Jamestown, and the Christian wife of the tobacco planter John Rolfe. This is certainly the case, for example, with John Gadsby Chapman's The Baptism of Pocahontas (1837–40), located in the Rotunda of the U.S. Capitol Building in Washington, D.C.

Representations of European captives among Native Americans were, like Chapman's painting, consciously constructed narratives meant to further the interests of the British colonists who produced and/or promoted them. As the anthropologist Pauline Turner Strong has recently pointed out, in the captivity narratives promulgated by colonial clergymen (who often edited or wrote the accounts):

the figure of the female captive represents the vulnerability of the English colonies in the New World, where they are preyed upon by the brutish and diabolical forces of the wilderness which destroy domestic and civil order and threaten to seduce or devour them. The opposition between a vulnerable female Captive and a male Captor unrestrained in his savagery is fundamental to this interpretation.

Vanderlyn's painting graphically illustrates this opposition between the Native American male as diabolical force and the European female as vulnerable captive. Yet it also reveals the complex play between attraction and repulsion that marked so many paintings of Native Americans by Euro-Americans and that was present in some of the written captivity narratives as well. In the many narratives documenting male captivity that appeared in the early nineteenth century (for example, that of Daniel Boone), the experience of captivity among Native Americans was presented as having toughened the European male, as having made him more virile, more masculine. Of course, the European returns to his own people, who are then

8.4

able to appreciate the transformation. Yet not everyone returned. In the Reverend John Williams's earlier account of his own captivity and that of his family in 1704, he records that once he and his family were freed, he was unable to "reclaim" his daughter Eunice, who was 7 years old at the time of her capture. Eunice eventually married a Mohawk who had been converted to Catholicism by the French Jesuits and remained in the community of Caughnawaga. She was thus doubly lost—to Catholicism and to a Native American male.

Eunice's story was soon buried, however, among the more numerous accounts of female deliverance from diabolical male Native forces through divine intervention or, as in Vanderlyn's painting, through death at the hands of these same forces. Vanderlyn's Mohawk warriors are not Catholic converts wedded in a Christian ceremony to white women, but fearful savages threatening to "seduce or devour" Jane McCrea. The attraction, or "seductiveness," of the Native male is present in the painting's sexual charge, in the powerful, "manly" physiques of the Native American men and the almost bared breasts of the supplicant Jane McCrea. These elements, in conjunction with the impending blow from the tomahawk, worked simultaneously to enrage and arouse (in a sexual sense) and strike fear into the hearts of the white viewers, both male and female, who attended Vanderlyn's pay-as-you-enter exhibitions of this painting and others in New York, Baltimore, New Orleans, and other cities across the nation. As if to emphasize the power of the Native men, European manhood is represented by the tiny, ineffectual figure of McCrea's fiancé in the distant right background running vainly toward his loved one.

While Native Americans no longer played an emblematic role as national symbols in the nineteenth century, they still remained closely tied to the land in both literary and pictorial representations, a land that Europeans viewed with covetous eyes. From their arrival in the New World onward, European colonists believed the key to prosperity and a new life lay in the acquisition of greater and greater quantities of land. Yet the land they desired was already occupied, and by a people who held it communally, rather than individually. There was no private property, no individual ownership. Native peoples did not practise European techniques of intensive cultivation or mining, nor did they make the land produce more than was necessary to sustain the tribe. This communal ownership and lack of "productivity" was deemed "uncivilized" by Europeans and even, in the late nineteenth century, "communistic." The taming and "civilizing" of Native Americans and the taming and "civilizing" of the land, accomplished by the forcible removal of the former from the latter, were thus crucial elements in the material establishment of the nation and in the confirmation of the concept of "America" as a country whose very existence depended upon private ownership and the rights of the individual, in particular the right to exploit the land.

For most of the nineteenth century, the richest land vet to be exploited by European colonists and their descendants lay west of the Mississippi River. This was the area most commonly conjured up in people's minds when they heard the term "the West." One highly visible image of this unconquered territory was Emmanuel Leutze's (1816–68) Westward the Course of Empire Takes Its Way (Westward Ho!), painted in 1861-2 for the Capitol building in Washington, D.C. Leutze had studied and worked in Dusseldorf between 1841 and 1859 and was contacted in 1854 about a possible commission to decorate the Capitol building. The title of Leutze's work is drawn from a poem by the Irish idealist philosopher Bishop George Berkeley entitled "Verses on the Prospect of Planting Arts and Learning in America" (1752). The poem was inspired by Berkelev's efforts in 1726 to establish an experimental college in Bermuda to convert American Indians to Christianity. Its final stanza reads:

Westward the course of Empire takes its way; The four first Acts already past, A fifth shall close the Drama with the day; Time's noblest offspring is the last.

Housed in the Capitol Building, Leutze's painting articulated the belief of European colonists since the sixteenth century that they had a Christian duty and an inalienable right to expand their territory and influence. This belief was codified in the U.S. in the nineteenth century in the doctrine of Manifest Destiny, which was used to justify the conquest and colonization of the western frontier. In conquering the west, the final New World frontier, Euro-Americans would bring to culmination the progress of civilization.

The sun-bleached bones and burial scene in the center of the painting attest to the hardships that the pioneers endured in crossing the vast continent, whose natural power and beauty is evoked by the towering, snow-capped mountains, the broad expanse of plateau land, and Golden Gate Bay, the port of San Francisco. Yet Leutze chooses to downplay one of the most written-about hardships encountered during the journey across the continent: Indian attacks. The only references to such attacks in the central scene are the bandaged head of the young man in the center foreground and the bow and arrows held by the boy who drives the first team of oxen (the latter is missing from the early oil study). Instead, Leutze places Native Americans in the margins of the composition, caught up among the plant tendrils of the painting's border along with wild animals, which, like Native Americans and the land itself, must be conquered and subdued. Native Americans are thus marginalized, both

literally and figuratively, functioning as a framing device for the exploits of the U.S. pioneers.

Also included in the painting's border are roundels containing such figures as Moses, the spies of Eshcol bearing the fruits from Canaan, and Hercules. Yet these Old World figures are not presented as the equals of the Native figures or even as occupying the same world. Rather, they occupy their own separate worlds contained within the leafy borders of the roundels instead of being caught up among the vines like the animals and Native figures. These Old World men serve to reinforce the sanctity and significance of the central scene. Like them, the U.S. settlers are embarked on a momentous journey of discovery marked by trials and tribulations.

THE STAIN ON A PAINTER'S PALETTE: CHARLES BIRD KING AND GEORGE CATLIN

There is one other reference to Native American life in 8.4 Leutze's painting *Westward the Course of Empire Takes Its Way*. It appears in the medallion portrait of the explorer

William Clark in the lower right-hand corner of the oil study. Unlike Daniel Boone in the left-hand portrait, who is dressed in recognizably European clothes, Clark wears a buckskin jacket and animal-fur headdress, clothing that would have been immediately associated with the dress of Native Americans. These medallion portraits were transferred to the vertical frame segments in the final composition. In their place in the lower border were painted symbols of mining, agriculture, and hunting, activities which would transform the land from a state of wilderness into one of civilized productivity.

The practise of white men dressing up as Indians in the nineteenth century was not uncommon. For explorers like Clark, wearing Indian clothes and learning Indian ways was often essential for survival. For white men living in urban centers, dressing up as Indians was often a way to express symbolically a dissatisfaction with the material results of the government's expansionist policies—the decimation of Native peoples and of the forests in which they lived—or with the very idea of Progress itself. This form of dissatisfaction was literally acted out in various plays throughout the nineteenth century, one of the most popular of which was Metamora: or, The Last of the Wampanoags; An Indian

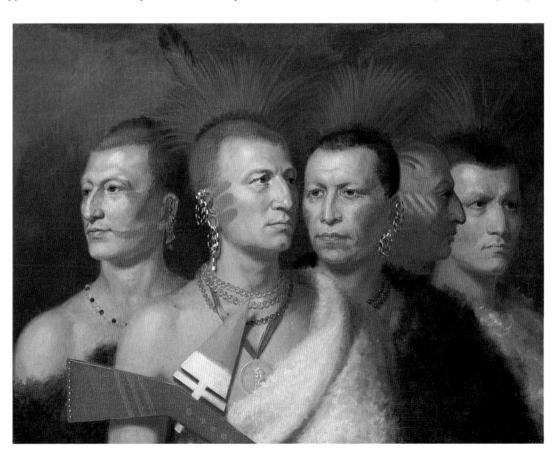

8.5 CHARLES BIRD KING Young Omahaw, War Eagle, Little Missouri, and Pawnees 1822. Oil on canvas, 361/8 × 28 (91.8 × 71.1)

Tragedy in Five Acts (1828) by John Augustus Stone. Native peoples represented a time of innocence and nobility before the development of urban centers and industrialization. As mentioned earlier, Native life also represented, for many men now caught up in urban professions, a more "manly" environment.

There were certain white men, however, who were not satisfied with simply donning the clothes of Native Americans; they also wanted to re-dress the Native Americans themselves, to define through pictorial representation what it meant to be or to look "Indian." Two such men were the painters Charles Bird King (1785–1862) and George Catlin (1796–1872). The works of King and Catlin can only be understood in the context of the U.S. government's official pronouncements about and actions against Native Americans

in the first half of the nineteenth century. In 1803 President Jefferson signed an agreement with France to purchase for \$15 million the region of Louisiana, which extended from the Mississippi River to the Rocky Mountains and from the Gulf of Mexico to British North America, thus effectively doubling the size of the U.S. This territory was inhabited, however, by numerous North American tribes. Their removal, therefore, became a central goal of U.S. Indian policy. What could not be settled by treaty or trading was settled by force or by disease. The removal of Native peoples from this territory was facilitated by pronouncements by government officials that Native peoples were already doomed, that their disappearance was inevitable not because of the actions of the U.S. government but because of their inherent inferiority. The popular literature of the period also

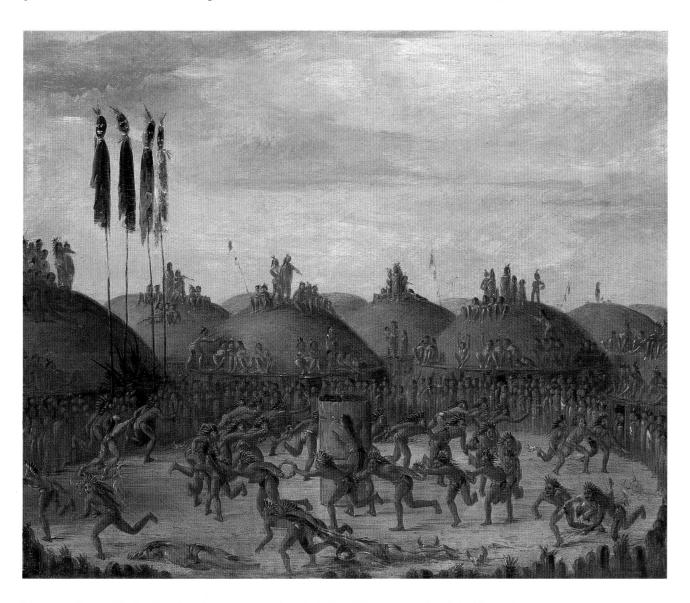

8.6 GEORGE CATLIN The Last Race, Part of Okipa Ceremony (Mandan), 1832. Oil on canvas, 231/8 × 281/8 (58.8 × 71.3)

abounded in stories of the "Last Indian," of noble savages who had to step aside because of the inevitable advance of civilization.

In 1824 the U.S. Secretary of War declared that Indians as a race were approaching extinction, despite the fact that their numbers were still significant. Many artists responded to this claim by hastening to paint what seemed to be the last generation of Native Americans. In 1856 the editor of the art magazine *The Crayon* wrote:

It seems to us that the Indian has not received justice in American art. . . . It should be held in dutiful remembrance that he is fast passing away from the face of the earth. . . . Absorbed in his quiet dignity, brave, honest, eminently truthful, and always thoroughly in earnest, he stands grandly apart from all other known savage life. As such let him be, for justice sake, sometimes represented.

The government encouraged such representation by commissioning artists like King to paint portraits of many tribal chiefs. King studied in London at the Royal Academy and in the studio of the U.S. expatriate painter Benjamin West before returning to the U.S. in 1812. He set up a studio as a portrait painter in Washington, D.C. in 1819, and between 1821 and 1842 completed approximately 143 portraits of Native Americans. He was able to record the likenesses of Native Americans and thus capture the frontier experience in the comfort of his studio in Washington, D.C. because many Native delegations traveled to the capital in the 1820's and '30's to sign treaties negotiated with the U.S. government which ceded large tracts of land for western expansion. Members of these delegations often sat for their portraits, which were subsequently included in the Department of War collection or sold through private galleries. The portraits thus became part of a series of documents that recorded the "legal" transfer of the ownership of land from Native peoples to the federal government, a transfer that signified the "civilizing" of the "untamed" frontier.

One of the earliest of such portraits was King's Young Omaham, War Eagle, Little Missouri, and Pawnees, painted in 1822. While the title of this multiple portrait suggests that this is an image of five different individuals, all bear a striking resemblance to one another. The art historian Julie Schimmel has suggested that the five men were based on the facial features of two Pawnee chiefs, Petalesharro, chief of the Pawnee Loups, and Peskelechaco, chief of the Republican Pawnees. King had painted these two chiefs when they had visited Washington, D.C. with a tribal delegation in 1821. Perhaps in attempting to emphasize the nobility of these individuals, King has sacrificed their individuality, creating a facial composite that he hoped would draw a sympathetic

response from a white audience. This facial type was interpreted by at least one observer, the English traveler William Faux who saw the delegation in Washington, D.C., as that of the ancient Roman. Faux noted that all of the men were "of large stature, very muscular, having fine open countenances, with the real noble Roman nose, dignified in their manners, and peaceful and quiet in their habits." Yet while the Roman noses and the peace medal around the neck of War Eagle reinforce the nobility and "peacefulness" of the five men, the face paint, jewelry, hair styles, and war club (its blade pointed ominously at War Eagle's neck) signify their difference and, ultimately, their savagery. Survival for Native peoples could be assured only through the abandoning of such signs of difference and the subsequent adoption of the signs of civilization—the clothing and habits of Euro-Americans.

While most mid-nineteenth-century viewers of King's multiple portrait would have read the costumes, facial paint, and hairstyles as evidence of a "noble savagery," late twentieth-century scholars have begun to read them, instead, as clues to a complex visual language used by many Native American tribes. The painted facial designs related to certain religious rituals and often signified a personal protective medicine. The way in which a person's buffalo robe was positioned also carried a specific message. Nine messageconveying robe positions are currently known, two of which involve baring one shoulder, which was either a courtship sign or a message of admonition. Hairstyles among the Omaha and Pawnee tribes signified tribal affiliation. The peace medals distributed by government officials were often prized possessions and signs of status. Thus while some contemporary art historians have questioned whether King's portrait contains accurate likenesses of five specific individuals, others have seen it, nevertheless, as providing valuable pieces of an historical puzzle now being reconstructed by contemporary scholars in their attempts to understand the dynamics of nineteenth-century tribal culture, even if only as filtered through the eyes of nineteenth- and twentieth-century Euro-Americans.

In 1830, two years after he was elected president, Andrew Jackson secured the passage of the Indian Removal Bill. By 1838, seventy thousand Native Americans had been forcibly removed from their homes east of the Mississippi to the Plains area west of the river, despite treaties signed earlier guaranteeing these people the right to their lands. Thousands died during this forced march. In the early 1830's the governor of Georgia summarized the general attitude of white negotiators toward treaties with Native peoples:

Treaties were expedients by which ignorant, intractable, and savage people were induced without bloodshed to yield up what civilized people had the right to possess by virtue

8.8

of that command of the Creator delivered to man upon his formation—be fruitful, multiply, and replenish the earth, and subdue it.

This religious justification, which formed the moral basis of the ideology of Manifest Destiny, would be called upon time and again in dealings with Native Americans. White Europeans were the chosen people, Native Americans the heathen savages, agents of the devil who had to be converted or destroyed.

Unlike King, George Catlin did not wait in the nation's capital for Native Americans to come to him to have their portraits painted. In 1830 he left his position as a successful portrait painter in Washington, D.C. and Philadelphia for the frontier city of St. Louis. Over the next six years he would make five trips into the territory west of the Mississippi. In 1832 he explained his reasons for wanting to paint Native American life:

I have, for some years past, contemplated the noble races of red men who are now spread over these trackless forests and boundless prairies, melting away at the approach of civilization. Their rights invaded, their morals corrupted, their lands wrested from them, their customs changed, and therefore lost to the world; and they at last sunk into the earth, and the plowshare turning the sod over their graves, and I have flown to their rescue-not of their lives or of their race (for they are doomed and must perish), but to the rescue of their looks and their modes, at which the acquisitive world may hurl their poison and every besom of destruction, and trample them down and crush them to death; yet, phoenixlike, they may rise from the "stain on a painter's palette", and live again upon canvas, and stand forth for centuries yet to come, the living monuments of a noble race.

While Catlin thus sympathized with the plight of Native Americans, he also believed that they were "doomed and must perish." He does not attempt to rescue "their lives or . . . their race" but only "their looks and their modes." Native Americans can survive only as representations constructed through the eyes of a white artist. Catlin engages in what the anthropologist Renato Rosaldo calls "imperialist nostalgia," a yearning for that which one has directly or indirectly participated in destroying, a preservation of "looks and modes" in the face of the "unfortunate but necessary" destruction of a people.

Catlin produced over five hundred scenes of Indian life, including *The Last Race, Part of Okipa Ceremony* (Mandan) in 1832 and *Clermont, First Chief of the Tribe* (Osage) in 1834. He organized many of these paintings, along with costumes

8.7

and a collection of native objects, into an "Indian Gallery," which toured the U.S. from 1837 to 1840 and then traveled to London and Paris in the 1840's. In 1837, the year the tour started, the Mandan, a tribe whose "looks and modes" Catlin had "rescued," was nearly completely wiped out by a plague of smallpox. Catlin's father wrote to him and commented that this event would greatly increase the value and importance of his son's works for they would, indeed, be one of the few reminders of a once flourishing tribe. The prophecy of the demise of Native Americans seemed to be coming true.

The success of Catlin's "Indian Gallery" in Europe was due in part to the fact that what Catlin presented was an affirmation of an already well-established conception of the Native American as "noble savage." The British poet and dramatist John Dryden first used this phrase in 1670 in a play about the New World entitled The Conquest of Granada: "I am free as nature first made man, Ere the base laws of servitude began, When wild in the woods the noble savage ran." This concept of "noble savagery" as a desirable condition was again promoted in the eighteenth century by Rousseau, Voltaire, and other French Enlightenment thinkers in their criticisms of what they viewed as corrupt contemporary French morals and practises. While Catlin's images were more particularized than earlier European representations of the generic "noble savage," they still participated in a larger discourse about an "innocence" or "purity" that, while desirable in many ways, was part of a past that, in the end, could not be recreated. The "noble savage," untainted by civilization, was destined to make way for its inevitable arrival.

Thus, despite Catlin's attempts to reproduce on canvas or paper exactly what he saw in front of him, his images of Native American life were filtered, by himself and by the many individuals who viewed his work, through the lens of an "imperialist nostalgia" that celebrated an ideal "noble savage." There were also instances when he intentionally altered a scene or composition. One example of this can be found in the frontispiece to his memoirs, Letters and Notes . . ., published in London in 1841. Catlin would like us to believe that this frontispiece records a scene that actually occurred. Beneath the engraving is the caption "The Author painting a Chief at the base of the Rocky Mountains." Yet in Catlin's description of this scene in the text of the memoirs he states that he painted the second chief of the Mandan tribe, Mah-To-Toh-Pa, indoors with a belt containing a tomahawk and scalping knife and wearing a bear claw necklace, surrounded by women and children. In the frontispiece these items have been removed. The scene has been shifted outdoors and two tipis have been located behind the group of figures.

What is the significance of these changes? How do they alter the meaning of the image? Removing some of the chief's

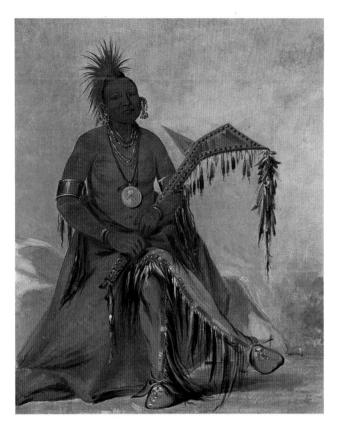

8.7 GEORGE CATLIN Clermont, First Chief of the Tribe (Osage), 1834. Oil on canvas, $29 \times 24 (73.7 \times 61)$

8.8 GEORGE CATLIN "The Author painting a Chief at the Base of the Rocky Mountains," frontispiece to Letters and Notes . . . , 1841. Engraving, $9\frac{1}{2} \times 6$ (24 × 15)

symbols of power as a warrior and spiritual leader—the tomahawk, scalping knife, and bear claw necklace—makes him appear less threatening, both to Catlin within the image itself and to the reader of Catlin's memoirs. Moving the scene outdoors allows Catlin to increase the number of figures who are witness to his recording of the features of the Mandan chief. This larger number, which now includes men as well as women and children, attests to the importance of the event and the significance of Catlin's artistic achievements. The expressions of fear and wonder on the faces of the spectators also attest not only to Catlin's own accomplishments as an artist, but also to those of European artistic mimesis in general. Catlin represents his ability to capture the physical likeness of the chief on canvas as an act of magic in the eyes of the Mandan villagers. While he has chosen to render his figures in the reductive graphic style of the Neoclassicist Flaxman, whose drawings of Greek vase figures were often described as "neo-primitive," Catlin's figures are still much more three-dimensional than the elementary stick figures on the sides of the tipi that represent Mandan artistic expression.

Catlin's familiarity with the pictorial art of the Mandan is recorded in his memoirs. In fact, Ma-To-Toh-Pa gave Catlin a replica of his own painted buffalo-skin robe on which he had recorded his military exploits. While the whereabouts of this robe are unknown today, another robe (collected in 1837) closely resembles Catlin's written and pictorial descriptions of the one he had been given. The horses and human figures are two-dimensional and highly schematic. Yet they are much more sophisticated in their rendering and design than the stick figures on the tipi. These stick figures, with their triangular torsos and frontal heads, more closely resemble the designs on an earlier Mandan buffalo robe sent to President Jefferson by the explorers Lewis and Clark in 1805. The later Mandan robe reveals an increasing sureness in the handling of human and animal bodies and a greater concern with decorative patterning. Artists in various Plains tribes would continue to develop this narrative artform throughout the nineteenth century and use it as a means of written communication, incorporating knowledge they had gained from observing the work of artists like Catlin while maintaining their own distinctive style and iconography. A major change in materials occurred in the middle of the century with the widespread introduction through trade of paper and new pigments. Some examples of these new works will be discussed below.

The inclusion of tipis in Catlin's frontispiece is puzzling, since he knew quite well that the distinctive architecture of the Mandan was a spherical earth structure—as evident in his painting The Last Race, Part of Okipa Ceremony. The tipis 8.6

8.9 GEORGE CATLIN
Catlin Painting the Portrait of
Mah-To-Toh-Pa—Mandan,
1857–69. Oil on board,
15½8 × 23½ (39 × 60.6)

8.10 Mandan buffalo robe, collected in 1837. Width $82\frac{3}{4}$ (210)

may have been included, in part, for compositional reasons. The central tipi provides a surface for the display of Native American imagery, and also connects the two major figures in the composition, Catlin and Mah-To-Toh-Pa. The lines marking its sides run through the heads of the two figures,

anchoring them within the pyramidal composition and suggesting a certain equality between them. The easel between the two figures also echoes the shape of the tipi, reinforcing the comparison between the stick figures there and the mimetic portrait resting on the easel, between the

"childlike" record of gun-toting exploits and the European celebration of noble individuality. The art historian Kathryn Hight has argued that by locating the Mandan in front of tipis, the dwelling structures of nomadic Plains tribes, rather than in front of the structures of the more sedentary, agricultural Mandan, Catlin participates in the creation of a generalized view of Native Americans, one which erases their differences and particularities (the tipi soon became a sign for "Indian"), even as he claims to be recording these particularities.

It is interesting to compare this engraving with a later painting based on it, Catlin Painting the Portrait of Mah-To-Toh-Pa—Mandan (1857–69). In this painting Catlin has removed the tipis and shifted Mah-To-Toh-Pa closer to the center of the painting, increasing the number of Mandan located behind the chief. He has also replaced the European easel of the earlier engraving with a makeshift structure of branches tied together, which replicates the structural framework of the tipi. In addition he leaves the canvas only roughly attached to its frame, suggesting the loosely attached hide coverings of the tipi. Thus, the tipi and easel of the engraving have been collapsed together in the painting.

8.8

8.9

The effect of these changes is to heighten the presence of the Mandan chief in the composition and the connection between the Mandan and nature, and to locate Catlin the artist more clearly within the Mandan world. The emphasis on Catlin and his talents as a painter of "Indians" was appropriate for the frontispiece of his memoirs. In his Indian Gallery, however, where he claimed to be recreating the "looks and modes" of various Native American tribes, viewers would have been more interested in the physical features and particularities of Mah-To-Toh-Pa and Mandan culture in general and in the surrounding landscape. Yet Catlin is still very much present as artist and creator in this image, and perhaps even more so than in the engraving, for in the painting Catlin presents himself as literally repainting the surfaces of the "Indian" tipi, as redefining the significance of the Mandan chief, and of pictorial representation in general, in Mandan culture.

ALTERNATIVE REPRESENTATIONS: PHOTOGRAPHY AND LEDGER ART

At the same time that Catlin was drawing on the conventions and tools of easel painting to construct his image of Native Americans, others were utilizing a different medium, one which they claimed was better able accurately to render the faces of the frontier—photography. How these photographic faces differed from the painted faces by Catlin can best be seen by comparing Catlin's *Clermont, First Chief of the Tribe* to

8.11 Thomas Easterly's *Keokuk, or the Watchful Fox* (1847).

Clermont is seated on a rock, with a loosely painted landscape behind him, an arrangement common in British portrait painting. He is at ease, legs crossed, head slightly tilted, eyes looking off into the distance, the hint of a smile on his face. His skin and clothes are painted a warm red-brown. The viewer's eye wanders freely over Clermont's body, stopping to examine the jewelry or feathers or painted war club cradled in his arms or the peace medal hanging around his neck. There is a sense of complicity between the viewer/painter and the sitter, a willingness on the part of Clermont to expose himself to such scrutiny.

The opposite is true of Easterly's photograph of the Sauk and Fox leader Keokuk. Confrontation replaces complicity. Rigidly posed in a stark interior setting, eves staring straight ahead, Keokuk forces the viewer to acknowledge the artificiality of the posing process even as the viewer is struck by the immediacy or presence of Keokuk himself. Paintings like Catlin's were able to sentimentalize, to romanticize, and thus to create a comfortable distance between the viewer and the subject. Easterly's photograph, like many mid-nineteenthcentury photographs, did not do this. Instead it presented in black and white the impassive, the stony-faced, rendered in sharp detail yet emotionally inaccessible. It captured the underlying hostility embedded in this encounter between white photographer and Native American chief. Keokuk's imprisonment within the photographic frame can be seen as the pictorial counterpart of the real imprisonment of his people on reservations (as I indicated earlier, conquering and recording often go hand in hand).

Keokuk was well-known for his diplomacy in negotiating with government officials. In 1837 he succeeded in protecting Sauk and Fox claims to their Iowa land holdings against counterclaims by the Sioux. Over a decade earlier, in 1824, he had traveled to Washington, D.C. with a delegation of Sauk and Fox, Iowa and Piankashaw leaders. During this visit his portrait was painted by King. A copy of this portrait, made by King in 1827—Keokuk, Sac (Watchful Fox—reveals King's reliance on the same European portrait tradition that Catlin drew upon in painting Clermont. The same contrasts exist, therefore, between King's painting of Keokuk and Easterly's photograph. In the painting Keokuk is at ease, a slight smile on his face, his gaze directed beyond the picture frame. The trees and sky in the background locate the tribal chief in an illdefined landscape, belving the fact that the portrait was painted in King's studio. Easterly engages in no such illusionism. Keokuk sits in front of a blank backdrop, directly engaging the viewer with his gaze. The bulky figure of the older man also contrasts with the slender, almost boylike body of the young Keokuk. It is difficult to imagine that the painted Keokuk is the same young man that the ethnologist Henry Rowe Schoolcraft, who met him in 1825, described as "like

8.11 THOMAS EASTERLY *Keokuk, or the Watchful Fox*, 1847. Daguerreotype.

another Coriolanus," "a prince, majestic and frowning. The wild, native pride of man, in the savage state, flushed by success in war, and confident in the strength of his arm, was never so fully depicted to my eyes." While Schoolcraft played upon the savagery of the "noble savage," King chose to emphasize the nobility, downplaying any sense of threat or aggression.

Many of the photographs of Native Americans taken by Easterly and others appeared in sets of stereoscopic photographs sold throughout the latter half of the nineteenth century for viewing in the home. Photographs were also added to official government records of transactions between Native American peoples and government representatives and were translated into illustrations that appeared in popular magazines and novels. Sometimes these photographs provided only general inspirations for such illustrations; other times they were literally copied. This was also the case with certain paintings and drawings. Sometimes the magazine illustrator utilized general painterly conventions in creating his or her image; other times s/he copied specific paintings or drawings in detail.

Page 41 of the January 16, 1869 issue of *Harper's Weekly* contains a series of images taken from the worlds of both painting and drawing, and photography. This page is part of a larger article recounting General Custer's surprise attack and

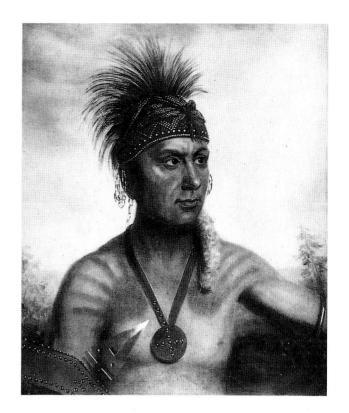

8.12 CHARLES BIRD KING Keokuk, Sac (Watchful Fox), 1827. Oil on panel, $17\frac{1}{2} \times 13\frac{3}{4}$ (44.4 × 34.9)

victory over the Cheyenne Chief Black Kettle at Washita River, Oklahoma, on November 27, 1868. After killing the chief and 102 of his warriors, Custer and his troops proceeded to the undefended village where all men over 8 years old and many of the women and younger children were also killed. The lodges and winter stores of food and ammunition were then destroyed, leaving those who survived to die a slow death from starvation or exposure to the cold. Custer also destroyed 875 Indian ponies.

The three wood engravings that take up most of the page are meant both to illustrate and justify what came to be known as the Washita River Massacre. The top and bottom images were engraved versions of drawings produced by Theodore R. Davis, a well-known illustrator-reporter on the *Harper's* staff. While Davis had spent six months with Custer out West in 1867, he had been back East for at least a year when the Washita River Massacre occurred. His experience with Custer undoubtedly made him the most logical person to be assigned the task of illustrating the article.

The drawings Davis produced give the impression that he had actually been present at Washita River, an impression that is reinforced by the very fact that they are "sketches," quickly executed, and by the phrase "Sketched by Theo. R. Davis" included in parentheses after the captions for each image. Davis did not portray the actual battle itself, but instead

8.13 THEODORE R. DAVIS and WILLIAM S. SOULE Page 41, Harper's Weekly, January 16, 1869

showed two events that happened immediately afterwards. The top engraving is captioned "Custer's Indian Scouts Celebrating the Victory Over Black Kettle." The opposition between the civilized white soldiers and the savage Indian scouts is spelled out in the wild gestures, face paint, and costumes of the group of Osage and Kaw scouts, who perform by firelight, and the impassive faces and poses of the white soldiers who watch. The demonic aspect of the scouts is further reinforced by the tails that form part of their costume. This sketch also suggests that Native Americans, as much as whites, were responsible for the massacre at Washita River. The U.S. Army took advantage of existing rivalries between tribes and played one tribe off against another, promising land or weapons in exchange for cooperation.

The bottom image shows Custer's soldiers engaged in an activity that the caption describes as "shooting down worthless horses." Again there is an opposition between the wild, terrified horses and the calm soldiers who shoot the horses in the head at close range. Thus, the horses—untamed

nature—and Native Americans are equated. This would not be the first time that the destruction of animals was seen as parallel to the destruction of Native Americans. The animal in question, however, was usually the buffalo. Just as the destruction of the Cheyenne horses (certainly not "worthless" to them) was part of the military strategy of the 1868–9 campaign, so too was the destruction of buffalo part of a larger military strategy. "Kill every buffalo you can," advised one army officer. "Every buffalo dead is an Indian gone."

The frantic activity contained in the upper and lower sketches is in sharp contrast to the stasis of the central image. The words in parentheses after the caption "The Scalped Hunter" explain this contrast—"Photographed by Wm. S. Soule." Photographic technology at that time required the subject to remain still for long periods of time—anywhere from five to thirty seconds. Photographs of military ventures, therefore, often included images of burned-out buildings or of corpse-filled battlefields. This is particularly evident in the extensive photographic record of the Civil War that was produced by photographers such as Mathew Brady and Alexander Gardner (see pp. 283–4). While the sketch could capture the action of war, even if only as conceived of in the imagination of the artist, the photograph could clearly capture only its more deadly aftermath.

This wood engraving after a photograph by William Soule contains the one dead person on the magazine page. But this white man did not die as a consequence of the Washita River battle. The source of the photograph is included in the *Harper's* article. The hunter Ralph Morrison was murdered and scalped by Cheyenne warriors less than a mile from Fort Dodge, Iowa, on December 7, 1868. William Soule, stationed at the Fort, "availed himself of the opportunity to benefit science and gratify the curiosity of your readers by taking a counterfeit presentment of the body, literally on the spot." This was, according to the author of the article, "the only picture ever taken on the Plains of the body of a scalped man, photographed from the corpse itself, and within an hour after the deed was done." The author continues:

The pose of the remains is delineated exactly as left by the savages, the horrible contortion of the ghastly features, the apertures left by the deadly bullet, the reeking scalp, the wounds, the despoiled pockets of the victim, all are true to life anomalous as the presentment of death may seem.

The gruesome detail of this description serves not only to titillate the reader but also to reinforce the veracity of the visual account. This aspect of truthfulness is further guaranteed by the scientific method used to capture the scene—photography—despite the fact that the written description includes elements not readily visible, or not visible at all

("horrible contortion"), in the engraving. Of course, even if the dead body had been photographed exactly as it had been found, the two figures behind it were obviously posed to create a connection between the dead man and the actions of the soldiers who would avenge his death. The death of one white hunter thus becomes the justification for the Washita River Massacre and its aftermath, as captured in the images at the top and bottom of the page, despite the fact that the hunter was killed ten days after the massacre itself had occurred.

The battles between Native American warriors and the U.S. Army continued throughout the late 1860's and early '70's, with the former suffering increasing numbers of defeats. In the spring of 1875 seventy-two Southern Plains chiefs and warriors were imprisoned at Fort Marion in Saint Augustine, Florida. These leaders of the Cheyenne, Kiowa, Arapaho, Comanche, and Caddo Indians were deemed "dangerous criminals" by the U.S. government for their wartime aggressions and were held in Fort Marion to ensure that their people would adjust more peacefully to the reservation life that had been imposed upon them in the aftermath of the Southern Plains wars.

During their three years of incarceration at Fort Marion, many of these chiefs and warriors filled drawing books with brightly colored images of Plains Indian life. Such drawings on paper were not unique to Fort Marion, but had appeared earlier in the century after the introduction of paper and drawing materials to the Plains Indians by white traders. By the last third of the century this "ledger art," so-called because the paper often came from accountants' ledgers, began to replace the traditional pictorial surface of buffalohide robes within tribal culture. The imagery that filled these ledger books continued a long tradition of narrative pictorial art that had developed within Plains tribal culture both before and after the arrival of Europeans. The figures were highly two-dimensional, with clear, dark outlines that were carefully filled in with flat areas of color. The exploits of warriors and hunters were the primary subject matter of these works, which were often taken along on hunts or into battle.

Captain Richard H. Pratt encouraged the artistic efforts of his prisoners by providing them with drawing materials and allowing them to sell their works to the tourists who often visited the fort. There was thus a new audience for the work of these artists—white tourists rather than fellow warriors or tribal members. The effect of both this new situation of imprisonment and this new audience can be seen in the changing subject matter: scenes from daily life at the fort were now added to war and hunting exploits—which led to new representations of the encounter between whites and Native Americans. At least one of the Fort Marion artists, the Cheyenne Howling Wolf, also had extensive contact with European artistic traditions during a trip to Boston for

medical treatment, which resulted in certain stylistic changes in his work, notably an increased painterliness that countered the two-dimensionality of his earlier ledger art.

In Fort Marion Prisoners Dancing for Tourists (1875–7) the Cheyenne warrior Cohoe presents his own interpretation of the theme of "the savage Indian entertaining civilized Euro-Americans" that had been represented by Davis approximately six years earlier in his Harper's sketch. There are striking differences between the two images. While Davis places the viewer at eye level, within the circle of army officers, Cohoe presents a double perspective. The viewer is simultaneously on the same level as the group and above it. The overall feeling is of distance, or removal, as opposed to the inclusiveness of Davis's piece. While Davis creates a sense of three-dimensionality through the use of shading and perspectival conventions, Cohoe emphasizes the two-dimensionality of his image through the use of flat areas of color and clearly outlined figures placed in a space devoid of ground lines or other orientational markers. Davis pays great attention to the costumes of the dancing scouts while Cohoe pays equal attention to the costumes of the white tourists, particularly those of the women. The identities of Cohoe's figures appear, indeed, to lie in their clothing rather than their facial features, for their faces are left completely blank.

Both Davis and Cohoe were creating for white audiences. They were, however, creating from strikingly different positions. The white artist Davis was creating within the conventions of Western art for an employer committed to the sensationalization of information and for an audience eager to experience—vicariously of course—some of the drama of the frontier, an audience that, for the most part, had accepted the distinction between "savage" and "civilized" that is embedded in Davis's image. The Cheyenne prisoner Cohoe, on the other hand, was drawing upon the conventions of Plains Indian hide painting to create images for white tourists who wanted to take with them a souvenir of their trip to what the art historian Janet Berlo describes as an "idealized penal colony, where a miniature but representative society of Plains warriors enacts scaled-down and sanitized simulacra of warfare for their captors' pleasure." The three-dimensionality and mimetic nature of Davis's work read as "real" to the white viewer; the two-dimensionality of Cohoe's work read as childlike, naive. The tourists who left Fort Marion thus took with them, again in Berlo's words, "a memento of their voyeuristic experience, secure in their privileged insight into 'the Indian Problem' and its solutions."

Yet Cohoe's fellow prisoners would have read the image differently. Having experienced, themselves, the indignity of having to don "traditional dress" to perform for tourists, they may well have read the scene as one of humiliation rather than pleasurable entertainment. The two-dimensional style would

8.14

8.13

8.14 COHOE Fort Marion Prisoners Dancing for Tourists, 1875-7. Graphite and colored pencil on paper.

have signified not "childlikeness," but their own art traditions, while the tourist audience arranged in rigid order around the dancers would have conveyed a sense of the dancers' own entrapment, both literally at Fort Marion and figuratively within a foreign culture. Yet the gaps between the groups of tourists suggest that this entrapment was far from complete. The continuation of their ceremonies and their visual arts traditions, in no matter how compromised a form, undoubtedly functioned as a means of resistance to the imposed white order. Through their ledger drawings the imprisoned chiefs and warriors represented their experiences at Fort Marion not only for themselves and for white tourists, but also for other members of their tribes: the Fort Marion prisoners often sent drawings to their families as "letters" and received similar pictographic responses in return.

The Kiowa artist prisoner Wo-Haw also created an image that spoke to the entrapment of Native Americans within white culture. In *Reading Class at Fort Marion* (1875–7) Wo-Haw depicts, again in the flat, two-dimensional Plains style, a schoolroom scene where nine warriors, in Western suits with hair shorn, attentively watch the female teacher in the center. But this group is also being watched, not by another white teacher or soldier but by the spectral form of a Native American with a feather in his long hair. Here is the ghostly

presence of that culture from which these warriors had been forcibly removed, a culture that their white captors wanted them to forget or to replicate only for the amusement of tourists.

In the late nineteenth century two solutions had been proposed to the "Indian problem": extermination ("the only good Indian is a dead Indian") and assimilation. The need for a "solution" became even greater after the defeat of Custer on June 25–26, 1876 by the Sioux at the Battle of Little Big Horn in southeast Montana. An article in the September 1876 issue of Frank Leslie's Popular Monthly suggested that reservations and the Indian way of life should be abolished and Indians given trousers and shirts instead of blankets. This blueprint for survival was also promoted a decade later by The Friends of the Indians, which included many wealthy philanthropists and Protestant clergymen, who felt Native Americans should be given membership in U.S. society in exchange for a repudiation of their Indian ways. The Friends lobbied in support of the Dawes Act, passed by Congress in 1887, which offered an allotment of land and eligibility for full citizenship to every Native American male who willingly cut his ties with his tribe and adopted the habits of "civilized" Euro-American life.

Yet the author of the article in Frank Leslie's Popular Monthly also acknowledged that there had been greater

8.15

8.15 Wo-HAW Reading Class at Fort Marion, 1875-7. Pencil and crayon on paper, $8\frac{3}{4} \times 11\frac{1}{4}$ (22.2 × 28.5)

success in assimilating Africans and Chinese than there had been in assimilating Indians, primarily because the former had been removed from their homelands and cultures, making their immediate survival in this new country more dependent upon assimilation. But this was not a "new" country for Native Americans, and their sense of entitlement to their ancestral lands and ways of life was strong. Assimilation was successful only after a large percentage of the Native population had been killed, and then only partially successful. The land on which they lived, and continue to live, functioned as a reminder of their culture and their history.

Another image speaks to this process of assimilation, an image captured almost a decade after the final major military encounter between Native Americans and the U.S. military at Wounded Knee, South Dakota, on December 29, 1890, a battle Native Americans lost. The image in question is a photograph by the Washington, D.C. photographer Frances Benjamin Johnston entitled *Class in American History* (1899–1900). It was part of a larger series Johnston had been commissioned to execute of the Hampton Institute, a coeducational school for African Americans and Native Americans founded just after the Civil War. The series was shown at the Universal Exposition in Paris in 1900 as part of an exhibit tracing the rapid progress of African Americans since the end

of the Civil War. Here again, as in Wo-Haw's drawing, Native Americans in Western European garb with cropped hair, this time accompanied by African Americans, are pictured with a Native American in "traditional" dress. This time the "traditional" Native American is not a ghostly presence—the scientific medium of photography did not traffic in ghosts. He is present in the flesh and blood—but not, however, as evidence of a living culture. Rather, he is presented as "history" and as artifact, a symbol of a noble yet "savage" culture done away with by the forces of "progress" embodied in the print of gunslinging cowboys or U.S. cavalry above the heads of the children and in the very clothes of the children themselves.

Both Wo-Haw and Johnston present, in their images, the juxtapositions marveled at by the anthropologist Lévi-Strauss and brushed away by the photographer Curtis. They mark the coming together of two worlds that was so crucial a part of the development of visual culture and of a sense of national identity in the U.S. in the nineteenth century. Wo-Haw presents Native American culture as a living presence (albeit a ghostly one) in the daily lives of his people; Johnston presents it as a curiosity, an example of what needs to be left behind as a lived experience, yet, at the same time, kept alive as a memory through endless pictorial representations. This living memory

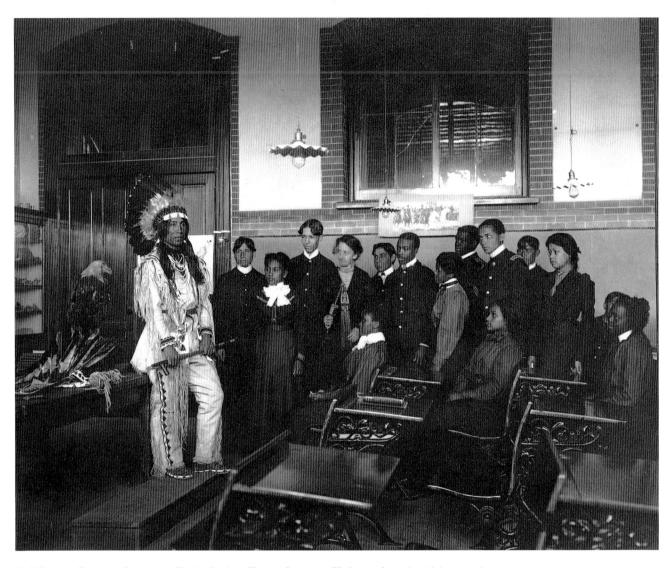

8.16 Frances Benjamin Johnston Class in American History, 1899–1900. Platinum print, $7\frac{1}{2} \times 9\frac{1}{2}$ (19 × 24.1)

is necessary, according to Slotkin, in order to assuage a national conscience trying to reconcile the near-destruction of a people with the establishment of a democratic nation. Wo-Haw's image, and others like it, however, also need to be brought to the fore in order to remind us now that Native American culture did not die in the nineteenth century, but

remained a resilient and dynamic force in Native life. Recognizing this allows us to read the many images of the American frontier critically, not as records of unchallengable facts or truths but as the products of individuals perpetuating or resisting the material and ideological processes of colonization and conquest.

BLACK AND WHITE IN AMERICA

FRANCES K. POHL

AMERICA AS AN AFRICAN INVENTION

WHEN EMMANUEL LEUTZE'S WESTWARD THE Course of Empire Takes Its Way (Westward Ho!) appeared in its final form in the Capitol building in Washington, D.C. in December 1862, there were certain significant changes from the oil study of 1861. One of these changes, already mentioned in Chapter 7, was the addition of symbols of mining, hunting, and agriculture. A second change, and perhaps the most important, was the inclusion of an African American man in the center foreground leading a white woman and child on a mule.

The historian Lerone Bennett, Jr. has argued that "it is impossible to understand white America, it is impossible to understand Thomas Jefferson or George Washington or the U.S. Constitution, without some understanding of Africa's gift to the New World. And what that means . . . is that America, contrary to the generally accepted view, is an African as well as a European invention." The presence of large numbers of peoples of African descent on the North American continent since the sixteenth century has had a profound effect on the development of social, political, and economic structures in the U.S. For example, African slave labor made possible the growth of a plantation economy in the South in the seventeenth and eighteenth centuries, while African American wage labor contributed to the expansion of industrialization in the North in the late nineteenth century. And just as colonists from Northern Europe attempted to justify their destruction of Native Americans through the construction of the myth of the "noble savage," so too did these same colonists and their descendants try to justify their enslavement and exploitation of Africans and African Americans through representations of them as inferior to white Europeans. On the one hand, Africans were childlike and in

need of care; on the other, they were savage and in need of disciplining (they were not, however, "doomed to perish" for their labor was central to the country's economy). Pictorial representations of Africans and African Americans played an integral part in the construction and perpetuation of these beliefs and in the defining of a national culture. But they also played an integral part in the challenges to these beliefs and to this definition of national culture, challenges which grew in number and intensity by the middle of the nineteenth century and led to armed conflict between the North and the South. This chapter will look at both kinds of representations, those which attempted to enforce the myth of the child savage, and those which condemned it and offered alternative visions of Africa(n) as America(n).

Leutze received his Capitol commission in June 1861, only a few months after the opening salvo of the Civil War. One of the many causes of this war was disagreement over whether or not slavery should be extended into the new territories. Secretary of War Simon Cameron, who approved Leutze's initial study, was an expansionist opposed to the emigration of African Americans into the western territories. Leutze's inclusion of an African American man in such a prominent position in the final version of his celebration of western expansion indicates that he differed with Cameron on this point (Leutze's pro-abolitionist sentiments were well known). Instead, he suggests that African Americans, like their white counterparts, might experience a new freedom in the West. The inclusion of the African American man as part of a family group on a mule also suggests a parallel between the flight of the Holy Family from persecution at the hands of Herod and the opening up of the West. Leutze therefore provides another gloss on the theme of Manifest Destiny, this time marked by the morally charged arguments of the abolitionist movement.

The Civil War forced a re-evaluation of the image of the African American in the art and literature of the U.S. Prior to the Civil War the dominant nineteenth-century stereotype of African American men was the high-stepping, banjo-playing "darkie," happy and childlike, who, when not working contentedly in the fields, performed either for his family or for his white owners. African American women were "mammys," protective of their white charges and proud of their place as servant, maid, and nanny within the white household. Enslavement was seen as "good" for Africans, who were inherently "savage" and had to be domesticated through slavery. To free them, therefore, would actually do them a disservice, for they would lose their childlike innocence (which some argued was achieved through enslavement and others claimed was "innate") and revert to savagery.

Such stereotypes appear in *Quilting Frolic* (1813) by John Lewis Krimmel (1786–1821). Krimmel was born in Germany and studied with the genre painter Johann Baptist Seele before coming to the U.S. in 1810. He was also an admirer of the works of the British artists William Hogarth and David Wilkie and, like them, recorded the looks and foibles of the peasant, merchant, and artisanal classes.

9.2

Quilting Frolic contains a detailed inventory of the belongings of a middle-income household. The paintings on the wall—a portrait of Washington flanked by two maritime scenes, one of which involves a battle-attest to both the cultured and patriotic character of the household members. Other objects hanging on the walls or resting on the tops of cupboards indicate the social status and lineage of the family. The black servant girl and the black fiddler also mark this family's social status, the girl through her role as a servant and the fiddler through his shabby clothing, which contrasts so markedly with the finery of the white figures next to him. According to the art historian Guy McElroy, Krimmel was also among the first "to utilize physiognomical distortions [toothy grins, oversized lips] as a basic element in the depiction of African-Americans; his comic portrayal was probably meant to establish a good-natured humorous scenario, but it profoundly reinforced developing ideas regarding the humorous, even 'debased' appearance of African-Americans."

While the stereotypical depictions of African Americans produced by Krimmel and others dominated the artworld in the first half of the nineteenth century, such images did not go totally unchallenged, particularly after the establishment of the American Anti-Slavery Society in 1833. Joining African American anti-slavery organizations such as the Free African Society, founded in 1787, and the General Coloured Association, founded in 1826, the American Anti-Slavery Society became one of the key organizations in the U.S. abolitionist movement. Led by both African Americans and whites, it

flooded the southern slave-holding states with abolitionist literature and lobbied throughout the U.S. for an end to slavery. It was fueled by the rise of evangelical religion in the 1820's, which called for an end to sinful practises and allowed African Americans to enter its ranks. The early abolitionist movement also revived the charges of political hypocrisy that had been leveled at the rebel revolutionaries by the British at the end of the eighteenth century. How could revolutionaries claim independence in the name of freedom and liberty when they themselves were enslaving a whole race of people? Many artists and writers belonged to, or were inspired by, the efforts of the abolitionist movement and translated its messages into written or painted form.

One such artist was Nathaniel Jocelyn (1796–1881). Initially trained as an engraver, he turned to painting in 1820 and became well-known as a portraitist in the New Haven area of Connecticut, although he returned to engraving at the end of his career after a disastrous studio fire. In 1839 he produced a large oil portrait entitled *Cinque*. It commemorates an event of that year in which Cinque, one of fifty-three men and women captured by Spanish slavers in the Mendi region of Africa, led a rebellion against the slavers on the ship La Amistad. The Spanish had transported their slaves to Havana, despite a treaty forbidding slave trading in British waters. The rebellion occurred after the slaves had been sold in Havana and were being transported to Puerto Rico. While Cinque and the others demanded that the ship return to Africa, the crew altered its course at night and managed to bring it ashore on Long Island. U.S. forces arrested the mutineers and freed the crew, but abolitionists defended the cause of the mutineers. After two years of legal proceedings, the Supreme Court ruled the Africans had been illegally seized. Cinque and his compatriots then toured the Northeast, appearing at numerous anti-slavery meetings, before returning to Africa in 1841.

In place of the physiognomical distortions used by Krimmel in his depiction of the black fiddler, Jocelyn has produced a highly individualized, noble portrait of an African man. Jocelyn's abolitionist sympathies played a major role in his decision to depict Cinque in this manner. But he was also undoubtedly influenced by the numerous accounts of Cinque's activities in the popular press that included descriptions of him as "of magnificent physique [and] commanding presence." Phrenologists had also carefully analyzed Cinque's head in an attempt to understand his daring behavior and had reported that the shape of his head indicated "great vigor of body and mind . . . ambition, independence . . . love of liberty." Such inquisitiveness suggests that, despite wellknown accounts of numerous slave rebellions on board slave ships, many Euro-Americans still assumed that "ambition," "independence," and the intelligence necessary to plan a successful revolt were anomalies among Africans. Their obsession with his physical features, recorded in Jocelyn's portrait, also suggests that they thought his intelligence could be due to the fact that he did not "look like an African": in other words, he did not look like the stereotype of Africans that had been created by white artists in the U.S.

Jocelyn has also rejected the ragged clothing of Krimmel's fiddler and instead has clothed Cinque in the white toga of ancient Greece and Rome. By utilizing certain conventions from European Neoclassical painting—the pose, the toga— Jocelyn creates a parallel between the struggles for freedom of Cinque and African slaves in general and the struggles of ancient Greeks and Romans. Cinque is thus re-dressed—his African clothing is removed and the suggestion of "otherness" displaced to the palm trees in the background—in order to make his message more palatable to a white audience accustomed to conceiving of the U.S. as a continuation of the political ideas of democratic Greece and Republican Rome. The reference to Greece also had a more contemporary relevance. The U.S. had supported the Greeks in the Greek War of Independence against the Turks that lasted from 1821 to 1830. Many U.S. politicians and abolitionists viewed this conflict as one between the civilized, heroic Greeks and the barbarous, heathen Turks, who often trafficked in slaves. Jocelyn included at least one reference, however, to the specific contemporary reality of African slaves. Instead of a spear, Cinque holds in his left hand a stalk of cane, a reference to the sugar-cane fields of the Caribbean where Cinque and the other fifty-two African slaves were to have labored.

The abolitionist movement also resulted in growing support for the education of African Americans. A number of African American writers and artists received both the financial and moral backing they needed in order to succeed in their chosen field. One such artist was Robert Scott Duncanson (1821 or 1822-72). Duncanson began his career as a painter of still lifes and "fancy pieces" in Cincinnati, Ohio and, with the help of funds from the Anti-Slavery League and private patrons, was able to make three trips to Europe (1852, 1865, 1870) where he studied European landscape traditions. He subsequently produced a number of landscape paintings with titles such as Valley Pasture (1857), Falls of Minnehaha (1862) and Landscape with a View of Vesuvius and Pompeii (1871) that reveal the influences of the U.S. landscape painter Thomas Cole and the Europeans Claude Lorrain and J. M. W. Turner.

Duncanson produced only two paintings that dealt directly with African American subjects, one of which was Uncle Tom and Little Eva (1853). Located in the foreground of a landscape that combines a luminous harbor scene with an overgrown arbor are the two central characters in Harriet Beecher Stowe's popular abolitionist novel *Uncle Tom's Cabin*; or, Life Among the Lowly (1852). Duncanson's composition

was patterned after a wood engraving by Hammatt Billings 9.4 (1818–74) that appeared in the illustrated edition of the novel (1852), as well as on the coversheet of the popular song Little Eva; Uncle Tom's Guardian Angel by John Greenleaf Whittier (1852).

Billings's engraving illustrates a scene at the opening of Chapter 22 at the St. Clare family's summer home, "on a little mossy seat, in an arbor, at the foot of the garden" on the shores of Lake Pontchartrain. It is sunset on a Sunday evening and Little Eva is reading from the Bible to her humble and faithful servant and friend Uncle Tom, who had earlier saved her from drowning. The scene illustrates Little Eva's commitment to educating the family's black servants and, ultimately, to using her inheritance to buy a home in one of the free states so all of the servants could be liberated. It also attests to Little Eva's (and thus Stowe's) belief that both spiritual and physical salvation for African Americans would be found through devotion to the Christian God. The little blond Eva thus represents the best of abolitionist sentiment and Christian love, although she dies shortly after the scene by the lake and thus leaves the task of freeing African American slaves to those who have been inspired by her example.

The patronizing tone of both the written passage and the engraving are unmistakable: the blond, white child will lead the old black man out of darkness and ignorance into salvation and light. The passivity and devotion of Uncle Tom was seen by white abolitionists as evidence of his humanity and of the rightness of their efforts to free him. While such portrayals may have been necessary in order for the abolitionist movement to make political headway, they were not wholeheartedly accepted by all African Americans. "Uncle Tom" soon became a derogatory label, used by some African Americans to criticize others who felt their salvation lay in working with, rather than against, white people and their interests. Stowe herself reaffirmed her commitment to the "Uncle Tom" approach to liberation in her second antislavery novel, *Dred* (1856), in which she condemns the idea of African Americans achieving freedom through retaliation against whites. The character of the African American rebel in the book is obviously patterned after Nat Turner, the slave who led a rebellion in 1831 in Virginia that resulted in the killing of fifty-five whites before the rebellion was crushed and Turner caught and hanged. Turner's was only the latest in a series of revolts or planned insurrections that had increased the tension between southern plantation owners and their growing slave population.

Duncanson's painting maintains the patronizing tone of the Billings engraving and the Stowe text, suggesting that he shared Stowe's sentiments regarding the "Uncle Tom" approach to the liberation of slaves. He has made the scene more dramatic than the Billings engraving, however, by

9.1 NATHANIEL JOCELYN Cinque, 1839. Oil on canvas, 30½ × 25½ (76.8 × 64.8)

placing Little Eva in front of Uncle Tom, standing and gesturing toward the setting sun with eyes turned upward. There is a sense of Christlike prophecy in her pose, suggesting her impending death, and an equal sense of religious devotion on the part of Uncle Tom. This interpretation of the scene draws, once again, upon Stowe's text: "[Uncle Tom] loved her as something frail and earthly, yet almost worshipped her as something heavenly and divine. He gazed on her as the Italian sailor gazes on his image of the child Jesus,—with a mixture of reverence and tenderness."

Those, like Nat Turner, who rejected the "Uncle Tom" approach to the problem of slavery advocated open rebellion. Indeed, the rebelliousness of southern slaves had forced the federal government to confront the real possibility that an end to slavery might come about through a massive slave uprising, which might well spread beyond slavery to an attack on the enslavers and the privileged classes in general. While the Civil War is connected in the minds of many to the liberation of African American slaves, it was as much, if not more, about controlling the *may* in which they were to be liberated.

9.2 JOHN LEWIS KRIMMEL Quilting Frolic, 1813. Oil on canvas, $16\% \times 22\%$ (42.8 \times 56.8)

9.3 ROBERT SCOTT DUNCANSON *Uncle Tom* and Little Eva, 1853. Oil on canvas, $27\frac{1}{4} \times 38\frac{1}{4}$ (69.2 × 97.2)

The possibility of a massive slave revolt was once again brought home to the southern states in 1859. That year, the sixty-year-old white man John Brown led a group of twenty-two men, five of whom were African American, in an attempt to seize the federal arsenal at Harper's Ferry in West Virginia and then set off a revolt of slaves throughout the South. His plan failed and he was executed by the state of Virginia with the approval of the federal government. Many in the South were convinced that northern abolitionists and politicians were behind Brown's actions and that the North was committed not only to depriving them of their property, but also, if necessary, of carrying out their objective through the arming of southern slaves.

The critical reception of two different images produced in 1859 gives an indication of the tensions surrounding the issue of slavery in the U.S. at this time. John Rogers (1829–1904), a Yale-trained engineer who turned to sculpture in the late 1850's, created many small genre scenes which were reproduced in plaster and sold in great numbers. The first work that Rogers mass-produced and offered for sale on a mail-order basis was his Slave Auction (1859), put on the market only a few weeks after the execution of John Brown. The group includes a white auctioneer in the center, calling for bids, while a slave family is located in front and to the right and left of the podium. The male slave assumes an angry and aggressive stance, arms crossed, a scowl on his face. The woman cradles one child in her arms while another hides behind her skirt. The message of the piece is twofold: slavery is an affront to the dignity and humanity of African

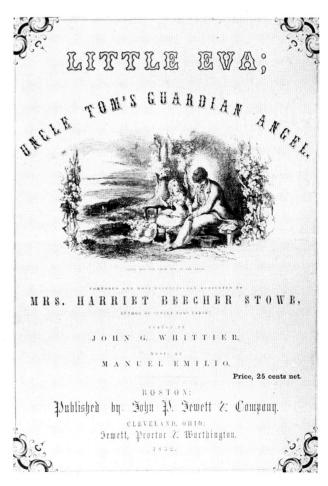

9.4 HAMMATT BILLINGS Uncle Tom and Little Eva, 1852. Wood engraving by Baker and Smith, $3\frac{1}{2} \times 5\frac{1}{2} (8.9 \times 14)$

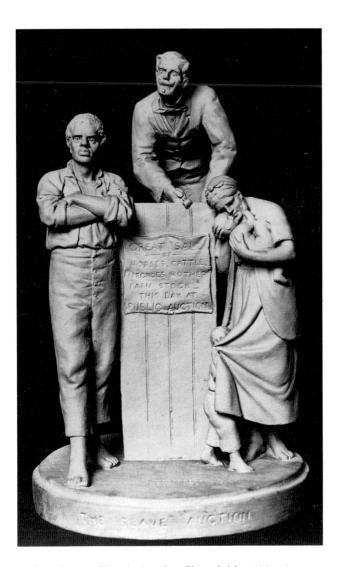

9.5 JOHN ROGERS Slave Auction, 1859. Plaster, height 131/4 (33.7)

Americans, and African American men are not passively going to accept this consignment to slavery. The work did not sell as well as Rogers had expected, prompting him to comment at the end of the year: "I find the times have quite headed me off... for the Slave Auction tells such a strong story that none of the stores will receive it to sell for fear of offending their southern customers."

The second work produced in 1859, which received a much more positive response, was *Negro Life in the South* by Eastman Johnson (1824–1906), later renamed *Old Kentucky Home* after the 1853 Stephen Foster popular song written in black dialect. The painting was exhibited at the National Academy of Design's 1859 spring exhibition and portrays African Americans engaged in a variety of leisure-time activities—playing the banjo, dancing, socializing, playing with children. In style and subject matter it shows the influence of Johnson's studies in Dusseldorf and Holland

from 1849 to 1855. While there he had been impressed by the minutely detailed studies of peasant and small-town life that had been recorded by Dutch artists, particularly in the seventeenth century.

The figures are arranged for the most part in discrete groups in front of a ramshackle house. A woman and child look out of the top window at the scene below. But they are not the only ones gazing upon these activities. Stepping through a hole in the fence between the slave quarters and the slaveowners' house is a young white girl, dressed in a finery that, as in the Krimmel painting, contrasts sharply with the ragged clothing of the slaves. Her presence is acknowledged by two young girls, one of whose skin is much darker than the other. While the varying shades of skin color contained in the painting could be accounted for by the varying skin colors of West Africans themselves, this variety could also be caused by another avenue of contact that was quite common between male slave-owners and their female slaves—rape. The offspring of such violent encounters were always considered African American, and thus slaves.

The painting was an instant success when it appeared before the public, due to both its style and its content. The scene was painted in painstaking detail, achieved in part through Johnson's use of the backyard and household servants of his father's house in Washington, D.C. as models. This detail engaged viewers and convinced them of the artist's consummate talents. The scene was also noncommital on the issue of slavery. Abolitionists in the North interpreted the scene as a condemnation of the dismal living conditions of southern slaves while slaveholders in the South were confirmed in their belief that, despite somewhat "uncomfortable" living conditions, southern slaves were basically a happy lot. The contrast between the delapidated slave quarters and the home of the white slave-owners could also be read in two ways—as evidence of the future prospects of a liberated people on the one hand, or as evidence of the peaceful coexistence of master and slave on the other.

AFRICAN AMERICANS AND THE CIVIL WAR

What was the relationship between this image—and the many others like it showing happy, dancing slaves—and the material conditions of slave life in the South? John Little, a freed slave, helps us formulate at least a partial answer:

They say slaves are happy, because they laugh, and are merry. I myself and three or four others, have received two hundred lashes in the day, and had our feet in fetters; yet, at night we would sing and dance, and make others laugh at the rattling of our chains. Happy men we must have been!

particularly volatile political issue in 1850, the year California applied for statehood. Before this, there were fifteen free states and fifteen slave states. The addition of California threatened to tip the balance in favor of the free states. A compromise was worked out between the North and the South that allowed California to join the Union. One element of this compromise was the Fugitive Slave Act, which called for the forced return of escaped slaves to the South. This Act was further reinforced by the Supreme Court's Dred Scott decision of 1857 which confirmed that a slave's arrival in the free North did not automatically give the slave his or her freedom. Three justices also held that an African American descended from

Many of the paintings of African Americans during and

immediately after the Civil War focused on the flight of slave

families. These images were often based on events artists had

witnessed while serving in the army or accompanying Union forces. The treatment of escaped slaves had become a

Two examples of images depicting the flight of slaves to the North are Eastman Johnson's A Ride for Liberty: The Fugitive 9.7 Slaves (ca. 1862–3) and Theodor Kaufmann's On to Liberty 9.8 (1867). Johnson's A Ride for Liberty is strikingly different from his earlier Old Kentucky Home. In place of a meticulously rendered anecdotal scene of slave families contentedly enjoying themselves, one finds a sketchily rendered nighttime

slaves had no rights as a U.S. citizen and therefore no standing

in court. It was not until the Civil War and, in particular, the January 1863 Emancipation Proclamation that arrival in the

North signified freedom for slaves.

done it myself—I have cut capers in chains. But the singing and dancing could not keep down trouble in the South. After Abraham Lincoln's election to the presidency in the fall of 1860, six southern states seceded from the Union, with five more joining them later. Their goal was to set up a separate, sovereign nation that would allow them to control their agricultural economy, which relied for its success on slave labor. The northern industrial states wanted economic expansion, wage labor, a free market economy and high protective tariffs for manufactured goods, all of which the southern states opposed. Lincoln's main aim during the early months of the war was to preserve the Union, even if it meant assuring the southern states that he would not dismantle the institution of slavery. As late as September 1862, when he issued his preliminary Emancipation Proclamation, he promised to leave slavery intact in the states that came over to the North. The January 1, 1863 Emancipation Proclamation declared slaves free in those areas still fighting the North but said nothing about slaves behind Union lines. But abolitionist forces pushed for a more all-encompassing declaration and, in April 1864, the Senate adopted the

Thirteenth Amendment declaring an end to slavery. The

House of Representatives followed with a vote of approval in

We did it to keep down trouble, and to keep our hearts from

being completely broken: that is as true as the gospel! Just

look at it,—must not we have been very happy? Yet I have

9.6 EASTMAN JOHNSON Old Kentucky Home (Negro Life in the South), 1859. Oil on canvas, $36 \times 45 (91.4 \times 114.3)$

January 1865.

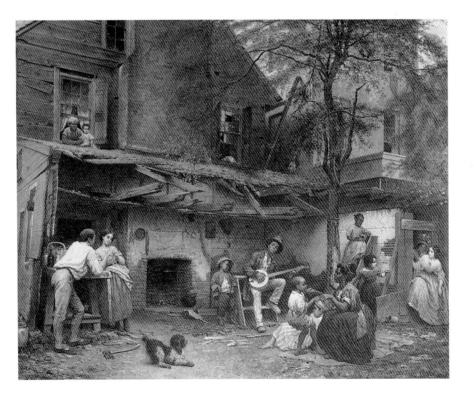

scene of flight from danger. The faces of the family on the horse, along with the horse itself, are mere dark silhouettes against a gray, smoke-filled sky. The scene certainly belies the southern claim that slave families were happy with their life on southern plantations. This fleeing family, like the scene in Leutze's *Westward the Course of Empire*, also contains Christian connotations, suggesting a parallel with the flight of Mary, Joseph, and the baby Jesus to Egypt.

Theodor Kaufmann (1814–after 1877) enlisted in the Union Army in 1861 and advocated the Union cause in his writings, lectures, and paintings. German-born, he received his artistic training in Munich and Hamburg before coming to the U.S. in the early 1850's. In his painting *On to Liberty*, Kaufmann creates a dramatic scene of the flight of African American women and children, although it is much more anecdotal in its detailed rendering of costumes and facial features than Johnson's *A Ride for Liberty*. Emerging out of a dark forest, the group of women and children head toward Union lines in the distant right of the painting. While the

9.8

9.7

scene is filled with tension, Kaufmann provides some comic relief in the group of children to the right, the older boy dragging the younger one along by the back of his shirt. He also adds an element of voyeurism to the painting, undoing the blouse of the female slave to the far left so that her breasts are partially revealed. The absence of adult men from the group attests to the fact that adult male slaves were often conscripted by the Confederate Army to work as laborers during the war and thus were less likely to be fleeing with their families.

African Americans were also enlisted in the war effort by the North. There were two categories in which they appeared, the first as "war contraband," or escaped slaves, the second as enlisted soldiers. In both capacities they carried out the more menial tasks of the war effort, including cooking for the troops, building roads, driving mule teams, and burying the dead. Until 1864, African American soldiers were also paid less than white soldiers. While the institution of slavery may not have existed in the North, racism certainly did.

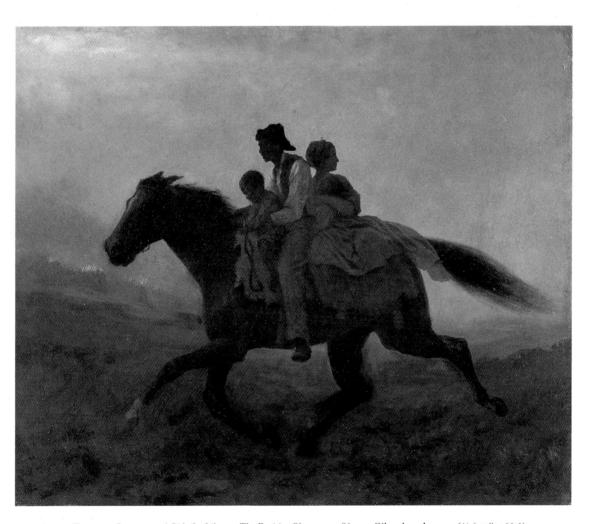

9.7 Eastman Johnson A Ride for Liberty: The Fugitive Slaves, ca. 1862-3. Oil on board, $22 \times 26\frac{1}{4}$ (55.8 × 66.6)

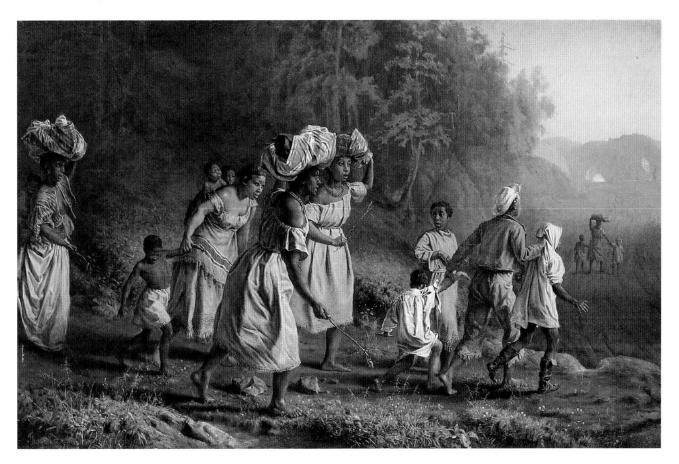

9.8 THEODOR KAUFMANN On to Liberty, 1867. Oil on canvas, 36 × 56 (91.4 × 142.2)

The lives of African Americans in the Union Army were portrayed in both photographs and paintings or engravings. As was the case with depictions of Native Americans, photographs tended to portray a starker image of wartime experiences than paintings or engravings. During the war many companies began producing sets of stereo views of the war for the home front audiences. As photographic technology was still unable to depict clearly objects in motion, most of the photographs included scenes of camp life or of the aftermath of war. In many cases each scene in the set was accompanied by a written explanation so that the viewing of these images could constitute an educational experience.

A Group of "Contrabands" (ca. 1861-5) was produced by the War Photograph and Exhibition Company. It shows a group of African American teamsters or mule drivers lined up in front of a large wagon and a shack which is described as their home. Their eclectic clothing indicates their contraband status, and their solemnity—if not sullenness—and placement in the middle ground of the composition suggest both a physical and psychological distance between them and the viewer. The image is a far cry from the dancing, banjo-playing slaves of earlier paintings.

Another stereoscopic view, this time produced by Taylor and Huntington Publishers, shows the fate of an African American soldier in the Union Army accused of having "attempted to commit a rape on a white woman" near Petersburg, Virginia. The soldier, whose name was Johnson, was tried by courtmartial, found guilty, and hanged. All this information is included on the back of the image. The photograph, entitled Execution of a Colored Soldier (1864), 9.10 shows the dead soldier hanging from the scaffold, his face covered by a white cloth. Union soldiers rest in the shade of a tree to the right. The descriptive paragraph on the back of the photograph also included the following: "A request was made of the Rebels, under a flag of truce, that we might be permitted to hang Johnson in plain sight of both armies, between the lines. The request was granted, and this is a photograph of him hanging where both armies can plainly see him." The educational value of this photograph lay in its assurance that freedom for African Americans would not be achieved at the expense of "white womanhood." While the description suggests that Johnson was fairly tried, few, if any, black men were ever acquitted when charged with a crime against a white person. The public display of his hanging for both armies also

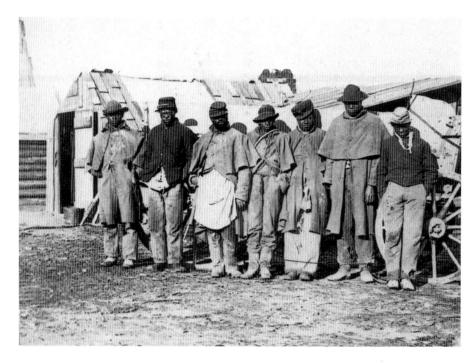

9.9 War Photograph and Exhibition Company A Group of "Contrabands", 'ca. 1861–5. Stereograph.

suggests that the white men on both sides of the war saw this as an occasion for racist entertainment.

The life of African American men in camp was also captured by the artist Winslow Homer (1836–1910). Homer was born in Boston in 1836 and grew up at a time when the city was filled with abolitionist debates and controversy. He was apprenticed in a lithography shop in the mid-1850's before taking up work as a freelance illustrator and then training as a fine artist in 1859 at the National Academy of Design, where he exhibited his first work the following year. After the outbreak of the Civil War, Homer joined the Union campaign as an artist–reporter for *Harper's Weekly*. He was also commissioned by the publishers Louis Prang and Co. in 1863 and 1864 to design sets of campaign sketches which were reproduced in lithographic form.

One of the earliest images Homer produced was *Bivouac Fire on the Potomac*, which appeared as a wood engraving in the December 21, 1861 issue of *Harper's Weekly*. As was the case with most of his war images, this one focuses on camp life rather than the battle front. The image is similar to the scene drawn eight years later by Davis for *Harper's Weekly* that was discussed in Chapter 8. This time, however, an African American, rather than Native Americans, dances around the fire for the pleasure of the white Union soldiers. Homer has utilized all of the stereotypes then in place for the depiction of African Americans—the shabbily clothed, high-stepping dancer with corkscrew curls, and the grinning, fat-lipped fiddler sitting at the edge of the fire playing for the dancer. Such antics and physiognomical distortions had become even more entrenched in both popular and fine art imagery with the

introduction in the 1840's of a new genre of entertainment, the minstrel show, and its subsequent widespread success. Performed by white men in black face, with tattered clothes and broad, grinning lips painted on their faces, minstrel shows were, according to the art historian Albert Boime, "a white fantasy projected upon black people—no wonder the safe, familiar vision of the grinning black who could 'hoof it off' through thick and thin had a powerful and lasting appeal for American whites."

9.10 Taylor and Huntington Publishers *Execution of a Colored Soldier*, 1864. Stereograph.

208 - BLACK AND WHITE IN AMERICA

9.11

9.11 WINSLOW HOMER A Bivouac Fire on the Potomac, 1861. Wood engraving, $13\frac{3}{4} \times 20$ (34.9 × 50.8)

An even more grotesque caricature of the dancing African American appears in Homer's lithograph *Our Jolly Cook* (1863), while the grinning musician, this time a banjo player, is found once again in his 1864 painting of Confederate forces entitled *Inviting a Shot before Petersburg, Virginia*. By adopting such stereotypes, Homer reinforced the subservient place of African Americans (and their satisfaction with this place), whether as contraband, enlisted men, or slave laborers, within both the Union and Confederate Armies.

One of Homer's first moves away from such stereotypical depictions of African Americans during the Civil War, a direction he would increasingly follow, can be found in his small painting The Bright Side (1865). The painting depicts five mule drivers, four of whom are caught asleep, leaning against the sunny side of a tent. Only the head of the fifth man is visible, appearing out of the opening in the tent. Homer claims to have sketched the scene from life, with the fifth man appearing from inside the tent just as he had finished drawing the first four. When the painting was first exhibited at the Brooklyn Art Association's Spring Exhibition in March 1865 and at the National Academy of Design Annual Exhibition in April of the same year, it received favorable critical and popular reviews. This favorable opinion was at least in part responsible for Homer's acceptance into the Academy in May 1865.

Critics praised *The Bright Side* for both its "truthfulness" and its "humor." One critic wrote: "The lazy sunlight, the lazy, nodding donkeys, the lazy, lolling negroes, make a humorously conceived and truthfully executed picture." For this critic, and for many others, a "truthful" depiction of

African Americans was, inherently, humorous. According to the scholar Robert F. Lucid, "the convention was that a negro, as such, was funny." He was also lazy, despite ample record of the often brutal labor that was involved in the work

9.12 WINSLOW HOMER Our Jolly Cook, 1863. Lithograph, $13\% \times 11\% (35.2 \times 28)$

9.13 WINSLOW HOMER The Bright Side, 1865. Oil on canvas, $13^{1/4} \times 17^{1/2}$ (33.7 × 44.4)

of a teamster. Teamsters were frequently compared with the mules they drove, animals regularly described as unintelligent, stubborn, and lazy, despite, again, evidence to the contrary.

9.13

The critical response to *The Bright Side* shows how critics often see what they want to see, rather than necessarily what is there. Many viewing this painting did not want to give up their stereotypes. The man whose head appears through the tent door was repeatedly described as comic and grinning, despite his serious expression and direct gaze, a gaze that recalls those of the teamsters in the photograph *A Group of "Contrabands,"* taken around the same time Homer was composing his scene. Not that humor is totally absent from this piece. Homer was undoubtedly quite aware of the comic tales of teamsters and their mules and knew that painting such a scene would produce a few laughs. There is also an element of philosophical playfulness in the title of the painting. On the surface, *The Bright Side* refers to the sunny side of the tent. But it could also be read as a commentary on the occupation of

the five men and their physical location. Driving mules for Union forces behind Union lines was preferable to laboring as a slave in the cotton fields of the South, although Homer must have been well aware of the fact that contraband teamsters were often immediately killed if captured by Confederate forces.

According to the art historian Marc Simpson, "if a seemingly racist humor can be found in Homer's painting of the teamsters, complicating elements are also there that require more than a chuckle in response." The direct gaze of the central teamster is one such complicating element. The depiction of all five men as closely observed individuals rather than stock characters is another. However, while Homer abandons the physiognomical stereotypes of African Americans, he still places them in a setting that allowed most viewers to deny the individuality of the figures in favor of the generalizing stereotypes.

Another artist who covered the Civil War for *Harper's Weekly* was Thomas Nast (1840–1902), best known for his

9.14 THOMAS NAST Entrance of the Fifty-fifth Massachusetts (Colored) Regiment into Charleston, South Carolina, February 21, 1865, 1865. Pencil, neutral wash, and oil, heightened with white, on board, $14\frac{1}{4} \times 21\frac{1}{4}(36.2 \times 53.9)$

scathing political cartoons of the late nineteenth century. Born in Germany, he came to the U.S. in 1846 and studied with Kaufmann, later entering the National Academy of Design. After working for Frank Leslie's Illustrated Weekly and the New York Illustrated News, Nast was engaged by Harper's Weekly in the summer of 1862 to cover the Civil War. In 1865 he produced an image that was strikingly different from the majority of portrayals of African Americans during the war. Entrance of the Fifty-fifth Massachusetts (Colored) Regiment into Charleston, South Carolina, February 21, 1865 (1865) shows the volunteer allblack Fifty-fifth Regiment from Massachusetts entering the city of Charleston. Nast's drawing is one of the few images that acknowledges the presence of African Americans as active Union soldiers who fought in many of the major battles of the Civil War. Once Lincoln's initial resistance to the enlistment of African Americans in the Union Army had been overcome, the numbers joining up increased throughout the war. Official records indicate that approximately 185,000

9.14

African Americans joined the Union Army. Over 200,000 African American civilians also worked in Union camps. Historians now agree that the presence of such large numbers of African Americans in the northern forces turned the tide against the Confederate Army in 1864 and 1865. The African American in the center foreground of Nast's drawing, therefore, is dancing not for the pleasure of the two white officers in the image, but in joy at the arrival of the heroic African American regiment into Charleston. The price of their victory is graphically present in the ruins towering over the regiment, ruins that are reminiscent of the many burned-out buildings that filled the photographs taken at the end of the war. Indeed, there is speculation that Nast's drawing is based, at least in part, on a photograph.

During the Civil War over half a million slaves fled the South. Four million remained, yet it was only a matter of time before many of them would also escape to the North. The African American activist and scholar W. E. B. DuBois later wrote in *Black Reconstruction* (1935):

AFRICAN AMERICANS AND THE CIVIL WAR . 211

9.13

Either the south must make terms with its slaves, free them, use them to fight the North and thereafter no longer treat them as bondsmen; or they could surrender to the North with the assumption that the North after the war must help them to defend slavery as it had before.

General Robert E. Lee chose the latter route, surrendering to General Ulysses S. Grant at Appomattox on April 9, 1865, five days before the assassination of President Lincoln. While slavery was never officially restored in the South, white politicians in the North did, in fact, collude with their counterparts in the South to reinforce in new ways the subservience of African Americans.

IMAGES OF RECONSTRUCTION: PRISONERS FROM THE FRONT AND VISIT FROM THE OLD MISTRESS

In the decade after the end of the Civil War, known as the Reconstruction Period, education was opened to African Americans in the South, and African American men were given the vote and allowed to run for political office. Many were elected to local, state, and federal positions. Discrimination in the use of public facilities was outlawed by the Civil Rights Act of 1875. Southern whites, however, did not accept these new laws and organized groups such as the Ku Klux Klan (founded in 1866) to terrorize African Americans and prevent them from exercising their new freedoms. As long as the Union Army remained in the South, African Americans were protected to a certain degree from these attacks. But in 1877 troops were withdrawn as part of a larger political deal in which Republicans agreed not to interfere with the reestablishment of white control of the South if southern Democrats would give the Republican presidential candidate Haves enough electoral college votes for him to become president. In 1883 the Civil Rights Act was nullified by the Supreme Court, which found the Act unconstitutional. It was replaced in 1896 with a Supreme Court decision allowing railroads, and thus, by precedent, all other public services, to segregate black and white if the segregated facilities were "equal." By 1900 all southern states had written into law the disenfranchisement and segregation of blacks.

Homer produced a number of paintings which addressed the tensions and accommodations produced by the end of the war and by the attempt to "reconstruct" the South. One such painting is *Prisoners From the Front*, painted in 1866. This work draws upon the well-established compositional conventions of confrontation scenes, which generally take place between the vanquished and the victor after a battle. In many major European paintings of confrontation scenes

connected to specific military enterprises, such as the campaigns of Napoleon, the designation of victor and vanquished is clearly marked. The vanquished kneel or dramatically bow down on the left, guarded by members of the victorious army. The victor stands to the right surveying the vanquished, often surrounded by his military retinue. A good example is Gros's *The Capitulation of Madrid, December* 4, 1808 (1810).

The general outlines of this compositional scheme have been maintained by Homer but he has made certain significant alterations. To the left of center stand three Confederate soldiers who have just surrendered. Two Union soldiers stand to the right and just behind this group. Facing the Confederate soldiers is a Union officer. He stands alone, although behind him at a distance are more Union soldiers with their horses and a Division flag. They all stand in a barren landscape, the young trees and bushes having been cleared by the advancing armies for firewood and to facilitate the movement of troops.

The Confederate soldiers have indicated their surrender by placing their rifles on the ground. They do not, however, bow down in submission. The prisoner closest to the Union officer stands defiantly, hand on hip, staring directly at his Union counterpart. Both appear to be in their twenties or thirties. The other two prisoners are of markedly different ages. The old man in the middle sports a full white beard and white hair and is the most submissive of the three, standing with his hands clasped in front of him. To the left of the old man is a very young man, probably in his teens, standing with his hands in his pockets, the slightly worried expression on his face belying his attempt at nonchalance. It is the defiant Confederate soldier who dominates, however. He occupies the center of the painting. Yet none of the figures—the prisoners, their two guards and the Union officer—is positioned above the others. They are all arranged on the same level in a horizontal band across the front of the picture plane, the high horizon line cutting through the head of each figure, locking them in place.

While the painting was well received when it was exhibited at the National Academy of Design Annual Exhibition in 1866 and, along with *The Bright Side*, at the Paris World Exposition of 1867, critics had some difficulty categorizing the work. Was it a figure painting, a genre painting, or a history painting? History paintings usually contained symbolic representations of lofty ideals or permanent truths or, at the very least, commemorated particular victories or heroes. *Prisoners From the Front* does none of these things. The Union officer is recognizable as General Francis Channing Barlow, a distant cousin of Homer's whom he had visited at the front early in the war, but the identity of the Confederate soldiers is unknown. The taking of prisoners is usually only accorded the

9.15

privilege of being commemorated in paint if the prisoners are high-ranking and well-known figures, such as in *The Sur-render of General Burgoyne at Saratoga, October 16, 1777* (ca. 1822) by the American artist John Trumbull (1756–1843). In certain ways Trumbull's painting more closely follows European confrontation scene conventions, yet like Homer's it downplays the distinction between the victor and the vanquished and the drama of the scene. As with the war between the North and the South, the American Revolution resulted not in a complete break with England, or a subjugation of one country by another, but in a renegotiation of the terms under which the two sides would conduct business.

Many critics, however, did see *Prisoners From the Front* as a symbolic commentary on the Civil War as a whole rather than simply a factual recording of one event that took place during the war. In this sense it was a history painting rather than an anecdotal genre painting. It was seen as a history painting for other reasons as well. In an 1869 article entitled "Historical Art in the United States," the art critic Eugene Benson argued that history painting should not be about events before the painter's lifetime but should deal with events that are contemporaneous. History painting should "give us art that shall become historical; not art that is intended to be so." He saw *Prisoners From the Front* as a perfect example of such history painting.

What, then, is the nature of Homer's commentary on the Civil War in *Prisoners From the Front?* The critic Sordello (a pseudonym for Benson) wrote the following in April 1866 for the New York *Evening Post* regarding the meaning of the painting:

On the one side the hard, firm-faced New England man, without bluster, and with the dignity of a life animated by principle, confronting the audacious, reckless impudent young Virginian, capable of heroism, because capable of impulse, but incapable of endurance because too ardent to be patient; next to him the poor, bewildered old man, perhaps a spy, with his furtive look . . . ; back of him "the poor white," stupid, stolid, helpless, yielding to the magnetism of superior natures and incapable of resisting authority. Mr. Homer shows us the North and South confronting each other; and looking at his facts, it is very easy to know why the South gave way. The basis of its resistance was ignorance, typified in the "poor white," its front was audacity and bluster, represented by the young Virginian—two very poor things to confront the quiet, reserved, intelligent, slow, sure North, represented by the prosaic face and firm figure and unmoved look of the Union officer.

Sordello was not the only critic who remarked on the contrasting class and breeding of the central characters. Another commented that "the Southern officer and the Northern officer are well contrasted, representing very accurately the widely differing classes to which they belong."

The main characters in the painting were thus read more as types than as individuals, and, as types, they were "keys" to the meaning and causes, and ultimately the outcome, of the Civil War. The defiant Confederate soldier in the center of the painting thus represents the defiance of the South in the face of defeat by the North. The Union officer's contemplative gaze, in turn, represents the North's evaluation of how best to deal with this implacable southern defiance. According to one critic, "the men are both young; they both understand each other." In 1888 another wrote that "the influence of this picture was strong on the side of brotherly feeling." It was this "understanding" and "brotherly feeling" that ultimately led to the deal struck between the North and the South discussed above. A new Union would be created that allowed southern whites to maintain political and economic control through concessions to northern industrialists and politicians. Those who lost out in this deal were those in whose name the Civil War was supposedly fought—African Americans. As early as 1865 and 1866, the years in which Homer was creating Prisoners From the Front, vagrancy and apprenticeship laws were being passed by southern legislatures (the Black Codes) which restricted the rights of freedmen.

Does Homer represent this aspect of the Civil War—the betrayal of African Americans—in his painting? The one figure who could possibly function as such is the dark-skinned soldier standing behind the three prisoners. He is the only figure in the foreground of the composition whose facial features are not clearly articulated. There is, instead, merely the faintest suggestion of eyes, nose, and mouth. Indeed, the facial features of the figures in the distant right background are more clearly discernible. Even the boots of the soldier are not completely sketched in. So unfinished is his presentation that it is possible, at first glance, to read this figure as a white soldier cast in shadow. Yet there is no source for such a shadow. The bodies of the Confederate prisoners are the only possible source visible in the painting and their positioning makes such a complete blocking out of the sun impossible. Is this soldier, therefore, African American?

Recent x-radiographs of the painting reveal that this soldier was absent from Homer's original composition. He was added after the Confederate prisoners had been laid in and the brown ground filled in around them, but he was not worked up in the same detail as the other figures. Instead, the face remains marked by the color of the brown ground. Perhaps Homer had intended to create an obviously white counterpart of the other Union guard. Yet in the painting he submitted as

9.15 WINSLOW HOMER Prisoners From the Front, 1866. Oil on canvas, 24 × 38 (60.9 × 96.5)

"finished" to the National Academy of Design in 1866, the soldier behind the prisoners remained dark-skinned and only faintly articulated. Perhaps after applying the general form of the figure, he realized that the ghostly presence of an African American Union soldier behind the Confederate prisoners would heighten the symbolic significance of the work as a commentary on the war and its aftermath. In other words, the figure would provide a subtle reference to the presence of African Americans in the Union forces and to the extent to which they would be sold out by "brotherly" negotiations between the North and the South.

The second painting by Homer that addresses the Civil War and its aftermath is also a confrontation scene. This time, however, the confrontation is located indoors and takes place between a white woman and her former female African American slaves. In *A Visit From the Old Mistress* (1876) the white woman is dressed, like the Union officer in *Prisoners From the Front*, in black. In addition, as in *Prisoners From the Front*, she confronts three adult figures. The former slaves, like at least two of the Confederate prisoners, are dressed in ragged clothing. Homer's manner of execution is even more "unfinished" in this painting than in *Prisoners From the Front*, although the greatest finish appears in the face and upper

costume of the white woman. This is particularly evident if we compare her to the African American woman closest to her whom she confronts directly, whose facial features, like those of the Union guard in the earlier painting, are only barely articulated. Indeed, this adult woman in front of her echoes the guard not only in her schematic manner of execution, but also in the shape and positioning of her head. If the African American has emerged from the shadows of the Confederacy, therefore, it is as a woman in the home rather than a man on the battlefield.

What is the nature of the confrontation being depicted here? Who is the victor and who the vanquished? The title of the painting might suggest that the women on the left are the victors. The white woman is, after all, the "old" mistress. Yet "old" could also be read as referring to the age of the woman, for her hair is distinctly gray. In compositional terms, the white woman is located in the position of the victor. She has a slight smile on her face and looks directly at the women in front of her. Yet, as in *Prisoners From the Front*, there is no show of obeisance on the part of the African American women. Rather, there is a distinct sense of suspicion and mistrust, particularly visible in the gesture and facial expression of the seated woman on the far left. In historical terms, the African American women are the victors. This was 1876,

9.16

9.15

9.16 WINSLOW HOMER A Visit From the Old Mistress, 1876. Oil on canvas, $18 \times 24^{1/8}$ (45.7 × 61.3)

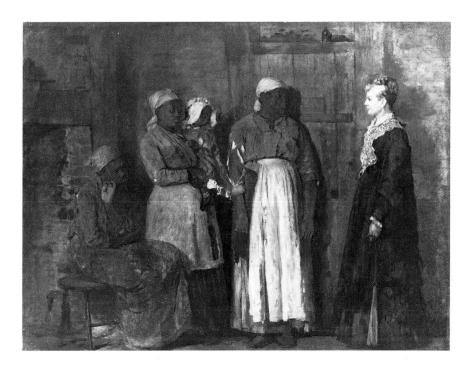

over a decade since the end of the Civil War and of the institution of slavery. The fact that the woman on the left remains seated rather than rising at the entrance of the white woman is a sign of the changed relations that now existed between white women and their former slaves. Yet the following year northern and southern politicians struck their deal to put Hayes in the White House, thus effectively ending Reconstruction. It was fitting that this deal was made immediately following the nation's centennial celebrations, for it marked a reaffirmation of the interests of the "founding fathers," many of whom had owned slaves. From this point on, the gains made by African Americans over the previous ten years would be systematically dismantled.

Like *Prisoners From the Front*, therefore, there is no clearcut victory or defeat in *A Visit From the Old Mistress*. Even the visit of a white woman to her slaves' quarters cannot be read as an act of capitulation. Such visits were common in the earlier slave-holding period, as is indicated in an engraving produced the same year as Homer's painting, *Virginia One Hundred Years Ago*, by Sol Eytinge, Jr., which appeared in the August 19, 1876 issue of *Harper's Weekly*. Eytinge, Jr.'s engraving was one of a series of similar images that appeared in the 1870's calling up scenes from "the good old days" when slaves knew their place and appreciated the benevolent gestures of their masters and mistresses. The engraving also marks the hierarchy that existed within the slave community, with the personal servant of the master distinguished by dress and attitude.

In creating an enclosed, almost claustrophobic, space for the women in A Visit From the Old Mistress, Homer acknowledges the intimate nature of the contact between white women and the African American slaves who worked for them in the plantation mansions. While white men also had personal servants, most of their contact with African American slaves occurred in the fields or potteries or other places of work separate from the home. The world of white women, particularly middle- or upper-class white women in the nineteenth century, was the home. It was in the domestic sphere that white women exerted their control—over their children and over their African American servants. These servants engaged in tasks that directly involved the health and wellbeing of the family—cooking, cleaning, and raising the children. As is suggested in *Uncle Tom's Cabin*, household servants often became the friends of their young white charges, if not of the older members of the household. Such friendships created the basis for an understanding of the inequities of slavery and a willingness to end slavery as a whole. The potential for understanding between the two races appeared to be greater in the female sphere of the home, therefore, than in the male spheres of business and politics.

Yet the potential for violence was also great in the home, as indicated by the numerous beatings of household slaves and by the attempts made by these same slaves, often successful, to murder their masters and mistresses. While the work of the household slave was generally lighter than the field slave, it was accompanied by a constant surveillance by whites that forced the continuous wearing of a public mask. Yet, according to Lerone Bennett, Jr., court records of the midnineteenth century "yield ample evidence that a large number of slaves refused to play the game of slavery: they would

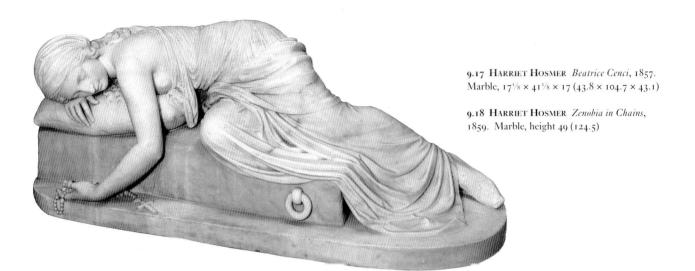

neither smile nor bow. Other slaves bowed but would not smile." Others bowed and smiled but, at the same time, deliberately sabotaged the system from within, breaking utensils or staging slowdowns. The close proximity of the female figures in Homer's painting and their demeanors suggest both the potential for understanding and the potential for harm. The physical and psychological distance between the white and African American women, while filled with tension and mistrust, is also bridgable by a single gesture.

THE AFRICAN AMERICAN ARTIST AT HOME AND ABROAD: EDMONIA LEWIS AND HENRY OSAWA TANNER

As was mentioned earlier, many white abolitionists attempted to bridge this distance by encouraging and supporting the educational and professional pursuits of African Americans. Robert Duncanson was one African American artist who benefited from such patronage. The sculptor Edmonia Lewis (ca. 1845-after 1909) was another. Born in upstate New York in the early 1840's of a Chippewa Indian mother and an African American father, Lewis—originally named Wildfire—was orphaned at four and raised by her mother's tribe until she was twelve. At thirteen, with the help of her brothers and of various abolitionists, she entered the Young Ladies Preparatory Department of Oberlin College, adopting the Christian name of Mary Edmonia Lewis. While at Oberlin, Lewis was accused of attempting to poison two of her white schoolmates and of stealing. Brought to trial, she was defended by the well-known African American lawyer John Mercer Langston, and acquitted of all charges. Yet she was not allowed to graduate and, with the help of the abolitionist William Lloyd Garrison, settled in Boston where she came

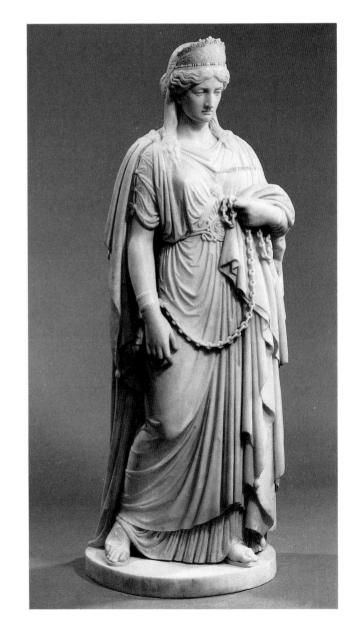

into contact with the sculptor Edward Brackett. He lent her sculpture fragments to copy and, along with the sculptor Anne Whitney, helped her develop her skills as an artist.

Lewis's first works were busts and medallions of various abolitionist leaders and heroes, including Garrison, Charles Sumner, Maria Weston Chapman and Colonel Robert Gould Shaw. The portrait of Shaw (1865) impressed his family who organized a group of friends to buy a hundred copies at fifteen dollars each. This money, and the help of her benefactors the Story family, allowed Lewis to finance a trip to Italy in 1865, where she joined the group of women gathered in Rome around the American sculptor Harriet Hosmer. These women went to Europe in search of good marble, historical collections of Classical sculpture, and trained carvers who would teach them. They were encouraged by liberal parents or, as was the case with Lewis, friends who could wholly or partly support them financially. Almost all remained single and devoted their lives to their artistic endeavors.

Harriet Hosmer (1830–1908) provided Lewis not only with a supportive environment within which to work in Rome, but also with examples of images that addressed the issues of slavery and rebellion. In 1857 Hosmer had carved the reclining *Beatrice Cenci*. Cenci was a late-sixteenth-century Roman noblewoman who, with her mother Lucretia, killed her abusive and tyrannical father Francesco. Both women were condemned to death and beheaded, despite numerous pleas for clemency. Hosmer shows Beatrice asleep the night before her execution, having come to terms with her actions and fate through prayer.

Two years later Hosmer produced Zenobia in Chains (1859). Zenobia was the third-century Queen of Palmyra who was defeated and captured by the Romans. Hosmer presents Zenobia as noble and resolute in her defeat; she gathers up her chains along with her robe, grasping them firmly in her hand as she contemplates her future. When the statue was exhibited in the U.S. in 1863, it was received with great enthusiasm as an example of moral rectitude and resistance to defeat, a fitting symbol for a country in the throes of a civil war. The art historian Whitney Chadwick notes that Hosmer's work stood in striking contrast to another equally well-known and popular sculpture of a woman in chains, The Greek Slave (1843) by Hiram Powers (1805–73). Both figures are presented as captives, but "Zenobia's resolute dignity stands as a rebuke to *The Greek Slave*'s prurient, if allegorical, nudity. More than one critic lauded Hosmer's figure as an embodiment of the new ideal of womanhood."

While Hosmer focused on the political and personal struggles of women against men and male-defined institutions, Lewis turned her attention to the struggles of African Americans against the institution of slavery in the U.S. She created two works on this subject while in Rome, *The Freed*

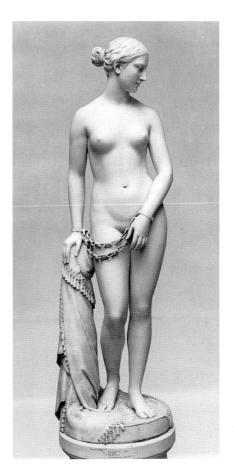

9.19 HIRAM POWERS The Greek Slave 1846. Marble after original plaster of 1843, height 65½ (166.4)

Woman and Her Child (now lost) and Forever Free (1867). 9.20 Originally titled The Morning of Liberty, Forever Free attempts to capture the emotional impact on African American slaves of Lincoln's proclamation, on the morning of January 1, 1863, that all persons held as slaves (in those areas still fighting the North) "are, and henceforward shall be, free." A woman, the manacle still around her ankle, kneels and clasps her hands in thanksgiving while a man stands above her, one hand on her shoulder, the other raised and holding the manacle and chains that had been previously attached to his ankle. Another manacle remains attached to his wrist, however, indicating that freedom has yet to be fully achieved. Both gaze upward, acknowledging the existence and help of a higher power (it was around this time that Lewis converted to Catholicism).

The subservient position of the woman in *Forever Free* may have been a subtle commentary on the struggles that lay ahead for African American women within their own community. Such struggles paled in comparison, however, to the fate of African American women in slavery, who were used not only as field workers and domestic workers, but also as sexual servants by their white male masters. Lewis chose to focus her

9.20 EDMONIA LEWIS Forever Free, 1867. Marble, $41\sqrt[4]{4} \times 11 \times 7$ (104.8 \times 27.9 \times 17.8)

artistic attention on at least one subject in which this combination of racism and sexism was present. A year after completing *Forever Free*, she produced *Hagar in the Wilderness* (1868), a tribute to the Egyptian maidservant of Abraham's wife Sarah, who was cast into the desert to escape the rage of Sarah after having borne Abraham a child. The parallel to the situation of African American women in the U.S. is clear. Lewis wrote, in reference to this work, "I have a strong sympathy for all women who have struggled and suffered."

9.21 EDMONIA LEWIS Hagar in the Wilderness, 1868. Marble, 52% × 151/4 × 17 (133.6 × 38.8 × 43.4)

In 1916 the African American writer Freeman Henry Morris Murray wrote of *Forever Free* and of the time in which it had been executed:

Reaction—re-enslavement, I had almost said—had set in.... Miss Lewis and "her people" had felt it. The Sun of Emancipation which had risen in 1863, had seemingly reached its zenith in 1865 with the passage of the 13th Amendment prohibiting slavery. But already it was being obscured by the clouds. Already the sheriff's handcuffs

were taking the place of the former master's chains; already

It is little wonder, therefore, that despite a growing reputation throughout the late 1860's and early '70's, Lewis remained in Rome and made only brief visits to the U.S. to promote her work. In October 1869 she visited Boston to present Forever Free to the Reverend L. A. Grimes at Tremont Temple. In 1873 she traveled to California where five of her works were exhibited at the San Francisco Art Association. She was in Boston in 1876 around the time of the Philadelphia Centennial Exposition, which included her Death of Cleopatra (1876). According to Boime, she "often took her show on the road, participating in western fairs to avoid the competition in New York and setting up booths in the form of wigwams, emphasizing the links between the West and her Native American heritage." She also created at least two small works in marble directly addressing her Native American heritage, one of which is Old Indian Arrowmaker and His Daughter (1872).

Lewis's financial success attested to her skill at producing the type and quality of work expected by the American artbuying public in the late nineteenth century. Yet, even in Rome, she was continually confronted by the prejudices of an art world accustomed to acknowledging only male members of the white race. She was often viewed as a novelty, as "exotic" because of her gender, her dress (often described as "mannish"), and her skin color. Henry James described her as "a negress, whose colour, picturesquely contrasted with that of her plastic material, was the pleading agent of her fame." In other words, her success was the result, not of her artistic talent, but of her novelty, which James sees in terms of a contrast—between her dark skin and the white marble in which she worked. The critic Laura Curtis Bullard wrote in 1871:

Edmonia Lewis is below the medium height, her complexion and features betray her African origin; her hair is more of the Indian type, black, straight and abundant. . . . Her manners are child-like, simple and most winning and pleasing. She has the proud spirit of her Indian ancestor, and if she has more of the African in her personal appearance, she has more of the Indian in her character.

Thus, despite the fact that Lewis was in her late twenties and an accomplished artist at the time this description was written, she was still seen as childlike, winning and pleasing, attributes which made her success and independence as an artist and single woman less threatening to men and to those women who believed in the need to maintain their "femininity" even as they entered professions previously closed to them. Bullard also combines two stereotypes—the "proud" Native American and the "child-like" African American—in her patronizing description of the artist. Little is known of Lewis's career after the mid-1880's. She disappeared from exhibition records and art journals and the last printed reference to her appears to have been in the Catholic Rosary magazine, which noted in 1909 that she was aging but "still with us."

Another African American artist who spent most of his adult life in Europe was Henry Osawa Tanner (1859–1937). Tanner was born in Pittsburgh and moved to Philadelphia with his family when he was a child. His father was a minister, and later a bishop, in the African Methodist Episcopal Church (A.M.E.), founded in 1816. The independent African American church movement began in the late 1770's with the

9.22 EDMONIA LEWIS Old Indian Arrowmaker and His Daughter, 1872. Marble, height 27 (69.6)

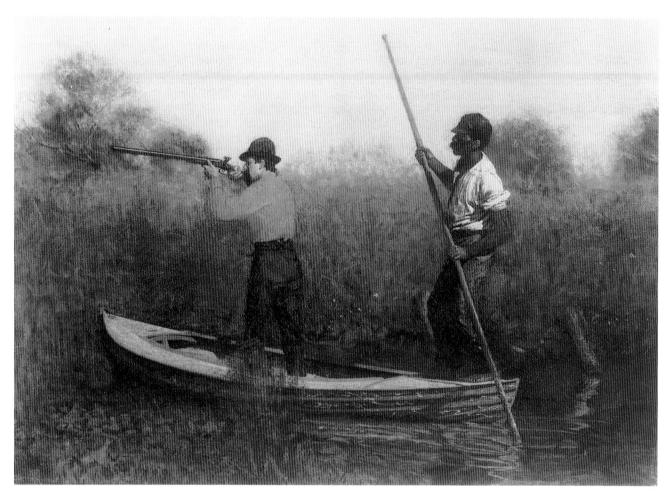

9.23 THOMAS EAKINS Will Schuster and Black Man Going Shooting (Rail Shooting), 1876. Oil on canvas, 221/8 × 301/4 (56.2 × 76.8)

founding of the first African Baptist churches in South Carolina and continued to grow throughout the nineteenth century, providing a source of spiritual, political, and educational strength and leadership. His father instilled in Tanner a stern belief in the Christian God and in the power of religion as a unifying force in the African American community, one which could help achieve the dignity of all human beings, whatever the color of their skin. Tanner's father was a prolific writer and intellectual, producing An Apology for African Methodism (1867), describing the schisms between the African American and white Methodist churches, and The Negro's Origins and Is the Negro Cursed? (1869). He was also editor of the A.M.E.'s newspaper the Christian Recorder and later founded the A.M.E. Church Review. The Tanner household was a gathering place for many of the country's leading African American intellectuals and politicians.

Tanner entered the Pennsylvania Academy of Fine Arts in 1880 in order to study with Thomas Eakins (1844–1916), who had achieved a widespread reputation as a painter of portraits and genre scenes. Yet the latter were not the nostalgic revivals

of antebellum or preindustrial America that had become popular after the Civil War, when the social, economic, and political upheavals caused many to wish for a return to "simpler" times. Eakins eschewed the more popular anecdotal rural scenes and chose, instead, to focus on the present and on an emerging socioeconomic group—the professional middle class. He was particularly interested in the work and leisuretime pursuits of the men of this class, painting images of surgeons in the midst of operations and men rowing or sculling on the Schuylkill River in Philadelphia (see p. 354). He also collaborated with the photographer Eadweard Muybridge in the 1880's, using sequential still photography to study motion in humans and animals.

Eakins included African Americans in several of his paintings. One such painting is *Will Schuster and Black Man Going Shooting (Rail Shooting)* of 1876. As in his rowing paintings, Eakins presents another leisuretime activity engaged in by many white middle-class men that involved concentration, skill, and discipline. It also involved the employment of a boatman guide who, in this instance, is African American.

9.24 THOMAS EAKINS *Negro Boy Dancing*, 1878. Watercolor, $18\frac{1}{8} \times 22\frac{5}{8}$ (46 × 57.7)

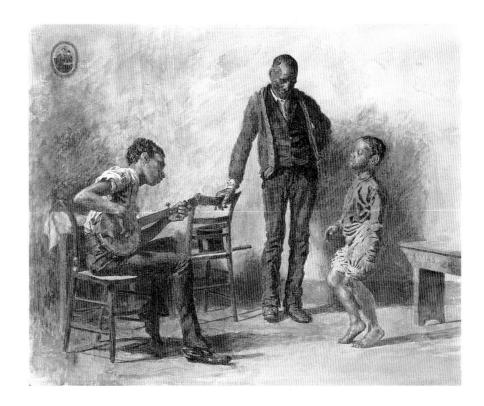

Each figure is painted with the same meticulous care in terms of clothing and physiognomy. Each figure is also thoroughly engrossed in his task, the hunter in aiming at the bird somewhere outside of the painting, the boatman in watching the bird as well while steadying the boat and preparing for the recoil from the fired gun. While the African American has been named only in terms of his race, the detail with which he is rendered suggests that he, like the many other figures in Eakins's outdoor paintings, is a portrait of a specific individual.

Another painting by Eakins depicting African Americans is Negro Boy Dancing, originally titled Study of Negroes (1878), executed two years after Will Schuster and Black Man and exhibited in that year's American Society of Painters of Water Color Exhibition in New York City. In this work Eakins takes up the theme of the dancing, banjo-playing African American, yet presents it in a way that differs significantly from earlier works like Johnson's Old Kentucky Home. Three African American males occupy a room containing two chairs, a small table, a bench, and a small oval portrait on the wall. The objects and figures are arranged in a pyramidal composition, with the old African American man at the apex. To the left sits a younger man, probably in his teens, playing a banjo, while on the right the youngest figure dances. Again, each figure's physical features and clothing are carefully rendered. So, too, are the expressions on each figure's face—the tight-lipped concentration of the youngest boy, the pleased smile on the face of the old man, the silent encouragement on that of the banjo player. The three figures constitute a self-contained, self-supporting unit. As in *Will Schuster and Black Man*, all concentrate intensely on the task at hand. The bareness of the room allows us to focus on the actions and attitudes of its inhabitants. While the top hat and cane on the chair suggest that this private lesson will lead to a public performance, for the moment the concern is learning a skill, passing on knowledge from one generation to the next.

Education, both formal schooling and informal transmission of cultural traditions, was of utmost importance to former slaves, who had been systematically denied access to education in the South. Many artists portrayed scenes of African Americans poring over books in the home or in roughly constructed schoolrooms. Eakins refers to this formal book-learning in the small oval portrait of Lincoln and his son "Tad" examining a book together, taken from a Mathew Brady Studio photograph of 1864, in the top lefthand corner of his painting. The focus of the painting, however, is the passing on of a broader cultural knowledge—dancing and playing the banjo—from one generation to the next and the pride and sense of hope and self-fulfillment attached to the acquisition and maintenance of this knowledge.

Eakins's Negro Boy Dancing may well have inspired Tanner's own tribute to the transmission of knowledge from one generation to the next, The Banjo Lesson (1893). This painting speaks to the theme of education on three levels: 1) the education of Tanner as an artist; 2) the education of the child by the grandfather; and 3) the education of the article viewing public by the painting itself.

1.43

While Tanner had benefited artistically from his lessons at the Pennsylvania Academy of Design, he could not escape the racism that forced so many artists of color either to abandon their pursuits or to leave the U.S. In his autobiographical work *Adventures of an Illustrator* (1925), Joseph Pennell, who attended the Academy at the same time as Tanner, described a scene where a young "octoroon, very well dressed . . . quiet and modest," with short cropped "wool" and a moustache, was tied to his easel in the middle of Broad Street one night by a group of white students "when he began to assert himself." "This is my only experience of my colored brothers in a white school," remarked Pennell, "but it was enough." While Pennell does not name Tanner, the physical description matches photographs of Tanner at the time.

In 1891 Tanner traveled to Paris where he entered the Académie Julian to study with artists such as Jean-Joseph Benjamin-Constant and Jean-Paul Laurens, and joined the American Art Students' Club of Paris. He also made trips to the village of Pont-Aven on the Brittany coast and enjoyed the company of fellow artists in an environment that was substantially less racist than the one he had left in Philadelphia. Tanner's early paintings were primarily seascapes, landscapes, and animal paintings. It was not until the mid-1890's that he began to take up the theme that would become the major focus of his work in the early twentieth century—religion. Before that, he took a brief detour and created a small number of genre paintings that addressed the life of African Americans, the best-known of which is *The Banjo Lesson*.

Tanner returned to Philadelphia in the summer of 1893 to recover from a bout with typhoid fever. In August he delivered a paper at the World's Congress on Africa, part of the World's Columbian Exposition in Chicago, on "The American Negro in Art." This paper, plus his return to Philadelphia and the inevitable re-encounter with a racism that he had fled two years earlier, may have prompted him to turn his attention to African Americans as subject matter. He gives a further indication of his reasons for painting African Americans in a statement the following year, referring to himself in the third person:

Since his return from Europe he has painted many Negro subjects, he feels drawn to such subjects on account of the newness of the field and because of a desire to represent the serious and pathetic side of life among them, and it is his thought that other things being equal, he who has most sympathy with his subject will obtain the best results. To his mind, many of the artists who have represented Negro life have only seen the comic, the ludicrous side of it and have lacked sympathy with and affection for the warm big heart within such a rough exterior.

Tanner may well have been thinking of paintings by artists such as Krimmel and the early Johnson.

How does Tanner's painting differ from the work of artists who saw only the "comic" or "ludicrous" side of African American life? While Johnson drew on the anecdotal genre scenes of peasant life painted by seventeenth-century Dutch artists, Tanner looked to a different Dutch artist for inspiration—Rembrandt van Rijn. In adopting Rembrandt's looser brushwork and in paring down the objects in the painting, Tanner forces the viewer to focus on the central figures in the scene and on their activity rather than the details of their costume or physiognomy. In addition, his use of a golden light entering from the side, which marks so many of Rembrandt's paintings and which highlights the faces and sharpens the outlines of the figures against the background, adds a sense of solemnity and religiosity to the painting. Tanner would develop this brushwork and use of light even further in his biblical paintings of the subsequent decades. Here, however, the sense of devotion is focused on the daily life of African Americans, on an elevation of the lives of the poor. In this respect Tanner once again reflects on Rembrandt and his own respect for the poor in seventeenth-century Holland.

Following Eakins's example, Tanner portrays the figures in The Banjo Lesson as distinct individuals intensely absorbed in the task at hand. The banjo becomes a conduit, a connection from one generation to the next. It also represents a bridge between Africa and America, for the banjo was developed from a stringed instrument brought over from Africa. In her 1990's work on the banjo in American popular culture, Karen S. Linn has traced the changing and conflicting meanings attached to the banjo as a result of its integration into national commercial culture after the Civil War. Before the Civil War the banjo was seen as primarily an African American instrument. In the late nineteenth century, however, urban entrepreneurs attempted to introduce the banjo into elite white culture and, in the process, to downplay its connections with the lives and culture of African Americans. One way of doing this was to promote a new style of playing. Instead of continuing the downward strokes and chording of minstrel performers whose songs grew out of African American culture, the "new" banjo players plucked the strings separately and upward, like a guitar, in order to play the new parlor music of the day. Many white colleges and youth social clubs took up the banjo in the 1880's and '90's, in part because of the promotion of the instrument as comparable to the guitar and piano, and in part because of its connection to the "unofficial," off-limits world of African American culture.

The 1884 dime novel by S. S. Steward *The Black Hercules, or the Adventures of a Banjo Player* shows, however, that many African American banjo players soon mastered the new way of playing and, like Horace Weston and the Bohee brothers,

performed in concert tours throughout the U.S. and England. Indeed, the boy in Tanner's *The Banjo Lesson* has his right hand positioned so as to facilitate the upward plucking motion involved in the new banjo technique. Tanner's painting could have been read as a reaffirmation, therefore, of the banjo as a distinctly African and African American instrument and of the ability of African Americans in this field, as in many others, to master new techniques and acquire new knowledge. One could add musicians, therefore, to the painters and sculptors referred to in Tanner's talk at the World's Congress on Africa, which was described as follows in a report on the Congress: "Professor Tanner (American) spoke of negro painters and sculptors, and claimed that actual achievement proved negroes to possess ability and talent for successful competition with white artists."

Tanner's *The Banjo Lesson* was exhibited in October 1893 at Earle's Galleries in Philadelphia and the following year in

the annual Paris Salon. It was purchased by Robert C. Ogden, a partner in John Wanamaker's dry-goods business and a promoter of African American public education who, in November 1894, donated the painting to the Hampton Institute. It was appropriate that a school committed to the education of Native American and African American children should come to possess a painting that presented in such a compelling and dignified way the role of education in African American life. It undoubtedly helped counteract the display of cowboys and Indians so graphically present in Johnston's photograph Class in American History. Rather than an image of cultural assimilation, which relegated Native American and African cultures to the past, Tanner produces a testimony to the changing and vital nature of cultural traditions and to the persistence with which African Americans (and Native Americans) would pursue the knowledge necessary to continue their struggles for equality into the twentieth century.

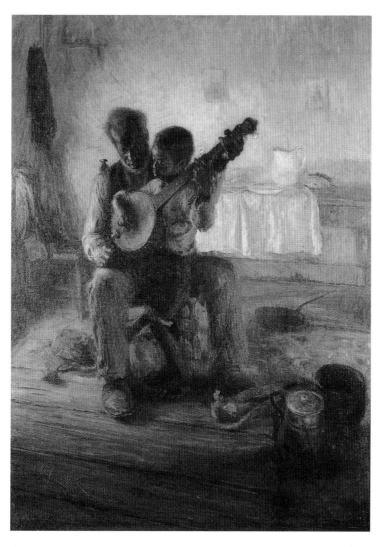

9.25 HENRY OSSAWA TANNER *The Banjo Lesson*, 1893. Oil on canvas, 48×35 (121.9 \times 88.9)

REALISM AND NATURALISM

· 10 ·

THE GENERATION OF 1830 AND THE CRISIS IN THE PUBLIC SPHERE

ROMANTICISM AND THE CRISIS OF MEANING

THE POPULARITY OF EARLY NINETEENTH-L century landscape painting would probably have surprised its creators; it is now admired for precisely those qualities that were once most disparaged—abstraction and expression. "The great vice of the present day," wrote Constable himself in 1802, "is bravura, an attempt to do something beyond the truth." A generation later, Friedrich wrote: "It is the [unfortunate] taste of our time to relish strong colors. Painters outdo one another in applying make-up to cheeks and lips in their paintings; the landscape painters carry exaggeration even further and put make-up on trees, rocks, water and air. . . . Landscape painting these days no longer aims for a spiritual conception of its subject." In contrast to this nineteenth-century unease, the twentieth century has embraced bravura and exaggeration in landscape; Turner, Constable, and Friedrich have been celebrated as prescient forerunners of the Impressionists and the Expressionists, and their virtuosity is seen as its own justification. Indeed, we are moved, and assured of Constable's integrity, when in Hadleigh Castle (1829) he loosens his hold on mimesis and paints his feelings; we receive a shock of recognition, and are convinced he is speaking to posterity when he writes in 1821: "Painting is for me but another word for feeling."

More than any previous generation of artists and writers, the Romantics prized personal autonomy and creative originality. Conceiving themselves independent geniuses above the common mien, they claimed to possess the almost divine gift of Imagination, which offered, as Blake wrote: "A Representation of what Eternally Exists, Really and Unchangeably." As Blake's, Constable's, Ruskin's, and Friedrich's

remarks suggest, the Romantics were not proclaiming unfettered artistic abstraction and license. Art must engage "what Eternally Exists" and it must also be more than sheer mimesis and personal expression. Even landscape painting—in a sense the genre most free of moral implications by virtue of its focus on the natural instead of the human world—was tasked by them with a public moral and ethical imperative beyond both virtuosity and expressivity. Ruskin exemplified this traditional and idealist view of art; he judged the landscape art of Turner "invaluable as the vehicle of thought but by itself nothing." In Modern Painters (1843) he wrote that "all those excellencies which are peculiar to the painter as such, are merely what rhythm, melody, precision and force are in the words of the orator and the poet, necessary to their greatness, but not the test of their greatness. It is not by the mode of representing and saying, but by what is represented and said, that the respective greatness either of the painter or the writer is to be finally determined."

Ruskin's view that the artist had a responsibility to imitate the essential truths of society, as he elsewhere wrote—and not just the appearance of nature—was shared even by those with very different politics and tastes. Although Constable was a Tory and Ruskin an early Socialist, the painter shared the critic's belief in the moral and ethical responsibility of landscape painters. It was his ambition, we have seen, scientifically to record, for purposes of instruction and moral suasion, his vision of England as richly productive, a land of social peace and hierarchic stability. Indeed, Constable's "sixfooters" were intended to carry the ideological burden of history paintings: they were to enshrine for future generations the conservative social vision of the class of industrious rural gentry to which the artist belonged.

In Germany, the landscapes of Friedrich were also

intended to offer moral lessons; the artist described his works as transcendental exercises with the potential to help overcome the spiritual alienation of individuals within society. "Close your eye," he instructed painters, "so that your picture will first appear before your mind's eye. Then bring to the light of day what you first saw in the inner darkness, and let it be reflected into the minds of others." The task of the painter was thus again, as with Constable, to reconcile self and other, self and society, nature and society through the unique procedures of landscape mimesis and idealization. The artist, the nature-philosopher F. W. Schelling wrote, must "withdraw himself from [nature] . . . but only in order to raise himself to the creative energy and to seize [it] spiritually. Thus he ascends into the realm of pure ideas; he forsakes the creature, to regain it with thousandfold interest, and in this sense to return to nature." Schelling's language is abstract, but his injunction to artists is unmistakable: they must show us that transcendent truths do exist by creating works that are in equal parts ideal and real. Art is a means by which people can be made to understand that their freedom resides precisely in their submission to morality.

In sum then, we have seen that however experimental, virtuosic, and original it may have been, English and German and also American landscape painting in the Romantic age was also expected to play an important discursive role in the unfolding of politics, ethics, and morality. Yet the very fact that painters and critics were beginning to notice a widening gap between artistic expressiveness and public meaning reveals that a cultural crisis was already underway. Increasingly estranged from a public they viewed as capricious and "simple minded" (in the English poet Shelley's phrase), artists were uncertain to whom exactly they owed allegiance. Increasingly subjected to the thrall of a market they saw as vulgar and factious, artists grew unsure about precisely how to measure their successes and failures. At once freed from oppressive structures of patronage and cut off from supportive communities, Romantic artists, finally, were unsure about just what values, morals, and precepts should be represented in their works. This crisis of cultural meaning, which ultimately led to the creation of a modern and critical nineteenthcentury art, was nothing less than a crisis of the public sphere itself.

The "public sphere," writes the critical philosopher Jürgen Habermas, is "that realm of our social life in which something approaching public opinion can be formed. Access is guaranteed to all citizens. A portion of the public sphere comes into being in every conversation in which private individuals assemble to form a public body." In England, the Royal Academy exhibitions, established in 1768, were important arenas for the formation of a progressive bourgeois public sphere; there (as in the French Salon exhibitions inaugurated

a generation earlier) artists, patrons, and public could informally assemble to discuss, debate, and negotiatethrough the medium of works of art—the new Enlightenment principles of liberty and equality, the hierarchies of class and gender, the roles of public and private authority, and the political structures of state and empire, among other issues. Artworks of every genre and description—especially history painting but also landscape—played parts in this drama of discursive exchange, helping to cement bourgeois class solidarity, and ultimately to secure its political hegemony. (A taste for art and literature, and the requisite skills of interpretation, was a measure of one's status within the bourgeoisie, and thus too an instrument of cultural power.) Ideally suited—by virtue of its simultaneously empirical and commodity character—to its role within the bourgeois public sphere, painting played a pivotal cultural part in the unfolding of world historical events in the eighteenth century. That elevated cultural status, however, could not outlive the public sphere itself.

What a bourgeois public sphere cannot tolerate is the intrusion of cultural and class factions whose beliefs and attitudes contradict its own cherished notions of reason and common sense. This was precisely what began to occur in England and France in the second and third decades of the nineteenth century. By around 1820, the temper of public life in England had indeed changed: trade unions, working-class corresponding (debating) societies, utopian socialism, dissenting churches, feminism, and an expanding radical press were signals of the decline of consensual politics and the breakup of the bourgeois public sphere that had prevailed (though not without significant strains) for a hundred years. The task of the bourgeois public sphere—debate, negotiation, and consensus-building among like-minded men-had become a paralyzing and debilitating burden in the midst of a social totality fractured by working-class dissent. The later landscape paintings of Constable may be seen as a symptom of the crisis. In the midst of rural revolt and economic hard times in 1823, Constable wrote to his friend Archdeacon Fisher: "Though I am here in the midst of the world, I am out of it, and am happy, and endeavour to keep myself unspotted. I have a kingdom of my own, both fertile and populous—my landscape and my children." Indeed, it was precisely Constable's attempt to keep his art "unspotted" by the plagues of insurrection and Luddism that, as we saw in an earlier chapter, precipitated the dichotomy of representation and abstraction in his last works. That division, prefigured nearly a generation before in the recondite and mystic imagery of William Blake, would soon come to dominate English and especially French nineteenth-century art. The accepted name for the phenomenon—whereby the truth of a representation is doubted and the materiality of its form embraced—is

"modernism"; it arose wherever a well-entrenched set of cultural traditions (for example, those associated with the term Classicism) collided with a new complex of social and political hierarchies.

Constable's artistic crisis, therefore, which I see as foreshadowing the exigencies of many subsequent European and American artists, was also a public sphere crisis. His historical situation and painterly response may be summed up as follows: the breakdown of political consensus-long in coming but accelerated by the boom and bust cycle of the 1820's—was marked by the rise of working-class "combinations," the growth of rural radicalism, and demands for economic and political enfranchisement. In the face of these challenges, the Tory Constable retreated more and more into an expressive, confessional, and idiosyncratic "kingdom of [his] own." Yet his quixotism was soon judged by critics to be a cipher of the very alienation Constable sought so desperately to fend off. "Nature [in Constable]," wrote the author of an 1837 obituary, "is one vast factory and every element in it condemned to perpetual toil." Constable's defensive response to political and cultural dissidence, in other words, was itself seen as dissident. How could the painter not retreat still further into the emotional sanctuary of "bravura" if even he was judged by his contemporaries to be radical?

In Constable's personally logical, but culturally ambiguous, response to the breakdown of the bourgeois public sphere, appears a premonition of the subsequent directions of nineteenth-century art. At once defensive and aggressive, conservative and radical, traditional and modern, Constable died at a time when art was undergoing an epochal transition. After the collapse of the bourgeois public sphere, painters and sculptors in England, France, the United States, and elsewhere in the West pursued several different but inevitably risk-filled and contradictory strategies.

1) Accepting without plaint the breakdown of the public sphere, many artists settled for a new, culturally diminished role for themselves. Ideologically plaint, culturally complacent, and stylistically eclectic, the art they made might be sponsored by the church or state, or produced "on spec." Regardless of its origin or destination, however, this work would always flatter and entertain. It might inform audiences of what they already knew, or cynically remind them of what they knew they were supposed to believe. The names given today to this varied art—which arose in France with Louis-Philippe and became anachronistic within two generations are "Academic" and "Official" painting. (The former is the art supported by the Académie des Beaux-Arts, the latter the art sponsored by the successive state administrations—the two were generally, but not always, in basic agreement.) With hindsight, Academic and Official painting may be seen as early instances of "mass culture" or "kitsch;" they were part of the French and European general provisions of bread and circuses intended to secure working-class and petit-bourgeois allegiance to capital. (A more or less straight line runs from the French Academician Paul Delaroche [1797-1856] to the Hollywood director Cecil B. DeMille). The historical origins and stylistic variety of this art will be explored later in this chapter under the subheading "The July Monarchy and the Art of *Juste Milieu*" and in Chapter 14, under "Individualism and Naturalism in French Salon Art."

2) Reasserting cultural authority and political engagement, a few artists embraced a newly emergent "counter-public sphere." By representing the interests of audiences, constituencies, and patrons from outside of the bourgeoisie—that is, from among the peasantry, proletariat, and petit bourgeoisie-artists once again created works that become vehicles for public and political debate, contest, and consensus. This ambitious direction in art, especially pronounced in France because of the salience of its revolutionary history, was fraught with personal and professional risk, because it generally fell foul of cultural, political, and military authority, and because it sought to address an audience lacking in political, financial, and critical wherewithal. As a result, this artistic mode—described below as avant-garde—was generally pursued only during periods of bourgeois vulnerability or subaltern empowerment. Avant-garde art arose in France during the Second Republic (1848–51); its great apostle was the Realist Gustave Courbet. Its re-emergence there some years later among Manet and the Impressionists and in Italy among the Macchiaioli was coincident with the decline and fall of the Second Empire (1870) and with the Italian movement for unification and independence called the Risorgimento. Moments of avant-garde volition are, however, visible (avant la lettre) earlier in the century—as we have seen with Goya and Géricault-and later, as in the works of Vincent van Gogh, Georges Seurat, and perhaps Paul Gauguin.

3) Seeking no social or political role at all—neither within a "counter public sphere" nor within the domain of Official and Academic entertainment—a small but gradually expanding number of artists pursued the chimera of autonomy. Carefully cultivating their posture of expressive and ideological disinterest, they were sponsored by few and criticized by all. At once embracing and disdaining modern life, these artists sought sanctuary in remote places or among people without clearly fixed class allegiances or ideological identities—the lumpen-proletariat, the petit bourgeois, and foreign and domestic "primitives." This artistic route—the origins of which, as indicated above, may be traced back at least to Goya, Blake, and Constable—is conventionally called "modernism." It flourished in periods of historical transition, political stasis, or cultural pessimism, especially during the Second Empire

with Manet, and during the *fin-de-siècle* with the Symbolists. (The art of Edouard Manet, we shall discover, engaged all three of these strategies.)

Surrender, defiance, and withdrawal—these terms broadly represent the gamut of critical responses to the crisis brought about by the decline of the bourgeois public sphere in the third and fourth decades of the nineteenth century. Academic and Official, Avant-Garde, and Modernist—these labels provide a framework for examining the visual arts of the middle and late years of the century; they also provide a vantage point from which to view the expanding critical consciousness of nineteenth-century art.

THE JULY MONARCHY AND THE ART OF THE JUSTE MILIEU

In France the crisis of the bourgeois public sphere grew acute in the years following the revolution of July 1830. Striving to reinvigorate the genre of history painting, Eugène Delacroix created The 28th of July: Liberty Leading the People in time for exhibition at the Salon of 1831. Far from the triumph he had hoped for and expected, the picture was little short of a public disaster. Boldly painted with the discordant colors of the French tricoleur, populated with workers, students, and bourgeois alike, Liberty was too literal a depiction of the sustaining myth that the July Revolution was the creation of all the classes of Paris acting in harmony. It was one thing for Delacroix to embrace, as the officially sanctioned Horace Vernet did in The Duc d'Orléans Proceeds to the Hôtel-de-Ville, July 31, 1830 (1833), comforting homilies about solidarity, but quite another thing to see Liberty herself wearing the disheveled costume of the proletariat: "Was there only this rabble . . . ," asked Dumas, "at those famous days in July?" Although purchased (cheaply) by the French Interior Ministry and exhibited at the Musée Luxembourg in 1832, Liberty was thereafter secreted from sight out of fear that it would incite sedition. The concern was not unreasonable.

No longer the social *mélange*, or *sans-culottes* of 1789, the Paris workers who fought on the barricades in July were becoming self-conscious *prolétaires* (the term was first used in its modern sense by Auguste Blanqui in 1832). For them, the Revolution was fought not only for restoration of the constitutional charter usurped by the Bourbon Charles X, but for the right to work, the right to a fair wage, and the right to organize trade unions. Within a year of the Revolution, a new round of insurrections had begun: in November 1831, the silk workers of Lyons were on strike in protest against economic *laissez-faire* and a low *tarif* (scale of wages for piece-work); in 1832, workers in Paris rose up in rebellion after the funeral of a popular Bonapartist general; in 1834, it was once again the

turn of Lyons workers who, backed by a local Republican party, fought police and national troops in a six-day pitched battle which left hundreds dead. Within days of the Lyons uprising in April, workers in the French capital rose in anger at the closure of a radical newspaper and the arrest of the leaders of the proletarian Society of the Rights of Man. On April 14, barricades were erected by the workers to block the passage of troops through the proletarian faubourgs of Paris. The tactic was unsuccessful, however, and within a short time, the uprising was defeated and dozens of workers were dead on the streets or in their homes. The government massacre was depicted by the young caricaturist Honoré Daumier (1808–79) in a large lithograph exhibited in a shopwindow in October, Rue Transnonain April 15, 1834 (1834). A few months later, a series of strict press censorship laws were passed, and the facade of constitutionalism dropped. Neither history paintings like Delacroix's, nor even political caricatures such as Daumier's "You have the floor, explain yourself" (1835), created during the trial of the rebels of 1834, would be permitted to engage the public sphere.

For nearly two decades following the July Revolution, French painting and sculpture were severely circumscribed by the policies and preferences of the French Académie and the regime of Louis-Philippe. The Classical tradition—once the grand, metaphoric language of enlightenment and revolution—was now compromised by bourgeois historicism, as in Delaroche's semicircular mural painting Artists of All Ages (1836–41). Created for the hemicycle auditorium in the Ecole des Beaux-Arts in Paris, the work (more than eighty feet wide at its base) depicts seventy-five figures representing the progress of art from ancient to modern times. Unlike Ingres's Apotheosis of Homer, however, which was its ostensible inspiration, Delaroche's hemicycle is anecdotal and conciliatory. Here artists-from Cimabue to Puget-are seen relaxing and kibitzing as if they were gathered during a theatre intermission. The Romantic sculptor David d'Angers called it a "scholarly genre painting," succinctly exposing its essentially intimate (despite its size) and antiquarian character.

Just as the Classical tradition of art was giving way to antique costume drama during the regime of Louis-Philippe, so too history painting itself (tableau d'histoire) was giving way to a hybridized historical genre painting (genre historique). Seeking to discourage the creation of large-scaled, politically tendentious subjects taken from Greek and Roman antiquity, the state and the Academy encouraged instead the exhibition and sale of easel-sized pictures representing nationalistic, patriotic, and familial themes drawn from past and present history. This new genre historique, as critics called it, consonant with the historical writings of François Guizot, Adolphe Thiers, and Jules Michelet, emphasized the achievements of the grands hommes of French history, as well as

10.2

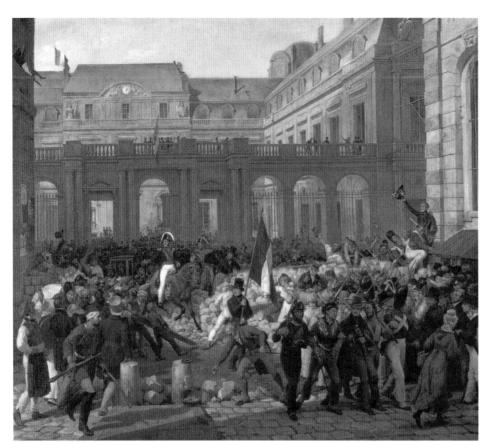

10.1 HORACE VERNET *The Duc d'Orléans Proceeds to the Hôtel-de-Ville, July 31, 1830*, 1833. Oil on canvas, 89¾ × 8′ 4½ (228 × 258)

10.2 HONORÉ DAUMIER *Rue Transnonain April 15, 1834,* 1834.

Lithograph, 11½ × 175% (29.2 × 44.8)

10.3 PAUL DELAROCHE *Artists* of All Ages, 1836–41. Encaustic, 12'5 × 82' (388.6 × 2499.4)

depicting the beliefs, manners, habits, and conditions of the everyday people of the past. The political impetus behind such works, represented by the lubricious Cockfight (1846) by Jean-Léon Gérôme (1824–1904) and the sentimental Saint Augustine and Saint Monica (1854) by Ary Scheffer (1795–1858), is of course profoundly conservative. While the Gérôme, for example, enshrines masculinism and the Scheffer Catholicism, both occlude historical change by implicitly arguing that the difference between the past and the present is only a matter of costume. Unlike previous history paintings intended to function as exemplum virtutis, the genre historique was intended to elevate the present by diminishing the splendor and distinctiveness of the past. (Official and Academic painting was completely successful in this latter regard: by the time of Thomas Couture's Romans of the Decadence [1847, see pp. 236–38], the Classical vocabulary was suited, for the most part, only to irony, satire, and melodrama.)

The *genre historique* may be observed in the medium of sculpture as well as painting during the July Monarchy. Although exhibited at the pre-revolutionary Salon of 1827, Félicie de Faveau's (1799–1866) plaster *Christina of Sweden Refusing to Give Mercy to Her Squire Monaldeschi* (ca. 1827) exemplifies the tendency in the 1830's for relief sculpture to

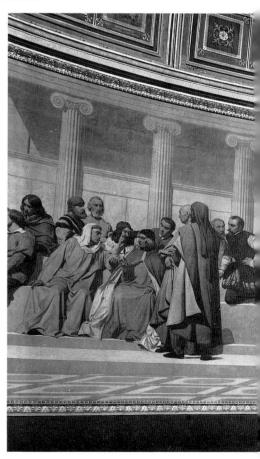

228 · THE GENERATION OF 1830

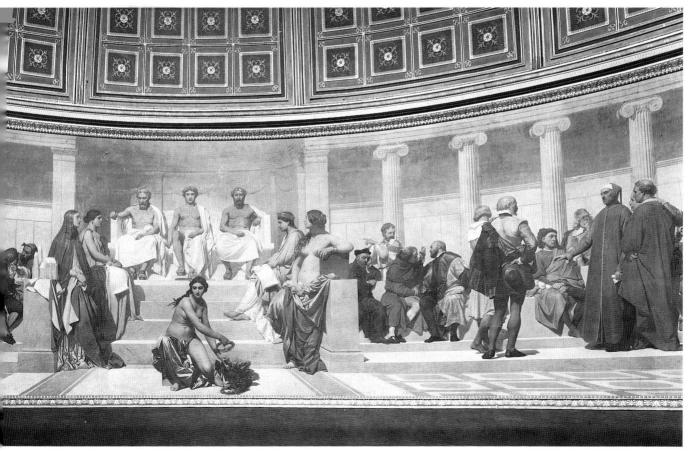

THE JULY MONARCHY AND THE ART OF THE ${\it JUSTE~MILIEU}$. 229

10.8

10.1.

10.4 ARY SCHEFFER Saint Augustine and Saint Monica, 1854. Oil on canvas, $53\frac{1}{4} \times 41\frac{1}{4}$ (135.2 × 104.7)

become portable, anecdotal, historicist, and intimate. Her work is, however, a remarkable example of the genre, because of both its treatment and its theme. The relief is serious and restrained in its dramatic action and setting, consisting of two distinct but proximate figural groupings set against a blank background. The subject is no less compelling, representing an act of militancy and resolve, not unlike the actions of the sculptor herself, who was briefly imprisoned in 1832 for her participation in a Bourbon Legitimist plot against Louis-Philippe.

More representative of July Monarchy sculpture, however, is the work of Antoine-Louis Barye (1796-1875). Like most sculptors of the period, Barye came from an artisanal background and maintained strong ties to the industrial and decorative arts traditions. He was a pioneer (along with the slightly older David d'Angers) in the revival of bronze sculpture, and was among the first serially to reproduce his designs in order to reach a large middle-class audience. Barve's class background, technical innovativeness, and longstanding association with unionized bronze-foundry workers, however, did not affect his thoroughly Orléanist political allegiances. His Lion Crushing a Serpent (1833), which won for him the Légion d'honneur, was widely regarded as an allegorical celebration of the July Revolution; it could be interpreted as the French people crushing the Bourbon dynasty, or as Orléanist law destroying Republican anarchy. (Both of these messages were fully consonant with Louis-Philippe's promotion of himself as the promulgator of moral order and national prosperity.) Although Barve thereafter only rarely ventured into the mode of political allegory, his many bronze sculptures of animals in combat appealed to the regime's taste for melodrama and scientific naturalism. Partly derived from ideal ancient and Renaissance prototypes, and partly from naturalist observation at the Paris Cabinet d'Anatomie Comparée (established in the late eighteenth century by Georges Cuvier), Barye's bronzes are thus the products of typical July Monarchy compromise.

Like Barye, most artists of the July Monarchy sought to achieve in their works the same juste milieu (golden mean) that the king was seeking to achieve in matters of state. Louis-Philippe saw his state as the preordained reconciliation of 1789 with the Restoration; his regime would pay homage to the memory of the heroic Bonaparte even as it set store by such men as the stolid bourgeois M. Louis-François Bertin, 10.7 painted by Ingres in 1832. Freedom and order, democracy and stability, science and faith, progress and business-asusual—these were the paired pillars of the juste milieu, paralleling France's dual revolutionary and monarchical traditions. Thus the king and his idéologues (the term had been coined by Napoleon) courted both eclecticism and synthesis in their cultural and economic policies alike. Alongside the new industrialization grew parochial monopolies; among the new national banks arose domestic tarifs and foreign protectionism. Together with the Classicism of Ingres was the Romanticism of Delacroix; beside the official, Romantic idealism of Scheffer was the Academic, Neoclassical verisimilitude of Gérôme.

As Boime has shown, the politics and art generally pursued during the July Monarchy were those which harmoniously blended these irreconcilables. "Take a portion of monarchy, a portion of aristocracy and a portion of democracy," wrote the socialist and cynic Pierre Leroux in 1839, "and you will have the Restoration or the juste milieu, and that will be eclecticism." "Genius is a ready and sure perception of the right proportion [of] the ideal and the natural, form and thought," wrote the influential philosopher Victor Cousin in Du vrai, du beau et du bien (1853). "This union is the perfection of art: masterpieces are produced by observing it." Like juste milieu politics, however, juste milieu art was ultimately contradictory and unstable. Two cases in point, dating from the beginning and end of the July Monarchy, are David d'Angers' sculpted pediment for the Pantheon and Couture's painting for the Salon of 1847, Romans of the Decadence.

10.5 FÉLICIE DE FAVEAU Christina of Sweden Refusing to Give Mercy to Her Squire Monaldeschi, ca. 1827. Plaster, 15¾ × 22¾ (40 × 58)

10.6 Antoine-Louis Barye Lion Crushing a Serpent, 1883. Bronze, length 70 (177.8)

10.7 JEAN-AUGUSTE-DOMINIQUE INGRES M. Louis-François Bertin, 1832. Oil on canvas, $46 \times 37^{1/2}$ (116.8 × 95.3)

THE PARADOX OF PATRIOTISM: DAVID D'ANGERS' PANTHEON PEDIMENT

2.33

10.8

Begun in 1830, the year Delacroix was painting Liberty Leading the People, David d'Angers' pediment of the Pantheon was an effort to engage the imagination and energy of a progressive and patriotic bourgeoisie. Like the painting, the relief combines real and allegorical figures in a stirring but heteroclite ensemble. Like the painting too, the colossal sculpture was received by political moderates and conservatives with anger and incomprehension, revealing a widening schism in the public sphere. Beneath the relief appears an inscription which announces its theme: "AUX GRANDS HOMMES LA PATRIE RECONNAISSANTE" ("To great men from the grateful Fatherland"). At the center of the pediment stands the allegorical figure of La Patrie, distributing laurel wreaths handed to her by Liberty, seated at her right. History sits at La Patrie's left, inscribing on a tablet the names of the grands hommes of military and civic affairs who are to be honored.

Military men occupy the right half of the pediment, led by the young Bonaparte, who reaches past History to take his crown. With the exception of the legendary drummer from

the battle of Arcole, the remainder of the military figures are anonymous soldiers of the Revolution and Empire, assembled left to right, in decreasing order of rank. The men of civic and cultural affairs fill the left half of the pediment, and represent a liberal Enlightenment canon. They include Rousseau and Voltaire (seated side by side on a bench), J.-L. David (standing, with palette and brushes), the jurist and victim of the Terror Malesherbes (standing, with counselor's robes), and behind him the deputy Manuel, expelled in 1823 from the Chamber of Deputies for his opposition to French intervention on behalf of the monarchy in Spain. Among the others are Cuvier, the Archbishop Fénélon, and the Marquis de Lafavette, who was instrumental in conferring the crown on Louis-Philippe but who soon thereafter became disenchanted with the monarchy

For the most part, David d'Angers' patriotic pantheon represents the range of his own generally liberal-to-Jacobin political sympathies, as well as reflecting the liberalism of the Orléans regime at its inception. (Even the inclusion of the monarchist Malesherbes does not detract from the overall left politics: he was as renowned for helping to end the issuance of lettres de cachet as for advocating the life of Louis XVI.) Yet the unanimity of artist, patron, and audience that underlay the program for the pediment would not survive 1830. As the revolutionary summer passed into a repressive winter and spring, David d'Angers' cast of characters—like those of Delacroix—was increasingly seen as tendentious, incendiary, or simply incoherent. Attempts were made by successive ministers of the interior in 1832-4 to block completion of the project, and the actual unveiling of the work was postponed in July 1837, probably out of nervousness over its political content. David d'Angers was relentless, however, in his determination to finish and display his work, and in September 1837 he finally succeeded in having the obscuring canvas and scaffolding removed.

During the succeeding months and years, the Pantheon pediment was vehemently criticized from the Legitimist and Ultramontane right and the Orléanist center of the political spectrum. David d'Angers' depiction of the atheists Voltaire and Rousseau among others, on the facade of a building originally consecrated in honor of Saint Genevieve (1756–90), 7.6 was anathema to conservative Catholics, who included Queen Amélie. In addition, his embrace of the principles and personages of the Revolutions of 1789 and 1830 was seen in official circles as both anachronistic and provocative: anachronistic because the King had already rejected the very revolutionary principles that brought him to power, and provocative because a series of recent ministerial and economic crises threatened to precipitate a new uprising; reconciliation and quietism were now most wanted in the arts. As might be expected, therefore, the left (its voice, however,

10.8 PIERRE-JEAN DAVID D'ANGERS Pediment of the Pantheon, Paris, 1830-37

muted by press restrictions) was much more favorably disposed toward the pediment than the right, seeing in it a condemnation of Catholic revanchism, Orléanist authoritarianism, and bourgeois corruption.

Yet it would probably be incorrect to view David d'Angers' pediment as existing wholly outside the juste milieu ideological orbit. For one thing, its representation of the concept of grands hommes was consonant with the historicist preoccupations of the Orléans court and its official historian, François Guizot. (We have already considered Delaroche's Artists of All Ages as one juste milieu result of that interest.) For another, the sculptor's creation of a bourgeois Enlightenment martyrology repudiates emerging radical ideas about the centrality of the proletariat in the revolutionary process, such as those held by Auguste Blanqui, represented by his friend the artist in 1840. Stylistically, too, the pediment is marked by juste milieu compromise, combining as it does Baroque Classicism with elements from the genre historique. Like his freestanding monument to Cuvier (1845), the pediment possesses the majesty and hierarchism found in works by the greatest sculptors of the late ancien régime—especially Bouchardon, Pigalle, and Pajou-vet individual figures also display an informality, particularism, and even homeliness suggestive of works by Delaroche, Scheffer, and Gérôme, among others.

In one significant way, however, David d'Angers' version of *juste milieu* stands apart from that of his contemporaries, and anticipates an emerging attitude of avant–gardism: his best sculptures achieve their power and perspicacity by embracing popular artistic traditions outside of the official mainstream.

The proportion, physiognomy, and placement of figures in his pediment were probably influenced by the popular prints then being issued in great numbers from the town of Epinal in northeastern France. In David d'Angers' pediment and in F. Georgin and J.-B. Thiébault's woodcut The Apotheosis of Napoleon (1834), for example, the Academic canons of graceful human proportion are rejected in favor of more squat or compact formulae. In addition, both works employ perspective only minimally; this flatness is immediately apparent in the serried ranks of soldiers in the woodcut, but it is also visible in the sculpture. Instead of conceiving the pedimental space as coextensive with the actual three dimensions of the lived world, David d'Angers had created a telescoped space of shallow planes in which figures are overlapped or superimposed, one above another. To some extent, this approach to composition is dictated by the peculiar triangular format, but the sculptor's stylistic populism is equally apparent in his rectangular relief panels, such as The Motherland Calling Her Children to the Defense of Liberty (1835) in the vault of the Arc de Triomphe at the Gate of Aix, in Marseille. Here the heroic plebeians are jumbled together in shallow relief and comic cacophany, at once recalling the paintings of Pieter Breugel the Elder and anticipating the frescos of Diego Rivera.

David d'Angers' skill at synthesizing diverse styles and traditions was shared by two other outstanding sculptors of the July Monarchy—François Rude (1784–1855) and Antoine-Augustin Préault (1809–79). In Rude's famous Marseillaise (or The Departure of the Volunteers of 1792,

10.9

APOTHÉOSE DE NAPOLÉON.

10.9 F. GEORGIN and J.-B. THIÉBAULT The Apotheosis of Napoleon, 1834. Print, 16×23 (40.6 \times 58.2)

10.10 Antoine-Augustin Préault Slaughter, 1833–4. Bronze, 43×55 (109.2 × 139.7)

10.11 PIERRE-JEAN DAVID D'ANGERS The Motherland Calling Her Children to the Defense of Liberty, 1835. Stone, 53½ × 10′11½ (135 × 333)

10.12 FRANÇOIS RUDE The Marseillaise (The Departure of the Volunteers of 1792), 1833-6. Limestone, height 42' (504)

1833–6), on the Arc de Triomphe in Paris, the sculptor depicts war as an ugly siren calling the volunteers of '92 to order and arms. Part of an elaborate sculptural program intended to promote domestic tranquility, Rude's relief is marked at once by violence and humor. The figure of War above emits a blood-curdling alarm while the soldiers below react with confusion; their dishevelment and *déshabille* lends the scene a quotidianism that is at variance with its ostensible heroism. A similar combination of high and low, or ideal and anecdotal, elements may be seen in the work of Préault, who was for a time a student of David d'Angers.

In Préault's plaster relief *Slaughter* (1833–4, later cast in bronze), the artist represents the massacre of a family by a helmeted warrior and a black man shown at the upper left. (The precise subject of the work, if there was one, remains unknown.) Though partly inspired by reliefs by the Baroque sculptors Pierre Puget and Alessandro Algardi, the work is remarkably abstract and experimental. The composition has the compactness of an ancient "episodic fragment of a low relief" (in the artist's words), and the flattened space of Epinal prints. Yet there is nothing static about *Slaughter*: indeed, its two-dimensionalism is almost Cubist in its jostling and juxtapositioning of forms and figures. (A century later, the figure of the screaming mother provided a model for Picasso's *Guernica*.) Préault's *Slaughter* did not find a

-.10

THE PARADOX OF PATRIOTISM - 235

sympathetic audience; after exhibiting it at the Salon of 1834 (the year of the slaughter of Transnonain: see p. 227), he was excluded from Salon exhibitions for the next fifteen years.

Less confrontational and better connected than his pupil, David d'Angers did not suffer a similar exile from patronage. However, for the remainder of his career after the Pantheon pediment he was forced to grapple with the political paradoxes of public sculpture. Indeed, it would seem that his very project had become untenable in the era in which it was conceived. The construction of an Enlightenment canon, the celebration of the principles of 1789, and the embrace of alternative or popular art traditions, were acts that engaged a progressive bourgeois public sphere that for the most part no longer existed. The insurrectionary events in Paris and Lyons had put an end to the myth of solidarity between classes on behalf of liberté. From now on, artists would either have to abjure highminded political principle or else embrace it and thereby unleash the very divisive ideological forces that the July Monarchy sought to control. The public sphere and the bourgeois juste milieu, in other words, were incompatible.

David d'Angers' last years were marked by political engagement (he was elected a departmental deputy during the Second Republic) and artistic hope. His dream of a great *Monument to Emancipation*, however, would remain unfulfilled

with the exception of a few drawings and models, while his small bronze medallions in commemoration of *grands hommes* would multiply to more than five hundred. In January 1841 he wrote to the German physician and painter Carl Gustav Carus (1789–1869) concerning a small terracotta statuette of Liberty: "I am very much afraid that the figure of Liberty that I am sending you will be confiscated by the German customs. The rulers of all countries fear it even in painting. They are right because Liberty is the sword of Damocles suspended continually above their heads. It is the powerful voice of humanity that will be heard some day from one end of the earth to the other." Within a decade, that voice would indeed be heard again in France, and a new, avant-garde art would be born in response.

THOMAS COUTURE: CLASSICISM AND THE WOMAN QUESTION

At the end of the July Monarchy, Thomas Couture (1815–79) painted *Romans of the Decadence* (1847) in an effort to revive monumental history painting for the public sphere. In many ways, as Boime has argued, the picture is a summation of *juste milieu* culture, combining history painting and the *genre*

10.13, 14 THOMAS COUTURE Romans of the Decadence, 1847. Oil on canvas, $15'6\frac{1}{2} \times 25'$ 10 (473.7 × 787.4)

historique, Classicism and Romanticism, eroticism and sexual repression, political criticism and Orléanist ingratiation. At the Salon of 1847 it achieved a success as vast as its size and ambition, and was soon among the most widely admired, discussed, and reproduced paintings of the nineteenth century. Yet for all its celebrity, Romans was as much an end as a beginning; like David d'Angers' Pantheon pediment, Couture's painting was contradictory and paradoxical, and may actually have helped to destroy public, monumental, and Classicizing art in the attempt to save it.

Romans of the Decadence represents the debauched morning after an orgiastic night before. Within a columned hall, some forty figures in Roman costume are seen lounging, sleeping, dancing, embracing, or, in the case of the two standing men at the right, casting censorious glances. On the intarsia marble floor in the foreground is a still life of fruit, flowers, and amphoras. On the triclinium (three-sided sofa) in the middle-ground are the bulk of the figures, organized into large and small groups and appearing as a frieze parallel to the picture plane. Surrounding the revelers and bordering the chamber are alternating Corinthian columns and statues of august Romans, including Germanicus at the center of the picture. In the background is a courtyard or atrium, articulated with Classical columns, arches, pilasters, niches, cornices, and friezes.

Couture's bacchanal has formal and thematic antecedents in the work of the Renaissance artists Bellini, Titian, Raphael, and Veronese and in the painting of Géricault, Ingres, and Delacroix, among many others. Two especially apposite sources for *Romans* are Delacroix's *Women of Algiers* (1834) and *The Dream of Happiness* (1843) by Dominique Papety (1815–49). Together they provided a basis for Couture's attempted unification of Romantic color and Classical draftsmanship, as well as his idiosyncratic combination of sensualism and moral rectitude.

10.16

10.15

10.16

Delacroix's picture, inspired by the artist's visit to a Moroccan harem in 1832 (which in turn was made possible by the recent French occupation of the region) is a dream image of "Oriental" indolence. The three harem women and their servant are the embodiment of the European masculinist image of Middle Eastern and North African people as sensual and irrational. The third woman from the left, who is the source for the nude in profile at the center of Romans, holds the tube of a hookah, suggesting the timelessness of intoxication and sexual delight. Unlike Delacroix's Liberty Leading the People, which honors the classes and heroic individuals that made the July Revolution, Women of Algiers celebrates social and cultural passivity: the Orient is vividly represented by the artist as a land of erotic freedom and languor outside of politics, history, and class. "It must be hard for them to understand," Delacroix wrote in his diary from Tangier, "the

easy-going ways of Christians and the restlessness that sends us perpetually seeking after new ideas. We notice a thousand things in which they are lacking, but their ignorance is the foundation of their peace and happiness. Can it be that we have reached the end of what a more advanced civilization can produce?"

For Delacroix and a succession of Orientalists culminating in the Symbolist Paul Gauguin, "the East" functioned as an ideal respite from the dispiriting sexual and ideological conflicts that existed in "the West." Whereas in Paris women had begun articulating demands for the reform of property, child-custody, and divorce laws, in the East women appeared to be chattel slaves; whereas in Paris, the feminist and radical Flora Tristan (1803–44) published several tracts and a novel (Méphis, 1838) describing the liberation of women and the prolétaire as necessary and interrelated projects, in the Orient gender and class hierarchies appeared stable and timeless. Yet however racist and sexist it might be thought today, Women of Algiers is also a utopian tract. Like the Saint-Simonian philosopher Prosper Enfantin who dreamed in 1832 of a "beautiful army" of prostitutes destined to sanctify the flesh by fulfilling natural desire, Delacroix imagined a vividly colored Oriental utopia of feminine sexual pleasure in Women of Algiers. "This is a place for painters," Delacroix wrote from Tangier. "Economists and Saint-Simonists would find much to criticize here, from the point of view of the rights of man and equality before the law, but beauty abounds. . . . Here you will see a nature which in our country is always disguised, here you will feel the rare and precious influence of the sun which gives an intense life to everything." Delacroix's Women is thus both a testimonial to and a condemnation of the "advanced [European] civilization" of its day. It offered Couture a model of sexual blame and praise.

In Papety's *The Dream of Happiness*, exhibited at the Salon of 1843, some two dozen men, women, and children rest, lounge, read, sing, and cavort in a bower framed by Classical sculpture and architecture. The picture is explicitly indebted to the utopian socialist doctrines of Charles Fourier (1772– 1837), whose treatise *Unité universelle* is read by the young men and women at the lower right. Couture, who worked beside Papety in the studio of their teacher Delaroche, borrowed the motif of the young man offering a toast to the statue of a flute player for his own semi-nude male toasting the statue of Germanicus in Romans. Like the Women of Algiers, The Dream of Happiness is located outside of European history; Papety represents a future utopia of abundance, peace, and pleasure modeled on an idealized past that combines the "noble simplicity and quiet grandeur" of the Classical age with the sumptuousness and indolence of the French ancien régime. The Dream of Happiness is a kind of juste milieu nudist colony, at once ascetic and libertine, which

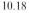

10.15 DOMINIQUE PAPETY The Dream of Happiness, 1843. Oil on canvas, $12'1\frac{3}{4} \times 20'8$ (370 × 635)

gave Couture a model marriage of conformism and liberalism.

Although inspired by these and many other works, Romans of the Decadence has its own specific content and origins. Its subject was taken, according to the 1847 Salon catalog, from two verses of the Roman writer Juvenal's sixth Satire, "Against Women," which compares the "plague" of feminine sexuality and betrayal in his age to the "blessings" of feminine chastity and loyalty in an earlier time: "Now we suffer the evils of long peace. Luxury hatches terrors worse than war, avenging a world beaten down." Juvenal's misogynist paean is succinctly represented at the center of Couture's picture by a crucial juxtaposition: the reclining woman (identified by contemporaries as a courtesan) beneath the erect statue of Germanicus. Just as sexually demanding women destroyed the might of Rome—so the modern argument went—the courtesan threatens the nobility and honor of France. If the Classical tradition has been brought low, it is the fault of modern women. In Couture's Romans, in short, feminine sexuality is figured as tragic decadence.

Couture's reclining courtesan, along with the other sexually usurpatious women in the picture, is an important instance of the increasingly widespread representation of the erotic female as the embodiment of modern decadence and death. In *Romans*, as in the exactly contemporaneous *Woman Bitten by a*

Snake by Jean-Baptiste Clésinger (1814–83) and Two Young Girls or The Beautiful Rosine by the Belgian Antoine Wiertz (1806-65), Woman is the repository of bourgeois fear and masculine loathing; by her erotic independence she is both a threat to male political prerogatives and a mockery of masculine sexual desire. At the same time as these artists, the poet Charles Baudelaire was beginning to sketch the theme of the vicious courtesan for his The Flowers of Evil (Les Fleurs du Mal, 1861) and Paris Spleen (Le Spleen de Paris, 1869). Unlike Delacroix, who appears to revel in what he takes to be the sexual freedom of the harem, Baudelaire hates the prostitute for her resemblance to himself. Subjected to the vicissitudes of the marketplace, the prostitute's sexuality—like the journalist's independence—is a mere sham of freedom. Irony is thus the rhetoric of Baudelairean sexuality: "Not so many years ago," says one of the old roués in "Portraits of Mistresses" from Paris Spleen, "Fate granted me the possession of a woman who was without doubt the sweetest, the most submissive, and the most devoted creature in the world, and who was always ready! And without enthusiasm!" The woman in the center of Romans of the Decadence, by contrast, is not lacking enthusiasm: her ennui is only the result of her insatiety. "What impossible sensuality," asked the critic Théophile Gautier, "does she dream of after that night of orgiastic passions?"

10.16 EUGÈNE DELACROIX Women of Algiers, 1834. Oil on canvas, 707/8 × 901/8 (180 × 229)

A year after the exhibition of *Romans*, the cliché of the temptress undermining virtue and ridiculing masculine desire would be supplemented by a still more virulent allegory: the modern prostitute would be identified with the radical proletariat leading society headlong to chaos and perdition. The origins of the "red whore" motif are to be found much earlier than 1848; certainly it may be detected in the conservative response to Delacroix's *Liberty*, described by the German poet and critic Heinrich Heine as an "alley-Venus." But amid the generalized panic of the months following the proletarian rising of June 1848, the image of the prostitute on

the barricades became seared in bourgeois memory. Jean-François Millet depicted the subject in a lost pastel, as did a host of reactionary caricaturists. Indeed, for the generation that followed the 1848 Revolution, the body of the prostitute—in fact and image—would become a battleground upon which class and gender struggles would be waged. Couture's *Romans of the Decadence* stands at the threshold of that new period of sexual and political antagonisms, just as surely as it stands at the close of an epoch in which the Classical tradition was the preferred metaphoric language for contest and debate within the bourgeois public sphere.

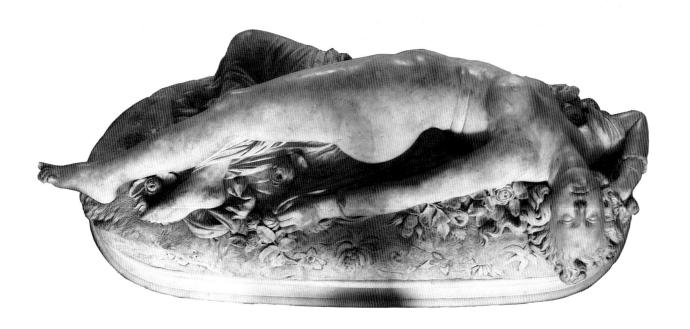

10.17 JEAN-BAPTISTE CLÉSINGER Woman Bitten by a Snake, 1847. Marble, length 31 (78.7)

10.18 Antoine Wiertz *Two Young Girls or The Beautiful Rosine*, 1847. Oil on canvas, $55\% \times 39\%$ (140 \times 100)

CLASSICISM AND THE WOMAN QUESTION - 241

· 11 ·

THE RHETORIC OF REALISM: COURBET AND THE ORIGINS OF THE AVANT-GARDE

RHETORICS OF REALIST ART AND POLITICS

USTAVE COURBET (1819-77) BELONGED TO THE Post-Romantic generation of French artists and writers that included Honoré Daumier, J.-F. Millet, Gustave Flaubert, and Charles Baudelaire. They were born at the close of an heroic age. In their youth, they witnessed the breakdown of a common language of Classicism, the dissipation of revolutionary idealism, and the growing division between artists and public. In their maturity, they saw the abandonment of Enlightenment principle and widespread accommodation of authoritarianism. At the end of their lives, they beheld the promise and threat of Communist insurrection and the complete collapse of a bourgeois public sphere. Together, these crises and caesuras combined to convince the artists and writers of the mid-century that they were living through a cultural rupture of unprecedented dimension: the name given for that broad epoch of change was "modernity," and the name for that specific post-Romantic generation was Realist. "I am not only a socialist," Courbet wrote provocatively to a newspaper in 1851, "but a democrat and a Republican as well—in a word, a partisan of all the revolution and above all a Realist . . . for 'Realist' means a sincere lover of the honest truth."

The rhetoric of Realism, however, is not confined to artists' manifestos or to France; it is written across the age and across Europe, in its politics, literature, and painting. The artists and writers mentioned above may not have read Marx's *Manifesto of the Communist Party* (1847), but their works shared with it a depiction of epochal anxiety, transformation, and desacralization:

The bourgeoisie has stripped of its halo every occupation hitherto honored and looked up to with reverent awe. It has converted the physician, the lawyer, the priest, the poet, the man of science into its paid wage-laborers. . . . Constant revolutionising of production, uninterrupted disturbance of all social conditions, everlasting uncertainty and agitation distinguish the bourgeois epoch from all earlier ones. . . . All that is solid melts into air, all that is holy is profaned, and man is at last compelled to face with sober senses, his real conditions of life, and his relations with his kind.

Marx's words are redolent with images from Realist art and literature. Physician, lawyer, priest, poet, and man of science are veritably the cast of characters in Flaubert's bitter satire of country life, *Madame Bovary* (1857); the depressing results for humankind of the "uninterrupted disturbance of all social conditions" are exposed in Daumier's *The Third-Class* 11.1 *Carriage* (ca. 1862), Millet's *The Gleaners* (1857), and 11.2 Courbet's *The Stonebreakers* (1850); the poet stripped of his 11.1 halo is the subject of Baudelaire's ironic prose-poem "The Loss of a Halo" in *Paris Spleen* (1869).

In the art and literature of Courbet and Flaubert, reverence for the ideal and honor of the Classic have no place: the former depicted gross wrestlers, drunken priests, peasants, prostitutes, and hunters; the latter described common scribes, pharmacists, journalists, students, and adulterers. In the caricatures of Daumier and the poems of Baudelaire, there appear no Romans in togas (except for purposes of satire) or medieval knights in armor: they preferred to honor ragpickers in their shreds and patches, country bumpkins in their ill-fitting city clothes, and bourgeois men in their black suits. "It is true that the great tradition has been lost," wrote Baudelaire

11.1 HONORÉ DAUMIER The Third-Class Carriage, ca. 1862. Oil on canvas, $25\frac{3}{4} \times 35\frac{1}{2} (65.4 \times 90.2)$

11.2 JEAN-FRANÇOIS MILLET *The Gleaners*, 1857. Oil on canvas, 33 × 44 (83.8 × 111.8)

at the dawn of this new age, in "On the Heroism of Modern Life" (1846),

and that the new one is not yet established. . . . But all the same, has not this much abused garb its own beauty and its native charm? Is it not the necessary garb of our suffering age, which wears the symbol of a perpetual mourning even upon its thin black shoulders? Note, too, that the dress-coat and the frock-coat not only possess their political

beauty, which is an expression of universal equality, but also their poetic beauty, which is an expression of the public soul—an immense cortège of undertakers' mutes (mutes in love, political mutes, bourgeois mutes . . .). We are each of us celebrating some funeral.

Compared to modern men in "frock-coats," like those from Balzac's novels, the poet then explains, "the heroes of the Iliad are but pygmies." J'avais lu *l'Art d'aimer* d'Ovide; plein de respect pour le beau sexe, et plus poli que Sextus, je me retirai.

La poussière du Forum m'avait desséché le gosier; j'entrai dans un café. — Puer! m'écriai-je, apportez-moi une glace à la pomme des Hespérides et au rhum.

Absorbé par un flamine qui payait la demi-tasse à deux vestales, le garçon ne prenait point garde à moi.

In contrast to Baudelaire's irony, Daumier and his fellow caricaturist Grandville (J.-I.-I. Gérard, 1803-47) chose anachronism to satirize the "real conditions" of their "suffering age." In the 1840's, they highlighted the dubious heroism of the present by depicting the stylishness of figures from the Classical past, as in Daumier's lithograph "The Abduction of Helen," from Le Charivari (1842), and Grandville's engraving of Romans ordering an "apple of the Hesperides and rum ice." In the latter sheet, from Un Autre Monde, sympathetic to the socialist ideals of Charles Fourier (see pp. 238 and 401), a modish ménage wearing Roman sandals are seated in a bistro, being served drinks by a surly waiter standing in Classical contrapposto. Once again the rhetorics of Realist art and politics may be seen to overlap. Anachronism and caricature were the linguistic weapons of choice for Karl Marx a few years later when he sought to describe the hypocrisy and servility of the bourgeoisie who permitted Louis Napoleon (nephew to the first Napoleon) to destroy the Second Republic in a *coup d'état* on December 2, 1851:

Hegel remarks somewhere that all great, world-historical facts and personages occur, as it were, twice. He forgot to add: the first time as tragedy, the second as farce. Caussidière for Danton, Louis Blanc for Robespierre, the Mountain of 1848–51 for the Mountain of 1793–1795, the Nephew for the Uncle. And the same caricature occurs in the circumstances in which the second edition of the

11.3 GRANDVILLE "Apple of the Hesperides and rum ice," from *Un Autre Monde*, 1844

11.4 WILLIAM HOLMAN HUNT Rienzi Vowing to Obtain Justice for the Death of his Young Brother, Slain in a Skirmish between the Colonna and Orsini Faction, 1848. Oil on canvas, 86.3 × 122 (34 × 48)

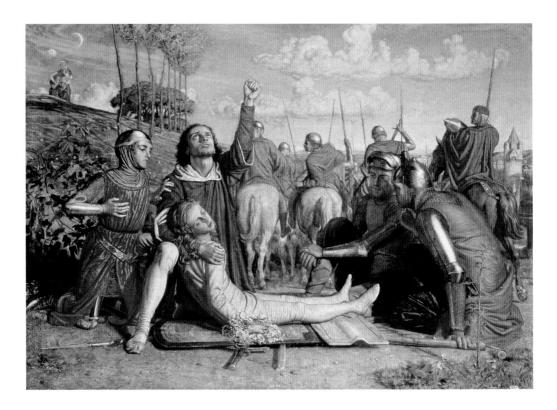

11.5 Dante Gabriel Rossetti Beata Beatrix, 1867–70. Oil on canvas, 34 × 26 (86.4 × 66)

Eighteenth Brumaire is taking place. [18 Brumaire is the date in 1799, according to the Revolutionary calendar, when Napoleon I assumed supreme power.]

No longer can Classical antiquity be plausibly invoked, Marx argues, to cloak from the men and women of 1851 the real nature of their unheroic deeds and attitudes. Neither the bourgeoisie nor their proletarian interlocutors can any longer have recourse to such idealist "self-deceptions." Because 1789 served to liberate only the bourgeoisie and not all of humanity from oppression, Marx writes, the revolutionists of that day "required world-historical recollections in order to drug themselves concerning their own content." Since, on the other hand, the present revolution was being waged by the proletariat on behalf of all humanity, it required absolute clarity as to means and ends. "In order to arrive at its content," Marx says, "the revolution of the nineteenth century must let the dead bury their dead. There the phrase went beyond the content; here the content goes beyond the phrase."

In England no less than France, the style and phrase of Classical antiquity—there only recently embraced—quickly gave way to an art and literature that emphasized fidelity to the materiality of things, directness of emotional appeal, and honesty to natural appearances. And here too the impetus for artistic revitalization—embodied by the young artists who in 1848 banded together and called themselves the Pre-Raphaelite Brotherhood—is found in the spheres of the social and political. 1848 marked the culmination of a period of economic recession dubbed "the Hungry Forties," and the simultaneous apogee of Chartism, a broad working-class movement that sought to overturn the Poor Law Reform Act of 1834 (which denied in-home relief to the poor and unemployed), enfranchise working men, and enact an array of wealth taxes. Plans for a mass Chartist demonstration and delivery of a petition for universal (male) suffrage on April 10, 1848 (just weeks after the revolution in France that toppled the regime of Louis Phillippe), led to the largest peacetime mobilization of military and civilian forces in British history. Public buildings were sandbagged, the Queen fled the capital, and an armed force of more than 100,000 police and specially deputized constables waited to confront the demonstrators at strategic locations in the city. London was geared for revolution. But the overwhelming show of force, combined with bad weather and disorganization on the part of the protestors, prematurely broke up the mass march and emboldened the government to rebuke the rally organizers and ignore Chartist demands. Government ministers even mocked the petition to Parliament, saying that it contained just 1.9 million signatures, not the almost 6 million claimed by the Chartist journalist and representative Feargus O'Connor, and that many of these were false, consisting of names such as No Cheese, Pug Nose and Victoria Rex. By 1850, Chartism was dead and nearly forgotten; the general increase in levels of employment and wages dissipated radical energies, and another generation would pass before the working class movement regained its footing. The Crystal Palace Exhibition a year later (see Chapter 7) was like the crowing of a cock, announcing the dawn of a renewed British imperium.

William Holman Hunt (1827–1910), John Everett Millais (1829–96), and Dante Gabriel Rossetti (1828–82) constituted the core of the young artists who in February 1848—the month of the revolution in France-formed the Pre-Raphaelite Brotherhood (PRB). Their early meetings at the studio of the sculptor Thomas Woolner (1825–92), or at the Millais family home in Bloomsbury, Hunt later recalled, were taken up with general commiseration with the poor and condemnation of the wealthy. Together, they read scripture and poetry, debated politics, and decried the policies and programs of the Royal Academy. Their adoption of the PRB moniker (which caused confusion and consternation on the part of critics and the public) indicates a desire for the comforting anonymity of group identity. They were an assembly of male adepts, like the Freemasons, Carbonari, or Skull and Bones who came before them. And they spoke—or rather painted—in a common argot of bright tonalities, vivid color, linearity and naturalism. Rejecting the mannerism of the later Raphael as much as the sentimental, neo-Baroque formulas of Royal Academicians such as Richard Redgrave (1804-88) dates added and David Wilkie (1785-1841) dates added, author of The First Earring (1835), the PRB turned for inspiration to fifteenth-century Italian and Flemish painting and to early nineteenth-century German art by Runge, Friedrich, and the Nazarenes. (The Nazarenes, so called for their Christ-like beards and long hair, were a counter-revolutionary, esoteric society of Catholic-converted German artists, active in Rome after 1810. They included Peter Cornelius, Friedrich Overbeck, and Franz Pforr: see p. 146.) From these sources, and from the political wellspring of Chartism, the PRB sought to build an artistic movement that would serve as a basis for the regeneration of British culture and society. The group's short-lived journal was named The Germ, its title evoking at once the organicist metaphors of Romanticism, the hermeticism of a closed religious community, and the interrogative naturalism of Victorian science.

One of the first pictures to carry the PRB initials, painted in 1848 and exhibited at the Royal Academy a year later, was a work that proclaimed the values of masculine and martial solidarity and political justice. Hunt's Rienzi Vowing to Obtain Justice for the Death of his Young Brother, Slain in a Skirmish between the Colonna and Orsini Factions depicts the

vengeful outcry of the fourteenth-century Roman plebeian leader Cola di Rienzi after the murder of his younger brother by the patrician Colonna knights. By its subject—drawn from history and the novel Rienzi, Last of the Roman Tribunes by Sir Edward Bulwer-Lytton (1835)—and its form, the painting makes a critical intervention into English art and politics; its egalitarian sentiment, frieze-like composition and focus upon virtuous, martyred youth recall the art of David just before and during the French Revolution. In addition, Hunt's vivid naturalism—apparent in the treatment of trees and grasses at left and right, and the un-idealized faces of the protagonists (modeled by members and associates of the PRB)—stands at a great remove from the idealism of Royal Academicians such as C. R. Leslie (1794–1859), or the eroticized classicism of William Etty (1787-1849), whose history paintings and nudes, such as The Golden Age (ca. 1840) evince at once the aura of the Venetian Renaissance and the libertine decadence of the artist's studio. More than any other PRB canvas, Rienzi appears to be drawn from the pride and hurt of April 10, 1848. Never again would political violence be so clearly represented in Pre-Raphaelite Art.

Millais too dispensed with Classical costume architecture as well as with High Renaissance grace and timelessness in Christ in the House of His Parents (1850). The historical genre scene of the boy-Christ (with cut finger) and his working-class family instead enshrines matter-offactness, physical labor, and the unidealized modern body. Derived from his observation of a carpenter's shop on Oxford Street in London, Millais's interior is filled with accurate details of métier—tools and wood shavings connoting the human and spiritual worth of sweat and handcraft. Its combination of typological symbolism—hand tools of the crucifixion, the ladder for the deposition, the bowl of water for baptism, the dove of the holy spirit—and grubby realism was startling and alarming to conservative critics. Even Charles Dickens, otherwise sympathetic to social reform, decried the work in his Household Words, A Weekly Journal as "mean, odious, repulsive and revolting." Its protagonist, he said, was a "hideous, wry-necked, blubbering red-headed boy in a bed gown," and his mother "so horrible in her ugliness, that she would stand out . . . in the vilest cabaret in France, or the lowest gin-shop in England." The reference to France was surely intended to invoke the disreputable politics of February, and especially June 1848, when the working class erected barricades across the streets of Paris. Rossetti's response to the poor reviews of his starkly realist Ecce Ancilla Domini! ("Behold the handmaid of the Lord") was simply to stop exhibiting his works in public, and eventually to abandon realism.

Never again was the language of English criticism so vivid or so angry as it was in 1850-51. The attainment of relative

11.5

social peace, the pleasurable distractions of the Crystal Palace Exhibition in 1851, the rapid dissolution of the Pre-Raphaelites' group identity and their shift from political to moral criticism-all combined to lower the rhetorical temperature and bring the movement closer to mainstream art and ideology. In contrast to the working-class ambience of Millais's Christ, the interior of Hunt's The Awakening 11.7 Conscience (1853) bears the stigma of the lower middle class, and of artistic condescension. It is filled with all manner of Victorian gewgaws and bric-a-brac, and records the moment when a young woman, "with a startled holy resolve," in the painter's words, determines to escape her sinful, fallen life. Like the woman and man themselves, the drawing-room has a physiognomy that tells a story which is, as Ruskin wrote, "common, modern, vulgar . . . tragical." It bespoke "the

11.6 DANTE GABRIEL ROSSETTI Ecce Ancilla Domini!, 1848. Oil on canvas, $28^{1/2} \times 16^{1/2}$ (72.4 × 42)

11.7 WILLIAM HOLMAN HUNT The Awakening Conscience, 1853. Oil on canvas, $29^{1/2} \times 22$ (74.9 \times 55.8)

11.8 John Everett Millais Christ in the House of His Parents, 1850. Oil on canvas, $33\frac{1}{2} \times 54 (85 \times 137.2)$

11.9 Ford Madox Brown $\it Work,\, 1852-65.$ Oil on canvas, $54\times78~(137\times197\cdot3)$

moral evil of the age in which it is painted." As with Couture's Romans of the Decadence, Hunt's Awakening Conscience argues that the issue of moral and material degeneracy is inseparable from "the woman question," but whereas the one depicts a female as the heedless agent of modern society's corruption, the other sees her as its guileless victim.

11.8

11.9

Like Millais's Christ in the House of His Parents, the monumental and complex painting Work (1852-65) by Ford Madox Brown (1821–93) preaches the Christian Socialist gospel of work as the cure for the social unrest and moral iniquity that plagued mid-Victorian England. (Both paintings, in fact, were commissioned by the same evangelizing patron, the Leeds stockbroker philanthropist Edward Plint.) Unlike the former painting, however, Brown's is based on contemporary London life, not on biblical narrative. The scene is set in mid-afternoon in Heath Street in Hampstead; a group of men known as navvies-"representing the outward and visible type of Work," as Brown wrote in his extended explication of the picture—is shown digging a trench into which a new waterworks main will be laid. To the left, carrying a basket of wildflowers for sale, stands a "ragged wretch," a representative of the lumpen (ignorant and disenfranchised) proletariat. In contrast to the "fully-developed navvy who does his work and loves his beer," he "has never been taught to work . . . [and] doubts and despairs of every one." Above him, on horseback and on foot, are the idle rich who "have no need to work." One of them-with umbrella, bonnet, and downward-cast eyes—has just handed a temperance tract to a navvy who returns a skeptical glance. To the far right of the painting stand "two men who appear to have nothing to do," but who are in fact "brainworkers." Their job is to think and criticize, like the "sages in ancient Greece," thereby helping to assure "well ordained work and happiness in others." These "sages," in fact, are the Christian Socialist Frederick Denison Maurice at right and the great polemicist and "reactionary socialist" (as Marx wrote in 1848) Thomas Carlyle at left.

Indeed, amid the extraordinary welter of persons, anecdotes, and details, "not the smallest [of which] has been considered unworthy of thought and deep study" (as the artist's granddaughter noted), the presence of Carlyle is especially significant. In his *Past and Present* (1843), Carlyle condemned the loss of affective human bonds in contemporary British society, and their replacement by a cold and impersonal "cash-payment nexus." The solution to the present crisis, he believed, lay in leadership by an aristocracy of talent, and in the cleansing power of hard work. Physical labor, he wrote, is like "a free-flowing channel, dug and torn by noble force . . . draining off the

sour, festering water . . . making instead of a pestilent swamp, a green fruitful meadow." In *Work*, Brown made the Carlyle metaphor concrete and real. His navvies are laying pipes, as the art historian Gerard Curtis has discussed, to provide fresh water to replace the fetid streams that turned working-class neighborhoods into filthy and pestilential slums. Hard work, Brown and Carlyle believed, is essential to human health and human nature itself; it ennobles people and cleanses their very souls in the face of a system that would otherwise degrade them, and enslave them to filthy lucre.

Millais, Hunt, Rossetti and Brown's pictures, like many others by the PRB and their associates, were initially disdained by critics precisely for their insistent particularity, contemporaneity, and topicality, regardless of the subject depicted. Indeed, at almost the same moment when Courbet's paintings of proletarian labor and ritual were condemned at the Paris Salon for their ugliness and vulgarity, Millais's Christ at the Royal Academy Exhibition was being attacked by Charles Dickens for depicting "what is mean, odious, repulsive and revolting." Brown's painting was subjected to no such obloquy when it was finally finished and exhibited in 1865; by then, the struggle over Chartism was a distant memory, and the English working-class movements stimulated by Marx, William Morris and others had not yet appeared on the scene. Instead, Work was ignored, for the most part, by critics and public alike. At no time in the nineteenth century were the visual cultures of England and France closer than during the European turmoil of 1848. And the quiescent aftermath of Chartism had its own parallel in France with the regime of Napoleon III and the emergence of artistic modernism.

In the exact middle of the nineteenth century, "the content went beyond the phrase," to repeat Marx's formulation, in both politics and art. A cataclysmic, European-wide economic decline during the years 1846-8, coinciding with a series of national political crises, led to an outbreak of revolution in France in February 1848. Uprisings quickly followed in Germany, Austria, Hungary, Poland, and Italy, among other states and kingdoms. The February revolution in France, however, was succeeded in June by a second and still more significant insurrection. The closure of the National Workshops—whose recent establishment had been a half-hearted attempt by the Provisional Government to placate the left—led to a massive proletarian rising on June 23. On the following day, barricades rapidly ribboned through the old twisting streets of Paris and a pitched battle was waged between working-class insurgents and the National Guard supported by a bourgeois and peasant "party of order." By the 26th, the workers (and such intellectual fellow-travelers as Baudelaire) were isolated in their faubourgs,

their defenses were in tatters, and their cause was doomed; 1500 died in the three days of battle, 3000 more were slaughtered in the immediate aftermath, and many thousands in addition were arrested, imprisoned, and transported to distant penal colonies. The June days, the conservative political theorist Alexis de Tocqueville wrote, were "a struggle of class against class"; Marx was in agreement, calling the insurrection "the first great battle . . . between the two classes that split modern society." The revolution was defeated in France and everywhere else in 1848, but the image of the *quarante-huitard*, armed and brimming with revolutionary ardor, informed the rhetoric of the age.

During and after 1848, artists and revolutionaries in France (the names of the latter include P.-J. Proudhon, Louis Blanc, and Auguste Blanqui) felt compelled as never before "to face with sober senses [the] real conditions of life and [man's] relations with his kind." Many now believed that, regardless of the immediate outcome of the insurrection, a new stage in European evolution had been reached in which working people—pressed by circumstance to forge alliances and form opinions of their own-were on the point of overturning or transforming not just single policies, ministries, or even governments, but society itself. On this point there was a strange unanimity between right and left, and between sober politicians and wisecracking artist journalists: writing in the tense interregnum between February and June 1848, the right-leaning de Tocqueville exclaimed that he saw "society cut into two: those who possessed nothing united in a common greed; those who possessed something in common terror." At the same time, the left-wing Daumier depicted a conversation between a peasant and his local mayor in Le Charivari (May 5, 1848): "'Tell me, what is a communist?' 'They are people who want to keep money in common, work in common and land in common.' 'That's fine, but how can it happen if they have no common sense?""

Of the existence of a dominant rhetorical timbre to the French art and literature of mid-century, there can be little doubt. Such diverse writers as Flaubert, Baudelaire, and de Tocqueville, and such varied painters as Courbet, Millet, Octave Tassaert, and Isidore Pils shared a perception of social dislocation, alienation from the Classical past, and concern or joy about a pending revolution. The Realist Daumier, who lived at this time in the midst of the working-class 9th Arrondissement of Paris, described and depicted in his paintings and caricatures, contemporary urban street life and leisure, and the domestic hardships and joys of working people. The Realist Millet, who left Paris in 1849 for the peaceful rural village of Barbizon, represented in *The Gleaners* and *The Sower* (1850) the virtue of agricultural labor and the biblical nobility of rural poverty. Both artists are

Realists by virtue of their common focus upon contemporary working-class life and urban and rural conflict. Yet the very commonality of this rhetoric of Realism should serve as a warning that we are in the presence of an ideology whose function was to obscure as much as it was to reveal "the content beyond the phrase" of 1848. Indeed, by 1855 the dictator Louis Napoleon had succeeded in establishing a conservative school of official realism—including Pils, Tassaert, Jules Breton, Rosa Bonheur, Théodule Ribot, and many others—in opposition to the insurgent Realism of Courbet. Thus, what was hidden beneath the Realist consensus was a fierce struggle among artists and art institutions over precisely the measures to be taken in either advancing or retarding the great historical changes then underway in France and the West.

The key question about Courbet and the Realists, therefore, does not primarily concern his and their particular attitudes toward modernity: all Realists more or less shared Daumier's credo il faut être de son temps; all more or less agreed with the novelist, critic, folklorist, and political chameleon Champfleury (Jules Husson) that art must represent the everyday life of common people. Rather, the issue concerns the actual position and function of Realist works within the mode and relations of production of their

11.10 JEAN-FRANÇOIS MILLET *The Sower*, 1850. Oil on canvas, $39\frac{1}{4} \times 32\frac{1}{2}$ (101 × 82.5)

COURBET'S TRILOGY OF 1849-50

time. "This question," Walter Benjamin writes, "is concerned, in other words, directly with the [artistic] *technique* of works." Thus the argument made below will be that the innovative technique of Gustave Courbet—more than any other artist of the day—propelled political change by challenging the existing institutional relationship between art and the public.

11.12

Like Jacques-Louis David before him, Courbet employed a technique alien to the established traditions and audiences for art. For the Enlightenment David, this alienation arose from his rejection of Rococo and aristocratic bon ton, and his embrace of Neoclassical and bourgeois noblesse. For the Realist Courbet, this alienation entailed a rejection of academic and bourgeois juste milieu, and an espousal of the formal principles found in nonclassical and working-class popular art. By this means, Courbet attempted to turn formerly neglected peasant and proletarian Salon spectators into artistic collaborators, thereby potentially ennobling and empowering them at the expense of their putative betters. In the course of the decade following 1848, Courbet enacted an interventionist cultural role that has since been defined as avant-garde. Avant-garde art, I shall argue at the end of this chapter, is exceptional in the nineteenth century, and exceptionally fragile. By the end of Courbet's life, it had mutated into a nearly quietist modernism.

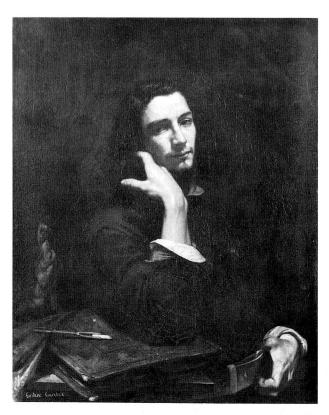

11.11 GUSTAVE COURBET Man With Leather Belt, ca. 1845. Oil on canvas, $39\frac{1}{8} \times 32\frac{1}{4}$ (100 × 82)

Courbet was born in the village of Ornans, near Besançon in the region of central-eastern France called the Franche-Comté. His father Régis was a wealthy farmer who resisted his son's decision to become an artist, but nevertheless paid his way to Paris in 1839. There, Courbet studied in the private studios of a succession of mediocre academic masters, learning at first a somewhat labored Romanticism which recalls the "Troubador Style" practised by Couture and others in the 1840's. Yet even as a young artist, Courbet demonstrated independence and self-assurance: his self-portraits including Man With Leather Belt (ca. 1845) and The Wounded Man (ca. 1844-54) in fact mark a kind of liberation from the reigning juste milieu. In place of the Neoclassical linearism of contemporary portraits by, for example, Hippolyte-Jean Flandrin and Théodore Chassériau (Portrait Drawing of de Tocqueville, 1844), Courbet's selfportraits reveal a Romantic painterliness combined with a compo-sitional informality or even awkwardness. In place of the sentimentality found in genre paintings by the emerging official Realists, such as Tassaert, Ribot, and Pils (The Death of a Sister of Charity, 1850), Courbet's paintings convey a psychological complexity, physical proximity, and eroticism that has precedents in Caravaggio and Géricault. (The former's Ecstasy of Saint Francis is perhaps a source for The Wounded

11.12 THÉODORE CHASSÉRIAU *Portrait Drawing* of de Tocqueville, 1844. Pencil on paper, 11⁷/₈ × 9¹/₂ (30 × 24)

Man; the latter's "portraits of the insane" are possible sources for Man With Leather Belt—along with Titian portraits such as Man With a Glove in the Louvre.

By 1848 Courbet was dividing his time among the Paris museums, his own atelier on the Left Bank, and the bohemian Brasserie Andler; at the Brasserie he came into contact with some of the most progressive and idiosyncratic figures of the day, including Baudelaire, the anarchist Proudhon, the leftist balladeer Pierre Dupont, and Champfleury. Bohemianism was a relatively new and contradictory subcultural stance in Paris—composed in equal parts of estheticism, asceticism, defiance, and sycophancy—and it functioned as a kind of laboratory for testing the various rhetorics of Realism. In January 1848 Courbet wrote to his family: "I am about to make it any time now, for I am surrounded by people who are very influential in the newspapers and the arts, and who are very excited about my painting. Indeed, we are about to form a new school, of which I will be the representative in the field of painting." Courbet was correct in his predictions, though he could not have known that a revolution would be necessary to help him accomplish his goals.

According to his letters, Courbet remained on the sidelines during the fighting in February 1848, though he was immensely pleased at the overthrow of Louis-Philippe and the establishment of a Republic. In June, too, he kept a safe distance from the shooting, stating in a letter to his family: "I do not believe in wars fought with guns and cannon. . . . For ten years now I have been waging a war of the intellect. It

would be inconsistent for me to act otherwise." Despite this expression of principled pacifism, Courbet's abstention from battle was probably the result of strategic as much as moral calculation: like many others, he quickly recognized the brutality and implacability of the bourgeois and peasant "party of order," and understood that a war fought for "the democratic and social republic" could not be won on the barricades of June. On the contrary, the struggle for labor cooperatives, fair wages, housing, debt relief, and full political enfranchisement for workers and peasants would require organization, propaganda, and a broadly based mass movement. Disdaining bayonets, therefore, Courbet became resolved to wage his combat with images; the time was ripe for such a battle, and he would not waste his chance.

After February, the exhibition policies of the Salon were liberalized, permitting Courbet free access for the first time. Whereas he had managed to show only 3 paintings in the previous seven years, he exhibited 10 works in 1848 and 11 the following year, including the peculiar *After Dinner at Ornans*. An ambitious and provocative picture, *After Dinner* was oddly oversized for its genre, indefinite in its lighting and composition, and indeterminate in its mood and subject. For all these anomalies, however, it sufficiently resembled Dutch genre paintings—then in renewed vogue—for it to garner praise from a number of Salon critics and the award of being purchased by the state.

The historical significance of *After Dinner* lies in two factors outside of its particular artistic weaknesses or merits:

11.13 ISIDORE PILS The Death of a Sister of Charity, 1850. Oil on canvas, $95 \times 10'$ (241 × 305)

11.14 GUSTAVE COURBET After Dinner at Ornans, 1849. Oil on canvas, 76¾ × 8′5⅓ (195 × 257)

11.15 GUSTAVE COURBET *The Stonebreakers*, 1850. Oil on canvas, 63 × 8′6 (160 × 259)

first, the gold medal Courbet received for it in 1849 automatically entitled him to free entry to the 1850 Salon; secondly, After Dinner is a precise mirror of Courbet's interest in the concurrent crises of French rural and urban life. In the wake of agrarian recession and urban insurrection, the definitions and political allegiances of both country and city were up for grabs, and any picture that treated ambiguously both realms could have been incendiary. The figures in After Dinner might as well be bohemians at the Andler as peasants at the home of the artist's Ornans friend Cuénot, thus potentially calling into question the opposition between worker and peasant that had ensured the failure of the insurrection of June. After Dinner was not scandalous in 1849, but its subject was and Courbet knew it. Therefore, in October 1849 Courbet left Paris and returned to Ornans in order to reflect upon and plan his future "intellectual" interventions. "I am a little like a snake . . . in a state of torpor," he wrote to his friends the Weys at the end of

October. "In that sort of beatitude one thinks so well!... Yet I will come out of it ..." Indeed, in the course of the next eight months, Courbet painted three colossal pictures that changed the history of art—The Stonebreakers (destroyed), A Burial at Ornans, and Peasants of Flagey Returning From the Fair. As the art historian T. J. Clark has shown, and as will be summarized here, each work constituted an attack upon the technical foundations of bourgeois art and a disquisition upon class and political antagonisms of the day.

The Stonebreakers, its author said, "is composed of two very pitiable figures," taken from life. "One is an old man, an old machine grown stiff with service and age. . . . The one behind him is a young man about fifteen years old, suffering from scurvy." Stonebreaking for roads was a rare, though not unprecedented, subject for art, but it had never been treated so unflinchingly and so monumentally (the painting was nearly 5½ by 8 feet). Two nearly lifesize figures are set against a hillside, in approximate profile. Their gazes are averted from

11.16 GUSTAVE COURBET The Meeting, 1854. Oil on canvas, 50\(\frac{3}{4} \times 58\frac{5}{8} \) (129 \times 149)

11.15

11.17 11.18

11.17 Gustave Courbet A Burial at Ornans, 1849. Oil on canvas, $10'4 \times 21'9$ (315 × 663)

11.18 Gustave Courbet Peasants of Flagey Returning From the Fair, 1849. Oil on canvas, $81\frac{1}{2} \times 9'1\frac{1}{2}$ (206 × 275)

11.19 ROSA BONHEUR Plowing in the Nivernais: The Dressing of the Vines, 1849. Oil on canvas, 69 × 8'8 (175.3 × 264.2)

view, their limbs are strained by effort, and their clothes are in tatters. The colors and surface of the picture (such as can be surmised from its prewar photograph and the surviving oil study) are earthen and clotted, and the composition is uncomplicated. The predominant impression, as Courbet's words suggest, is of humans acting as machines: hands, elbows, shoulders, backs, thighs, knees, ankles, and feet are all treated as alien appendages that only serve, as Ruskin wrote in *The Stones of Venice* (1853), to "make a tool of the creature."

For A Burial at Ornans, Courbet gathered together some fifty-one men, women, and children on the grounds of the new cemetery, and painted their portraits on a canvas almost 22 feet long. The mourners include the artist's father and sisters, the town mayor, Courbet's late grandfather, and a spotted dog. The coffin, draped in white with black teardrops and crossbones, belongs to one C.-E. Teste, a distant relative of Courbet; the ostentatious pair dressed in red with bulbous noses are beadles. No one in the picture is paying much attention to either the coffin or the future resting place of the deceased; indeed, the crowd is composed of at least three discrete groups—women mourners at right, clergy and pall bearers at left, and a bourgeois and mongrel dog at center right—that are compositionally and emotionally disconnected from each other and the funeral ritual. (How different from the postures and expressions of rapt piety among the mourners in Pils's exactly contemporaneous and acclaimed The Death of a Sister of Charity!) Adding to the impression of

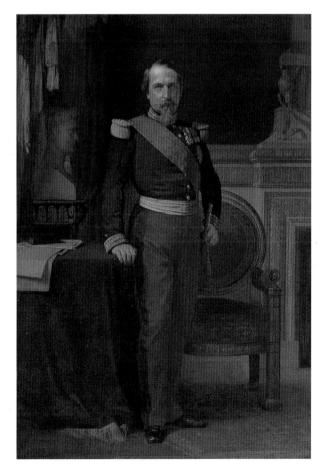

11.20 HIPPOLYTE-JEAN FLANDRIN Napoleon III, 1860–61. Oil on canvas, $83\frac{1}{2}\times58$ (212 × 147)

.13

17

artifice and distraction in Courbet's work is the insistent black and white of the canvas (compare the dog's coat to the drapery over the coffin), as well as the odd superimposition of figures above one another.

Tonal simplicity, compositional fracture, and emotional opacity also characterize the Peasants of Flagey. Like the Burial, its subject was conventional (for example, Thomas Gainsborough's Road from Market, ca. 1767) but its treatment certainly was not. The Peasants is made up of discrete groupings of figures and animals unified only by a dull repetition of color and tonality: foreground and middleground planes awkwardly collide at the edge of a road extending from lower left to middle right; a boy and two peasant women are oddly insinuated among the inconsistently scaled horses and cattle; a man being led by a pig seems to float across the surface of the picture. Unlike Rosa Bonheur (1822–99), whose *Plowing in the Nivernais: The* Dressing of the Vines (1849) records with patriotic specificity the agricultural practises of a particular region, Courbet disregards the cultural and physiognomic particulars of his human and animal subjects in *Peasants*. (Are those Jersey or Charolais cows under yoke?) Unlike Jules Breton (1827–1906), whose The Gleaners (1854) depicts the poor peasants of Marlotte as a faceless herd, Courbet provides his protagonists with individual and class identity, albeit ambiguous. (Is the man with peasant smock and stovepipe hat the same Régis Courbet who wears a bourgeois greatcoat in the Burial?) In place of the reassuring binary oppositions that official realism—city/country, dominate bourgeois/peasant, proletarian/peasant—Courbet proposes a countryside that is as awkward, indefinite, and contingent as the immigrant city of Paris.

Like the Stonebreakers and the Burial at Ornans, therefore, the Peasants of Flagey Returning From the Fair is all about the awkward antagonisms and injuries of social class. In the Stonebreakers, two peasants, reduced to penury, resort to stonebreaking in order to survive; in the Burial, a peasant community, got up in its Sunday bourgeois best, celebrates a funeral; in Peasants, a motley group of men, women, and animals, returning from an agricultural fair, meet a rural bourgeois in waistcoat walking his pig. This was the ungraceful form and subject of Courbet's much attacked trilogy shown in Paris at the Salon of 1850–51.

11.18

11.15

11.17

It would be easy to expound further—as the critics and caricaturists of 1851 did—upon the strange formal and thematic disjunctiveness of the *Peasants*, the *Stonebreakers*, and the *Burial*. Yet to do so would be to risk overlooking a new and provocative coherence in the works. In place of the old academic and political logic based upon Classical mimesis and clear class difference, Courbet has erected an alternative coherence based upon popular culture and social or class

ambiguity and opacity. As Meyer Schapiro and T. J. Clark have shown, the formal touchstone for Courbet's trilogy was the "naive" artistic tradition—Epinal woodcuts and popular broadsheets, catchpenny prints and almanacs, chapbooks and songsheets—then being revived and contested across France as a component of the political and class war of 1848. Especially in the months before the Napoleonic *coup d'état* of December 2, 1851, popular culture—best defined negatively as the unofficial culture of the non-elite—was a weapon used by peasants, workers, and their urban, bourgeois allies to help secure the *égalité* promised but not delivered by the first French Revolution. Courbet was a soldier in this war and the trilogy was his weapon.

In its lack of depth, its shadowlessness, stark color contrasts, superimposition of figures, and emotional neutrality, the Burial especially recalls the style and aspect of popular woodcuts, engravings, and lithographs, such as those used to decorate the many generic souvenirs mortuaires printed to help rural communities broadcast and commemorate local deaths, or the woodcuts that illustrated the traditional Funeral of Marlborough or other tales and ballads. (Indeed, in a letter to the Weys from 1850, Courbet cites the nonsense refrain "mironton, mirontaine" from the popular ballad of Marlborough.) Courbet was fascinated by popular culture during this period; in addition to composing several folk ballads and pantomimes, he illustrated a broadsheet of songs dedicated to the Fourierist apostle Jean Journet in 1850, and a decade later executed two drawings for Champfleury's Les Chansons populaires de France. Further examples of the artist's interests in popular culture are his 1853 depiction of a wrestling match, and his employment, a year later, of an Epinal print of the Wandering Jew as the basis for his autobiographical painting The Meeting (1854).

11.

In embracing popular art and culture—its audience, its subjects, and even its ingenuous and anonymous style-Courbet was explicitly rejecting the hierarchism and personality cult fostered by the regime of President and then Emperor Louis Napoleon, and represented in Flandrin's Napoleon III (1860-61). Indeed, even as Courbet was exhibiting his works in Paris during the winter of 1850-51, Bonapartists in the rural provinces were clamping down the activities of a legion of colporteurs, balladeers and pamphleteers who they judged were active in the revival of popular culture and the establishment of a radical, peasant solidarity. In Paris, too, the popular entertainers—clowns, street musicians, mountebanks and saltimbanques—were viewed by the police and the Prefects as the natural allies of subversives and Socialists; their activities were curtailed after 1849 for being inconsistent with order and social peace. In this feverish political context, when a celebration of the popular was understood as an expression of support for the "democratic

and social republic," it is not surprising that Courbet's works were received with fear and hostility. "Socialist painting," one critic said of Courbet's Salon entries in 1851; "democratic and popular," said another; "an engine of revolution," exclaimed a third.

What appears to have most disturbed conservative critics about Courbet's art, and what prompted these and other charges, was its "deliberate ugliness," which meant its embrace of both a popular ("ugly") content and a popular (working-class) Salon audience. Artwork and audience waltzed in a strange and morbid syncopation, critics of the Salon suggested, and vainglorious Courbet was dancingmaster. After surveying the critical response to the artist's trilogy, T. J. Clark summarized Courbet's historic achievement: "He exploited high art-its techniques, its size and something of its sophistication—in order to revive popular art. . . . He made an art which claimed, by its scale and its proud title of 'History Painting', a kind of hegemony over the culture of the dominant classes." It should be mentioned that the claim was fragile, and turned out to be short-lived, but that to many at the time it appeared powerful enough to threaten the stability of the public sphere. Courbet's grand and sophisticated popular art could not survive intact the coup d'état and the inevitable dissipation of revolutionary consciousness that followed. Nevertheless, his trilogy has survived until the present as a model of artistic activism.

Indeed, it may be argued that Courbet's three paintings and the scandal they precipitated proved to be the historical point of origin of avant-gardism as a cultural stance of ideological opposition and political contestation. The goal of the artistic avant-garde, from Courbet to the Surrealists, has been to intervene in the domain of real life by changing the language of art so as to turn passive spectators into active interlocutors. Like the many artists who followed-Manet, the Impressionists, Van Gogh, Seurat, and the Russian avantgarde—Courbet sought to effect this intervention by recourse to the "popular," that is to a cultural form or tradition from without the fixed canon of cultural legitimacy and ruling-class authority. Yet like those artists too, Courbet was ultimately unable to pursue his ambition to its promised end—events overtook him and the overwhelming assimilative powers of the dominant culture won out. Thus his trilogy also marks the onset of modernism as a formal procedure of esthetic self-reference and political abstention. The loss of an active and engaged oppositional public following the consolidation of the Second Empire (especially after 1857) led to the abstraction and generalization, as Thomas Crow has described it, of the antagonistic pictorial strategies adopted by Courbet in 1850. From this point forward, the interventionist goals of the avant-garde faded before the ultimate aim of modernism which-from Courbet to Frank Stella—was the achievement of artistic autonomy. Indeed, for Courbet, political insignificance always lurked just the other side of popular engagement. In July 1850, while crating his pictures for shipment to Paris, he wrote to the Weys:

The people have my sympathy. I must turn to them directly, I must get my knowledge from them, and they must provide me with a living. Therefore I have just embarked on the great wandering and independent life of the bohemian.

Don't be mistaken, I am not what you call a flimflammer. A flimflammer is an idler, he has only the appearance of what he professes to be, like the members of the Academy and like toothdrawers who have their own carriages and handle gold.

For Courbet as for later ambitious French and European artists, avant-garde and modern are the two sides of a coin that don't add up to a whole; the one connotes community, the other individuality; the one implies engagement, the other an ivory tower; the one invites bohemianism, the other flimflammery. In fact, however, avant-garde and modern possess the same specific gravity since the technical procedures that make possible the first are the very ones that inevitably conjure up the second. My argument in sum is this: the interventionist stance of the avant-garde entailed a rejection of established academic procedures and an embrace of the formal simplicity, clarity, and flatness of popular art as found in nineteenth-century broadsheets, chapbooks, Epinal prints, and tradesmen's signs, as well as in the performances of saltimbanques, balladeers, and café singers. To employ such forms—such a new technique—was to carve out a new position for art within the means and relations of production of the day and thereby potentially to turn formerly alienated or passive working-class spectators into active participants. The cool self-regard of modernism entailed many of the same formal strategies, but in the absence of an oppositional public of like mind, the techniques were no more than vestiges of the dreamed interventionism. After 1852, avantgarde and modern marched in virtual lockstep. Courbet noticed this and made an allegory on the subject in 1855.

COURBET'S THE STUDIO OF THE PAINTER

On May 8, 1853 a decree was published announcing that the Salon of 1854 was canceled, but that a colossal art exhibition would be included among the exhibits of a great Universal Exposition to be held in 1855. The idea of the fair was to display to the world the marvelous industrial, cultural, and

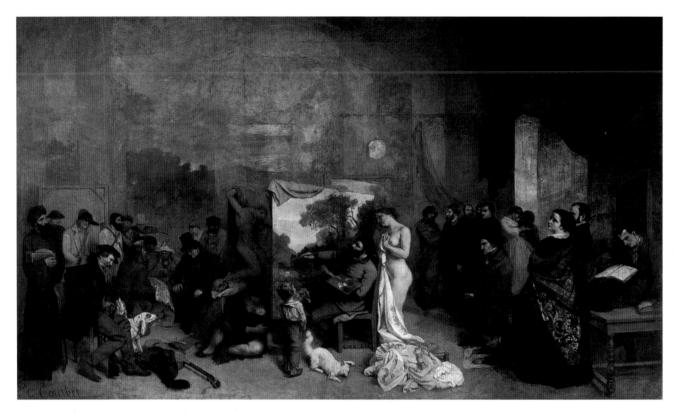

11.21 GUSTAVE COURBET The Studio of the Painter: A Real Allegory Summing Up Seven Years of My Artistic Life, 1854–5. Oil on canvas, 11'10 × 19'8 (361 × 600)

social progress achieved in France since Napoleon III's assumption of dictatorial powers in 1851. As a demonstration of his liberalism and magnanimity, the Emperor had his Intendant des beaux-arts, the Comte de Nieuwerkerke, invite Gustave Courbet to luncheon in order to propose that the artist cooperate with his government's plans, and submit to the Exposition jury a work of which the Comte and the Emperor would approve. In a letter to his friend and patron Bruyas, Courbet described his indignant response to this naked effort at cooptation:

You can imagine into what rage I flew after such an overture . . . first, because he was stating to me that he was a government and because I did not feel that I was in any way a part of that government; and that I too was a government and that I defied his to do anything for mine that I could accept. . . . I went on to tell him that I was the sole judge of my painting; that I was not only a painter but a human being; that I had practised painting not in order to make art for art's sake, but rather to win my intellectual freedom, and that by studying tradition I had managed to free myself of it; that I alone, of all the French artists of my time, had the power to represent and translate in an original way both my personality and my society.

Courbet's letter went on to describe the rest of his tense and abortive luncheon with Nieuwerkerke—additional sparring, dressings-down, and protestations of sincerity and pride and the artist's intention to press ahead in his artistic project "with full knowledge of the facts." What is perhaps most salient about the letter, however, is that it announces a kind of program for future work, in particular for the very painting that Courbet would make and then insinuate into the heart of the Exposition grounds, The Studio of the Painter: A Real Allegory Summing Up Seven Years of My Artistic Life. According to his remarks above, Courbet was seeking in his painting to explore the social and cultural position of the artist; to cast off "art for art's sake" while nevertheless maintaining independence; and to explore the complexities of reality in order to "represent and translate . . . my personality and my society." Courbet's manifesto in paint was underway by November 1854 and finished six months later, just in time for it to be rejected by the Exposition jury.

The Studio is a vast (some 11 by 20 feet) and somewhat lugubrious depiction of the artist's atelier and its thirty-odd occupants. The composition is divided into two parts with the painter himself in the middle. He is seen painting a landscape and is accompanied (in perfect Oedipal fashion, as Linda Nochlin has said) by a small boy and nude woman who

cast admiring glances. To the right are the painter's "share-holders," as he called them in a letter to Champfleury, that is, his various artistic and bohemian friends. These include Baudelaire (at the far right, reading), Champfleury (seated), and Bruyas (with the beard, in profile). To the left are "the people, misery, poverty, wealth, the exploited and the exploiters, the people who live off death." The identification of this group is less clear, but it appears to include Louis Napoleon (seated, accompanied by spaniels), the Minister of State Achille Fould (standing with cask, at far left, and described by the artist as "a Jew whom I saw in England"), the late regicide Lazare Carnot (in white coat and peaked hat), and perhaps the European revolutionaries Garibaldi, Kossuth, and Kosciuszko. The upper half of *The Studio*, above the heads of

all of the figures, consists of an expanse of brown paint ("a great blank wall") that inadequately covers the ghost of the *Peasants of Flagey*.

Denied the chance to display the puzzling *Studio* alongside his other accepted works, Courbet decided to erect a "Pavilion of Realism," in the form of a circus tent, on land just opposite the entrance to the Exposition. There he would display his new paintings as well as his most controversial older works, and steal the thunder from the officially sanctioned Ingres, Delacroix, Vernet, and Descamps, among others.

With the financial assistance of Bruyas, the "Pavilion of Realism" was indeed quickly built, but the public response was not what Courbet hoped for and planned: attendance was

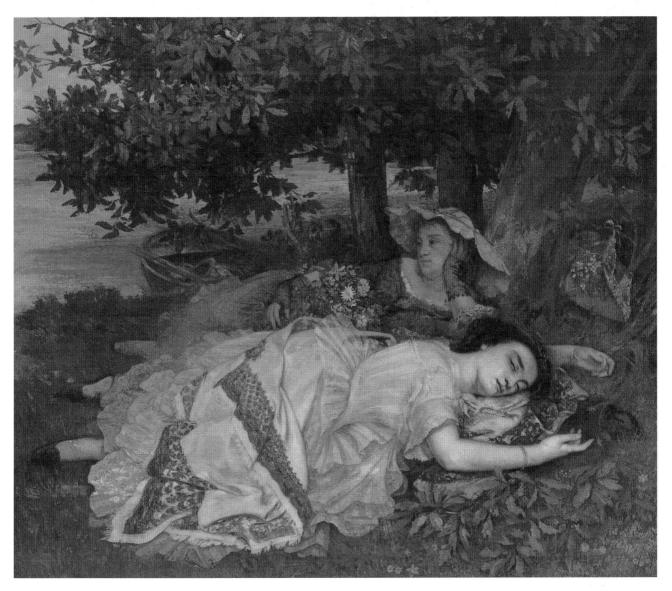

11.22 GUSTAVE COURBET The Young Ladies on the Banks of the Seine, 1856-7. Oil on canvas, $68\% \times 81\% (173 \times 206)$

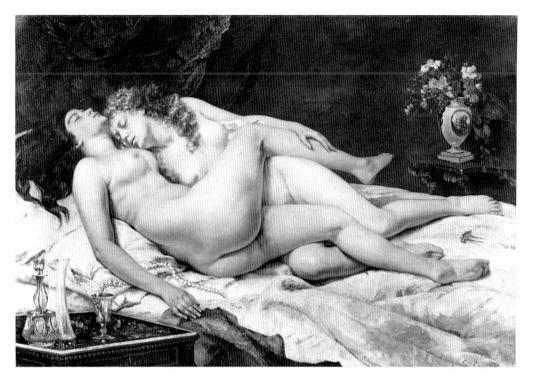

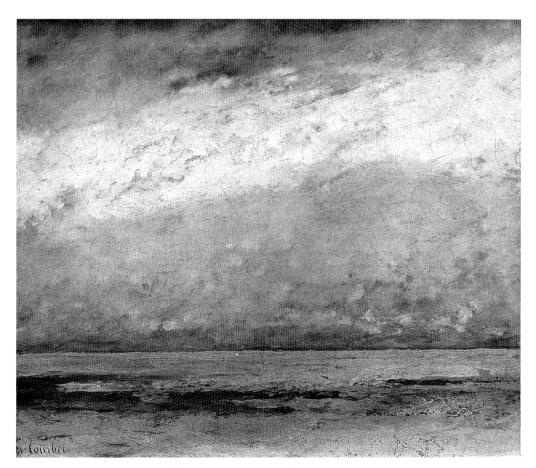

11.24 GUSTAVE COURBET Seaside, 1866. Oil on canvas, $21\frac{1}{8} \times 25\frac{1}{4} (53.5 \times 64)$

poor and the critics were largely indifferent. The most considered response to Courbet's *Studio*, in fact, is found in the private diaries of Delacroix:

Paris, 3 August

Went to the Exposition, where I noticed the fountain that spouts artificial flowers.

I think all these machines are very depressing. I hate these contrivances that look as though they were producing remarkable effects entirely on their own volition.

Afterwards I went to the Courbet exhibition. He has reduced the price of admission to ten sous. I stayed there alone for nearly an hour and discovered a masterpiece in the picture they rejected . . . In [*The Studio*] the planes are well understood, there is atmosphere, and in some passages the execution is really remarkable, especially the thighs and hips of the nude model and the breasts. . . . The only fault is that the picture, as he has painted it, seems to contain an ambiguity. It looks as though there were a real sky in the middle of the painting. They have rejected one of the most remarkable works of our time, but Courbet is not the man to be discouraged by a little thing like that.

Delacroix's chief insights occur at the beginning and near the end of this passage. His remark about the "machines . . . acting entirely on their own volition" constitutes a succinct account of "commodity fetishism," a term coined and

defined a few years later by Marx in Capital (1867) as the disguising of the "social relation between men . . . [in] the fantastic form of a relation between things." The 1855 Exposition, which consisted primarily of the mass display of consumer goods and the machines that produced them, was indeed an early important landmark in the fetishization of commodities. It heralded the beginnings of a world that would increasingly identify progress with the rationalization of production, liberty with the freedom to consume standardized goods, and human intimacy with the market exchange of sex. Delacroix appears to have understood something of this historic aspect of the Exposition, and found it (with unusual understatement) depressing. Courbet's picture was thus judged a triumph in opposition to this sobering exhibition of modernity.

Delacroix's other insights into Courbet's *The Studio of the Painter: A Real Allegory Summing Up Seven Years of My Artistic Life* are contained in his comments about the "remarkable" execution of the thighs, hips, and breasts of the nude and the "ambiguity [of] a real sky in the middle of the picture." In these few lines, the Romantic painter has encapsulated the woman/nature dyad that constituted Courbet's personal response to the dispiriting forces of modernization on display at the Exposition. For Courbet, woman and nature are the "real" touchstones for the personal and political "allegory" that began in 1848 and ended with the exhibition of 1855.

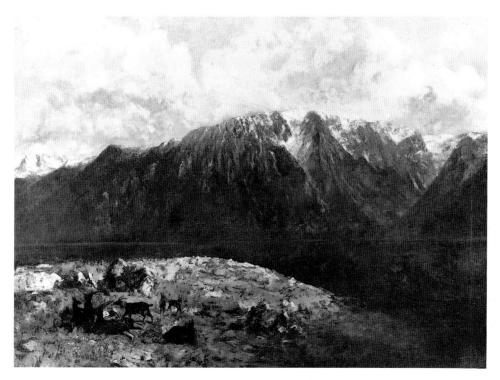

11.25 GUSTAVE COURBET Grand Panorama of the Alps With the Dents du Midi, 1877. Oil on canvas, 591/2 × 823/4 (151 × 210)

The nude woman in The Studio (as Delacroix and Courbet both wrote) is a model and nothing more: she is not Venus. She is not muse or Source, as in Ingres's painting of 1856; she is not the allegory of Liberty, the Republic, Spring, Misery, Tragedy, or War and Peace, as in Pierre Puvis de Chavannes's paintings of 1867. At once freed of the allegorical burdens placed upon her by innumerable academic artists of the Second Empire, and stripped of her only sources of cultural power, she is instead a blank canvas, like the cloth she holds, upon which the modern male painter will figure his authority and independence. In painting after painting until the end of his life, including The Young Ladies on the Banks of the Seine (1856-7) and The Sleepers (1866), Courbet reenacted this dialectic of the feminine. Divested of any but sexual power, Courbet's women are reduced to mere passive vehicles of painterly dexterity and authority; relieved of the burden of allegorization, women are for perhaps the first time in the history of Western art shown actually to possess a sexuality. (The politically incendiary aspect of this latter emancipation would be strikingly exposed in the critical response, a decade after The Studio, to Edouard Manet's Olympia.)

11.22

11.23

Just as Courbet's nude model functions as a cipher of artistic volition, so too does the landscape and "real sky," in Delacroix's words, function as an anchor for painterly autonomy. For the Realist, landscape—especially the type of rugged and inaccessible woodlands represented on the artist's easel—constituted the dream space of personal freedom, and the idealized locus, as the art historian Klaus Herding has described it, of social reconciliation. In landscape painting after landscape painting, from the *Château d'Ornans* (1850) to *Seaside* (1866) to the *Grand Panorama of the Alps*

With the Dents du Midi (1877), Courbet represented his dreamed personal autonomy and social equality ("I too was a government") by his rejection of the traditional formulas of the genre. His landscapes, like those of the Impressionists who followed, lacked compositional focus, internal framing devices, repoussoir elements, atmospheric perspective, and coloristic sobriety and balance. They were instead painterly, sketchy, vibrant in color, bright in tonality, spatially flat (though texturally three-dimensional), and democratic, meaning that the painter paid nearly equal attention to all parts of the picture—the sides, bottom, top, and corners, as well as the center of the picture.

Courbet's The Studio of the Painter is thus as much a 11.2 foretelling of the painter's future as it is a summary of his past. In addition, it is an early instance of the modernism represented by the nude, the landscape, and the great swathe of brown paint that constitutes the upper half of the painting—that would flourish in succeeding generations. Modernism is the name for the visual art that would increasingly de-emphasize representation in favor of the integrated material surface; it is the art that would avoid direct engagement in the ongoing battle of classes and interests in the name of individual and pictorial autonomy. Another way to describe the development of modernism is simply to say that it involved the rejection of allegory and the embrace of the real in all its contradictoriness. "The people who want to judge [The Studio of the Painter: A Real Allegory]," Courbet wrote to Champfleury, "will have their work cut out for them." The numerous, conflicting, and often convoluted interpretations of the painting (not excepting this one) bear out the artist's words, but it may be that Courbet himself supplied the painting's best gloss in its title.

· 12 · PHOTOGRAPHY, MODERNITY, AND ART

DAVID LLEWELLYN PHILLIPS

NATURAL MAGIC

N JULY 3, 1839, THE PHYSICIST AND EMINENT academician, François Arago (1786–1853), Director of the Paris Observatory, Permanent Secretary of the French Academy of Science, and Deputy of the East Pyrénées, tabled a report in the French lower house, the Chamber of Deputies. In his report Arago proposed that the French government award two annual life pensions, of 6000 francs and 4000 francs respectively, to Louis Jacques Mandé Daguerre and Isidore Niépce (the son of Joseph Nicéphore Niépce), "in return for the cession made by them of the process to fix the objects reflected in a camera obscura." Although the award of a state pension to an inventor was virtually unprecedented, Arago's recommendation received almost unanimous support when the Deputies voted on July 9. The report was subsequently endorsed by the upper house, the Chamber of Peers, where it had been introduced by the scientist, Joseph Louis Gay-Lussac, who described Daguerre's "great discovery" as "the beginning of a new art in an ancient civilization." In exchange for the pensions, the state was to acquire the patent on Daguerre's photographic process. Following the final approval of his pension in a vote on July 30, Daguerre gave a public demonstration of his process on August 19 to a joint session of the Academies of Sciences and Fine Arts. As a result of his articulate political lobbying, Arago had not only secured pensions for Daguerre and Niépce by the end of the summer of 1839, but had effectively promoted Daguerre as photography's sole inventor and, in doing so, had made himself, rather than Daguerre, the public voice of the new process.

The desire to fix the image produced within a camera obscura had been an enduring one. Not only did the idea of photography exist long before its actual realization in the

early nineteenth century, but a number of photography's technical preconditions had already been met. An apparatus for capturing an image was readily available (the principles of the pinhole or camera obscura had been known to the Ancient Greeks and the device had been widely used by artists since the Renaissance). There was also a growing, but incomplete, knowledge of light-sensitive chemicals. What was still lacking in the early nineteenth century, however, was the means to permanently retain the reversed mirror-image produced within the camera obscura. Although the invention of photography was predicated upon decades of cumulative research into chemistry and optics, Arago was keen to cite Daguerre as its only inventor. However, several contemporaries had an equally legitimate claim to the title, and in France alone almost a dozen claims were made in 1839. Most notably, Hippolyte Bayard, an official in the Ministry of Finance, had devised a crude direct positive process as early as 1837 (for which he was eventually awarded a prize of 3000 francs by the Society for the Encouragement of National Industry).

Born into a petit-bourgeois family, Daguerre (1787–1851) had established himself in Paris as a successful entrepreneur, decorator, and set designer, and as the promoter, in partnership with the painter Charles-Marie Bouton, of a new form of entertainment, the Diorama, which first opened to the public in July 1822. Housed within a custom-built theatre with a rotating cylindrical auditorium (enabling the swift substitution of *tableaux*), the Diorama consisted of a show, lasting ten to fifteen minutes, produced by the illumination of very large and translucent *trompe l'oeil* scenes (painted on linen) depicting dramatic landscapes, volcanic effects, and architectural interiors. By skilfully manipulating the lighting effects within the darkened auditorium, the scenes were transformed as the designer simulated the transition from

day to evening or evoked a variety of atmospheric effects. The combination of Romantic subject-matter and illusionism proved to be highly popular, and similar theatres soon opened throughout Europe. More immediately, however, Daguerre recognized the public's appetite for visual verisimilitude and, having already used a camera obscura to produce the perspectival depth of his painted diorama scenes, sought a method to make permanent the image that it produced.

Substantial headway had already been made by Joseph Nicéphore Niépce (1765–1833) who, aided by his brother Claude, had been trying to fix the image within his own home-made camera obscura by using sensitized lithographic stones as well as metal and glass plates. Initially unsuccessful, Niépce's heliography ("sun writing") was based upon the technique of using a bitumen-coated glass surface that hardened to produce an image when exposed to light within the camera obscura. By 1822 Niépce could copy engravings by this method, but was still unable to fix the image. However, in 1826, having acquired a professionally-built camera obscura, he used zinc plates, coated with bitumen, to produce an image that has acquired the status of being the first photograph. The image—depicting a view, taken from an upstairs window, of the courtyard at Niépce's family estate in Chalonsur-Sôane—required an exposure time of eight hours (during which the shadows moved, thereby blurring the scene) and was developed with lavender oil, which removed any unhardened bitumen from the plate. Hoping to secure patronage, Niépce presented his process to the Royal Society

in London, but was unsuccessful due to his refusal to reveal his technique, so instead he sought a commercial partner. Having already learned of Daguerre's experiments, Niépce met the latter in 1827 and the two established a partnership that lasted until Niépce's death in July 1833. At that point, Daguerre drew up an agreement with Niépce's son, Isidore, which was later revised so that the invention carried only Daguerre's name.

Niépce laid the foundation for Daguerre, but it was Daguerre who in 1831 discovered the light-sensitive properties of silver iodide and who, six years later, made the key breakthrough of using mercury fumes to develop and retain the latent (invisible) image on a silver iodide-coated plate. Using silver-coated copper plates as a ground, Daguerre's first extant picture produced by this method a still life of plaster casts—was made in 1837. Yet despite Daguerre's discovery of the latent image and of the means to develop it, his process had major limitations. Above all, although images—albeit laterally reversed—of extraordinary clarity and delicacy (they had to be kept under glass) could be produced, the daguerreotype was a unique image—a direct positive-and copies could not be made. Moreover, the iodine vapor required to develop the silver plates was dangerous to handle, the plate itself had to be prepared and developed when used, and exposure time was still at least half an hour. Because of this, all the pedestrians in Daguerre's Boulevard du Temple, Paris failed to register, except for the man having his shoes polished.

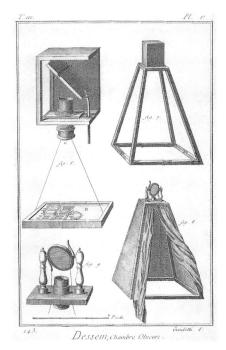

12.1 F. GUIDOTT A Camera Obscura, ca. 1751. Engraving.

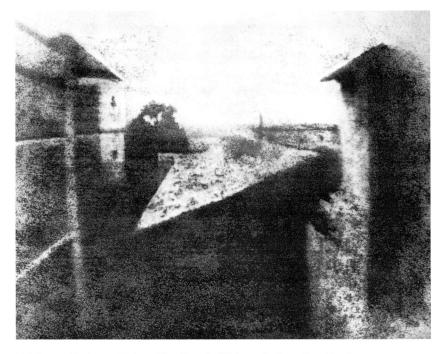

12.2 JOSEPH NICÉPHORE NIÉPCE View From the Window at Le Gras, 1827. Tinplate.

Unable to sell stock options in his invention, but alert to its nationalist appeal, Daguerre turned to the government for support, finding an enthusiastic sponsor in François Arago. A liberal member of the Republican party in the Chamber of Deputies, Arago was heir to the Enlightenment and Revolutionary belief in the intrinsic connection between social and industrial progress, and supported bills for the building of railways and the telegraph. More specifically, he encouraged the state's active role in rewarding and sponsoring scientific research which, since Napoleon, had been promoted as a national enterprise. Recognizing Daguerre's invention as an opportunity to enhance French scientific prestige, Arago also believed that social benefit would derive from making the photographic process freely available. He urged the government to purchase Daguerre's process, in part so as to prevent restrictive monopolistic patents.

Citing the daguerreotype as "one of the most wonderful discoveries of which our country can boast," Arago presented photography as both an "entirely new" French invention and as the achievement of just one inspired "genius," Daguerre (an attribution partly motivated perhaps by Arago's Republican antipathy to Niépce's Royalist and aristocratic lineage). In addition, Arago highlighted photography's potential role in the "great national enterprise" of the Historic Monuments Commission that had been established in 1837 to document and restore French medieval architecture. Pursuing this claim for photography's potential, both pictorial and economic, for preserving national heritage and history, Arago further promoted photography (while simultaneously offering a justification for French colonialism) by citing France's occupation of Egypt some forty years earlier. He referred his fellow Deputies to some "examples of the daguerreotype process" (which included "a head of Jupiter Olympian, a view of the Tuileries, a view of Notre-Dame and several views of an interior") and observed that, "While these pictures are exhibited to you, everyone will imagine the extraordinary advantages which could have been derived from so exact and rapid a means of reproduction during the expedition to Egypt; everyone will realize that had we had photography in 1798 we would possess today faithful pictorial records of that which the learned world is forever deprived of by the greed of the Arabs and the vandalism of certain travelers . . . To copy the millions of hieroglyphics which cover even the exterior of the great monuments of Thebes, Memphis, Karnak, and others would require decades of time and legions of draughtsmen. By daguerreotype one person would suffice to accomplish this immense work successfully . . . These designs will excel the works of the most accomplished painters, in fidelity of detail and true reproduction of the local atmosphere."

Arago's triumphalist belief in French science, Republican values, and imperialist glory provided both a rationale and an

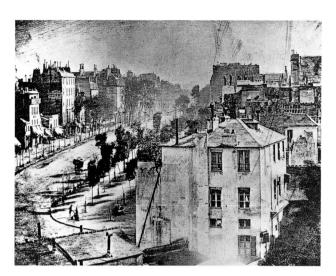

12.3 LOUIS JACQUES MANDÉ DAGUERRE Boulevard du Temple, Paris, ca. 1838. Daguerreotype.

identity for photography, and was motivated also by a longstanding rivalry with Britain that had become particularly intense in the 1830's. Britain was the only nation to be excluded when the French government offered photography as a gift to the world five days after purchasing the patent from Daguerre. A number of British scientists, howevermost notably, Humphry Davy and Thomas Wedgwood—had already made significant advances in photochemistry. Daguerre's principal British rival was William Henry Fox Talbot (1800–77). Prompted by the announcement in Paris on January 7, 1839 of the invention of the daguerreotype in the bulletin of the French Academy of Science, Talbot made public, at the Royal Society in London on January 31, his own experiments in fixing images produced by exposing lightsensitive paper. Talbot's announcement failed to provoke the response generated in Paris by news of the daguerreotype and, while Daguerre was able to benefit from official government sponsorship, comparable support did not exist in laissez-faire Britain. Instead, Talbot's research remained entirely self-funded, and was to be further handicapped by the complexities of British patenting processes.

Of a similar economic status to Niépce, and unlike the entrepreneur Daguerre, Talbot was a university-educated scholar, wealthy landowner, and sometime Member of Parliament whose interests included mathematics, linguistics, classical studies, chemistry, and botany. On a visit to Lake Como in Italy in 1833, his frustration with existing optical drawing aids and with his own limited draftsmanship led him to explore the possibility of permanently capturing the image produced within the camera obscura. Following his return to his estate at Lacock Abbey, Talbot began experimenting by placing small objects, such as leaves, on

12.4 WILLIAM HENRY FOX TALBOT Latticed Window at Lacock Abbey, 1835. Calotype negative.

12.4

Latticed Windows

(with the Camera Obscura)

August 1835

When first made, the squares

of glass about 200 m number

could be counted, with help

of a lens.

sheets of paper treated with a mixture of silver nitrate and salt solution. Exposing the paper to sunlight, Talbot was able to produce crude reverse images of his chosen objects, which he called "photogenic drawings," and he subsequently applied this direct contact principle to images produced by the camera obscura by having small lens cameras made (described by his wife as "mousetraps") which contained the treated paper. Despite requiring an exposure time of up to two hours, Talbot succeeded in producing negative images, no larger than postage stamps, such as the Latticed Window at Lacock Abbey of 1835. Four years later, in "Some Account of the Art of Photogenic Drawing," Talbot described how "the phaenomenon [sic] which I have now briefly mentioned appears to me to partake of the character of the marvelous [sic]... The most transitory of things, a shadow, the proverbial emblem of all that is fleeting and momentary, may be fettered by the spells of our 'natural magic,' and may be fixed forever in the position which it seems only destined for a single instant to occupy."

Talbot's early photogenic drawings lacked the clarity and detail of the daguerreotype, and also required lengthy exposure times, but the creation of an original negative image that could be endlessly reproduced was to be essential for the rise of photography as a mass medium. (Even Daguerre had largely promoted his own process as a novel curiosity which the "leisured class will find . . . a most attractive occupation.") At the time of Talbot's initial announcement, however, the possibilities of the positive-negative method went unnoticed, including by Talbot himself. But, unlike Daguerre, Talbot continued to refine his process, and it was this that was to provide a method for the multiple replication of images. In contrast to French experiments (particularly Niépce's heliographic process), this had not been Talbot's original objective: his first goal had been to replace the singular pencil drawing by a mechanical means of image-making. Assisted through his correspondence with the astronomer and scientist Sir John Herschel (who had earlier suggested to Talbot that he substitute the term photography—"light writing" for photogenic drawing, and who also coined the terms "negative" and "positive"), Talbot had, by the end of 1840, produced a chemical developer that made visible the latent image on the exposed paper. He had also significantly reduced exposure time. In 1841 he took out the first in a series of patents for his new method of negative-positive photography (whereby a positive print could be produced by laying the negative on a sheet of salt-treated paper) which, using the Greek word "kalos" (beauty), he named the calotype (later the Talbotype). Unlike the unique daguerreotype, the paper process offered far greater flexibility in both the creation and subsequent uses of the image in that, akin to other print media such as etching or lithography, the paper print could be cropped and retouched. It could also be modified by using different papers and printing processes.

Although controversy over patenting hindered the development of photography in Britain, Talbot was alert to the potential of paper photography for both book illustration and as a creative medium in its own right, and between 1844 and 1846 he produced in serial form the first photographically illustrated book, The Pencil of Nature. The book not only outlined the principles and applications of photography but plates, such as The Open Door, which referenced the composition and lighting of Dutch genre painting, also demonstrated both the esthetic possibilities of photography and Talbot's belief that photography would enable "an alliance of science with art [that] will prove conducive to the improvement of both." Although The Pencil of Nature adhered to established pictorial categories (with architectural views and still lifes predominating), Talbot's self-conscious association of his photographs with the tradition of European painting was not an attempt to simply contain photography within art, but was indicative instead of his confidence in the esthetic possibilities of the new medium. By the time he produced the book, Talbot had recognized that photography was more than just a mechanical means of copying objects;

12.5 WILLIAM HENRY FOX TALBOT The Open Door (The Pencil of Nature, Plate VI), 1843. Salted paper print from calotype negative.

it was also an interpretive, rather than merely transcriptive, medium. As John Ward comments, "The text of *The Pencil of Nature* proved Talbot to be not only a brilliant inventor but also one of the most perceptive forecasters of the future of photography. Where so many of his contemporaries saw the art [of photography] as painting in another medium, Talbot saw it as a working tool, a recording system, a means of multiplying and manipulating visual images, a means of providing a different view of the world around him . . . Almost alone, Talbot saw photography as it is practised today."

Talbot may have prefigured aspects of modern photography, but he had neither a clear nor consistent conception of what photography was. The various corrections, crossingsout, and now unfamiliar terminology in the manuscript of *The Pencil of Nature* attest to his struggle to find a vocabulary adequate to describing his process, and confirm Geoffrey Batchen's observation that "the identity of photography—both as a system of representation and as a social phenomenon—has been a matter of contention ever since the

medium's inception." But while recognizing this, it is necessary to retrieve specifically nineteenth-century beliefs about photography, which were often radically different from twentieth-century conceptualizations. Photography has also become such a pervasive aspect of modern society that it is difficult to fully grasp its impact (from the mid-nineteenth century onwards) not only upon the visual arts, but upon the broader experience and meanings of modernity. Not least, despite the prior existence of the camera obscura, the sheer astonishment and sense of mystery that photography initially provoked should be acknowledged. As Talbot observed in The Pencil of Nature, photography was "an Art of . . . great singularity, which employs processes entirely new . . . having no analogy to any thing in use before." The French photographer, Nadar, was to put it more bluntly, commenting that "people were stunned" by the news that an image could be permanently captured on a metal plate.

Wonderment and a belief in photography's almost magical status were commonplace during its early years. Although

12.6 Anonymous (American) Spirit Photograph—Woman's Spirit behind Table with Photograph, ca. 1865. Albumen print carte-de-visite.

12.7 ALBERT SANDS SOUTHWORTH and JOSIAH JOHNSON HAWES Postmortem photograph of an unidentified child, ca. 1850's. Daguerreotype.

assertions such as Talbot's, that his "photogenic" process was "a little bit of magic realised," were consistent with the contemporary habit of describing scientific inventions as "marvellous" or "miraculous" when presenting them to a wider public, the perception of photography as a modern alchemy was an enduring one (reinforced no doubt by publicity promoting the daguerreotype as a further refinement of the "smoke-and-mirrors" illusionism of the Diorama). But this perception was symptomatic also of the blurred boundaries of "scientific" thought in the early nineteenth century which, as Talbot's own eclectic interests demonstrated, had vet to be codified into distinct and discrete specialisms. Indeed, it was the polymath breadth of Talbot's research, which was more akin to Enlightenment and Romantic conceptions of natural philosophy than to modern technocratic science, that enabled him to advance his photographic experiments successfully.

This absence of disciplinary boundaries was especially evident in the overlap of science and spiritualism. Even the stolidly empirical Talbot could offer the "speculation . . . somewhat too refined to be introduced with effect into a modern novel or romance" that photography might register "certain invisible rays," imperceptible to human vision, so that "the eve of the camera would plainly see where the human eye would find nothing but darkness." In fact, this "speculation" merely echoed the views of another of Talbot's collaborators, Sir David Brewster, who, in his Letters on Natural Magic (1832), had described the human eye as "the sentinel which guards the pass between the worlds of matter and of spirit." The belief that the photograph could both reveal and capture the physical imprint of the invisible or noumenal, and the association of photography with necromancy, found its most literal expression in spirit and phantom photography and, to a lesser extent, in that other typically nineteenth-century genre, the deathbed portrait. Similarly, Nadar, in his memoirs, recounted the occult Theory of Specters espoused by the novelist Honoré de Balzac: "According to Balzac's theory, all physical bodies are made up entirely of layers of ghostlike images, an infinite number of leaflike skins laid one on top of another. Since Balzac believed man was incapable of making something material from an apparition, from something impalpable—that is, creating something from nothing—he concluded that every time someone had his photograph taken, one of the spectral layers was removed from the body and transferred to the photograph. Repeated exposures entailed the unavoidable loss of subsequent ghostly layers, that is, the very essence of life." The notion that the body could shed images of itself had a lineage back to the Ancient Greek philosopher, Democritus, and although Nadar is somewhat patronizing when recounting this anecdote (joking that "Balzac had only to gain from his loss, his ample proportions allowing him to squander his layers without a thought"), he is not entirely dismissive of it either. Of all the inventions that had transformed nineteenth-century society (including the steam engine, electric light, the phonograph, radio, and bacteriology), Nadar insisted that it was photography that was the most mysterious: "But do not all these miracles pale when compared to the most astonishing and disturbing one of all, that one which finally seems to endow man himself with the divine power of creation: the power to give physical form to the insubstantial image that vanishes as soon as it is perceived, leaving no shadow in the mirror, no ripple on the surface of the water?"

This strangeness of photography had potentially sinister overtones. Nadar's claim that "Night . . . reigned supreme in the sombre darkness of the camera obscura, that place appointed for the Prince of Darkness," may well have been a fanciful reference to Fantastic and Gothic literature, which had been especially popular during the early years of photography, but the diabolical association was not unique. Brewster had, for example, referred to Talbot's images as "your specimens of the black art," and Herschel, noting the "magical" and "supernatural" aspects of Talbot's experiments, had rhetorically observed, "Surely you must deal with the naughty one [Satan]." Even The Athenaeum in 1845 praised The Pencil of Nature as "a wonderful illustration of modern necromancy." Although not always to be read literally, such "irrational" beliefs in its otherworldly properties belie any easy alignment of photography with "scientific" objectivity. Indeed, the co-existence of ostensibly disparate photographic genres and beliefs in the nineteenth century (such as spiritualism and positivism) is symptomatic of the polarities that have persistently structured the discourses of photography—for example, between nature and culture, human agency and mechanized automatism, humanity and divinity, and the external world and the interior self. Nor were such oppositions mutually exclusive, as an innate connection was assumed to exist, for example, between photography's mimetic power and its magical properties. Above all, however, as Allan Sekula has argued, "Photography is haunted by two chattering ghosts: that of bourgeois science and that of bourgeois art . . . Thus, from 1839 onward, affirmative commentaries on photography have engaged in a comic, shuffling dance between technological determinism and auteurism, between faith in the objective powers of the machine and a belief in the subjective, imaginative capabilities of the artist. In persistently arguing for the harmonious coexistence of optical truths and visual pleasures, in yoking a positivist scientism with a romantic metaphysics, photographic discourse has attempted to bridge the philosophical and institutional separation of scientific and artistic practices that has characterized bourgeois society from the late eighteenth century onward."

Uncertainty as to how photography was to be defined is evident from the earliest commentaries. Like Arago, Talbot was unable to decide if photography was a "discovery" (of a process occurring in nature) or an "invention" (something man-made), but instead used both terms interchangeably. This terminological indecision or double-identity of photography (as both natural and mechanical) continued to haunt it, but the perception of photography as a process immanent to nature itself was especially prevalent. For Daguerre, the daguerreotype was "not merely an instrument which serves to draw nature . . . [but] on the contrary it is a chemical and physical process which gives her the power to reproduce herself." For Arago, also, daguerreotypes were "images drawn by nature's most subtle pencil, the light ray." This notion of photography as a hitherto unprecedented method by which objects drew themselves was a recurrent one. Commenting upon an image he had made in 1835 of his own house, Talbot noted, "This building I believe to be the first that was ever yet known to have drawn its own picture." Talbot's claim that the photographs in The Pencil of Nature were "impressed by Nature's hand" was echoed across the Atlantic by Samuel Morse, for whom daguerreotypes were "painted by Nature's self with a minuteness of detail, which the pencil of light in her hands alone can trace . . . they cannot be called copies of nature, but portions of nature herself." Metaphorical allusions to nature's own hand or pencil (and to "the pencil of fire" or the "pencil of rays") abound in early descriptions of photography and, while they served to affirm the purported verisimilitude of the photographic image, they simultaneously undermined the role of the photographer. Indeed, for Arago, the specific qualities of the daguerreotype —its accuracy, relative speed and ease of use—were largely independent of human action, and a major attribute of photography was that it required no artistic skills: "[the] Daguerreotype calls for no manipulation which anyone cannot perform. It presumes no knowledge of the art of drawing and demands no special dexterity. When, step by step, a few simple prescribed rules are followed, there is no one who cannot succeed as certainly and as well as can M. Daguerre himself."

Although Arago was capable of assessing photography esthetically (describing Niépce's early images as "flat and monotonous in tones, lacking all the pleasing effects which arise from the contrast of light and shade"), he regarded it principally as a scientific invention whose value lay in its "practical use." Outlining four criteria against which the daguerreotype should be judged, Arago asked: "Is the process of M. Daguerre an original invention? Is this invention one which will render a valuable service to archaeology and the fine arts? Can this invention be practically useful? And,

12.8 LEWIS M. RUTHERFORD Moon, March 4, 1865. Albumen print.

finally, is it to be expected that the sciences may derive any benefit from it?" Far from regarding photography as an independent art or as a challenge to art, Arago, citing the painter Paul Delaroche (an early enthusiast of photography), claimed that the accuracy and precision of the daguerreotype would make it an invaluable tool for artists. This reassurance that photography was not a threat to artists' livelihoods was in part a response to a broader anxiety, which cut across class differences, about the impact of industrial processes upon artistic production. Concern over artists' incomes prompted Saint-Simonians in France and Chartists in Britain to warn of the debasing effects of mechanization upon art. Citing the highly successful daguerreotypist, Richard Beard, who had recently opened the first professional photography studio in Britain at the Royal Polytechnic Institute in London, the Chartist journal, The Union, stated in 1842 that "art seemed secure from the encroachments of machinery; yet, by Beard's new patent, this has been effected."

Critics of photography also argued that the automatism of photography necessarily precluded it from having any artistic potential. Ruskin, an early but subsequently disillusioned admirer of photography, claimed that "a photograph is *not* a work of art" as only art "expresses the personality, the activity, the living perception of a good and great human soul."

For Baudelaire, photography was both cause and symptom of a cultural degeneration that threatened to install a narrow and reductive version of realism (as the exact replication of an external reality) as the only model for art. Such commentaries extended beyond the debate over the artistic legitimacy of photography and gave voice to deeply ambivalent responses to modernity, and in particular to the technological modernization heralded by the machine and mechanization. Just as television in the 1950's was a focus and scapegoat for concerns about social and demographic changes (including the perceived decline of family life and rise of youth delinquency), so photography in the nineteenth century was, as Mary Warner Marien observes, "an internally conflicted symbol of the modern . . . [which] symbolized the social effects of industrialization and urbanization and the perceived threat posed by mass culture to the individual and to individual creativity." Yet, concurrently, the insistent assertion that photography provided an absolute and inviolable objectivity—a guarantee of truth in a rapidly changing world—functioned as a defense against a dynamic modernity. As Alan Trachtenberg notes, "the conventional idea of photography's infallibility is not a demonstrable truth but a belief, held with the irrational conviction of a myth. The persistence of this popularly held idea in the face of counterevidence . . . implies that it answers a cultural need."

12.9 Anonymous (French?) Odalisque, ca. 1840's. Daguerreotype.

12.10 THÉODORE MAURISSET *La Daguerréotypomanie*, 1839. Lithograph.

The structuring polarities of photography's discourses and its status as a contradictory symbol or metonym for modernity underpin photography's resistance to codification or definition, despite repeated attempts to locate its essence or identity or, at least, to contain it within conventional art historical categories and narratives. As John Tagg has argued, "Photography as such has no identity. Its status as a technology varies with the power relations which invest it. Its nature as a practise depends on the institutions and agents which define it and set it to work. Its function as a mode of cultural production is tied to definite conditions of existence, and its products are meaningful and legible only within the particular currencies they have. Its history has no unity. It is a flickering across institutional spaces."

This claim that photography's identity is external to it, indeed that there is no photography "as such," is at odds with recurrent attempts—evident also from the earliest commentaries, such as Arago's—to construct an internal history of photography that would in fact provide a stable identity or unity for it. In his account of the daguerreotype's evolution, Arago cited it as the logical conclusion to a teleological narrative of increasing proficiency in the mechanical production of an accurate likeness, and this model of incremental technical progress dominated historical accounts of photography well into the twentieth century. By presenting the daguerreotype as the inevitable conclusion of the search "to capture the images in the camera obscura," Arago implied that early researchers had a clear goal in view. However, improving

the design of the camera obscura had been just one objective among many (such as refining the illusionism of the Diorama or research into photochemistry), and photography's pre-history and early decades are more a narrative of accidental insights, paths not taken, and dead ends, than a story of inevitable outcomes. Indeed, for many early pioneers, the appeal of photography lay in its open-ended possibilities.

Although the various reports on the daguerreotype presented by Arago during 1839 were mostly taken up with accounts of its technical evolution, he nonetheless foreshadowed many of the historical narratives, conceptual frameworks, and social agendas that were to shape photography. But by appraising photography in terms of its potentially immense practical benefits across a variety of spheres including the physical sciences and medicine, astronomy and meteorology, topography, the visual arts, nationalism and colonialism, commerce and the economy, but, curiously, not portraiture—Arago implicitly undermined the neat linear narrative of technical progress within which he aimed to place photography. Instead, his account reveals how, from its beginnings, photography was shaped by the entire social field (including Arago's own political agendas) and, as such, was never a discrete invention or process. Within just a few decades of the announcement of the daguerreotype, photography had been adopted across a disparate range of cultural practises, including advertising, criminology, urban planning, scientific research, policing and surveillance, pornography,

12.11 MATHEW BRADY Portrait of Lincoln, 1860. Salted paper print carte-de-visite.

12.12 Anonymous (after a woodburytype by Mathew Brady) *Harper's Weekly*, 1860. Woodcut.

medicine and psychiatry, travel and tourism, in addition to more conventional genres such as portraiture and landscape. Indeed, the rise of self-styled Art Photography in the later nineteenth century, and the attempt to hierarchically differentiate it from commercial and amateur genres, was partly a reaction against photography's mass penetration of society. Yet the sheer diversity of photography's applications makes conventional art historical categories and interpretive frameworks inappropriate for its history. What is clear, however, is that the identities and meanings of photography are profoundly historical and inseparable from the social contexts within which it was deployed.

COMMERCIAL PORTRAITURE AND THE INDUSTRIALIZATION OF PHOTOGRAPHY

Arago's claim for the universal accessibility of photography was not only premature, but signaled the enduring myth of photography's democratizing effects. Although the announcement of Daguerre's invention, in conjunction with the publication of his manual on daguerreotyping (which sold over 9000 copies within three months and ran to over thirty editions), led to the craze of "daguerréotypomanie," the prohibitive cost of the equipment and materials, together with the difficulties in transporting and using the cameras, meant that the new technology was far beyond most people's reach. Except for daguerreotypists, who were almost invariably

commercial practitioners, photography in Europe throughout the 1840's was largely an activity confined to a small and eclectic group of financially independent amateurs. Often closely collaborating and motivated more by intellectual curiosity than by commercial gain, these individuals pursued their photographic research in almost artisanal conditions. For Walter Benjamin, however, writing in 1931, these preindustrial practises underpinned "the first flowering of photography . . . [which] came in the first decade," enabling a brief period of authenticity before the medium fell under the sway of the commodity and fetishized notions of art.

Rather than in Europe, it was in America that the democratizing possibilities of photography—in terms of popular access to the new medium and its role in the dissemination of knowledge—were initially promoted. The daguerreotype was enthusiastically greeted in America where there was little evidence of the anxiety, indeed outright condemnation, that photography was to provoke from some European commentators. Echoing Arago, Edgar Allan Poe claimed in 1840 that the daguerreotype "must undoubtedly be regarded as the most important, and perhaps the most extraordinary triumph of modern science," the potential of which would "exceed . . . the wildest expectations of the most imaginative." Long after it had been superseded in Europe by paper print methods, the daguerreotype remained the dominant photographic process in antebellum America. Not only did Americans, such as Samuel Morse, introduce significant technical improvements (notably a reduction in exposure time), but by the spring of 1840 portrait studios had been established in New York and

Philadelphia—a year before the first European studio. Spurred on by a dynamic entrepreneurial culture and a desire to outdo Europe (to the extent that the daguerreotype became known as "the American process"), it was in America also that a nascent photographic industry first evolved, comprised of large commercial studios, galleries, and technical supply companies.

From its beginnings, photographic culture in America was shaped by the twin ideals of universal access and pedagogic enlightenment. In 1841 Ralph Waldo Emerson noted in his journal that "Tis certain that the Daguerreotype is the true Republican style of painting," and two decades later, Oliver Wendell Holmes, discussing the stereoscope in three articles published between 1859 and 1863 in the Atlantic Monthly, outlined an encyclopedic fantasy in which photography— "the mirror with a memory"—could provide an image of everything: "Every conceivable object of nature and Art will soon scale off its surface for us. Men will hunt all curious, beautiful, grand objects . . . for their skins . . . The consequence of this will be such an enormous collection of forms, that they will have to be classified and arranged in vast libraries, as books are now. The time will come when a man who wishes to see any object, natural or artificial, will go to the Imperial, National or City Stereographic Library and call for its skin or form, as he would for a book at any common library ... And as a means of facilitating the formation of public and private stereographic collections, there must be arranged a comprehensive system of exchanges, so that there may grow up something like a universal currency of these bank notes, or promises to pay in solid substance, which the sun has engraved for the great Bank of Nature."

Employing a simile of "skins" (that recalls Balzac's Theory of Specters), Holmes describes photography as a universal language founded upon a "currency" of equivalence in which the photograph is not merely a copy of its referent, but a substitute for it. Within his explicitly monetary model of photographic representation and consumption, Holmes presents the photograph as a seemingly autonomous product of nature ("which the sun has engraved"), rather than as a product of industrialized labor. Circulating freely within a "system of exchanges," the infinitely reproducible photograph (as banknote) becomes an analogue of the concealed labor of the commodity. Moreover, as both a process of nature and a mass commodity defined by its exchange-value, the photograph, as described by Holmes, prefigures Marx's description, in the opening chapter of Capital (1867), of the "mystical" and "enigmatic" character of commodity fetish. For, although not explicitly reiterating earlier associations of photography with magic, there is a striking correspondence between not only Holmes's language, but many other nineteenth-century accounts of photography, and the terminology employed by Marx to describe the "whole mystery of commodities, all the magic and necromancy that surrounds the products of labor as long as they take the form of commodities."

Holmes's three essays referred to the stereoscope and paper photography, but it was the daguerreotype portrait that embodied, at least initially, the practical utility so enthusiastically extolled by Holmes, and that was swiftly employed also as a powerful instrument for national self-definition. As Richard Rudisill has observed, early photography in America had three principal roles: "It served as a direct aid to cultural nationalism, it helped Americans adjust themselves intuitively to the transition from an agrarian to a technological society, and it was ultimately a reflection of the spiritual concerns motivating the nation." Indeed, for many photographers, the new medium could not only reflect American society, but should actively shape it—for example, by fostering patriotic ideals. According to the daguerreotypist and author Marcus Aurelius Root, the daguerreotype could even "train society" by "developing . . . [the] idealistic capabilities of the masses."

Such didacticism was evident in the regular publication of lithographs based upon daguerreotypes of national figures. These included the National Plumbeotype Gallery issued in 1847 by the Philadelphia daguerreotypist, John Plumbe Jnr., and A Gallery of Illustrious Americans (1850), an edition of the twelve lithographs by François d'Avignon, based on the daguerreotypes of Mathew B. Brady (1823–96). By this time, Brady had already gained a reputation as a society portraitist, having established his Daguerrean Miniature Gallery in New York in 1844 and a second studio in Washington, D.C. three years later. His portraits were also displayed at the Great Exhibition in London in 1851 where, as one commentator noted, machine-polished American daguerreotypes "beat the world," with Brady himself winning a prize. In London, Brady learned the new wet collodion process, which he used on his return home to produce "Imperial" and carte-de-visite portraits. In 1860 he founded his largest gallery, the National Portrait Gallery, in New York, the same year in which he took his first and most widely published portrait of Abraham Lincoln, which Lincoln himself credited for his election to the presidency the following year. With the outbreak of Civil War that year, Brady devoted himself to its documentation, hiring teams of photographic "operators," including Alexander Gardner, Timothy O'Sullivan, and John Reekie, whose photographs, in line with standard studio practise, were usually credited to him. Brady's expectation that he would sell these photographs, and those purchased from freelancers, as historical records of the war, failed to be realized, as people wished to forget the trauma of the conflict. It was not until 1875 that the government finally bought Brady's archives, by which time he was living in poverty, having been forced to sell his assets to cover his wartime expenditure.

12.11, 12.12

12.13 Anonymous (American) Woman Seated, Holding Daguerreotype, ca. 1850. Daguerreotype.

12.14 ALBERT SANDS SOUTHWORTH and JOSIAH JOHNSON HAWES Portrait of Albert Sands Southworth, ca. 1848. Daguerreotype.

Like Brady's, much American photography was motivated by a desire to produce a pictorial record of the nation and to capture a distinct national character. Individuals from all levels of society were depicted (the showman P. T. Barnum hoped to find the first "Miss America" through a photographic competition) and albums of views of cities and localities throughout the nation were produced. This search for a uniquely American type went hand in hand with a quest for an authentically vernacular mode of depiction, and the frontal directness, diffuse and sober lighting, and visual simplicity—in effect, the "styleless" style—of many daguerreotypes from this period contrast strongly with the artifice, self-conscious poses, elaborate lighting, and frequent clutter of studio props typical of much European studio photography. This strongly functional attitude to photography endured, and it was not until the turn of the century, when Alfred Stieglitz and the Photo-Secessionist movement actively promoted Pictorialism, that the idea of art photography gained significant currency in America. For some American daguerreotypists, however, a portrait was more than a copy or faithful likeness, but could be both a material record and an idealized image combining empirical and spiritual truths. Not only was there a widespread assumption that moral character and public virtue could be read from an individual's physiognomy and deportment, but photography was seen as providing access to a transcendent realm and to the inner workings of nature—qualities that photographers, such as William H. Jackson (1843–1942), Timothy O'Sullivan (1840–82) and Carleton E. Watkins (1829–1916), sought also in the sublime epic landscapes of the American West.

Emerson claimed, "Every natural fact is a symbol of some spiritual fact. Every appearance in nature corresponds to some state of mind, and that state of mind can only be described by presenting that natural appearance as its picture." In portraiture, this was best exemplified in the some 1500 extant daguerreotypes produced by the former painters, Albert Sands Southworth (1811-94) and Josiah Johnson Hawes (1808–1901), who between 1843 and 1862 ran a studio in Boston, then an important centre for Transcendentalist philosophy. Rejecting the plain deadpan format and sharp precision of most daguerreotypes, Southworth and Hawes looked to established conventions, and produced highly individualized expressive portraits, including selfportraits. For Southworth, "the artist, even in photography, must go beyond discovery and the knowledge of facts: he must create and invent truths and produce new developments of facts . . . He should not only be familiar with nature and her philosophy, but he should be informed as to the principles which govern or influence human character . . . Nature is not at all to be represented as it is, but as it ought to be, and might possibly have been; and it is required of and should be the aim

12.15 DAVID OCTAVIUS HILL and ROBERT ADAMSON Mrs. Elizabeth (Johnstone) Hall, ca. 1846. Salted paper print.

12.16 CARLETON E. WATKINS Cape Horn near Celilo, 1867. Albumen print.

of the artist-photographer to produce in the likeness the best possible character and finest expression of which that particular face could ever have been capable."

Throughout the 1840's two photographic processes were available in Europe and America—the daguerreotype (a unique image on a copper plate) and the calotype (a salted paper print produced by the negative-positive method). While professional portraitists largely employed the daguerreotype, the calotype was the process of choice for amateurs and artist-photographers who were attracted by the specific qualities of paper photography, such as lack of sharpness and variability of printing effects. However, these qualities, together with the relative slowness and awkwardness of paper printing (compared to the daguerreotype) precluded the calotype's commercial appeal, which was also hindered by Talbot's strict licensing restrictions (which he finally relinquished in 1855).

In Britain, the possibilities of the salted print were realized early, most notably during the five-year collaboration between the chemist Robert Adamson (1821–48) and the painter and lithographer David Octavius Hill (1802–70). Commissioned in 1843 to paint a monumental canvas (known as *The Disruption Picture*, 1843–66) depicting some 470 ministers who had broken with the Church of Scotland to establish the Free Church of Scotland, Hill was introduced to Adamson by Talbot's colleague, David Brewster (a member of the newly formed Free Church), who suggested that calotype portraits of the ministers could be used as models for the painting. Although, once again, photography was initially viewed as an

aid to art, it is the photographs that have endured. Around 1500 negatives were produced by the pair, with Adamson taking the photographs and attending to the technical aspects and Hill organizing the composition and styling. These images included not only the ministers' portraits but also portraits of Edinburgh notables, landscapes, and architectural scenes, and some 130 outdoor portraits of fishermen and women from the small village of Newhaven just outside Edinburgh. Echoing the literary precedents of Robert Burns and Walter Scott, who celebrated the independence and moral integrity of working people, the photographs, under Hill's artistic direction, achieved a direct naturalism and presence quite distinct from the conventions of later studio photography, prompting Walter Benjamin to observe that, "With photography . . . we encounter something new and strange: in Hill's Newhaven fishwife, her eyes cast down in such indolent, seductive modesty, there remains something that goes beyond testimony to the photographer's art, something that cannot be silenced, that fills you with an unruly desire to know what her name was, the woman who was alive there, who even now is still real and will never consent to be wholly absorbed in art."

In France, paper photography was further refined by Gustave Le Gray (1820–82), a student of Delaroche, who in 1851 made public his waxed paper process which enhanced the translucency of the calotype negative, and by Louis-Désiré Blanquart-Evrard (1802–72), who in the same year announced a method for quickly producing multiple prints from a single negative. Unlike Talbot's continuous contact

12.17 MAXIME DU CAMP Thebes: The Eastern Part of the Peristyle of the Temple of Ramases, 1849–51. Salted paper print.

printing method (which required strong and unbroken natural light for the printing-out process), Blanquart-Evrard was able to chemically develop a print after only briefly exposing it to a negative. Capable of producing over one hundred machine-finished prints an hour, of uniform quality and permanence (unlike Talbot's often variable printing results), Blanquart-Evrard's printery at Lille published extensively illustrated photographic albums, including the album *Egypt*, *Nubia*, *Palestine and Syria* (1852), comprised of 125 photographs by Maxime du Camp who between 1849 and 1852 had toured the Middle East with the novelist Gustave Flaubert.

Blanquart-Evrard's process was an important advance in printing methods, but by the early 1850's both the daguerreotype and the calotype had been superseded by technical developments enabling the mass production of photographs. Most notably, these included the introduction of the wetplate (wet collodion) process and the albumen print. Echoing the parallel French and British discoveries of the late 1830's, Gustave Le Gray in France and R. J. Bingham and Frederick Scott Archer in Britain simultaneously recognized in 1851 the potential of collodion (produced by dissolving gun-cotton in alcohol and ether) as an emulsion carrier. As Le Gray did not

fully publish his results, Scott Archer's process, which he also made freely available without restrictive patents, became the standard. Although the need for the plate to be prepared and developed when used was a major drawback to the wet collo dion method (as it necessitated ready access to cumbersome apparatus including a portable darkroom, processing equipment, chemicals, water, and a supply of prepared glass plates that had to be kept permanently damp), such difficulties were justified by the greater sensitivity of the emulsion, which reduced exposure time to under one second and produced a sharp, easily reproducible negative.

The enhanced sensitivity of the wet collodion glass negative could only be fully realized when combined with an improved positive printing method that prevented the grain and texture of the paper becoming an integral aspect of the print (as with the calotype). This was provided in 1851 by Blanquart-Evrard's introduction of a process using salted egg white (albumen) to coat the printing paper. Producing a smoother finish and sharper image than salted paper prints, and ranging in hue from golden vellows to deep browns (the characteristic tonality of much nineteenth-century photography), albumen printing expanded the artistic possibilities of photography, and became the standard printing method until the 1890's. These new processes fundamentally altered the appearance of photographs. As Joel Snyder has noted, "The changing surface structure of the photographs and the change in the variety of their hues has a dual effect: it draws attention to the photographic origins of the picture—other print forms in this period were rarely glossy—and it produces the impression in the viewer that the prints are machined, exactly reproducible, rather than handmade. It brings photography into a new world."

The displacement of both the daguerreotype and the calotype by the faster and more reliable collodion negative and albumen print in the 1850's was also a catalyst for the commercial expansion of photography, especially portraiture, which was now capable of meeting the public's demand for images—a demand already evident since the 1790's in the popularity of copying devices such as the physionotrace (a traced silhouette which, when transferred to a copper plate, could be engraved as multiple copies). Two photographic formats—the stereograph and the carte-de-visite—became especially popular during the 1860's, and heralded the arrival of mass photography. Replicating human binocular vision (whereby the brain combines the slightly different image seen by each eye), the stereograph consisted of a pair of photographs mounted on a single card. Typically made by a dual-lens camera, with the distance between the lenses matching that between two eyes, the photographs were almost identical, except for the slight lateral shift between them. When viewed through a stereoscope (invented by

David Brewster in 1849), the pair of images fused to produce an effect of increased depth that not only recalled the three-dimensional illusionism of the diorama, but also entirely filled the viewer's visual field. Although peaking in the 1860's (in 1862, for example, the London Stereoscopic Co. sold over 300,000 stereos of the International Exhibition) and again in the 1890's, the fad for viewing and collecting stereographs lasted well into the twentieth century and gave rise to hundreds of companies in both Europe and the U.S. producing millions of cards in all genres.

The 1860's were also the heyday of cartes-de-visite and of "cartomania" (the fashion for producing and collecting cartede-visite portraits). As with stereocards, millions of cartes were produced worldwide, but it was in Paris during the Second Empire that the commercial potential of the carte-devisite portrait was first exploited. The Second Empire (1852-70) was a period of unprecedented economic growth and industrialization in France, and gave rise to major changes within the class structure. Spurred on by the modernizing agenda of Napoleon III, who had declared himself Emperor in December 1852, the period saw a transformation of the banking system and the expansion of credit (often subsidized by the State), a dramatic expansion of major capital investment projects (especially those fostering mechanization such as the railroads), the growth of small commercial businesses and overseas trade, and the doubling of the population of Paris. This Bonapartist economic activity (dubbed "industrial madness" by Baudelaire) and the massive expansion of State bureaucracies swelled the ranks of the bourgeoisie and petite bourgeoisie. Fuelled by the demands of these rising classes, this was an era of conspicuous consumption typified by the opening of the first department stores in Paris (Bon Marché, La Belle Jardinière, Le Louvre) and by events such as the 1855 Exposition Universelle, which included a special display on photography.

The prototype for these international exhibitions and world fairs, which created a new mass audience for photography, was the Great Exhibition of the Works of Industry of All Nations (see pp. 177–9). It opened in May 1851 at the Crystal Palace in London and attracted six million visitors. Comprised of four sections—Raw Material, Machinery, Manufacturers, and Fine Arts—and including some 109,000 exhibits, the Great Exhibition significantly increased public awareness of photography. Not only were several photographers commissioned to document the actual construction of the Crystal Palace, designed by Joseph Paxton, and itself a marvel of mass-production techniques, but photographs (both daguerreotype and calotype processes) and new photographic equipment, such as the stereoscope, were included in many of the displays. Although examples of landscape and architectural photography were exhibited in the Fine Arts section, most photographic exhibits were classed alongside forms of instrumentation such as time-keeping devices, telescopes, and, the latest wonder, the electric telegraph. As Anne McCauley has noted, with reference to international economic rivalries during this period, "The photograph provided a standard of objectivity against which all industrializing countries could measure their economic accomplishments. Its triumph paralleled the ascendancy of the centralized, bureaucratic state legitimized by an apparently democratic process and contingent upon an ever-increasing flow of disposable consumer goods."

By the mid-century, social and technical conditions were ripe for the expansion of photography. For the Goncourts, the photographer was emblematic of "revolution in the streets of Paris" in the 1860's: "The Parisian of twenty years ago, the man about town, unmarried and not particularly rich, interested in everything, keen on taking part . . . was an artist, a senior civil servant, an officer, a bourgeois, a sporting gentleman with an income of sixty thousand pounds. Nowadays . . . the Parisian diner is almost always a stock-exchange speculator or photographer."

No photographer better epitomized and exploited this new social landscape than André Adolphe-Eugène Disdéri (1819-ca. 1889), who almost singlehandedly established the portrait industry in Paris, and whose own rapid rise to self-made millionaire, and equally swift financial collapse (he ended his days in poverty as a beach photographer in Nice), was emblematic of the vagaries of an expanding and speculative economy. Disdéri had worked in a variety of photographic genres and recognized the commercial potential of faster and cheaper photographic processes. He made his fortune by popularizing the carte-de-visite portrait, which he patented in 1854. Consisting of an albumen print glued to a mount the size of a visiting card, the portraits themselves were made using a multiple-lens camera, which simultaneously took several photographs, or else with a single lens camera, which took a sequence of images on a single plate. Reducing both the size of the print to that of a standard visiting card (approximately $2\frac{1}{2}$ by $3\frac{1}{2}$ inches) as well as its cost to around 20 francs for a dozen identical images made from a single negative (a single print had previously cost up to 100 francs), Disdéri's reputation was further consolidated in May 1859 when Napoleon III, en route to Italy with his troops, had his portrait taken and subsequently appointed Disdéri as court photographer.

Disdéri's "portrait factories" introduced mass manufacturing methods into portrait photography. At the height of his success, he employed over seventy assistants, each assigned to specific aspects of the production process, in studios in Paris, London, and Madrid providing a forty-eight-hour service for portraits that fulfilled the self-image of the *nouveaux riches*

12.18 ANDRÉ ADOLPHE EUGÈNE DISDÉRI Portrait of an Unidentified Woman, ca. 1860–65. Uncut albumen print from a carte-de-visite negative.

and social aspirations of the lower middle classes. Paralleling his mass-production methods, Disdéri's studios employed a stock repertoire of formats and conventions, which Disdéri himself itemized in his book, *The Art of Photography* (1862). Fashionably dressed, and often placed within elaborate settings suggestive of an aristocratic lifestyle, Disdéri's sitters were usually depicted full-length, framed by props such as columns, curtains, and pedestals or defined by accessories indicative of their professional status.

Disdéri's formulaic depiction of the individual as a class type, indeed as merely another studio prop, was symptomatic of the emergent commodification and standardization of the self within capitalist culture during the latter half of the nineteenth century. In response to consumer demand, the function of such portraits was social emplacement and the consolidation of class identity, according to the norms of current fashion, rather than the registration of individual character or expression. However, other Second Empire photographers, most notably Nadar (Gaspard-Félix Tournachon; 1820-1910), aimed—at least initially—to produce a very different kind of portraiture, which took its cue from an earlier Romantic individualism. While Disdéri cultivated a clientele drawn from the royal court (including the Emperor himself), Nadar's sitters came mainly from his own bohemian and republican milieu. However, making specific reference to the liquidation of Gustave Le Gray's studio in 1860, Nadar later acknowledged in his autobiography, When I Was a Photographer (1900), that professional artist photographers had either "to submit or resign" when confronted by the new methods of mass production. While scornful of Disdéri's clientele (although acknowledging the photographer's "intelligence"), Nadar was increasingly unable to ignore the demand for cheap cartes-de-visite, just as his portrait editions (Figures contemporaines) partook of the cult of celebrity that fed the market for cartes and stereocards.

Born in Paris in 1820, Tournachon was initially a writer and caricaturist (working for publications such as *Le Charivari* and the *Revue comique*), who turned to photography as an aid in producing the second edition of his most well-known but unfinished lithograph, the *Panthéon Nadar*. Recalling Hill and Adamson's use of photographs for their monumental group portrait, *The Disruption Picture*, the *Panthéon Nadar* depicted some three hundred caricatures of contemporary personalities and was published in the *Lanterne magique* (1854) and, as a version including yet more personalities, in *Le Figaro* (1858). Initially working in partnership with his younger brother Adrien, Nadar photographed friends and acquaintances such as Gautier, Gérard de Nerval, Daumier, Baudelaire, and Manet. Rejecting the evenly filtered lighting, painted backdrops, and fashionable props of conventional

studio portraiture, Nadar sought instead to capture what he referred to as "the moral grasp of the subject—that instant understanding which puts you in touch with the model." Nadar's construction of his sitters' "character," in particular their defining psychological traits, was premised upon an assumed correspondence between physiognomy and personality that not only bore the trace of his earlier career as a caricaturist, but also paralleled techniques of characterization used in the novels of Balzac and Dickens. Producing fullplate "lifesize" prints, Nadar depicted his (usually hatless) subjects either sitting or standing three-quarter-length against a darkened neutral backcloth. Dramatic chiaroscuro effects, achieved by the use of strong natural light (often from a source directly overhead), accentuated facial physiognomy and posture, and metaphorically connoted the sitter's inner creative illumination. Harsh and potentially unflattering lighting (Delacroix, for one, refused to be photographed again after sitting for Nadar), combined with the photographer's frequent practise of costuming his subjects in bulky overcoats or loosely draped cloaks, served to stress the sitter's intellectual presence, even genius, and further distanced Nadar's portraits from the surface social display of most carte-de-visite portraiture.

Nadar's success led in 1860 to his relocating from his first studio, at 113 rue St.-Lazare, to much larger premises at 35 boulevard des Capucines (which in 1874 was to host the first public exhibition of Impressionist paintings). This move to the new "crystal palace" was also an overt challenge to the large commercial studios already established in Paris by Disdéri, Mayer and Pierson, and the Bisson brothers. Commercial expansion necessitated a shift away from the crafted individual print to rationalized factory production methods, which in turn led to a decline in quality. As salted paper prints, with their subtle tonal ranges, were replaced in Nadar's studio by albumen prints, and large format prints gave way to uniform and often inferior quality cartes-devisite formats, Nadar also made greater use of the props and poses of conventional studio photography (for example, Sarah Bernhardt's arm resting upon a column) that he had avoided in his earlier work. Now employing up to fifty assistants, Nadar's own role became less that of creative auteur (despite reassuring the public that he still had direct personal involvement in production of the photographic plates), but was more akin to that of studio overseer and owner of the brand name "Nadar," which in 1857 he had gained sole ownership of after successfully filing a lawsuit prohibiting his brother's commercial use of the name for his own photographic business.

Nadar's career as caricaturist, novelist, and photographer was indicative of the dramatic expansion during the Second Empire of visual and print media—illustrated newspapers

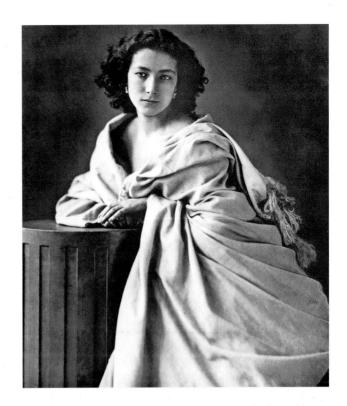

12.19 NADAR (Gaspard-Félix Tournachon) *Sarah Bernhardt*, ca. 1860. Printed from a collodion negative.

and journals, serialized novels, and the popularity of mass photography (including postcards, cartes-de-visite, stereocards, and photo albums). Not only did Nadar move with ease between various media, but he also anticipated subsequent developments in photography. A pioneer of aerial photography (using a hot air balloon), microphotography, and the use of artificial lighting, Nadar also prefigured the photographic interview format of twentieth-century photojournalism when he published, in the Journal illustré (September 1886), a sequence of photographs, taken on roll film by his son Paul, of his conversation with the chemist Michel-Eugène Chevreul. Yet, despite his flair for self-publicity and his talents as a canny, but ultimately overly-ambitious, commercial operator, Nadar was also deeply ambivalent about the economic and social transformations brought about by mass production. Characterizing Nadar's career as an "attempted fusion of the disinterested artist and small-town businessman," Anne McCauley concludes that by "adhering to an elitist stance that was anti-cheap, anti-Bonapartist, anti-materialist, and anti- ostentatious in an age that was all of these things, Nadar unwittingly made himself a martyr to photography." In his memoirs, Nadar characterized this period of photography as a conflict between commercial interests and artistic integrity. Although asserting the artistic pedigree of his work—a claim framed in a language that echoed the emergent avant-garde's privileging of artistic temperament and creative originality over technical skill and training—Nadar's photography was unavoidably affected by economic imperatives. As Ulrich Keller comments, "as dear as the idea of Nadar the great artist has become to us, we will have to accept that he was also an entrepreneur first... what might appear to the art historically conditioned researcher as a model case of an 'artist' going through a 'stylistic' evolution and personally producing 'original' works of 'art' could be described upon closer examination as a radically different phenomenon, namely, an 'entrepreneur' establishing for every business cycle a set of 'standard' procedures to manufacture visually 'streamlined,' if not stereotyped 'commodities' on a division-of-labor basis."

PHOTOGRAPHY, ART, AND THE DEBATE OVER FOCUS

By the beginning of the 1860's photography was no longer a "marvellous" novelty primarily of interest to a small network of experimental amateurs, but had become an increasingly standardized mass commodity produced by a burgeoning class of professionals. The publication of manuals with titles such as Photography Considered as an Art and as an Industry (produced by the Mayer Brothers and Pierson's studio in 1862) affirmed the change that had occurred, prompting Ingres to exclaim in 1863: "Now they want to confuse industry and art. Industry! We refuse to have anything to do with it!" So too, regardless of Disdéri's reasoned argument in The Art of Photography that photographers could be sophisticated artists, his own highly commercialized business confirmed, at least for those critics hostile to photography, the immense gulf between the new medium and the traditional fine arts. In an essay, "The Modern Public and Photography," that was part of his review of the Salon of 1859, Baudelaire asserted that, "As the photographic industry became the refuge of all failed painters with too little talent, or too lazy to complete their studies, this universal craze not only assumed the air of blind imbecile infatuation, but took on the aspect of revenge . . . the badly applied advances of photography, like all purely material progress for that matter, have greatly contributed to the impoverishment of French artistic genius." This "revenge" on art was most evident in portraiture, about which Baudelaire was especially scathing, despite himself posing for remarkable portraits by Nadar and Etienne Carjat: "An avenging God has heard the prayers of this multitude; Daguerre was his Messiah . . . From that moment onwards, our loathsome society rushed, like Narcissus, to contemplate its trivial image on the metallic plate."

For Baudelaire, as for critics such as Ruskin, there was no necessary correspondence between technological progress and cultural development. But Baudelaire's tirade against

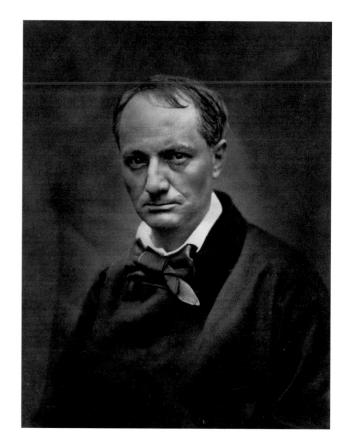

12.20 ETIENNE CARJAT Charles Baudelaire, ca. 1863. Salted paper print.

photography also voiced a warning about the conformism of mass culture and "the pressure of society upon the individual, and the involuntary, inevitable obedience of the individual to society." Specifically, this tension between an emergent popular culture (the "idolatrous multitude") and an assertion of individualism (that took its extreme form in the Romantic theory of genius) devolved around the hegemony of realism (or, at least, a particular version of it) in that, for Baudelaire, photography typified a populist conception of art as merely the accurate rendition of external reality, often in conjunction with overtly sentimental narratives. Identifying photography with technocratic values, Baudelaire claimed, "It is simple common sense that, when industry erupts into the sphere of art, it becomes the latter's mortal enemy . . . If photography is allowed to deputize for art in some of art's activities, it will not be long before it has supplanted or corrupted art altogether, thanks to the stupidity of the masses, its natural ally." Within Baudelaire's esthetic framework, photography substituted mechanistic naturalism (truth defined merely as mimetic accuracy) for the imagination and idealism of art which, in response to mass culture, was now "prostrating itself before external reality . . . [as] the painter is becoming more and more inclined to paint, not what he dreams, but what he sees." Mimetic record, for Baudelaire,

was both the strength and limitation of photography, which at best should be seen as no more than "the handmaid of the arts and sciences." Thus, echoing Arago's inventory of the potential applications of photography, Baudelaire observed, "Let photography quickly enrich the traveller's album, and restore to his eyes the precision his memory may lack; let it adorn the library of the naturalist, magnify microscopic insects . . . let it, in short, be the secretary and record-keeper of whomsoever needs absolute material accuracy for professional reasons."

Similar anxieties over photography's role in the lowering of artistic standards were also voiced in Britain. In an (unsigned) article, "Photography," published in the Quarterly Review of March 1857, Lady Elizabeth Eastlake, wife of Sir Charles Eastlake, President of the Royal Academy and first President of the Royal Photographic Society, commended the precision and clarity of the photograph but argued that these mechanical qualities also precluded photography's claims to artistic status: "For everything for which Art, so-called, has hitherto been the means but not the ends, photography is the allotted agent—for all that requires mere manual correctness, and mere manual slavery, without the employment of artistic feeling, she is the proper and therefore the perfect medium. She is made for the present age, in which the desire for art resides in a small minority, but the craving, or rather necessity, for cheap, prompt, and correct facts in the public at large." Although not sharing Baudelaire's outright antipathy to photography, Lady Eastlake nonetheless represented the views of a cultural elite alarmed by a growing middle-class appetite for photographs that threatened to debase "that mystery called Art." Facilitated by the collodion method, this demand for mass-produced images across a variety of genres fuelled the dramatic rise in commercial studios and workshops, and in London alone some 130 studios were in operation by the late 1860's. This period also saw the emergence of photographic societies across Europe and America the Photographic Club (also called the Calotype Society) and the Photographic Society of London (subsequently the Royal Photographic Society) had already been established in 1847 and 1853 respectively, and the Société héliographique and Société française de photographie in 1851 and 1855—and publications, including the *Photographic Journal* (London) and La Lumière (Paris), which promoted extensive debate on the applications and artistic status of photography.

Despite demarcating the esthetic values of "a small minority" from "the public at large," Lady Eastlake claimed that, rather than superseding art, the "literal, unreasoning imitation" of photography could in fact "relieve the artist of a burden rather than supplant him" in that, released from literal mimesis, art could pursue its proper concerns of beauty, expression, and truth. One obvious service that photography could provide the fine arts was the reproduction of works of art. Talbot had already recognized this application by including in *The Pencil of Nature* photographs (referred to as "facsimiles") of various decorative objects and artworks, including a sculpture (the Bust of Patroclus), a lithograph and a "sketch . . . by Francesco Mola." Noting that "to the Antiquarian this application of the photographic art seems destined to be of great advantage," Talbot prefigured the enormous transformative effect of photography not only upon the new discipline of art history in the latter part of the century but upon the broader dissemination of images of artworks as institutions, including the British Museum and the South Kensington Museum in London, employed photographers such as Roger Fenton and Charles Thurston Thompson to photograph the museums' collections. Reinforcing the pedagogic function of the great international exhibitions of the 1850's and 1860's, such images were sold commercially or else distributed free of charge by organizations such as the Art Union of London as a means of educating public taste. Fenton, however, who photographed in a variety of genres, went a step further than documenting artworks and produced still-life photographs that were 12.21 exhibited as works of art in their own right. Fenton also photographed the Crimean War, his sanitized images of the conflict, with their focus on the stable continuity of class relations and social rituals rather than the carnage of warfare, contrasting with the frequently graphic photographs 12.23 produced during the American Civil War.

Although photography in the mid-century was still widely

12.21 ROGER FENTON Still Life with Fruit and Decanter, ca. 1856. Albumen print.

12.22 ROGER FENTON Hardships at the Crimea: Portrait of Captain George, Colonel Lowe, and Captain Brown. 4th Light Dragoons, 1855. Albumen print from wet collodion negative.

perceived as a graphic art, alongside lithography, engraving, and etching, some photographers were keen to shake off the medium's artisanal status by promoting the artistphotographer and photography's artistic pedigree. Two related issues were pertinent here: firstly, where was photography to be placed within the hierarchy of the arts, and, secondly, was there a distinct photographic esthetic? As Lady Eastlake had noted, photographs were "facts which are neither the province of art nor of description, but of that new form of communication between man and man-neither letter, message, or picture." Yet despite this prescient recognition of photography as a "new language," the only critical terminology available to it was largely derived from painting. In Britain especially, the promotion of self-conscious art photography did not acknowledge the differences between painting and photography. Rather, it entailed the production of highly theatrical narrative photographs that not only emulated the look of genre and history paintings, but were also intended to have a morally uplifting or didactic function.

The most ambitious example of such High Art photography was produced in 1857 by Oscar Gustav Rejlander (1813–75), dubbed "the father of art photography." A Swedish-born painter and lithographer who had trained in

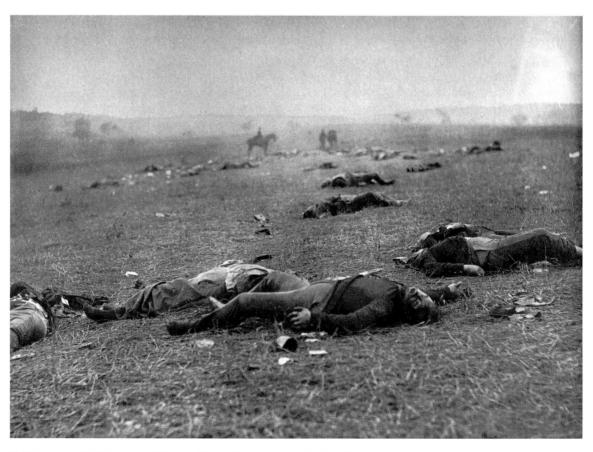

12.23 TIMOTHY H. O'SULLIVAN A Harvest of Death, Gettysburg, July 4th, 1863. Albumen print.

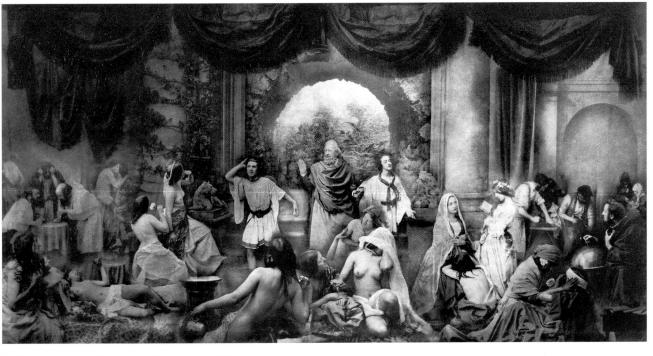

12.24 OSCAR GUSTAV REJLANDER The Two Ways of Life, 1857. Combination albumen print.

12.25 OSCAR GUSTAV REJLANDER (top) and GUILLAUME-BENJAMIN DUCHENNE DE BOULOGNE (bottom) Illustration from Charles Darwin's The Expression of Emotion in Man and Animals, Plate VII, 1872. Collotype print.

Rome in the 1830's as a copyist of Old Masters, Rejlander subsequently worked as a portrait painter in England where his interest in facial expression and psychological characterization was to be evident in his self-portrait photographs which, alongside photographs by the French physiognomist Duchenne de Boulogne, illustrated Charles Darwin's The Expression of the Emotions in Man and Animals (1872). At the Manchester Art Treasures Exhibition of 1857 Rejlander exhibited an allegorical photograph, The Two Ways of Life, which was an extreme application of the combination method first used by Gustave Le Gray, who had used double printing (with two negatives) as a means of counteracting the bleachingout of the sky in his seascape photographs. In order to make the final print of The Two Ways of Life (which exists in five versions), Rejlander made some thirty separate negatives of individual figures and scenes that had each been photographed separately. After preparing every negative by blacking out with varnish those parts of it that were not to be included in the final picture, Rejlander produced the final print by successively exposing the sensitized paper under each negative. Combination printing was an extremely slow process and The Two Ways of Life took six weeks to make, while the final print (made from two pieces of albumen paper) was also extremely large, the biggest version being 31 by 16 inches.

Specifically conceived as a competition picture to be viewed as equal to the European paintings included in the Manchester exhibition, Rejlander explained his motivation: "Firstly, it was to be competitive with what might be expected from abroad. Secondly, I wished to show to artists how useful

12.25

12.26 12.24

photography might be as an aid to their art, not only in details, but in preparing what may be regarded as a most perfect sketch of their composition, thereby enabling them to judge of effect, before proceeding to the elaboration of their finished work. Thirdly, to show the plasticity of photography. I sought to bring in figures both draped and nude, some clear and rounded in the light, others transparent in the shade, and to prove that you are not, by my way of proceeding, confined to one plane, but may place figures and objects at any distances, as clear and distinct as they relatively ought to be."

Based loosely upon Raphael's fresco of *The School of Athens* of ca. 1510 and Thomas Couture's *Romans of the Decadence* of 1847, *The Two Ways of Life* depicts the choice between good and evil, work and idleness, as a father and his two sons, framed by an arch symbolizing the separation between country and city, are summoned by the contrasted worlds of decadence and virtue. The photograph's subtitle, *Hope in Repentance*, together with the veiled nude in the foreground who may be the penitent Magdalene, reinforced its allegorical Christian message. Despite the moral tenor of the picture, there was criticism of the nudity (with some of the figures being covered when the photograph was exhibited in Edinburgh the following year). Nonetheless, Queen Victoria, who purchased a print for Prince Albert, declared it to be "the finest photograph of its class ever produced."

10.13, 14

The use of multiple negatives to construct a photograph according to the principles of painting also characterized the work of another former painter, Henry Peach Robinson (1830–1901). Like Rejlander (his tutor in the use of combination printing), Robinson was associated with the Pre-Raphaelite Brotherhood (see pp. 246–50). His first book, *The*

Pictorial Effect in Photography: Being Hints on Composition and Chiaroscuro for Photographers (1869), was to be an influential exposition of Pictorialism which, through the efforts of groups such as The Linked Ring (of which Robinson was to be a founder member in 1892), became the dominant form of art photography by the end of the century. Robinson's most popular photograph, Fading Away, also bought by Queen Victoria, was made in 1858 from five negatives, and depicts a young woman dying, possibly from consumption (tuberculosis). However, if seen in association with another photograph, titled She Never Told Her Love, unrequited desire (perhaps for the unidentified man at the window) may be the true cause of her condition. Like Rejlander, Robinson argued that photographic manipulation and the mixing of the "real with the artificial" was justified if it served a serious (moral or didactic) artistic purpose: "Any 'dodge, trick and conjuration' of any kind is open to the photographer's use so that it belongs to his art, and is not false to nature . . . It is his higher imperative duty to avoid the mean, the bare and the ugly, and to aim to elevate his subject, to avoid awkward forms, and to correct the un-picturesque." For some viewers, however, Robinson's photograph was offensive, not only because of its subject matter, but because its deliberate artifice (including the use of a model who Robinson conceded was "a fine healthy girl") was seen as a violation of photographic authenticity. As one reviewer noted, "Apart from the liberty taken with a sacred subject that will jar on the feelings of many, the utter impossibility of such a thing ever being presented to the camera, the absolute certainty that the figure is that of a young woman in the flesh, travestying the ideal rendering which imaginative painters have given to spiritual

beings, at once impresses the beholder with the untruth of the whole thing."

Critics of composite photography saw its artifice as a betrayal of the photograph's singular virtue—its indexical veracity. Moreover, if a photograph could not be believed, photography would be redundant. Such hostile responses to the trickery of composite photography inhibited its wide-spread adoption, despite Robinson's ambitions for the combination method, which he continued to use until the 1880's. According to Rejlander, public demand for conventional picturesque themes had curtailed the new possibilities for pictorial construction offered by combination printing. The complaint had some basis, yet for many viewers the "unnatural" look of combination photographs (in which, for example, all the elements and planes had an equal focus) justified the epithet "the patchwork quilt school of photography."

Despite the efforts of Rejlander and Robinson to achieve artistic status for photography, their work demonstrated that the principles and techniques of painting could not be readily appropriated. Much as Robinson and other art photographers looked to "the grammar of art" to produce a photographic equivalent to the Old Masters (both in terms of subject matter and by using academic rules of composition and chiaroscuro), the perceived literalism of photography—its apparently indiscriminate realism—was seen by many as antithetical to the idealism of the classical tradition. Indeed, it was argued, the autogenesis of the photographic image (the process of objects drawing themselves) inherently separated it from the highly skilled specialized labor (both physical and

conceptual) of art. Rejlander sidestepped this problem by asserting that "it is the mind of the artist, and not the nature of his materials, which makes his production a work of art," thereby rendering photographic technology invisible, or at least secondary, to the image's pedagogic or ennobling function. Robinson, however, conceded that "the absolute reproduction" of the camera was distinct from representations offered by the artist, who does not provide "an exact portrait of his model," but he hoped nonetheless to transcend the difference between media by claiming that "it was the effectiveness of a picture that mattered—the degree to which it was convincing rather than true." Yet this attempt to establish parity between photography and painting, by ascribing a shared purpose to both and by claiming that the persuasiveness of a "pictorial representation" was more important than "the fact of reality," could not suppress the distinctiveness of the photograph. It was this photographic literalism that had, for example, prompted Baudelaire to ridicule photographic tableaux vivants in which "strange abominations took form," adding that "some democratic writer ought to have seen here a cheap method of disseminating a loathing for history and for painting amongst the masses."

Ironically, improvements in lens technology and printing methods were seen as a threat to photographic artistry, and the belief endured that the verisimilitude of photography (in particular its sharp focus and excess of detail) was inimical to artistic "effect." As early as 1853, the portrait miniaturist Sir William Newton had read a paper to the Photographic Society arguing that, "I do not consider it necessary that the

12.27 HENRY PEACH ROBINSON Fading Away, 1858. Combination albumen print.

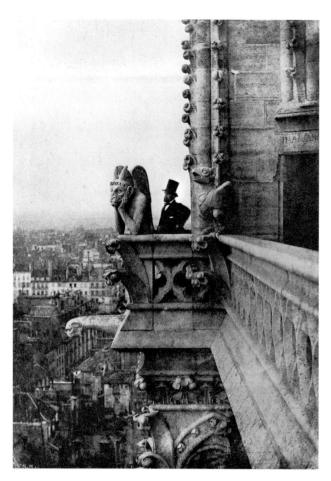

12.28 CHARLES NÈGRE Henri Le Secq at Notre Dame Cathedral, ca. 1851. Gelatin silver print from the original calotype negative.

whole of the subject should be what is called *in focus*; on the contrary, I have found in many instances that the object is better obtained by the whole subject being a little *out of focus*, thereby giving a greater breadth of effect, and consequently more *suggestive* of the true character of nature." Newton's views divided the Photographic Society, with one photographer, George Shadbolt, commenting in its journal that "there is a very strong party feeling between the two classes of members, whom I may call the Pre-Raphaelites and the Modern School. I confess I am a Pre-Raphaelite myself."

While Shadbolt defended photographic precision, other photographers avoided it. In France, Charles Nègre (1820–80) was deliberately suppressing detail in his calotype and gravure prints, seeking instead the broad masses and abstract tonal effects of the "picturesque." Just as Nègre distanced his photography from the harshness of detail associated with the daguerreotype, and sought also to maintain a continuity between photography and traditional printing techniques, a preference for the calotype (over the more recent collodion method) informed Lady Eastlake's essay. Posing the question "as to how far photography is really a picturesque agent,"

12.28

Lady Eastlake nostalgically recalled the "small, broadly-treated, Rembrandt-like studies" of Hill and Adamson which had been "replaced by portraits of the most elaborate detail," noting that "the photograph in its early and imperfect scientific state was more consonant to our feelings for art . . . because . . . it was more true to our experience of Nature."

This claim that "greater precision and detail" diminished artistic "truth" was indicative of a debate over photographic focus that was especially intense during the 1860's, but which continued well into the next century, and it was the implications of focus, rather than subject matter, that became critical to the polemics concerning photography's artistic or "picturesque" possibilities. The debate over the artistic meanings of focus and the growing division between art photography and the mass market were of particular significance in the critical reception of Julia Margaret Cameron (1815–79) who, together with Lewis Carroll (1832–98) and Clementina, Viscountess Hawarden (1822–65), was the most significant amateur photographer of the 1860's and 1870's.

Born in Calcutta and educated in Europe, Cameron subsequently moved to England, settling permanently on the Isle of Wight in 1860. She took up photography in 1864 as a hobby while her husband and sons were at the family's coffee estates in Ceylon, and later explained in a letter to Sir John Herschel that, "My aspirations are to ennoble Photography and to secure for it the character and uses of High Art by combining the real and the ideal and sacrificing nothing of Truth by all possible devotion to Poetry and Beauty." Cameron rejected the technical developments and pictorial values of commercially produced carte-de-visite photography, cultivating instead a distinct signature style combining expressive and symbolic lighting with a soft focus, indeed out of focus, technique. Looking to artistic models such as Perugino and Rembrandt, and to contemporaries such as G. F. Watts and David Wilkie Wynfield (the latter had in 1863 made a series of fancy-dress portrait photographs), Cameron produced over five hundred photographs, ensuring their "From Life" authenticity by refusing to retouch them. In addition to illustrating the Bible and contemporary poetry, including her two-volume Illustrations to Tennyson's "Idylls of the King" and Other Poems (1874-5), Cameron made numerous images of idealized women and children, and heroic portraits of notable male contemporaries. The latter works, especially, reveal her distinctive approach to portraiture, with the depiction of epic "types," indeed archetypes, taking precedence over the capturing of mere physical "likeness."

For many contemporaries, especially professional photographers, Cameron's photographic style was due to technical incompetence but, as she explained to Herschel, "[I] believe in other than mere conventional topographic photography—map-making and skeleton rendering of feature and form

12.29 LEWIS CARROLL (Rev. Charles Lutwidge Dodgson) Xie Kitchin with Umbrella, ca. 1875. Albumen print.

 ${\bf 12.30\ Julia\ Margaret\ Cameron\ } \textit{The\ Whisper\ of\ the\ Muse},\ {\bf 1865}.$ Albumen print.

12.31 CLEMENTINA, LADY HAWARDEN $\it{Photograph}$ of a \it{Model} , 1860's. Albumen print.

without that roundness and fullness of force and feature, that modelling of flesh and limb, which the focus I use only can give, tho' called and condemned 'out of focus'. What is focus—and who has the right to say what focus is the legitimate focus?" Although not cited in her essay for the *Quarterly* Review, Cameron's photographs complemented Lady Eastlake's approving reference to Sir William Newton's "heresy that pictures taken slightly out of focus, that is, with slightly uncertain and undefined forms, 'though less chemically, would be found more artistically beautiful." But more was at stake here than artistic effect; for, in challenging current definitions of focus, Cameron was resisting the process by which an increasingly normative and standardized photographic vision was becoming naturalized. These specifically photographic debates (over focus, the choice of printing paper, perspectival depth-of-field, lighting, and visual clarity) were symptomatic of the broader contestation of vision throughout the nineteenth century. As Lindsay Smith has argued, "Cameron threatens more than a merely esthetic principle. She represents the possibility of demobilizing the whole mechanism of fetishism in the field of vision, and all that demobilization clearly implies for the Victorian patriarchal sanctity of home and hearth."

Cameron's technique did have its supporters and she sold a number of prints, but her style provoked a particularly intense reaction from Henry Peach Robinson, who declaimed, "It is not the mission of photography to produce smudges." However, Robinson's own methods and sentimental genre subjects were themselves subsequently challenged, notably by Peter Henry Emerson (1856-1936) who wished to produce "sun pictures . . . free from fake, dodge, and all the mischievous arts of the charlatan and the 'photographic artist." Trained as a doctor, Emerson permanently gave up medicine for photography in 1886, producing limited-edition photographic albums depicting the East Anglia fen country and its inhabitants. Although an admirer of Cameron's work, Emerson represented a new generation of photographers distinct from the "aristocratic amateurs" of the 1860's and 1870's. While this new generation retained the separation between art photography and commercial photography, it rejected the label of "amateur." For with the arrival of the first Kodak camera in 1888 (marketed under the slogan, "You Press the Button, We Do the Rest"), photography was able to reach a mass consumer base. The term "amateur" now took on increasingly pejorative connotations as the hierarchical distinction between the serious practitioner and the casual hobbyist was further entrenched. The mass marketing of photography was made possible by easily operated handheld cameras and rolled film, but art photographers also benefited from new technical processes. These included the introduction in 1879 of gelatin bromide dry plates, which replaced the cumbersome wet collodion process, and the advent in the same year of the photogravure process and the platinum print, which provided a more sensitive and permanent form of photo-reproduction and greatly enhanced print quality.

Emerson's significance lay in his attempt to synthesize the polarities that had structured photographic discourse, notably the tension between art and science. Although ultimately concluding that such a synthesis was impossible, Emerson's most influential theoretical treatise, Naturalistic Photography for Students of the Art (1889), was intended to base photography upon scientific principles rather than frame it in the borrowed language of art theory. While previous art photographers had eschewed scientific developments and the language of positivism, looking instead to the art of the past, Emerson aimed to integrate photography within technological modernity, arguing that, "All good art has its scientific basis." Central to Emerson's theory of scientific naturalism and to his photographic practise was the notion of "differential focus" which, he argued, produced photographs that corresponded to the selective focal pattern of human vision: "The rule in focusing, therefore, should be, focus for the principal object of the picture, but all else must not be sharp; and even that principal object must not be as perfectly sharp as the optical lens will make it."

If photographic vision was to be objective and faithful to nature, it had to be based upon the empirical science of optics and knowledge of human physiology, rather than upon artistic temperament and the vagaries of subjective "taste." Directly recalling Emile Zola's theory of realism, Emerson asserted that "anyone who has read the history of Art . . . will look with pity on the unthinking millions who have been swaved by opinions based on no reason. The days of metaphysics are over, and with them, we hope, has died all that class of pernicious illogical literature." Presented now as a naturalism founded upon scientific precepts, photographic realism was no longer a sign of cultural decline but of a postmetaphysical progressive rationality. But despite his confident assertion that "Art has at last found a scientific basis, and can be rationally discussed," Emerson's photographic practise was affected by the very oppositions he wished to transcend (for example, between artistic interpretation and scientific description), just as his vision of a pre-industrial rural culture maintained a long-standing pastoral tradition.

In Emerson's first album, *Life and Landscape on the Norfolk Broads* (1886), co-authored with the landscape painter Thomas F. Goodall, dramatic expressive effect is combined with disinterested information. This tension between different representational modes is most evident in the division between the photographs and Goodall's accompanying text. In *Poling the Marsh Hay*, for example, the atmospheric

12.32 PETER HENRY EMERSON Poling the Marsh Hay, 1886. Platinum print.

intensity and plunging diagonal recession of the composition is belied by the prosaic commentary that makes no mention of the striking presence of the woman in the foreground, but which instead describes "the picturesque mode of conveyance" of carrying dried hay upon two poles. This failure to textually acknowledge the powerful visual impact of the woman was one way of responding to the realities of rural labor. But in the photographs themselves, Emerson (who was familiar with the work of Millet and Jules Bastien-Lepage) consistently presented rural workers as generic types rather than as distinct individuals, referring to them as "typical specimens of the Norfolk peasant . . . [whose] lot, though hard, is not unpleasant." In the later albums, the possibility of registering individuality was further denied, as people were placed deeper into the picture space. With the eventual disappearance of figures from the photographs, the ethnographic survey was replaced by an explicitly idyllic and subjective meditation upon the landscape.

Emerson's disengagement from the social dimension of the landscape was bound up with his strengthening belief that the incompatible procedures of art and science precluded their reconciliation, for while science involved accumulative description, art involved selection. This incompatibility was already evident in the disjunctions between image and text in *Life and Landscape on the Norfolk Broads* that Emerson himself had acknowledged when he observed that writing and pictures convey different kinds of information. This scepticism about securing a scientific foundation for art photography was reinforced by the publication in 1890 of

experiments, conducted by the chemists Ferdinand Hurter and Vero Charles Driffield, in the relation between exposure time and development. For Emerson, these experiments demonstrated that the photographer was not fully in control of pictorial tonalities, thereby proving the unscientific nature of photography. Recognition of these technical constraints, compounded by the influence of a "great painter" (most likely Whistler), led Emerson to publish an appropriately black-edged pamphlet, The Death of Naturalistic Photography (1890), in which he announced that "the limitations of photography are so great, though the results may and sometimes do give a certain esthetic pleasure, the medium must always rank the lowest of all the arts . . . No differential analysis can be made, no subduing of parts, no emphasis—save by dodging, and that is not pure photography. Impure photography is merely the confession of limitations."

Intrinsic to Emerson's critique of photography was his distinction between the "esthetic" and the "artistic." For although a photograph could have esthetic qualities (as could a natural object or a landscape), its "machine-made" and "impersonal" production precluded it from being art. In short, "the photographer does not make his picture—a machine does it all for him." Emerson continued to photograph after the publication of his pamphlet, but his disavowal of naturalistic photography arose from a growing doubt as to whether the methodologies of science could in fact provide unitary and comprehensive explanatory frameworks, including foundations for art. Unable to resolve the tensions between subjective sensibility ("the personal element of real

art") and objective (scientific) vision, Emerson argued, in a speech on "Science and Art," that "we in the photographic world should aim to be either scientists or pictorial photographers; we should be aiming either to increase knowledge—that is, science—or to produce works whose aim and end is to give aesthetic pleasure."

Emerson's evaluation of photography as an irreducibly mechanical process was hardly new, but his disillusion with establishing a scientific foundation for it illustrates the transformations that had occurred in the six decades since the daguerreotype had been heralded as an example of the convergence of technology, art, and nature, and since Talbot (like the early Emerson) had confidently expressed the hope that photography would enable a mutually beneficial "alliance" between science and art. Such shifts in both the perception and uses of photography necessitate a re-evaluation of its early decades. Neither a "primitive" prelude to the photographic modernism of the twentieth century, nor a realist backdrop to radical avant-garde innovation in other areas such as painting, nineteenth-century photography, and the contemporary assessments of it, entailed a diverse range of practises and polemical stances. The procedures of composite photography may well have been far removed from an understanding of the photograph as an impassive machine-made imprint, but these disparate approaches co-existed nonetheless. Any identification of photography with "realism" needs to acknowledge this diversity of photographic practises and the inapplicability of normative twentieth-century categories (including "documentary" realism, "straight" or "pure" photography, and the "decisive moment") to nineteenth-century photography.

Miles Orvell has argued that nineteenth-century photography was a "continuum of modes, with frank artifice at one end and mimetic realism at the other. Across the continuum is the shared assumption within the photographic community that all images were a kind of replication, that the photographer actively constructs the image, thus creating what we might call an 'artificial realism." While not universally accepted, claims such as Robinson's and Cameron's—that photography entailed more than literal mimesis and that it could combine "the real and artificial" or "the real and ideal"—might be regarded as strong versions of this more general understanding of photography as a flexible and hybrid medium. The practise of actively constructing a unique photograph, as opposed to mechanically "taking" one, had been implicit to the artistic claims made for the medium, and the abandonment of photography by many of its early practitioners, when standardized factory methods became the norm, was indicative of the intrinsic connection between technology and meaning. This is not, however, to privilege a narrative of autonomous technical development. Rather, it is to draw attention to the terminology at work in much of the nineteenth-century debate on photography, which referred to the attributes of particular technical processes, rather than to a generalized conception of photography. More often than not, this terminology indicated specific pictorial values (focal definition and depth, glossy factory-finished prints versus softer papers, precision versus broad effects)—values which, as Joel Snyder has argued, frequently devolved around "the conflicting values of 'transparency' and 'artistry." However, the connotations of these visual properties extended beyond photography. The qualities that, for example, Arago had admired in daguerreotypes (their exactitude and detail) were anathema to Baudelaire, for whom the "sharpness and cruelty" of photography (at least in its daguerreotype and collodion forms) was both a synecdoche of a modernity increasingly obsessed with measurement, standardization, and mechanized production, and an index of populist cultural values.

Photography was inseparable from the broader industrial transformations that occurred during the nineteenth century, not only because it was bound up with these technological processes, but because it was also a symbol of them. As Allan Sekula suggests, ambivalent responses to photography are "evidence of a sustained crisis at the very center of bourgeois culture, a crisis rooted in the emergence of science and technology as seemingly autonomous productive forces. Bourgeois culture has had to contend with the threat and the promise of the machine, which it continues to both resist and embrace." But although intrinsically connected to the ascendancy of industrial capitalism and its attendant social dynamics, the pluralism of nineteenth-century photography and its discourses preclude it from being reductively posited as a self-evident manifestation of bourgeois hegemony, any more than it can be unequivocally identified with positivism, instrumentalist realism, or bureaucratic rationalization. Instead, photography revealed deep tensions within the hierarchical structures of bourgeois society, and raised questions, both epistemological and ideological, as to how the world should be viewed and comprehended. Not least, photography provoked an examination of the meanings of labor, in particular the specialized labor of art, in an age of mechanization.

As both an agent and product of the enormous expansion of nineteenth-century visual culture, especially in the 1850's and 1860's, photography was a major addition to the repertoire of image-making techniques. Yet it was never just another means of producing pictures, nor was it to be readily subsumed into art. Instead, photography not only provoked a continuing debate about pictorial truth, and about the specific value and identity of the work of art and of the figure of the artist, but it was to fundamentally alter the categories and practises of artistic production.

• 13 •

THE DECLINE OF HISTORY PAINTING: GERMANY, ITALY, AND FRANCE

THE RISE OF NATURALISM IN GERMANY

URING THE TWO DECADES FOLLOWING THE Universal Exposition (1855), the status of history painting declined precipitously in Europe. Indeed, by the time of the first Impressionist exhibition in Paris in 1874, the creation and display of complex narrative paintings of Classical or religious subjects had nearly ended in France and other European countries, replaced by the depiction of contemporary history, daily life, landscape, and still life. The decline and fall of history painting had been long in coming (and the end came as something of a relief to all concerned) but was nonetheless momentous. Now for the first time, painting was fully liberated from its parasitical dependence upon an anachronistic complex of cultural hierarchies, academic regulations, and codified ancien régime tastes. Now for the first time, too, painting was freed from the responsibility—implicit since David and the Revolution—of representing the bourgeois Enlightenment dream of an infinite advance toward intellectual, social, and moral betterment. Hereafter, painters were free to focus their attention upon the transience and ephemera of modernity, which is just another way of saying that, like other petty manufacturers, artists were now independent commodity producers, and every bit as liberated and as subservient as that position implies: on the one hand, they were individuals who sought (and to a degree achieved) autonomy from a dominant bourgeois society that tailored all cultural production to the narrow ends of profit, and on the other, they were the very mirror of that society by virtue of their masculinist and entrepreneurial stance of individualism. Modern art—in all its complexity and contradictoriness-arose in France and elsewhere from the ashes of history painting and the seeds of modern capital.

In Germany, history painting may be said to have died with the painter Peter Cornelius in 1867, though morbid symptoms had been apparent for nearly a generation. By mid-century, in fact, the Classical revivalism that had dominated German painting since the rise to power of Friedrich Wilhelm III of Prussia (1797) and Ludwig I of Bavaria (1825) was succumbing to both naturalism and a juste-milieu historicism similar to that which arose in France. In Munich and Berlin, private and parochial values and sentiments were replacing public and enlightened ones, as the generation of Winckelmann, Mengs, Carstens, and the subsequent Nazarenes was fading from memory and view. No longer would there be heroic Neoclassicists, like the Danishborn Carstens, living in Rome, who protested against an official summons to Berlin: "I belong to Humanity, not to the Academy of Berlin." No longer, either, would there be committed Romanticists, such as the Nazarene Cornelius or his student Wilhelm von Kaulbach (1804-74), whose many grandiose murals for religious and state buildings in Munich were replete with the trappings of religious and historical allegory and symbol.

In their place—in the academies of Berlin, Munich, Dresden, and elsewhere in German-speaking Europe—were artists who represented so-called Biedermeier culture. (The term was coined by a pair of poets in 1853, to satirize the bourgeois self-satisfaction of the previous generation.) These painters and designers, mostly active before 1848, promoted an alternately restrained and sentimental style that eschewed emotional intensity, domestic disharmony, or indeed any kind of extremism. For this reason, they generally abjured history painting for the lower genres. The Viennese artist Josef Danhauser (1805–45), for example, heir to the great family of Biedermeier furniture manufacturers and merchants, combined historical, quotidian and portrait genres in single

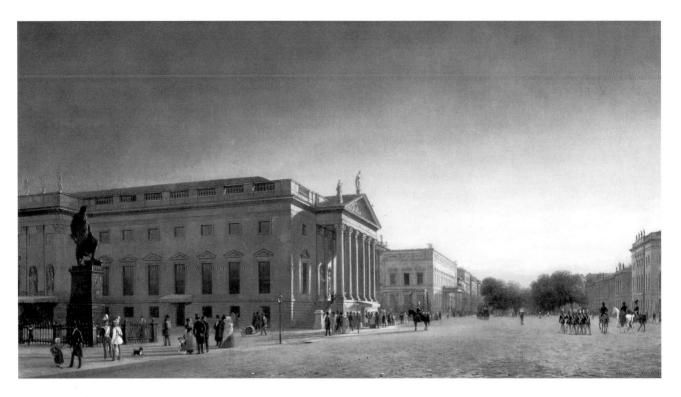

13.1 EDUARD GAERTNER A View of the Opera and Unter den Linden, Berlin, 1845. Oil on canvas, 42×78 (312 \times 365)

13.2 KARL VON PILOTY Seni Before Wallenstein's Corpse, 1855. Oil on canvas, $10'2\frac{3}{4} \times 11'11\frac{3}{4} (312 \times 365)$

13.4

works. His *Eye Doctor* (1837) recalls the eighteenth-century painters William Hogarth and J. B. Greuze by its emphasis upon the petty drama of bourgeois life. In this case, a family celebrates the success of an eye operation performed by Dr Friedrich Jäger von Jaxtthal, shown standing at the center of the canvas. As the physician removes the bandage, the seated patient is able for the first time to see his new baby.

Biedermeier was a politically conformist art that championed the rights of wealthy urban merchants and manufacturers and rural landowners, and the interests of consolidated nation-states and the Habsburg Empire. The detailed and luminous View of the Opera and Unter den Linden, Berlin (1845) by Eduard Gaertner (1801-77) summarizes past, and even anticipates future, Prussian history and art in the guise of an urban panorama. The painting represents the Neoclassical Opera House in Berlin, designed by Georg Wenzeslaus von Knobelsdorff (1741-3), intended anchor of the Forum Fridericianum, a vast and uncompleted civic center planned by the Prussian King Frederick the Great. To the left is the bronze statue of General Blücher (who came to Wellington's assistance at Waterloo, assuring victory over Napoleon), cast in 1826 by the Berlin sculptor Christian Daniel Rauch (1777–1857). To the right is a troop of uniformed soldiers on parade, partly eclipsing a wing of the University. Directly in the center of the picture, just to the left of the twin lines of linden trees that gave the fashionable boulevard its name, is the square, Biedermeier-style palace of Crown Prince William (1834-7), built by Carl Ferdinand Langhans (1781–1869). As emperor, William I would go on to have a prodigious career. He helped crush the Baden revolutionists of 1849, reorganized and strengthened the Prussian army, and appointed Otto von Bismarck prime minister. In 1871, William presided over the destruction of the armies of France in the Franco-Prussian War and achieved the long-dreamed German unification.

A few other artists, trained at the major academies and conversant with French Salon art, attempted to maintain the tradition of history painting. Munich artists such as the celebrated Karl von Piloty (1826-86), influenced by Delaroche's bathetic genre historique, painted at once idealizing and anecdotal scenes from German history, such as Seni Before Wallenstein's Corpse (1855). Piloty's many pupils, including Gabriel von Max (1840–1915), Franz von Defregger (1835-1921), and Wilhelm Leibl (1844-1900), continued their teacher's tendency to sentimentality, but gradually abandoned the depiction of history subjects altogether. Indeed, Leibl-an admirer of Courbet and painter of such ingenuous works as the 1877 Town Politicians—expressed the now widespread rejection of history painting when he cheerfully confessed in a letter written the same year as the above work: "You know that I

am used to painting according to nature, and that it is a matter of indifference to me whether I paint a landscape, people or animals." His *Town Politicians*, which represents a group of five seated men apparently reading a newspaper containing a list of voters or candidates, is in fact painted with scrupulous—even scientific—regard for physiognomic and other details.

By the time of Leibl, and his Munich-based colleague Hans Thoma (1839–1924), critical discourse in support of naturalist landscape and genre painting was well established. To the Munich critic Anton Springer, Classicism and antiquarianism were no more than feeble ruses through which to escape the present. "If our history painters only possessed half the courage of our landscape painters," wrote Springer in his 1858 review of the "All-German Historical Exhibition" in Munich, "if they had the courage to look without prejudice and to forget about worn-out aesthetic concepts, the artistic value of contemporary life would soon be looked upon differently."

The Berlin painter Adolf von Menzel (1851–1905) apparently took the critic's words to heart; between his *The* Flute Recital of Frederick the Great at Sansoucci (1852) and the monumental Iron Rolling Mill (1872–5), Menzel gradually rid his work of the anecdotal "stylistic embellishments" that, Springer believed, stood in the way of the historical selfrealization of the German people. In the former work, part of a monumental effort—in drawings and prints as well as paintings—to depict the life of Frederick, and express the artist's conviction that political reform required the firm hand of a wise and creative monarch, Menzel employed a veritably rococo style to convey the enlightened eighteenthcentury ambience. In The Iron Rolling Mill, Menzel dispensed with such historicizing affectation, using instead a vivid, full-blooded manner that memorialized and mythologized Germany's refulgent industrial capitalism (its share of world industrial production was growing at the expense of its rival Great Britain's). In this monumental canvas, Menzel depicted the Königshütte mill in Upper Silesia as a kind of rationalized Vulcan's forge. If anecdotalism is diminished in Menzel's naturalist art, however, Classicism is not: his workers are disposed in space like the disciples in Tintoretto's Last Supper, and their heroic poses are derived from, among other works, Pollaiuolo's Battle of Nudes and Velázquez's Triumph of Bacchus. And like these figures from Renaissance paintings, Menzel's proletarians are placed at the mercy of larger and more powerful forces; they represent the Gründerzeit, the foundation of German industrial and imperial might, and thus are made to toil ceaselessly and apparently without fatigue.

Thus despite its thematic modernity, Menzel's Iron Rolling Mill, like Leibl's nearly contemporary Town

13.3 ADOLF VON MENZEL. The Flute Recital of Frederick the Great at Sansoucci, 1852. Oil on canvas, 55% × 80¾ (142 × 205)

Politicians, exposes the limits of artistic modernization in Germany during the second half of the nineteenth century. History painting in Germany may have ended with the death of Cornelius, but the naturalism that arose and flourished in its place drew upon many of the same academic conventions and Classical sources. Naturalism was thus in Germany—as elsewhere, we shall discover—an art of compromise between an insurgent modernizing Realism and a persistent academic Classicism.

THE ITALIAN MACCHIAIOLI

In Italy, history painting was faring only a little better; its last hurrah was probably sounded in 1861 at the Fine Arts section of the Esposizione Nazionale held in Florence. There, amid nationalist and entrepreneurial celebration, were exhibited the works of three generations of Florentine history painters, including Pietro Benvenuti (1769–1844), his pupil Giuseppe Bezzuoli (1784–1855), and his pupil's pupil, Stefano Ussi (1822–1901). The latter's The Expulsion of the Duke of Athens

From Florence (1861), along with The 26th of April, 1859 13 (1861) by the young Odoardo Borrani (1833–1905), were the sensations of the show, and represented the past and future of Italian art. Ussi's painting, which depicts the final dispatch of the French usurper Walter de Brienne from the Palazzo Vecchio in 1343, was rendered with the dramatic focus found in works by Bezzuoli, and the coloristic radiance of those by the Italian "purists" Luigi Mussini and Enrico Pollastrini (who, in turn, were influenced by the German Nazarenes). Borrani's painting, on the other hand, while similarly depicting an act of patriotism—the sewing of the Italian tricolor flag on the day before the expulsion from Florence of Grand Duke Leopold II—was small, domestic, intimist, and composed out of sharp tonal contrasts and luminous patches (macchia) of color. By virtue of its technique and scale, therefore, the work represented a stern rebuke to the established academic tradition of history painting. "Never was there such an empty, slovenly style of work," complained one critic, upon viewing the history paintings and landscapes of Borrani and the other painters who the following year would be dubbed the "Macchiaioli." Yet it was the persistent

13.4 WILHELM LEIBL Town Politicians, 1877. Oil on canvas, 30 × 38½ (76 × 97)

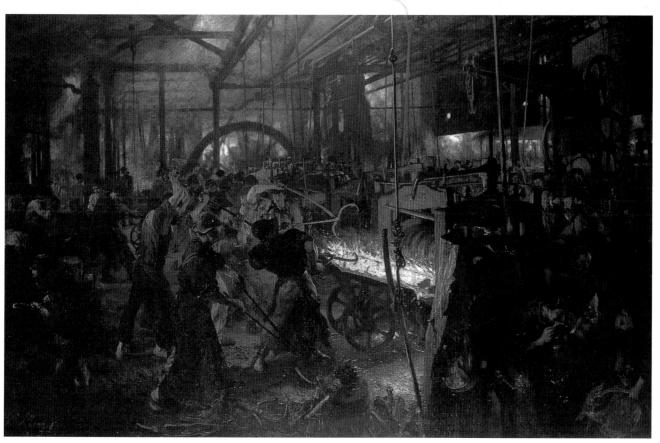

13.5 Adolf von Menzel $\it Iron \, Rolling \, Mill, \, 1872-5.$ Oil on canvas, $60 \frac{1}{4} \times 99 \frac{5}{8} \, (153 \times 253)$

13.6 ODOARDO BORRANI *The 26th of April*, 1859, 1861. Oil on canvas, $20\frac{1}{2} \times 22\frac{7}{8}$ (75 × 58)

hammer-blows of these same artists that would doom history painting in Italy to collapse and fall, as the critic Pietro Selvatico wrote in 1861, "as a dead body falls under the blows of prosaic realism."

To Selvatico and many others at the time, the only hope for the future of a unified Italian art lay in "another kind of painting which is historical with respect to the daily life of society, but does not depict particular events except as revelations of the feelings, affections, and special tendencies of our time." The artists who would principally answer this naturalist and modernist call were the Macchiaioli, though the academic stickler Selvatico in fact questioned their tendency to elevate painted, chiaroscuro sketches employing mezza-macchia ("half-effects") to the status of finished works of art. These young painters (most were born around 1830) were veterans of the Italian movement for independence and unification (the Risorgimento) and habitués of the Caffé Michelangiolo, a hotbed of Florentine bohemianism and political radicalism. Beginning about 1855, the painters Telemaco Signorini, Vito D'Ancona, Giovanni Fattori, Raffaello Sernesi, and Silvestro Lega, among others, began to meet at the café to discuss Risorgimento politics and an art characterized by what Signorini called a "violent chiaroscuro." By the end of the decade, they had created a body of paintings remarkable for their depiction of the informal activities and ceremonies of bourgeois and working-class daily life, through an equally informal vocabulary of tonal and color contrast, and compositional and mimetic relaxation.

Roofs in Sunlight (1860–61) by Sernesi (1838–66) and Cloister (1861–2) by Giuseppe Abbati (1836–68) are typical

13.7 STEFANO USSI *The Expulsion of the Duke of Athens From Florence*, 1861. Oil on canvas, 10'6 × 14'10 (320 × 452)

of the best Macchiaioli paintings: they are very small and quickly brushed, but monumental in scale and fully completed. The former work, just 47/8 by 71/2 inches, depicts a compact cluster of Florentine walls, roofs, eaves, and chimneys beneath a brilliant blue sky. A white, dolphinshaped cloud or puff of smoke at the upper left rests on top of a chimney-pipe or smoke-stack ambiguously located in the middle or background. The latter painting, only 75/8 by 10 inches, represents a row of cream- and gray-colored marble blocks in the middle-ground, set against a low cloister wall upon which is perched a boy with a brown vest and pants and a cool-blue cap. The lower and upper thirds of the painting are dominated by broad and loosely brushed areas of cool tan and warm sienna, representing a vacant foreground and a sheltered background. Both paintings articulate a dialectic of flatness and depth. The insistent geometries of walls, blocks, and midday shadows echo the very shape and materiality of the cardboard panels upon which the scenes are painted; the dominance of chiaroscuro in each—indeed, the reduction of tonal contrast to the simple on/off of mezza-macchia similarly reiterates the two-dimensionality of the medium and the basic terms of pictorial facture. At the same time, however, the deep shadows in the two paintings, combined with the slightly oblique viewpoint—a characteristic

Macchiaioli device found in Cristiano Banti's uncompromising painting *The Brush Gatherers (Le Macchiaole)* (ca. 1861)—create a compelling spatial depth and physical breadth.

In paintings by the Macchiaioli, Boime has persuasively argued, the formal structures that underlay the grand fictions of mimesis are unambiguously revealed. In the works discussed here, and many others, light and dark, line and color, surface and depth, impression and composition, discovery and understanding are unguardedly exposed in utter disregard for the formal injunctions of the Florentine Academy on the need for finish. Yet in estranging themselves from their academic predecessors and contemporaries, the Macchiaioli were in fact seeking the revival of an Italian art that had once been marked by a dialectic of individual genius and national consensus. By honestly exposing the techniques and preconceptions that underlay pictorial representation, these Risorgimento artists were celebrating their unique individuality within a national culture that they themselves were forging, both by their political activity and by their depictions of workers, bourgeoisie, soldiers, fields, farmhouses, cloisters, and city streets. The Macchiaioli movement was short-lived—by the late 1860's its dialectics were compromised by an excessive embrace of the Quattrocento—

13.68 GIUSEPPE ABBATI Cloister, 1861–2. Oil on cardboard, 75/8 × 10 (19.3 × 25.2)

13.9 RAFFAELLO SERNESI Roofs in Sunlight, 1860–61. Oil on cardboard, $4\frac{7}{8} \times 7\frac{1}{2}$ (12.3 × 19)

but it had already succeeded in ending history painting in Italy, and inaugurating, as Selvatico wrote, "another kind of painting which is [only] historical with respect to the daily life of society."

INDIVIDUALISM AND NATURALISM IN French Salon art

In France, history painting had been distressed since at least the Romantic generation of 1830, but it was probably the combined attacks of Courbet and Louis Napoleon during the early years of the Second Empire that accelerated the art's demise. The Realist painter's role in the tragic drama was to undermine the elite class status of the genre by employing its scale, sophistication, and ambitiousness for the purpose of creating a new and politically contentious popular art intended for an audience of workers and peasants. The dictator's part was to forbid the free expression upon which a progressive and enlightened bourgeois public art depended and, further, to criminalize even the marginal avant-garde culture that arose in its wake. Indeed in 1857, the same year that Courbet exhibited his ironically titled (and scandalous)

The Young Ladies on the Banks of the Seine, Flaubert and Baudelaire were brought separately to trial on charges of "immorality" and "irreligion" for their Madame Bovary and Flowers of Evil. (The former was acquitted while the latter was convicted.)

The censorious cultural policies of Louis Napoleon and his ministers were accepted by working class and bourgeoisie alike with more or less complaisance—the one was exhausted from revolution and the other was hushed by money gained from bribes, industrialization, and speculation. Indeed, the French bourgeoisie of the Second Empire-effectively caricatured by Daumier in his sculpture of the jaunty and duplicitous Ratapoil (ca. 1851)—willingly swapped its Revolutionary artistic and political inheritance for "the protection," as Marx venomously wrote, "of a strong and unrestricted government. It declared unequivocally that it longed to get rid of its own political role in order to get rid of the troubles and dangers of ruling." (The two decades following the Napoleonic coup d'état were in fact a period of tremendous economic expansion and modernization in France; during that time, overall industrial production more than doubled, the percentage of people who gained their livelihood by agriculture, forestry, or fishing dropped below

13.10 James Abbot McNeill Whistler \it The White Girl, 1862. Oil on canvas, $84^{1/2}\times42^{1/2}$ (214.6 \times 107.9)

fifty percent, and the number who worked in industry, transport, trade, and banking reached nearly forty percent.)

Thus, with political and cultural authority vested as never before in the person of a vain and parochial Caesar, French artists and authors were discouraged from engaging the public culture and moral life of their nation. Daumier kept his sculpture of Ratapoil hidden during the Emperor's reign (the former shared the latter's extravagant moustache) and generally pulled punches in the lithographs based on the figure. In addition, the legion of history painters trained at the Ecole lowered their sights, often enough, from Grand Manner to Grand Guignol, as in Misery the Procuress, an allegory of women's descent into debauchery shown and acclaimed at the Salon of 1861, by Auguste-Barthélemy Glaize (1807–93). By the time of Louis Napoleon's political liberalizations of the 1860's, it was too late; ambitious history painting was moribund, and in its place had arisen, we shall soon discover, a bewildering variety of uniformly depressing substitutes.

Attempting to put a positive gloss on this unprecedented situation of political evacuation and cultural impoverishment, the young critic Jules Castagnary described the current sad fate of history painting as the natural result of the aging of certain outmoded social institutions. In his "Salon" of 1857 he wrote: "Religious painting and history or heroic painting have gradually lost strength as the social organismstheocracy and monarchy—to which they refer become weakened. Their elimination, which is almost complete today, leads to the absolute domination of genre, landscape, and portraiture, which are the result of individualism: in art, as in contemporary society, man becomes more and more himself." Castagnary's final confident phrases, which he developed in a series of incisive published "Salons" extending into the early years of the Third Republic, may be taken as a summary of the ambitions and self-perceptions of a subsequent generation of French artists. Individualism—whether in the form of genre, landscape, or portraiture—was what replaced the grand public art of history painting; it was pursued with a vengeance at official Salon and unofficial avant-garde venues alike, and soon became the dialectical basis of modernism.

Although the word individualism was a neologism that came into parlance in the 1820's as a term of disparagement used against Jacobins, Romantics, and Liberals, it had largely shed its negative cast by the time of Castagnary's usage in 1857. Indeed, in many respects, individualism was developing into one of the most important ideological paradigms of the Second Empire and the subsequent Third Republic. Seeking to enfold or outflank all dissident or insurgent cultural tendencies in a vast authoritarian structure called "eclecticism," as the art historian Patricia Mainardi has shown, Louis Napoleon and his diverse apologists—ranging from the religious historian Ernest Renan to the anarchist P.-J.

Proudhon—began to celebrate an emerging spirit of individualism in politics, philosophy, and art. By the 1860's and '70's, the word—but more importantly the concept of subordinating the interests of the social whole to the particular commercial and affective interests of the individual—may be said to have become hegemonic; it was basic to the emergent ideologies of entrepreneurial capitalism, political liberalism, and even revolutionary anarchism. In addition, it provided a basis for the new, naturalist art theory and criticism practised by, among others, Castagnary, Edmond Duranty, and Emile Zola, and it offered a common vocabulary and studio jargon for practising artists. "Individualism is the idea of the century," wrote the historian Hippolyte Castille in 1853, and its artistic correlatives were first visible at the Salons.

The demise of history painting did not diminish the popularity of the Salons or the other state-sponsored exhibitions of fine art. On the contrary, exhibitions of contemporary painting and sculpture were mass cultural attractions during the Second Empire and early Third Republic as they never had been before and never would be again. At the 1855 Exposition Universelle des Beaux-Arts, nearly 2000 works by 700 painters were seen by almost a million visitors during a six-month run. In 1857, the biennial Salon des Beaux-Art exhibition held at the same Palais de l'Industrie, included almost 3500 works by 500 artists and was seen by more than 100,000 people during two months. In 1868, 4200 works were exhibited at the Salon. In 1870, a more conservative jury accepted just 2000 works for display, but by 1880 the number had climbed back to over 7000 works, seen by perhaps a halfmillion people. On any given Sunday, when admission was free, more than 50,000 visitors might pass through the Salon turnstiles.

The generally massive scale of these Salons and other exhibitions, however, was not always greeted with equanimity by their sponsors. By 1863, the number of submissions for the Salon was judged by authorities to be excessive and their quality inferior; thus an effort was undertaken by the state to persuade the Academic jurors to be more selective. This "reform" turned out to be more successful than was perhaps intended: of the approximately 5000 works submitted in that year by 3000 artists, more than seventy percent were rejected, occasioning the need for a special Salon des Refusés at the nearby Palais de l'Expositions. This officially sanctioned anti-Salon, consisting of more than 600 paintings by dozens of artists-including Edouard Manet, Théodore Fantin-Latour, J. A. M. Whistler, and Camille Pissarro—was an unexpected, if modest, success, attracting 3-4000 rictus visitors on Sundays, and much shrill publicity.

The most discussed and abused painters at the Salon des Refusés were undoubtedly Whistler (1834–1903), whose The White Girl (1862) was conspicuously hung near the entrance 13.10 to the exhibition, and Manet, whose The Bath (better known as Le Déjeuner sur l'herbe [Luncheon on the Grass]) was judged "shameless" and "slipshod" by the reviewer Louis Etienne, among others. The socialist critic Théophile Thoré, on the other hand, applauded these artists for their very "barbarity," comparing them to the painter of Native Americans, George Catlin. In remarks that anticipate the writings of the Impressionists and especially Paul Gauguin, Thoré continued: "It seems that these artists are taking art back to its origin, without having to worry about what civilized men have been able to do before them." Thus the Salon des Refusés, according to the critic, marked a kind of return of Realist populism: "It is even good to descend, or, if you will, to rise once more to the classes that scarcely ever had the privilege of being studied and put into the light of painting. . . . The portrait of a worker in his smock is certainly worth as much as the portrait of a prince in his golden costume." Public discussion and implicit political debate, such as between Etienne and Thoré over the relative merits of pauper and prince, were certainly never sanctioned by Napoleon III when he decreed the establishment of an exhibition of rejected artists. In fact, the Salon des Refusés turned out to be a oneshot deal (though there was a half-hearted reprise in 1864): despite repeated pleadings, cajolings and even harrassing petitions by rejected artists (such as the young Paul Cézanne) for the rest of the decade, the Emperor and his ministers never again repeated this experiment in cultural democracy.

As the controversy over the Salon des Refusés indicates, Second Empire arts policy was often a matter of experiment, improvisation, misstep and correction. From 1855 until the end of Louis Napoleon's regime, there were frequent changes of rules governing the selection of judges, the number and type of acceptable submissions, exhibition frequency and duration, and even admission price. Yet none of these variations—excepting perhaps the unique experiment of the Salon des Refusés-appears to have had any significant effect upon the actual type or quality of the art on display; a superficial diversity, in short, masked an underlying uniformity. With history painting approaching obsolescence, as Castagnary observed, Salon painting was dominated by genre, landscape, and portraiture; with the authority of the Académie des Beaux-Arts in decline, artists could be roughly divided, he said, "into three principal groups: the classicists, the romanticists, and the naturalists."

The Classicists, descended largely from David and Ingres, included H. J. Flandrin (1809–64), J.-J. Henner (1829–1905), Jean-Léon Gérôme, Alexandre Cabanal (1823–89) and William-Adolphe Bouguereau (1825–1905) (the latter two artists were in fact pupils of F. E. Picot but Castagnary understandably grouped them with artists of like temperament). As might be expected, they emphasized precise drawing, contour, and

finish in their paintings, and strict adherence to the rules of anatomy, perspective, academic modeling and physiognomic expression. Their works often represent Classical, mythological, allegorical, or Orientalist themes in addition to contemporary history. The latter three subjects, for example, are represented in Gérôme's Reception of the Siamese Ambassadors by Napoleon III and the Empress Eugénie at Fontainebleau, June 27, 1861 (1861–4). This grandiose work was commissioned by Nieuwerkerke in 1861 in commemoration of an historically insignificant meeting between Louis Napoleon and a group of Siamese ambassadors in the Salon d'Hercule following the conclusion of several minor trade agreements.

Deriving the composition of the *Reception* primarily from David's Coronation of Napoleon, Gérôme strives to imbue the Imperial nephew with the same grandeur as the uncle: seated at the far right beside the Empress, Napoleon receives tribute from the first in a double line of Siamese ambassadors seen crawling in obscene supplication before their French master and mistress. The ambassadors' gifts, rendered with the same painstaking exactitude as the costumes, the carpets, the chandeliers, and the Primaticcio-frescoed ambience, are piled up in the right foreground as if in allegorical expression of the benefits of France's imperialism. (In fact, the painting is an exercise in colonialist wishful thinking since Britain remained dominant in Siam until 1893, when France seized control of trade in the eastern part of the country, a region adjacent to its other Indochinese holdings.) Gérôme's depiction of Thais in the Reception, like his representation of Arabs and Black Africans in Slave Market (1867) and other pictures, is racist; it may have been influenced by the Bonapartist ideologue Arthur de Gobineau's tripartite division of humanity in his Essay on the Inequality of the Human Races (1853-5). In that work, a veritable primer in European racial theory, Gobineau described people of the "vellow race" as apathetic, materialistic, and respectful of order, just as Gérôme represented them in the Reception, and people of the "black race" ("Hamitic")-including Arabs-as violent, capricious, and possessed of "an intensity of desire . . . which may be called terrible." This "strength of sensation" resulted in an indifference to human life among the Hamites, and an embrace of slavery and prostitution, such as depicted in Gérôme's Slave Market.

Not all Classicist painting was so nakedly subservient to Imperialist ideology as Gérôme's, but most acceded to governing class, gender, and racial hierarchies, employed a highflown (and anachronistic) rhetoric of facial expression and physical gesture, and strove to impart religious, historical, scientific, political, or moral lessons through narrative anecdote. Classicist Salon painting of the Second Empire, in sum—like the *genre historique* of the July Monarchy before it—by its combined highmindedness and vulgar anecdotalism

13.11 JEAN-LÉON GÉRÔME Reception of the Siamese Ambassadors by Napoleon III and the Empress Eugénie at Fontainebleau, June 27, 1861, 1861–4. Oil on canvas, 50½ × 8′6⅓ (128 × 260)

tended to bathos; indeed, it is the very glut of Imperial pomp and Orientalist circumstance in Gérôme's *Reception* and *Slave Market* that ultimately undermines our confidence in the seriousness and authority of these pictures. A similar ideological instability, resulting from the awkward combination of grand style and vulgar subject, is apparent in works by Cabanal and Bouguereau, as well as in the paintings of the Romanticists discussed next.

The second group of artists described by Castagnary in his 1863 Salon review was the Romanticists, descended in spirit, if not in actual training, from Géricault, Gros, and Delacroix, but now much reduced in number and influence. Chassériau, Scheffer, Descamps, Vernet, and Delacroix would all be dead by the year's end, and their places taken by a small number of artists that included, for lesser and greater periods of time, Léon Bonnat (1833-1922), Fantin-Latour (1836-1904), and especially Gustave Moreau (1826–98). Moreau's Oedipus and the Sphinx (1864), shown at the Salon of 1864, well represents the tendency toward the exotic, the violent, and the grotesque (Castagnary's "rain of sulphur") that characterized the earlier Romantic generation of Hugo, Goethe, Delacroix, and Ingres. Notwithstanding these basic, common themes, however, Moreau differs profoundly from the earlier authors and artists in his sacrifice of dramatic breadth and panoramic viewpoint in favor of the evocation of psychic and spatial claustrophobia. Compared with Ingres's prototypical Oedipus and the Sphinx (1808), which celebrates the Classical Greek ideal of a combined physical and intellectual self-prepossession, Mor-

13.12

eau's painting is all about sexual terror and emotional impenetrability. His archaic Oedipus, pressed against a cliff and threatened by the Sphinx (like Prometheus tortured by the eagle), shrinks at once from woman and knowledge—each threatens the frigid integrity of his body and mind. "[The Sphinx] is a terrestrial chimera," Moreau wrote in one of his notebooks, "as vile as earthly matter and equally bewitching, represented by that charming head of a woman, with a winged body . . . [it offers] promises of the ideal, but with the body of a monster, of the carnivore who tears prey to shreds." Moreau's subsequent Salon successes—culminating in his Salome and Hercules and the Hydra of Lerna (both 1876)—were increasingly dominated by his misogyny and bloodlust as well as by his obsessive concern for Orientalist detail. The later praise and blame of Moreau from the likes of Odilon Redon and Edgar Degas are indicative of the general fate of the Second Empire Salon Romantics: "What admirable virtuosity," wrote Redon, "in the accessory effects!" "He would have usbelieve," quipped Degas, "that the gods wear watch chains." By surrendering to the lure of "accessory effect" and surface accoutrement, Romanticism succumbed to the thrall of a superficial Naturalism.

More than Classicism and Romanticism, it was Naturalism, according to many critics, that represented the future of art at the Salon. Inaugurated, the Republican Castagnary wrote, a generation earlier by the Barbizon landscapists—who included Jules Dupré (1811–89), Millet, Théodore Rousseau (1812–67), Constant Troyon (1810–65) and Narcisse Diaz

(1808–76)—Naturalism was claimed by him to represent a new principle of equality and individualism in society and culture: Naturalism "springs from our politics," he wrote, "which, by taking for a principle the equality of individuals and the equality of conditions as a *desideratum*, has banished from the mind false hierarchies and lying distinctions." The basis for Castagnary's linkage of Naturalist art and democratic politics was his belief, especially widespread during the first decade of the Second Empire, that nature, particularly the unspoiled Barbizon of the eponymous painters, or the untrammeled Franche-Comté of Courbet, represented the only remaining loci for personal fulfillment and independence during a time of mass urbanization and Bonapartist absolutism. As such, it was the fundamental principle upon which all artistic creations, regardless of genre, must be constructed.

Indeed, Castagnary and other critics increasingly applied the label Naturalism to more artists than just the insurgent Courbet and the Barbizon group, citing, for example, the Bonapartist animal painter Rosa Bonheur and the Catholic peasant artist Louis Cabat (1812–93). Thus the rubric, despite its defining "principle of equality," was in fact increasingly an expression of that official eclecticism which masked a profound hierarchism at the Salons of the Second Empire. The Naturalists who were most favored by patrons and jurors during these years were not the radicals—Courbet, Rousseau, and Millet—but the idealists, like Alexandre Antigna (1817– 78) and Jules Breton, who upheld the superiority of the ruling notables, the value of simple peasant virtues, and the need for proletarian subservience. In Breton's award-winning Blessing the Wheat in the Artois, for example, shown at the 1857 Salon, the rural laborers literally bow before higher authorities. Employing a composition that echoes Courbet's A Burial at Ornans and anticipates Gérôme's Reception of the Siamese Ambassadors, Breton depicts a ragged group of peasants in the foreground kneeling in supplication before a procession representing Church (priests), Commerce (the bourgeoisie in suits), and State (the uniformed gendarme). Few works of the period represent more clearly the tripartite foundation of Second Empire authority, or the tendency of Salon Naturalists to adhere to class and ethnic idées recues.

3.14

1.17 3.11

The extreme of Naturalist reticence about depicting social complexity and contradiction was probably achieved by the animal painter Rosa Bonheur. Undoubtedly the most celebrated woman artist of the nineteenth century (she was awarded a *Légion d'honneur* in 1865), Bonheur maintained a menagerie at her By estate precisely in order to avoid unpleasant interactions with society. Despite her misanthropy, however, celebrity and wealth came early to Bonheur. Encouraged by her Saint-Simonian father Raimond to become an independent woman and an artist, she copied both from earlier animal painters and life, and by 1849 had

13.12 GUSTAVE MOREAU Oedipus and the Sphinx, 1864 Oil on canvas, 805/8 × 41 (204.7 × 104.1)

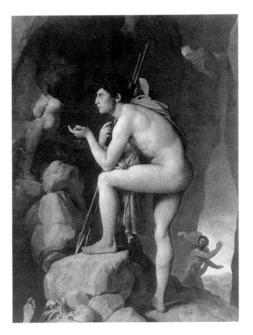

13.13 JEAN-AUGUSTE-DOMINIQUE INGRES *Oedipus and the Sphinx*, 1808. Oil on canvas, 74³/8 × 56³/8 (188.9 × 143.8)

13.14 JULES BRETON Blessing the Wheat in the Artois, 1857. Oil on canvas, $51 \times 10'6$ (129.5 \times 320)

13.15 ROSA BONHEUR The Horse Fair, 1853. Oil on canvas, $94\frac{1}{4} \times 16^{7}\frac{1}{2} (239.3 \times 506.7)$

15.18 achieved a considerable success at the Salon for her *Ploming in the Nivernais: The Dressing of the Vines.* In that work, as in 13.15 *The Horse Fair* (1853), shown at the 1853 Salon and the 1855 Exposition Universelle, humans are reduced to mere appendages beside the yokes of cattle or the magnificent Percheron horses. Observing Bonheur's transformation of people into mere operatives, John Ruskin objected in 1855: "This lady gains in power every year, but here is one stern fact concerning art which she would do well to consider. . . . No painter of animals ever yet was entirely great who shrank from painting the human face; and Mlle. Bonheur clearly *does* shrink from it. . . . In the *Horse Fair* the human faces were

nearly all dextrously, but disagreeably, hidden, and the one chiefly shown had not the slightest character." By now, however, Bonheur was largely exempt from criticism: granted a special police dispensation to dress as a man, she contentedly retreated to her estate and sold her works privately, independent of critical or Salon sanction.

French Salon art of the Second Empire, in conclusion, came in countless shapes and sizes, and critics past and present have sweated over the best labels. History painting, historical genre, Orientalist, eclecticist, academicist, Classicist, Romanticist, Naturalist, and Realist are all terms that have been used to describe this art in whole or in parts.

Perhaps the only safe conclusion that can be drawn is that Salon art was a mixed and variable body of work that nevertheless shared a single fundamental aspect and purpose—reducing the act of vision to seeing only what has been seen before.

Indeed, more than anything else, Salon painting positively reveled in stereotypes and clichés; it consistently displayed an attitude of tongue-in-cheek and wink-and-a-nod, inviting spectators to believe that they were being let in on a joke at someone else's expense. (As we shall soon see, that someone else was usually a woman.) Salon art therefore performed its ideological work not by facilitating audience absorption in the object-whether through illusionistic tricks or narrative power—but on the contrary by encouraging a stance of diffidence and self-consciousness before the work. In this way. Salon spectators were encouraged to exercise and gratify their individual powers of esthetic delectation and connoisseurship—to become experts—the better to identify with the particular received idea on view. What was positively discouraged at the Salon was the exercise of any insurgent, collective, or class consciousness: that is, any identification with the outmoded "social organisms," as Castagnary wrote, that might interfere with the development of a society in which "man becomes more and more himself." Individual consumption, not class solidarity-individual retreat into nature, not collective resistance to the alienation of society was promoted at the Salons of the Second Empire.

Individualism and commodified consciousness—masked and justified by a crude ideology of Naturalism—was what replaced history painting in Germany, Italy, and France around the middle of the nineteenth century. In Risorgimento Italy, the Macchiaioli briefly intruded upon this bleak horizon by depicting non-elite classes, occupations, and locations in a style that was honest about its own facture and fictitiousness. In France, where a critical consciousness of society was profoundly rooted in three quarters of a century of insurgency and revolution, Courbet, Manet, and the Impressionists offered a still more compelling challenge to the new Salon paradigm. Among these artists, individualism was dialectically redefined to include both personal autonomy and the popular collectivity: thus was modernism born, in Paris, at the close of the Second Empire.

CHALLENGES TO ACADEMIC PAINTING IN RUSSIA

In Russia, the thrall of the Imperial Academy of Art in St. Petersburg—founded in 1757 by the Empress Elizabeth and subsequently supported by Catherine the Great—remained largely undisturbed until the regime of Alexander II and the "Reform Era" of the 1860s. Russia's defeat by England and France in the Crimean War (1854-6) was a blow to czarist absolutism, encouraging the modernization of education, law, state bureaucracies and ministries, and prompting the elimination of serfdom in 1861. The Academy itself was reformed in 1859 in order to encourage a greater independence of students from their faculty mentors and to permit them to choose their own areas of specialization. But in fact, liberalization was circumscribed by the continuing power of the czar and wealthy nobles over the ministries, by the maintenance of feudal relations in the vast countryside, and by the limited inroad of capitalist means and relations of production. (The freed serfs were freighted by enormous redemption payments agricultural technology remained primitive, and industrialization limited.)

The Imperial Academy was thus only barely touched by reform, when in 1863 a group of fourteen young graduates seceded from the state-supported system in protest against its rigid assessment system. They rejected in particular the imposition of preordained subjects upon all contestants for the Gold Medal, the prize guaranteeing high social status and a period of paid study abroad. (The assigned subject that year, "Odin's Feast in Valhalla, from Scandinavian Mythology," must have especially rankled, since it both recalled outmoded Neoclassical canvases, such as Girodet's Ossian Receiving the Napoleonic Officers into 1.32 Valhalla (1802), and ostentatiously denied recent, tumultuous Russian history.) In addition, they criticized the Academy for failing, in the words of its defender, Fedor Bruni, "to accede to the demands of the age." No longer, the secessionists hoped, would academic machines, such as the famous and bathetic Last Day of Pompeii (1830-33) by Karl Briullov (1799-1852), represent the highest aspirations of Russian artists.

The group of fourteen, led by the radical artist and intellectual Ivan Kramskoi (1837-87), quickly formed an Artists' Cooperative Society, Artel' Khudoznikov. Like the artists in Paris who the same year organized the Salon des Refusés, the young Russians sought to encourage individual artistic development (Alexander II had recently rescinded strict censorship laws, encouraging greater freedom of expression) and advance artistic, political and economic reform by depicting modern Russian life. The sentimental genre scenes of Aleksei Korzukhin (1835-94), such as his Day of the Parting (1872), which represents a boy being sent off to boarding school, recall those of the English Victorian painter Augustus Egg, and enshrine the heroism of modern bourgeois life. Kramskoi's own work at this time, including his Self-Portrait (1867) and Portrait of a Peasant (1868), exposes his bohemianism, Realist sensibilities, and extreme self-confidence. The Self-Portrait, with its oval format,

13.16

13.17

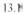

13.16 ALEKSEI KORZUKHIN *The Day of the Parting*, 1872. Oil on canvas, $30\frac{1}{8} \times 22\frac{7}{8}$ (77×58)

strong chiaroscuro, warm hues and evident impasto, is clearly derived from Rembrandt's self-portraits, suggesting a like desire to record the expressive and changing physiognomy of the artist, and provide a picture of the ethos of his time.

The Artel' Khudoznikov formed the nucleus of another organization that formed in 1870, "The Wanderers" or "The Itinerants" (*Peredvizhniki*), which dominated Russian esthetics and art practices until the 1920's. Believing that art should be seen throughout the entire nation of Russia, rather than just the two cultural capitals—St. Petersburg and Moscow—and that it should represent the lives of peasants, workers, minor gentry and the merchant class, the Wanderers, who included among dozens of exhibitors Kramskoi, Vasily Perov (1834–82), and Nikolai Ge (1831–94), mounted self-juried exhibitions in regional cities, attracting widespread attention. They even exhibited abroad at world's fairs in Paris and Vienna.

The best-known artist of this group is Ilya Repin (1844–1930), whose large, detailed, melodramatic and anecdotal canvases represented to the mid-twentieth-century critic Clement Greenberg the very epitome of kitsch, that is, an academic art "in which the really important issues are left untouched because they involve controversy, and in which creative activity dwindles to virtuosity in the small details of form." Repin was in fact a product of the Academy where he was trained, and where he exhibited until joining the Wanderers in 1877. His panoramic painting of Barge-Haulers on the Volga (1873), though based upon actual observations during travels on the river in 1870, is a highly contrived work that by virtue of its subject matter, pathos and strong diagonal composition recalls Tintoretto's Ascent to Calvary. In its academic contrivance and emphasis upon labor, it also recalls the exactly contemporaneous Iron Rolling Mill by

Adolf von Menzel. But whereas Menzel's proletarians are made to seem the timeless embodiment of the dawning industrial and economic *Gründerzeit*, Repin's *lumpen* mass represents the oppressive weight of a Russian past that, as Marx wrote in *The Eighteenth Brumaire* (1852), "weighs like a nightmare on the brain of the living." Only by exposing past serfdom and present misery, Repin and the Wanderers believed, could a modern Russia be forged. The critic Vladimir Stasov, in a letter to the *St. Petersburg Gazette* in 1873, proclaimed that "Mr Repin is a realist as Gogol is a realist, and he is as profoundly national as Gogol. With a daring that is unprecedented amongst us he has abandoned all former conceptions of the ideal in art, and has plunged headfirst into the very heart of the people's life, the people's interests, and the people's oppressive reality."

By the 1880's, the Wanderers had made peace with the Academy, and the group's masters—including Repin—had become academic masters. More than that, Wanderer exhibitions became venues for the display of a wide variety of artworks, including naturalist and even plein-air landscape paintings, such as those of Isaak Levitan (1860–1900) and Alexander Kiselev (1838–1911). The latter's painting *The Mill* (1890) is a large and ambitious work, undoubtedly intended to be shown at the Academy or one of the exhibitions of the Wanderers. The location of the subject depicted—an old, thatched mill building next to a recently constructed wooden dam—is unknown, but like the French

13.17 IVAN KRAMSKOI Self-Portrait, 1867. Oil on canvas

13.18

13.18 ILYA REPIN Barge-Haulers on the Volga, 1873. Oil on canvas, 515/8 × 1105/8 (131 × 281). Detail

13.19 ALEXANDER KISELEV *The Mill*, 1890. Oil on canvas, $29\frac{3}{8} \times 49$ (74.6 × 124.5)

Barbizon works from which it is generally descended, it connotes rural anonymity and the surcease of social pressure. The capital city is as far away culturally from this silent, evacuated landscape world as it might have been physically, and Kiselev—like naturalist authors from Ivan Goncharov to Boris Pasternak—was trying to bring the consolation of the

Russian countryside directly into its capital city, St. Petersburg, where he lived, worked, and exhibited. Soon, however, the social and political contradictions of czarist Russia—acknowledged in the works of the generation who came of age in the 1860's—would overwhelm the ability of its artists or the Academy to project an image of calm.

· 14 ·

ARCHITECTURE AND DESIGN IN THE AGE OF INDUSTRY

HAND CRAFT AND MACHINE PRODUCTION

In Europe and the United States, the thrall of the machine is nearly complete. The words printed on this page, the clothes we wear, and even the sounds we hear are almost entirely the product of machines, and we take this fact for granted. But just two centuries ago, the non-natural, object world was first of all a human world, made by the coordination of hand and eye and the physical mastery of matter. Individual identity was skills-based: people were what they did, and were known by what they made. Architecture and the decorative arts, even when domineering or monumental, were primarily the product of handcraft.

In the late eighteenth century, architects such as the Scot Robert Adam (1728–92), the Englishman William Chambers (1723–96), and the French Jacques-Germain Soufflot (1713– 80), understood cut and dressed stone as the foundation of the built environment; these materials—and the specialized craft skills their manipulation demanded—had been the basis of the architecture of the Classical civilizations of antiquity and the Renaissance, and the subject of recent illustrated treatises and print albums by the French Jacques-François Blondel (1705-75) and the Italian G. B. Piranesi (1720–78). By the 1860s and '70s, an ambitious generation of architects-trained as scientists and engineers as much as artists and humanists-used cast iron, wrought iron and glass to establish the foundation of a new tradition of construction and ornamentation for secular architecture that derived its metaphors from geology, biology and evolutionism rather than from ancient myth, Christianity or Renaissance humanism. The architectural profession itself—in France, England, the United States, Germany and Austria-Hungary—had been reorganized by the middle of the nineteenth century to enable its practitioners to compete more successfully with engineers, and to obtain important public commissions. Hammer, mallet, point, chisel and saw, tools used since the time of ancient Athens, were replaced by blasting furnace, iron pig, glass furnace and cutting wheel, machines that turned craftsmen into mere appendages of machines. Whereas the greatest architectural talents once designed palaces and cathedrals, the new engineers or architects (the two sometimes working in collaboration) built train stations, such as St. Pancras in London by the engineer W. H. Barlow (1812–1902) and the architect George Gilbert Scott (1864–74), and department stores, such as the Magasin au Bon Marché in Paris (extended in 1876) by the architect L. A. Boileau and the engineer Gustave Eiffel (1832–1923). The former building required iron to span the vast space of the train shed and to dramatically cantilever the staircase of the conjoined hotel; the latter featured metal catwalks, and plate-glass and iron lightwells to create a luminous and seductive open shopping space in which cheap nouveauté became phantasmagoria. The new architecture of iron and glass thus arose first of all in order to facilitate the transport of manufactured goods, industrial workers and salesmen, and to valorize the commodities that were the foundation of the industrial capitalist order.

Traditional styles of architecture—based upon models from Antiquity and the Middle Ages—were to be replaced by self-consciously modern ones, derived from industrial materials and the new functional requirements. To be sure, the five orders of architecture were still widely used in the second half of the nineteenth century (and well beyond), but they existed largely as "survivals," in the sense of the term found in E. B. Tylor's *Primitive Culture* (1871): "A custom, an art or an opinion, fairly started in the world . . . the meaning of which has perished, may continue to exist, simply because it has existed." For the French architect

7.25

14.1

Henri Labrouste (1801–75), classicism—in particular the example of the three-story Renaissance palace, with its rusticated stones, stringcourses and vertical succession of orders—remained in principle a prestigious template for organizing the elevations of large urban masonry blocks. But his Bibliothèque Ste.-Geneviève in Paris (1839-50) was in fact a highly rationalist building, the manifestation of an ideal of transparency, by which the interior functions of a building would be visible on the outside, right down to the inscription of the names of library authors on the exterior walls. Its boxy ground plan was well adapted to its constricted site, and its parade of arched windows, set atop narrow pilasters, was designed to permit maximum light into the two-story reading-room. The latter, with attenuated cast-iron columns and trusses and vast, bright, twin-barrelvaulted space—signifying the light of reason and the democracy of learning—is logical and functional; it was the first use of an interior iron skeleton in a major public building in the history of architecture, and established a model for library design (including Carnegie Libraries across the United States) for the rest of the century.

Labrouste's later reading room for the Bibliothèque Nationale (1859–68), built into the courtvard of the seventeenth-century Palais Mazarin in Paris, with its slender cast-iron columns supporting iron and porcelain domes, elaborates his earlier conceit; here the interior resembles nothing so much as a tent or baldachin, with light and air flooding the space, and architecture itself both unshackled from classicism and dematerialized. This transparency of the design, combined with the extensive use of cast iron, painted landscapes and foliage in the lunettes, and Celticinspired ornamental friezes (probably inspired by the work of Owen Jones (1809–74—see below) ringing each dome, is both retrospective and avant-garde; it is thus a veritable repudiation of architectural antiquity that recalls Laugier's eighteenth-century primitive hut (see Chapter 7, pp. 162 3) as the origin of architecture, and anticipates the freedom and fantasy of Art Nouveau. For many other architects of Labrouste's generation too, the rules and priorities of building had changed: speed of assembly, economy of construction, transparency and utility now trumped the former Classical and academic paradigms of anthropomorphy (resemblance of a building to the human body), proportion (mathematical properties underlying architectural composition), and decorum (rhetorical as well as practical fitness of a building).

In the late eighteenth century, the English furniture designers Thomas Chippendale (1718–79) and George Hepplewhite (d. 1786) and the French cabinetmaker Jean-Henri Riesener (1734–1806) oversaw from conception to execution the production of fine chairs, chests, tables, cupboards and

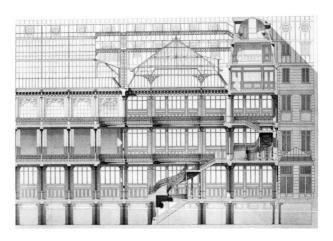

14.1 Paris, Bon Marché store, by L.-C. Boileau and Gustave Eiffel: section, from *Encyclopédie d'architecture et des travaux publics*, 1876

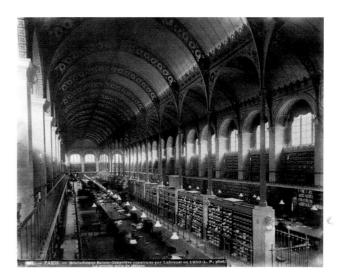

14.2 Paris, Bibliothèque Ste Geneviève, by Henri Labrouste, 1839–50: reading room

cabinets; they knew the wealthy men and women for whom they worked, and were certain their skills and products were highly prized. By the 1860s and '70s, the job of designing and manufacturing fine furniture was often extended over several studios, factories or even continents, with the assembly in one shop of finished parts made elsewhere by other, unknown hands. For example, the marquetry visible on the tables and reception room cabinet in the Italianate Morse-Libby Mansion (1860) in Portland, Maine, was prefabricated in Paris and assembled and glued in the New York City factory of the exclusive German émigré firm of the Herter Brothers. Less expensive, standardized furniture by larger companies, such as Thonet Brothers of Vienna (with branches in Moravia, Hungary and Poland), reduced handwork to a minimum. In the mid-1870s, the concern employed 4,500 workers and produced—by means of new technology and a manufacturing division of labor-2,000

14.4

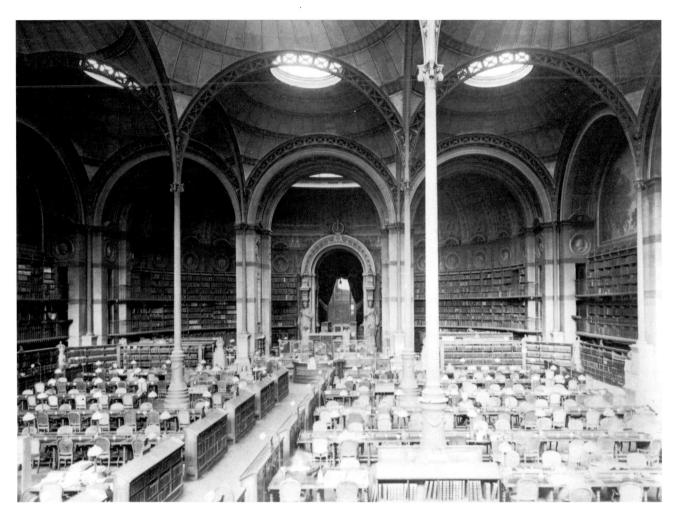

14.3 Paris, Bibliothèque Nationale, by Henri Labrouste, 1859-68: reading room

pieces per day of bentwood furniture, like his café chair, used 14.5 in many of the new urban coffee houses, restaurants and nightclubs in Paris, Berlin and Vienna. The workers in these factories possessed little knowledge of, and no say over, the end-users of their products, and their labor did not require a high level of skill or even extensive training. They did not conceive their furniture before they made it (that work was left to specialized designers), but instead acted automatically: they were mere hands, tied to machines, operated by remote brains. In the place of the old handsaws, awls, levels, planes and files—tools that were themselves the product of fine craft—were power lathes, band saws, scroll saws, mortising machines, casting molds, edge-molding devices and industrial adhesives. (And many of these machines were made in part by other machines.) What had been the "workmanship of risk," as the historian David Pye called it, was replaced by the "workmanship of certainty." A craft tradition that permitted creative fault, and even the occasional failure, was overcome by an industrial regime that demanded perfection and infinite repeatability.

This transformation of the means of production, along with new needs, entailed a change of decorative form and style. While many of the design traditions from the eighteenth century—associated with the art-historical labels Rococo and Neo-Classicism, and which employed foliate, grotesque, harp and candelabra designs-survived well into the nineteenth, they were now often marked by an extravagance or promiscuity made possible by the new manufacturing technologies. John Ruskin referred precisely to this ornamental license in his famous letter from 1854 to The Times defending Holman Hunt's painting, The Amakening Conscience, for its revelation of "the moral evil of the age in which it is painted." A "terrible luster and fatal newness," he wrote, which suggested vanity, uselessness, and vice infected all the furniture, books and tapestry in the painted interior. The glossy finish of the scrolled corbel at the base of the piano at the lower right, highlighted by a shaft of light, was the symbolic mark of a reigning industrial system that abjured restraint, creative labor and, Ruskin believed, the modesty born of Christian faith. Just

two years before, precisely such ostentatious furniture and design—often with decoration closely imitative of natural forms (like the tapestry with birds and corn in the right background of *The Awakening Conscience*)—was lampooned in a London exhibition called "Examples of False Principles in Decoration," (popularly known as the "Chamber of Horrors"), in the newly established Museum of Ornamental Art. With mechanization, Ruskin and others believed, any ornamental extravagance, including a gas jet (ca. 1848) now in the Victoria and Albert Museum (successor to the Museum of Ornamental Art), was possible. An improved public taste, achieved through education, was considered the only check on vulgarity. (Complaints by British manufacturers forced closing of the didactic installation a year later.)

OPPOSITION TO MECHANIZATION

The change from the earlier to the later system of labor and production—in architecture and design no less than general manufactures—was as profound and complete as any in human history, and was naturally accompanied by anxiety, protest, and even outright rebellion. By the middle of the nineteenth century however, the most ostentatious form of antagonism to mechanization—the illegal destruction of machinery known in England as Luddism—was relegated to the past. Champions of industry, such as the publisher and pedagogue Charles Knight (1791-1873), felt confident enough—in the wake of the success of the "Great Exhibition of the Works of Industry of all Nations" held in London in 1851 (the Crystal Palace Exhibition—see below and Chapter 7, p. XXX) to proclaim "the complete union [of machinery] with skilled labor as the triumph of the productive forces of modern society." In France at about the same time, the Saint-Simonian businessmen, engineers and architects including Baron Georges Haussmann, (1809-91) Prefect of the Seine, who organized for the Emperor Louis Napoleon the rebuilding of Paris—believed that workers and capitalists were now united in a single industrial class that would produce universal peace and prosperity.

But in fact, the political and cultural contest in Europe and the United States over the proper relationship between mechanical production and handcraft was far from over, and would remain vexed for the rest of the century, and beyond. On one side of the conflict between mechanization and craft was capitalist industry, politically represented by Whigs in England, Republicans in the U.S., and Liberals in Prussia, as well as by other national, civic and business groups in Europe and the U.S. that championed laissez-faire economics and rapid modernization; and on the other was labor and small-

14.4 GUSTAVE HERTER Reception room cabinet, ca. 1860

14.5 MICHAEL THONET Bentwood "café chair" no. 14, 1859

scale entrepreneurs, represented by cooperative associations of artists and craftsmen, including the Pre-Raphaelite Brotherhood (supported by Ruskin), and the design firm of Morris, Marshall, Faulkner and Company (established in 1861, later just Morris and Co.), as well as newly created unions, for example the Amalgamated Society of Engineers, organized in England in 1851, the socialist Gewerkschaften launched in Berlin in 1868, and the Noble Order of Knights of Labor in the U.S., formed in 1869. They struggled to preserve creative independence, protect craft skills, and "uphold the dignity of labor" (according to the creed of the Knights). Industrial workers also sought shorter hours, better wages, and the elimination of child labor. A few sympathetic philosophers from right or left, such as Thomas Carlyle and Karl Marx, upheld the cause of workers displaced by mechanization, as did many artists and writers including Gustave Courbet in France and George Eliot in England. Courbet's Stonebreakers (1850), as we have seen (p. xxx), was precisely an image of displaced peasants or craftsmen turned proletarians; Eliot's novel Silas Marner -Weaver of Raveloe (1861) is the tragic story of an independent treadle-loom weaver, plagued by the curse of lucre, at the dawn of the age of industry.

Another dissident was the German architect and theorist Gottfried Semper (1803-79), who had contributed designs to the Crystal Palace scheme, and joined with Henry Cole in the effort to modernize arts education and improve public taste in Britain by opening the Museum of Ornamental Art. Writing for a German audience in 1852, he expressed anxiety about the impact of mechanization upon traditional craft skills. Using language recalling the radicalism that necessitated his flight from Dresden in 1849 after a failed republican uprising, he wrote: "there is a difference between working at the behest of speculation and producing one's own work as a free individual. In the former case, one is doubly dependent: a slave to one's employer and to the fashion of the moment . . . All our industry, and all our art along with it . . . is calculated with an eye to the market." Semper therefore called for a renewed attention to traditional or indigenous crafts—both German and colonial—in order to reinvigorate artistic culture and national manufacture. His theories concerning the origins of architecture in "primitive" textile arts, such as those by "the New Zealanders" (Maori)—most fully developed in his massive, uncompleted book Der Stil (1860-63)—helped spur the establishment of museums of decorative art (Kunstgewerbe and Kleingewerbe) across German-speaking Europe, such as the Kunstgewerbe Museum in Berlin (established in 1867), as well as a succession of arts and crafts schools. The most significant of these were the Kunstgewerbeschule organized near the end of the century by Hermann Muthesius (1861–1927) in open emulation of English models, such as the School of Design, established by Cole, at the South Kensington Museum. These in turn paved the way for the establishment of the Deutsche Werkbund, founded in 1907 by Peter Behrens (1868–1940), the key German institution for the propagation of modern design for both handcraft and industry in the early twentieth century.

Semper's own architecture however, in Zurich, Dresden and Vienna, such as the Neo-Renaissance Naturhistorisches Museum (1872)—part of a grand Kaiserforum (imperial forum) in honor of Franz Josef bisecting the newly developed Ringstrasse in Vienna—advanced the very generic, pompous style that he earlier seemed to decry for its obedience to fashion, authority and grandiosity. The Kaiserforum was never fully completed, its imperial monumentality in conflict with demands for speed and mobility on the arterial Ringstrasse. But Semper's basic recognition—articulated here and in Der Stil—of the value of creating a "metropolitan image" (gross-städtisches Bild) to counter the alienation that disfigured industrial production and distribution in the second half of the nineteenth century, and of the need to study the crafts of untutored masons, weavers, metalworkers, potters and carpenters, was nevertheless astute and influential. It would be taken up in a very different context by the English designer, poet and socialist William Morris (1834–96), and his followers in England, the United States, Belgium, Spain, and elsewhere.

WILLIAM MORRIS

The cause of handcrafts and satisfying labor found its greatest champion in the person of William Morris. Educated at Oxford, influenced by Thomas Carlyle and John Ruskin, and teamed with the painters Dante Gabriel Rossetti, Ford Madox Brown and Edward Burne-Jones (1833-98) and the architect Philip Webb (1831–1915), Morris was concerned with understanding and changing the totality of the lived environment. Such a colossal task, he realized required study and concerted effort at many different levels. Thus he was a historian and antiquarian, poet and designer, entrepreneur and labor activist, journalist and revolutionary. The house designed for him by Webb in 1859, Red House in Bexleyheath, Kent (so named for its brickwork), was an early expression of this drive to understand and effect the fundamentals upon which a society and its material culture were built. Its plan—with rooms radiating off an L-shaped corridor-and the sobriety of its elevation recall various medieval and modern communal building types, and philanthropic housing schemes, such as the cottages, school, church and parsonage of Baldersby St. James, in Yorkshire (1854–58) by

William Butterfield (1814–1900). Like Butterfield's modest, softly hued stone church and simple brick houses, Webb's Red House reduces Gothicism to a few, mere inflections: steeply pitched roofs and some pointed arches over windows. The result is a clear expression of the structural integrity of the house, its relation to local architectural forms, and the architect and patron's respect for traditional building trades and crafts along with the skills-based identities they promote. The interior of the house, with built-in and freestanding furniture, glass and tiles designed and decorated by Webb, Rossetti, Morris, Elizabeth Siddal (1829-62) and Burne-Jones, (for example the great settle) is similarly earnest and restrained, with emphasis given to whitewashed walls and plain woodwork and joinery. It was in fact the unavailability of such simple, even rudimentary furnishings in the Victorian marketplace that gave Morris the impetus to establish his design firm.

Between 1861, the year of its founding, and 1896, the year of Morris's death, Morris and Co. invented dozens of flat patterns for wallpapers and textiles, and an even greater number of designs for furniture, ceramics, stained glass and metalwork. (William de Morgan (1839–1917) was the

greatest ceramicist supplying works for the firm, Webb, Rossetti and George Jack (1855-1932) the most important furniture designers.) Morris also created new print typefaces such as the "Troy-type," a rationalized Gothic used in his edition of Utopia by the Renaissance humanist Sir Thomas More (1894) and other books made at his private press, the Kelmscott Press in Hammersmith; he even put his hand to the production of dyes, papers and inks. Morris was in addition—particularly after 1880—a champion of socialism, proposing that a democratic and egalitarian society would be the inevitable product of a regime in which all men and women engaged in what he called "the right kind of labor," that is, work which was creative, independent and a pleasure for the producer and the consumer alike. The result of all this artistic invention and these ideas was a new aesthetic philosophy that emphasized natural forms, honesty about materials, restoration of traditional crafts and craft-identities, and clarity concerning the work process that brought objects into being.

By the 1890s, Morris's ideas had been taken up by dozens of small entrepreneurs and "arts and crafts" societies in England and elsewhere, including the Century Guild (est.

14.7 WILLIAM MORRIS Preliminary design for the "Troy" typeface, 1891 14.8 (right) WILLIAM MORRIS "Pimpernel" wallpaper, 1876

1882) of A. H. Mackmurdo (1851-1942), the Guild of Handicraft (est. 1888), led by C. R. Ashbee (1863-1942) and the Gustav Stickley Company, founded by Stickley (1858-1942) in 1898 in Syracuse, New York, and quickly renamed the United Crafts-A Guild of Cabinet Makers, Metal and Leather Workers. Stickley's enterprise, which entailed a highly developed division of labor and a sophisticated marketing strategy, reveals the permeable boundary between industrial manufactures and so-called traditional craft at the fin-de-siècle. Nevertheless, his best furniture, such as the "chalet table" of 1900, is much indebted to 14.

Morris's early experiments in painted oak, such as the table of ca. 1856, described by Rossetti as "firm, and as heavy as a rock."

More than other decorative artists of the time, Morris built his designs out of the very conflicts and contrasts that marked his era. Embroideries such as "Sunflower" (1876, worked by Catherine Holiday) and "Acanthus" (ca. 1880, worked by May Morris and others) are construed from the assembly of colliding and interlocking shallow planes, from the tension between strongly weighted vertical and equally stressed horizontal elements, and from the antagonism of axial and diagonal lines of force. The dynamic interplay between opposing shapes, forms and directions, and the evident denial of any simple identification of figure/ground, is the foundation of a visual perspective that was new in the ornamental arts and became a resource for subsequent modern designers, such as the American Louis Sullivan (1856–1924, see below) and the Belgian Henry van de Velde (1863–1957), whose poster for Tropon (a nutrient derived from eggwhites) appears abstract, though it in fact represents the separation of yolks from whites.

Unlike Morris's exact contemporary (and rival) Christopher Dresser (1834–1904), who, beginning in the 1850s employed flat and relatively static all-over designs in his untitled wallpapers for William Cooke and Sons, and other manufacturers, Morris—avoiding photographic naturalism—used patterns that consistently placed viewers in uncertain or unstable positions: in seeing a wallpaper such as "Willow Bough' (1887), or a printed cotton like "Cray' (1884), they may envision themselves inside a pergola or out in the open air, and imagine that it is morning, afternoon or evening. A wallpaper pattern such as "Pimpernel' (1876), hung in the dining-room of Morris's Kelmscott House in Hammersmith, appears to oscillate between an appearance that is flat and volumetric, pictorial and sculptural, or naturalistic and abstract. That animation, and that charged relationship between pattern and beholder, is far different from the implied interplay between design and spectator in the work of Dresser, or the latter's mentor Owen Jones. For these men, botanical forms, derived from an unchanging, geometrical type—what Goethe had called Urpflanze functioned to uphold the hierarchies of state and society. Their abstract and idealized ornamentation suggests a static, pre-Darwinisn nature in which all species are the stable creation of an intelligent designer; their decorative

14.10 (right, above) A. H. MACKMURDO Cover of Wren's City Churches, 1883

14.11 (right) HENRY VAN DE VELDE Poster for "Tropon," 1897. Lithograph

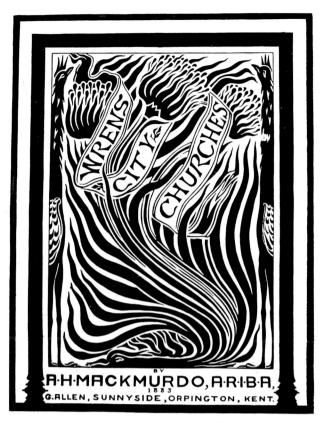

discretion—the conviction that ornament takes a back seat to painting and the other high arts—implies acceptance of a hierarchy of wealth and class. Indeed, if pleasure in ornament, as Morris believed, was the province of all human beings by virtue of their membership in the species, then there should be no superiority of taste; Queen, minister and industrialist had no more right to beauty, and no more ability to enjoy it, than clerk, peasant and day laborer.

Morris's designs, like those of his best followers, such as A. H. Mackmurdo, whose design for the book cover of Wren's City Churches is widely taken as the first expression of Art Nouveau (see below), and C. F. A. Voysey (1857–1941), often expose a feeling for movement and perspective that is thematic as much as formal. Plants and animals, like those that appear in the printed cottons "Brother Rabbit" (1880-81) and "Strawberry Thief' (1883), designed by Morris, alternatively appear to be reminders of a remote and idealized past known from late medieval manuscript illuminations or tapestries, and anticipations of that future of natural abundance dreamed by utopian thinkers such as Thomas More and Morris himself. His repeating patterns of plants, flowers, fruits, birds and animals may either stir nightmares of unstoppable growth and replication, or stimulate fantasies of an ideal of pleasure and fecundity. The basis of this ornamental contradiction lay in Morris's intuition of the actual historical antagonism—grown acute in his lifetime, as we have seen—between labor and mechanization, and nature and industrial development. His patterns may thus be understood as allegories of modernization, and expressions of romantic anti-capitalism.

ARTS AND CRAFTS ARCHITECTURE AND TOWN PLANNING

William Morris's effort to transform architecture—which he defined as "the whole external surroundings of the life of man"—may be termed utopian. Not in the sense of a vain and quixotic dream, but in the original meaning of the word, found in Morris's much admired Thomas More, of a determined place in which, as Morris summarized, "the individual can scarcely conceive of his existence apart from the Commonwealth of which he forms a portion." To advance the goal of constructing such a cooperative community, a number of architects in Morris's shadow proposed and built individual houses and town-planning schemes that broadly expressed the ideal of integrating architecture and nature—that is, eliminating the distinction between town and country—in order to break up the urban concentrations required by large-scale and dehumanizing industrial production.

Webb was one of these architects. Like Morris an avowed socialist, he acknowledged the inherent (and unavoidable) contradictions of his circumstances: that as an architect and designer in an age of capital, he was forced to cater (in his his own words) "to the swinish luxury of the rich," while still seeking to advance the revolutionary aspirations of the industrial proletariat. It is not clear that he was able to reconcile these activities, but in his later country houses such as Standen (1892-4), near East Grinstead, in Sussex, built for a London lawyer, he abjured the hierarchism inherent in classicism—with its essential notions of balance, decorum and proportion—in favor of a Gothic Revival asymmetry and an extreme informality of both plan and elevation that emphasized functional clarity and decorative plainness. (Morris and Co. supplied most of the furnishings for the interior of Standen.) Webb understood and prized local craft traditions and materials; this was knowledge gained in part through his co-leadership (with Morris), starting in 1877, of the Society for the Protection of Ancient Buildings, the first architectural preservation society in the world, and the results are visible at Standen. Here, the combination of brick and tilehung walls and roofs—a feature of seventeenth-century or "Queen Anne" design—and weather-boarded gables on the garden façade, reveal considerable, highly skilled work. The architect closely supervised construction on-site, thereby upholding—at least at Standen—an ideal of work-based identity.

Voysey too embraced handwork and local craft and materials. The very simplicity of his chairs and cabinets—planks of solid wood, joined with dovetails, and decorated with cut-out hearts and other folkloric shapes—is the clear sign of their distance from the ostentation of industrial manufacture. He stated: "It is quite easy to see when our articles of daily use are made by loving hands and thoughtful heads, and when they are made by human drudges working for wage alone." But his country houses and cottages, such as Moorcrag (1898–99) near Gillhead, Cumbria, however ingratiating, are remote from the socialist dream-visions of Morris. Set into a gentle slope near Lake Windermere, with plain, whitewashed exterior walls, twin cross-gables, a cat-slide roof extending nearly to the ground, and a broad, low entrance door surrounded by climbing roses, Moorcrag expressed the nostalgic dream of a wealthy textile manufacturer —one J.W. Buckley—that he belonged to a class of rural gentry, untroubled by unions, socialists, Fabians, or the rising price of labor and raw materials and falling rate of profit. That palliative architectural vocabulary would continue to mark rural and suburban villas for decades to come.

Richard Norman Shaw (1831–1912) was less concerned than Webb or Voysey about the preservation of indigenous craft—contractors for his houses were almost always summoned from London—but he was important for having designed, beginning in 1877, the first "garden city" suburb, Bedford Park, west of the capital. It was commissioned by a real estate speculator named Jonathan Carr, and became a model for similar developments in England, the United States and elsewhere. Shaw's architectural formula—minimally decorated red brick houses, tree-lined streets, and for important commercial and ceremonial buildings prominent gables, mullioned windows and half-timbering—was used a decade later for the factory town at Port Sunlight, near Liverpool, designed by William Owen, and even as late as 1913 at Forest Hills, Queens, New York City, by Grosvenor Atterbury (1869–1956) and the Olmstead brothers (John Charles Olmsted, 1852–1920, and Frederick Law Olmsted, Jr. 1870–1957).

These and other garden city schemes were conceived in conscious opposition both to liberal, or market-driven, utopian urban designs, such the Ringstrasse in Vienna and Haussmannized Paris (see Chapter 14), and industrial town plans that emphasized either corporatist paternalism or Fourierist concentration and collectivism. For example, Titus Salt's Saltaire near Bradford in Yorkshire, England, established in 1850, and laid out by the local architects H. F. Lockwood and William Mawson, was an ideal town in which workers (including young children)—employed at the largest and most modern textile mill in Europe—were provided with new homes, schools, a library, clean water and other urban amenities (but no pubs, so as not to encourage inebriation or unthrift). The Familistère at Guise, France (begun 1859), conceived by the industrialist J.-B.-A. Godin (1817–88), was a communal housing scheme for more than 1,000 iron and steelworkers, consisting of three large redbrick apartment buildings (each unit had individual kitchens but shared baths) with internal balconies encircling a glassroofed court. Families received decent wages (including profit sharing), food and other provisions for reduced prices at company stores, and care for the sick and elderly in company clinics. Sobriety and thrift were ensured by, among other measures, the staggering of paydays so that no large groups of men and women would have money at the same time that might be spent on liquor. (In the Deed of Trust for the new, picturesque, industrial town of Bournville, near Birmingham (1879), the chocolate manufacturer George Cadbury declared that all profits from the sale of liquor be used to pay for alternative attractions and recreations.)

Pullman (established 1880), south of Chicago, designed by Solon S. Berman (1853–1914) and the landscape architect Nathan Barrett (d. 1919), provided worker housing, as well as educational, recreational and shopping facilities, the latter housed in the glass-roofed Arcade Building (1882). The town itself—which offered its residents a high level of services-was located adjacent to the Pullman Palace Car Company factory in order to enhance productivity and exert maximum control over the workforce, separating them from the growing union activity of nearby Chicago. The railroad industry could not however be isolated from larger capitalist relations or the business cycle, and the strike of 1894 (following recession, mass layoffs and evictions) led to the breakdown of this paternalistic model of corporate-labor relations in Chicago and the United States. By 1907, all nonindustrial Pullman property was sold off to private owners.

In contrast to industrial towns, like Saltaire in which factory laborers (and a very small number of middle-class and lower-middle-class managers and highly skilled workers) had limited independence and mobility and lived in two and three-story structures resembling early nineteenth-century row-houses and tenements, garden cities were designed for bourgeois managers and petit-bourgeois clerical

14.12 Standen, near East Grinstead, Sussex, by Philip Webb: garden front, 1802–4

14.17

14.13 Moorcrag, near Gillhead, Cumbria, by C. F. A. Voysey, 1898–9

14.14 London, Bedford Park. Color lithograph, 1882

or bureaucratic workers as well as for proletarians; here, private home ownership and family autonomy were the model. Ebenezer Howard (1850–1928), author of *Tomorrow:* A Peaceful Path to Real Reform (1898), was the most influential of all garden city theorists, and while the first realization of his dream (and that of the group that formed the Garden City Association), Letchworth, northwest of London, designed by Barry Parker (1867–1947) and Raymond Unwin (1863–1941), was not begin until 1903, his ideas constitute

a summary and culmination of many of the concerns of the previous generation of Arts and Crafts designers and theorists.

Influenced by Rousseau, Pugin, Ruskin and Morris, as well as by his visit in 1874 to the park-like Chicago suburb of Riverside, designed in 1868–69 by Calvert Vaux (1824–95) and Frederick Law Olmsted (1822–1903), Howard had an expansive view of the relationship between architecture, nature and work. He embraced the model of a communal

14.15 Saltaire, Yorkshire, by Lockwood and Mawson, 1851-76: the factory is in the foreground, the public buildings and houses beyond

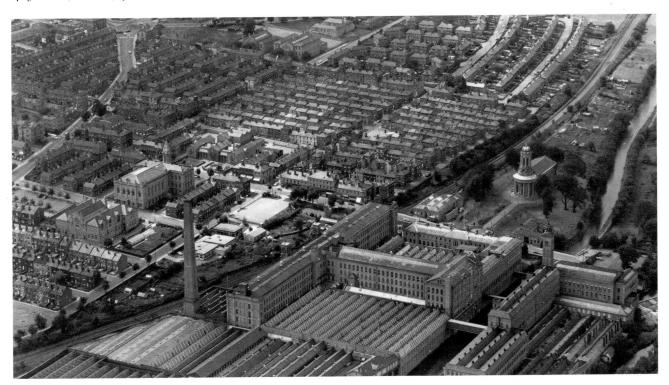

14.16 Guise: the Familistère, begun 1859, and associated factory, from J.-B.-A. Godin, Solutions sociales, 1871

14.17 Pullman, Illinois, Arcade Building, by Solon S. Berman, 1882

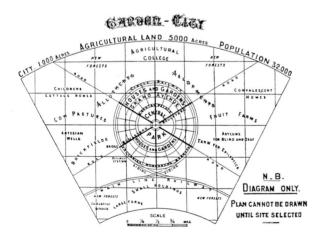

14.18 EBENEZER HOWARD Diagram of a garden city, from *Tomorrow: A Peaceful Path to Real Reform*, 1898

society with small farms and factories dispersed across the country, and people engaged in satisfying physical and mental work, like the characters in Morris's romance, News from Nowhere (1891). This practical, utopian vision inspired by the single-tax theory of Henry George, the Land Nationalization Society of Alfred Russel Wallace, the anarchism of Peter Kropotkin (who proposed to dissolve the distinction of town and country) and the socialism of Morris—would be achieved, Howard believed, by means of economic cooperation and mutual aid, without state intervention or violent revolution. The design template for his garden city was a circle, dissected by broad avenues with parks and public buildings in the center (employing a diversity of architectural styles), and a Crystal Palace nearby for shopping and winter recreation. Further from the town center would be sports facilities, factories, a circular rail line, and finally, an agricultural zone with farms, forests and pastures. Population would be fixed at 30,000, after which new towns would be established, all linked by a rail network. However, despite specification of a transportation system, Howard's vision was clearly centripetal, unlike that of the Spaniard Arturo Soria y Mata (1844-1920), whose Linear City (Ciudad Lineal), developed in the 1880s, envisioned dense, low-rise housing along the axis of a rail line and boulevard. Though the latter scheme was partly constructed on the outskirts of Madrid by the Compañía Madrileña de Urbanización in the 1890s, the Spaniard's plans were undermined by weak capitalization. Linear city ideas were taken up again by Soviet planners in the 1920s, and by the Swiss Le Corbusier (1887–1965) in the 1940s.

Howard was not able to achieve at Letchworth his dream of planting the seeds of a great utopia. Insufficient funds were available to permit land to be purchased outright, preventing the realization of dividends and the achievement of economic independence. Moreover, failure to attract manufacturers meant that the population of Letchworth—like other garden cities to follow, such as Forest Hills-was mostly made up of middle-class commuters and their families, attracted to handsome architecture and landscaping, but lacking any particular communalist sentiments. Thus while garden cities in Europe and the U.S. presented fine models of town and regional planning and controlled development, they did little to solve the colossal urban problems—unemployment, poverty, overcrowding, disease, squalor—faced by nations and populations during an age of rapid industrialization.

By the end of the nineteenth century, many architects, planners, craftsmen and critics wearied of the more than half-century-long contest between partisans of industrial manufacture and handwork, and argued that the struggle against the new productive forces was both anachronistic and futile. They had witnessed the inability of the Arts and Crafts movement to re-orient overall production and consumption toward fine (and expensive) handmade goods, and seen as well the continued expansion of large cities and the factory system, especially in England, Germany and the U.S. Did mechanization inevitably destroy the pleasure and creativity of labor, they wondered, or could there be, in the words of the American Frank Lloyd Wright (1867-1959) in 1901, a new "art and craft of the machine" that might combine rationalization and standardization with creativity and inspiration. Indeed, might industrial production, in the architect and designer Ashbee's words, "be socialized, and not merely used to enable men to exploit each other"?

Among the key figures in the historic effort to produce an art and craft of the machine were the Englishmen Dresser, Voysey and Ashbee, the Belgians Victor Horta (1861–1947) and Henry van de Velde, and the American Frank Lloyd Wright. The first three, along with William Morris, were perhaps the most important designers in England during the second half of the nineteenth century; whereas Morris, as we have seen, generally disdained mechanical production and expounded the right and even necessity of "joy in labor," they came to embrace the machine for offering a solution to the very cultural and social crises—unemployment and the degradation of work—created by capitalist industrialization in the first place. To the industrial designer Dresser a wellmade consumer product—by whatever means it was actually manufactured—was a testament to the spiritual ideal of the perfect marriage of form and function. To the younger architect and designer Voysey, reared in the Morris tradition, the judicious use of machines, he came increasingly to believe, did not violate the Arts and Crafts credo, but rather facilitated its realization; machinery could be a partner of the designer, liberating him from dull and degrading work, and permitting a greater freedom of mind and spirit. In addition, both Dresser and Voysey believed that hard work, no matter how dull or alienating, was the essential method whereby, as the former wrote, "we raise ourselves above our fellows; labour is the means by which we arrive at affluence."

Ashbee's commitment to high artistic standards and pleasurable work, evidenced by his silver cutlery setting (1900), led him to found in East London in 1888 a cooperative and independent Guild and School of Handicrafts, modeled upon Ruskin's Guild of St. George, itself an experiment in

Christian, craft-based, rural communalism that had numerous incarnations after its establishment in 1871. But by the turn of the new century, after relocating his guild to Chipping Camden in the rural Cotswolds, and partly due to the influence of Wright (whom he met in 1896), Ashbee came to embrace industrial production and standardization in the belief that it could relieve men and women of the drudgery of routine work, and permit them time for education, self-improvement and the attainment of individuality and political progress.

Victor Horta and Henry van de Velde were key figures in European Art Nouveau, an international style also known by the German and English names "Jugendstil' and "Liberty Style." (The latter name was popular in Italy-as "stile Liberty"—because of admiration for the design products sold at Liberty and Co.'s fashion and furnishings store in London.) This "youthful style," which flourished from about 1890 to 1905, marked a decisive break from both classicism and the long tradition of academic instruction. Its many protagonists, including Hector Guimard (1867–1942) in France, Antoni Gaudí (1852–1926) in Spain, and Louis Comfort Tiffany (1848–1933) in the U.S., instilled in the practice of architecture and design a greater cosmopolitanism than had ever before existed, drawing inspiration from Japanese, Chinese, Islamic and Polynesian, as well as Rococo, styles, and emphasizing—in the teeth of an increasingly bureaucratized culture and society—the emotive and expressive capacities of ornament.

Art Nouveau, with its organic, twisting and undulating metal armatures and tendrils, and its rising and swelling, asymmetric masses—as visible in Gaudi's Palau Guell in Barcelona (1888), Guimard's Maison Coilliot (1897) in Lille, and Tiffany's "Cobweb" library lamp (ca. 1900)—was also notable for highlighting as never before the modern, industrial structure and function of architecture and design, a concern derived in part from the theories of the French architect Eugène-Emmanuel Viollet-le-Duc (1814-1879) and the work of his pupils. Viollet-le-Duc, author of the highly influential Entretiens sur l'architecture (1863–72), had long embraced the frank revelation of iron in monumental architecture, and as early as 1869 his best student, Anatole de Baudot (1834-1915), transformed the Gothic Revival style by combining cast iron with more traditional brick, mortar and stone in his Church at Rambouillet. Almost three decades later, amidst the fervency of Art Nouveau, Baudot and the engineer Paul Cottancin turned to the use of reinforced concrete and Mudéjar design in the church of St. Jean de Montmartre in Paris (1894-1904), in order to realize their dream of constructing-through modern engineering—a great gathering space for an emerging democratic mass.

14.22, 11

14.20

14.19

14.21

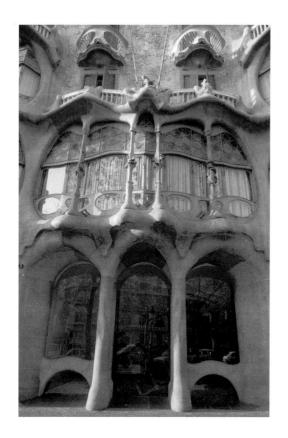

Horta and van de Velde had similar democratizing and communitarian aims. Each knew and admired the art and ideas of Morris in addition to Viollet-le-Duc, having read some of the Englishman's writings and seen his Kelmscott Press books at the 1892 exhibition of "Les XX," the avantgarde artists' society that included the painters James Ensor, Fernand Khnopff (1858–1921) and Jan Toorop (1858– 1928). Each was in addition a socialist, supporting the ideals of the Parti Ouvrier Belge (Belgian Workers' Party, established 1885); indeed, Horta designed their headquarters in Brussels, the Maison du Peuple, in 1897, a writhing brick, stone, iron and glass structure (destroyed), that hugged its irregularly shaped urban site. The building was rational and exuberant inside and out; the iron and glass in the meeting rooms, no less than the steel and glass on the façade (its startling, honeycomb appearance suggesting the contemporary office towers of the American Louis Sullivan, such as the Guaranty Building in Buffalo, 1895), was readable at once as ornament and structure, botanical effusion and rational plan. Like Horta, Van de Velde was a designer as much as an architect, but a more penetrating theorist. He believed, as

14.19 Barcelona, Palau Guell, by Antoni Gaudí, 1888: detail of entrance

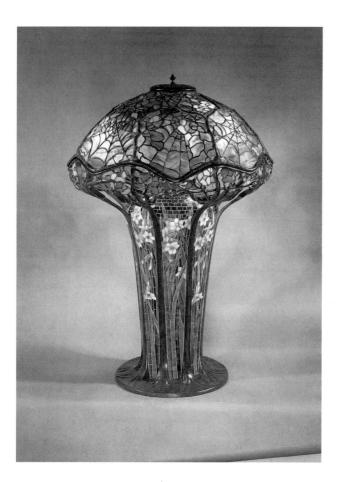

14.20 "Cobweb" library lamp, by Louis Comfort Tiffany, ca. 1900

14.21 Paris, St. Jean de Montmartre, by Anatole de Baudot and Paul Cottancin, 1894–1904: interior, looking west

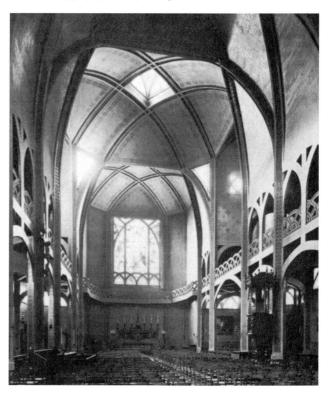

324 - ARCHITECTURE AND DESIGN IN THE AGE OF INDUSTRY

14.22 Brussels, Maison du Peuple, by Victor Horta, 1897-1900

had Morris, that it was not enough simply to create new designs, though his own furniture, such as the vitalist desk for the art historian Julius Meier-Graefe, hardly lacked novelty. Instead, he argued that the designer must help develop a regulatory system to order the production and distribution of works of ornamental art. Moreover, modern design itself must manifest a synthetic principle: decorative and structural functions, and psychological and physiognomic effects, must be indistinguishable. To this end, Van de Velde sought to control all aspects of the interior and exterior ornament of a house—in some cases down to the clothes worn by its occupants-in order to achieve an aesthetic unity, or "empathy" (Einfühlung) between the perceiving subject and the architectural or design object. The desk for Meier-Graefe appears to be composed of muscle and sinew, stretched, strained and pinched by the energy of criticism and thought. For Van de Velde, the machine would be an essential instrument in the achievement of the coming aesthetic and political order; engineers, he wrote, are "the architects of the present day."

Frank Lloyd Wright was the pre-eminent American architect of the last decade of the nineteenth, and the first half of

the twentieth century, and his career thus falls largely outside the scope of this book. But his early work and ideas both recall debates from fifty years before, and announce the architectural project of the new era. Profoundly influenced by the anti-industrial ideas of Ruskin, Morris and Kropotkin, he nevertheless asserted in 1901 that the coming "Machine Age" would emancipate workers from the numbing craft exertions to which they had always been bound. (The Viennese architect and theorist Adolf Loos (1870-1933) had made a similar announcement five years before, going so far as to argue that "ornament is crime.") The new, machine-born building and decorative arts would be frank in their expression of structure and yet at the same time would avoid the "affectation of the naïve," by which Wright meant the false simplicity of the Arts and Crafts movement. They would be freed from extraneous ornament—his Ward W. Willits House (1900–1902) in Highland Park, Illinois, is exemplary—and purified of classicism, and would at long last reveal the nature and beauty of materials: stone, wood, steel, clay, stucco and cement. Wright's own furniture, such as his side chair (ca. 1904) designed for the Hillside Home School at Spring Green, Wisconsin (1902)

14.24

14.23 Desk for Julius Meier-Graefe, by Henry van de Velde, 1899

but also used in the Larkin Office Building in Buffalo, New York (1904, demolished), with its simple plank back of machine-planed, quarter-sawn oak, exemplifies his proposition: "The machine, by its wonderful cutting, shaping, smoothing, and repetitive capacity, has made it possible to use [wood] without waste that the poor as well as the rich may enjoy today beautiful surface treatments of clean, strong forms that the branch veneers of Sheraton and Chippendale only hinted at, with dire extravagance, and which the middle ages utterly ignored." The inspiration of the craftsman, Wright believed, and the ruthless logic of the machine would soon be unified for the betterment of all. Above the doors of his red-brick Larkin Building, with its five-story, top-lit interior court and side galleries, was inscribed the motto: "Honest labor needs no master, simple justice needs no slaves."

The same idealist and rationalist convictions would motivate the many craft and industrial organizations that appeared in the two decades following the turn of the century, such as the Wiener Werkstätte, the Deutsche Werkstätten and the Deutscher Werkbund, mentioned earlier:

"There is no fixed boundary between tool and machine," wrote the Werkbund architect Theodor Fischer (1862–1938) in 1907: "It is not the machines in themselves that make work inferior, but our inability to use them properly." What was needed now, Muthesius argued, was a *Maschinenstil* that discarded meretricious ornament and responded to the needs of consumers and capitalists, that is, to "the economic nature of the age." Thus was sounded—at least in theory—the end of the dispute that was the very framework of later nineteenth-century design. Machine production had decisively trumped handcraft, and the struggle between skilled labor and industrial capital would in the future take new forms.

THE ARCHITECTURE OF WORLD'S FAIRS AND CAPITALIST COMMERCE

The chief monuments of architecture and design from the second half of the nineteenth century thus were born of the anxiety that arose from the ongoing conflict between capitalists and wage-laborers, and the lingering divide between old and new productive forces. The signs of that agonistic origin are everywhere apparent: in the survival of ancient formal traditions derived from Egyptian, Greek, Roman, Gothic and Renaissance civilizations, and the development of a new, modern, stylistic vocabulary devoid of obvious historical reference; in the stubborn maintenance of traditional ways of building, and the enthusiastic embrace of new modes of engineering with iron, steel, glass and reinforced concrete; and in the ongoing dispute over the representation of nature and the human body in architecture and decoration. Often the scissions are visible in single buildings, such as Labrouste's great Paris libraries or the Oxford Museum, (1853-60), designed by Thomas Deane (1828-99) and

14.24 Highland Park, Illinois, Ward W. Willits House, by Frank Lloyd Wright, 1900-1902

Benjamin Woodward (1816–61) which is at once Gothic and rationalist, and exhibits both naturalistic and highly stylized ornamentation. Or the Marshall Field Wholesale Store in Chicago (1885–87, demolished) by H. H. Richardson (1838–86). Here the rhetoric of historicism—a rusticated Renaissance palazzo inflected with Romanesque arches—is subsumed by a breathtaking clarity of form and function. Despite massive granite and brownstone walls, the enormous masonry block (325 feet long x 190 feet deep x 125 feet high) reads as a single, continuous space; the repetition of windows and arcades at each level, the monochrome uniformity of surface texture from bottom to top, and the shallow overhanging cornice create a volumetric feel, revealing its open and expansive interior, suitable for the display of

.25

But the contradictions between tradition and modernity, craft and industry—and dreams of transcendence—are perhaps most clearly expressed in two completely new building types that emerged during the age of industry: the world's fair and the high-rise commercial or office building. The first is best represented by a pair of exposition projects that are bookends for the period under consideration: the 1851 Crystal Palace Exhibition in London, and the 1889 Universal Exposition or Eiffel Tower Exhibition in Paris. The second building type is most clearly revealed by the work of Louis Sullivan in Chicago.

clothing, dry goods and other merchandise to successive

armies of salesmen, wholesalers and job-lotters.

The Great Exhibition (see Chapter 7, pp. 177–9), was the result of royal patronage and a period of bourgeois confidence and prosperity following the suppression of Chartist agitation in the 1840s. It served to trumpet the industrial and colonial progress of Great Britain, and to proclaim the nation's cultural and mercantile supremacy. In addition to an exhibition of industrial technology, manufactured goods and raw materials, it was a "Great Festival of Labour" as one observer wrote, and the building itself "the equator of the world in Hyde Park." Designed and erected in less than six months by a greenhouse builder named Joseph Paxton, its architectural significance, as H. R. Hitchcock and others since have observed, lay in its rational and modular character, its utilization of mass production (glass, iron and wood) and the advanced division of labor that made possible its rapid assembly. As Hitchcock wrote, the Crystal Palace "owed its aesthetic qualities to factors hitherto unrecognized—the repetition of units manufactured in series, the functional lace-like patterns of criss-cross trusses, the transparent definition of space, the total elimination of mass and the sense of tensile, almost live, strength as opposed to the solid and gravitational quality of previous masonry architecture."

Inside the building were exhibits of the goods of nearly all nations and peoples on earth, with a special emphasis upon the products of the British colonies, including India, Canada, Australia and New Zealand. There were also exhibits devoted to the history and evolution of art,

14.25 Chicago, Marshall Field Wholesale Store, by H. H. Richardson, 1885–7

architecture and design, and courts representing Egyptian, Islamic, medieval and Renaissance forms. These latter historical displays were augmented when the building was disassembled, moved, re-erected and widened two years later at Sydenham. Here, Owen Jones and Matthew Digby Wyatt (1820–77) installed their Fine Arts Courts, including paradigmatic Egyptian, Greek, Roman and Alhambra sections, promoting a notion of universal design that would receive its fullest expression between the pages of a book: Jones's enormously influential Grammar of Ornament (1856). In this large tome, profusely illustrated with chromolithographs depicting nineteen styles of ornament from "Savage" to "Renaissance" to "Hindoo," Jones proposed that art and decoration were the province of all peoples and cultures, and that the rules of good design were universal. To prove his point, Jones began his book with an examination of the interlacements of a tattooed Maori head and carved canoe paddle, claiming that the latter "rivals works of the highest civilization . . . and the decoration everywhere the best adapted to the form. A modern manufacturer, with his stripes and plaids, would have continued the bands or rings round the handle across the blade. The New Zealander's instinct taught him better. He desired not only that his paddle should be strong, but should appear so, and his ornament is so disposed as to give an appearance of additional strength to what it would have had if the surface had remained undecorated."

14.26

As democratic and internationalist as it at first appears, however, Jones's essentially static and typological vision of ornament—of decoration as pure form, divorced from people, history and meaning-served to relegate non-European design to a temporal no-man's-land, or what has been called the "ethnographic present" of anthropology. In this way, the Grammar of Ornament, and the Crystal Palace exhibitions in Hyde Park and Sydenham, were deeply contradictory, at once cosmopolitan and imperial, progressive and static. To many spectators and observers at the time, the exhibitions were a rebuke to parochialism, and an arena in which was waged a peaceful contest between nations and peoples over achievements in industry, art, science and commerce. In fact, however, they were a paean to nationalism and an emergent imperialism, and their articulation of an essential link between domestic prosperity and overseas colonial dominance structured British policy and popular ideology for generations to come.

A similar ideological and political purpose was served by the Universal Exposition which opened in Paris in 1889. In 1798, the first exhibition of industrial manufactures in Europe, the "Exposition publique des produits de l'industrie française," had been held in Paris. It was conceived under the regime of the Directory to celebrate the anniversary of the founding of the republic a decade before, to honor labor and

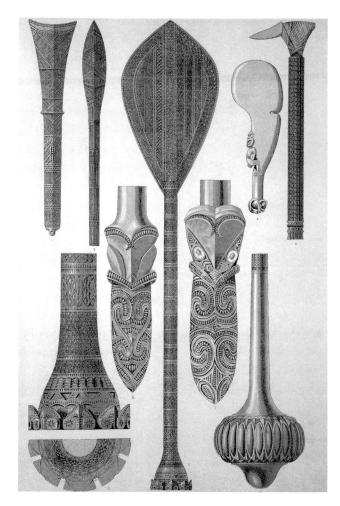

14.26 "Savage Tribes No. 3", plate from Owen Jones, *The Grammar of Ornament*, 1856

the industrial arts, and to trumpet the successes of France in its economic competition with England (these were in fact very few). But it was not until after 1850, and the policy of economic liberalization undertaken by Louis Napoleon, that France mounted showcases on the model of the Crystal Palace. The expositions held in 1855, 1867 and 1889—the last under the aegis of the Third Republic—were intended to contest English dominance in the arenas of art, craft, consumer goods and heavy industry. The 1889 Exposition, commemorating the storming of the Bastille a hundred years earlier, was the greatest of all; like the Crystal Palace Exhibition, it is known for its iconic monument, in this case the Eiffel Tower.

The tower was promoted and planned by the bridge and viaduct builder Gustave Eiffel, and designed by the engineers Emile Nouguier (1840–1898) and Maurice Koechlin (1856–1946), in collaboration with the architect Stephen Sauvestre (1874–1919). The basic scheme for the "300-Meter Pylon," as seen in a presentation drawing, was

14.2

14.27 Paris, Eiffel Tower, 1889, before modification (especially of the lowest balcony) in 1937

completed (and patented!) by late 1884. There followed two years of architectural elaboration: massive stone foundations, four arches at the base, enlarged platforms at each level, elevators, a bell-shaped cupola at the top and stylized acanthus ornament. The tower was then erected in some haste to meet the exposition deadline, and perhaps also to forestall the bitter criticism heaped upon the design when it was made public. The architect Charles Garnier, whose Paris Opera House (1863-75) represents the very epitome of Beaux-Arts design, was among the prominent signatories (others included the painter Ernest Meissonier and novelist and critic Emile Zola) of a letter of protest to the commissioner of the exhibition, Adolphe Alphand, published in Le Temps: "We . . . protest with all our might in the name of slighted French taste against the erection, in the heart of our capital, of the useless and monstrous Eiffel Tower, which public ill-feeling, often inspired by good sense and the spirit of justice, has already christened the Tower of Babel. . . . For the Eiffel Tower, which not even trade-conscious America would wish to call its own, is without doubt the dishonor of Paris."

In fact, upon its completion, the Eiffel Tower was quickly embraced by intellectuals and the general public, and can be said to symbolize at once the vaunted rationality and internationalism of the bourgeois Third Republic, and its superstition and chauvinism. The form of the monument was derived from viaduct pylons—its peculiar arcs, struts, buttresses, solids and voids the result of precise calculation, according to Eiffel, of the forces of wind, water and gravity. It was also (and still is) visible from nearly all parts of the city, and thus serves as an inevitable culmination of views from both modern and historic Paris.

But the monument was in addition a summary of national and imperial traditions and ambitions. The pinnacle, buttresses and much of the ornament (some was removed in 1937) are both Roman and Gothic in inspiration: the four great arches at the base recall the Napoleonic Arc de Triomphe de l'Etoile, designed by J.-F. Chalgrin and built in 1806–36, and the smaller Arc de Triomphe du Carrousel, just west of the Louvre, designed by Charles Percier and P.-F.-L. Fontaine and erected in 1806-8; its pinnacle calls to mind Gothic cathedral spires, and thus the spiritual origins of the French State. The Eiffel Tower thereby connotes, by its materials, scale, modernity, and range of architectural references, French national ambition and imperial reach at the moment of its greatest thrust-into Africa, Southeast Asia and the Pacific—and national will to challenge the economic hegemony of Great Britain.

Louis Sullivan is generally considered to have invented, around the year 1890, the modern, steel-framed office building, a form-type as new as the exposition halls of England

and France. Indeed, the Wainwright Building (1890–91) in St. Louis presents at once a novel and a highly imitable schema. A large doorway at the center of the ground level is flanked on each side by plate-glass shop windows with transoms. Above these, at the mezzanine level, are twice as many smaller, vertical windows for additional retail and trade. Above them is a stringcourse and seven successive, identical stories, "cells in a honeycomb," in Sullivan's words, for office work; these are separated on the vertical axis by tall, slender piers, and on the horizontal axis by rectangular spandrels of ornamental terracotta. The composition culminates in an entablature, above which are an attic story with round windows (masking mechanical functions) and a prominent cornice serving as a culmination or coda. It is the transparency of the design-its formal articulation of function—that made it paradigmatic of the supposed ration ality both of modern commerce and of modernism in architecture.

"Form even follows function," wrote Sullivan, in his 1896 essay, "The Tall Office Building Artistically Considered," meaning that the formal articulation of parts, as well as the details of ornamentation must derive from the uses to which

14.28 St. Louis, Missouri, Wainwright Building, by Louis Sullivan, 1800–01

14.29 Chicago, Carson, Pirie, Scott and Company department store, by Louis Sullivan, 1898–1904: detail of ironwork facing and canopy

a building is put. The motto surely lay behind his own other commercial and office buildings such as the Carson, Pirie, Scott and Company Store-originally Schlesinger and Mayer—in Chicago (1898–1904), and a number of buildings by his colleagues and competitors in Chicago, especially Burnham and Root (Daniel Burnham, 1846-1912; John Welborn Root, 1850-1912) architects of the Reliance Building (1894-95) and Holabird and Roche (William Holabird, 1854–1923; Martin Roche, 1853–1927), designers of the Marquette Building (1893–94). Though the latter edifice lack the organic ornament of Sullivan, their façades admirably express their internal functions. The Reliance Building, in fact, its surface dematerialized by glass and white terracotta into a mere woven curtain, expresses on the outside the steel skeleton within that supports the whole structure. (It also invokes the mythic origin of architecture, according to Gottfried Semper, in the warp and weft of textiles.)

But what sets Sullivan apart from his estimable contemporaries, as the architectural historian David van Zanten has observed, is his embrace of an ornamental exuberance, especially visible on the street level of Carson, Pirie, Scott, that

greatly exceeds the pure expression of function. Sullivan's ornament—twisting and writhing overlays and arabesques of ribbons, tendrils, acanthus, beads, shells, ivy, ferns, palm fronds and starbursts—hearkens to an earlier moment in the history of European architecture and design. It encapsulates the debate—basic to the age of industry—between the ideal, organic form-types of Christopher Dresser and the contingent, plant forms of William Morris. For the one, nature supplies a repertoire of pre-existing forms that modern art and industry may reproduce and elaborate at will. For the other, plant and animal forms are the products of history and processes of evolution, and can no more be organized into a single coherent system than can human beings and their societies. The debate—elaborated in the fervid and unsettled ornament of Carson, Pirie, Scott and elsewhere-was not settled until the second and third decades of the twentieth century, when a new, so-called International Style put paid to the language of organicism and the dream of handcraft and joy in labor. Sullivan's Midwest buildings and system of ornament were a last gasp of the Romantic dream of emancipation from the thrall of the machine.

Modern Art and Life

· 15 ·

MANET AND THE IMPRESSIONISTS

EDOUARD MANET AND HAUSSMANNIZATION

Edied there in 1883, a lifespan largely coincident with the modernization of the French capital. Until 1850, Paris was still in many respects medieval: its streets were narrow and twisting, many houses were made of wood, and water and sewage facilities were inadequate at best. As the population of the city grew—it reached one million by 1836 and one and a half million by 1856—city squares, parks, and cemeteries were built over, seriously restricting the healthy passage of light and air and the movement of people and goods. The progress of commerce and industry and the battle against tuberculosis and cholera were thus seriously compromised at mid-century, by the occluded urban pattern and decrepit infrastructure of Paris.

All this began to change in 1852. Within days of the Napoleonic *coup d'état*, the Emperor announced a massive public works project to redesign and rebuild the city of Paris. Implemented under the supervision of a city superintendent, Baron Georges Haussmann, the campaign—which lasted for the entire Second Empire—resulted in the construction of new water and sewer systems, the cutting of new boulevards and the straightening and widening of old ones, the installation of street lighting, the creation of parks and transportation hubs and the building of new, speculative residential and commercial structures.

In addition to improving health and transportation, the intention of the Emperor and his superintendent was to secure popular consent or obedience to undemocratic rule: the public works program provided employment for thousands at a time of massive unemployment, and the urban renewal broke up the radical communities that existed in the Cité and the

Faubourg St.-Antoine, among other places. The rebuilding of Paris was thus a strategic as much as it was an economic endeavor, and while it may not be strictly true, as many at the time believed, that the boulevards were straightened to facilitate the flight of cannonballs, the idea cannot have been wholly absent from the minds of the governors of a city that had already witnessed three revolutions in as many generations. Indeed, those fine, straight avenues were put to efficient use during the mass executions that followed the defeat of the Paris Commune in the late Spring of 1871, as shown by Manet in his drawing called *The Barricade* (ca. 15. 1871).

The social and cultural, as much as the economic and strategic, effects of Haussmannization (as the rebuilding came to be called) were tremendous. Within a generation, Paris became the place we know today, a city of fashion, elegance, effrontery, and detachment. Architectural homogeneity replaced urban syncretism; class segregation replaced social integration; a blasé public attitude replaced a changeable and energetic mien. Where rich and poor had once lived in relative proximity, they were now increasingly separated from each other, the former in the smart new apartment blocks lining the grands boulevards on the right bank of the Seine, and the latter in the houses and tenements of the communes annexées, such as Ménilmontant, Belleville and La Villette, outlying the city. Whereas in former times the center of the city was marked by the confused crush and din of carriage traffic, travelers, beggars, entertainers, and street hawkers of every kind—old clothes men, crockery menders, dog barbers, and others—it was now, as Baedeker's wrote, "a far less noisy place than many other large cities . . . [a place of] comparative tranquility." Whereas in a previous age, the signs of social class, occupation, and sexual availability were instantly readable in costume and deportment, the mass-produced

15.4

clothes sold in the new department stores, combined with the growth of a lower middle class between bourgeois and proletarian, made such identifications more difficult. The city became a place inhabited by strangers, orphans, and refugees.

The extent of the erosion of the rich and complex symbolic life in Paris during the Second Empire can easily be exaggerated. The fear and disparagement of modernity, after all, are integral parts of modern culture itself, and can be traced, as Raymond Williams has shown, to the time of Piers Plowman if not before. Alarms concerning urban desecration and alienation in Paris were being issued by Victor Hugo in the preface to Nôtre-Dame de Paris from 1830 and by Balzac in Les Petits Bourgeois a decade later. Nevertheless, the appearance in Paris of a number of strange and neurotic symptoms at approximately mid-century would seem to point to the uniqueness of the changes that overtook the capital at this time. "Flaneurie" and modernist painting are two related examples of this symptomatology.

Seeking to cushion themselves against the shocks of capital, or to carve out an identity in an environment increasingly bereft of social markers, a number of individuals, including the poet Baudelaire and the painter Manet, adopted the subcultural stance of the flâneur. The very embodiment of the modern male individualist "become more and more himself," the *flâneur* was a perpetual idler, browser, or window-shopper who saw the city of Paris as a spectacle created for his entertainment, and judged commodities to be icons made for his veneration. "The street becomes a dwelling place for the flâneur," Walter Benjamin has written:

he is as much at home among the facades of houses as a citizen is in his four walls. To him the shiny, enamelled signs of businesses are at least as good a wall ornament as an oil painting is to a bourgeois in his salon. The walls are the desk against which he presses his notebooks; news-stands are his libraries and the terraces of cafés are the balconies from which he looks down on his household after his work is done. That life, in all its variety and inexhaustible wealth of variations . . . [thrived] among the grey cobble streets and against the grey background of despotism.

The *flâneur* slowly strolled the streets of Paris, scrutinizing everything he saw, like a detective searching for clues to help him solve a mysterious crime. In such difficult cases, every piece of evidence counts: the cut of a sleeve or trouser, the sheen on a piece of satin, the trim of whiskers, and the depth of a plunging neckline are all prerequisite for the discovery of identity in a city of strangers. And the work of detection in Paris was all the more subtle and rewarding given the meagerness of the signs of social and psychological difference on display, as, for example, in the Tuileries park, in Manet's

15.1 EDOUARD MANET The Barricade, ca. 1871. Watercolor and gouache, $18\frac{3}{8} \times 13\frac{1}{8} (46.5 \times 33.4)$

Music in the Tuileries (1862), or on a balcony, as in his 15.2 A Balcony (1868-9).

In Music in the Tuileries, perhaps the "earliest true example of modern painting in both subject matter and technique," as the art historian and curator Françoise Cachin wrote, Manet has interspersed his many fashionable friends and acquaintances among a larger cross section of elegant society. Manet himself stands at the far left, brush in hand; Baudelaire stands in lost profile, coincident with the largest tree at middle left; beneath him sit the Mmes. Lejosne and Loubens, distinguished wives of notable men in government and education; Eugène Manet—the painter's brother—also stands in profile, bowing and facing left in the middle right foreground; seated just to the right is the composer Jacques Offenbach, with moustache, no beard, and neatly circumscribed by the largest tree at middle right. The painting constitutes, in brief, a kind of Parisian, elite roman à clef, in which the table is turned upon the *flâneur*; now he is subject to perusal; now his costume and features—hidden beneath a blur of white, black, and tan and a confused tangle of phallic trees (or exclamation points!)—will be spied for signs of class and temperament.

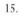

15.2 EDOUARD MANET Music in the Tuileries, 1862. Oil on canvas, $30 \times 46\frac{1}{2}$ (76 × 118)

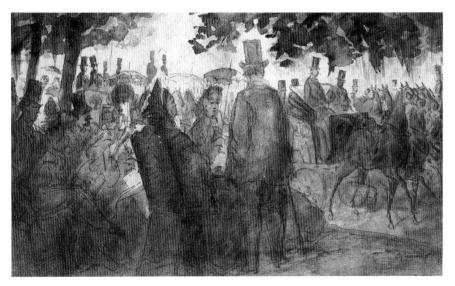

15.3 CONSTANTIN GUYS *The Champs-Elysées*, 1855. Oil on paper, 9½ × 16¾ (24.1 × 41.6)

15.4 (opposite, above) EDOUARD MANET A Balcony, 1868–9. Oil on canvas, $66\frac{1}{2} \times 49\frac{1}{4}$ (169 × 125)

A similar reversal of the position of seer and seen is effected 15.4 in *A Balcony* (and in Cassatt's *Woman in Black at the Opera:* see pp. 357–8). There, two women dressed in white with green accessories, a man in black with blue cravat, a servant in the upper left shadows, and an uncertain breed of dog at the lower left, all pose behind a green iron balcony and between green shutters. The seated woman is the painter Berthe Morisot

(1841–95), whose particular keenness of vision and insight would be revealed in her paintings of the next decade. They cast their eyes left, right, and center in imitation of the shifting gaze of the bewildered spectators who saw the work at the Salon of 1869. "This contradictory attitude [of the two women in *The Balcony*]," Castagnary wrote, "bewilders me. . . . Like characters in a comedy, so in a painting each figure

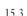

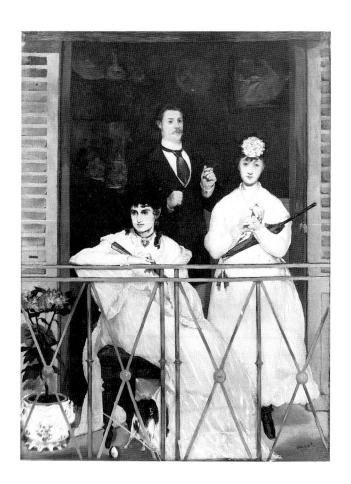

must be in place, play its part and so contribute to the expression of the general idea." Manet would accept no such circumscribed role for his women characters or for himself. He pursued the much vaunted principle of individualism even at the cost of public incomprehension, comforted that he lived and worked among like-minded artists and writers on the borderland between bohemia and high society.

Artists like Manet and the painter and graphic artist Constantin Guys (1802-92)—who worked outside of the institutional framework of the Academy-were natural flaneurs; they had no fixed occupation and hardly even a settled abode, traveling between home and studio and vagrantly searching the city for models and motifs. "The crowd is his domain," wrote Baudelaire about Guys, author of the vacuous drawing The Champs-Elysées (1855), "as the air 15.3 is for birds and water is for fish. His passion and his profession is to marry [épouser] the crowd." Like Baudelaire, the male artist-flaneur was a politically contradictory figure. By virtue of his furtive insinuation into the middle of the crowd, and his deadpan style and humor, the flaneur was a minor thorn in the side of a despotic regime that survived on the pageant of manipulated consent. He was, for the most part, no patriot and no cheerleader, and was totally lacking in ingenuousness. Yet he was at the same time an eager propagandist for modernity and thus of some use: by believing with his entire

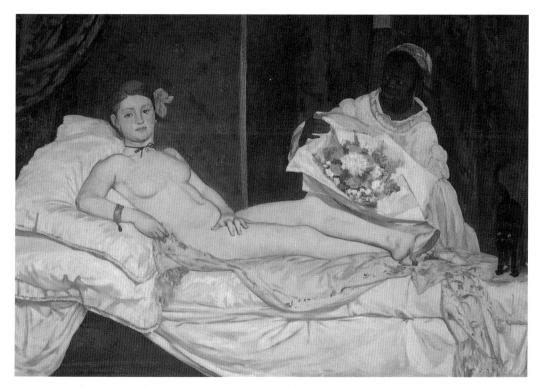

15.5 EDOUARD MANET Olympia, 1863. Oil on canvas, 513/8 × 747/8 (130.5 × 190)

heart and soul that the mass-produced clothes slung across the mannequins in the Au Bon Marché department store or draping the sloped shoulders of the good bourgeois on the Boulevard des Capucines contained the clues to a unique identity, he was accepting and propagandizing the commodity fetishism that buttressed both the dazzling facade of the Second Empire and its "grey background of despotism." Paris was both phantasmagorical and dictatorial; it was a perpetual-motion machine that seemingly worked its magic as Delacroix had noted at the 1855 Exposition—entirely of its own volition and independent of the labor of workers or the struggle of classes and genders. Paris, with its gaslighted boulevards and omnibuses, glass-fronted stores that functioned like reliquaries, glass-roofed arcades that resembled Gothic cathedrals, and mock festive café-concerts with names like Alcazar, El Dorado, and Ambassadeurs, was a modern city born of the commodity and dedicated to keeping that fact a secret. Flaneurie was complicit in commodity fetishization and intrigue, as was the artist Manet in these pictures.

OLYMPIA

At times, however, Manet appeared to resist the given structures of class and gender ideology, thereby achieving something of the individualism or autonomy which he and 15.5 his contemporaries claimed to seek. Olympia (1863, exhibited 1865), which immediately eclipsed his own Déjeuner sur l'herbe (1863) as the most notorious painting in the history of art, is the case in point. It depicts a naked white woman reclining on a bed gazing at the viewer, and a clothed black woman holding a bouquet of flowers and gazing at Olympia. A black cat arches its back at the lower right, a green drape is drawn back at the upper left, and a partition and curtain fail to meet in the middle—behind Olympia—permitting a glimpse into an alcove or waiting area beyond. The plane of the bed upon which the protagonist lies is almost exactly parallel to the spectator's line of sight, and the bedclothes at lower left and dressing-gown at lower right cascade into the viewer's space. The painting's composition is thus rather mechanically balanced between left and right, and top and bottom, further highlighting by contrast its immodest or imbalanced subject.

The handling of paint in *Olympia* is as discordant as its contents and composition. Whereas academically approved Salon painting was generally highly polished, with its brush-strokes invisible and its forms smoothly modeled, *Olympia* presents something of the appearance of an *ébauche* (preliminary, rough underpainting), with its clearly distinct touches of color and abrupt contrasts of tonality, as on the nude's shoulders, breasts, belly, and hips. In addition, the

bed-clothes, dressing-gown, nude body, and paper are all hard and angular, like the drapery in works by the early Flemish painters. The overall pictorial effect of this refusal of modeling and subtle chiaroscuro, as well as of the mechanically poised compositional elements and angularity, is a flatness and ungainliness such as found in "primitive" and children's art or in Epinal prints. Like Courbet, then, Manet has sought refuge and resource in the naive and the popular: therein lies his avant–garde suit to the Salon public, one very different from the disingenuous entreaties of Academic and Official art.

The times were inauspicious for popular art, however, and Manet's *Olympia*—exhibited alongside his *Christ Mocked* at the 1865 Salon—was lambasted by the critics: "We find him again this year," wrote the usually sensible Jules Claretie, "with two dreadful canvases, challenges hurled at the public, mock-eries or parodies, how can one tell? Yes mockeries. What is this Odalisque with a yellow stomach, a base model picked up I know not where who represents Olympia? . . . A courtesan no doubt." Another critic, cited by T. J. Clark in his indispen-sable study of the picture, spoke of Olympia as "a courtesan with dirty hands and wrinkled feet . . . her body has the livid tint of a cadaver displayed in the morgue; her outlines are drawn in charcoal and her greenish, bloodshot eyes appear to be provoking the public, protected all the while by a hideous Negress."

Manet indeed provoked critics and bourgeois public alike by his subversion of the genre of the nude and his rejection of the received ideas of sex and race. To depict nudes, "fallen" and alluring women, was, we have seen, common enough in nineteenth-century France. Couture, who was Manet's teacher between 1850 and 1856, had made a courtesan the focus of his 1847 Romans of the Decadence, and by 1865 the Salon walls would have seemed half-bare without their full complement of dissolute Venuses, Bacchantes, Nymphs, Sapphos, Salomes, Dianas, and Odalisques, by the likes of Bouguereau, Cabanal, and Paul Baudry. In addition, before the decade ended, the sculptor Jean-Baptiste Carpeaux (1827-75) and the painter Claude Monet (1840-1926) ventured to create what they believed to be more naturalistic representations of female figures—naked, clothed, and in ensemble. In both Carpeaux's The Dance (1867-9) and 15. Monet's Women in the Garden (1866-7) women are represented in counter-clockwise orbit around a central axis; in the Monet, the fashionable women encircle a slender and animate tree, and in the Carpeaux around an adolescent male personifying "the Genius of Dance." When Carpeaux's sculptural group on the facade of the new Paris Opera was unveiled in 1869 it caused a scandal by what was seen as its "immodesty," "realism," and modernity; in fact, it was profoundly influenced by Raphael, Michelangelo, and Bernini, and formed part of the decorative ensemble of the very building that symbolized the regime of Napoleon III with all its imperial and Classical pretensions. Monet's early Impressionist *Women in the Garden* was also rejected, by the jury of the Salon, reportedly because of its potential to corrupt youthful artists, despite its Classical and hierarchically structured composition. Images of women—painted, sculpted, academic, and modern—positively dominated the visual culture of the Second Empire, but none was so controversial as Manet's.

The practise of depicting "negresses" in art, though less common, was nearly as longstanding and revered as the representation of "fallen" women: black women began to appear in painting, sculpture, and the decorative arts in the middle of the eighteenth century as allegories of Africa or in order to signal the presence of illicit or animal-like sexuality. By the early nineteenth century, when racist theories of polygenesis (the notion of the separate biological origins of humans) prevailed, they represented lasciviousness and evolutionary retardation. Delacroix, for example, whose colorism and expressive drawing style profoundly influenced Manet, had depicted a turbaned black African serving woman in his hothouse Women of Algiers. By the early Second Empire, black women became almost ubiquitous in the Orientalist pictures of Ingres, Gérôme, Chassériau, and Eugène Fromentin, among others. In 1870, the young

15.6 Jean-Baptiste Carpeaux *The Dance*, 1867–9. Stone, height $13'9^{3/8}$ (420)

15.7 Frédéric Bazille $\it La$ Toilette, 1870. Oil on canvas, 83×79 (211 \times 201)

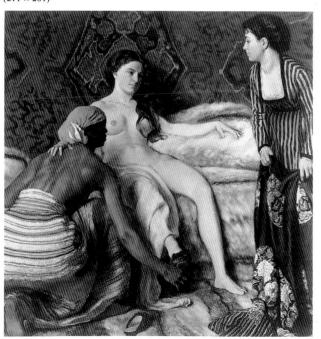

Impressionist Frédéric Bazille (1841–70) painted *La Toilette* in which a black woman at the lower left—perhaps the same Laura (last name unknown) who posed for Manet—is shown dressing a naked and voluptuous white woman in the center. (The composition, as well perhaps as the subject, is derived from the central figural group of Courbet's *Toilette of the Bride*, 1865, which depicts the preparation of a body for burial.) Unlike these artists, however, Manet offered his male spectators neither secure art historical moorings nor any patriarchal consolation in *Olympia*.

The body of Olympia lacked pliancy and suppleness, suggesting instead an independent sexuality which emerged, as a critic wrote, "[from beneath her] hand flexed in a sort of shameless contraction." She was not a grand courtesan paid to confirm the myths of masculine desire, but a proletarian who owned only her labor power and her sex. And as such, critics argued, she was subhuman: "A sort of female gorilla . . . ape[s] on a bed," wrote one, "a monkey," wrote a second, and "a corpse . . . from the [working-class] Rue Mouffetard," stated a third. The repeated references to Olympia's blackness and simian aspect suggest that a critical elision

between the nude and the West Indian maid has occurred. The body of the lower-class prostitute and the body of the Afro-Caribbean woman, according to Manet's interlocutors, were linked by their common dégénérescence, that is, by their combined intellectual, physical, and moral depravity, morbidity, and inferiority. (Black women and prostitutes were widely understood, according to the science of the day, possess congenitally deformed genitals to preconditioned them to hypersexuality.) Each was judged more grotesque than the other and harbingers of the feared degeneracy which, according to the respected doctor Bénédict Augustin Morel—author of the Treatise on Degeneracy (1857)—was infecting French society as a whole. Manet's picture represented something of that decay, and for that reason—as well as for its overall pictorial strangeness precipitated the very complicated, fantastic, and idiotic chain of criticisms that constituted its scandal.

In the end, it must be observed that Manet's *Olympia* was probably more modern than it was avant-garde, in the senses those terms have been used here. Although it represented two proletarian women, they were of the politically ambiguous *lumpen* variety; though it employed the two-dimensionality of popular art, it did so within the confines of a genre—the nude—that was, for all its rebarbativeness in Manet's case, still constitutive of the old class and gender

hierarchies; and finally, though Olympia incited a frenzy of shrill critical antagonism, it did so in the name of no other clearly particular social class, political principle, or oppositional ideology. Manet did not succeed in fashioning a new, artistic public sphere in 1865; still less did he create a new sort of history painting to replace the once exalted and now moribund genre. "You are only the first in the decrepitude of your art," wrote Baudelaire to him in 1865 and, indeed, Olympia was a suitable end and beginning of painting. It marked the conclusion of a heroic tradition of art for an enlightened bourgeois public, and the origins of a modern art that instead denies or negates the verities of that class's rule. In addition, it signaled the (temporary) end of the Courbetist dream of a Realist art for the masses, and the beginning of an equally idealist dream of an autonomous art intended for a society of free individuals.

IMPRESSIONISM AND THE COMMODITY

Like the *flaneur* Manet, the Impressionists were determined to discover for themselves a semblance of the individual freedom, self-determinacy, and sensual pleasure that constituted the utopian legacy of enlightenment and revolution. Unlike him, they generally lacked irony and guile, seeing in

15.8 CLAUDE MONET Regatta at Argenteuil, 1872. Oil on canvas, $19 \times 20^{1/2}$ (48 × 75)

15.9 CAMILLE PISSARRO *Hoarfrost*, 1873. Oil on canvas, $25\% \times 36\%$ (65×93)

15.10 Claude Monet Women in the Garden, 1866–7. Oil on canvas, $8'4 \times 81~(255 \times 205)$

the existing urban, and especially the suburban, spaces of modernity the dream-terrain of that quest. "Early Impressionism," as Meyer Schapiro wrote:

had a moral aspect. In its discovery of a constantly changing phenomenal outdoor world of which the shapes depended upon the momentary position of the casual or mobile spectator, there was an implicit criticism of symbolic social and domestic formalities, or at least a norm opposed to these. It is remarkable how many pictures we have in early Impressionism of informal and spontaneous sociability, of breakfasts, picnics, promenades, boating trips, holidays and vacation travel. These urban idylls not only present the objective forms of bourgeois recreation in the 1860s and 1870s; they also reflect in the very choice of subjects and in the new aesthetic devices the conception of art as solely a field of individual enjoyment . . . for an enlightened bourgeois detached from the official beliefs of his class.

The Impressionists were indeed individualists who lacked the world-historical ambition, Romantic fervor, and avant-garde convictions of the two previous generations of French and European artists. Born around 1840, they were too young to be firebrand quarant-huitards, but were old enough to watch in shock and horror (mostly from a safe distance) the Prussian dismemberment of France in 1870-71, and the French massacre of its own citizens during the suppression of the Commune that followed. They beheld the industrialization of agriculture in the provinces and the Haussmannization of urban space in Paris, and understood that the old France of agrarian autarchy and distinct urban quartiers was no more. To all of these events and transformations, they responded for the most part with the officially approved mix of nostalgia for the old and complacency at the new. The Impressionists were thus in the main passive witnesses of, or willing propagandists for, the emerging and modern "forms of bourgeois recreation" of their day, but the acuity of their observation and the depth of their enthusiasm was such that they nevertheless managed to precipitate a crisis of representation that ended only with the severance of the formerly existing relationship between art and its public.

The term Impressionism, used after 1874 to define the group of eponymous artists, derives from the word *impression*, which Emile Littré defined in his *Dictionnaire* (1866) as "the more or less pronounced effect which exterior objects make upon the sense organs." In 1870, the word was applied by the critic Théodore Duret to Manet: "He brings back from the vision he casts on things an impression truly his own. . . . Everything is summed up, in his eyes, in a variant of coloration; each nuance or distinct color becomes a definite

tone, a particular note of the palette." Duret thus described two aspects of Manet's art that have already been considered: first, its utter individuality, and secondly, its structure of discrete color "notes" juxtaposed against, but not blended with, their adjacent tone. The dual nature of Impressionism also underlay Castagnary's celebrated description of the thirty artists who exhibited together for the first time under the name Société Anonyme at the Paris studios of the photographer Nadar in 1874: "They are Impressionists in the sense that they render not the landscape but the sensation produced by the landscape. . . . [The Impressionists] leave reality and enter into full idealism." By "idealism," as the art historian Richard Shiff has shown, Castagnary meant the individualism of the artists, that corresponded to their technique of laying down a mosaic of colors and forms determined by the peculiar impression of the exterior world upon their sense organs.

In 1874, therefore, the term Impressionism connoted a vaguely defined technique of painting and an attitude of individualism shared by a group of allied artists unofficially led by Manet (who, however, never exhibited with them). Indeed, the two definitions are aptly conjoined, since the formal and technical innovations of the movement effectively served to represent an ideal of personal pleasure and individualist freedom. These innovations may be summed up under three rubrics: 1) the rejection of chiaroscuro; 2) the depiction of the interaction of light and color *en plein air*; and 3) the equalizing of brushstrokes across the surface of the canvas.

1) Academic painting depended upon chiaroscuro (the modeling of form and space through light and dark gradation and contrast) for its drama and putative three-dimensionality. In the early stages of their paintings, academically trained artists employed a dark, often reddish brown underpainting in order to establish a deep pictorial space even before they painted anything else. By proceeding to leave areas of shadow thinly painted and areas of mass thickly painted with bright colors and highlights, they were able to establish strong contrasts between dark and light, shadow and mass, and far and near. In Monet's Regatta at Argenteuil (1872) and 15. Hoarfrost (1873) by Camille Pissarro (1830–1903), by 15 contrast, a light-toned underpainting—creamy yellow in the first case and gray in the second—is employed instead of the conventional reddish brown. In addition, dark tones are largely eliminated from the mixtures of hue, and paint is applied in a fairly uniform thickness all across the surface of the picture. The effect of these changes from academic practise, in conjunction with others noted below, is greatly to reduce tonal contrast in the pictures and thereby to flatten them. Although Monet and Pissarro include fore-, middle-, and backgrounds in their Regatta and Hoarfrost, their

elimination of chiaroscuro causes us to see all three zones as lying on approximately the same shallow, foreground plane.

2) Before the nineteenth century, artists drew but rarely painted out of doors. By the middle of the century, the painting of small outdoor études was common to Corot and the Barbizon school, and to the "Pre-Impressionist" painters Eugène Boudin and I.-B. Jongkind, who were active in Normandy. Yet these artists seldom painted fully finished compositions out of doors, and equally rarely exhibited their études at the Salons. The Impressionists, on the other hand especially Monet, Pissarro, Pierre-Auguste Renoir (1841-1919), Morisot, and Alfred Sisley (1839-99)—painted many of their most ambitious works en plein air, and discovered a technique for evoking the interaction of light and air in nature. Monet's Women in the Garden, considered earlier for the conservatism of its subject and composition, was nevertheless almost unprecedented in its depiction of colored shadows and light. Painted almost entirely en plein air (the artist actually dug a trench into which he could lower the work so as to paint its upper reaches without changing his point of view), Women in the Garden features colored shadows and the juxtaposition of warm and cool hues to achieve modeling of faces and hands. The dress of the woman at left is tinted green from the filtration of light through the canopy of trees, and the shadows on the dress of the seated woman in the foreground are tinted violet, the complement of the yellow light of the sun. The women's faces and hands, as well as their bouquets of flowers, are made vivid by the juxtaposition of similar, and especially complementary, colors—red/green, blue/orange, and yellow/ violet—and by the use of thick, broad patches of paint. The optical effect of complements, which are pronounced in Regatta at Argenteuil (red/green) and Pissarro's Hoarfrost (vellow/violet), was described by Monet in 1888: "Color owes 15.9 its brightness to force of contrast rather than to inherent qualities; . . . primary colors look brightest when they are brought into contrast with complementarities."

3) Most paintings submitted for exhibition at the Salons had a surface that was smooth, clean, and impersonal, whereas most paintings shown at the eight Impressionist exhibitions held between 1874 and 1886 had coarse, irregular, and idiosyncratic surfaces. Indeed, as much as for its rejection of chiaroscuro and its embrace of *plein air*, Impressionism was notable in its day for the use of discrete patches (*taches*) of color. To be sure, a loaded brush and impasto technique were deployed by Rubens and Rembrandt among many other artists from the past, but rarely had they covered their works with such a density of paint regardless of the subject depicted. In Pissarro's *Corner of a Village in Winter* (1877) and Renoir's *Bal du Moulin de la Galette* (1876) the entire canvas surface is densely clotted with paint. Individual brushstrokes are varied in width, breadth, and direction, and the pictorial field is

uniformly animate, agitated, and immediate. The complex and dynamic Impressionist *tache* was largely responsible for the incomprehension and anger of the critics: "Seen up close [Pissarro's landscapes] are incomprehensible and hideous;" wrote Léon de Lora in 1877, "seen from a distance they are hideous and incomprehensible." "I recommend Renoir's *The Swing* [1876]," wrote Bertall (Charles Albert d'Arnoux) in 1876, "sublime in its grotesqueness . . . and *Bal du Moulin de la Galette*, which is in no way inferior to his other work in its incoherence of draftsmanship, composition, and color."

In the face of the reigning formal and technical paradigms of Salon art, Impressionism offered nothing less than a redefinition of the pictorial. If the Classical and academic tradition insisted that a picture should be a recreation in two dimensions of the three-dimensional world, that is, if painting was previously conceived as first and foremost mimetic, Impressionist art was first of all optical. In 1876, the poet Stéphane Mallarmé wrote an essay entitled "The Impressionists and Edouard Manet," in which he precisely described Impressionism as the return of art to its "simplest perfection:"

The scope and aim . . . of Manet and his followers is that painting shall be steeped again in its cause, and its relation to nature. But what, except to decorate the ceilings of saloons and palaces with a crowd of idealized types in magnificent foreshortening, what can be the aim of a painter before everyday nature? To imitate her? Then his best efforts can never equal the original with the inestimable advantage of life and space. . . . [That] which I [the artist preserve through the power of Impressionism is not the material portion which already exists, superior to any mere representation of it, but the delight of having recreated nature touch by touch. I leave the massive and tangible solidity to its fitter exponent, sculpture. I content myself with reflecting on the clear and durable mirror of painting, that which perpetually lives yet dies every moment, which only exists by the will of Idea, yet constitutes in my domain the only authentic and certain merit of nature—the Aspect.

Although sculpture may be fit to reproduce the tactile qualities of nature, Mallarmé's ideal Impressionist argues, painting is not. It can only focus upon "the clear and durable mirror of painting," that is, upon the flattened, optical screen which constitutes the artist's field of vision; the Impressionist painter's responsibility and delight is to reproduce nature's "aspect" touch by touch.

The Impressionist world, according to this view, is one which cannot be manipulated, grasped, or even touched, except with the eyes. It is a world where use-value has been banished, and exchange-value—which posits the universal

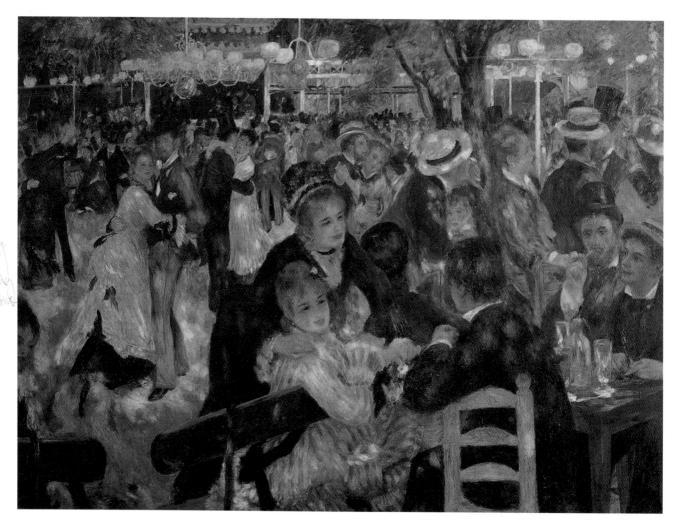

15.11 AUGUSTE RENOIR Bal du Moulin de la Galette, 1876. Oil on canvas, $51\frac{1}{2} \times 68\frac{7}{8}$ (131 × 175)

equality of things—enshrined instead. For the Impressionist painter, nature and the built environment appear as commodity-forms, or fetishes (as defined by Marx), alienated from the biological processes or human labor that brought them into being. Indeed, Impressionist optics and style—defined by their negotiation and compromise between hues across the flat expanse of the picture surface—may be said to repeat the mistaking of illusion for reality that constitutes the basis of commodity fetishism. In the first volume of *Capital* (1867) Marx described the "mysterious character" of the commodity-form as consisting in the fact that it (mis)represents the social and class relations of the human labor that produced it as an autonomous relationship between things:

Through this substitution [by the social relations between objects for the social relation between producers], the products of labor become commodities, sensuous things which are at the same time suprasensible or social. In the

same way, the impression [Lichteindruck] made by a thing on the optic nerve is perceived not as a subjective excitation of that nerve but as the objective form of a thing outside the eye.

Impressionist art is precisely concerned with the bestowal of a phantasmagorical reality upon "the objective form of thing[s] outside the eye." In 1883, the poet Jules Laforgue described the magic of Impressionist color:

In a landscape flooded with light . . . where the academic painter sees nothing but a broad expanse of whiteness, the Impressionist sees light as bathing everything not with a dead whiteness, but rather with a thousand vibrant struggling colours of rich prismatic decomposition. Where the one sees only the external outline of objects, the other sees the real living lines built not in geometric forms but in a thousand irregular strokes, which at a distance, establish life. . . .

The Impressionist sees and renders nature as it is—that is, wholly in the vibration of color. No drawing, light, modelling, perspective or chiaroscuro, none of those childish classifications: all these are in reality converted into the vibration of color and must be obtained on the canvas solely by the vibration of color. . . . [In the work of] Monet and Pissarro, everything is obtained by a thousand little dancing strokes in every direction like straws of color—all in vital competition for the whole impression.

The fetishistic character of Impressionist art, with its "real living lines" which "establish life," has of course been revealed by its subsequent commercial and institutional history. As early as the mid-1880's, the French dealer Paul Durand-Ruel, backed by the financier Charles Edwards, succeeded in establishing an international market for Impressionist works, with exhibitions and sales in Berlin, Boston, New York, Rotterdam, and London, as well as Paris. Indeed, the key years for the transformation of French art dealers from petty tradesmen to international entrepreneurial capitalists coincided with the rise and success of Impressionism. (To this day, works by Monet, Renoir, Degas, and the others are common tender in the international art market.) Moreover, the exchange-value represented by Impressionist art did not remain circumscribed by the narrow confines of the trade. Since the beginning of the twentieth century, the forms and imagery of Impressionism have informed and invigorated the publicity apparatus of many of the key culture and leisure industries of Europe, North America, and (more lately) Japan, including suburban, vacation, and retirement homes, travel and tourism, automobiles, home gardening, sportswear, and health and exercise products. The modern bourgeois world, it may be claimed with only slight exaggeration, has modeled itself upon the "aspect" of Impressionism.

But the gift of ideology has not been all in one direction. The triumph of modern tourism and leisure has also tended to inform prevailing interpretations of Impressionism, masking the genuinely counter-cultural and even subversive aspects of the movement. Indeed, in the years between its first (1874) and third (1877) exhibitions, the self-proclaimed Société Anonyme was often dubbed in the press "the Intransigents," a term from the contemporary political lexicon, as I have shown elsewhere, meaning radical, anarchist or communist. "At first they were called 'the painters of the open air'," wrote the critic Marius Chaumelin in 1876. "They were then given a generous name, 'Impressionists,' which no doubt brought pleasure to Mlle Berthe Morisot and to the other young lady painters who have embraced these doctrines. But there is a title which described them much better, that is the Intransigents. . . . They have a hatred for classical traditions and an ambition to reform the laws of drawing and color. They preach the separation of Academy and State. They demand an amnesty for the 'school of the *taches*,' of whom M. Manet was the founder and to whom they are all indebted." With less irony, the critic for the official *Moniteur Universel* flatly stated: "The Intransigents in art holding hands with the Intransigents in politics, nothing could be more natural."

At the same time that these critics were condemning the Impressionists as political Intransigents, Mallarmé was applauding them for the same reason. In the essay cited above, he forthrightly argued that Impressionist art was an expression of working-class—not bourgeois—vision, and a celebration of the newly emergent ideology of collectivism:

At a time when the romantic tradition of the first half of the century only lingers among a few surviving masters of that time, the transition from the old imaginative artist and dreamer to the energetic modern worker is found in Impressionism. The participation of a hitherto ignored people in the political life of France is a social fact that will honour the whole of the close of the nineteenth century. A parallel is found in artistic matters, the way being prepared by an evolution which the public with rare prescience dubbed, from its first appearance, *Intransigent*, which in political language means radical and democratic.

To Mallarmé, therefore, Impressionism marked a new stage in the social and cultural evolution of France; it was an art of "truth, simplicity and child-like charm," he wrote, which affirmed and paid homage to the mode of vision of a new and surging working-class "multitude [which] demands to see with its own eyes."

Two conflicting interpretations of Impressionism thus appear to be on offer: one situates the movement beside the other early manifestations-vaudeville shows, spectator sports, World's Fairs, and Sundays in the country-of the emergent culture of commodity capitalism; the other locates the movement within the radical confines of the avant-garde, accepting Mallarmé's contention that Impressionism-by rejecting Classical mimesis and Romantic fantasy-was the vision and voice of an increasingly self-conscious and confident proletariat. In fact, both interpretations have validity, because modern capital has consistently fed from the plate of the avant-garde. From its shaky origins in Haussmannized Paris, to its swaggering maturity today, mass (commodity) culture has learned about what desires it can exploit from observation of the ways in which avant-gardes and other subcultures devise strategies for self-fulfillment and individual expression. Impressionist leisure and vision—with its easefulness, unproductiveness, ephemerality, intangibility,

15.12 GUSTAVE CAILLEBOTTE A Balcony, Boulevard Haussmann, ca. 1880. Oil on canvas, $26\frac{3}{4} \times 24$ (67.9 × 61)

luminosity, colorism, and overall opticality—was one such strategy for sensual emancipation and personal pleasure that could not be ignored. It was not, and a certain part of the world was eventually made over into its image.

As for the artists themselves, they resisted labels of all kinds; by the mid-1880's, the shifting alliance of men and women that first coalesced in 1874 had rejected the names Société Anonyme, Impressionist, Intransigent, and even Independent, preferring to designate the various group and solo exhibitions simply by the word "Exhibition." Indeed, the group's struggles over nomenclature signal the presence of a specifically modernist, formal strategy of evasiveness, displacement, effacement, and abstraction. In their art as well as their ideology, the Impressionists sought refuge on the margins or in the shadows: they cultivated the borderlands of city and country at Montmartre or Gennevilliers (where the solid waste of Paris was spread as manure), as in Morisot's sketchy Laundresses Hanging Out the Wash (1875); they spied from balconies or crouched in woodland glades, as in A Balcony, Boulevard Haussmann (ca. 1880), by Gustave Caillebotte (1848-94), and Pissarro's Edge of the Woods, or Undergrowth in Summer (1879); and they secreted themselves backstage at the ballet, or amid the crowd outside the Bourse, as in The Dance School (1873) and Portraits at the Stock Exchange (ca. 1879) by Degas (1834–1917).

15.1

15.1

15.13 Camille Pissarro Edge of the Woods, or Undergrowth in Summer, 1879. Oil on canvas, $49\% \times 63\%$ (126 × 162)

In the latter two works, exhibited respectively at the third and fourth Impressionist Exhibitions in 1877 and 1879, Degas displayed his peculiar naturalist and conspiratorial penchants. The dancers are so many diverse examples of a single common species; they bend, stretch, gaze vacantly, scratch, bite thumbs, practise at the bar, and stand on toes. The alien character of Degas's dancers is perhaps even more apparent in the dozens of mostly small wax figures he made between approximately 1870 and his death. His Little Dancer Aged Fourteen (ca. 1881), the only sculpture by him exhibited in his lifetime, was described by critics as a "monkey," and "a monster . . . [from] a museum of zoology." In Portraits, Degas has chosen to examine another modern institution—no less exotic and marked with dégénérescence than the world of the ballet the Stock Exchange. "A few minutes before noon," writes Baedeker (1882), "the Place de la Bourse begins to present a busy scene . . . [as] the money-seeking throng hurries into the building. . . . [Inside], amidst the Babel of tongues, are heard the constantly recurring words '7'ai . . . ; qui-est qui a . . . ? je prends; je vends!"" Standing on the threshold of the Bourse, the Iewish banker and art collector Ernest May is shown receiving a note from a man in front of him (actually only a detached hand and profile head), and a conspiratorial tap on the shoulder from a man behind (Nochlin has defined the gesture as "confidential touching"). In the wings at left are two more figures whose prominent noses and abbreviated brows connote-according to the physiognomic and psychological theories of the day—both degeneracy and Jewishness. (Indeed, in 1881 Degas depicted a similar pair of heads in pastel and called them Criminal Physiognomies.) In Portraits at the Stock Exchange, therefore, Degas has indulged that most pernicious and consequential of modern myths-announced by the "Young Hegelian" philosopher Bruno Bauer in 1843, reiterated by Marx, and espoused as gospel by a subsequent generation of anti-Semites that included the notorious Frenchman Edouard Drumont and Degas: "The Jew, who may be entirely without rights in the smallest . . . state, decides the destiny of Europe." "Anti-Semite" was in fact the only label that Degas ever wholeheartedly embraced, but for him as for others it too functioned as a disguise, hiding class and gender antagonisms behind a false brotherhood built upon a common hatred.

Fortunately, Impressionist evasiveness and disguise were rarely so paranoid and humorless as they were with Degas. More often they involved mysterious masks at fancy-dress balls and preposterous boating clothes at the dockside as in Manet's Masked Ball at the Opéra and Argenteuil (1874); at other times, they took the form of bathing costumes worn by the petit bourgeois at La Grenouillère, a popular bathing spot on the Seine, near Bougival, painted in 1869 by Monet and Renoir, or else of garishly illumined evening clothes at caféconcerts such as the Folies-Bergère, painted by Manet in his last major work, A Bar at the Folies-Bergère, shown at the 15.17 Salon of 1882. Indeed, café-concerts, which were popular hang-outs for Degas, Manet, and the young Georges Seurat, were devised precisely in order to accommodate disguise: "Here [at the café Eldorado] amid volumes of smoke," the guide-book author Galignani informed the tourist in 1862, "the blouse and the frock-coat are conspicuous, interspersed here and there with a muslin cap and merino gown, listening to the comic scenes, or snatches from favorite operas, retailed to the audience by the performers."

The Bar by Manet, with its recalcitrant mirror and equally refractory barmaid, reveals a complex understanding of class and gender that is also apparent in works by Berthe Morisot. In the Bar, as in Morisot's The Psyché (1876), a woman stands before a mirror that fails accurately to reflect her. The barmaid who confronts the spectator is upright and poised whereas her mirror image is bent forward in unsavory conversation with the top-hatted customer at right. Moreover, the location of the barmaid and reflected dandy implies that the mirror is curved, whereas the reflections of the bottles and the marble-top bar suggest that it is flat or parallel to the picture surface. The result of this purposeful ambiguity (the painted study in Amsterdam has the reflection approximately right), and of Manet's studied indifference to face painting, is the creation of a peculiar tension—a sense of "detachment," as T. J. Clark writes—between the barmaid and her glittering modern ambience. Unlike Galignani's securely classed café

15.14 EDGAR DEGAS Little Dancer Aged Fourteen, ca. 1881. Yellow wax, cotton skirt, satin ribbon, wooden base, height 39 (99.1)

IMPRESSIONISM AND THE COMMODITY . 345

15.14 EDGAR DEGAS
Portraits at the Stock
Exchange, ca. 1879.
Oil on canvas, 39½8 × 32½8
(100 × 82)

15.16 EDGAR DEGAS The Dance School, 1873. Oil on canvas, $19 \times 24^{5/8}$ (48.3×62.5)

346 · MANET AND THE IMPRESSIONISTS

15.17 EDOUARD MANET A Bar at the Folies-Bergère, ca. 1882. Oil on canvas, $37\frac{3}{4} \times 51\frac{1}{8} (96 \times 130)$

15.18 BERTHE MORISOT Laundresses Hanging Out the Wash, 1875. Oil on canvas, 13 × 16 (33 × 40.6)

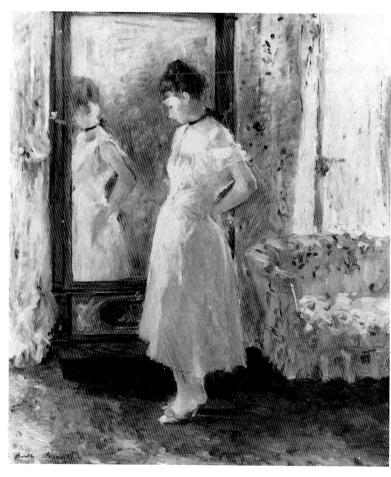

15.19 The Psyché, 1876. Oil on canvas, $25\frac{1}{4} \times 21\frac{1}{4}$ (64 × 54)

patrons, she wears her costume and expression uneasily, and the (male) spectator responds with doubts about the stability of the game of class and gender which he plays.

In Morisot's painting, too, the empirical validity of "the mirror of painting," in Mallarmé's phrase, is challenged. The woman who stands bunching her loose peignoir before the psyché mirror, exposes a seductively supple shoulder, downcast eye, and pouty mouth, whereas the image in the mirror reveals no such conventional signs of coquetterie (save the Olympia-like neck ribbon). Instead of celebrating the masculine prerogative to see and the feminine responsibility to be seen, therefore, Morisot's toilette paintings such as this one expose the artifice and irony of modern painting made by a woman. To paint a picture, Morisot seems to claim, is no more, but also no less, than artistically to adorn one's own body. In both The Bar at the Folies-Bergère and The Psyché the established circuits of sexual seeing and knowing —of temptation and desire—are crossed and produce a spark of insight. Café-concert and boudoir are thus alike in modern Paris; they are the places where class and gender—at once hidden and revealed by the fashionable dazzle of electric lights, trapeze, make-up, and lace-are made over into commodities to be bought and sold like so many bottles of beer or bolts of chiffon.

Impressionisme is a masculine noun, Larousse tells us, but in its intimacy with fashion and the commodity it was gendered feminine. Indeed, among the greatest practitioners of Impressionism, only Berthe Morisot and to a lesser extent Mary Cassatt managed to escape the withering criticisms flung at the movement. Praised for possessing charm, sensibility, grace, and delicacy, paintings by the two women were exempted from the usual charge against Impressionist works, that they were merely unfinished sketches. Impulsiveness, sensuousness, and lightness of touch were deemed essential to women's nature and therefore wholly appropriate in Impressionist works by women. Thus in addition to the marginality and elusiveness described above, a final transgressive feature of Impressionism must be noted: unlike contemporary Salon painting, it did not wholly reiterate the prevailing gender stereotypes about artmaking. Impressionism's chief practitioners were either males who painted in a style judged appropriate only for women, or women who painted with the ambition and conviction which it was then thought could be found only among men. Cassatt, however, went still further: she actually painted the liberation of women, and in so doing helped turn American painting from a local into an international achievement.

· 16 ·

ISSUES OF GENDER IN CASSATT AND EAKINS

LINDA NOCHLIN

GENDER AND DIFFERENCE

THE TENSIONS, OPPOSITIONS, AND ACHIEVEMENTS ▲ of American painting of the late nineteenth century can best be approached through an examination of two of its major practitioners—Mary Cassatt and Thomas Eakins. A careful analysis of their work also reveals the difficulty of making clear-cut stylistic distinctions in high art based on either national origin or gender. Of course, until recently, the question of national origin—what is American about American art?—might have loomed much larger than that of gender. In recent years, on the contrary, the fact that Cassatt was a woman artist has been central to the more complex and problematic readings of her work by such revisionist art historians as Nancy Mowll Mathews and Griselda Pollock. Yet it seems to me that there is no better way of exploring the vexed issues of American-ness versus the cosmopolitanism represented by the French vanguard of the period or male versus female production than in exploring, in detail, the lives and works of these two artist-contemporaries, so alike in their ambitions and stature, so unlike in their choice of milieu and their pictorial language.

Mary Cassatt and Thomas Eakins had a good deal in common as far as biography goes. Both were born almost midcentury, in the year 1844; both were born in Pennsylvania; neither had to depend on painting to make a living; both studied at the Pennsylvania Academy of the Fine Arts and later in Europe, Eakins in France with Gérôme from 1866 to 1870, Cassatt traveling to Spain, like Eakins, and to Italy as well, yet basically French in her orientation, settling in Paris in 1866. Both were painters dedicated to the representation of the human figure, primarily the portrait. Yet there are extraordinary differences between them, too, differences inscribed in their work itself, as their self-portraits clearly

reveal (Cassatt's of 1878, Eakins's of 1902). Cassatt came from a much wealthier and more socially prominent family than Eakins; she learned in Paris not from the relatively conservative Gérôme but from the pictorial radicals Manet and Degas; she did not return to conservative Philadelphia to pass the rest of her life, as a loner, like Eakins, but stayed on in Paris where she actively participated in the most advanced painting movement of her time, Impressionism. Indeed, she was one of the most faithful participants in the Impressionist exhibitions, showing with the group in 1879, 1880, 1881, and 1886.

Equally important in establishing the difference between the two is the fact that Eakins was a man and Cassatt a woman. This gender difference seems to me of prime importance in the interpretation of the salient characteristics of their work. Gender difference, however, must not be interpreted as directly expressed in the work in terms of some formal structure or inevitable iconographic choice; nor should gender be understood in terms of essential, fixed, timeless, inborn qualities of masculinity or femininity. Rather, gender must be envisioned as a social construct, mediated by historical conditions and the specific practise of painting. It can only signify through the concrete qualities of pictorial language in specific situations. In other words, the readings must be at once incisive and subtle; forceful yet complex. Nor must the sex of the artist be seen as always and in every circumstance the determining factor. Both Eakins and Cassatt, for example, strikingly reject (whether completely consciously or not) the notion, taken for granted at the time, that the portrait of a woman, especially a commissioned portrait, must be flattering in order to be successful. Both artists seem resolutely to refuse to idealize or prettify their female sitters. In Cassatt's pastel portrait of her friend, the important art collector and suffragist, Louisine Elder Havemeyer (ca. 1896), the sitter is represented as uncompromisingly unglamorous and serious.

16.4

16.1, 2

16.1 Thomas Eakins Self-Portrait, 1902. Oil on canvas, $30 \times 25 \ (76.2 \times 63.5)$

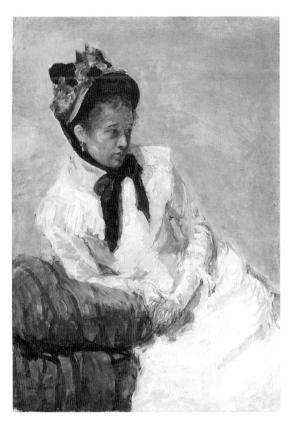

16.2 Mary Cassatt Self-Portrait, 1878. Gouache on paper, $23\frac{1}{2} \times 17\frac{1}{2} (59.6 \times 44.4)$

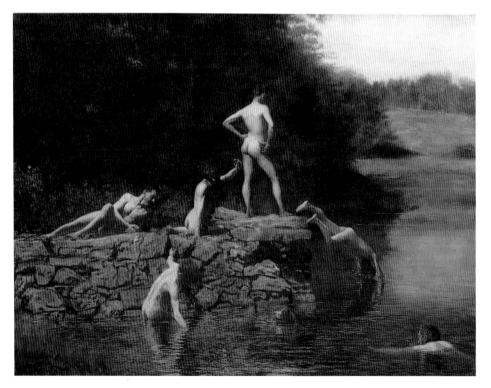

16.3 Thomas Eakins The Swimming Hole, ca. 1883–5. Oil on canvas, $27 \times 36 \ (68.5 \times 91.4)$

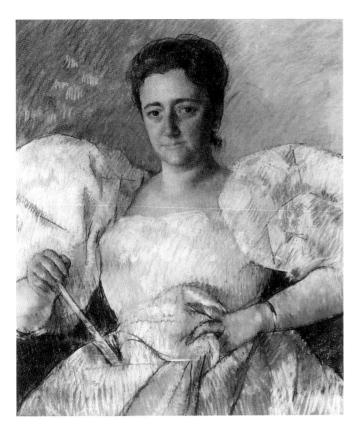

16.4 Mary Cassatt Portrait of Louisine Elder Havemeyer, ca. 1896. Pastel, 29×24 (73.6 \times 61)

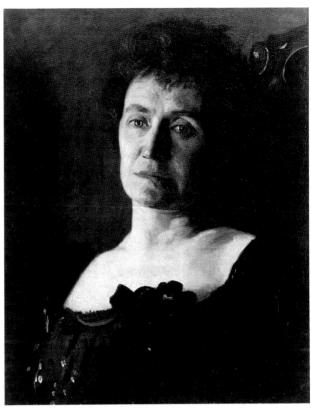

16.5 THOMAS EAKINS *Portrait of Mrs. Edith Mahon*, 1904. Oil on canvas, 20 × 16 (50.8 × 40.6)

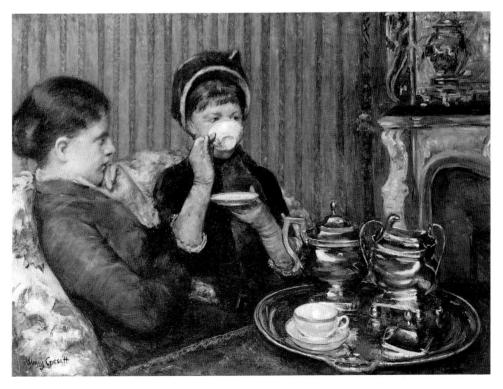

16.6 MARY CASSATT Five O'Clock Tea, ca. 1880. Oil on canvas, $25^{1/2} \times 36^{1/2}$ (64.7 × 92.7)

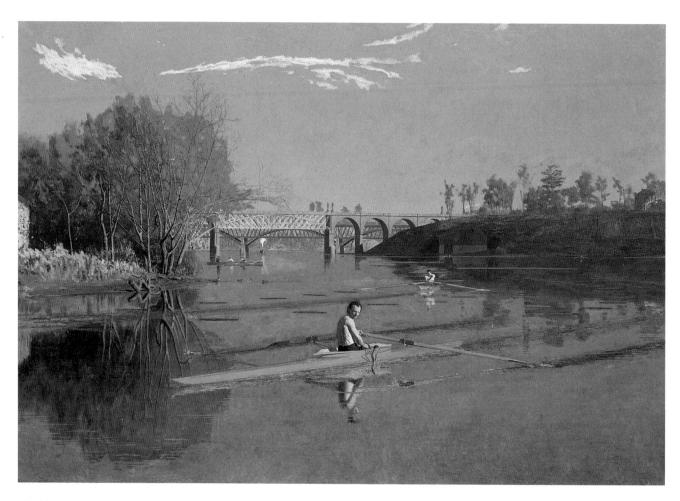

16.7 Thomas Eakins Max Schmitt in a Single Scull, 1871. Oil on canvas, $32\frac{1}{4} \times 46\frac{1}{4}$ (81.9 × 117.5)

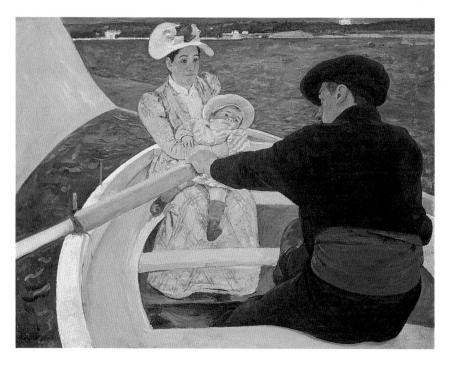

16.8 Mary Cassatt The Boating Party, 1893–4. Oil on canvas, $35\frac{1}{2} \times 46\frac{1}{8}$ (90.1 × 117.1)

16.9 JOHN SINGER SARGENT *Lady Agnew of Lochnaw*, ca. 1892–3. Oil on canvas, $49\frac{1}{2} \times 39\frac{1}{2}$ (125.7 × 100.3)

Mrs. Havemeyer is middle-aged, dark, powerful. Despite the diaphanous white butterfly wings of her puffed-sleeved, low-necked dress, or perhaps in purposeful contrast with them, the somber, square-cut head with its deep-set eyes and irregular yet sensitive mouth conveys a sense of that forceful individual character usually reserved for the male sitter, rather than the conventional beauty and elegance considered appropriate to the upper-class female one; the same might be said, to a lesser degree, of the unbeautiful head, rather like that of a sympathetically introverted bull-dog, and lack of coquettish self-consciousness of the sitter in Eakins's *Portrait of Mrs. Edith Mahon* of 1904.

Yet the two artists seem to me more strikingly different than similar. Often, it is a difference created by the subjects male and female artists were encouraged, or permitted, to paint. Gender difference is easiest to discern when a simple opposition in iconography is involved: young men and boys swimming naked out of doors in Eakins's *Swimming Hole*

(ca. 1883–5) versus ladies taking tea in an elegant parlor in Cassatt's *Five O'Clock Tea* (ca. 1880). But even where it is simply a question of quintessentially "male" versus "female" subject matter, the issue is complicated. Are Eakins's naked men versus Cassatt's tea-drinking ladies reducible to a mere question of gender, to what is permitted to or socially acceptable for the male artist versus the female one? Isn't the issue of class also implicated, or even the artist's relationship to the social order as a totality?

Eakins's *Swimming Hole* projects a heady sense of escape from social constraint through sheer bodily freedom. The youthful male nudes, including Eakins himself in the foreground, are represented modestly, from the back or with strategically bent leg, in the classical *Dying Gaul* posture, and evoke moral qualities of honesty and purity in the out-of-doors context. In other words, in the Eakins painting, democratic freedom is signified by the youthful male American body in the American landscape: to be American is at once

16.6

16.3

16.7

16.8

16.6

to be natural and to have a privileged relation to Nature. In Cassatt's Five O'Clock Tea, a more cosmopolitan sense of the operations of social convention is conveved through the refinement and elegance of pose, setting, and accourrements. Rejecting the timelessness of the nude, or more accurately, deprived of access to the representation of unclothed bodies, Cassatt deploys fashion to define a specific historical moment, a concrete social milieu within the supposed a-historicity of the female domestic realm. Fashion and objects also specify the social milieu: these are not "just folks", not "natural" country women but refined members of the upper class. The painting, featuring the artist's sister Lydia and a visitor, is set in Cassatt's tastefully decorated Parisian drawing-room, with a silver tea-set, an heirloom which had been made in 1813 for the artist's grandmother, Mary Stevenson, prominent in the foreground. Not freedom, but what the poet William Butler Yeats described as "the ceremony of innocence" is recorded here in all its significant detail. One might say that gender difference is always overlaid with and intersected by other kinds of difference as well in the paintings of these two American artists.

The complex nature of the differences between the work of Eakins and that of Cassatt becomes even more obvious when the subjects in question are extremely close or indeed almost identical, as they are in Eakins's Max Schmitt in a Single Scull of 1871 and Cassatt's The Boating Party of 1893-4-an oarsman in a boat on the water. Eakins, in this early painting, was constructing an image to represent the democratic hero, not just a hero of modern life but of American modern life, a theme he was to pursue throughout much of his career. Schmitt was a friend of Eakins and a prominent oarsman, at a time when rowing was becoming increasingly popular in both the United States and France. The painting, one of nineteen by the artist representing the sport of rowing, celebrates a champion. Yet at the same time that it is a portrait of an amateur hero of sport, it may also be said metaphorically to celebrate Eakins's recent return from France to his native turf, specifically the Schuylkill River and the banks of Fairmont Park. Schmitt had just won an important and well-attended race of single sculls, so the portrait commemorates a specific victory, but in the larger sense it also celebrates the moral and physical virtues of rowing—above all, single-scull rowing as a demanding sport which provided a much-needed respite from the crowds and urban confusion then seen to threaten the American citizen. The social historian Jackson Lears has pointed out the prominent position occupied by sport in the putative redemption of the decadent American male psyche in late nineteenth-century medical and social discourse: "To a bourgeoisie feeling enervated and fearful of lower-class unrest, the worship of force presented paths to class revitalization . . . the mania for sport reinforced bourgeois values of discipline and productivity . . . Outdoor exercise seemed the perfect antidote to 'morbid self-consciousness' and excessive mental work."

Cassatt, on the other hand, cannot be said to celebrate the heroic virtues of sport, much less its prophylactic qualities, in her painting: on the contrary, her oarsman is hired help, distinguished as a member of the working classes by his sash and beret. Although the oarsman is prominent in the foreground of the painting, the figure is certainly not meant as a portrait: one can only glimpse his face in *profil perdu*. Rather, this rower's effort is constructed as part of a scene of leisure, of which the "real" subjects are the charming and fashionably dressed mother and child in the front of the boat. Yet even these differences in intention and iconography cannot account for the striking dissimilarity in total effect created by these works, a dissimilarity in which the construction of gender may play only a partial role.

For Eakins, a more traditional painter, the canvas functions as a transparent window through which we see a vividly reconstituted three-dimensional space, with a vanishing point drawing our eye to the horizon. Near, middle, and distant space are constructed within this illusory world: brushstrokes are rendered modestly invisible in their task of conveying the glassy surface of the water, the fuzzy texture of autumnal trees, the fluffiness of clouds, the diaphanousness of air, the solid flesh and blood of the portrait subject himself, isolated in the fictive solitude at the center of the painting. We, the viewers, are positioned at a seemly distance from the subject; we move into the pictorial world over a period of time.

Cassatt's work, on the contrary, taking its cue from Manet's Boating of 1874, erases space and eradicates the temporal factor suggested by Eakins's. Cassatt erases as well the meaningful, narrative implications of spatial depth and temporal endurance produced by shadow, modeling, and linear and aerial perspective, in favor of surface, immediacy, and focus on the formal means of construction. Boat and figures are tilted up onto the surface of the canvas: Manet and Japanese prints rather than nature rendered through traditional perspective lie behind this construction; the horizon is almost, but not quite, obliterated in the interest of destroying depth. Shapes, forms, and color-areas are boldly reiterated as focal factors: the cut-off sail is related both to the triangular shape of the boat's bow and the woman's hat; the lines of the thwarts reiterate horizontally the diagonal of the oar; the varying blue shapes of the oarsman's suit, his sash, the bottom of the boat and the flat, textured surface of the water create interrelated flat patterns. Cassatt, as opposed to Eakins, is resolutely antidepth, whether we take this word literally or metaphorically, and thus her project must be related to that of the French avant-garde of her time in a way that Eakins's most definitely cannot.

Before turning to a detailed analysis of Eakins and Cassatt as portrait painters, a few words are in order about the portrait in general and the portrait in the nineteenth century specifically. The Western tradition of the portrait, which reached its full development with the stress on individualism initiated by the Renaissance, obviously tells us as much about the artist—the period when, the place where he or she is working, the patron who commissioned the image or the free choice of subject—as it does about the sitter represented.

By the late nineteenth century, the portrait genre could also establish the social class of the sitter, as it does most notably in two works by Sargent and Van Gogh respectively, *Lady Agnew of Lochnaw* (ca. 1892–3) and *La Berceuse (La Mère Roulin)* (1889). Aside from fulfilling the obligation to body forth their respective artists' stylistic identities, these portraits also constitute iconic models for identifying "the aristocrat" versus the "working-class" woman.

Did the American-born cosmopolite John Singer Sargent (1865–1925) accept commissions to paint only lovely women? Or was the veil of glamor he cast over his female subjects merely an essential element of the *imaginaire* of upper-class appearance of his time, an element contravened, it must be added, by the portraiture of both Eakins and Cassatt? In portraits of American aristocrats, like Mr. and Mrs. I. N. Phelps Stokes (1897), Sargent skillfully established a new iconography of elongated, fine-limbed, casually superior beauties, ancestors of those young women whose sheer physical confidence, not to speak of social self-assurance, were to give girls from Brooklyn like me an inferiority complex at Vassar half a century later. That there are no ugly members of the upper classes is the lesson these suavely painted portraits teach, although admittedly, the artist seems to have had to work harder deploying what Henry James referred to as his "pure tact of vision" when the subjects were even slightly marginal—Jewish, for example—like Ena and Betty, Daughters of Mr. and Mrs. Asher Wertheimer (1901). Here, the smallest hint of a thick waist, a short neck is raised but quickly obliterated by dazzling brushwork and overpowering elegance of setting and costume. But of course, these people are merely rich, not born aristocrats.

Sargent stirred up a rich pictorial brew, concocted from ingredients drawn from the European tradition of aristocratic and high bourgeois portraiture of the seventeenth and eighteenth centuries—Velázquez, Van Dyck, and Hals—and spiced with more up-to-date precedents, like those offered by his teacher, the fashionable French portraitist Carolus-Duran, as well as, more discreetly deployed, those of Manet and Monet. Clearly, he was offering the wealthy clients who commissioned his portraits up-to-date esthetic value for their

money as well as a mere likeness. In the exemplary case of Lady Agnew, the physicality of the body of the sitter is almost denied, dissolved by pale, diaphanous or silky fabrics. The delicate amethyst of the huge but simple jewel about Lady Agnew's throat is repeated in the mauve-violet sash about her waist and the bows on her sleeves; this pale simplicity is enlivened by the printed silk fabric of the chair she sits in as well as the exotic pale blue Chinese hanging which marks the back plane of the portrait, adding a touch of esthetic refinement to the scene.

The sitter's class position is signified through the sheer physical grace of her being as well as by dress and decor: her impossibly slender waist, her lovely dark eyes set beneath perfectly modeled dark brows, her delicate features haloed by a cloud of tastefully coiffed dark hair. The frankness of her glance reveals—nothing. The well-brought up woman gives nothing away. Her pose is at once dignified yet relaxed, the désinvolture of her posture emphasized by her asymmetric placing on the chair, an asymmetry which nevertheless does nothing to lessen her casual dominance of the pictorial space. All of this bespeaks wealth and breeding, a classy portrait of a high-class woman: the portrait of a lady, in short.

16.10 JOHN SINGER SARGENT Ena and Betty, Daughters of Mr. and Mrs. Asher Wertheimer, 1901. Oil on canvas, $73 \times 51\frac{1}{2}$ (185.4 × 130.8)

16.11 THOMAS EAKINS *Miss Van Buren*, 1891. Oil on canvas, 45×32 (114.3 \times 81.2)

16.12 THOMAS EAKINS Portrait of Benjamin Howard Professor Rand, 1874. Oil on canvas, 60×48 (152.4 × 121.9)

Van Gogh, on the contrary, establishes the working-class credentials of La Mère Roulin by emphasizing the proletarian maternal stockiness of her body, the angularity and awkwardness of both her pose and his draftsmanship, the crude, burning oppositions of the color relationships and the honest expressive directness of the material application of the paint itself. La Berceuse is indeed one of the artist's group of works in which he explores the relatively novel notion that the lower classes were as much entitled to the commemorative homage of portraiture as their "betters." Following the precedent established by English graphic artists of the time, he announced his intention to create "portraits of the People," uncommissioned images which, in his view, engaged that specificity of individual appearance and character, as well as that aura of spiritual dignity, up to this time deemed a specifically middle- and upper-class privilege.

As early as the first decade of the nineteenth century, the inspired and inventive French portraitist Ingres had constructed pictorial configurations to establish gender difference as an easily readable variable: in the case of the portraits of a husband and wife like the Rivière couple (*M. Rivière* and *Mme. Rivière*, both 1807), by means of relatively subtle but telling differences in pose, relation to space, drawing style, and elaboration of decorative texture.

Eakins too, in his portraits, established subtle yet powerful signifiers of difference for the representation of male and female sitters (Miss Van Buren, 1891, and Portrait of Professor Rand, 1874). Miss Van Buren is a being wrapped in her own thoughts, a representative of the inner world rather than the outer one of practical intellect represented by the professor. She muses or meditates, without specific focus, diffusely, resting her head on her hands, her posture slightly off balance; he, on the contrary, thinks, his attention studiously concentrated. Professor Rand, a physician, had been Eakins's chemistry and physics teacher in high school and later joined Dr. Gross at Jefferson Medical College in Philadelphia. His character is defined by his intellectual and worldly achievement. The painting crackles with energy, as though charged with the intellectual concentration of its subject. Details like the microscope and the test-tubes establish Dr. Rand's professional credentials: this is a portrait à l'apparat. His studiousness and concentration are attested by his glasses, slightly wrinkled forehead, and his forefinger pressing down the pages of the book he reads with such relentless singlemindedness, and by the firmness of his grasp on the cat (pet or object of scientific observation? we are unsure just which) on the table before him.

If, to paraphrase the title of the art historian Elizabeth Johns's study of Eakins, the artist's male sitters are indeed in some sense "heroes of modern life," conceived of as active contributors—professionals, artists, religious dignitaries—to

16.13 MARY CASSATT Woman in Black at the Opera, 1880. Oil on canvas, $31\frac{1}{2} \times 25\frac{1}{2}$ (80 × 64.8)

the welfare of democracy and humanity, then his women subjects, like those represented in The Coral Necklace, The Old Fashioned Dress (Portrait of Helen Parker) (ca. 1908) or Mrs. Edith Mahon (1904), act as a kind of counterweight, a contrary and supplementary force. On them is laid the burden of inwardness, of diffuse if subtle emotionality, of passive acceptance of or resistance to life and its depredations. A common inner anxiety, an air of longsuffering-ness-of martyrdom, even—a veiled appeal self-withdrawal seems to characterize all of Eakins's female sitters. The same half-conscious awareness of time and its depredations—the past for the mature, the future for the women sitters—scars them all, holds them in wistful yet uneasy bondage.

CASSATT AND THE GAZE

.11

Nothing would seem more different in pose, glance, and the spatial setting associated with refined femininity in Eakins's *Miss Van Buren* than the image created by Cassatt in her 1880 portrait of a young woman at the opera (*Woman in Black at the Opera*). Cassatt's woman is all active, aggressive looking. At a

16.14 THOMAS EAKINS The Concert Singer (Weda Cook), 1892. Oil on canvas, $75\frac{3}{8} \times 54\frac{3}{8}$ (191.4 \times 138.1)

time when women were rarely understood to possess what recent psychoanalytic theory has denominated as "the power of the gaze," Cassatt has given it forcefully and completely to her opera-goer. She holds the opera-glasses, that prototypical instrument of male specular power, firmly to her eyes; even her fan is somewhat raised in the tense excitement of her active looking (as opposed to the relaxed horizontal position of the fan locking Eakins's Miss Van Buren into the enclosure created by the arms of her overpowering chair). Energy, control, the vividness of active looking, even the suggestion of veins standing out beneath the glove on the wrist of the hand which grasps the opera-glasses; all this and the forcefulness of the dark silhouette against the light of the house behind: one can see this portrait in some way functioning as a self-image of the modern woman artist herself.

This is not to say that Eakins never represented what one might call "heroines of modern life." He did paint portraits of women singers, most notably in *The Concert Singer (Weda Cook)* (1892). But although Cook is shown actively performing, on the stage, she is in some sense figured as less active, less self-propelled than Cassatt's *spectator* of the performance in *Woman in Black at the Opera*. As Johns has pointed out, the pose of the singer is a relatively pliant, wavering one rather

16.14

16.15 AUGUSTE RENOIR *The Loge*, 1874. Oil on canvas, $31\frac{1}{2} \times 25\frac{1}{8}$ (80 × 64)

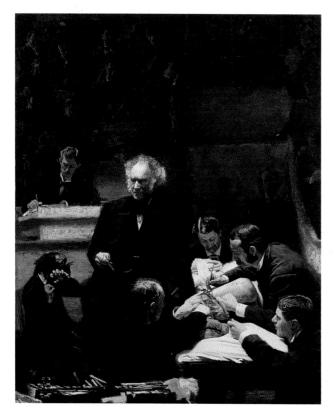

16.16 THOMAS EAKINS *The Gross Clinic*, 1875. Oil on canvas, 96×78 (243.8 \times 198.1)

than a posture of easy command. She seems to have surrendered her separateness to the spell of what she is doing. To put it another way, Eakins interprets the female singer as the instrument of the music that flows forth from her rather than as a creator in her own right. Indeed, this notion of instrumentality is carried further by the presence of the male hand to the lower left, meant as a synecdochal reference to the otherwise invisible orchestra leader. Yet the hand can also be read as a sign of masculine control and dominance; it is, in fact, the hand of Weda Cook's teacher, Dr. Schmitz: his almost unseen masculine presence figures as the active, generating force of the artistic creativity bodied forth in the painting.

Cassatt's painting stands out as something of an anomaly even within the context of (male) Impressionist painting itself. Renoir's vision of a lovely young woman at the opera in *The* Loge (1874) positions her clearly as the object of the masculine viewer's gaze, both within the paintings and outside it; it is the male companion who has the privilege of wielding the operaglasses. In the same artist's First Evening (1876), similar to Cassatt's painting in its profile representation of a young woman at the opera, the subject is depicted as though relegated by youthful shyness to a sheltered position in relation to the viewing audience, rather than pressing tensely forward to satisfy her own visual concerns. Cassatt, in fact, emphasizes the novelty of her construction of the feminine subject here by including in her painting the conventional male viewer watching the young woman; but he has no effect on her independence or self-motivation.

EAKINS AND THE AMERICAN HERO

Eakins, on the contrary, in his major portrait of a hero of modern life, *The Gross Clinic* (1875), positions the one woman in the composition as the one—the only one—who *cannot* look, who *will* not look. As the mother of the young victim undergoing the operation, she functions both as the repository of feeling and as the signifier of a momentary, irrational reaction to the event: the figure whose loss of control, as she is hysterically swept away by emotion, is opposed to the reasoned, longterm attention to ends and means embodied in the sober and restrained male medical personnel and audience, all of whom have their eyes fixed dispassionately on the business at hand.

In this, possibly his greatest portrait, specifically a group portrait, and certainly his most ambitious attempt to depict the heroic quality of American professional achievement, Eakins obviously turned to the precedent established by Rembrandt in his famous portrait of a professional group, the *Anatomy Lesson of Dr. Tulp* (1632). But aside from the fact

that Eakins is representing a more philanthropic and practical activity in line with nineteenth-century American standards of heroism—a life-saving operation on a living person rather than an anatomical demonstration carried out on a corpse—he has changed the format of his illustrious prototype from horizontal to vertical, thereby changing the focus from concentration on the group of observers and the corpse to the isolated, light-revealed hero, Dr. Samuel D. Gross, who is represented performing an operation—the removal of a piece of dead bone from the thigh of a child—in the cavernous amphitheater of Jefferson Medical College in Philadelphia. The scene is an extremely dramatic one, perhaps even melodramatic, and its intensity is highlighted by Eakins's skillful manipulation of his pictorial means—light, space, color, brushwork—to focus on the meaning of the action and its moral overtones. The dominating figure is of course the good doctor who turns from his work to explain some detail of his procedure to an audience of future physicians and surgeons: heroes of modern life in the making, as it were, and the frightening, even the morbid aspects of this challenging feat are directly conveyed not so much by narrative description as by color—the all-over presence of the color red, suggesting blood, token of mortality as well as the life-force at stake. Johns has pointed out that the underpainting is red, there is red in the doorway and in the depth of the amphitheater as well as the blood-stained dressings on the left of the tables; more red in the sawdust box and red in the pen of Franklin West on the left, in Eakins's own pen on the right, and again on the shirt cuffs of the assisting surgeons and on

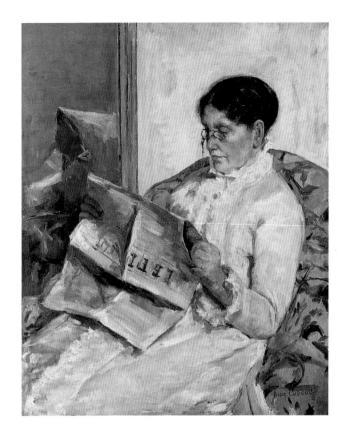

Gross's coat, in the patient's incision, and, as a kind of climax, on Gross's hand and scalpel. As in portraits and self-portraits of artists (to which this may in some sense refer), the paint, as the art historian Michael Fried has shown, is densest and most vivid here, at the site of the working hands of the protagonist.

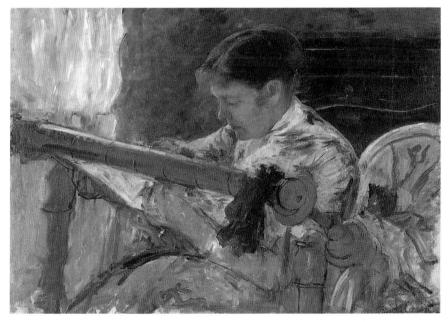

16.17 (above) MARY CASSATT Reading Le Figaro, 1883. Oil on canvas, 41 × 33 (104 × 83.7)

16.18 MARY CASSATT *Lydia Working at a Tupestry Frame*, ca. 1881. Oil on canvas, 25% × 36¼ (65.5 × 92)

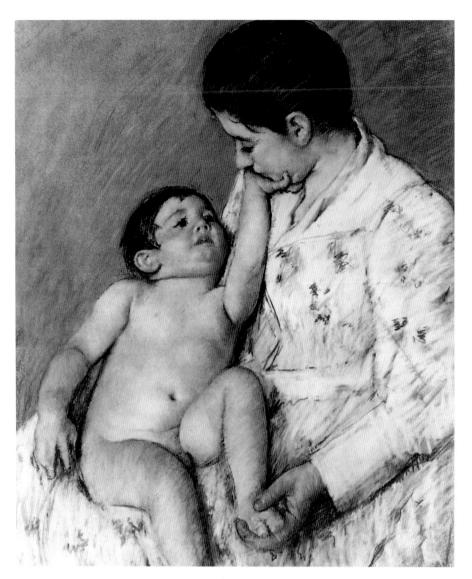

WOMEN AND CHILDREN

For Cassatt, this world of public performance and professional achievement—the male-coded "heroism" of modern life—did not exist as a subject for painting. Her world was the world of women and their children, a world of cultivated, well-bred, upper-class family members, friends, and acquaintances—a world private and intimate in its relationships rather than public and heroic. Yet bound by convention and restriction though this world may have been, there is nothing conventional or restricted about her conception of it, or the formal means she uses to embody it. Cassatt's formal language is at once forceful and sophisticated, whether she is portraying her sister or her mother absorbed in reading or a family friend presiding over one of the rituals of genteel sociability.

Her mother in the dignified, concentrated pose of the

thinker (Reading Le Figaro, 1883) or Mrs. Riddle at her tea table (Lady at her Tea Table (Mrs. Robert Riddle), 1883–5)— both of these older women of considerable presence and dignity—are neither overwhelmed nor oppressed by the passage of time or the ominous shadows of interior space, but are constructed as firmly in control and at ease in their social and pictorial settings. Her sister Lydia is shown calmly absorbed in her tapestry work, or crocheting in the garden (Lydia Working at a Tapestry Frame, ca. 1881, and Lydia 16 Crocheting in the Garden at Marly, 1880).

Yet from the 1880's on, Cassatt did focus on a theme which might be considered the female equivalent of the notion of modern heroism—modern motherhood. In a series of works in oil, pastel, and print, she invented and constructed a gendered alternative for the masculine hero—the female nurturer and her offspring. Two relatively early representations of the motherhood theme, *Emmie and her Child* (1889)

and The First Caress (ca. 1890), reveal Cassatt's Impressionist ability to capture the momentary, the intimate, and the playful; her gift of observation and for creating fresh pictorial equivalents for what she has observed are striking. Later examples from the beginning of the twentieth century (like The Caress, 1902, and Mother and Child, 1908) are more formal, more highly finished, with perhaps certain Symbolist overtones and muted references to the art of the Italian Renaissance which she had admired earlier in her career. In Cassatt's passionate devotion to the nude, childish body, one senses the presence of desire, but a different desire. One might almost speak of Cassatt's lust for baby flesh, for the touch, smell, and feel of plump, naked, smooth-skinned bodies, kept carefully in control by both formal strategies and a certain emotional diffidence, in rare cases—the less successful ones displaced and oversweetened as sentimentality. The psychoanalytic terms "displacement," "repression," and "sublimation" inevitably creep into the discourse when the subject of sexuality is broached in relation to the works of both Cassatt and Eakins. Yet we must be wary of anachronistic readings of the mobility of desire and its objects. For the nineteenth century, the naked bodies of children were often envisioned as simultaneously pure and desirable, as exemplified in the seductively nude or nearly nude photographs of little girls by the English Reverend Dodgson, otherwise known as Lewis Carroll. Although it is tempting to see Cassatt's lusciously nude babies as examples of Freudian "displacement"—to assert that in the absence, in the representational codes of the time, of socially acceptable mature objects of female desire she simply displaced that desire onto immature ones—this may not be the case at all. Desire takes many different forms at different historical moments and in different situations and we decide what is "normal," what "displaced" or "repressed" at our peril. What Eakins and his contemporaries might have envisioned simply as healthy male bonding in the out-ofdoors, in his various representations of naked men, boys, and adolescents, may well be read as homosocial or even repressed homosexual desire today. A troubling female sexuality seems closer to the surface in some of Eakins's proto-Balthusian representations of pubescent or pre-pubescent girls like Home Scene of 1871 (surely based on Courbet's renditions of the daughters of P.-J. Proudhon in his portrait of the anarchist philosopher of 1865) or his Girl With Cat (1872), where the young woman, drenched in shadow, is teasing the animal crouched in her outspread lap, her burgeoning sexuality reiterated by the suggestive shape of the open fan in her hand.

Perhaps nowhere is the theme of mother and child treated with more formal boldness, more emotional restraint than in Cassatt's representations of mothers bathing their children, like two works titled *The Bath* (a print of 1891 and an oil of ca. 1892). One has only to think of all the adult female *Bathers* of

5.21

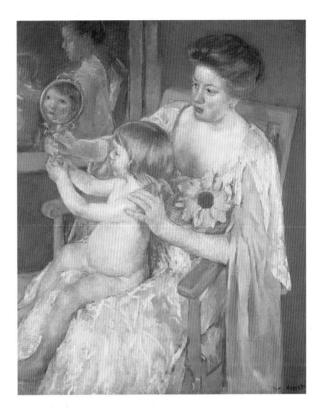

16.20 MARY CASSATT Mother and Child, 1908. Oil on canvas, $36\frac{1}{4} \times 29$ (92.1 \times 73.7)

16.21 THOMAS EAKINS *Girl With Cat*, 1872. Oil on canvas, $62\frac{3}{4} \times 48\frac{3}{4}$ (159.4 × 122.6)

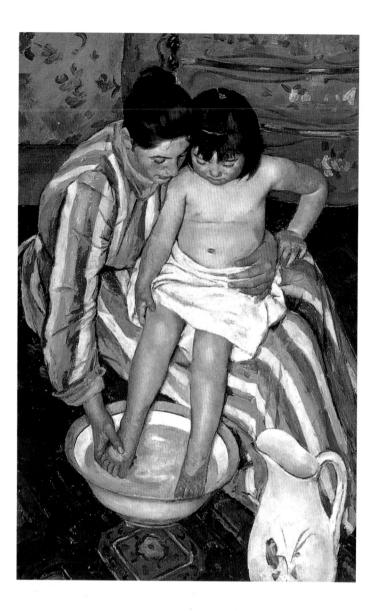

16.23 KITAGAWA UTAMARO A Mother Bathing Her Son, Edo period, eighteenth century. Print, $14\frac{3}{4} \times 9^{7/8} (37.5 \times 25)$

16.22 MARY CASSATT *The Bath*, ca. 1892. Oil on canvas, $39 \times 26 (99 \times 66)$

the period, from Courbet through Degas and Cézanne, to see how Cassatt makes this theme particularly her own. Any of the sentimental clichés natural to this theme, and not always completely expunged from it by Cassatt herself, are canceled in these cases by the lessons of the Japanese Ukiyoe, like Utamaro's *A Mother Bathing Her Son* (eighteenth century), and Cassatt's respect for the formal demands of the surface—carefully deployed in pattern, texture, and color—which moves our eye up and across the canvas rather than into it, or, in the case of the print, the demands of the technically difficult drypoint and aquatint medium.

Indeed, one might say that Cassatt's masterpiece was the series of color prints she executed in etching, drypoint, and aquatint in the beginning of the '90's, at the height of her career (*Maternal Caress*, ca. 1891, and *The Mother's Kiss*, 1891). These prints encapsulate the undramatic events constituting the daily life of the upper-class woman, the

woman of refinement and leisure. They include: playing with the baby; the private preparations of the body or clothing; letter-writing; visiting; and riding on the omnibus. In the latter cases, despite the fact that the subject demands venturing into the outside world of a great city, the female subject is always represented existing within a protected and enclosed—even encapsulated—world. The closed, protected world of genteel womanhood is daringly filtered through the stylized and elliptical rendering of reality characteristic of the Japanese print, whose lessons her friends and fellow Impressionists Degas and Pissarro were also taking seriously at the same time; the artists often shared ideas, technical data, and criticism (The Coiffure, 1891, and The Fitting, 1891). Cassatt transposes the Ukiyoe idiom into her own modern and Western terms, terms in which feminine experience functions as a complete language system, with its own tropes and inventions. Here Cassatt completely erases the meaningful

16.24

narrative implications of temporality, traditionally produced by shadow, modeling or deep space, signifiers of the unfolding of time in painting, in favor of surface, presentness, and antinarrative surface in a series of subjects, which, because of their very unimportance, their antiheroic qualities, lend themselves perfectly to the idiom of modernism (The Letter, 1891, and The Lamp, 1891). The transformation of intimate spaces into formal elegance by means of bold reduction and sophisticated patterning is one of Cassatt's many achievements in these works, like Afternoon Tea Party (1891) or The Omnibus (1891). Worldly sociability, the tête-à-tête of two fashionably dressed ladies, can serve as the basis of a print of great coloristic and compositional subtlety, playing the black of the visitor's jacket against the white of the hostess's gown, which is, of course, created by the white of the paper itself. In The Omnibus, a trip into the world is represented as so protected that the public vehicle, whose open windows provide an admirable formal scaffolding for the composition, is figured like a traveling parlor for elegant mother, baby, and nursemaid, and the city of Paris itself, locus of so much Impressionist attention, functions as a mere backdrop for the domesticated interior.

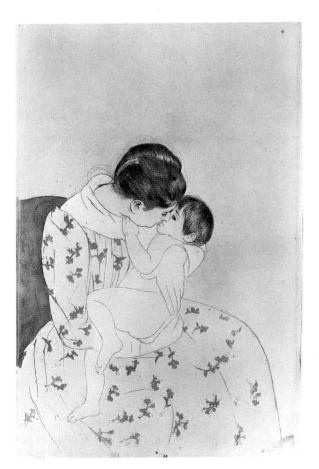

16.24 MARY CASSATT The Mother's Kiss (5th state), 1891. Drypoint and aquatint on paper, $17^{1/8} \times 11^{7/8} (43.5 \times 30)$

CASSATT, EAKINS, AND THE MODERN ALLEGORY

Like Eakins, Cassatt also created an allegorical painting, and, like his, it is an allegory referring to their trade, or craft, or calling—the creation of art. Eakins's William Rush Carving His Allegorical Figure of the Schuylkill River (1877) is an allegory of the past, commemorating a sculptural commission completed in 1809 for the city of Philadelphia. The painting evokes the history and the deeper meaning of artistic creation by means of its shadowy spatial setting with a glinting light which sets the artist himself in vague and enveloping darkness, transforming him into a mere metaphor of the artist in general, and setting his source of inspiration in relative brightness. Color is muted, surface dissolved into suggestive adumbration. Cassatt's, on the contrary, is an allegory of the present and future. Prepared for the North tympanum of the Woman's Building at the World's Columbian Exposition of 1893 in Chicago, Cassatt's mural (later lost or destroyed) was entitled Modern Woman. Cassatt became involved in this monumental project through the intermediary of Bertha

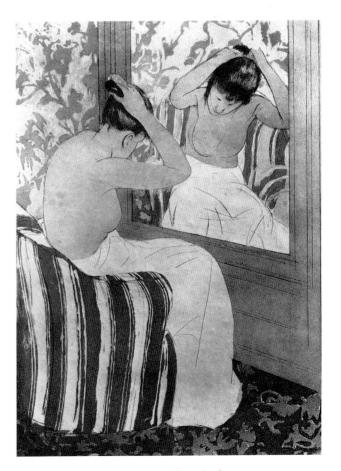

16.25 MARY CASSATT The Coiffure (5th state), 1891 Drypoint and aquatint in color on paper, $19 \times 12^{1/8}$ (48 × 30.9)

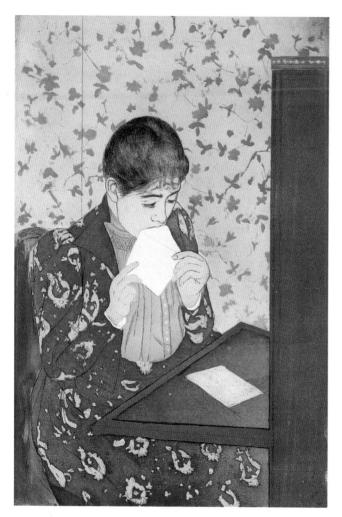

16.27 MARY CASSATT Afternoon Tea Party (4th state), 1891. Color drypoint and aquatint on paper, $16\frac{3}{4} \times 12\frac{1}{4} (42.5 \times 31.1)$

16.28 Mary Cassatt *The Omnibus* (4th state), 1891. Soft-ground etching, drypoint, and aquatint in color, $18\times12^{3/8}$ (45.7 × 31.4)

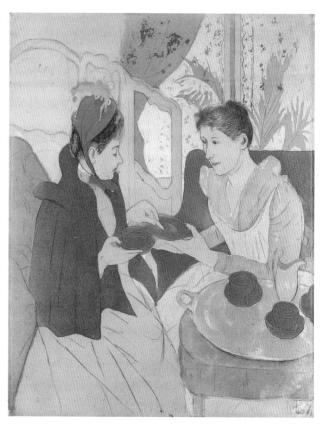

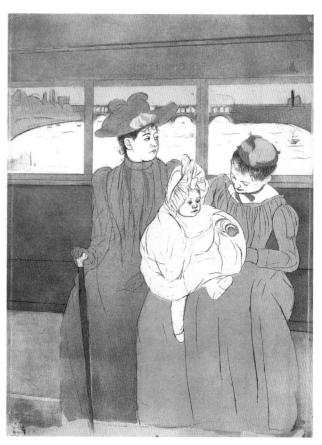

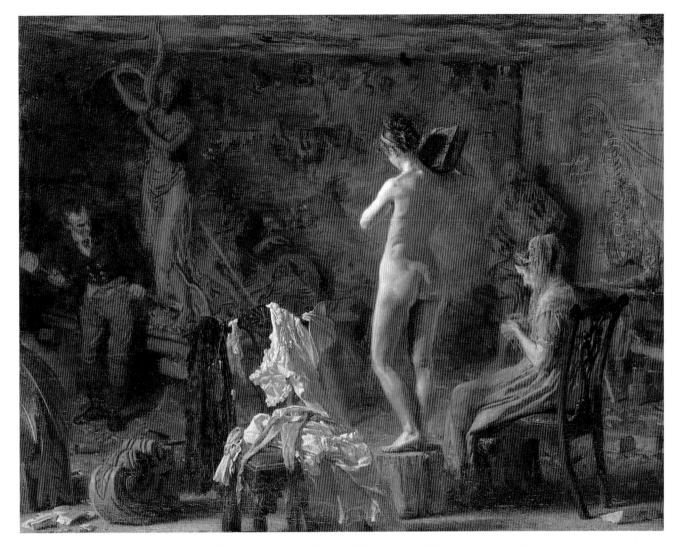

16.29 THOMAS EAKINS William Rush Carving His Allegorical Figure of the Schuylkill River, 1877. Oil on canvas, 201/8 × 261/8 (51.1 × 66.3)

Potter Palmer, a prominent suffragist and member of high society in Chicago who was President of the Board of Lady Managers for the Woman's Building. Mrs. Palmer met Cassatt in Paris in 1892, admired her work, and commissioned her to do one of the two murals for the Hall of Honor (the other, more traditional, theme of "Primitive Woman" being allotted to the more academic Mary Fairchild MacMonies). For the large-scale canvas, which measured about 12 feet by 58 feet, Cassatt had a glass-roofed studio constructed at her summer house in Bachivilliers; as Monet had done for his earlier *Women in the Garden*, she had a trench dug in the studio so that she could raise and lower the canvas as she needed to. By so doing, she secured the advantages of *plein-air* painting and those of monumentality at the same time.

The central panel represented a scene of young women picking fruit, allegorizing the notion of "Young Women Plucking the Fruits of Knowledge and Science" in an Edenlike garden; to the left, in Young Women Pursuing Fame, young women were represented allegorically—and rather humorously—running after what looks like a kite but is actually a little winged figure, with geese at their heels. To the right, Arts, Music, Dancing are represented by young women engaged in these activities. Although the originals have been lost, a sketch provides some notion of the brilliance of the color in the final version. It is clear from examining related works of the period (Baby Reaching for an Apple, 1893) that Cassatt conceived Modern Woman boldly, as a large-scale decorative project. It is equally clear from textual evidence of approximately the same time that she intended to demonstrate that in her garden the picking of the fruit of knowledge by women was not a condemned activity: on the contrary, it was to be strongly encouraged. The promoters of the Woman's Building had stated their purpose as follows: "We [women] have eaten of the Tree of Knowledge and the Eden of Idleness

is hateful to us. We claim our inheritance, and are become workers not cumberers of the earth." Nevertheless, Cassatt refuses to make her allegory grim, moralistic or formally old-fashioned: on the contrary, her style is that of the vanguard of the day, Postimpressionist or Symbolist. She was fully aware of the modernity and innovativeness of her project and emphasized the seriousness of her commitment to its formal aspects. At the same time, she wrote to Mrs. Palmer of her work-in-progress as follows, using words and phrases that stress her belief in a new, strong role for women:

I have tried to express the modern woman in the fashions of the day, and I have tried to represent those fashions as accurately and in as much detail as possible. I took for the subject of the centre and largest composition Young Women Plucking the Fruits of Knowledge and Science . . . An American friend asked me in rather a huffy tone the other day "Then this is woman apart from her relations to man?" I told him it was. Men I have no doubt are painted in all their vigour on the wall of the other buildings; to us the sweetness of childhood, the charm of womanhood, if I have not conveyed some sense of that charm, in a word if I have not been absolutely feminine then I have failed . . . I will still have place on the side panels for two compositions, one which I shall begin immediately is Young Girls pursuing Fame. This seems to

me very modern . . . The other panel will represent the Arts and Music (nothing of St. Cecilia).

Cassatt had become more and more radical in her politics with the passage of time. She was a supporter of Dreyfus at the time of the Affair and, increasingly, she felt herself allied with the cause of feminism. Writing to Mrs. Palmer, she declared: "After all give me France. Women do not have to fight for recognition here if they do serious work," and she refers positively to women's determination to be *someone* rather than *something*. She participated enthusiastically in a benefit exhibition for the suffragettes in New York in 1915, and wrote to her activist friend Mrs. Havemeyer, "You know how I feel about *the*, to me, question of the day, and if such an exhibition is to take place, I wish it to be for the cause of Woman Suffrage."

Eakins never engaged in politics so overtly: his late work is, in fact, rather conservative. It is difficult to imagine him supporting feminism in such outspoken terms, although he seems to have encouraged some of his female students and to have demanded greater availability of the nude model in his classes. Yet together, these two artists, so different in their formal conceptions and their notions of human existence and the social order inscribed by painting, transformed American art from a provincial, rather limited pursuit into a world-class enterprise.

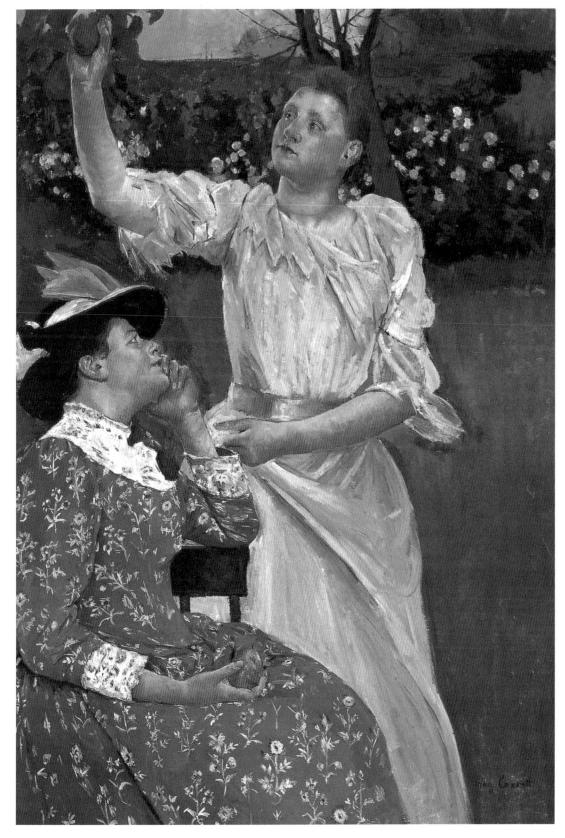

16.30 MARY CASSATT Young Women Picking Fruit, 1892. Oil on canvas, 52×36 (132 \times 91.5)

• 17 •

MASS CULTURE AND UTOPIA: SEURAT AND NEOIMPRESSIONISM

THE ANTINOMIES OF GEORGES SEURAT

N 1929, THE BRITISH CRITIC ROGER FRY WROTE THAT **⊥** the art of Georges Seurat (1859–91) was stretched between the poles of "photographic literalness" and a condition "as abstract . . . as pictorial art ever attained." This basic antinomy, I believe, accurately describes the efforts and achievements of Seurat and his Neoimpressionist followers. Born nearly a generation after the Impressionists, these artists sought to return Impressionism to its collective and democratic roots, while at the same time maintaining their personal and expressive autonomy. The goal was largely impracticable given the social and cultural constraints of the age, and resulted in an art of paradox: Neoimpressionism was guided at once by the lessons of science and by an often abstruse idealism; it was influenced both by popular culture and the elite art of the Classical and Academic tradition; it aimed to be at the same time politically tendentious and formally pure; it represented together the alienation of modern life and the utopian dream of a life of leisure and unending pleasure; and it was, in sum, intellectually rigorous and an "armchair for the tired businessman," in Matisse's words. By these antinomies, therefore, the art of Seurat and his followers laid the foundation for twentieth-century modernism, whose antinomies are named Picasso and Matisse, Mondrian and Miró, Albers and Rivera.

SEURAT'S DRAWINGS AND THEIR DISPERSION OF MEANING

The founder and leader of Neoimpressionism (and its only genius) was undoubtedly Georges Seurat. Apart from a few summers spent on the Normandy or Brittany coasts, he lived his entire brief life in Paris, either in the company of his family in their apartment at 136 boulevard Magenta (halfway between the new Gare du Nord and the old St. Lazare Prison) or in his own apartment-studio. His mother was the daughter of a coachman turned jeweler, and his father was a minor civil servant and real estate speculator who retired early and spent his free time at a suburban villa at Le Raincy. The success of Antoine Seurat permitted Georges to take up an artist's career without financial worry, but the young man was clearly affected by more than just the fortunate financial circumstances of his upbringing: he must have been impressed as well by the modernity of the section of Paris in which he lived, by the cultural novelty of suburban life at Le Raincy, and by the power of his father's capital; these are all subjects represented in his mature art.

Initially trained in the industrial and decorative arts, Seurat applied for, and was granted, admission to the Ecole des Beaux-Arts in 1878. He studied in the atelier of Henri Lehmann (1814–82) for a little more than a year before leaving on account of boredom, poor grades, and political ostracism (his fellows called him a communard). After a year of compulsory military service, Seurat returned to Paris, rented a studio with his friend Edmond-François Aman-Jean (1860–1935), and immediately proceeded to develop and refine a style of drawing that was utterly without precedent. In Aman-Jean 17.1 (1882–3) and *The Echo* (1883), and many other works, Seurat 17.2 largely dispensed with line, the one indispensable element of all previous drawings. In so doing, he also dispensed with meaning in the work of art, as formerly understood.

Aman-Jean is a large independent portrait drawing in conté crayon on rough Michallet paper. The male subject is depicted in half-length profile with gaze directed to the lower right. His right hand is extended and holds a small brush with which he makes a mark on a surface nearly coincident with the

368

17.1 GEORGES SEURAT Aman-Jean, 1882–3. Conté crayon, $24\frac{1}{2} \times 18\frac{1}{4}$ (62.2 × 46.4)

17.2 GEORGES SEURAT *The Echo*, 1883. Conté crayon, $12\frac{1}{4} \times 9\frac{1}{4} (31.1 \times 23.4)$

17.3 GEORGES SEURAT A Bathing Place, Asnières, 1883–4. Oil on canvas, $79\frac{1}{8} \times 9^{\prime}$ 10 (200.9 × 299.7)

right margin. Echo is exactly half the size of Aman-Jean, and is a highly finished study for Seurat's first major painting, A Bathing Place, Asnières (1883–4). The boy in the drawing is shown close up and in profile. His back and extended arms form an "L" which echoes the left and bottom margins of the paper; his cap is shaped into an isosceles triangle, and his nose and right forearm create a diagonal extending from upper left to lower right. His hands are cupped around his mouth in order to amplify a shout.

In both of these drawings, Seurat rubbed the greasy black crayon all over the surface of the paper in order to create a subtle continuum of dark and light uninterrupted by the hard contour of a line. (The only exception to this exclusion of line is the reinforcement of the profile of Aman-Jean.) Relief is created by the absence of crayon, as in the bare shoulders of the boy in *Echo*, and by contrasts of light and dark, as in the shirt collar and jacket lapels of Aman-Jean. Yet to speak of relief, modeling, and volume in these drawings is misleading; a simultaneous evanescence and tangibility is present here in areas of mass as much as in areas of shadow. Physical presence and absence commingle in a single, haunting rhetoric. Aman-Jean and Echo are thus, in a sense, not representations at all. They are useless as interrogations of human character, they reveal nothing of the physical nature of the subjects they depict, they refuse any clear distinction between figure and ground, and they are valueless as renderings of the artist's personality or psyche. By abjuring line in his drawings, Seurat thus more closely approached pure abstraction than any artist we have considered so far. Because these drawings are so central to an understanding of Seurat's break with the Classical tradition, they must be considered a little further before we turn to his equally epochal paintings.

Since before the Renaissance, the art of drawing was based upon the control and manipulation of line: contour, movement, direction, volume, light, and expression were all judged dependent upon it. To Federico Zuccaro at the end of the sixteenth century, linear drawing had attained a nearly divine status: as the material expression of the Platonic *Idea*, drawing was the essential instrument for the representation of the divine within the human. Lines for him were both the means by which bodies were physically manifested in works of art (disegno esterno), and the material traces of the imagination and genius of the artist (disegno interno). Thus, the art of drawing with lines had a moral, as well as a representational, value that allowed it to become the foundation for seventeenth-century history paintings concerned with the great men and deeds of history, mythology, and religion. By the early nineteenth century, this Classical and idealist tradition of linear drawing was principally upheld by Ingres, who instructed his pupils (including Seurat's teacher Lehmann): "To draw does not simply mean to reproduce contours; drawing does not simply consist of line: drawing is also expression, the inner form, the surface modeling. . . . That is why the painters of expression among the moderns happen to have been the greatest draftsmen—witness Raphael!"

In addition to Ingres and his pupils, support for the tenets of Neoclassical art theory with its championing of the role of line in drawing came from Charles Blanc. An influential critic, esthetician, and pedagogue, Blanc wrote in his Grammaire des arts du dessin (1867), "that lines—straight, curved, horizontal and oblique—are directly related to our sentiments, and can themselves be expressive and eloquent." Even Delacroix and Manet, both of whom sought to dethrone line from its exalted rank, nevertheless found it indispensable for the creation of movement and plasticity in drawings. Yet in the hands of Seurat the tradition of linear drawing is ended and in its place is substituted the abstraction of what the art historian Bernd Growe has called a "light-dark continuum." Solid bodies are dissolved by the light emitted from beneath a carpet of conté crayon; light is given material substance by the ebb and flow of tonality. In Aman-Jean and Echo, the unseen canvas upon which the artist labors and the unheard shout of a workingclass boy are perhaps Seurat's real subjects. "Meaning" in these drawings of Seurat, as in others, is thereby dispersed beyond the ragged and indefinite edges of the Michallet paper into a spectatorial space that is dynamic and contested. In this way, Seurat's drawings are very like his paintings: they are unusually, and radically, critical in their effort to spark an exchange between the artwork and the diverse classes and cultures the artist saw and depicted. By their rejection of meaning as it was formerly conceived-within the circumscribed frame of the artwork—Seurat's drawings and paintings therefore mark an attempt to restore social and political meaning to the work of art. Now their significance is to be determined, almost as never before, by a broad and diverse community of spectators responsive to the formal imperatives of art. Even as the works reject important aspects of Neoclassical art theory, they mark a return to the values of Revolutionary, Neoclassical history painting as practised by David exactly one hundred years earlier.

Seurat studied and understood the contested spaces and cultural diversity of the city that lay beyond the frame of his canvas and studio door. In his youth he frequented the newly built working-class park of the Buttes-Chaumont just a few blocks east of his family's apartment. Further east was his father's retreat at Le Raincy, a suburban area only recently subdivided into lots for middle-class "villas." Thus Seurat was already familiar with the complex signs of social class on display in the Haussmannized urban and suburban leisure spaces of Paris, when he and some of his friends began to spend time at Clichy, Asnières, and the Island of the Grande Jatte. A Bathing Place, Asnières is a heroically scaled depiction 17.3 of working-class men and boys relaxing and bathing at a well-known if somewhat down-at-heel resort on the left bank of the Seine. The picture, composed out of a regularized and systematized Impressionist palette and facture, was refused by the Salon judges, and was instead shown twice in 1884 at jury-free exhibitions of the Artistes Indépendants, a large group which included Odilon Redon and Paul Signac (1863–1935). There it was acclaimed by a handful of Naturalist writers, critics, and artists, including Signac, who would form the nucleus of a movement dubbed by the writer, art critic, and anarchist Félix Fénéon "Neoimpressionism." The "manifesto" of the new movement, however, as the critic Maurice Hermel called it, appeared two years later at the eighth and last Impressionist Exhibition, in the form of Seurat's A Sunday Afternoon on the Island of the Grande Jatte (1884–6).

A "MANIFESTO PAINTING": A SUNDAY AFTERNOON ON THE ISLAND OF THE GRANDE JATTE

Seurat's *Grande Jatte* is a life-sized depiction of a Sunday idyll at a suburban park located on a small, narrow island opposite the banks of Asnières. Women, men, and children of all classes are got up in their good clothes to picnic, promenade, boat, fish, and gaze upon one another on this particular sunny, Sabbath noon. A black labrador grazes, a pug gambols, and a monkey poses in the foreground. Above, trees form an intermittent canopy while a cotton swab floats across the sky at upper left. The island and its habitués constitute a modern Cythera, but with this difference: the

pleasure appears extremely vitiated. The critic Henri Fèvre wrote in May 1886:

Little by little, one understands the intention of the painter; the dazzle and blindness lift and one becomes familiar with, divines, sees and admires the great yellow patch of grass eaten away by the sun, the clouds of golden dust in the treetops, the details that the retina, dazzled by light, cannot make out; then one understands the stiltedness of the Parisian promenade, stiff and distorted; even its recreation is affected. . . . It is materialist Puvis de Chavannes, a coarse summary of nature, savagely colored.

Another critic, Alfred Paulet, wrote: "The painter has given his figures the automatic gestures of lead soldiers, moving about on regimented squares. Maids, clerks, and soldiers all move around with a similar slow, banal, identical step." Seurat's *Grande Jatte* is thus at once an ingenuously Impressionist image of suburban recreation and leisure, and a critical Realist picture of the artifice and alienation of modern class society. His mentors are at once Monet, the author of *La Grenouillère* (*The Frog Pond*), and Manet, the painter of *Le Déjeuner* (*Luncheon*).

Even a cursory glance at the picture, however, reveals that its style differs markedly from works by either of these two painters. Unlike them, but in common with some academicians, Seurat is rigid and systematic in his method. "The Pan-Athenaic Frieze of Phidias [on the Parthenon] was a procession," Seurat told his friend the poet and critic Gustave Kahn in 1888, "I want to make the moderns file past like figures on that frieze, in their essential form, to place them in compositions arranged harmoniously by virtue of the

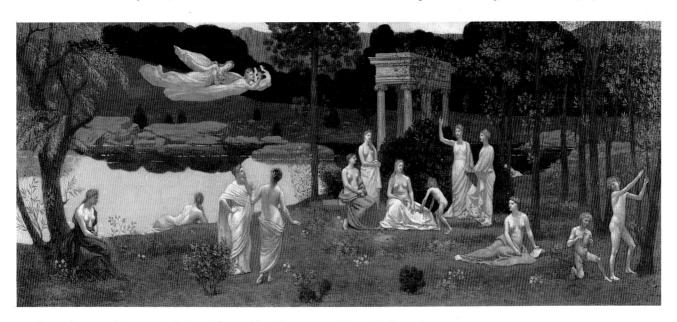

17.4 PIERRE PUVIS DE CHAVANNES The Sacred Grove, 1884. Oil on canvas, $36\frac{1}{2} \times 91$ (92.6 × 231)

directions of the colors and lines, line and color arranged in accordance with one another." Like the Academic muralist Pierre Puvis de Chavannes (1824–98), whose The Sacred Grove (1884) was exhibited at the Salon in the very year the Grande Jatte was begun, Seurat has subjected his landscape and especially his figures to a strict proportional and Classical schema based upon Vitruvius: heads are half the height of bodies, and faces are turned precisely full frontal, threequarter view, full profile, three-quarters from the back, or full back. Seurat is equally rule-bound in his application of color, though in this case the source is contemporary color theory written by Michel-Eugène Chevreul, Charles Henry, and especially Ogden Rood. Atop a thin underpainting consisting of broad, rectangular strokes of a few closely related hues of local color, Seurat carefully placed curved, horizontal, vertical, or crisscrossed strokes of unmixed or partially blended paint. Above this he applied myriad, nearly identically sized dabs or points of mostly unblended complementary and adjacent colors, animating the surface and causing it to take on the quality of a mosaic.

Rejecting the relative tonal sobriety of Puvis, Seurat employed this technique of "Chromo-luminarism," as he called it, in order to achieve a luminosity that would exceed even that in Impressionist paintings. Fénéon was informed by Seurat of his methods in 1886 and published them that year:

These colors, isolated on the canvas, recombine on the retina: we have, therefore, not a mixture of material colors (pigments), but a mixture of differently colored rays of light. Need we recall that even when the colors are the same, mixed pigments and mixed rays of light do not necessarily produce the same results? It is also generally understood that the luminosity of optical mixtures is always superior to that of material mixture, as the many equations worked out by M. Rood demonstrate.

The following year, Fénéon again expounded the technique of Seurat and his colleagues Signac, Lucien Pissarro (1863–1944, Camille's son), Maximilien Luce (1858–1941), Charles Angrand (1854–1926), and Albert Dubois-Pillet (1845–90), whose works were on display at the third annual exhibition of

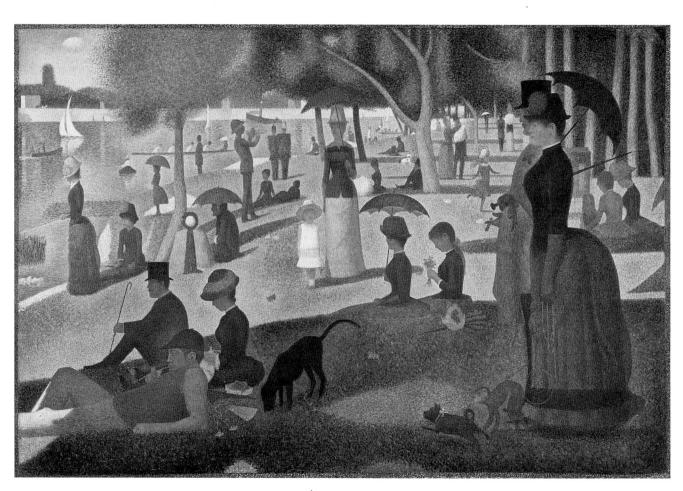

17.5 GEORGES SEURAT A Sunday Afternoon on the Island of the Grande Jatte, 1884-6. Oil on canvas, 811/4 × 10'11/4 (207.6 × 307.9)

17.6 PAUL SIGNAC The Dining Room, Breakfast, 1886-7. Oil on canvas, $35 \times 45^{1/2} (89 \times 115)$

17.8 CAMILLE PISSARRO L'Isle Lacroix, Rouen, Mist, 1888. Oil on canvas, $18\frac{1}{4} \times 21\frac{7}{8} (44 \times 55)$

A "MANIFESTO PAINTING": THE $\textit{GRANDE JATTE} \cdot 373$

17.8 GEORGES SEURAT Le Crotoy, Upstream, 1889. Oil on canvas, $28\frac{3}{4} \times 36\frac{3}{4} (73 \times 93.3)$

17.9 GEORGES SEURAT *The Models*, 1886–8. Oil on canvas, $79 \times 98\%$ (200.6 × 250.8)

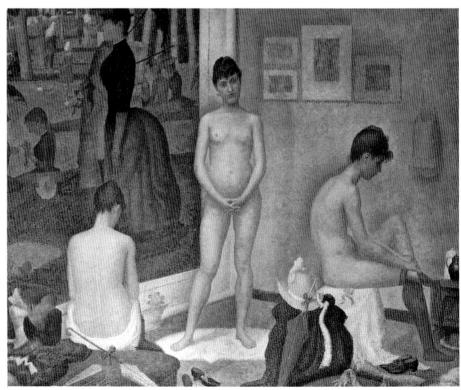

the Société des Artistes Indépendants. Calling them "Neoimpressionists" for their rejection of Impressionism's "fugitive appearances," he described their attempts, in such works as Signac's The Gasometer at Clichy (1886) and The Dining Room, Breakfast (1886-7), to "synthesize the landscape in a definitive aspect which perpetuates the sensation [it produces]. . . . Step back a bit [from their pictures] and all these variocolored spots melt into undulating, luminous masses; the brushwork vanishes, so to speak; the eye is no longer solicited by anything but the essence of painting." Even the mature Camille Pissarro was intoxicated by Chromo-luminarism, practising it for approximately five vears between 1885 and 1890. His L'Ile Lacroix, Rouen, Mist (1888) employs a subtle palette of white, pink, and green in the brightly lit areas, and complementary orange and blue in the shadows. Its carefully divided brushstrokes were an attempt to master the "laws" of colored light, and to produce, as he wrote, "a robust art, based on sensation."

In fact, however, Fénéon, Seurat, and his followers misunderstood the color theories of the American physicist Ogden Rood, believing he had claimed that *every* material mixture was deficient in luminosity when compared to color achieved by optical mix. This misunderstanding resulted in colors in the *Grande Jatte* that Emile Hennequin, as early as 1886, correctly perceived to be "dusty or lusterless" and "almost entirely lacking in luminosity," especially in those areas, such as the trousers of the reclining man in the left foreground or the dress of the woman with the fishing pole, where complementary dots or strokes of paint have been intermingled. Nevertheless, Seurat continued in his pursuit of a scientific esthetic, and was soon convinced that he had indeed discovered, as Kahn wrote, "scientifically, with the experience of art... the law of pictorial color."

In a short letter of 1890, Seurat described his method. Under the rubric "Esthetic," he wrote:

Art is Harmony.

Harmony is the analogy of opposites, the analogy of similarities of *tone*, *of tint*, *of line*, taking account of a dominant, and under the influence of the lighting, in combinations that are gay, calm or sad.

Further on, beneath the word "Technique," he wrote:

Given the phenomenon [...] of the duration of the luminous impression on the retina, [...]

Synthesis is logically the result.

The means of expression is the optical mixture of tones, of tints (of local color and the illuminating color: sun, oil lamp, gas, etc.), that is, of the lights and their reactions (shadows) following the laws of *contrast*, of gradation, of irradiation.

The frame [...] is in a harmony opposed to those of the tones, tints and lines of the [...] picture.

The basis of Seurat's method, as he wrote, was color "contrast" and "synthesis;" his motto "Art is Harmony" was thus a proclamation that beauty arises from a continuous process of opposition and resolution among contrasting colors, values, and lines. (Line must here be understood primarily to mean direction.) This dynamic relationship, moreover, was extended by Seurat beyond the limits of the canvas to the frame, and then beyond the frame to the world of the spectator. According to the testimony of the poet and critic Emile Verhaeren, Seurat compared his painted frames, spectacularly represented by his landscape *Le Crotoy, Upstream* (1889), to the stagecraft of Wagner's opera house at Bayreuth, in which the contrast between the illuminated stage and the darkened theater "is continued and extends itself to meet the eye of the spectator."

By means of Seurat's scientific and dialectic approach to painting, in which the barriers between artwork and world are broken down, he sought to restore to painting the cultural significance it had lost with the demise of Classicism and Academic history painting. The artist's only known comment about the Grande Jatte, set down much later by Signac, should be taken as an indicator of his respect for the Davidian paradigm: "In another vein I would just as willingly have painted the struggle between the Horatii and the Curatii." By means of his relentless focus upon the laws of harmony, Seurat sought as well to return to the enterprise of painting the social and collective meaning it had lost with the destruction, as we have seen, of Courbet's project of Realism. Indeed, Courbet's Burial at Ornans, despite the differences in color and tonality, is recalled by the Grande Jatte: both are large, indeed heroically, scaled pictures depicting occasions of awkward, and ambiguously classed, rituals.

Idealist and Realist, Classical and modernist, the Grande Jatte may thus be said to possess, like its author, in Meyer Schapiro's words, "an earnest democratic spirit;" it affirms the right and opportunity of a diverse audience, like the Sunday crowd in the picture itself, to become legitimate and critical spectators of painting. Like many modernists to follow, Seurat sought to break down the distinction between artist and worker, fine and industrial art. It is significant that when asked by his friend the critic Octave Maus the selling price of *The Models* (1886–8), a depiction of working-class models relaxedly posed against the starched bourgeoisie in the Grande Jatte, Seurat computed its value like a day laborer would figure his wages: "one year at 7 francs a day." When asked by Angrand about the significance of his works, Seurat replied: "They [writers and critics] see poetry in what I do. No. I apply my method and that is all." Indeed, for Seurat and

17.8

17.8

11.17

....

17.10 Georges Seurat Final study for Chahut 1889. Oil on canvas, 217/8 \times 184/8 (55.6 \times 46.7)

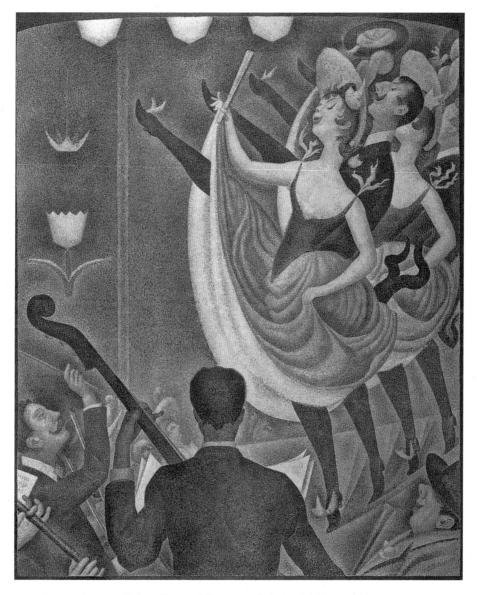

17.11 GEORGES SEURAT Chahut, 1889-90. Oil on canvas, 663/8 × 551/2 (168.9 × 140.9)

the Neoimpressionists, as for few other artists of the time, the division between the physical creation and intellectual cognition of the artwork was nearly absolute. Painted in discrete dots of color, applied according to a preconceived system, Neoimpressionist pictures are a kind of exaggeration or parody of the very type of industrial and alienated labor then expanding in France, in which workers see no relationship between their individual work-gesture and the final product. To what, then, can be attributed the sense of alienation and isolation perceived by contemporary and subsequent critics of the Grande Jatte? Precisely this: that it was a picture which sought to discover and employ a

rationalized, esthetic formula for the representation of idleness, quietness, and pleasure. Short of a revolution in daily life and labor, these two halves could not make a whole; the result was parody.

MASS CULTURE AND THE PARADOX OF PLEASURE: CHAHUT

The paradoxical nature of Seurat's quest for harmony is unmistakably manifest in his pictures of popular entertainments—Sideshow (1887-8), Chahut (1889-90), and Circus 17.10, 11

(1890–91)—all shown at exhibitions of the Salon des Indépendants. In Chahut Seurat depicts two men and two women performing the vulgar quadrille known as the Chahut on a stage in a dance hall like those he knew in Montmartre (it is almost certainly the café-concert known as Le Divan Japonais at 75 rue des Martyrs). In fact, we are seeing the climax of the performance, or the curtain call, when the dancers break out of their square, form a line, and perform a few last high kicks for the crowd. The members of the orchestra are embraced by the extended legs of the foreground female dancer, like a great erotic parenthesis; the bass player is seen in the extreme foreground with his back to us and his instrument pointed upward and to the left; the flute player is recognizable by his hands and instrument in the lower left corner; the conductor is shown in profile with raised head, arm, baton, and moustache; and two fiddlers are indicated by the presence of their raised

The audience in *Chahut*, seated in the *parterre* or pit beside the musicians, consists of a gentleman in the lower right, described by Kahn as "pig-snouted," but otherwise nattily dressed in hat, cane, and overcoat with flowered lapel, and three other figures on the opposite side of the runway—from right to left, a woman wearing a crown like the Statue of Liberty's, a woman wearing a feathered toque, and a man with a bald head and beard. Everything else about the picture is obscure—the gas lamps at the top and those suspended in mid-air at the left, the vertical bar or pole approximately one quarter the distance from the left margin, the location of the rear wall, the precise arrangement of seating for audience and orchestra, and the curious vignette-shape of the picture itself within its painted frame. Equally mysterious is the mood of the picture. In Chahut, it would seem, Seurat paradoxically depicts both a dream of unrestrained pleasure and a nightmare vision of vulgarity.

The opposition was observed and ascribed political significance at the time by Kahn when he wrote: "If you are looking at all costs for a 'symbol,' you will find it in the contrast between the beauty of the dancer, an elegant and modest sprite, and the ugliness of her admirer; in the hieratic structure of the canvas and its subject, a contemporary ignominy." Signac had a similar view of the picture, which he expressed in 1891, just a few months after Seurat's death. He wrote that by painting images of working-class life, "or better still, the pleasures of decadence like dance halls, *chahuts* and circuses—as the painter Seurat did, who had such a vivid perception of the degeneration of our transitional era—[the Neoimpressionists] bring their evidence to the great social trial that is taking place between workers and Capital." One way to

understand the opposition of dream and nightmare in *Chahut* is simply to say, following Kahn, that in the Montmartre cabarets where Chahuts are performed, the dancers experience the utopian delight of free and expressive movement while the audience is subjected to the dystopia of bad food and spirits, seedy surroundings, and lewd display. In fact, however, the opposite can just as easily be claimed. We may say, following Signac, that in the Parisian dance called Chahut, the performers are no "sprites," but are reduced to mere automata; their limbs, buttocks, breasts, crotches, and smiles are visibly alienated from their bodies and their minds in a dystopia of fetishism and objectification. At the same time, the spectators are treated to the utopian pleasures of music, light, frenetic dance, and sexual stimulation.

Each of these antinomies is equally plausible and implausible: how can the performers actually have experienced the delight of free and expressive movement when we know that their dance was designed precisely to subordinate expressivity in favor of crude sexual display? On the other hand, how can the performers have felt alienated and degraded when their kicks are so clearly exuberant and they wear such broad smiles? Regarding the spectators, how can they have suffered the dystopia of degradation and exploitation, when they are so clearly enraptured and so splendidly attired? On the other hand, how can we assert that the audience has experienced the joyous utopia of sensual stimulation and erotic delight, when they themselves are barred from the dance and, apparently, from human companionship? Everyone came alone to the Chahut. (The bald man with the beard and the woman with the toque might just belong together, but they are separated by the neck of the bass viol and anyway make an unlikely couple.)

The question which arose in considering the *Grande Jatte* must be considered again: is *Chahut* a satire? If so, why did Seurat go to such lengths to include tonal, linear, and coloristic devices that, he believed, would guarantee that his picture would stimulate feelings of joyousness in his audience? The predominating high luminosity, warm hues, and upward pointed angles and accents (lines) were believed by him to be conducive to happiness. In the letter cited earlier, Seurat wrote: "*Gaiety of tone* is the luminous dominant, *of tint*, the warm dominant, *of line*, lines above the horizontal." *Chahut* contains just this vocabulary of gaiety. In *Chahut*, it would seem, Seurat set out to make a democratic and happy picture.

And yet, no matter what we know of Seurat's esthetic theories and practise, the imputation of satire remains inescapable when actually viewing *Chahut*. The conviction is even further strengthened if we compare the painting to

17.14

Henri de Toulouse-Lautrec's (1864–1901) lithographed poster of the same cabaret, *Le Divan Japonais* (1892–3). Toulouse-Lautrec depicts uncritically the Parisian world of fashion and celebrity; the popular *chanteuse* Yvette Guilbert is shown on stage (her head audaciously cut off by the top edge of the poster), above the dancer Jane Avril (in one of her famous and outlandish hats) and her companion Edouard Dujardin, the dandified founder of the avantgarde *Revue Wagnérienne*. No such celebrity and playful injoking is in evidence in Seurat's picture. At some level, then, Kahn and Signac must be right in their perception of social and political criticism in *Chahut*. As with the *Grande Jatte*, Seurat has created a painting which records the paradox—both the alienation and the delight—of modern leisure and mass culture.

Indeed, mass culture in Seurat's day was, as we have already begun to understand (see Chapter 13), new and contradictory. Upon entering Seurat's Divan Japonais, Degas's Cirque Fernando (in his Miss Lola at the Cirque Fernando, 1879), Manet's Folies-Bergère, or the hundreds of other theaters and places of entertainment depicted by French and European artists of the late nineteenth century, things were not what they seemed. Take the question of the theater audience, for example. Occupying "the center seats in the pit, under the chandelier or *lustre*," writes Baedeker's in 1888, "the *claque*, or paid applauders, form an annoving, although characteristic feature in most of the theatres . . . and are easily recognized by the obtrusive and simultaneous vigor of their exertions. There are even entrepreneurs de succès dramatique, a class of mercantile adventurers who furnish theaters with *claques* at stated terms."

At the many Paris cafés chantants, or nightclubs, the guide continues, "the music and singing is never of a high class, while the audience is of a very mixed character. . . . The alluring display of the words entrée libre outside the cafés chantants is a ruse to attract the public, as each visitor is obliged to order refreshments (consommation), which are generally of inferior quality." If the innocent visitor chooses instead to attend one of the innumerable balls or dance halls of Paris, things are no better:

The balls, which take place all the year round at public dancing rooms, may be regarded as one of the specialities of Paris. Many of these entertainments, however, have for some years past been to a great extent "got up" for the benefit of strangers, numbers of the supposed visitors being hired as decoys by the lessee of the saloon. . . . At the Bal Bullier . . . a famous establishment in its way, the dancing of the students and artisans with their étudiantes and ouvrières is generally of a wild and Bacchanalian character. Here the famous Can-Can may be seen.

In Chahut, Seurat appears to have depicted a fully professionalized performance, and not a mock amateur cancan danced by ersatz students and workers. The audience seems genuine enough (they are not applauding), and no particular inducements are in evidence. But if Seurat omits from his painting any obvious clues as to the put-on nature of the audience, the location, and the performance, it is only because he understood that these entertainments were sufficiently effective and insidious even without ostentatious guile. His knowledge and respect for the power of mass culture is revealed, for example, by his admiration and even occasional emulation, as the art historian Robert Herbert has shown, of the cabaret posters of Jules Chéret (Le Bal du Moulin Rouge, 1889, for example). In 1891, Verhaeren described Seurat's affinity for Chéret: "The poster artist Chéret, whose genius he greatly admired, had charmed him with the joy and the gaiety of his designs. He had studied them, wanting to analyze their means of expression and uncover their aesthetic secrets." Chéret had apparently understood the secret allure of mass culture and found a recipe for representing it in his posters. Perhaps Seurat could take a lesson from him and also discover what underlay the hypnotic power of the nascent culture industry.

A highly cultured and circumspect man (Degas called him "the notary"), Seurat must have felt a profound ambivalence about the world of artifice and contrived pleasures in *Chahut* and *Circus*, his last painting. On the one hand, he surely deplored its vulgarity and reduction of the spectator to the condition of passive spectator, but on the other, he probably saw it as offering working people a place of refuge—even perhaps a sense of honor; notice the serried ranks of smiling spectators in Circus. Like the modern factory, the sideshows, dance halls and circuses were alienating, yet the alienation was collective. Perhaps some sense of camaraderie, some collective desire for freedom and autonomy could be salvaged from even this world; perhaps the artist could be instrumental in providing a new (harmonic) vocabulary through which this freedom could be felt and even acted upon by everyone?

At Asnières, the Grande Jatte, and the other new haunts provided by a growing culture industry, Seurat understood that he was witnessing the very utopia of which he dreamed, as well as its opposite. This dialectic was succinctly described by the social critic and philosopher Herbert Marcuse in 1937, in terms that might have been inspired by the pictures of Seurat:

In suffering the most extreme reification, humans triumph over reification. The artistry of the beautiful body, its effortless agility and relaxation, which can be

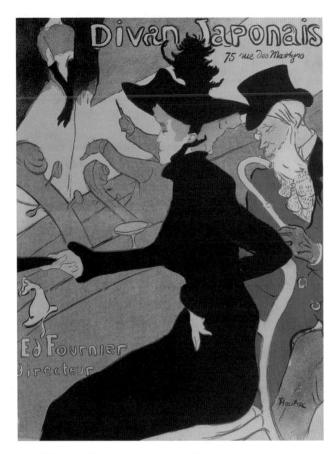

17.12 HENRI DE TOULOUSE-LAUTREC Le Divan Japonais, 1892–3. Color lithograph poster, $31\% \times 24 (80.8 \times 60.8)$

displayed today only in the circus, vaudeville and burlesque, herald the joy to which humans will attain in being liberated from the ideal. Once humankind, having become a true [independent] subject, succeeds in the mastery of matter . . . when sensuality, in other words, is entirely released by the soul, then the first glimmer of a new culture emerges.

In the very degradation of the performers at these venues, in the very objectification of the body, in the very focus upon the erotic at the expense of the ideal, Seurat must have seen anticipations of the world of harmony and pleasure of which he dreamed. Indeed, modern mass culture, of which

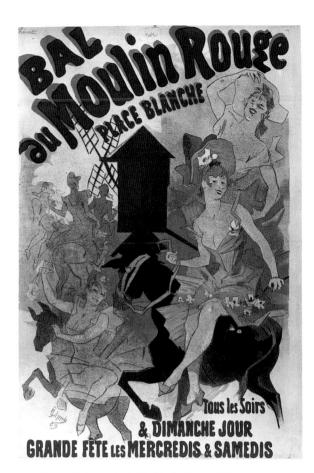

17.13 JULES CHÉRET *Le Bal du Moulin Rouge*, 1889. Lithograph poster, 23½ × 16½ (59.7 × 41.9)

the parks, cabarets, and circuses of Paris are early examples, is construed from just this dialectic of alienation and freedom: the pleasures it offers are at once the result of the extremely circumscribed act of commodity consumption and of the anticipatory utopian joy of "effortless agility" and the "mastery of matter." Seurat's achievement was to explore this paradox through an art that was itself dialectical. The drawings and paintings of Seurat are at once relentlessly scientistic and ingratiatingly popular; they are by turns abstract and literal, formalist and naturalist. Along with the works of Toulouse-Lautrec and Vincent van Gogh, to which we shall now turn, they were among the last such synthesizing efforts of the nineteenth century.

17.14 Georges Seurat *The Circus*, 1890–91. Oil on canvas, 73×60 (185.4 \times 152.4)

· 18 ·

THE APPEAL OF MODERN ART: TOULOUSE-LAUTREC

NOVELTY AND DESIRE

"His passion and his profession is to marry the crowd." Charles Baudelaire's famous phrase from 1859 was intended to describe the illustrator Constantin Guys. But it is more apt for Henri de Toulouse-Lautrec thirty years later, and for two principal reasons: first, because the crowd (the word foule also means mob, multitude, and mass) came more fully into being at the later date; and second, because Toulouse-Lautrec exploited print techniques and a medium (the poster) that, compared to the drawings of Guys, were more precisely tailored to mass spectatorship. Yet even Toulouse-Lautrec's paintings had a popular character. Many were large, raucous affairs, intended for exhibition at cabarets, restaurants, circuses, and other venues frequented by working-class and lower-middle-class crowds.

The popular appeal of Toulouse-Lautrec's artworks is not just a matter of their novel technique, medium, and exhibition circumstances: it consists equally in their peculiar, erotic urgency. In his paintings and especially his posters, the nouveauté of urban life-shoes, gloves, make-up, hair, hats, and the grinning faces of popular entertainers—are given over to the celebration of sexual desire. And not just any desire, but the fetishistic desire that was catalogued by sexologists of the time, practised by clients and sex workers at the new maisons de specialité, and embraced by an emergent lesbian and gay subculture. And herein lies the source both of the great appeal of Toulouse-Lautrec's art and of its modernity. For more than a hundred years, capitalist commerce has used sex to sell commodities and thereby intervene in the domain of erotic and imaginative life. By crafting images that stimulate desires and then proposing that these may be gratified by the purchase of designated commodities-industry and advertising have rationalized and regulated both sex and consumption. Parisian

visual culture from the *fin-de-siècle* is an important early example of the practise. Toulouse- Lautrec's paintings and posters, however, may be said to have used commodities to sell sex, not the other way around. They highlight sexual pleasure as a refuge from working-class labor, and fetishism as a form of emancipation. His model of metropolitan desire is thus as unruly and unregulated as the *insoumises* (unlicensed prostitutes) who walked the streets of Paris and posed—dressed, half-clothed or naked—for the artist.

THE CROWD

The growth of European cities and the emergence of crowds were epochal developments in nineteenth-century history. Between 1800 and 1900, Berlin grew from 200,000 to 3 million, London from 1 to 6 million, and Paris from 500,000 to nearly 3 million. The reason these cities grew at so unprecedented a rate was that modernization and capitalization in the countryside reduced or in some cases nearly ended small-scale ownership of rural lands, as well as nearly eliminated open lands available for common use. The cities were where industry and factories were located, and that is where the people had to move.

Within factories, working conditions were appalling, but circumstances were often not much better in the surrounding streets themselves. Metropolitan engineering rarely kept pace with population growth. As a consequence, there were teeming slums in all major European cities, and frequent outbreaks of disease. In France, a series of spectacular bank failures in 1882 exacerbated depressed economic conditions, and unemployment levels rose greatly. Masses of people in the French capital thus daily scraped, scrambled, begged, and stole to survive. Working-class women were subject to especially gross forms of exploitation, and were judged by bourgeois men to

be indistinguishable from prostitutes. Indeed, even if they were regularly employed as flower-sellers, shop girls, artist's models, laundresses, or barmaids— the last two depicted in Morisot's Laundresses and Manet's A Bar at the Folies-Bergère—the working women of Paris were often forced to sell themselves in order to live. Estimates of the number of fulltime prostitutes range from 30,000 to 120,000, though the number of part-time or occasional prostitutes must have been even greater. Nineteenth-century Paris may thus have constituted one of the most oppressive environments for women in modern human history, and it is necessary to keep this in mind when looking at the art of Toulouse-Lautrec. It is not so much that he regularly chose prostitutes as his models and companions, as that the categories "prostitute" and "working-class woman" were in ideology, and often in fact, nearly indistinguishable. Toulouse-Lautrec depicted this cruel ambiguity with extraordinary purposefulness, but without moralism or sentimentality.

Of course, wherever there is oppression, there is resistance. The forced assembly of so many people in brothels, factories, on the streets, and in the slums—their subjection to law, industrial discipline, and time management—meant that they gained knowledge of each other, of their work, their common poverty, and their common culture. While the English countryside was the place where capital was first organized, the metropolis was the place where labor was first organized, and where feminism made its first inroads. An International Working Men's Association, formed in London by Karl Marx and others in 1864, grew rapidly during the last quarter of the nineteenth century, and established important headquarters in all the major European capitals. The Association for the Rights of Women was founded in France in 1870, as was a newspaper, Le Droit de Femmes. International Congresses on the Rights of Women were held in Paris in 1878, 1889, 1892, and 1896, at which feminists demanded that wives and prostitutes be freed from the domination of men. The subservient condition of wives necessitated changes in the Civil Code; the desperate circumstances of prostitutes required additional measures extraction of child-support from fly-by-night fathers, the abolition of the repressive police des moeurs, and closure of the notorious St. Lazare Prison where insoumises were routinely incarcerated.

The impact of urban, working-class, and feminist organizations on the development of art and culture in France and elsewhere, it is now generally understood, was enormous. For one thing, the surviving artistic bureaucracies of the old regime—in France the Salon and Académie des Beaux-Arts—came increasingly to be seen as fossils; their standards and programs were simply irrelevant to the concerns and experiences of emancipated women and lower-class spectators. For another, the increased confidence and sophistication of working people meant that they would demand the recreation in the metropolis of the rich and affective art and culture that had been theirs in the countryside—or at least they would expect a pretty good substitute. The creation of a replacement popular culture and art was the aim and achievement of the burgeoning entertainment, or culture, industry.

TOULOUSE-LAUTREC AND URBAN ART

The explosive growth in the numbers of workers and popular, mass organizations at the end of the nineteenth century meant a new audience for art at a time when traditional patronage from state and church had greatly declined. Though women, workers, and the petite bourgeoisie generally could not afford to buy pictures, they could be induced to pay small entrance fees to exhibitions and panoramas. (Panoramas, like the cinemas that took their place, were cheap and spectacular. For just ½ franc on Sunday, for example, audiences in the 1880's could see the Storming of the Bastille by Poilpot and Jacob.) Men had more opportunities than women to be consumers of mass culture. They could go where they wanted at night, and were seduced to pay for admission—and watered-down drinks—at cafés and nightclubs; these latter included the Grand Bouillon, restaurant du Chalet at 43 avenue de Clichy, and the cabarets Chat Noir, Mirliton, and Moulin Rouge—where paintings and other works of art were exhibited. At such places, social class itself was as much part of the show as the artworks, drunkenness, and ribald songs. To think of artworks by Toulouse-Lautrec, Van Gogh, Anquetin, Bernard, and Guillaumin in these prosaic settings—and they in fact exhibited in November and December 1887 at the vast Grand Bouillon (établissements de Bouillon were large, salubrious, inexpensive restaurants found across Paris, in which all items, even napkins, were separately reckoned)—is to begin to transform our understanding of the popularity of modern art. Here Van Gogh showed his Portrait of Père Tanguy, and Toulouse- 19.11 Lautrec some paintings of prostitutes. Van Gogh also exhibited that year at the café Le Tambourin on the Boulevard de Clichy, and in the lobby of the avant-garde Théâtre Libre of André Antoine.

Laborers, shop assistants, clerks, servants, and prostitutes might in addition see works by these and other artists at the newspaper offices of La Vie Moderne and Le Gaulois, and in the pages of cheap illustrated papers, such as Le Courrier français, Le Mirliton (the product of the eponymous cabaret), and L'Escaramouche. Outdoor circuses and amusement parks had painted sets, and artworks were now also visible in the streets: the posters of Chéret, Steinlen, Grasset, Mucha, Bonnard, Toulouse-Lautrec, and many others decorated the walls and

kiosks of the Parisian metropolis. These posters, Roger-Marx wrote with excess sobriety in 1897, have "no less meaning, and no less prestige than the art of the fresco."

The new spaces for public art generated enormous interest among painters and sculptors, and not simply because they offered opportunities for employment. Artists such as Toulouse-Lautrec, who disdained the jury system still employed at the Salon des Artistes Français, were especially glad about the new circumstances for exhibition. At these new venues, they could directly communicate with large numbers of spectators, and thereby achieve something of that public renown that had long been the goal of ambitious French artists. In addition, those artists who counted themselves on the anarchist or socialist left-Toulouse-Lautrec flirted with them—could now believe it was possible both to follow their individual artistic inclinations, and remain in close contact with the proletarian mass, those "newcomers of tomorrow," as Mallarmé once called them, who promised to become the ruling force in the next century.

18.1 HENRI DE TOULOUSE-LAUTREC *Poudre de Riz*, 1887. Oil on cardboard, $22 \times 18\%$ (56×46)

18.2 HENRI DE TOULOUSE-LAUTREC Au Cirque Fernando: Equestrienne, 1887-8. Oil on canvas, 381/4 × 631/2 (98.4 × 161.3)

18.4 (above) Charles-Emile-Auguste Carolus-Duran The Kiss, 1868. Oil on canvas, $36^{1/4} \times 35^{7/8} (92 \times 91)$

18.3 (*lefi*) Henri de Toulouse-Lautrec *In Bed*, 1893. Oil on cardboard, $21\frac{1}{4} \times 27\frac{3}{4}$ (54 × 70.5)

18.5 Henri de Toulouse-Lautrec *Two Friends*, 1895. Oil on cardboard, with strip added on the left, $17^{7/8} \times 26^{5/8} (45.5 \times 67.5)$

Toulouse-Lautrec, in fact, took great advantage of these new patronage circumstances, and devised novel solutions to the integration of modern art and popular culture. Like Degas, for whom he had unbounded admiration, he was highly experimental in his approach to form. He employed unorthodox perspectives, garish stage lighting, strong contour, startling color choices, and peinture a l'essence—oil paint thinned with turpentine and freely brushed, lending works a sketchy and spontaneous aspect. From the standpoint of any Salon juror, Toulouse-Lautrec's works would have been deemed unfinished and laid, or "ugly"—the epithet routinely used to describe both modern paintings and those with working-class subject matter. But that was precisely the point of the works. Toulouse-Lautrec literally brought the metropolitan crowd within his orbit of address: they are both the subject and the object of many of his best works. Paintings such as Poudre de Riz (1887), Au Cirque Fer-18.1 nando: Equestrienne (1887–8) and Bal du Moulin de la Galette (1889) represent working-class people in the places they frequented, and the paintings were exhibited in those very same places-Poudre de Riz at Aristide Bruant's Cabaret Mirliton, and the second at the Moulin Rouge. Van Gogh saw Poudre de Riz as representing an archetypically Montmartrois character; he wrote Theo Van Gogh in August 1888 that he wished to see it hung beside his own Provençal Patience Escalier. Bal 0.5du Moulin de la Galette was, in a sense, brought even closer to its subjects: it was reproduced on the pages of the cheap and popular newspaper Le Courrier français.

Toulouse-Lautrec's most ambitious efforts to combine popular subjects and audacious, modernist means are his large paintings of cabaret and circus scenes, such as Au Cirque Fernando: Equestrienne. The picture anticipates by two years Seurat's The Circus, and is certainly more spontaneous and more gross. It is also the artist's first large-scale engagement with a fetishistic theme current in the decadent literature of the day. Au Cirque Fernando: Equestrienne is broadly and thinly painted with pinkish white relieved by stripes of red and patches of green, gray, and violet. The artist has taken particular delight in painting the horse's massive croup (we can easily see it is a stallion), which is then implicitly compared to that of the ringmaster, bareback rider, and even clown at the left. The red-haired équestrienne has heavily rouged cheeks and painted eyes and mouth, recalling the dissipated rider in Catulle Mendes's "L'Amant de sa femme," from Monstres parisiens (1882). In that story, a man is irresistibly compelled to return to his wife whom he had thrown out of his house years before for her adulteries. Now she is a circus performer, "starring at the Hippodrome, under a pseudonym, in the pageant of Riquet à la Houpe."

18.2

17.14

Indeed it is the very degeneracy of Mendes's bareback rider—evidenced by her sagging flesh, livid face paint, and ripe odor-that arouses the lust and devotion of her cuckolded husband.

Whereas Seurat's bareback rider is a weightless sprite note the upward direction of the skirt, arms, and hair-Toulouse-Lautrec's figure is awkward and angular, and her body is as hard and flat as her paste make-up. This very crudeness, this very visible corruption, like that associated with Mendes's wife turned circus equestrienne, is the source of the picture's erotic charge, and the intended basis of its popular appeal. Toulouse-Lautrec in fact painted an overlifesized version of the composition. Known today as the "missing Ecuyère," the picture is lost, but its scale—and a confirming letter from the artist to his mother-indicates it was intended for exhibition at the Cirque Fernando itself. In any event the smaller canvas was exhibited above the bar at the cabaret Moulin Rouge beside Dressage des nouvelles (1889-90) and Adolphe Willette's Danseuse (ca. 1890). There, workingclass spectators could easily glimpse its vulgar humor, while bourgeois men could revel in its degeneracy.

Even when Toulouse-Lautrec was not painting for the metropolitan public, his works often exhibited a similar embrace of popular themes and exotic sexual perspectives. There is no evidence that Two Friends (1895), for example, was exhibited at a brothel; on the contrary, it appears to have been made for the private delectation of a male friend of the artist. But it addresses one particular aspect of contemporary prostitution with considerable directness-that is, lesbianism. Though Toulouse-Lautrec's several paintings of sexual intimacy between women recall poetry and painting devoted to the theme-consider Baudelaire's condemned "Lesbos" from The Flowers of Evil and Courbet's The Sleepers (1866)— 11.2 they are also derived from contemporary literary and sexological sources. Mendes was enamored of lesbian themes, though his Satanism and misogyny is largely absent from Toulouse-Lautrec's paintings. More apposite is Richard von Krafft-Ebing, whose scholarly monograph Psychopathia-Sexualis (1886) was read by Toulouse-Lautrec and cited by him with some regularity, according to the painter's friend Thadée Natanson. In this celebrated book, Krafft-Ebing specifically described lesbian love ("congenital sexual inversion among women") as the frequent solace of prostitutes. He writes:

Prostitutes of gross sensuality who, disgusted with their intercourse with perverse and impotent men by whom they are used for the performance of the most revolting sexual acts, seek compensation in the sympathetic embrace of persons of their own sex. These cases are of very frequent occurrence.

386 . THE APPEAL OF MODERN ART: TOULOUSE-LAUTREC

Two Friends, like The Kiss (1892), In Bed (1893), and several others, clearly represents the solace provided by lesbian sex and intimacy—the proximity of the figures to the picture plane, the warmth of the colors, and the great emphasis upon pillows, blankets, and varied patterns and textures, all combine to create a palpable physicality and closeness. Indeed, it may be that male spectators, used to seeing male/female pairings in Academic paintings such as Carolus-Duran's *The Kiss* (1868), were encouraged to experience a measure of transvestic identification with one or another of the women. If this was the case, then the familiar circuit of seeing and being seen-of men as disembodied possessors of sight, and women as passive and embodied objects of vision—was challenged, at least in painted fiction. Toulouse-Lautrec's pictures of lesbians may thus have confronted their spectators with something of the same vitality and disembodied confidence we observed in Cassatt's Woman in Black at the Opera. Like the large decorative panels and oval portraits made by the artist for the brothel on the rue d'Amboise, their pictorial address is to sex-workers as

POSTER ART

much as to their clients.

At about the same time that he was working on lesbian and brothel pictures, Toulouse-Lautrec turned his attention to poster art. The posters are extremely audacious—flat colors, hard, clear outlines, exaggerated foreshortening, and bold repetition of shapes and words. They are remarkable as well for essentially disregarding the most commonly used erotic motifs in the advertisements of the day. There is nothing in Toulouse-Lautrec's poster oeuvre comparable, for example, to Chéret's *Le Bal du Moulin Rouge* (1889) in which *décolletage* and bared thighs tell the whole story. Instead, the artist combines an elaborate vocabulary of metropolitan styles, attitudes, and expressions into a complex and fetishistic elixir.

18.6 Jane Avril (1893) was created on the occasion of an appearance by the celebrated dancer at the café-concert Jardin de Paris. The five-color lithographed poster reveals the full range of the artist's technique and style, including ink spatters, colors that overflow contours, and an expressive framing line which meanders from foreground to back, unifying pictorial surface and fictive depth. The dancer herself accordingly occupies an ambiguous zone; her plumed bonnet caresses the background framing line at upper left while her raised leg taunts the phallic bass viol neck in the extreme foreground. Thus, the dancer's legs seem to rise and fall, open and close, move forward and back in rhythm with the viewer's alternating perception of the picture as surface or

depth. Jane Avril is like an erotic automaton who is operated both by the spectacled musician with the giant instrument and, imaginatively, by the spectator who stands before any public kiosk bearing her image. But like the lesbians in Toulouse-Lautrec's brothel pictures, Avril is not a mere passive object of sight. Her haughty expression suggests that she delights in controlling her audiences, in placing them in her thrall. Indeed, Jane Avril understood fetishistic desire and the casting of spells. She had been a patient of Jean-Martin Charcot at the asylum of Salpêtrière in the early 1880's when the doctor published his landmark study of fetishism, "Inversions du sens genital" in the *Archives de la neurologie* (1882).

In the poster Ambassadeurs, Aristide Bruant (1892), a slightly different erotic game is played, but once more the working-class and bourgeois viewer is dominated by a celebrated entertainer. Known for his lusty gestures, crude double-entendres, and for abusing his audiences, Bruant was a star from the 1880's until after the turn of the century. The sign outside his Montmartre cabaret read "Le Mirliton, for Audiences that Enjoy Being Insulted." In 1892, Bruant moved from Le Mirliton to the tonier Café des Ambassadeurs on the Champs-Elysées. Still favored by the masses, but now, too, according to Edmond de Goncourt, by unblushed society women eager to hear his "purulent slang," Aristide Bruant commissioned his friend, the artist, to represent him in his unique and instantly recognizable attire: wide brimmed hat, Inverness cape, and long, red scarf. Bruant fills the poster, squeezed between its four borders, and between the spectator and the seductively posed sailor who gazes out from the upper right. The silhouetted sailor may have been a sly reference to the corvette, a term used in the French Navy both for a small, fast battleship and for someone who is courbé, or "bent," that is to say, queer. Aristide Bruant actually revived and popularized this term, and other non-nautical synonyms, including jésus, mignon, pédé, rivet, sonnette, etc. (Most of these arc found in Bruant's Dictionnaire Français Argot from 1901.) The viewer of Toulouse-Lautrec's poster, and Bruant's performances, was thus required to submit both to verbal abuse and to a homosexual come-on! Like Bruant, Toulouse-Lautrec observed the gay subcultures of France and England. In England in 1895, he painted a portrait of Oscar Wilde while the esthete was in the midst of his disastrous lawsuit. In addition, he undoubtedly witnessed the parade of gay men who sought their petit jésus in the relatively secure precincts of Montmartre brothels.

At the request of Bruant, the poster was displayed on both sides of the stage of the *café-concert* Ambassadeurs, as well as on hundreds of walls and kiosks throughout Paris, transforming the city into one man's image. "Who will rid us of

18.6 HENRI DE TOULOUSE-LAUTREC Jane Avril, 1893. Color lithograph, $487/8 \times 36 (124 \times 91.5)$

this picture of Aristide Bruant?" wrote a columnist in La Vie Parisienne. "You cannot move a step without being confronted by it. Bruant is supposed to be an artist; why then, does he put himself up on the walls beside the gas-lamps and other advertisements? Doesn't he object to neighbors like these?" Here was the new art intended for the metropolitan crowd: it was cheap, public, and democratic; it spoke in the argot of working men and women; it chastised the bourgeoisie while giving them an erotic charge; it derived its authority from the brothel, the vaudeville stage, and the alienist's laboratory.

THE METROPOLITAN FETISH

The posters and paintings of Toulouse-Lautrec, we may conclude, were at once deeply manipulative and highly incendiary. Whereas nineteenth-century urbanization and industrialization, in Eugen Weber's phrase, had "turned peasants into Frenchmen," advertising and mass culture during the fin-de-siècle turned Frenchmen into consumers. The working-class and petit bourgeois crowd was encouraged to believe that its most fervent desires could be gratified by

visits to the new grand magasin and by the purchase of commodities. It was led, too, to believe that passive spectatorship at circuses and cabarets was somehow the same thing as sharing and participating in a common culture. And, finally, they were persuaded that they could receive sexual gratification from individual acts of consumption and spectatorship. Toulouse-Lautrec and his friends-Jane Avril, Aristide Bruant, and the others—were especially good at making this latter case. "Bruant, La Golue and most recently the Divan Japonais," wrote Gustave Geffroy in La Justice in 1893, "have taken possession of the streets with an irresistible authority." This very evident erotic authority is the basis of the unsettling power and popularity of Toulouse-Lautrec's art.

For Toulouse-Lautrec was a fetishist, and fetishism is a form of unreason or madness: the displacement of easel paintings from the walls of the Salon to the walls of the cabaret; the desire of a wealthy bourgeois man for a dissipated bareback rider; the imaginative identification of a straight man with a lesbian prostitute; the castigating glance of Jane Avril; the willing insertion of the heterosexual male spectator into a circuit of homosexuality. In each instance, the fetishistic object of desire is evidently of lesser social or economic value than the thing it replaces, and yet the exchange is made in any case. In Guy de Maupassant's classic story "La Chevelure" (1884), a rope made of hair is more alluring to the story's protagonist than any mistress. Surely it is cold company on the streets of Paris, in a theater box or a boudoir. And yet for this fetishist, the blond tresses induced transports of "superhuman delight." Fetishes such as hair, hands, gloves, feet, and shoes, Krafft-Ebbing wrote, provoke such powerful "optical and emotional impressions" that they have the power to arouse "visual memory" and "sexual excitement, even orgasm." The gloves of Yvette Guilbert highlighted in Le Divan Japonais and in an important 1894 album of 17.1 lithographs are images of fetishistic madness.

In Toulouse-Lautrec's Paris—a modern city, a city of immigrants, workers, paupers, and prostitutes; a city governed by the reason of cold cash—in that metropolis, the fetish had especial authority. It seemed to uphold or celebrate individualism in the midst of anonymity, imagination in a world of routine, personal autonomy in a political culture that prized obedience, and intrinsic worth in an economy based upon exchange value. This, in any case, was Toulouse-Lautrec's proposition—his particular artistic gambit. For a time, in fact, he—like Seurat and Vincent van Gogh seemed to be remaking popular culture along modernist lines and his posters stand at the beginning of an advertising tradition that extends to this day. But after 1887 their paths diverged. Van Gogh, as we shall shortly discover, could not abide the speed, anonymity, and extremism of metropolitan life and its new mass culture.

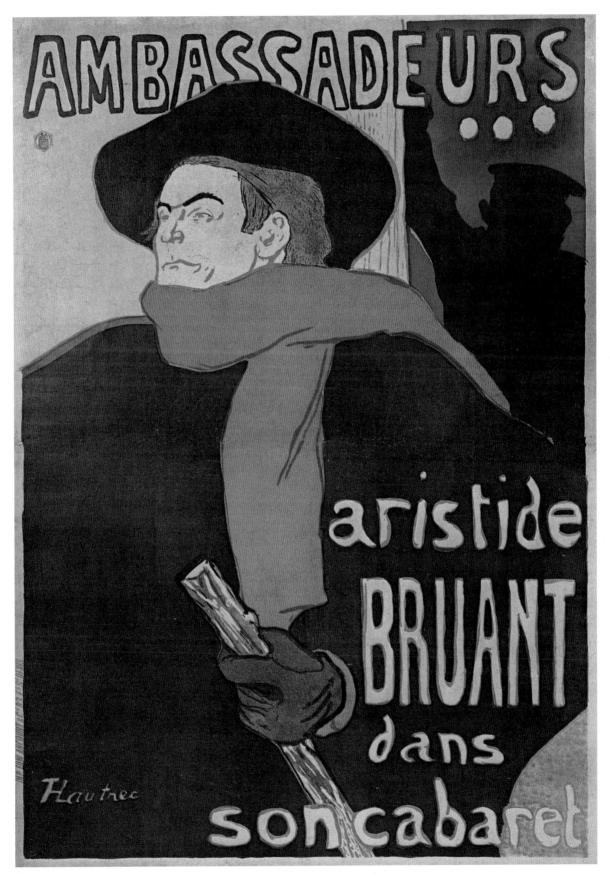

18.7 HENRI DE TOULOUSE-LAUTREC Ambassadeurs, Aristide Bruant, 1892. Color lithograph, 51 × 393/8 (150 × 100)

· 19 ·

ABSTRACTION AND POPULISM: VAN GOGH

SEURAT AND VAN GOGH COMPARED

LOSE CONTEMPORARIES WHOSE PATHS SEVERAL ₄ times crossed, Vincent van Gogh (1853–90) and Georges Seurat are nonetheless often seen as opposites. Whereas the Dutch-born artist, it is said, was essentially a man of nature and the countryside, the Frenchman was archetypically urban and cosmopolitan. Whereas the one was unsettled and passionate in his temperament and his art, the other was generally calm and dispassionate in both. And whereas Van Gogh's painting was romantic and self-expressive, Seurat's was classical and disciplined. The list of such oppositions could easily be lengthened to include those other binaries—Baroque/Classical, Modern/Ancient, Rubéniste/ Poussiniste—that have provided a comforting structure to nineteenth-century and subsequent art historical thought. Yet the dichotomy is mostly false, as can immediately be seen by a comparison of Van Gogh's portrait of Madame Augustine Roulin, called by him La Berceuse (1889), and Seurat's portrait of his mistress, Madeleine Knoblock, called 19.2 Young Woman Powdering Herself (1889-90).

Both paintings are three-quarter-length seated portraits of women. Each woman's body and gaze is oriented to the left, while her preponderant bulk is anchored at the lower right. Each is accompanied by an attribute—a make-up kit, and a rope attached to an unseen cradle—which determines the picture's title. Flowers are a prominent part of the decorative ensemble of each painting, serving at once to disperse the viewer's attention across the surface of the picture and to reinforce an overall flatness; in the Seurat, flowers are seen on the background wallpaper and reflected in the bambooframed mirror at the upper left, while in the Van Gogh they are found only-but spectacularly-in the background wallpaper. Each painting, moreover, is structured according to Neoimpressionist principles of divided color. Seurat's portrait contains a complex mixture of tints of blue, red, green, orange, yellow, and purple, with a predominant blue/ orange complementary pairing. Van Gogh employs divided color everywhere in the painting: in the red/green complements of the floor and Madame Roulin's ample skirt and sweater, in the orange/blue complements of her eves, collar, and sleeves and especially in the hallucinatory wallpaper, composed of flowers of pink, white, red, green, and yellow, floating above a pattern of green and yellow paisley above a field of black ovals surrounding orange dots above a sea of dark green. (The peculiar wallpaper may have been derived from the wallpaper pattern in Dubois-Pillet's Portrait of Mlle. M. D., 1886).

Van Gogh's portrait of his friend Madame Roulin, who had offered him succor during a period of convalescence, was clearly intended as a composition in restfulness and harmony, orchestrated with the instruments of Chromo-luminarism, or what Seurat called "the harmony of opposites." In January 1889, Van Gogh described La Berceuse in a letter written to his friend the Dutch painter Koning in Paris:

At present I have in mind, or rather on my easel, the portrait of a woman. I call it "La Berceuse," or as we say in Dutch . . . "our lullaby or the woman rocking the cradle." It is a woman in a green dress (the bust olive green and the skirt pale malachite green). The hair is quite orange and in plaits. The complexion is chrome yellow, worked up with some naturally broken tones for the purpose of modeling. The hands holding the rope of the cradle, the same. At the bottom the background is vermilion (simply representing a tiled floor or else a stone floor). The wall is covered with wallpaper, which of course I have calculated in conformity with the rest of the colors. This wallpaper is bluish-green

with pink dahlias spotted with orange and ultramarine. . . . Whether I really sang a lullaby in colors is something I leave to the critics (Letter 571a).

A few weeks later, Van Gogh wrote to his brother Theo about his intention to make *La Berceuse* into a work of truly popular art, crafted (as he would later say of his *Bedroom in Arles*) with a "Seurat-like simplicity." Such a picture, he wrote, could soothe the hearts and souls of even coarse fishermen:

I have just said to Gauguin that following those intimate talks of ours the idea came to me to paint the picture in such a way that sailors, who are at once children and martyrs, seeing it in the cabin of their Icelandic fishing boat, would feel the old sense of being rocked come over them and remember their own lullabys. Now it may be said that it is like a chromolithograph from a cheap shop. A woman in green with orange hair standing out against a background of green with pink flowers. Now these discordant sharps of crude pink, crude orange, and crude green are softened by flats of red and green. I picture to myself these same canvases between those of the sunflowers, which would thus form torches or candelabra beside them, the same size, and so the whole would be composed of seven or nine canvases (Letter 574).

"Perhaps there's an attempt," he later added to Theo, "to get all the *music* of the color here into *La Berceuse*" (Letter 576). In his stated emulation of musical effect and quest for Wagnerian scope, Van Gogh must again be compared with Seurat, who painted mural-sized works and constructed chromatic *gesamtkunstwerke* (total works of art) with his elaborate painted frames.

Comparison of La Berceuse with Young Woman Powdering Herself, in short, reveals a quite profound agreement between their authors as to what constitutes a successful modern painting. Both artists accepted the validity of the traditional genre of portraiture (they were among the last modern painters to do so) but expanded its parameters and range of affect through a "science" of Chromo-luminarism. Each sought to stimulate in their audience feelings of harmony, by which was meant not just a feeling of peace but an ideal and musical consonance that was both conducive to present social amity and predictive of a utopian concord that could be achieved in the future. In addition, each artist desired to democratize art through the "high" cultural adaptation of "low" cultural forms, such as cheap chromolithographs and popular prints. Yet here a distinction must be announced, which will be elaborated in the following pages. The Young Woman of Seurat is a modern, fashionable woman of the sort we have met before in paintings by Manet, Degas, Morisot, and Cassatt; La Berceuse of Van Gogh is the nononsense wife of a proletarian, akin to the heroic working men and women in the Realist art of Daumier, Courbet, and Millet. Whereas Seurat admired as well as sought to capture in his art the promised pleasures of the new mass culture of Paris—the cabarets, circuses, and suburban parks—Van Gogh remained wedded to the ideal of an indigenous or autochthonous popular culture, more or less traditional and uncontaminated by a modern culture industry. "Yesterday I was at the Café-concert Scala," Van Gogh wrote from Antwerp in 1885 to Theo, "something like the Folies Bergères; I found it very dull, and of course insipid" (Letter 438). Later in the same letter, he wrote: "I also have the idea for a kind of signboard, which I hope to carry out. I mean for instance, for a fishmonger, still life of fishes, for flowers, for vegetables, for restaurants. . . . One thing is certain, that I want my things to be seen."

TWO MYTHS ABOUT VAN GOGH

Two myths about Van Gogh must at once be dispelled. First, he was not insane. His progressively worsening mental condition (culminating in suicide), and intermittent institutionalization at the end of his life, were almost certainly the result of an organic dysfunction, probably psycho-motor or symptomatic epilepsy or perhaps some other inner-ear or metabolic disorder exacerbated by liquor, medicines, or poor diet. His doctor at the Hospital of St. Rémy near Arles wrote to Theo in May 1889: "You ask for my opinion regarding the probable cause of his illness. I must tell you that for the time being I will not make any prognosis, but I fear that it may be serious as I have every reason to believe that the attack which he has had is the result of a state of epilepsy and if this should be confirmed one should be concerned about the future." Vincent van Gogh apparently agreed with his physician's general assessment, writing at the time to his brother: "I think Dr. Peyron is right when he says I am not, strictly speaking, mad, for my mind is absolutely normal in the intervals . . . but during the attacks it is terrible, then I lose consciousness of everything" (Letter 610). Van Gogh obviously could not paint during his seizures or their aftermath, and his art was mature (or well on its way to maturity) long before his first attacks. Thus, though his desperation in the face of what was to him a mysterious and sometimes disabling illness was undoubtedly great, we are probably safe in assuming that his sickness had little or nothing to do with his art.

Secondly, and consequently, Van Gogh's art was not conceived by him as a form of therapy—as a balm for his tormented soul. As we have already begun to see, he became an artist for all the same sorts of reasons, and in pursuit of many of the same goals, as other great nineteenth-century

19.1 VINCENT VAN GOGH $\it La$ Berceuse, 1889. Oil on canvas, $36 \% \times 28 \% (92 \times 73)$

19.2 Georges Seurat Young Woman Powdering Herself, 1889–90. Oil on canvas, $27\frac{1}{4} \times 34\frac{1}{8}$ (70.4 × 86.6)

19.3 VINCENT VAN GOGH The Artist's Bedroom in Arles, 1888. Oil on canvas, $28\frac{1}{4} \times 35\frac{1}{2}$ (79 × 90)

painters. Indeed, he went about his work with as much or more conscious diligence and intellectual resource as any other artist of the century. Van Gogh read voraciously in four languages—Dutch, French, English, and German and had a modest competence in Latin and Greek. He kept well abreast of local, national, and international news and events and was completely current about contemporary art and literature. Far from being purely instinctual and reclusive. Van Gogh was unusually learned communicative, and his art was dedicated to dialogue. expression, decisiveness, and action in the world. His more than five hundred published letters to Theo are not primarily a personal diary; they are progress reports to a beloved brother and main financial backer, as well as a selfconscious gloss upon a vast, ambitious, and complex body of art.

VAN GOGH'S FIRST STATEMENTS OF PURPOSE

In 1882, at the dawn of his career as an artist (after a decade as an art dealer, school teacher, and evangelist, among other jobs), Van Gogh wrote to Theo concerning his desire to form a community of artists, and his simultaneous realization that the times were probably not ripe:

One would like to speak [with the authority of] the people of '93 [the year of the French Revolution's Reign of Terror]: this and that must be done, first these have to die, then those, then the last ones, it is duty, so it is unarguable, and nothing more need be said.

But is this the time to combine and speak out?

Or is it better, as so many have fallen asleep, and do not like to be aroused, to try to stick to things one can do alone, for which one is alone liable and responsible, so that those who sleep may go on sleeping and resting? (Letter 248)

Six months later, Van Gogh spoke again about the need for artistic collectives: "I am privileged above many others, but I cannot do everything which I might have the courage, the energy to undertake. . . . Why shouldn't more painters join hands to work together, like soldiers of the rank and file?" Two years later, Van Gogh was confirmed in his determination to act as a kind of cultural insurgent. He wrote again to his brother:

I wish you could just imagine that you and I had lived in the year 1848. . . . [During the revolution of 1848] we might have confronted each other as direct enemies, you before the barricades as a soldier of the government, I behind it as a revolutionary or rebel. . . . Neither you nor I meddle with politics, but we live in the world, in society, and

involuntarily, ranks of people group themselves. . . . As an individual one is part of all humanity. That humanity is divided into parties. How much is it one's own free will, how much is it the fatality of circumstances which makes one belong to one party or to its opposite. Well, then it was '48, now it is '84, "le moulin n'y est plus, mais le vent y est encore." [The mill is no longer there, but the wind still blows.] But try to know for yourself where you really belong, as I try to know that for myself (Letter 379).

To explore social "ranks" or classes, to depict the life and culture of peasants and proletarians, to construct an art that is at once an expression of the individual and of his or her community, and to represent a beautiful dream of utopia—these are among the subjects of Van Gogh's mature art, first announced in the years 1882–4.

EARLY ART IN THE HAGUE AND NEUNEN: THE POTATO EATERS

In March 1882, Van Gogh's professional career was launched by a commission from his uncle, C. M. van Gogh, for two sets of drawings of The Hague, where the artist had that year taken up residence. The works were undoubtedly expected to draw upon the great tradition of Dutch cityscape painting of the seventeenth century (especially by Jan Vermeer and Pieter de Hooch) and upon contemporary Hague School Realism as practised by George Breitner (1857-1923), Jacob Maris (1837-99), Isaac Israels (1865-1934), and Anton Mauve (1838–88), among others. Yet in a drawing from the second set, such as Carpenter's Workshop and Laundry (1882), Van Gogh has rejected the comforting balance of land, religion, and working-class industriousness found, for example, in Maris's The Bleaching Yard (1870). Whereas the latter combines panoramic landscape, church, and laundress in order to embrace Dutch bourgeois pieties, Van Gogh's work offers an unsentimental cross-section of wage labor and small-scale factories. Van Gogh's patron was apparently disappointed with this and the other drawings in the set, for he paid Van Gogh far less than he promised.

Although drawn with the aid of a perspective window, such as devised by Albrecht Dürer, Carpenter's Workshop and Laundry is nevertheless marked with willful violations of perspective and proportion. The diagonal lines at the upper right and left which recede so rapidly toward the horizon belong to a different pictorial order from the lazy dipping and swelling of the foreground zones, as if the space of human labor had to be distinguished from that of nature and its laws. "I have tried to draw the things as naïvely as possible," Van Gogh wrote Theo, "exactly as I saw them before me. . . . As

19.4

19.4 VINCENT VAN GOGH Carpenter's Workshop and Laundry, 1882. Pencil, ink, and paint on laid paper, $11\frac{1}{4} \times 18\frac{3}{8}$ (28.5 × 47)

19.5 JACOB MARIS The Bleaching Yard, 1870. Oil on canvas, $16\frac{1}{8} \times 22\frac{1}{2} (41 \times 57)$

you can see, there are already several planes in this drawing, and one can look around it and through it, in every nook and cranny. It still lacks vigor . . . but it will come by and by" (Letter 205). The purposeful exaggerations and distortions of light, atmosphere, and anatomy (notice, for example, the angular contours of the idle washerwoman in the right foreground), as well as perspective, which would become so significant a feature of the later oil paintings, are thus already announced in this drawing with pencil, pen, and brush.

Prompted by his acquisition of a collection of popular wood engravings by the English illustrators Luke Fildes, Hubert van Herkomer, Frank Holl, and others, Van Gogh proceeded at this time to explore working-class life and labor in a group of over fifty single-figure drawings of men and women from a local almshouse, as well as in dozens of more complex compositions depicting miners, navvies, agricultural workers, and weavers. The artist's perception of these workers is revealed in a letter from 1880, in which he described an excursion from his home in the Borinage (a coal-mining region of Belgium) to a small village of weavers:

The miners and the weaver still constitute a race apart from other laborers and artisans, and I feel a great sympathy for them. I should be happy if someday I could draw them, so

19.6 VINCENT VAN GOGH *The Bearers of the Burden*, 1881. Pencil and ink on laid paper, $17 \times 23^{5/8} (43 \times 60)$

19.7 VINCENT VAN GOGH The Potato Eaters, 1885. Oil on canvas, $32\frac{1}{4} \times 44\frac{7}{8}$ (82 × 114)

19.8 JOZEF ISRAËLS *The Frugal Meal*, 1876. Oil on canvas, $35 \times 54^{5/8}$ (88.9 \times 138.7)

19.9 WILLIAM-ADOLPHE BOUGUEREAU The Nut Gatherers the 1880. Oil on canvas, $34\% \times 52\% (88 \times 134)$

that those unknown or little known types would be brought before the eyes of the people. The man from the depths of the abyss, *de profundis*—that is the miner; the other, with his dreamy air, somewhat absent minded, almost a somnambulist—that is the weaver. . . And increasingly I find something touching and almost sad in these poor, obscure laborers—of the lowest order, so to speak, and the most despised—who are generally represented as a race of criminals and thieves by a perhaps vivid but very false and unjust imagination (Letter 136).

Van Gogh's words of sympathy reveal the stance of Christian paternalism that dominated his art and thought at the beginning of his career. In *The Bearers of the Burden* (1881), Van Gogh mimics Breugel's parable painting of *The Blind*

Leading the Blind (1568), in depicting women in rags weighed down with sacks of coal trudging in a blind and dejected procession. A narrow band of sky above presses down upon these lost and despised souls, while sooty clogs below trace a staggered arc across the foreground. Two years later at Neunen, Van Gogh continued his representation of proletarians in several dozen drawings and small paintings of weavers trapped amid their hand-powered looms. In 1885, he represented peasants in a major work, *The Potato Eaters*.

Composed out of a somber and restricted palette of earth tones—grays, browns, and black—*The Potato Eaters* represents Van Gogh's most accomplished work prior to his move to Paris in 1886. It was completed just three weeks after it was begun and depicts a poor family from the Brabant consuming a humble meal of potatoes and coffee within a meagerly

furnished home or *bakhuis* (a small cottage separate from a peasant family's main house, kept exclusively for cooking and eating). An oil lamp casts highlights on men's and women's knuckles, cheekbones, and noses, and upon the various tokens of family wealth: at the upper left are a clock with pendulum and a framed crucifixion scene, and at the upper right a tool rack and a clog filled with spoons. Van Gogh's many visits to his subject-family (the De Groots), dozens of large and small studies in several media (including lithography), and written description of the project, reveal an almost anthropological perspective; his analysis below, for example, exposes a critical self-consciousness at odds with his earlier Christian allegorizing:

I have tried to emphasize that these people, eating their potatoes in the lamplight, have dug the earth with those very hands they put in the dish, and so it speaks of *manual labor*, and how they have honestly earned their food. I have wanted to give an impression of a way of life quite different from us civilized human beings. . . . Painting peasants is a serious thing, and I should reproach myself if I did not try to make pictures which will arouse serious thoughts in those who think seriously about art and about life. Millet, De Groux and so many others have given an example of character, and of not minding criticisms such as nasty, coarse, dirty, stinking, etc., etc., so it would be a shame to waver. No, one must paint the peasants as being one of them, as feeling, thinking as they do (Letter 404).

There is no doubt that *Potato Eaters* is profoundly different from other peasant paintings Van Gogh would have known. Whereas Jules Breton emphasized the timelessness of peasant ritual piety, in such works as *Blessing the Wheat in the Artois* (1857), Van Gogh has relegated Christianity to the crude image of a framed crucifixion; whereas Jozef Israëls (1824–1911) depicted a wholesome and well-washed nuclear family in *The Frugal Meal* (1876), Van Gogh represented the awkward and unclean men and women of an extended and fatherless family; and whereas William-Adolphe Bouguereau depicted feminine leisure and coquettishness in *The Nut Gatherers* (1880), Van Gogh shows cheap food to be the meager reward for peasant hard labor.

Yet despite Van Gogh's relative distance from bourgeois peasant painting, he was unable completely to rid his art of convention. For one thing, his vision was filtered through innumerable art historical sources, from Rembrandt to Millet to Breton, and *Potato Eaters* shows it. More importantly, as the art historian Griselda Pollock has demonstrated, the intended interlocutors of the painting are not peasants but urban bourgeois—"us civilized human beings," as Van Gogh wrote. In *Potato Eaters*, Van Gogh tried to address a vanguard

bourgeois public in an artistic language born, so he thought, in the soot and soil of peasant life itself. Not surprisingly, his efforts were received with indifference or disdain, and he thereupon undertook still another self-refashioning. This entailed a move to Antwerp and then Paris, and the pursuit of an emerging dream of utopia.

ACADEMIC TRAINING AND AVANT-GARDE EDUCATION IN ANTWERP AND PARIS

Van Gogh spent just three months in Antwerp, during which time he attended art classes at the Academy of Fine Arts, studied the paintings of Rubens, and began to collect Japanese woodblock prints. His experience at the Academy was frustrating, as it was for so many others at the Paris Ecole des Beaux-Arts. "First make a contour," Van Gogh was instructed by his teacher, "your contour isn't right; I won't correct it if you do your modeling before having seriously fixed your contour. . . . Color and modeling aren't much, one can learn that very quickly, it's the contour that is essential and the most difficult." Van Gogh then exclaimed to Theo: "And now you ought to see how flat, how lifeless and how insipid the results of that system are . . . Like David, or even worse, like [Jan Willem] Pieneman [1779-1853] in full bloom" (Letter 452). A few years earlier, another artist of independent and romantic temperament, Odilon Redon (see Chapter 18), had a similar experience at the Paris atelier of Gérôme: "I was tortured by the teacher. . . . His corrections were vehement to the point that his very approach to my easel upset my comrades. All was in vain. He recommended that I enclose in an outline a form that I saw palpitating. . . . [He] drew with authority a stone, a shaft or a column, a table, a chair, an inanimate accessory, a rock and all of inorganic nature. The pupil saw only the expression, only the expansion of the triumphant feeling of forms." For both artists, Academic Classicism was at once moribund pedagogy and the token of an elite and discredited social and class hierarchy; for both, Classicism was opposed by what they considered the naive and naturally expressive art of Delacroix, Millet, and Corot. Shortly after describing his academic instruction in Antwerp, Van Gogh wrote again to Theo, but this time about art and politics and the economic depression:

I do not think it exaggerated to be pessimistic about the various strikes, etc., everywhere. They will certainly prove not to have been useless for the following generations, for *then* they will have proved a success. . . . The laborer against the bourgeois is as justifiable as was the third estate against the other two, a hundred years ago. And the best thing to do is to keep silent, for fate is not on the bourgeois

19.10 VINCENT VAN GOGH Portrait of Père Tanguy, 1887–8. Oil on canvas, $36\frac{1}{4} \times 29\frac{1}{2} (92 \times 75)$

19.11 EMILE BERNARD Self-Portrait With Portrait of Gauguin, 1888. Oil on canvas, 181/8 × 215/8 (46 × 54.9)

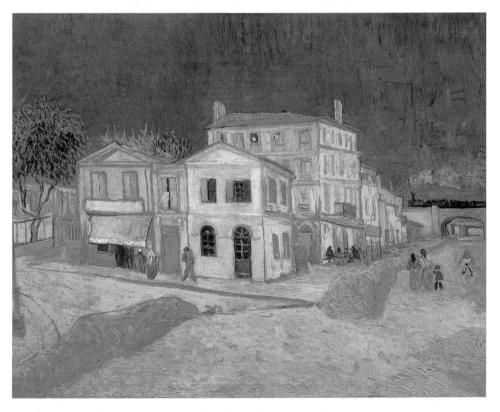

19.12 VINCENT VAN GOGH Yellow House at Arles, 1888. Oil on canvas, $28\frac{3}{8} \times 36$ (72 × 91.5)

side, and we shall live to see more of it; we are still far from the end. So although it's spring, how many thousands are wandering about, desolate. . . . Corot, who after all had more serenity than anybody else, who felt the spring so deeply, was he not as simple as a workingman all his life, and so sensitive to all the miseries of others? (Letter 453).

The letter exposes at once Van Gogh's solidarity with the working-class movement and his bourgeois fear and guilthis political progressivism and his paternalistic conservatism. His solution to the dilemma of class conflict was akin to the utopian one proposed more than two generations before by Henri de Saint-Simon, who wrote in his Nouveau Christianisme (1825) that "all men should treat one another as brothers," adding that his new religion would, by "improving the moral and physical well being of the poorest class . . . bring prosperity to all classes of society and all nations with the greatest possible speed." More broadly still, Van Gogh must be understood as one of the many artists, writers, and philosophers of the nineteenth century who shared an attitude of romantic anticapitalism. This perspective, which is especially marked in Van Gogh's favorite romantic authors including Carlyle, Dickens, and Michelet—may be recognized by its critique of the nineteenth-century economic and social order from the perspective of precapitalist cultural values. For the romantic anticapitalist, the longed for vision of the future is always the reflection of an imagined past. Van Gogh's two years in Paris, from February 1886 to February 1888, would accelerate this already established critical trajectory of his art and thought.

Van Gogh's Paris period taught him the decisive lessons of Impressionism. He grew confident in his treatment of sunlight and prismatic color (lessons gleaned from works by Seurat as well as by Renoir and Monet) and used his new skills to portray modern life, urban and suburban entertainments, and bourgeois and petit bourgeois sociability. In addition, he undertook a thorough study of Japanese Edo Period woodblock prints, exhibiting his personal collection of them at the Café Tambourin in March 1887. In his collecting, Van Gogh was manifesting the Japonisme that had become widespread in the two decades since the display of Japanese arts and crafts at the Paris Universal Exposition of 1867. Yet for him, unlike for the dealer Samuel Bing or the Belgian-born painter Alfred Stevens (1823–1906; see, for example, his The Japanese Dress, ca. 1880), Japan was not simply a sign of chicness and exoticism: it was also a dream-image of utopia. Japanese prints appear as the backdrop for his most extraordinary painting of the Paris period, the *Portrait of* Père Tanguy (1887–8). Tanguy was an art dealer, color merchant, and ardent socialist who was especially kind to the often scorned artist, extending him friendship and

19.13

19.13 ALFRED STEVENS The Japanese Dress, ca. 1880. Oil on canvas, $59 \times 41^{1/2} \, (150 \times 105)$

hospitality as well as considerable credit. They shared, according to their friend the painter Emile Bernard, both poverty and a sustaining faith in the coming dawn of a utopian "era of happiness . . . [and] social harmony." Van Gogh depicts Tanguy seated with eyes downcast and hands somewhat stiffly interlocked, in the posture of a Japanese bonze (Buddhist monk). Behind him are at least five freely rendered Japanese prints depicting geishas and landscapes (by Yoshitara, Toyokuni, and Hiroshige), including Mount Fuji, which seems to rise like a crown from Tanguy's hat. By its Chromo-luminarist color and its fashionable "japonaiserie" (a term Van Gogh discovered in Edmond de Goncourt's novel Chérie, 1884), the painting is a kind of summary of the artist's assimilation of Parisian avant-garde fashion. Yet in many ways, it is also an announcement, as Fred Orton and Griselda Pollock have written, of the artistic life—the dream of utopia—that was beckoning from Arles in the South of France.

Feeling that his art and life were too narrowly circumscribed by the reigning art institutions and constricting

sociability of Paris, Van Gogh had begun to contemplate a move to Arles. There, warmed by a brilliant Provençal sun and solaced by a community of generous and like-minded artist-friends, he would pursue his twin generic ambitions of portrait and landscape painting. All in all, Arles "would be the painter's paradise," Van Gogh wrote in a joyful moment, "it would be absolute Japan" (Letter 543). By the "japonaiserie" of the *Portrait of Père Tanguy*, Van Gogh expressed his utopian hope of creating in France the Orientalist ideal world of Japan—a land of sun-filled peace and pleasure whose artists were all as wise as Buddhist monks.

VAN GOGH IN ARLES

Thus, in February 1888, Van Gogh moved to Arles, eager to renew his health and imagination, and to realize his dream of establishing an artists' commune, called the Studio of the South. This esthetic settlement, part monastery and part Fourierist phalanstère (socialist colonies described in the writings of Charles Fourier), would be sustained by the warm dry breezes and timeless popular culture of Provence, as well as by the modest financial support of Theo, who had become an important Impressionist impresario for Goupil and Co. of Paris. Inspired by the example of other avant-garde subcultures, such as the Barbizon school, the Impressionists, and the Pre-Raphaelite Brotherhood, and by fantasies of a primitivistic Oriental paradise in the Occident, Van Gogh set about enlisting the participation of several of his artist friends, particularly the young Emile Bernard (1868–1941), who was then engaged, with Gauguin, in his own utopian fantasizing at Pont-Aven in Brittany. Van Gogh wrote to encourage an exchange of artworks (Bernard's Self-Portrait With Portrait of Gauguin [1888], which he inscribed to Van Gogh, was sent in reply), and to persuade Bernard to come to Arles:

For a long time now I have thought it touching that the Japanese artists used to exchange works among themselves very often. It certainly proves that they liked and upheld each other and that there reigned a certain harmony among them; and that they were living in some sort of fraternal community, quite naturally and not in intrigues. The more we are like them in this respect, the better it will be for us. It also appears that the Japanese earned very little money, and lived like simple workmen (Letter B 18).

At about the same time he wrote to Theo: "Come now, isn't it almost a true religion which these simple Japanese teach us, who live in nature as though they themselves were flowers? And you cannot study Japanese art, it seems to me, without becoming much gayer and happier, and we must return to

nature in spite of our education and our work in a world of convention" (Letter 542).

By September 1888, Van Gogh was settled in his Yellow House at Arles (1888), the planned center of what the art historian Tsukasa Kodera has called the artist's "primitivistic utopia." At this time, he was painting with an unprecedented rapidity and virtuosity, perhaps in anticipation of the imminent arrival of Gauguin, the only artist who finally came to live and work with him. Van Gogh's The Night Cafe (1888) and The Artist's Bedroom in Arles (1888) are two of the more than three dozen paintings created during the late summer and fall of 1888. They are simultaneously crude in their disregard of conventional perspective, modeling, and anatomy, and subtle in their use of color modulation (see Chapter 19) to designate both spatial planes and emotional tenor. Van Gogh described The Artist's Bedroom in a letter to Theo:

This time it's just simply my bedroom, only here color is to do everything, and, giving by its simplification a grander style to things, is to be suggestive here of rest or of sleep in general. In a word, looking at the picture ought to rest the brain, or rather the imagination. The walls are pale violet. The floor is red tiles. The wood of the bed and chairs is the vellow of fresh butter, the sheets and pillows very light greenish citron. The coverlet scarlet. The window green. The toilet table orange, the basin blue. The doors lilac. And that is all—there is nothing else in this room with its closed shutters. The broad lines of the furniture again must express inviolable rest. Portraits on the walls, and a mirror and a towel and some clothes. The frame—as there is no white in the picture—will be white. . . . The shadows and the cast shadows are suppressed; it is painted in free flat tints like the Japanese prints (Letter 554).

Indeed, in spite of the uniformly high-key colors, the painting does achieve balance and restfulness. The buttery yellow bed is kept flat by exaggerated foreshortening, reminiscent of the vertiginous distortions in works by the Flemish "primitives" (see, for instance, the central panel of the Mérode Altarpiece, ca. 1425-8, by Robert Campin). The warm red-tiled floor is similarly held in spatial equilibrium by the cool blue recessional lines, while the remainder of the picture is constructed out of balanced complements: "The coverlet scarlet. The window green. The toilet table orange, the basin blue." A few large elements on one side of the picture (the door and bed on the right), are balanced against several smaller ones on the other side (window, dressing-table, mirror, rush chairs), anticipating the abstract compositions of the Dutch artist Piet Mondrian (1872–1944), who shared Van Gogh's understanding that the affective quality of color is determined in part by its proximity to other colors and in part by its quantity. Yet for all its subtleties, The Artist's Bedroom 19.14 19.3

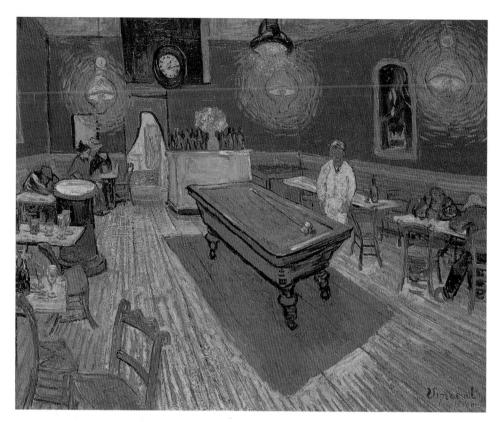

19.14 VINCENT VAN GOGH The Night Café, 1888. Oil on canvas, $28\frac{1}{2} \times 36\frac{1}{4} (72.4 \times 92)$

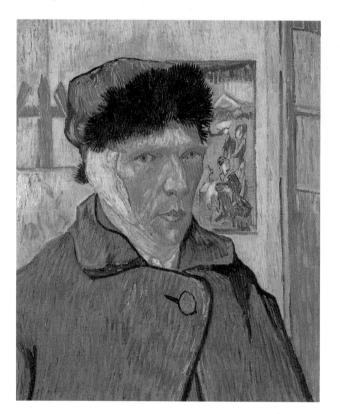

19.15 VINCENT VAN GOGH Self-Portrait With Bandaged Ear, 1889. Oil on canvas, 23 $\%\times$ 19½ (60 \times 49)

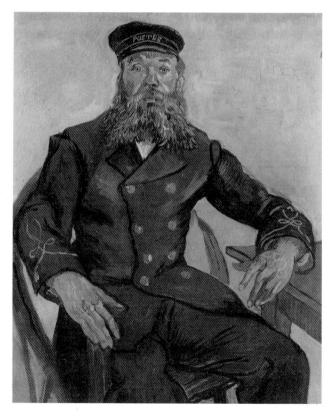

19.16 VINCENT VAN GOGH Joseph Roulin, 1888. Oil on canvas, 32 × 25 $^{3/4}$ (81.2 × 65.3)

in Arles has the aspect of a humbly crafted object; the placement of furniture and accessories in the composition and the thick impasto suggest the ingenuousness of needlework samplers or other pieces of homespun. The whole was conceived, Van Gogh writes, "in harmony . . . of a Seurat-like simplicity."

Precisely such a workmanlike simplicity was sought as well, we have seen, in Van Gogh's portrait La Berceuse. Begun in December 1888 during his period of collaboration with Gauguin, the work was only completed in late January after his recovery from the famous and terrible seizure that left him mutilated and hospitalized—as can be seen in his Self-Portrait With Bandaged Ear (1889). (Gauguin's stay with Van Gogh at Arles—about which relatively little is known—lasted from October 23 until December 26 1888. Van Gogh's letters to Theo during this period indicate, however, that the two artists got along very poorly; their relationship was marred by

19.17 VINCENT VAN GOGH Eugène Boch, 1888. Oil on canvas, $23^{5/8} \times 17^{3/4}$ (60 × 45)

mutual suspicion, jealousy, and misunderstanding.) Besides landscapes, portraits and self-portraits now dominated Van Gogh's art; they were, he wrote to Bernard, "the thing of the future," part of his effort to record for posterity the physiognomy of a person, a class, a culture, and an epoch. As with the group portrait of the De Groot family in Potato Eaters, the single portraits of Joseph Roulin (1888) and Eugène Boch (1888) are nearly anthropological in their attentiveness 19.17 to signs of class and occupation. The postman is posed proud and stiff in his uniform, like the policeman in August Sander's 1925 photograph. Yet unlike the neue sachlichkeit (new objectivity) photographer, Van Gogh employed abstraction as well as objectivity to achieve "the great simple thing: the painting of humanity . . . by means of portraiture" (Letter B 13). He described his portrait of Boch in a letter to Theo:

19.16

What a mistake Parisians make in not having a palate for crude things, for [paintings by] Monticelli, for common earthenware. But there, one must not lose heart because Utopia is not coming true. It is only that what I learned in Paris is leaving me, and I am returning to the ideas I had in the country before knowing the Impressionists. . . . Because instead of trying to reproduce exactly what I have before my eyes, I use color more arbitrarily, in order to express myself forcibly. . . .

I should like to paint the portrait of an artist friend, a man who dreams great dreams, who works as the nightingale sings, because it is his nature. . . . So I paint him as he is, as faithfully as I can, to begin with.

But the picture is not yet finished. To finish it I am now going to be the arbitrary colorist. I exaggerate the fairness of the hair, I even get to orange tones, chromes and pale citron-yellow.

Behind the head, instead of painting the ordinary wall of the mean room, I paint infinity, a plain background of the richest, intensest blue that I can contrive, and by this simple combination of the bright head against the rich blue background, I get a mysterious effect, like a star in the depths of an azure sky (Letter 520).

Having always insisted in his letters upon the necessity of drawing and painting from models, Van Gogh now was finding mimesis inadequate to his expressive ends. Dissonance and abstraction are loosed in the clash of complements and the collapsing of foreground and background in portraits and landscapes from the last year of his life.

STARRY NIGHT AND CRITICAL MODERNISM

9.18 Starry Night (1889) is a depiction of the eastern night sky seen from the window of Van Gogh's barred cell on the upper floor of the St. Rémy mental hospital in the monastery of St. Paul de Mausole, some fifteen miles northeast of Arles. Van Gogh was confined there for one year between May 1889 and May 1890, during which time he painted numerous views of the asylum grounds and the surrounding countryside. Starry Night is in many ways a compendium of the artist's interests and preoccupations. Thickly painted in a kind of whorling chain-stitch, the picture has the crafted surface of the "crude things" Van Gogh admired most: "common earthenware," rush-seated chairs, and old pairs of workmen's shoes. Symbols are drawn from a well-thumbed dictionary of romantic anticapitalism: mournful cypress trees, church

steeples, peasant cottages with glowing hearths, hills and stars and planets. Indeed, the work is in part a reverie upon a utopian future based on the imagined social integrity of a simpler past. Yet at the same time it is a modernist rejection of the pictorial conventions of Realism and Naturalism. The dichotomy was remarked on by Van Gogh: *Starry Night* is not a return to romantic or religious ideas, no. Nevertheless, by going the way of Delacroix, more than is apparent, by color and a more spontaneous drawing than delusive precision, one could express the purer nature of a countryside compared with the suburbs and cabarets of Paris" (Letter 595).

In his painting of Starry Night and in his brief explication of it to Theo, Van Gogh is revealed as a critical modernist as much as a romantic anticapitalist, "Precision" of representation is "delusive" to Van Gogh exactly because it obscures behind an empirical veil the historically contingent conflicts of class, politics, and ideology that were so keenly felt and understood by the artist throughout his life. Yet the assumption of a critical stance—as we have seen repeatedly in the lives and works of nineteenth-century artists from Goya to Turner to Courbet—entailed considerable risks. Without the old rules of representation (and they have been almost entirely disregarded in such final works as Roots and Trunks of Trees, 1890), how can coherence and comprehensibility be upheld? "At one time," Vincent wrote to Theo in 1889, "abstraction seemed to me a charmed path. But it is bewitched ground, old man, and one soon finds oneself up against a wall." For Van Gogh as for so many of his fellow avant-gardists, the old Classical order was dead, but the new modern one could not be born; the goal of creating an art at once radically democratic and completely modern would remain a dream for at least another two generations. Van Gogh, however, would not be part of that continuing quest: for reasons that remain obscure, but which may have been related to despair over his illness, Van Gogh shot himself on July 27, 1890 outside the village of Auvers-sur-Oise, where he had not long before moved. He died in his bed two days later.

As much as Seurat, Van Gogh created an art of antinomy. Traditionalist and revolutionary, he has achieved greater renown than any other artist of his century, yet at the same time been construed as inscrutable and reclusive. Realist and Symbolist, Van Gogh succeeded in breaking down the barriers between popular and elite art, yet at the same time was taken to exemplify the unbridgeable chasm between the common person and the artistic genius. A summary of the life and art of Van Gogh is thus also a summary of the contradictions of modernism, and especially of the simultaneous "charmed path," and "bewitched ground," of abstraction.

19.18 VINCENT VAN GOGH Starry Night, 1889. Oil on canvas, 29 × 36½ (73.7 × 92.1)

SYMBOLISM AND THE DIALECTICS OF RETREAT

MODERNISM VERSUS SYMBOLISM

THROUGHOUT THE NINETEENTH CENTURY, modern artists sought to assert their connection to the Classical past by continually strengthening their links to the present: "The true painter we're looking for," we have heard Baudelaire proclaim, "will be the one who can snatch from the life of today its epic quality, and make us feel how great and poetic we are in our cravats and our patent-leather boots." Modernism, it is now possible to state in summary, as it evolved in Europe and North America over the course of the nineteenth century, was not so much a rejection of older European forms as a radical (and more or less last-ditch) effort to keep the Classical tradition alive in all its epic and imperial authority. "All we were really after," the Impressionist Renoir declared, "was to try to induce painters in general to get in line and follow the Masters, if they did not wish to see painting definitely go by the board." The work of Van Gogh revealed as clearly as any other the simultaneous conservatism and revolutionism of this modern cultural strategy.

Van Gogh's primary genre interests—portraiture and landscape—were traditional forms that harked back to the Flemish and Dutch Golden Ages of Breugel, Rembrandt, and Van Ruisdael. Indeed, for all his Chromo-luminarism and use of "arbitrary" color, Van Gogh in such final paintings as *Croms In the Wheatfields* (1890) paid homage not so much to the landscapes of Seurat as to the rural allegories of Breugel: "They are vast fields of wheat under troubled skies," Van Gogh wrote to Theo in July 1890 concerning these works, "and I did not need to go out of my way to express sadness and extreme loneliness. I hope you will see them soon—for I hope to bring them to you in Paris as soon as possible, since I almost

think that these canvases will tell you what I cannot say in words, the health and restorative forces that I see in the country" (Letter 649).

Despite his traditionalism, however, Van Gogh expressed in his work the revolutionary stamp and tenor of his times. His landscape subject and facture implicitly criticized the Classical rules and hierarchies of late Renaissance and Baroque painting and its Academic descendants. In addition, his portraits of workers and peasants were efforts to reveal the physiognomy of a dawning twentieth century; by their employment of dissonance or chromaticism, moreover, they suggested the recent music of Wagner. Since the early 1880's, Wagnerism had gained numerous adherents in Paris, especially among the artists and writers who clustered around the poets Jules Laforgue and Stéphane Mallarmé, and the journalists Edouard Dujardin and Théodore de Wyzewa, founders in 1885 of the Revue Wagnérienne. For this coterie which also included the painters Gustave Moreau, Odilon and Henri Fantin-Latour—Wagner's music represented the long sought esthetic and philosophical unity of sensation, emotion, and intellection, what Wyzewa called "la vie totale de l'univers." Van Gogh too was infatuated by Wagnerism, apparently believing that it offered him a means to revitalize an otherwise stultified artistic tradition. "I made a vain attempt to learn music," he wrote to Theo in the summer of 1888, "so much did I already feel the relation between our color and Wagner's music." Indeed, in La Berceuse we saw Van Gogh's modification of the normal harmonic scale progression through the introduction of color accidentals almost to the point of abstraction. But this was an abstraction that was intended not to destroy the art of portraiture but to save it, that is, to make it once more a

20.1 VINCENT VAN GOGH Crows in the Wheatfields, 1890. Oil on canvas, $19^{7/8} \times 39^{1/2}$ (50.5 × 100.3)

vehicle for the revelation of human character, the recording of social station, and the expression of feeling. Van Gogh's project of reconciling expression and representation, therefore, like the modernist project as a whole, was complex and fraught with difficulty, and engendered an anxiety: how could he keep his work in touch both with modern life and with the masters, without falling victim to either complete abstraction or historicism, both of which signaled to him meaninglessness and the death of art.

At least some of Van Gogh's contemporaries, including the French Gauguin, Auguste Rodin, and Redon, the Belgian James Ensor, the Russian Mikhail Vrubel, the Norwegian Edvard Munch, and the Swiss Ferdinand Hodler had much less anxiety about abstraction. To them, the subtle critical prerogatives of modernism were useless ingenuities in a society tumbling headlong into decay and perdition. To them, painting and sculpture might as well become as abstract or "Symbolist" as imagination demanded, since reality itself was hopelessly degraded and no significant public sphere for art any longer existed. Besides, they reasoned, had not an earlier generation of Romantics shown that form alone—line, color, or pattern—was adequate to convey spiritual meaning and personal expression? "Art is an abstraction;" Gauguin wrote to his friend the painter Emile Schuffenecker in August 1888, "take from nature as you dream, and think more of the creation that will come of it. The only way to rise up to God is by doing like our divine master, by creating." Gauguin's emphasis upon dreams and the spiritual as bases for art was repeated by many others of this generation.

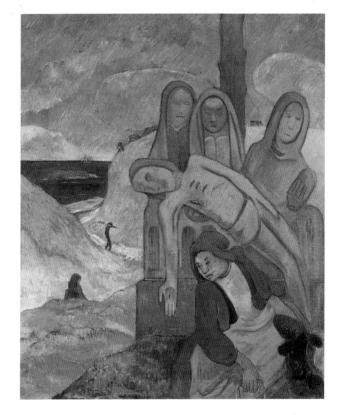

20.2 PAUL GAUGUIN *Green Christ*, 1889. Oil on canvas, $36\frac{1}{4} \times 28\frac{3}{4}$ (92 × 73)

Conceived during a period of widespread European pessimism and disenchantment stemming from a capitalist depression lasting nearly a generation, Symbolism was the artistic symptom of a structural crisis. It was an inwarddirected art, antihistorical, intensely personal, and sometimes even confessional. Not daily life but the arcadias of Puvis de Chavannes (see p. 321) and the funereal dreams of the Swiss painter Arnold Böcklin (1827-1901) inspired it. Symbolism marked, therefore, the conclusion of a four-centuries-old tradition of representation founded on Classical concepts of mimesis, and the end of a fifty-year period described by the American art historian Elizabeth Gilmore Holt as "the triumph of art for the public." Yet Symbolism was not only a retreat from representation and public meaning; by rejecting a European mimetic tradition, it also pioneered a new art of sensual liberation and personal expression founded in part on non-Western "primitivism." As much as it was an art of retreat, decadence, and recondite meaning, it was also an engine of cultural criticism, political reinvigoration, and international perspective. Symbolism accelerated the predominant nineteenth-century conflict between Classical representation and critical modernity to a point of crisis; on the horizon lay the irregular terrain of Cubism, the abyss of nonrepresentation, and the revolutionary dreamscape of Surrealism. Symbolism was not an avant-garde subculture like the Pre-Raphaelite Brotherhood, the Impressionist Société Anonyme or the Neoimpressionist Société des Indépendants—structured societies with membership lists, dues, proscribed exhibition venues, and sectarian rules of inclusion and exclusion; it was an international cultural and esthetic direction that, however, spawned numerous local avant-gardes. During the final two decades of the nineteenth century, Symbolism became an irresistible cultural tide that swept across Europe and North America.

THE RHETORIC OF SYMBOLISM

Symbolism may first of all be recognized by its rhetoric. In what many regarded as a Symbolist manifesto, published in the Paris *Figaro Littéraire* on September 18, 1886, the poet Jean Moréas proclaimed the value of pure subjectivity and representation of the "Idea." He wrote: "Symbolic poetry endeavors to clothe the Idea in a sensitive form which, nevertheless, would not be an end in itself, but would be subordinate to the idea while serving to express it . . . art can derive from objectivity only a simple and extremely succinct point of departure." A week later, the poet and critic Gustave Kahn penned a response to Moréas in which he too insisted upon the right of poets and artists to disdain history and contemporaneity and indulge in a world of dream:

As to subject matter we are tired of the quotidian, the near at hand, and the compulsorily contemporaneous; we wish to be able to place the development of the symbol in any period whatsoever, and even in outright dreams (the dream being indistinguishable from life). . . . The essential aim of our art is to objectify the subjective (the externalization of the Idea) instead of subjectifying the objective (nature seen through the eyes of a temperament).

Kahn's final pithy formulation, that the artist should "objectify the subjective . . . instead of subjectifying the objective," which Naturalist writers and painters such as Zola and Monet had done, was rapidly seized upon by a diverse array of painters as well as poets as the essential maxim of Symbolist esthetics. Thus, by 1891, the young critic Albert Aurier, in an article called "Symbolism in Painting: Paul Gauguin," was able formally to codify a definition of Symbolist painting under five terms:

- Ideist, for its unique ideal will be the expression of the Idea.
- 2. Symbolist, for it will express this idea by means of forms.
- 3. Synthetist, for it will present these forms, these signs, according to a method which is generally understandable.
- Subjective, for the object will never be considered as an object but as the sign of an idea perceived by the subject.
- 5. (It is consequentially) *Decorative*—for decorative painting in its proper sense, as the Egyptians and, very probably the Greeks and the Primitives understood it, is nothing other than a manifestation of art at once subjective, synthetic, symbolic and ideist.

In practise, these recipes for Symbolist art were distilled by French, and later other European and American, artists, critics, and a small public down to this simple formula: Symbolism was that theory of art which ascribed the greatest value to the representation of dreams, visions, or other subjective states by means of a restrictive and non-naturalistic vocabulary of line, tone, and color.

Yet if Symbolism had a generally accepted rhetoric, its historical and ideological significance was much less widely agreed upon. To some, such as the painter Maurice Denis (1870–1943) who, along with Paul Sérusier, Edouard Vuillard (1868–1940), and Pierre Bonnard (1867–1947), was a member of the avant–garde group called the Nabis (the word is Hebrew for prophets), Symbolism was a form of "Neotraditionism" that stressed Christian values of quietism, piety, asceticism, and hierarchical stability. In 1890, Denis described how the Symbolist rejection of Naturalism and embrace of formal abstraction was paving the way toward a new and earnestly felt spirituality: "All the sentiment of the work of art comes

unconsciously, or almost so, from the state of the artist's soul: 'He who wants to paint the story of Christ must live with Christ,' said Fra Angelico. This is a truism. . . . Our . . . impression of moral order opposite [Gauguin's] Green Christ [1889] and the bas-relief Be in Love and You Will Be Happy cannot spring from the motif or motifs of nature represented, but from the representation itself, forms and coloring."

To other critics, such as the Neoimpressionist apologist Fénéon, Symbolism was an art of creative freedom and sensual liberation that furthered the growing impetus toward revolutionary anarchism. Describing the work of Paul Gauguin (1848–1903) in 1889, he invoked the anarchist dream of free and autonomous nations or communities living side by side in cooperation and harmony:

Reality for [Gauguin] was only the pretext for a creation quite removed from it: he puts into a new order the material furnished for him by reality; he disdains all illusion, even the illusion of atmosphere; he accentuates lines, limits their number, makes them hierarchic; and within each of the spacious cantons formed by their interlacing, an opulent and sultry color bleakly extends its own pride without in any way threatening the independence of its neighbors, and at the same time without compromising itself.

Fénéon's description of Gauguin's Symbolist painting as political allegory could hardly be more different from Denis's description of it as an "unconscious" rendering of a traditional "moral order." Thus, any adequate definition of Symbolism must take account of the complex ideological distinctions marked by these opposing interpretations. The art of Gauguin was at the time, and remains today, the chief field on which the Symbolist battle was waged; our survey of the movement will therefore begin and end with him. In between, we will briefly examine the results of the improbable collision of an antinaturalist Symbolism and the naturalist genre of landscape painting.

PAUL GAUGUIN AND SYMBOLISM IN BRITTANY

While no single artwork succinctly exemplifies all of Aurier's Symbolist preconditions, Gauguin's Yellow Christ, contem-20.3 porary critics generally agreed, came close. Painted in Pont-Aven in Brittany in September 1889, the work depicts a group of three Breton women gathered around a crucified Christ (or sculpture of Christ) planted in the gray rock of Golgotha. The shrill vellow color of the divided fields of grain and of Christ's body, the latter thickly outlined in Prussian blue like the leading around the painted glass in medieval church windows,

creates an abstract and therefore decorative pattern upon the picture surface. Inspired by an eighteenth-century polychromed wooden Christ which the artist had seen in the rustic chapel of Trémalo near Pont-Aven in Brittany, the painting is purposely crude, populist or synthetist in aspect. (Synthétisme was the term used by artists who were close to Gauguin at Pont-Aven during 1886-90: a painting was meant to synthesize the artist's impressions and memories. During the Universal Exposition of 1889, an exhibition of Synthétisme was held and a Groupe Synthétiste was formed in 1891.) Indeed, examination of Yellow Christ reveals the impression of newsprint on its upper third, perhaps the result of being blotted with, or rolled up in newspaper, but in any case anticipating the "low-culture"-inspired pasted paper collages of Picasso and Braque from nearly a generation later. Gauguin's landscape receives a somewhat more complex compositional articulation than his figures, but here too the ideist intent—the antinaturalist and decorative aspect—is clearly manifest. The trees are flat red clouds that zig-zag from middle right to background left, the stone wall and serpentine path in the middle-ground are painted without tonal modeling, and the crisp edge of the horizon at upper right is unrelieved by atmospheric perspective. Finally, and in sum, the event Gauguin represented is neither historical nor clearly contemporary, the scene neither quotidian nor clearly visionary, and the technique neither mimetic nor clearly abstract. By these ambiguities the painting is *subjective* and *symbolist* in its suggestion of an alternative reality that lay beyond objective knowledge or sight. The critic Octave Mirbeau assented to the evocativeness of the painting when he described it in 1891 as "a rich, disturbing blend of barbaric splendor, Catholic liturgy, Hindu reverie, Gothic imagery, and obscure and subtle symbolism."

Yet however esoteric its sources or syncretism, what is perhaps most noteworthy about Yellow Christ and other Brittany pictures by him, such as The Vision After the Sermon (Jacob Wrestling With the Angel) (1888) and The Green 20.2 Christ—and what reveals them to be Symbolist—is what is left largely unpainted and unsaid. Gauguin's decorative, pietistic, and populist representations of Breton spirituality pointedly overlooked the modernizing transformations which the people and their region were then undergoing. During the 1870's and '80's, Brittany experienced an economic boom and cultural redevelopment. Despite a nationwide reduction in wholesale prices and extremely sluggish growth rates in the generation following the (nearly worldwide) "crash" of 1873, Brittany, like some other formerly underdeveloped regions of France, thrived. Agriculture was becoming rationalized (small landholders were dispossessed and the landless made into wage-laborers), fishing and other industries expanded, and tourism rapidly grew. The latter development is

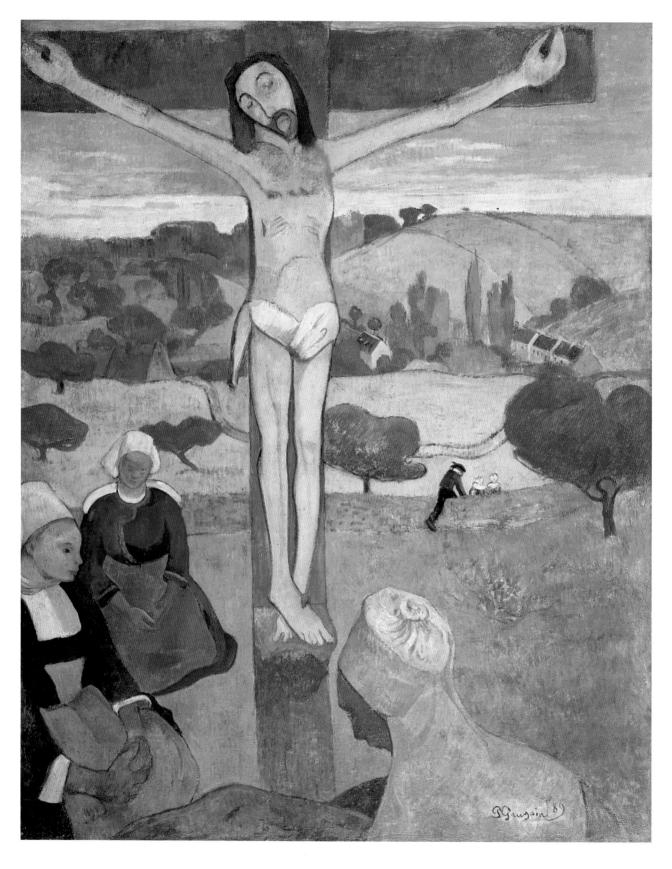

20.3 PAUL GAUGUIN Yellow Christ, 1889. Oil on canvas, $36\frac{1}{2} \times 28\frac{3}{4} (92 \times 73)$

20.4 PAUL GAUGUIN The Seaweed Gatherers, 1889. Oil on canvas, $34^{1/4} \times 48^{1/2} (87 \times 123)$

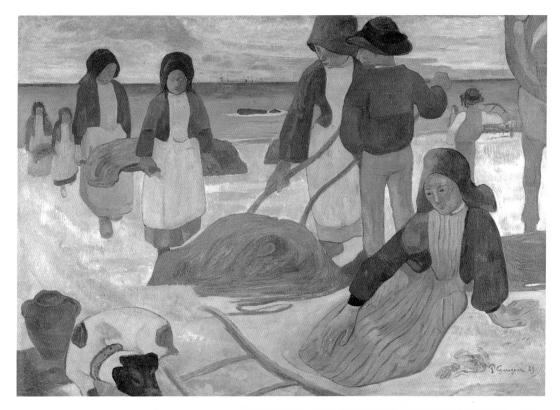

especially significant for our account since, ironically, it was the touristic marketing of Breton "primitiveness" that brought Gauguin and many other artists to the region in the first place. The unique and picturesque Breton costumes, for example, which we see represented in works by artists such as Gauguin, Bernard, and Pascal Dagnan-Bouveret, were not a residue of ancient Celtic culture, but rather a complex and modern expression of social hierarchy, class mobility, and cultural aspiration. They permitted people proudly to express their indigenous identities, while at the same time encouraging touristic consumption. Yet Gauguin's representations of what he called in a letter to Theo Van Gogh "savage" and "primitive" Brittany, in pictures created between 1886 and 1890 and again in 1894, largely avoid any reckoning with tourism or with the larger conflict there (and in much of rural agrarian France) between traditional culture and what the philosopher Paul Ricoeur has described as the forces of "universalizing civilization," that is, modern industrial capitalism and its colonizing mass culture.

Gauguin's strategy of evasion thus provides a further preliminary gloss upon Symbolism. The painters who will be considered below—Gauguin, Ensor, Redon, Munch, Vrubel, and Hodler—are Symbolist because their works share certain formal features: flatness, decorativeness, reductiveness, and abstraction; certain iconographic features: a concern with dreams, visions, and the spiritual; and certain ideological features: avoidance of contradiction, disdain for history, and a flight from modernity. Symbolist painting, unlike previous

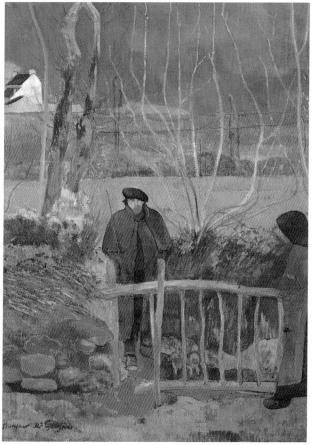

20.5 PAUL GAUGUIN Bonjour Monsieur Gauguin, 1889. Oil on canvas, $44\frac{1}{2} \times 36\frac{1}{4} (113 \times 92)$

modernisms considered in this book, was as Denis wrote, a form of "Neotraditionism" that upheld a conservative and hierarchical "moral order" in the midst of a society in profound transition. Symbolism was thus "mythical," functioning, as modern European myth does, to "de-politicize speech." "Myth today," wrote the mid-twentieth-century critic Roland Barthes, "turns reality inside out, empties it of history and fills it with nature. . . . [Its function is] to empty reality: it is, literally, a ceaseless flowing out, a hemorrhage, or perhaps an evaporation, in short, a perceptible absence." Barthes argues that at the core of modern myth—embodied today in advertising, mass media, fashion, and tourism—lies an historical amnesia. A similar forgetfulness lurks amid the decorative fanfare of much Symbolist art.

Yet the complexity of Symbolism, and especially the art of Gauguin, does not permit Denis and Barthes to have the final say; Fénéon's words too must be remembered. To him, Gauguin's "synthetist" art from Brittany represented not "Neotraditionism" but a beckoning "new order;" its at once harmonic and independent colors and forms anticipated, he believed, a political future based upon the anarchist principles of mutual respect alongside individual autonomy. Indeed, according to him the art of Gauguin was anything but "depoliticized," despite the fact that it was "removed from reality." Perhaps instead of Barthes, it should be to Claude Lévi-Strauss that we turn for a definition of myth that is germane to Symbolism. The function of myth in "primitive" societies (those without writing), Lévi-Strauss writes, "is to provide a logical model capable of overcoming a contradiction (an impossible achievement if, as happens, the contradiction is real)." Primitive myths are valuable to their cultures not because they mask or occlude contradictions, but because they manage or organize them. In so doing, they underline the prevailing communitarian principle in primitive societies, that, as the anthropologist writes, "self-interest is the source of all evil." Much of the best Symbolist art (especially Gauguin's), I shall argue below, shares this "primitivist" perspective, providing audiences with a new and compelling critique of European culture.

In fact, a closer look at Gauguin's paintings, sculptures, and ceramics from Brittany reveals that he did not entirely abjure modernity and politics. The best works are subtly but forcibly marked by modern signs of artistic alienation, class division, and degrading labor. After organizing in Paris an exhibition of Impressionist and Synthetist art at the Café des Arts (also known as the Café Volpini, after the proprietor), adjacent to the great 1889 Universal Exposition, Gauguin returned to Pont-Aven in June of that year and soon after moved to the nearby hamlet of Le Pouldu. During the next six months, he depicted such modern subjects as proletarian labor in The Seaweed Gatherers (1889), subdivided and enclosed grain

fields in Yellow Christ and other landscapes, and himself as a 20 kind of refugee in Bonjour Monsieur Gauguin (1889), a picture inspired by Courbet's The Meeting (1854), in which the Realist painter represented himself as the Wandering Jew, forever condemned to walk the earth. In Christ in the Garden of Olives (1889) and the extraordinary and disturbing Jug in the Form of a Head, Self-Portrait (1889), Gauguin portrayed 20 himself as a savior and a martyr. "This painting is fated to be misunderstood," he said of the Christ in a letter to Vincent van Gogh, "so I shall keep it for a long time." Later he wrote to a journalist: "[Christ in the Garden of Olives] represents the crushing of an ideal, and a pain that is both divine and human." What was crushed was the ideal of establishing a harmonious artistic community in "savage and primitive" Brittany in concert with his friends and followers Bernard. Schuffenecker (1851–1934), Louis Anquetin (1861–1932), Jacob Meyer de Haan (1852–95), and Paul Sérusier (1865– 1927). Crushed too was the ideal of mutual support and selflessness with Van Gogh at Arles. In Brittany as in the South Seas, Gauguin's response to pain and alienation was the creation of myths, both of the modern and of the primitive sort described above; his Symbolism consisted precisely of a dialectic of avoidance and earnest expression of social contradiction. Many other Symbolist painters, such as Ensor, simply denied modernity outright, finding solace in fantastic imaginings of an ideal past and utopian future.

ENSOR AND POPULISM

James Ensor was born in 1860 at the seaside resort of Ostend, in northwestern Belgium, and died there at the age of 89 in 1949. For most of his life he remained aloof from urban, avant-garde culture as he indulged his carnivalesque imagination in partial emulation of past Dutch and Flemish artists— Van Eyck, Bosch, Breugel, Rembrandt, and Rubens. Thus, like his Symbolist contemporaries in France, Switzerland, and Norway, Ensor was a self-imposed exile from modernization and contemporaneity. "Long live naive and ignorant painting!" Ensor exclaimed in 1900: "Long live the peasant in art . . . Flemish art since Breugel, Bosch, Rubens and Jordaens is dead, truly dead. . . . Long live free, free, free art!" If Ensor was disdainful of modern artistic sophistication and feeling, he was equally scornful of academicism: "All the rules," Ensor wrote, "all the canons of art vomit death like their bronze brethren."

For all his extravagance and vitriol, however, Ensor began his artistic training conventionally enough with private lessons in Ostend, and enrollment in 1877 at the Brussels Academy of Fine Arts. Although he later disparaged the Academy as "that establishment for the near blind," he remained there nearly three years and even earned an award

20.4

20.6 PAUL GAUGUIN Jug in the Form of a Head, Self-Portrait, 1889. Glazed stoneware, height 7½ (19.3)

for his drawings after Classical busts. Between 1880 and 1885 he continued his studies on his own by making dozens of copies and interpretations of master drawings by Rembrandt, Callot, Watteau, Goya, Turner, Daumier, and others. Ensor's complex assimilation of this mainly Northern European and generally anticlassical graphic tradition is apparent in the extraordinary and bizarre etching entitled *Iston, Pouffamatus, Cracozie, and Transmouff, Famous Persian Physicians Examining the Stools of King Darius after the Batle of Arbela* (1886). The subject of this work, very loosely based upon Plutarch's life of the Persian king Darius, of course satirizes the Classical narratives usually assigned to enterprising Academy students, but its style reveals an earnest effort to understand and employ Baroque (especially Rembrandtesque) conventions of hatching and chiaroscuro.

Yet even at the level of form, Ensor's iconoclastic tendencies could not be restrained. Rembrandt allowed every contour line in his etchings an expressive independence, and every section of hatching an articulate clarity and orderliness; Ensor, in contrast, purposely confuses both hatching and contour lines, lending his composition a peculiarly anarchic and comic quality wholly consistent with its scatological content. This mixture of emulation and mockery of Northern Renaissance and Baroque traditions is apparent in the majority of Ensor's works in the decade following his departure from the Academy, including the Bosch-like *Tribulations of Saint Antony* (1887). The red-cowled hermit Antony is tempted and tormented by women and soldiers, frogs and balloonists, angels and demons, all painted with the textures and hues of blood and feces.

Beginning in 1881 and continuing for more than two decades, Ensor regularly submitted etchings, drawings, and

20.7 JAMES ENSOR Iston, Pouffamatus, Cracozie, and Transmouff, Famous Persian Physicians Examining the Stools of King Darius after the Battle of Arbela, 1886. Etching, 93/8 × 7 (23.7 × 17.8)

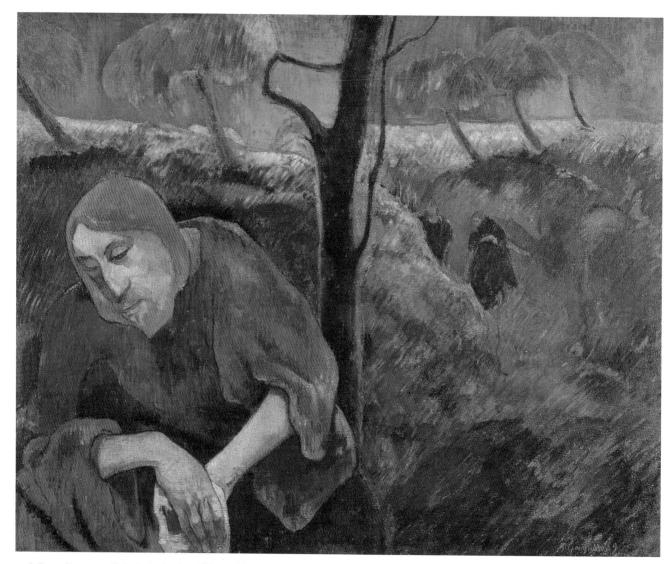

20.8 PAUL GAUGUIN Christ in the Garden of Olives, 1889. Oil on canvas, $28\frac{3}{4} \times 36\frac{1}{4} (73 \times 92)$

paintings like these to exhibitions in Brussels organized by the avant-garde groups La Chrysalide, L'Essor, Les Vingt, and La Libre Esthétique as well, on occasion, to more conservative venues, even including the Paris Salon in 1882. Ensor was clearly uncomfortable about exhibition with the various rulebound Salons des Beaux-Arts, yet he was hardly more enthusiastic about showing with the avant-garde organizations. The Brussels fraternity called Le Groupe des Vingt (Les Vingt) is a case in point. Formed in 1883 by a number of artists, writers, and critics that included Ensor, the selfproclaimed Symbolist Fernand Khnopff (1858–1921), the Neoimpressionist Théo Van Rysselberghe (1862–1926), and the critics and lawyers Octave Maus and Edmond Picard, Les Vingt was an exhibition society that, like its counterpart Les Indépendants in France, sought to create and exhibit progressive artworks exclusive of the constraints imposed by Salon juries. At first, the group embraced several artistic tendencies and directions, claiming a commitment to the creation of both explicitly partisan and disinterestedly pure works of art. Accordingly, they ambiguously stated their goal in 1884 to be: "The study and the direct interpretation of contemporary reality by the artist, letting himself go freely in his temperament and [gaining] thorough mastery of technique." Although the organization became factionalized by 1886 between champions of an unambiguous socialist direction in art (Picard) and proponents of unfettered choice in matters of content as well as form (the poet Georges Rodenbach and Khnopff, among others), subsequent group exhibitions were clearly dominated by the latter Parnassian tendency.

Ensor initially shared Les Vingt's dichotomous artistic stance, but became distressed, after 1886, at the increasing estheticism and cosmopolitanism of the group's exhibitions. He was especially disturbed by the inclusion in Les Vingt

20.6

20.9 James Ensor The Entry of Christ into Brussels in 1889, 1888. Oil on canvas, $8'6\frac{1}{2} \times 14'6$ (260 × 430.5)

20.10 ODILON REDON Ophelia Among the Flowers, 1905. Pastel, $25\frac{1}{8} \times 35\frac{5}{8} (64 \times 91)$

membership lists of non-Belgian artists, including Seurat, Redon, Whistler, Rodin, and others. For him, the avant-garde was a vehicle for the consolidation and rejuvenation of "pauvre Belgique," as Baudelaire had called it, in the face of seemingly insuperable national divisions of language and ethnicity. In November 1886, he wrote to Octave Maus, the group's secretary: "It would be with much pain were I to see Les XX lose their virginity, their nationality, and perhaps their personality by falling into the clutches of the interlopers." Thus, from the moment Les Vingt began to adopt a Pan-European or internationalist perspective, Ensor rejected the group; he now saw himself as isolated from all artistic rules and institutions, and claimed the status of an exile even from those who had already been exiled from official art.

20.9

11.14

Although Ensor was granted the luxury of a small retrospective of his best works at the 1886 exhibition of Les Vingt, he was largely ostracized from his fellows two years later, when he sought to exhibit his prophetic Entry of Christ into Brussels in 1889 (1888). This painting, Ensor's chef d'oeuvre, is a vast (nearly 9 by 15 feet), cacophonous, and splenetic affair that represents his conviction about the decadence of his age. Accompanied by military bands, masked marchers, historical and literary figures, urban bourgeoisie, workers, and politicians of every political persuasion, Christ enters Brussels in seeming triumph. A red banner exclaiming "Vive La Sociale" ("Long Live Socialism") is suspended above the diminutive savior who is mounted on a donkey in the upper center of the picture; to his right, above the serried ranks of revelers, a poster announces "Fanfares Doctrinaires Toujours Réussi" [sic] ("Doctrinal Fanfares Always Succeed"); to his left a green reviewing stand offers various clowns and dignitaries an ideal vantage point for watching the spectacle below. In the fore and middle-ground, figures are roughly stacked one above the other as if standing on risers, in a manner reminiscent of Courbet's Burial at Ornans and the several images d'Epinal upon which that work was based. More extravagant and grotesque than Courbet's painting, each face in The Entry of Christ is a mask or a caricature and each expression a grimace. These faces, like the picture as a whole, are coarsely painted in discordant hues of red, white, blue, and green. Though in every sense a history painting created with a contemporary public in mind, The Entry of Christ into Brussels in 1889 was never exhibited in Ensor's lifetime; making a virtue of necessity, he wrote late in life that it remained "untarnished by exhibition."

Rejecting both academicism and estheticism in *The Entry of Christ into Brussels in 1889*, Ensor sought artistic legitimacy by recourse to the grotesque and the fantastic, genres rooted in those ancient Flemish habits and traditions—even today called Breugelian—whose rudiments survived in the Ostend festivals that Ensor cherished. Indeed, Ensor himself (some-

20.11 JAMES ENSOR Old Woman With Masks, 1889. Oil on canvas, $21\frac{1}{4} \times 18\frac{1}{2}$ (54 × 47)

times in the company of his young Brussels friend Ernest Rousseau) frequented the Ostend carnivals, masques, and parades (held each year at Lent, in June, and in August), and beginning in the middle 1880's included them in his art. Ensor's drawings, prints, and paintings from this time are filled with characters and motifs that appear to be based on contemporary festivals and Breugelian depictions of proverbs, the seven deadly sins, or the battle between Carnival and Lent, as in *Skeletons Fighting for the Body of a Hanged Man* (1891), which recalls Breugel's *The Battle Between Carnival and Lent* (1559).

Yet if Ensor sought, in the manner of Courbet, to marry popular traditions to the modern art of easel painting, he cannot be said to have fully succeeded. What stands out most prominently in *The Entry of Christ* and his other mature works of the 1880's and '90's is not the expression of an integrated cultural whole, but rather a melancholic reckoning with a culture in ruins. However carnivalesque the inspiration, Ensor's pictures evoke a mood of neurasthenia and anguish. Indeed, Ensor himself appears to have believed his synthesizing project was doomed. Condemning the "mercurial speculators" who were ruining traditional Ostend by modernizing it, Ensor pleaded in his writings and art for the re-creation of carnival life and for the cultural unities that are presumed to have attended it: "Let us re-establish our pure and natural

carnivals . . . those which included great coats of arms and redlipped prostitutes, ostrich plumes and wooden shoes." In fact, fin-de-siècle Ostend could hardly have been further from Ensor's ideal of a unified, "pure and natural" Belgian community. A city of 27,000 people, Ostend was one of the chief bathing resorts in Europe, and during the summer its population tripled. Ensor knew too well this modernized and commercialized Ostend; for the first half of his life he lived in an apartment near the beach above a small curio shop run by his grandmother, mother, and aunt who sold souvenirs, including shells, costumes, and masks, to the throng of summer tourists.

Like other alienated artists of the period—Hodler, Munch, and Redon, among others—Ensor witnessed the collapse of precisely those romantic ideals he most cherished. He prized handicraft at a time of rapid industrialization, he exalted familial and communal bonds in a society increasingly structured upon a cash nexus, and he dreamed of a pure and natural society in a Belgium increasingly structured, like the rest of Europe, on fashion and the commodity. Less admirably (but in common with the above artists too), Ensor targeted women with his antimodern polemics, as in his chauvinist remark about red-lipped prostitutes, and his Old Woman With Masks (1889), in which a portrait of a family friend has been turned into an arena for childish doodling and misogynist mockery. Lifeless yet leering carnival masks surround the old woman; her painted face too is a mask, the picture argues, behind which lurks the hollowness of death.

20.12 James Ensor *The Gendarmes*, 1892. Oil on canvas, $14 \times 21^{5/8}$ (35.5 \times 55)

Given the overall pattern of his resentments, it is not surprising that Ensor took a keen interest in the radical politics of his day. The Brussels home of his friend Rousseau which he first entered in 1879, was a center for progressive politics and culture, frequented by the iconoclastic Belgian artist Félicien Rops (1833–98), the radical author and critic Eugène Demolder, and the noted French geographer and anarchist Elisée Reclus. Indeed, Brussels had been a center of radical politics for some time, especially since a young printer named Edouard Anséele had established a series of worker cooperatives called voohuit in 1874, and soon thereafter a maison du peuple. By 1879 several progressive parties representing social-democratic, Marxist, and anarchist factions of socialism had been formed, which in 1885 would be united under the umbrella of the Belgian Workers' Party. The year 1886 was crucial to the development of the workers' movement in Belgium, to the artistic avant-garde and to Ensor alike: an anarchist celebration of the fifteenth anniversary of the Paris Commune and a coincident strike by coal miners led to a general strike on March 25, followed by a sequence of massive popular demonstrations that were halted only by police violence and the proclamation of a state of siege. "Now is the time to dip our pens into red ink," wrote Picard in 1886 in review articles in L'Art moderne dedicated to books by the anarchists Peter Kropotkin and Jules Vallé. It was now the task of art and literature, he believed, to serve "in preparing or facilitating the accomplishment of historical destiny." Now, too, the political schisms within the Brussels avant-garde,

20.13 James Ensor My Portrait in 1960, 1888. Etching, $2\frac{3}{4} \times 4\frac{3}{4}$ (6.9 × 12)

described above, were too great to be overcome by broad esthetic manifestos or vague statements of common purpose.

Ensor's engagement with Belgian socialism during the turbulent decade between 1885 and 1895 is reflected in his artwork. His vitriolic satires of King Leopold, such as Belgium in the Nineteenth Century (1889), his inclusion in The Entry of Christ of banners proclaiming "Vive la Sociale" and "Vive Anséele et Jésus" (later painted out by the artist), as well as his depiction of strikers and strike victims, such as The Gendarmes (1892), reveal his general leftist sympathies clearly enough. Yet the precise political significance of these artworks remains difficult to establish. Even The Entry of Christ, with all its slogans, may be interpreted as a satire and not a celebration of socialist politics. In his book on the painting, Stephen C. McGough has very plausibly interpreted Ensor's painting as an attack upon all "fanfares doctrinaires," upon all manipulative doctrines, and upon all institutions, either governmental or religious, that restrict individual freedom. Indeed, Ensor's frequently expressed disdain for bourgeois society and simultaneous rejection of any compromise of his own artistic liberty suggest that he was sympathetic to socialism, but only to socialism of an antiauthoritarian or anarchist kind. The shocking character of his art—its independence, violence, and vulgarity-conforms to the impetuosity, vehemence, antiintellectualism, and masculinism of fin-de-siècle anarchism.

Unlike Marxists who proposed that the seizure by the industrial proletariat of the institutions of the state was a necessary first stage in the creation of a classless, egalitarian society, anarchists such as Reclus generally argued that any revolution that permitted the maintenance of a state (even provisionally) was authoritarian and bourgeois. Disdaining revolutionary elites (but at the same time necessitating them

by stressing individualism and voluntarism), anarchists constantly sought ways to bring the masses into the revolutionary process. In order to do so, many believed they must purge themselves of greed and corruption and be united with the people in body and soul. The famous case of the Italian anarchist Carlo Cafiero (1846–92), driven to madness by the idea that he was enjoying more than his fair share of sunshine, is one extreme form of this exaggerated stress upon populism and purity. A parallel fanaticism may be detected in the art of Ensor. His vocabulary of grotesque and caricatural forms, his comedy and his scatology, his misogyny and his intransigence, reveal at once an effort to unite with the popular classes of past and present Belgium, and a voluntarist desire single-handedly to strike the hammer blows that will bring down the twin edifices of bourgeois propriety and avant-gardist elitism.

In the art and ideas of Ensor are thus found populism and megalomania in equal mixture. In 1931, the 70-year-old artist wrote: "I have no child except light, my daughter; light, one and indivisible, light, bread of the painter, light, the painter's mie, light, queen of our senses, light, light, illuminate us! Animate us, reveal to us the new paths we must follow toward joy and happiness." Ensor's rich imagination may be seen as the inversion of Cafiero's madness; he wished to absorb all the light, to absorb and retransmit to posterity the lessons of the Dutch and Flemish masters and the popular culture of the late Middle Ages. Yet because of Ensor's nearly messianic selfregard, he had, as he himself admitted, no real progeny; his art, like much other Symbolist production, was an end not a beginning. It was based on the still-born and phantasmagoric dream of a modern nation dressed up in the epic garb of a preindustrial age. Ensor's art thus resembles nothing so much as the bones, shells, and fossils sold in his mother's curio shop,

20.1.

which were his chief motif; his paintings represent the desiccation of Romantic imagination—the reduction to mere bone of the once embodied hopes of Delacroix and Ingres, Constable, Turner, and Friedrich for an organic society in which artists created art as naturally as trees produced fruit. Ensor was preoccupied with his own failure to achieve such transcendence, and depicted his impotence, marginality, and literal decay in the macabre etching *My Portrait in 1960* (1888).

SYMBOLIST LANDSCAPE PAINTING: MUNCH, REDON, MONET, AND HODLER

The issue of Symbolism's renunciation of modern society (or of what Kahn called "the compulsorily contemporaneous") may be illustrated by examining the movement's position within the history of landscape painting. Since its origins in the late Renaissance, landscape painting has represented not just the physical appearance of land but the social relations between humans in nature. During the seventeenth century, such painters as Claude Lorrain and Nicolas Poussin represented the Italian countryside as a pastoral realm of peace and plenty, recalling a Classical Golden Age described by the Roman poets Virgil and Ovid. In The Netherlands, landscape painting was similarly idealizing and inspiring, although its greater verisimilitude and contemporaneity permitted it to function as an ideological support to an economic order that depended upon rationality, productivity, and expansionism. By the beginning of the nineteenth century, we have seen, during the Romantic period, landscape art (and nature generally) often served as a protest against supposed unnatural intrusions into social life—industrial capitalism, urban living, and the money economy. Yet in all

20.14 ARNOLD BÖCKLIN *Vita Somnium Breve*, 1888. Tempera on wood, $70^{7/8} \times 45$ (180 × 114.5)

20.15 ARNOLD BÖCKLIN *Island of the Dead*, 1880. Oil on canvas, 29 × 48 (73.6 × 121.9)

these cases, including of course such art movements as Realism and Impressionism, the relations between nature and society or country and city were intensely dialectical—that is, the mythic stability of the one depended upon the stability of the other, the measure of the one revealed the hidden dimensions of the other. In this way, nature continued to serve a progressive function for society, offering itself up as a measure against which both human accomplishments and failures could be gauged.

At the end of the nineteenth century, however, the dialectical relation between nature and society was severed in the literature and art of Symbolism. During a period of wrenching economic expansion and contraction, colossal urban and industrial growth, and the final eradication in Europe of the remaining pockets of premodern community, nature came to be considered by some writers and artists as an inviolable sanctuary and not simply a standard of judgment. Unlike Caspar David Friedrich, who in the first quarter of the century depicted nature as a locus for spiritual fulfillment and social reconciliation, Arnold Böcklin represented it in the last three decades as a place of escape or eternal rest. *Vita Somnium Breve* [*Life is a Short Dream*], an allegorical landscape of 1888, and *Island of the Dead* (1880), for example,

20.14

20.15

are siren songs in praise of blissful solitude and easeful death. In 1937, the Frankfurt School critic Leo Lowenthal described this generational sea-change in the representation of nature in his essay about the popular *fin-de-siècle* Norwegian novelist Knut Hamsun:

However, with the coming of doubt and even despair about personal fulfillment within society, the image of nature was no longer a basis for a new perspective, but became an alternative. Nature was increasingly envisaged as the ultimate surcease of social pressure. In this context, man could submit to nature and feel at peace—at least in fantasy. His soul, inviolable in ideology but outraged in reality, could find solace in such a submission; frustrated in his attempt to participate autonomously in the societal world, he could join the world of nature. He could become a "thing," like the tree or the brook, and find more pleasure in this surrender than in a hopeless struggle against manmade forces. This is the most significant change in man's imagery of his environment to take place in the closing decades of the nineteenth century in Europe. The novels of Knut Hamsun portray this antinomy of society and nature in an extreme form.

20.16 EDVARD MUNCH Sick Child, 1885–6. Oil on canvas, $47 \times 46\frac{1}{2}$ (119.4 × 119)

20.17 CHRISTIAN KROHG *Sick Girl*, 1880–81. Oil on canvas, $40\frac{3}{4} \times 23\frac{1}{4} (103.5 \times 51.4)$

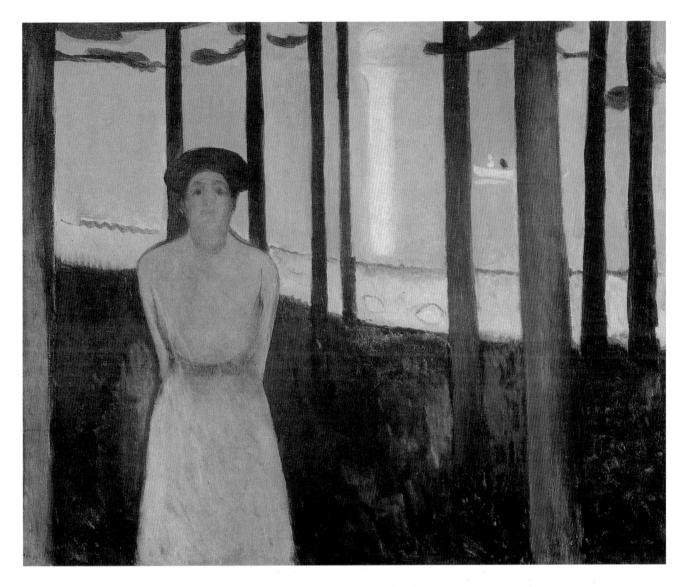

20.18 EDVARD MUNCH *The Voice*, 1893. Oil on canvas, $34^{1/2} \times 42^{1/2} (87.6 \times 108)$

20.19 John Everett Millais Ophelia, 1851. Oil on canvas, 30 \times 40 (76.2 \times 101.6)

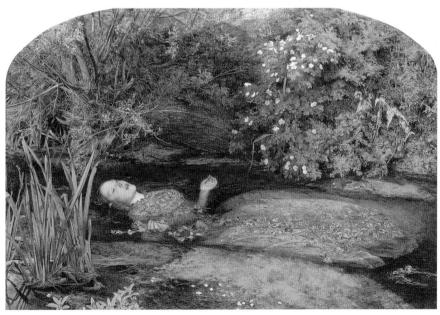

SYMBOLIST LANDSCAPE PAINTING - 421

As Lowenthal's remarks indicate, the *fin-de-siècle* was a watershed period in the literary representation of the antinomy between society and nature, but examples from the visual arts are in fact more vivid since only there had the Classical rhetorics which defined the landscape genre—such as the Virgilian pastoral and georgic—continued to exert their thrall. The Symbolist painters of landscape, in short, knew and understood the former paradigms of landscape art, and set out to destroy them. In so doing, they destroyed as well any critical engagement with modernity and created instead a mythic landscape of dreams.

The Norwegian Edvard Munch (1863–1944) began his career in the circle of Christiania (Oslo) anarchists that included the journalist and activist Hans Jaeger and the naturalist painter Christian Krohg (1852–1925). Munch's Sick Child (1885–6), inspired in part by memories of his sister's death from consumption and in part by Krohg's Sick Girl (1880–81), is an angry and vivid study of the ravages of a degenerative disease. By its content, large size, and scraped and battle-scarred surface, Munch's Sick Child was clearly an indictment of a perceived social and cultural sickness as well as of a tubercular epidemic. The work was bitterly condemned by contemporary critics upon its initial exhibition; Munch soon thereafter retreated to Paris to study drawing at Léon Bonnat's conservative academy, and returned in 1891, a confirmed Symbolist.

20.16

20.17

20.18 In The Voice (1893), a painting included among a group of six called by the artist "The Frieze of Life," Munch depicted a lone young woman standing amid trees near the shore of the resort at Asgårdstrand. Starkly dressed in white, she thrusts her chin forward and keeps her hands behind her back; she is as rigid as the trees and as ghostly as the shaft of moonlight at right. This is how Munch described the significance of the six paintings: "The frieze is intended as a series of decorative pictures, which, gathered together, would give a picture of life. Through them all there winds the curving shoreline, and beyond it the sea, while under the trees, life, with all its complexity of grief and joy, carries on." Like his compatriot Hamsun with whom he was often compared, Munch found in nature alone a world of sentiment and pathos. "Have you ever walked along the shoreline and listened to the sea?" Munch asked a friend about Asgårdstrand: "Have you ever noticed how the evening light dissolves into night? I know of no place on earth that has such beautiful, lingering twilight." In Pan (1894), Hamsun wrote: "The sky was all open and clean. I stared into that clear sea, and it seemed as if I were lying face to face with the uttermost depth of the world; my heart beating tensely against it, and at home there." In The Voice, as in Jealousy (1890), Munch depicted his simultaneous fear and longing to submit to what he saw as the magical, womanly thrall of superior and omniscient natural forces. History is

forgotten and human society is powerless before the onslaught of nature, destiny, and the eternal feminine.

The French painter and graphic artist Odilon Redon (1840–1916) similarly articulated the fin-de-siècle antagonism between nature and society by portraying humans as passive and powerless objects acted upon by uncontrollable natural forces. In Ophelia Among the Flowers (1905), Redon created a meditation upon Shakespeare's irrational Ophelia, seduced by the physical charms of nature. The uniqueness of Redon's image may be judged by a comparison with the Pre-Raphaelite Millais's widely reproduced and much exhibited Ophelia of 1851 (Redon may have seen it during his visit to London in 1895). Unlike Millais, Redon chose not to represent the fully stretched out figure of Ophelia, but only her head and shoulders. "Native and indued unto" nature, as Shakespeare wrote, Redon's Ophelia is barely visible; attention is primarily drawn to the clouds of abundant flowers which surround her. Indeed, the heroine is endowed by the artist with no greater personality than the ambient flora; like the ghostly woman in Munch's The Voice, she is identified with the irrational and irresistible forces of nature. Similarly, in Roger and Angelica (ca. 1908), Redon created a field of glowing hue by means of a technique he called "mutual exaltation of colors." The dazzling luminosity of the ultramarine water and sky is intensified by orange complements, purple and gray-blue adjacents, and the judicious introduction of white or black accents and highlights. The result induces a feeling of disorientation and phantasmagoria.

Created during the twilight of a career marked by isolation and public incomprehension, Ophelia Among the Flowers and Roger and Angelica eschew the unnatural and assaultive grotesques found in Redon's early noirs ("blacks"), such as the nightmarish charcoal The Eye (1882) and the lithograph The Smiling Spider (1885). In these late works in color, Redon instead focused a pantheistic vision on the minutiae of the natural world: "I cannot say what have been my sources," he wrote in 1903, "I love nature in all its forms; I love it in the smallest blade of grass, the humblest flower, the tree, the ground and the rocks—all things for their character in themselves, more than in the ensemble." In 1904, Redon instructed the novelist André Gide: "Enclose vourself in nature," expressing that desire to "become a thing," as Lowenthal writes: "like the tree or the brook, and find more pleasure in this surrender than in a hopeless struggle against manmade forces."

A parallel surrender before nature is represented in works by the sophisticated and idiosyncratic Russian painter Mikhail Aleksandrovich Vrubel (1856–1910). Rejecting the populism and sentimentality that characterized paintings by the earlier *peredvizhniki* (Wanderers) group—who included Ivan Nikolaevich Kramskoy (1837–87) and his student Ilya

Efimovich Repin (1844–1930)—Vrubel embraced the stance of the European Symbolist esthete. Possessed, as he wrote, by a "mania" for technique, his paintings are densely packed with broad impastoed planes of color, anticipating the nonobjective works of the early twentieth-century Russian avant-garde. Indeed, Vrubel was conversant with many of the same artists, musicians, and authors who influenced the later generation. He read the works of Tolstoy and Nietzsche, designed stage sets for Rimsky-Korsakov and knew the paintings of Böcklin, Degas, Monet, Moreau, Whistler, and many others through their reproduction in the pages of the Russian journal Mir Iskusstva (The World of Art). Vrubel's Pan (1899), which uncannily anticipates Redon's painting The Cyclops (1905), was inspired by Anatole France's story Le Saint Satyre. It depicts a kindly satyr—with cloven hoof and pan pipes in hand—who appears to have emerged from the earth. The crescent moon rising on the horizon echoes the shape of the creature's horns and wisps of hair and beard; the cool agua color of the water at middle right and left is reflected in the blue pools of Pan's gentle eyes. Like the Cyclops in Redon's painting, the Pan in Vrubel's is an autochthonous product of nature who must soon return to its native bourn.

Whereas for Romantic artists, like Friedrich and Turner, the confrontation between the autonomous individual and nature signified the limitless potential for human growth or social development, for Redon, Vrubel, and other Symbolist landscape painters, nature is wholly "other," an entity independent of human society or volition, a space designed for passive and private pleasure. A similar vitalism is apparent in the late paintings of Monet, especially the works made at Giverny, such as Waterlilies (1905), in which the artist and 20.20 spectator are immersed in a fantastical world of water, color, and light. The only changes that occur in Monet's garden are seasonal, the result of natural forces. Once again, Lowenthal's remarks are illuminating:

Nature's timetable replaces the timetable of history. . . . Whoever senses and accepts these rhythmic patterns as fundamental has full knowledge immediately and without rational effort. At the same time, the endless reproduction of natural phenomena, the cyclic order of nature, as opposed to the apparent disorder and happenstance of all individual and historical facts, testifies to the powerlessness of humans. It is the extreme opposite of human selfassurance before nature.

Such a conception of nature in the work of these artists arose from the desire to evade social contradiction, history, and contemporaneity, to evade, that is, the dispiriting forces of "universalizing civilization." The antagonism of nature and society that is described here occurred specifically at the

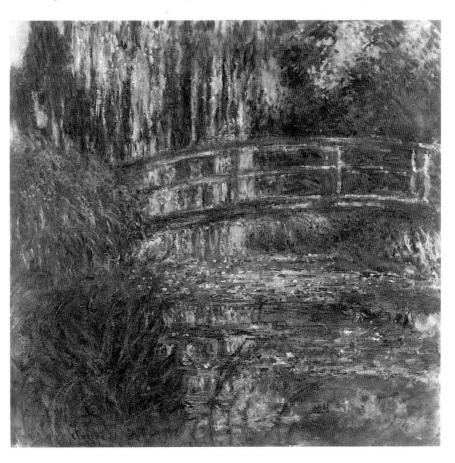

20.20 CLAUDE MONET Waterlilies, 1905. Oil on canvas, $35\frac{1}{8} \times 36\frac{1}{2} (89.2 \times 92.7)$

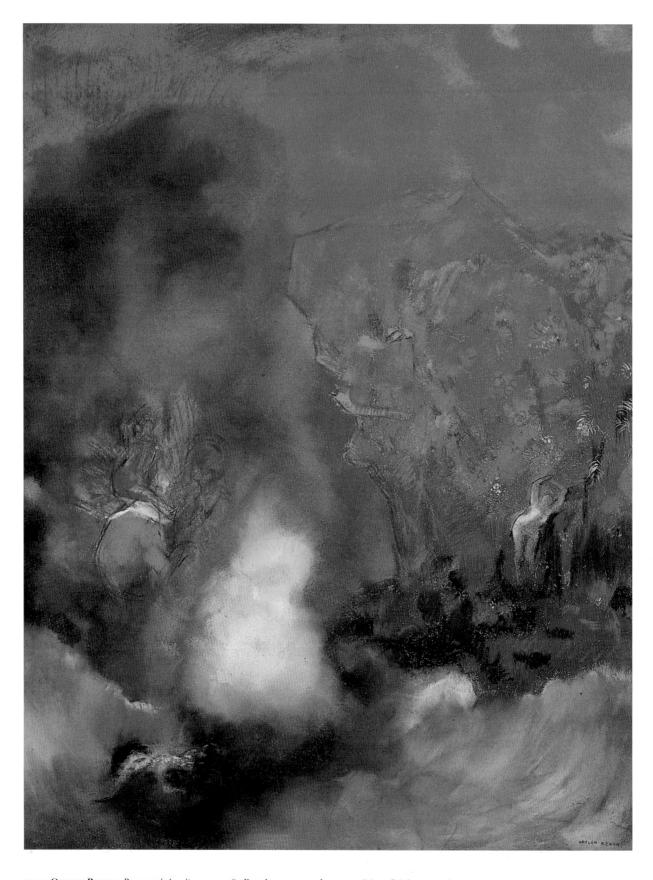

20.21 ODILON REDON Roger and Angelica, ca. 1908. Pastel on paper and canvas, $36\frac{1}{2} \times 28\frac{3}{4}$ (92.7 × 73)

20.22 ODILON REDON *The Smiling Spider*, 1885. Lithograph, $10\frac{1}{4} \times 8\frac{3}{8} (26 \times 21.5)$

20.23 (*below*) **MIKHAIL VRUBEL** *Pan*, 1899. Oil on canvas, $48\% \times 41\%$ (124 × 106.3)

20.24 (below, right) **ODILON REDON** The Cyclops, 1905. Oil on canvas, $25\frac{1}{4} \times 20$ (64.1 × 50.8)

moment in history when the colonization and commodification of nature and society had progressed so far that the earlier dialectic conception was ideologically unsustainable. Not a trace of the modern, the quotidian, or the insouciant could be permitted to invade painted landscapes for fear of shattering the Romantic dream of plenitude and thereby admitting the threatening nightmare of alienation and powerlessness. The Symbolist opposition of nature and society is nowhere more compellingly revealed than in the landscapes of Hodler.

The disappearance of an independent peasantry, the erosion of cantonal autarchy, the loss of a rich and vivid "folk" culture, and the concommitant rise of a tourist industry were the factors that led to the artistic segregation of humans and nature in the Symbolist landscapes of Ferdinand Hodler (1853-1918). Indeed, the duration of Hodler's life coincided with a crucially important period of modernization and industrialization, not to say commodification of Switzerland. Apprenticed in 1867 to Ferdinand Sommer, a painter of tourist pictures in the village of Thun in the Bernese Oberland, Hodler was witness to and participant in the explosive growth of the Swiss tourist industry. Yet what marks Hodler's mature landscape art from the 1880's and after is the elimination of nearly all traces of the touristic. The rhetorical justification for this erasure is found in Hodler's Symbolist theory of "parallelism."

After achieving considerable success and celebrity in the 1890's with the exhibition in Paris of such disturbing and 20.25 dreamlike figure paintings as *The Night* (1891) and *The Chosen One* (1893–4), Hodler increasingly devoted his talents to landscape painting. In 1897, he discussed the essential precepts of that art in a lecture called "The Mission of the Artist," delivered to the Society of the Friends of the Fine Arts in Freiburg. His address repeated many of the prevailing Symbolist tenets of the day, but added a new one:

Parallelism, whether it is the main feature of the picture or whether it is used to set off an element of variety, always produces a feeling of unity. If I go for a walk in a forest of very high fir trees, I can see ahead of me, to the right and to the left, the innumerable columns formed by the tree trunks. . . . Whether those tree trunks stand out clear against a darker background or whether they are silhouetted against a deep blue sky, the main note, causing that impression of unity, is the parallelism of the trunks.

20.26 Hodler's first parallel landscape was probably *The Beech Forest* (1885), painted more than a decade before the exposition of the theory, but it was only after 1900, with the series of paintings depicting Lake Leman, Lake Silvaplana, Lake Thun, Lake Geneva, and the summits of the Alps that 20.27 parallelism came to dominate his art. *Lake Geneva Seen From Chexbres* (1904) consists of an arc of land in the foreground embracing parallel bands of blue, violet, and pink water. The clouds at the horizon resemble identical puffs of smoke from a locomotive passing from right to left; the clouds at the top are a series of parallel and interlocked chevrons. In 1908, Hodler traveled to the Schynige Platte in the Bernese Oberland, a

region he had known and loved in his youth, and painted a number of mountain landscapes, including *Eiger, Mönch and Jungfrau Above the Fog* in a still more radically simplified style; the mass of the mountains is rendered with thin oil washes of gray and blue, while the three summits are precisely outlined in blue, green, and red. Finally, in *The Mönch With Clouds* (1911), Hodler was at his furthest remove from the busy tourist pictures of his early career. Here he has depicted the massif and summit of the second of the three great peaks of the Bernese Oberland near Grindelwald. The mountain appears as a steel-blue pyramid with pasty white excrescences; serpentine clouds, recalling the spermatazoa that enframe Munch's lithograph *Madonna* (1895–7), parallel the picture 20 surface and rectangular borders, lending by contrast a still greater mass and stability to the rock.

The late parallel landscapes of Hodler are visions of a world frozen in time and space. Evacuated and dreamlike, they conform to no conventional rules of landscape painting and, unlike the paintings of his exact contemporary Van Gogh, lack bravura facture and expressionistic color contrasts. Most striking of all, however, Hodler renounces the integration of figures or even buildings in his landscapes, a practise essential for Van Gogh in his representation of agrarian utopias in Arles and Auvers. Neither are Hodler's landscapes much like the paintings of Cézanne, whose Mont Sainte-Victoire (1904–06) 21. would seem to offer the closest analogy to The Mönch With 20. Clouds. Both artists sought completeness and stability in their art, but where the latter included in his paintings the unavoidable elisions or lacunas of vision, the former carefully excised all that was fragmentary, untidy, or uncontrollable; where Cézanne captured temporal flux through energetic brushwork, a juxtaposition of warm and cool colors, and a

20.25 FERDINAND HODLER *The Night*, 1891. Oil on canvas, $45\% \times 9'9\%$ (116 × 299)

20.26 FERDINAND HODLER *The Beech Forest*, 1885. Oil on canvas, 39³/₄ × 51¹/₂ (101 × 131)

20.27 FERDINAND HODLER Lake Geneva Seen From Chexbres, 1904. Oil on canvas, 275/8 × 421/2 (70.2 × 108)

20.28 FERDINAND HODLER The Mönch With Clouds, 1911. Oil on canvas, 25% × 36 (64.5 × 91.5)

20.29 EDVARD MUNCH *Madonna*, 1895–7. Color lithograph, $23\% \times 17\% (60.6 \times 44.5)$

multiplicity of outlines, Hodler's images are largely static, often built of adjacent hues of a single temperature, and of repeated shapes or outlines in accordance with his theory of parallelism.

In "The Mission of the Artist," Hodler stated:

If we compare these decorative instances [of parallelism in nature] with occurrences from our daily life, we again find the principle of parallelism. . . . If there is a public festival, you see everybody walking in the same direction. On other occasions, they are grouped around a speaker who represents an idea. Walk into a church during a religious service: the feeling of unity will impress you. When we are gathered for a happy occasion, we do not like to be disturbed by a dissenting voice. In all the examples given, it is easy to see that the parallelism of the events is at the same time a decorative parallelism. . . . The work of art reveals a newly apprehended order of things and is beautiful because it expresses a general harmony.

Hodler's theory of parallelism and the landscape art that arose from it articulated a social or political as much as a compositional imperative. To represent nature and society by means of a system of decorative parallels was to make the unity and wholeness of the work of art a substitute for the completeness and social integration lacking in real life; it was, in addition, to endow the artist with heroic powers to recreate at will the harmony and order presumed to characterize an earlier age dominated by festivals, popular democracy, and religious faith. Like Maurice Denis's arcadian April (1892), Munch's haunting The Voice, and Monet's lyrical Poplars (1891), Hodler's The Mönch With

Clouds displays a decorative balance and hierarchism quite unlike earlier Impressionist or Realist works. Yet the "general harmony" of which Hodler spoke was only the mirror image of a terror that was equally omnipresent in his art; it is seen in The Night in the face of the artist shrinking beneath the black- 20.25 shrouded figure that squats over his loins, and in Valentine in 20.31 Agony (1915) in the face of his lover in the hours before her death. It is visible as well, I would argue, in the jagged profiles of frigid rock that Hodler painted in the Oberland. Symbolist art reveals those feelings of powerlessness and fear that preoccupied a generation. Gauguin too experienced this alienation and fright, and he fled Europe because of it.

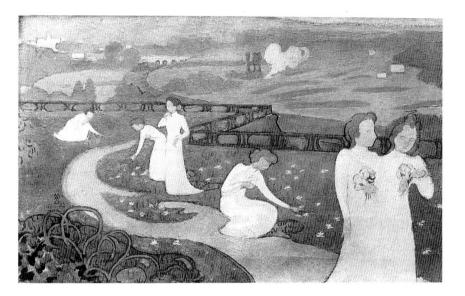

20.30 MAURICE DENIS *April*, 1892. Oil on canvas, $14\frac{3}{4} \times 24 (37.5 \times 61)$

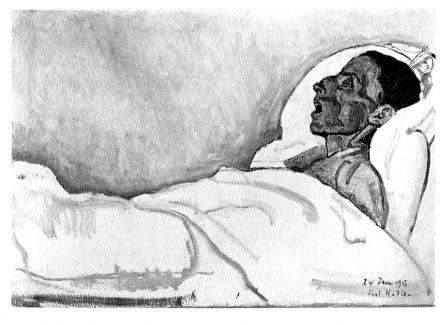

20.31 FERDINAND HODLER *Valentine in Agony*, 1915. Oil on canvas, 23⁷/₈ × 35⁵/₈ (60.5 × 90.5)

THE VIENNA SECESSION

The anxiety of the Symbolist generation is further revealed in works by the leading Austrian artist of the fin-de-siècle, the painter Gustav Klimt (1862–1918). In Vienna, capital of the Austro-Hungarian Empire and a city with a population of 1.4 million, the long established *Künstlergenossenschaft* or Artists' Association was challenged in 1897 by the youth-oriented Secession, led by Klimt. The latter organization charged that the Künstlergenossenschaft was in fact a manufacturers' or businessmen's association rather than a group of artists dedicated, the critic Hermann Bahr wrote, to revealing "innermost being."

In the poster designed for the first Secession exhibition in 20.32 1894, Klimt represents the intended artistic liberation in mythic terms: Theseus is shown slaving the Minotaur in order to free Athenian youth from the tyranny of the monster. At right, Athena stands in profile, gazing approvingly at the artistic and political battle, while her archaic, Gorgon-head breast ornament faces the spectator. 20.33 Four years later, Klimt again depicted Pallas Athene, once more with archaic helmet and Gorgon breast ornament, but this time with rouge, lipstick and flowing red hair, recalling figures by the English Pre-Raphaelites Millais and Rossetti, such as the latter's Beata Beatrix (1867-70). Behind the 11.5 figure of Athena, Herakles is shown fighting against Triton, presumably symbolizing the struggle of new against old artistic forces, while at her right side is a diminutive, nude figure of Nike (victory), holding up a mirror to expose the moral and sexual feebleness of the ancien régime, and to announce her own sexual vitality.

> The Vienna Secession, according to the editors of its journal, Ver Sacrum ("The Sacred Spring") stood for sacred art, not "merchandise," "modern art," not "rigid Byzantinism," "art from abroad," not parochialism, and "art . . . for everyone," not just the rich. But the group was not nearly as politically or artistically radical as the English Pre-Raphaelites or European Symbolists who inspired them. Over the portals of the classically proportioned and templelike House of the Secession designed in 1898 by Josef Olbrich (1867–1908) and Gustav Klimt, was the inscription Der Zeit Ihre Kunst, Der Kunst Ihre Freiheit ("To the Age its Art, To Art its Freedom"). This was simply a call for the modernization of art and the freedom of artists, not the overall democratizing of culture and politics. Beneath the building's cornice was a laurel frieze (symbol of Apollo), and on top, mounted between four pylons, was a perforated and gilt orb, its decoration again based upon the laurel. The simultaneous modernity and classicism of the building—like that in Klimt's Secession poster—attests to the political and cultural ambivalence and anxiety of the Vienna aesthetes.

20.34

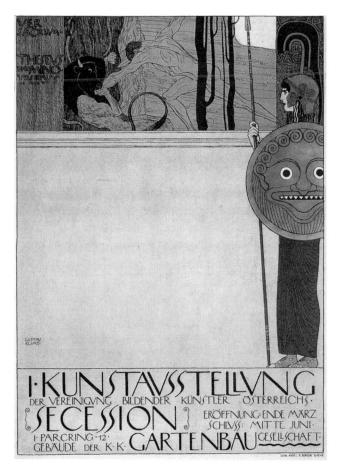

20.32 GUSTAV KLIMT Poster for the first Secession exhibition, 1894

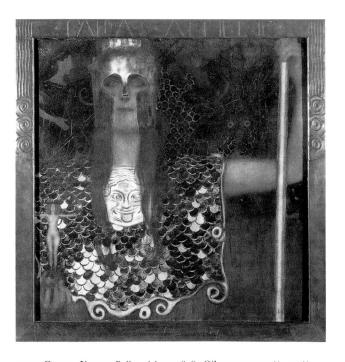

20.33 GUSTAV KLIMT *Pallas Athene*, 1898. Oil on canvas, $29\frac{1}{2} \times 29\frac{1}{2}$ (75 × 75)

20.34 Vienna, House of the Secession, by Joseph Olbrich, 1898

They were opposed not to the Classical tradition itself but to the stultifying historicism sponsored by the official academies. They rejected not bourgeois modernization but the continued thrall of the Viennese aristocrats. Indeed, the name "Secession" was deliberately chosen for its liberal-at once insurgent and classic—overtones. It derives from the ancient Roman secessio plebis, the periodic departure from the city of the plebs, or common people, who threatened to establish a new republic if their demand for economic and governmental reform was not accepted. Classicists of an Apollonian more than a Dionysian kind (despite the eroticism of Klimt's art), the Secessionists were reformers from within, not revolutionists from without. A more thorough—and more thoroughly Dionysian—renunciation of the European Classical tradition had already been undertaken by Paul Gauguin in the South Pacific.

GAUGUIN AND SYMBOLISM IN TAHITI

In an effort to restore his fading ideals, health, and finances, Gauguin resolved in 1890 to abandon both Brittany and Paris and move to the French island colony of Tahiti in the Polynesian archipelago. In September, he wrote to Redon:

The reasons you give me for remaining in Europe are more flattering than they are convincing. My mind is made up, although since I returned to Brittany I have modified my plans. Madagascar is still too close to the civilized world; I want to go to Tahiti and finish my existence there. I believe

that the art which you like so much today is only the germ of what will be created down there, as I cultivate in myself a state of primitiveness and savagery.

In Tahiti, Gauguin sought to indulge fully his primitivist longing to "go back, far back . . . as far back as the dada from my childhood, the good old wooden horse." As his words suggest, Tahiti for Gauguin represented both a personal and artistic regression. To go and live among indigenes meant to return to his own childhood and, in the familiar Rousseauist metaphor, to the originary innocence of humanity. Three weeks after his arrival at the colonial capital Papeete, Gauguin described the Tahitian night in a letter to his wife Mette:

Such a beautiful night it is. Thousands of persons are doing the same as I do this night; abandoning themselves to sheer living, leaving their children to grow up quite alone. All these people roam about everywhere, no matter into what village, no matter by what road, sleeping in any house, eating etc., without even returning thanks, being equally ready to reciprocate. And these people are called savages! . . . They sing; they never steal; my door is never closed; they do not kill. Two Tahitian words describe them: *Iorama* (good morning, good bye, thanks, etc.) . . . and *Onatu* (I don't care, what does it matter, etc.) and they are called savages! I heard of the death of King Pomare with keen regret. The Tahitian soil is becoming quite French, and the old order is gradually disappearing.

Our missionaries have already introduced a good deal of Protestant hypocrisy and are destroying a part of the country, not to mention the pox which has attacked the whole race. . . . I should like to have your memory to learn the language quickly, for very few here speak French.

As his letter indicates, Tahiti was at once a dream-becomereality and a profound disappointment to Gauguin; he observed native selflessness giving ground to European greed and traditional sexual freedom surrendering to a cash economy, and responded with nostalgia and bittersweet imaginings. Childhood and native innocence were frequent subjects in Gauguin's Tahitian art at this time, appearing, for example, in Te tiare farani (The Flowers of France, 1891) and The Meal, or The Bananas (1891). In the latter work, three children are shown behind an overlarge table covered with white paper or canvas and an assortment of still-life objects bananas, lemons, a knife, a half-eaten guava, a gourd and ceramic bowl, and a wooden bowl filled with water. The odd disjunction of scale between the table and children (who appear to be at least on the verge of adolescence) and the simple tripartite division of the composition may be an attempt to represent the meal from a child's point of view, or else to reconstruct childish and native seeing.

20.55

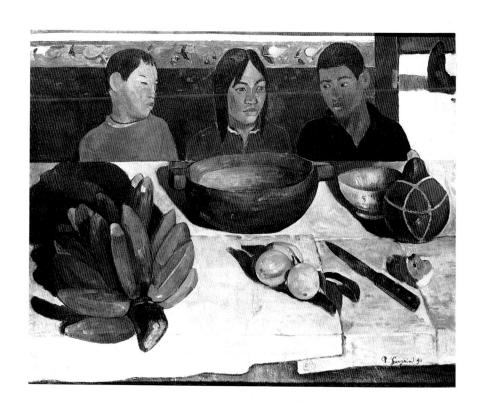

20.35 PAUL GAUGUIN The Meal or The Bananas, 1891. Oil on canvas, $28\frac{1}{4} \times 36\frac{1}{2} (73 \times 92)$

20.36

20.36 PAUL GAUGUIN Vahine no te vi (Woman of the Mango), 1892. Oil on canvas, 285/8 × 17½ (72.7 × 44.5)

Gauguin's depiction of young native women, which dominated his art from his arrival in Tahiti in 1891 until his death in 1903, seems to arise from some of the same personal and cultural impulses as in his paintings of children. Just as children represented a lost and earnestly sought natural innocence, so indigenous women were associated in Gauguin's mind, as in the collective colonialist imagination, with natural fecundity and beneficence, as well as with the restoration of male political authority and sexual prerogative. For the French nation as a whole, the acquisition of colonial possessions (Tahiti was only annexed in 1881) was a means of compensating for a vanished military and demographic vigor: France had suffered an ignominious defeat by Prussia in 1871 and a significant drop in its birth rate since the epoch of Napoleon. For Gauguin as well, the acquisition and depiction of successive colonial vahines (wives, women), such as Teha'amana in Vahine no te vi (Woman of the Mango, 1892), was a means of compensating for a powerlessness before modernity. Once a successful stockbroker, Gauguin was left vulnerable by the spectacular collapse of the Union Générale bank in 1882 to the legitimate demands of his wife, Mette Gadd, and to the caprice of patrons and critics. Now, in his "House of Pleasure" (as he called his last house in the Marquesas Islands), in this land of "amorous harmony" (Tahiti had indeed once been named La Nouvelle Cythère), he would regain his mastery.

20.37 In Manao tupapau (The Specter Watches Her, 1892), Gauguin depicted a young Tahitian woman whom he

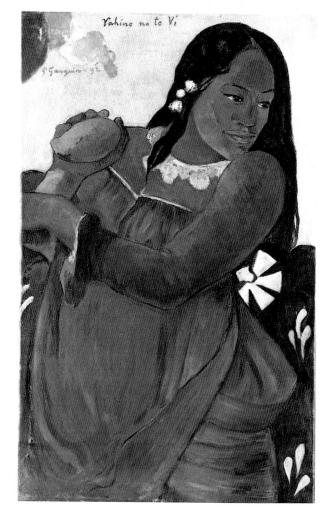

identified as Tehura, lying on her stomach on a bed, facing the spectator. She lies on yellow-white sheets, shaded with blue and violet, above a bedspread printed in blue with yellow fruit and flowers. The background is violet, pink, orange, and blue, illuminated with white and green sparks or light-bursts. Above and to the left stands a figure in profile dressed in a black robe and cowl. Gauguin described the genesis of *Manao tupapau* in *Noa Noa*, his Tahitian diary and novel, first published in 1897:

One day I was obliged to go to Papeete. I had promised to return that evening, but . . . I didn't get home till one o'clock in the morning. . . . When I opened the door . . . I saw [her]. . . .

Tehura lay motionless, naked, belly down on the bed; she stared up at me, her eyes wide with fear, and she seemed not to know who I was. For a moment, I too felt a

strange uncertainty. Tehura's dread was contagious: it seemed to me that a phosphorescent light poured from her staring eyes. I had never seen her so lovely; above all, I had never seen her beauty so moving. And, in the half-shadow, which no doubt seethed with dangerous apparitions and ambiguous shapes, I feared to make the slightest movement, in case the child should be terrified out of her mind. . . . Perhaps she took me, with my anguished face, for one of those legendary demons or specters, the *Tupapaus* that filled the sleepless nights of her people.

The picture, and the artist's description of it, appears to be a veritable encyclopedia of primitivism and misogyny. That the young native woman is portrayed as "terrified out of her mind" by "specters," suggests that she is ruled by emotion and mysticism and incapable of disinterestedness and rational thought, a characterization consistent with widespread racist

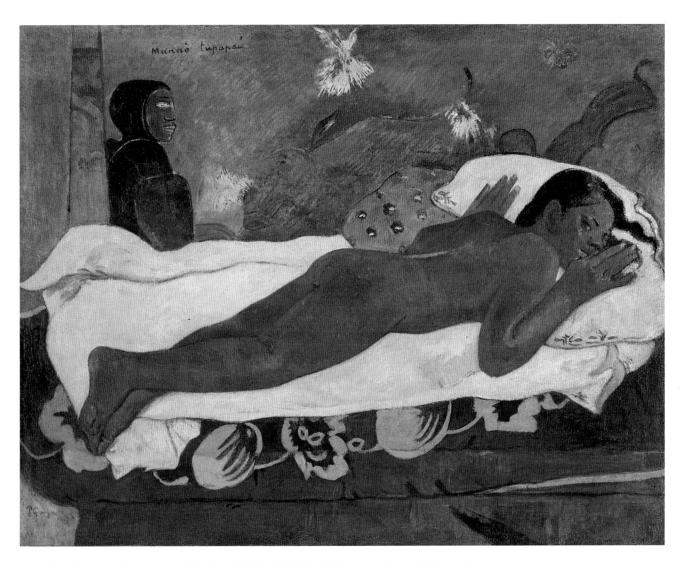

20.37 PAUL GAUGUIN Manao tupapau (The Specter Watches Her), 1892. Oil on canvas, $28\frac{3}{4} \times 36\frac{1}{2}$ (73 × 92)

20.38 ODILON REDON "Death: My Irony Exceeds All Others," from *To Gustave Flaubert*, 1889. Lithograph, $10\frac{1}{4} \times 7\frac{1}{4} (26.2 \times 19.7)$

stereotypes of native peoples as mentally inferior to West-erners. "The Tahitians are veritable children," Henri le Chartier wrote in his 1887 book on the French colonies of Polynesia, "[and of a marked] fickleness. . . . But the principle trait of their character is superstition: the solitude of the forest, the darkness of the night and especially spirits—tupapaus—frighten them." Moreover, Gauguin's association of the young woman's dread with his own rekindled desire affirms the misogynist canard that women "long to be taken, violently," as Gauguin wrote in *Noa Noa*. At the same time, Gauguin's own Oedipal fear of losing mastery, control, or even bodily integrity before the body of his young lover is suggested by his discussion and representation in *Manao tupapau* of "half-shadows," "dangerous apparitions," "ambiguous shapes," "demons," and "specters." For Gauguin, as

for other Symbolists such as Redon and Munch, women were alternatively blessed virgins and *femmes fatales* whose insistent sexuality portended castration and death. Like *Manao tupapau*, Redon's lithograph "Death: My Irony Exceeds all Others," from his album entitled *To Gustave Flaubert* (1889), and Munch's etching *The Kiss* (1895) represent those unholy unions of lust and death that threaten masculine authority.

Auguste Rodin (1840–1917) also depicted themes of male dominance in his colossal and uncompleted *Gates of Hell* (1880–1917), and his twenty-two illustrations for Baudelaire's *Flowers of Evil* (1887–8), among other works. In the former sculpture, women veritably cascade from the Dantesque portal, twisting and writhing in simultaneous death shudder and orgasm. In the latter ink drawings, women are shown dead and dying, luring and repelling male

434 · SYMBOLISM AND THE DIALECTICS OF RETREAT

embraces, entwined in lesbian love and seized by demons or a skeleton. *Fugit Amor* (ca. 1887), a small independent bronze derived from two similar figural groups on the right-hand panel of the *Gates*, depicts the pair of adulterers described by Dante as inhabiting the Second Circle of Hell. As in the drawing entitled *De Profundis Clamavi* (*Out of the Depths Have I Cried*) from *The Flowers of Evil*, the sculpture represents, as a critic in 1898 wrote, the "dangerous enigma" of the feminine: "She flies along, listless and disdainful, her lips curling with a smile of victorious witchery."

Like the paintings and prints of his contemporaries mentioned above, though unlike the anodyne sculpture The Waltz (1895) by his lover Camille Claudel (1864–1943), Rodin based many of his works on clichéd themes of sexual violence and the femme fatale. Yet there is at the same time an erotic extremism in some of Rodin's works, such as in the sculpturally raw and genitally frank Iris, Messenger of the Gods (ca. 1890), or in the several masturbation drawings, that would appear to permit a very different interpretation of sexuality, one which, as the art historian Anne Wagner has written, "allows women to possess their bodies." Something of the same dichotomy between masculine control and dispossession, I believe, is at work in Gauguin's treatment of Tahitian women and of the cultural construct called "the primitive." Indeed, the question of Gauguin's primitivism and attitude toward women is much more complex than initially suggested by Manao tupapau. In depicting tupapaus and in employing the Tahitian language in his title, Gauguin was in fact celebrating aspects of the native culture that the French colonial authorities were attempting to suppress in the name of "assimilation," the stated policy of subjecting the islands and their inhabitants to French legal and economic obligations and cultural controls. Instrumental to this policy was the effort of Catholic and Protestant missionaries to eradicate local religious beliefs and instruct the natives in Christian religion and the French language. Gauguin's depiction of native "superstition" in Manao tupapau and use of a Tahitian title must therefore be seen in the context of native resistance to assimilation and what the artist later called the colonial "reign of terror." Absent from Gauguin's picture is any of the hypocritical smugness or ignorant condescension found in Le Chartier, quoted above, or in the travel writer Mativet, who argued in his 1888 guide to La Nouvelle Cythère that tupapaus were simply the result of indigenous confusion between sleep, dreams, nightmares, and reality. Gauguin, by contrast, appears to have recognized that spirits (Mo'a) played a crucial role in Tahitian culture and religion. Indeed, spirits such as the tupapaus form one half of the basic "conceptual antithesis" (as the anthropologist Douglas Oliver writes) of Polynesian culture, the other half of which is Noa, meaning secular, wordly, or human. To be a Tahitian is to be in almost

constant interaction with spirits, which can take the form of sharks, pigs, horses, dogs, cats, and birds. Indeed, that Gauguin's Tahitian diary novel is called *Noa Noa* is one indication, among others, of his frank recognition of the inevitability of his own separation as a European from Polynesian spirituality.

Thus Gauguin's primitivism, like the phenomenon generally, is not reducible to simple masculinism and Eurocentrism. While nineteenth-century primitivism (or exoticism) was mostly notable for its naked assertion that non-European peoples were fit only for conquest, conversion, or extirpation, it also at times fostered critical reflection upon the differences between Western and non-Western cultures, and upon the failures of the former. In the letter to Redon already cited, Gauguin clearly engaged in this primitivist dialectic:

Gauguin is finished here, and no one will see him anymore. Yet you know that I am an egoist. I carry with me in photographs and drawings, a whole little world of comrades that bring me pleasure; of you, I have memories of all you have done. I also have in my mind the image of a star; in following this, in my case to Tahiti, I do not dream of death, I promise you, but on the contrary of eternal life—not death in life but life in death. In Europe, that death with its serpent's tail [Redon's "Death: My Irony ..."] is inescapable, but in Tahiti, it must be seen with its roots pushing upward among the flowers. . . . I recall a phrase of Wagner that explains my thought: "I believe that the practitioners of great art are glorified, and that, enveloped in a celestial tissue of rays, perfumes and melodious concord, they will be restored for all eternity to the breast of the divine sources of harmony."

On the one hand, Gauguin's vulgar association of the primitive, the non-European, the natural, and the feminine in his letter to Redon conforms to the reigning Eurocentrism that sanctioned violence upon the bodies of real Tahitian women and men during the 125 years since their "discovery" by Captain Samuel Wallis. On the other hand, however, Gauguin's utopian embrace of the natural "harmony" of non-Western cultures was an explicit criticism of the very instrumentalism and hierarchism that sanctioned European exploitation. By jettisoning the "death in life" of Europe and embracing the culture of Polynesia, Gauguin was expressing an internationalism that was as rare as it was potentially subversive in an age of empire. Indeed, Gauguin was a consistent supporter of indigenous rights, jeopardizing his own life in the Marquesas by protesting in support of Polynesian rights in February 1903 (two months before his death) in a letter to the French colonial governor: "This hypocritical proclamation of Liberty, Equality, and

20.39 AUGUSTE **R**ODIN *The Gates of Hell*, 1880–1917. Bronze, 22′3¾ × 13′1½ × 33½ (680 × 400 × 85)

20.40 (left) AUGUSTE RODIN Iris, Messenger of the Gods, ca. 1890. Bronze, height 371/2 (95.3)

20.41 (left, below) CAMILLE CLAUDEL The Waltz, 1895. Bronze, $18\frac{1}{4} \times 13 \times 7\frac{3}{4} (46.4 \times 33 \times 19.7)$

20.42 (below) AUGUSTE RODIN Fugit Amor, ca. 1887. Bronze, $15 \times 18^{7/8} \times 7^{7/8} (38 \times 48 \times 20)$

Fraternity under the French flag takes on a singular irony with respect to [native] people who are no more than tax fodder in the hands of despotic gendarmes."

In Gauguin's Mahana no atua (Day of the God, 1894), he 20.43 has juxtaposed, without hierarchy or favor, several religious and pictorial traditions. In the upper third of the painting, women, men, and children are naturalistically depicted beneath an azure sky streaked with white clouds. Behind them are a line of breaking waves, yellow sand, and a distant village with houses, a horseman, and boaters. In the middle of this zone stands the monumental statue of a god inspired at once by Easter Island megaliths, Buddhist figures from the temple of Borobudur in Java, and the feminine Tahitian deity Hina. In the middle third of the painting are three figures, sitting or reclining on pink sand. To the left, a child lies facing us with head resting on hands, legs bent, and toes touching the water; to the right, another child facing away from us, is folded into a fetal posture; in the center a woman is facing us, posed in a graceful contraposto: her upper torso is framed by a kind of

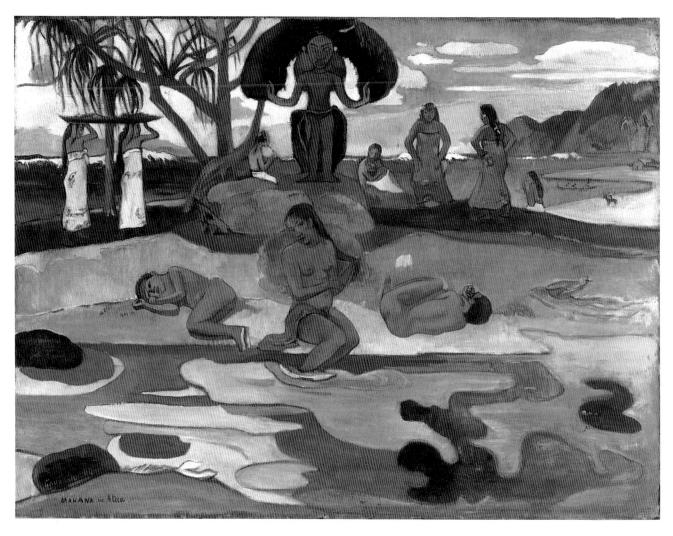

20.43 PAUL GAUGUIN Mahana no atua (Day of the God), 1894. Oil on canvas, 267/8 × 36 (68.3 × 91.5)

green mandorla, her loins are accented by a red pareu and her calves are immersed in the phantasmagorically colored water below. The water constitutes the lower third of the painting. Here is seen a jigsaw-puzzle pattern of colors that bears only the merest resemblance to the upper world it would mirror. Here, the sensuality of color has its own way; the lower third of Mahana no atua thus represents the abstract, Polynesian antipode to the illusionistic, European manner seen in the two upper registers. Besides Cézanne, no other nineteenthcentury painter progressed further than Gauguin in the direction of liberating color from the slavish labor of illusionism, thereby paving a road that leads to the nonrepresentational achievements of Kandinsky and Mondrian, as well as to the new twentieth-century appreciation of the esthetic achievements of non-Western and especially indigenous peoples.

In Mahana no atua, as in many of his other Tahitian works such as Faaturuma (Reverie, 1891), Te Faaturuma (Silence, or

20.43

20.44

To Be Dejected, 1891), Fatata te miti (Near the Sea, 1892) and the monumental Where Do We Come From? What Are We? Where Are We Going? (1897), Gauguin admits profound uncertainties about his own cultural heritage and posits the value of a new syncretic and international culture. In these works, Western illusionism is juxtaposed to non-European abstraction and patterning, Christian deities are paired with Hindu, Buddhist, or Tahitian gods, and European narratives of fall and redemption are transformed into parables of healthful eroticism and natural abundance. Moreover, native women are depicted in the works cited above as intellectual and contemplative people (a relative novelty in depictions of Europeans, much less Polynesians), and possessed of a powerful and independent sexuality.

In this radical ethnographic endeavor (admittedly partial, contradictory, and at times even wholly unsuccessful), Gauguin anticipated the stance of the Surrealist author André Breton who wrote fifty years after Gauguin's death:

"Surrealism is allied with peoples of color, first because it has sided with them against all forms of imperialism and white brigandage . . . and secondly because of the profound affinities between surrealism and primitive thought." To the Surrealists and to their friend Lévi-Strauss, "primitive" art was the expression of an equilibrium between humans and nature which aboriginal cultures had achieved but which capitalism destroyed. The goal of the Surrealist movement, therefore, as Breton wrote, "was the elaboration of a collective myth appropriate to our time" that could resurrect a primitive balance between nature and society, albeit at a much higher level of technological achievement and global interconnectedness. Gauguin's art and thought, finally-conceived a generation before Freud, Lévi-Strauss, and the Surrealistslack this progressive notion of an *aufhebung*, or transcendence to a historically higher level. In common with the other Symbolists, Gauguin sought refuge from modernity in a remote and unspoiled land; like them, too, he was frightened by, and vet accepted (at times even revelled in), his own powerlessness and marginality. Unlike them, however, he posited in his art a primitive alternative to the European social and cultural order.

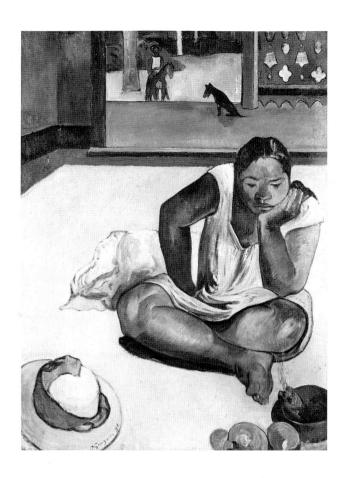

20.45 PAUL GAUGUIN Where Do We Come From? What Are We? Where Are We Going?, 1897. Oil on canvas, $54\sqrt[3]{4} \times 12\sqrt[3]{2}$ (139 × 374.5)

· 21 ·

THE FAILURE AND SUCCESS OF CÉZANNE

SYMBOLISM IN EXTREMIS

THE ART OF PAUL GAUGUIN WAS PAINTED ON A canvas as large as the French imperium. Enacting the modern roles of tourist and colonialist, Gauguin traveled from Paris to Pont-Aven, Quimper, Arles, Martinique, Papeete, and the Marquesas, seeking consolation for the loss of a bourgeois and masculine prerogative in the metropolis. In so doing, Gauguin, like many avant-gardists before him, was also fleeing modernization and indeed history itself—fleeing, that is, those forces of "universalizing civilization" that left the artist victim to the caprice of the market during a period of economic depression. For the most part, we have seen, Gauguin brought along as baggage on his travels the various hierarchies that generally sustained Europeans of his gender and class. In Tahiti he dreamed of rape (if he did not actually commit it) and he swaggered and patronized, at first, like any colonialist bureaucrat. Yet in the end, it was clear to him (as it was to his Surrealist descendants) that the dynamics of flight and retrospection also propelled an unallayed radicalism and utopianism. In his extreme retreat from metropolitan culture, Classical painting, and mimesis, Gauguin also mapped the contours of a future cultural realm of sensual gratification and human freedom; in his masculinism and primitivism, he charted an expressive terrain more truly androgynous and internationalist than any that had been imagined in Europe before; in his retreat from modernity and partisan politics, he also explored the radical political potential of an autonomous art that intransigently refused the blandishments of a deplored contemporaneity.

Gauguin's art was thus an extremist and a dialectical response to the alienation and despair that wracked the Symbolist generation. Yet there was at least one other achieved artistic response during the *fin-de-siècle*, equally

vehement in disdaining what Kahn called "the near at hand and the compulsorily contemporaneous," but very different from what has been considered here thus far. Where Gauguin was internationalist in his perspective, Paul Cézanne (1839– 1906) was almost parochial in his. He nevertheless created a body of work that, like Gauguin's, announced the modernist conception of art as (in Herbert Marcuse's later words) "the Great Refusal to accept the rules of a game in which the dice are loaded." The game in question is played to enshrine Western progress, power, modernization, and instrumental reason; the Great Refusal is a contrary celebration of traditional culture, erotic surrender, and utopia. These critical values may be detected in the art of Cézanne. For the young Cézanne, painting was a bomb, set to detonate beneath the Ecole, the Academy, and the Salon. Undoubtedly the wild child of Impressionism, Cézanne stimulated critical apoplexies during the 1860's and '70's. Yet he also attained a maturity during which he created a manner of painting and drawing that can be called nothing less than dialectical in its complexity and its critical logic. It was an art of sensual liberation as much as one of formal rigor and it thus laid a foundation for much of the artistic accomplishment of the twentieth century.

PAUL CÉZANNE AND THE END OF NINETEENTH-CENTURY ART

The art and career of Paul Cézanne is the logical endpoint of a book devoted to the critical examination of nineteenthcentury art. The reason is simple: no artist was more critical than he himself in exploring both the cognitive and perceptual mechanisms of seeing and representing; indeed, his art reveals more clearly than any before it the inseparability of these two meanings of the word "seeing." Though Cézanne benefited greatly from the artistic insights of Delacroix, Courbet, Manet, and Pissarro, he alone risked the destruction of mimesis in the quest for a manner of representation that was true to both individual apperception and the facts of material reality. To achieve this dialectical seeing, all previous artistic paradigms had to be suspended and a wholly new formal vocabulary devised. The task was daunting, and at times even debilitating. "Cézanne's doubt," as the existentialist philosopher Maurice Merleau-Ponty described it, was a primal uncertainty, the doubt of a first utterance. "I am the primitive of the way that I discovered," Cézanne told Emile Bernard at the end of his life. Yet the new language he spoke was so articulate and compelling that few afterwards could even remember, much less speak, the old.

What therefore emerges as most salient from a survey of Cézanne's art is the aspect of search, invention, discovery, and critical synthesis. Indeed, in the course of his long career, Cézanne changed from a Romantic rebel to a cultural revolutionary. From an artist who, like Delacroix, saw himself in heroic antagonism to a corrupt world, he became an artist who was in his words, "submissive to nature." From an artist who, like Ingres before and the Symbolists after, dreamed of a future based upon the moral verities of the past, he became an artist who devised a means through which a new cultural order could be represented and understood. Yet his artistic revolutionism assumed a form different from any that preceded it. Unlike the work of his much admired Courbet, Cézanne's radical art was not the product of an insurgent content: though artists and critics alike called him "communard," "intransigent," and "anarchist," he mostly eschewed politically charged subject matter. Unlike the painting of his almost equally admired Manet, Cézanne's revolutionary work was not the result of unprecedented esthetic effects: though he

21.1 PAUL CÉZANNE *Pastoral Scene*, ca. 1870. Oil on canvas, 25³/₄ × 31³/₄ (65 × 81)

The radical newness of Cézanne's paintings was instead a matter of, in Adorno's phrase, their "inherent structure. They are knowledge as nonconceptual objects." The best works by Cézanne, according to this formulation, do not represent the world, they are themselves worlds. "In front of a work by Cézanne," wrote Maurice Denis in 1907, "we think only of the picture; neither the object represented nor the artist's personality holds our attention. . . And if at once we say: this is a picture and a classic picture, the word begins to take on a precise meaning, that, namely, of an equilibrium, a reconciliation of the objective and the subjective."

The mature works of Cézanne may then fairly be seen as instances of what the twentieth century has termed "autonomous" creation. These refrain from the expression of ameliorative social or political solutions in the name of that human "free space" that we saw was only glimpsed by the Impressionists in their years of greatest achievement. The autonomous artwork, as Adorno writes, "is mediated through nothing other than the form of the work itself. . . . As eminently constructed and produced objects, such works of art . . . point to a practice from which they abstain: the creation of a just life." By virtue of their intellectual rigor and sensual desirability, such works exist in silent opposition to a degraded political sphere and a Western society "suffocated in the cultivation of kitsch." Cézanne's art thus becomes the signal instance of that modernist paradigm, the revolutionary artwork that is at the same time apolitical. For this reason, the usual terms of art historical analysis-stylistic sources and influences, literary iconography, biographical references, and critical reception—are stretched beyond their limits in attempts to describe the works produced after about 1885. Formal analysis and dialectics provide the only vocabularies that make any sense for understanding the mature paintings of Cézanne. "A man, a tree, an apple, are not represented," wrote the Russian painter Wassily Kandinsky (1866-1944) in "Concerning the Spiritual in Art" (1912), "but used by Cézanne in building up a painterly thing called a 'picture'."

CÉZANNE'S DEVELOPMENT: THE QUEST FOR TOTALITY

Cézanne began his career by embracing the cultural revivalism that dominated his native region. Born in 1839 in Aix-en-Provence, he read the vernacular Provençal poetry of Frédéric Mistral (1830–1914), and attended the local Corpus Christi and other religious and secular festivals that flourished during the middle years of the century. In addition, the young

Cézanne admired and emulated in early paintings, such as Sorrow, or Mary Magdalen (ca. 1867) and Pastoral Scene (ca. 1870), the work of native Baroque and early nineteenthcentury artists, such as the Neoclassical history painter and landscapist François-Marius Granet (1775–1849), in an effort to uphold or revive regional Aixois traditions of religious and landscape art. In fact, it may be argued that Cézanne remained a Provençal artist his whole life; even in his final two decades, after having come to know and share in the fervid, international artistic life of the French capital, Cézanne was drawn back to Aix as to a magnet—its scenery, its architectural monuments, its legends, and traditions. In the last two years before his death, he devoted more time than ever before to the depiction of Mont Sainte-Victoire, site of the ancient Roman victory over an army of invading Teutons and the fabled origin of Aix. He also concentrated upon the theme of bathing, perhaps partially in homage to the Roman Aquae Sextiae (Waters of Sextius) that gave the town its name. Cézanne thus began and concluded his career desiring to be the natural product of his beloved land; he would surely have wished it said of him, as the poet Max Buchon did of Courbet, that he "produced his paintings as simply as an apple tree produced apples."

As a youth, Cézanne roamed the Provençal countryside with his friend Emile Zola, and rhapsodized in French and Latin about the hills, brooks, and clouds he saw, and the panpipes, shepherds, and maidens' love of which he dreamed. But a darker romantic vision also accompanied him on his rambles, and from this the innovative artist emerged. In letters written to Zola in Paris after 1858, Cézanne frequently assumed a tone of Baudelairean irony and spleen in describing his sadistic and misogynist fantasies. In one letter of 1859 to the future Naturalist writer, Cézanne enclosed a verse allegory entitled "A Terrible Story," which concludes: ". . . and the woman in my arms who had been so pink and rosy suddenly disappeared and turned into a pale cadaver with angular body and rattling bones, and dull empty eyes." This is the Cézanne who painted the deathly Self-Portrait (ca. 1861-2), the violent The Rape (ca. 1867), the tormented Pastoral Scene, and the Temptation of Saint Antony (ca. 1870). These works, and others depicting murders, orgies, and an autopsy, are passionate, violent, and expressionistic, invested with the energy and vehemence of an unresolved Oedipal nightmare.

In the *Temptation*, young Paul (prematurely bald) appears in the guise of the tempted and tormented Saint Antony; in *Pastoral Scene*, he sits uncomfortably in the foreground of his own version of Manet's *Déjeuner*; in *A Modern Olympia* (ca. 1869–70), he is a pasha seated stiffly before his concubine. Even the portraits of his father are painted in a high emotional timbre. In the *Portrait of Louis-Auguste Cézanne*, *Father of the Artist*, *Reading L'Evénement* (1866), the sitter's torso is

21.4

awkwardly separated from his crossed legs by the bottom edge of the newspaper slicing across his groin. The erect right arm is similarly cut off from his body by the newspaper, and is set in front of an ominous shadow of gray/orange on the high-backed easy chair. In each of these works, Cézanne demonstrates a willingness to flout moral proprieties and artistic conventions. The violence, eroticism, confessional character, and purposeful awkwardness of these early paintings led observers to characterize them as childish and naive.

Throughout these years, Cézanne repeatedly submitted his works to the Salon with the knowledge that they would never be accepted. He even had the temerity in 1866 to write to the eminent Nieuwerkerke, Superintendent of Fine Arts, demanding a second Salon des Refusés and, in effect, an apology for past injuries. In a reprise of Courbet's words in 1853 to the same Nieuwerkerke, Cézanne wrote: "I am unable to accept the unauthorized judgment of colleagues whom I have not myself appointed to evaluate my work." Thus rejecting the cultural authority of the state, as he did his father's career wishes for him (Louis-Auguste would have preferred his son to be a banker or lawyer, like himself), Cézanne became a romantic and an intransigent. Despising the person and rule of Napoleon III, and approving the character and politics of Jacques Vingtras (from Jules Vallé's anarchist novel of the same name), the young artist was a rebel but not yet a revolutionary. Jean-Paul Sartre described the difference: "The revolutionary wants to change the world; he transcends it and moves toward the future, toward an order of values which he himself invents. The rebel is careful to preserve the abuses from which he suffers so that he can go on rebelling against them. He always shows signs of a bad conscience and of something resembling a feeling of guilt. He does not want to destroy or transcend the existing order; he simply wants to rise up against it."

Indications of the future revolutionary temperament are, however, also visible in the early, expressionistic paintings. Their stark contrasts of tonality, shrill juxtapositions of hue, and dense coagulations of paint (often applied with variously shaped palette knives) are new and noteworthy. But what is most important in Cézanne's pictures from before about 1873 is their pictorial clarity and sense of expressive *totality*. All parts of, for example, the *Portrait of Uncle Dominique* (1866) are equally dense, worked, and elaborated. The black outlining of nose and brow serves both to establish the contour of the face and to flatten it against the background plane. This quality of pictorial consistency or totality—at once naive and monumental—is unlike anything found in the work of Cézanne's Romantic, Realist, and Impressionist predecessors and foreshadows the achievements of the mature artist.

In *The Rape* (probably representing Pluto's abduction of Persephone), Cézanne focuses equally upon the nude fore-

21.5

ground figures, the female attendants in the left middle-ground, and the truncated Mont Sainte-Victoire in the background. Painted with looping and undulating strokes of paint, the riverbank, water, foliage, mountain, and sky are given nearly equal visual weight, suggesting an all-over two-dimensional structure and balance that act as a counterforce to the emotional depth and expressiveness of the narrative. In other words, even though the picture represents a misogynist dream, its style suggests detachment, abstractness, and objectivity. Even as the young Cézanne indulged his obsessional fears and hatreds of modern woman, he struggled to overcome them in order to re-order vision and design into a single unified procedure.

Lawrence Gowing, the art historian and painter, has summarized Cézanne's achievement in works such as The Rape and Portrait of the Painter, Achille Emperaire (ca. 1868– 70) as nothing less than "the invention of *forme* in the French modernist sense—meaning the condition of paint that constitutes a pictorial structure. It is the discovery of an intrinsic structure inherent in the medium and the material." What Gowing refers to as *forme* may be seen, for example, in the tectonic armature created by the insistent verticality of the Achille Emperaire: notice the parallels formed by the sides of the chair, the sitter's spindly legs, the pleats in his dressinggown, the black line running from his red collar to his slippers, and the attenuated Bodoni-style stenciling at the top of the canvas. These parallel lines create a feeling of architectural stability at the same time that they evince a sense of picturality—a perception, that is, of the painting as a

21.2 PAUL CÉZANNE A Modern Olympia, ca. 1869–70 Oil on canvas, 22 × 21 $\frac{5}{8}$ (56 × 55)

21.3 PAUL CÉZANNE Portrait of Uncle Dominique, 1866. Oil on canvas, $15\frac{1}{2}\times12$ (39.5 × 30.5)

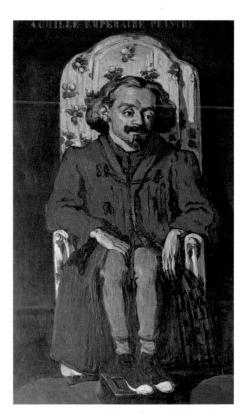

21.4 PAUL CÉZANNE
Portrait of the Painter,
Achille Emperaire,
ca. 1868–70.
Oil on canvas,
78¾ × 48 (200 × 122)

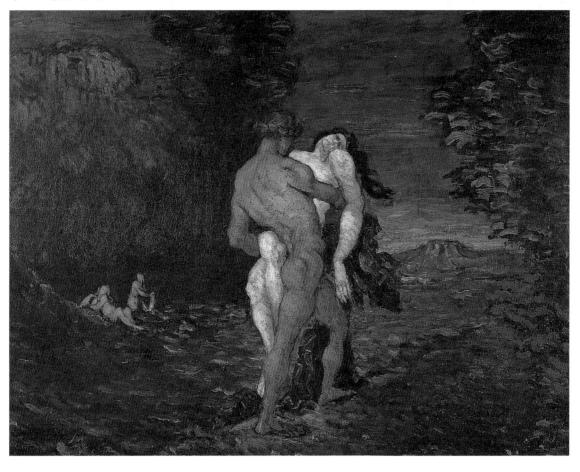

21.5 PAUL CÉZANNE *The Rape*, ca. 1867. Oil on canvas, $35^{1/2} \times 46 (90.5 \times 117)$

444 · THE FAILURE AND SUCCESS OF CÉZANNE

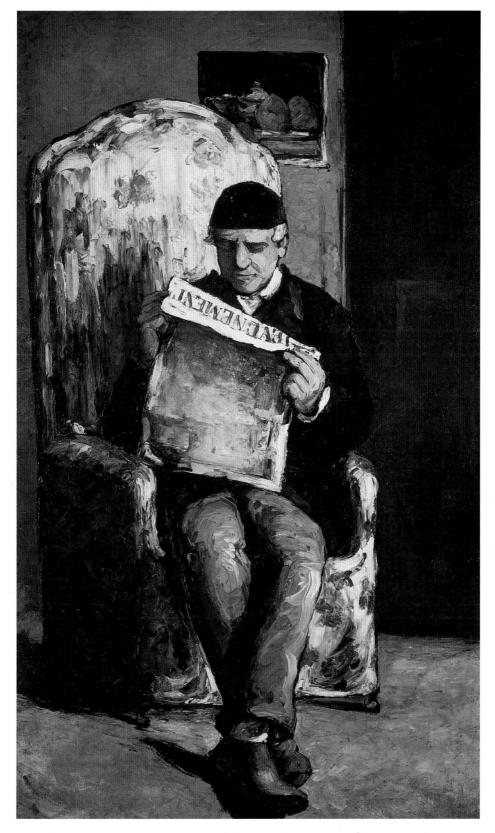

21.6 PAUL CÉZANNE Portrait of Louis-Auguste Cézanne, Father of the Artist, Reading L'Evénement, 1866. Oil on canvas, $78\% \times 47\%$ (200 × 120)

self-sufficient two-dimensional structure built from vertical and horizontal wooden ribs, covered with canvas, and painted with a viscous colored medium.

The 1867 correspondence of Cézanne's friend A. F. Marion offers some confirmation of the artist's totalizing intentions: "Paul is really very much stronger than [Courbet and Manet]. He is convinced of being able, by a more skillful execution and perception, to admit details while retaining breadth. Thus he would achieve his aims, and his works would become more complete." Fifteen years later, the artist's intention was the same, as Gauguin revealed in a mocking letter to Cézanne's friend Pissarro: "Has M. Césanne [sic] discovered the exact formula for a work that would be accepted by everyone? If he should find the recipe for concentrating the full expression of all his sensations into a single and unique procedure, try, I beg you, to get him to talk about it in his sleep by administering one of those mysterious homeopathic drugs and come directly to Paris to share it with us." At the end of his life, Cézanne almost believed he had found his formula; he told Bernard in 1904: "I owe you the truth in painting and I will tell it to you."

CÉZANNE'S ARTISTIC MATURITY

Although Cézanne's quest for artistic totality is visible from the beginning, there can be no question that it changed and grew over the four decades of his career. The paintings of the 1860's and early '70's possess an unprecedented formal consistency and tectonic structure, but they are still dominated by the Baroque drama of chiaroscuro and tonal contrast. Color is not yet fully integrated into their pictorial fabric. In the paintings considered above, color functions primarily to express moods or strong feelings and only partially to indicate mass, volume, depth, and pictorial unity. The "intrinsic structure" of Uncle Dominique and Achille Emperaire is for the most part the product of paint density, composition, and tonal contrast and not the result of choice of colors or modulation. It is as if the colorless genre of melodrama, as the art historian and curator John Elderfield has written, was fully adequate to express the violent dreams and Oedipal longings of the youthful artist. But as Cézanne gradually attained psychological maturity (perhaps hastened by his liaison, beginning in 1869, with Hortense Figuet), his artistic vision became richer and more inclusive. As he gradually dismissed from his art the clichéd, adolescent roster of femmes fatales, he increasingly explored the dynamics of hue. Impressionism, and especially the art and instruction of Pissarro, would be the most important instrument of Cézanne's totalization of subjective experience and objective reality.

In early 1872, during the bleak dawn following the dark night of the Commune's destruction, Cézanne was living beside Pissarro at Pontoise in the Ile de France, and learning from him the decisive lessons of Impressionism. Cézanne shared with his anarchist friend and mentor a love of landscape and a faith in the healing capacity of rural life. Together they discovered a method for representing their feelings about the plenitude of nature; for Pissarro this meant the depiction of peasant laborers in worked fields, and the creation of textural and coloristic unities of figure and ground. For Cézanne, this method meant the fashioning of a pictorial universe sufficiently complete and nuanced that it could approximate both the motif itself and the powerful and complex sensations he felt before his subject. "I paint as I see, as I feel," he told a critic in 1870, "and I have very strong sensations."

Cézanne used the narrowed tonal range and prismatic hues of Impressionism as a means both of capturing the effects of light and air and of disciplining his sometimes violent and disordered imagination. Indeed, Impressionism, we have seen, was precisely an art of social and psychological distance; it was the artistic expression of a subculture that disdained alienated work and celebrated the implicit freedom of bourgeois and petit-bourgeois leisure. Cézanne accepted Impressionism's principled rejection of instrumentality, but he could not accept its frequent emotional and intellectual shallowness. By the end of the 1870's, he had outstripped his Impressionist teacher by creating works that are both convincing semblances of physical objects and figures and records of the artist's own shifting perceptions over time.

Compared with Pissarro's Village Near Pontoise (1873), 21.7 Cézanne's House of the Hanged Man, Auvers-sur-Oise (ca. 1873) possesses an unusually dense and clotted surface. Its color is more uniformly warm than Pissarro's work (note the latter's cool blues alternating with the red roofs in the middleground) and its tonality is more even. Unlike his friend and teacher, moreover, Cézanne marks the contours and boundaries of objects with broad lines (compare the treatment of tree-trunks in each), and clearly anchors trees and buildings in the earth. Cézanne's landscape, in sum, suggests a greater planarity and pictorality than Pissarro's, together with a greater mass and solidity.

Beside Pissarro's The Côte des Boeufs at L'Hermitage, Near 21.1 Pontoise (ca. 1873), Cézanne's L'Estaque (ca. 1876) appears balanced and calm. Both works employ divided and multi-directional brushstrokes of brown, green, and blue, but Cézanne's strokes are broader than Pissarro's and manage to evoke the shape, density, and surface texture of the objects they describe. In addition, Cézanne has chosen to highlight and explore, rather than obscure, all the areas in his landscape motif that are physically and visually complex or ambiguous; thus he lavishes attention on the intersection of roof hips and cornices, the convex edges of buildings, the joinings of leaf to

21.7 Camille Pissarro *Village Near Pontoise*, 1873. Oil on canvas, $24 \times 31\%$ (61 × 81)

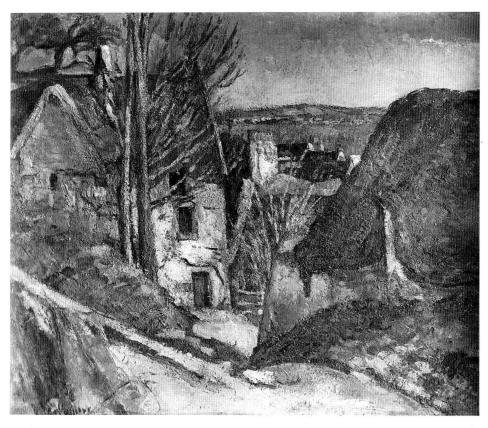

21.8 PAUL CÉZANNE House of the Hanged Man, Auvers-sur-Oise, ca. 1873. Oil on canvas, $21\%8 \times 26$ (54.9 \times 66)

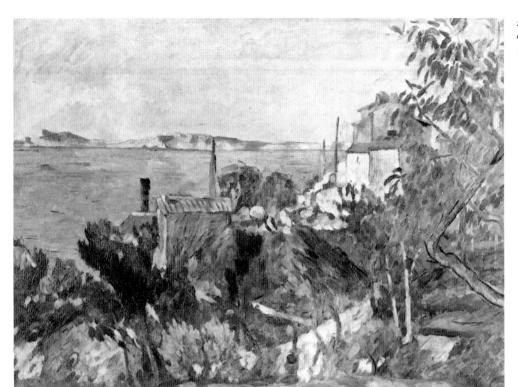

21.9 PAUL CÉZANNE *L'Estaque*, ca. 1876. Oil on canvas, $16\frac{1}{2} \times 23\frac{1}{4} (41.9 \times 59)$

branch, the lines where mountains meet the sea, and the places where chimneys (or masts?) break the horizon.

Comparison of these landscapes suggests that while Cézanne may have believed that the energy and ephemerality of Pissarro's Impressionism were appropriate to the depiction of transient atmospheric effects, he found the style to be too unstable, intangible, and inexpressive for the convincing representation of the countryside and its people. But while Cézanne judged Impressionism to be flawed by insubstantiality and emotional remove, he also definitively determined that traditional academic technique, which he understood—linear drawing, single-point thoroughly perspective, Classical anatomy, tonal modeling, and chiaroscuro—was equally flawed by its very procrusteanism; these stolid formal tricks were wholly inadequate to the artist's shifting perceptions of the world as he moved through it, and besides, they were the remnant of an old and discredited order. Thus Cézanne, beginning in the late 1870's, devised an art that employed the faceted, mosaic surface of Impressionism without its evasiveness. Put another way, he marshaled the dynamic, kinesthetic features of Impressionist art, with the architectonic tangibility and expressiveness of his early works. Cézanne wanted monumentality and emotional resolve in his art; he wished, he told Bernard, "to make of Impressionism something solid, like the art in the museums."

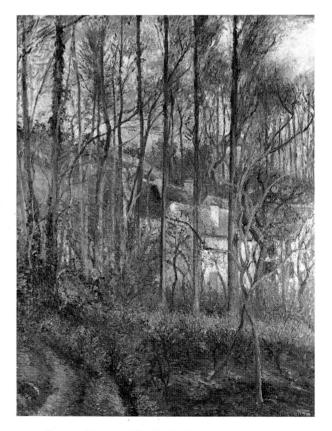

21.10 CAMILLE PISSARRO The Côte des Boeufs at L'Hermitage, Near Pontoise, ca. 1873. Oil on canvas, $45\frac{1}{4} \times 34\frac{1}{2}$ (115 × 87.5)

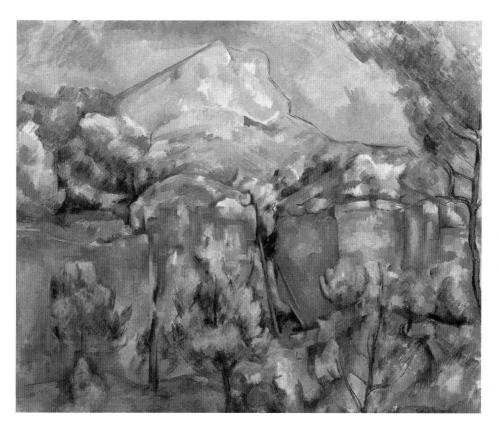

21.11 Paul Cézanne Houses in Provence (Vicinity of L'Estaque), 1879–82. Oil on canvas, $25\frac{1}{2} \times 32$ (64.7 \times 81.2)

21.12 PAUL CÉZANNE Mont Sainte-Victoire Seen From Bibémus, ca. 1898–1900. Oil on canvas, $25^{1/2} \times 31^{1/2}$ (65 × 80).

THE FAILURE AND SUCCESS OF CÉZANNE

After exhibiting with the Impressionists in their third group exhibition in 1877, Cézanne essentially struck off on his own. Though he kept in occasional contact with members of the group (especially Renoir) he needed no further lessons from them. Nor did he try to exhibit with them; for seven out of the next eight years he tried in vain to show at the Salon, his only success coming in 1882 when he was admitted as a "pupil" of the charitable juror Antoine Guillemet. His few press notices were as uncomprehending and patronizing as they had been when he first exhibited with the Impressionists nearly a decade earlier; the Portrait of L. A. (present whereabouts unknown) was described by the critic of the Dictionnaire Véron as "a beginner's work painted at great expense of color." Increasingly melancholic and reclusive, Cézanne was fast fading from public view and becoming legendary. In 1885, Gauguin professed admiration for his art but called him "that misunderstood man, whose nature is essentially mystical...he spends whole days on the tops of mountains reading Virgil and gazing at the sky."

At the same time that he was suffering alienation from both avant-garde and academic Paris, Cézanne suffered a number of personal blows that further affected his art. In 1885, an unconsummated passion for a maid from his parents' house at Aix left him angry and confused. The same year, Zola's cruel portrayal of him in L'Oeuvre ended the only friendship he ever had. In April 1886, Cézanne grudgingly married Hortense Figuet (they were already living apart), and six months later attended his father's funeral. This latter event secured him financially but exhausted him emotionally. Convinced by all that had transpired of the futility of human intercourse, and certain that his own death was at hand, Cézanne now worked ceaselessly and with unprecedented dedication. His landscapes, still lifes, and figure paintings progressed apace, and his style quickly achieved the complexity and resolve that a later generation would see as the foundation for its own modern and abstract art.

The twenty years between 1886 and the artist's death in 1906 spanned the careers of Van Gogh, Seurat, Gauguin, and the Symbolists. They witnessed the last Impressionist exhibition (1886), the Eiffel Tower Exposition in Paris (1889), the Dreyfus Affair (1894–1902), the deaths of Zola (1902) and Pissarro (1903), and the exhibition of the Fauves at the Salon d'Automne (1905). None of this had any discernible impact on Cézanne's art; by virtue of his unusual powers of concentration or his paranoia, he devised an autonomous art of extraordinary formal rigor. Generalizations about this art, as Elderfield has observed, are difficult to make because of Cézanne's always different responses to the specific motifs before him, but three basic principles of

pictorial invention may be extrapolated through examination of selected works.

- 1) Holding illusionism at bay—in *Houses in Provence* (1879–82), a perverse humor results from the purposeful avoidance of linear clarity and perspectival exactness. Cézanne lines up the vertical edges of the two largest houses without clarifying their exact spatial locations. He both reveals and obscures the underside of roof eaves and the flat tops of rocks in order to hide the artist's point of view. This game of illusionistic cat-and-mouse helps to preserve the complexity and ambiguity of perception in time and space, and to preserve the integrated surface which is a record of that perception.
- 2) Use of tectonic facture, or passage—in Mont Sainte-Victoire Seen From Bibémus (ca. 1898–1900), the brushstroke shape, size, boundary, and direction is independent of the structure and texture of the objects that are represented. This painterly freedom may be considered another example of the resistance to mimesis described above, but in fact a kind of alternative illusionism is involved. The so-called passage brushstrokes on the rocks in the middle-ground are like colored gemstone facets, roof shingles or overlapping affiches; they are themselves planes that cling to the picture surface yet which constitute the tectonic authenticity of the rock. Once again, the two-dimensional authority of the pictorial support is reconciled with the depth and breadth of nature.
- 3) A consistent concentration upon the edges of things—in *Still Life With Apples* (ca. 1895–8), the most important parts of the picture are where objects meet—lemon, tablecloth, lime, peach, and goblet; pitcher, tabletop, tablecloth, shadow, peach, apple, peach, tablecloth. At these junctions, colors are juxtaposed and the drama of surface and depth—sensation and understanding—is enacted. For the picture to represent totality, it had to comprise fugitive sensations and unanticipated interactions, not merely independent objects. Colors had to be adjusted across the boundaries of things, and hierarchies between absence and presence eliminated.

Physical objects in *Still Life With Apples* are formed from the collision of one color with another. "One should not say model," Cézanne told Bernard, "one should say modulate." What the artist undoubtedly meant was that in order to attend to the depth as well as the surface appearance of things, he must reject traditional modeling with light and dark and instead modulate with warm and cool hues. The *point culminant* of the nearest lemon, for example, is not created by a white highlight but by a subtle array of cooler (receding) greens and yellows against a warmer (advancing) mustard. Indeed, the entire gamut of objects in this monumental painting—fruits, goblet, pitcher, tureen, curtains, table, and cloth—are constituted not by tonal modeling and local color but by color modulation.

Cézanne's art, Merleau-Ponty has written, was paradoxical: "He was pursuing reality without giving up the sensuous surface, with no other guide than the immediate impression of nature, without following the contours, with no outline to enclose the color, with no perspectival or pictorial arrangement. This is Cézanne's suicide: aiming for reality while denying himself the means to attain it." His art was contradictory, as Gauguin described it: "Has Cézanne discovered the prescription for compressing the intense expression of all his sensations into a single and unique procedure?" His art was abstract, as Cézanne himself told Denis: "I wished to copy nature, but I could not. I was only satisfied when I discovered that the sun, for instance, could not be reproduced, but that it must be represented by something else . . . by color."

Paradoxical, contradictory, and abstract, Cézanne's late paintings might also be called utopian. Though they recall, unlike Ensor's, no fabled past of popular enchantment, and though they imagine, unlike Seurat's, no future of sensual harmony, they are nevertheless themselves dreams of concord, cooperation, and totality. In The Large Bathers (1900– 06), one of three monumental paintings on this subject made in the artist's last half-decade, the boundaries between earth, plant, and human are elided while the autonomy of each is assured. The ten bathers, irregularly outlined in blue (their sex is mostly undetermined), the three large, blueblack trees that strain upward at left and right, and the yellow-brown earth below, share the task of composing the base, sides, and mass of a single great pyramid or mountain, like Mont Sainte-Victoire itself. Yet each of the three elements possess at the same time a purposiveness and formal rigor not present in contemporary works by the Symbolists Munch, Redon, Vrubel, and Hodler. Those artists expressed a vitalistic longing for the subordination of humans before nature. Cézanne expressed—through a subtle balance of facture, tonality, color, volume, and mass-the desire for the simultaneous independence and cooperation of each.

Mont Sainte-Victoire (1902–6), like the Large Bathers, is not only a depiction of a cherished subject—one that recalled the

painter's youth amid the hills and waters of Provence—it is also a symphony of color modulation, orchestrated with at once balanced and variegated passage. Dozens of tints of blue, gray, and brown, applied with discrete oblong brushstrokes, create an up-and-down and side-to-side jostling; warm browns and yellows and cooler blues and greens instigate a constant shuttling between surface and depth. The mountain peak itself is outlined in blue—once, twice, three times—in order both to record the kinesthesia of the painter's eye, hand, arm, and body and to assert the clarity of that vaunted architecture. Both of these paintings, therefore, one focused on the human and one on the natural—by their unmistakable inscription of the drama of self and environment—express the utopian longing for a reconciliation. That image of concord, which had earlier been dreamed (though somewhat less elementally) by Constable, Courbet, and Van Gogh among others, was one of the most salient critical legacies of the nineteenth century.

"As eminently constructed and produced objects," Adorno writes, "[autonomous artworks] point to a practice from which they abstain: the creation of a just life." To combine perception and apperception, the sensual and the cognitive, the intellectual and the emotional within a single work of art—so Adorno argues—is to betoken a totality that is absent in a world scarred and fragmented by modernization and an exclusive reliance upon reason. Cézanne strove to achieve totality in his art, and in so doing insinuated his criticism of society in the very form of the artwork itself. That formal insinuation—the achievement both of a single artist and of the generations that labored before—may be judged, however, a failure as well as a success. During Cézanne's last years, and especially in the decades that followed, the embedding of criticism in form came more and more to resemble a hibernation of criticism. Indeed, by the time Cézanne was rediscovered by a public familiar with Cubism and abstraction, art and cultural criticism inhabited wholly separate spheres. The story of that fateful segregation cannot be told here; the effort of the present book has been only to show that in the nineteenth century things were different, and that the best art was critical.

21.3 Paul Cézanne Still Life With Apples, ca. 1895–8. Oil on canvas, $27 \times 36 \frac{1}{2} (68.6 \times 92.7)$

21.14 PAUL CÉZANNE The Large Bathers, 1900–06. Oil on canvas, $67\% \times 77\%$ (172.2 × 196.1)

21.15 Paul Cézanne Mont Sainte-Victoire, 1902–6. Oil on canvas, $33 \times 25\%$ (83.8 × 65)

CHRONOLOGY

	HISTORICAL AND CULTURAL EVENTS	VISUAL ARTS
1780	The American War of Independence (begun in 1776) continues. The Gordon Riots in London.	JAD. Ingres born.
1781	Surrender of the troops of Lord Cornwallis at Yorktown, Virginia, ending the British military effort against the American revolutionists. Immanuel Kant, <i>Critique of Pure Reason</i> . Jean-Jacques Rousseau, <i>Confessions</i> . Gotthold Ephraim Lessing dies.	JL. David, <i>Belisarius</i> . John Singleton Copley, <i>Death of Major Pierson</i> (completed 1784).
1782	John Howard urges the reform of Newgate prison, London. Choderlos de Laclos, <i>Dangerous Liaisons</i> .	
1783	Treaty of Paris signed, granting recognition and vast lands to the 13 former American colonies. Kant, <i>Prolegomena</i> (Prolegomena to Any Future Metaphysics). Mozart, <i>Idomeneo</i> . Stendhal born.	
1784	Beaumarchais, The Marriage of Figaro. Denis Diderot dies.	David, Oath of the Horatii. Goya, The Family of the Infante Don Luis. Sir Joshua Reynolds, Mrs Siddons as The Tragic Muse.
1785	Kant, Foundations of the Metaphysics of Morals. Alessandro Manzoni born.	Benjamin West, Queen Philippa Intercedes for the Burghers of Calais.
1786	Death of Frederick the Great of Prussia. Kant, Metaphysical First Principles of Natural Science. Mozart, The Marriage of Figaro.	JG. Drouais, Marius at Minturnae.
1787	Federal government established in the U.S. Free African Society founded in Philadelphia by Richard Allen. J. W. von Goethe, <i>Egmont</i> . John Adams, <i>A Defense of the Constitution of Government of the U.S.A</i> . Mozart, <i>Don Giovanni</i> .	David, Death of Socrates. J. H. W. Tischbein, Goethe in the Campagna. EL. Vigée-Lebrun, Marie-Antoinette with Her Children.
1788	Louis XVI summons States-General and recalls Jacques Necker as finance minister. New York is federal capital of U.S. Kant, <i>Critique of Practical Reason</i> . Arthur Schopenhauer and Byron born.	David, Love of Paris and Helena. Sir John Soane appointed Architect and Surveyor to the Bank of England, London.
1789	The French Revolution begins; storming of the Bastille; feudalism abolished; Declaration of the Rights of Man in France; King and court move from Versailles to Paris. George Washington becomes first U.S. President. William Blake, <i>Songs of Innocence</i> .	David, Lictors Returning to Brutus the Bodies of His Sons.
1790	Louis XVI accepts French constitution. Philadelphia is U.S. federal capital. Jews granted civil rights in France. Edmund Burke, Reflections on the Revolution in France. Kant, Critique of Judgment. Alphonse de Lamartine born.	Ste. Geneviève, Paris, by J. G. Soufflot, completed, and transformed into Pantheon.
1791	Louis XVI arrested at Varennes. Massacre of the Champ de Mars in Paris. James Boswell, <i>Life of Johnson</i> . J. G. von Herder, <i>Outlines of a Philosophy on the History of Man</i> (begun 1784). Thomas Paine, <i>Rights of Man</i> , part I. Mozart, <i>The Magic Flute</i> . Death of Mozart.	David, The Oath of the Tennis Court. Théodore Géricault born.
1792	Girondist ministry in France; revolutionary Commune established; royal family imprisoned; First Republic proclaimed; trial of Louis XVI; France declares war on Austria, Prussia, and Sardinia. Thomas Paine, <i>Rights of Man</i> , part II. Mary Wollstonecraft, <i>Vindication of the Rights of Women</i> . C. J. Rouget de Lisle, <i>La Marseillaise</i> . Percy Bysshe Shelley born.	James Wyatt begins Fonthill Abbey, Wiltshire.
1793	Louis XVI and Marie Antoinette executed; Reign of Terror; Charlotte Corday murders Marat; Robespierre and St. Just join Committee of Public Safety headed by Danton; worship of God is banned; Holy Roman Empire declares war on France. William Godwin, The Inquiry Concerning Political Justice. Kant, Religion within the Limit of Mara Present	Louvre, Paris, opens. David, <i>Death of Marat</i> . Goya, <i>Courtyard with Lunatics</i> (completed 1794).

within the Limits of Mere Reason.

- 1794 'Feast of the Supreme Being' in Paris; Danton and St. Just executed; Legislative Assembly abolishes slavery in French colonies; Robespierre overthrown on 9 Thermidor (July 27). William Blake, Songs of Experience. J. G. Fichte, The Science of Knowledge. Thomas Paine, The Age of Reason.
- 1795 Bread riots and White Terror in Paris; establishment of a ruling Directory in France; French occupy Belgium.
- Napoleon assumes command in Italy. Babeuf's socialist
 "Conspiracy of Equals" defeated in France. George Washington's
 "Farewell Address." Spain declares war on Britain. Goethe,
 Wilhelm Meister's Apprentice Years. Friedrich Schlegel,
 Essay on the Concept of Republicanism.
- Napoleon appointed to lead invasion of England. French capture and proclaim Rome a republic. Napoleon commands Battle of the Pyramids. Ferdinand IV of Naples takes Rome, French recapture. Samuel Taylor Coleridge, Kubla Khan (published 1816). François René de Chateaubriand, A Historical, Political and Moral Study into the Effect of Ancient and Modern Revolutions on the French Revolution. Friedrich Hölderlin, Hyperion.

 Kant, Metaphysics of Morals. Haydn, "Emperor" Quartet. Franz Schubert born.
- 1798 Goethe, Hermann and Dorothea. Wordsworth and Coleridge,
 Lyrical Ballads. The German literary and esthetic journal
 Athenaeum, founded by the Schlegel brothers as the manifesto of
 the new Romantic movement, published in Berlin (until 1800).
- 1799 Napoleon's Parthenopean Republic in Piedmont; Napoleon made first consul on 18 Brumaire (November 19). Austria declares war on France. Friedrich Schlegel, *Lucinde*. Haydn, *The Creation*. Giacomo Leopardi, Alexander Pushkin, and Honoré de Balzac born. Death of George Washington.
- 1800 French army advances on Cairo and Vienna; Napoleon's army conquers Italy. Washington, DC, is federal capital of U.S. Hölderlin, three odes. Schiller, *Mary Stuart*. Schlegel, *Letter on the Novel*. Thomas Babington Macaulay born.
- 1801 Union between Ireland and Great Britain. Czar Paul I assassinated, succeeded by Alexander I. English enter Cairo, French troops leave Egypt, recovered by Turks. Slavery reintroduced in French colonies. Hegel and Schelling, Critical Journal of Philosophy. Schelling, Ideas for a Philosophy of Nature. Haydn, The Seasons.
- 1802 Napoleon President of Italian Republic. Wordsworth begins *The Prelude.* Victor Hugo born.
- 1803 France and Britain renew war. Louisiana Purchase doubles territory of the U.S. Prosper Mérimée born. Choderlos de Laclos and J. G. Herder—theoretician of *Sturm und Drang* (Storm and Stress)—die.
- Napoleon proclaimed emperor, crowned before Pope Pius VII;
 Code Napoléon composed and promulgated. Schiller, *William Tell*. Beethoven, "Eroica" symphony. George Sand born. Kant dies.
- Britain, Russia, Sweden, and Austria sign treaty against France.
 Battle of Trafalgar. Napoleon king of Italy. Peace between
 Austria and France. William Hazlitt, *An Essay on the Principles of Human Action*. Beethoven, *Fidelio*. Hans Christian Andersen,
 Giuseppe Mazzini, and Alexis de Tocqueville born. Schiller dies.
- 1806 British occupy Cape of Good Hope. Prussia declares war on France. Napoleon enters Berlin. End of Holy Roman Empire. John Stuart Mill born.

VISUAL ARTS

Goya, Procession of the Flagellants. John Trumbull, The Declaration of Independence.

Friedrich Gilly begins to design monument to

Goya, The Duquesa de Alba. Blake, Newton. J.-A. Houdon, George Washington. Edward Savage, The Washington Family. West, Death on a Pale Horse.

A.-L. Girodet, *Portrait of Jean-Baptiste Belley*. Turner, *Millbank*, *Moon Light*.

David, Intervention of the Sabine Women. Goya, Los Caprichos.

Blake, The Great Red Dragon and the Woman Clothed with the Sun. Antonio Canova, Cupid and Psyche. David, Madame Récamier.

David, Napoleon at the St. Bernard Pass. Goya, Family of Charles IV. Gros, Battle of Nazareth.

Gérard, Madame Récamier. Girodet, Ossian Receiving the Napoleonic Officers into Valhalla. Thomas Girtin dies.

James Barry, Self-Portrait. Henry Raeburn, The Macnab. Turner, Calais Pier. Soane, Tivoli Corner, Bank of England.

Gros, Napoleon in the Plague House at Jaffa. Claude-Nicolas Ledoux, ideal city of Chaux.

Canova, *Tomb of the Archduchess Maria Christina*. Goya, *Naked* and *Clothed Maja* completed. Philipp Otto Runge, *The Hülsenbeck Children*. Turner, *Shipwreck*. Samuel Palmer born.

Canova, *Napoleon as Mars*. J.-F. Chalgrin begins Arc de Triomphe, Paris. Ingres, *Napoleon on the Imperial Throne*. Bertel Thorvaldsen, *Hebe*.

1807 Prussian and Russian troops fight French forces at Eylau. Abolition of the slave trade throughout the British colonies. Wordsworth, *Ode on Intimations of Immortality*. Hegel, Phenomenology of the Mind. Beethoven, "Leonora" overture. Henry Wadsworth Longfellow born.

U.S. Congress forbids importation of slaves from Africa.
 French army occupies Rome, invades Spain. Napoleon recaptures
 Madrid after rebellion and Joseph Bonaparte's flight. Goethe,
 Faust, part I. Charles Fourier, The Social Destiny of Man.
 Heinrich von Kleist, Penthesilea. Beethoven, "Pastoral" symphony.
 Gérard de Nerval born.

1809 Austria and France at war. French take Vienna. Napoleon annexes Papal States. A.W. Schlegel, *Lectures on Dramatic Art and Literature*, 3 vols., 1809–11. Beethoven, "Emperor" concerto. Nikolai Gogol, Abraham Lincoln, Felix Mendelssohn, Pierre-Joseph Proudhon, Georges Haussmann, and Alfred, Lord Tennyson, born.

1810 France declares abortion illegal. Goethe, *Theory of Colors*.

Walter Scott, *The Lady of the Lake*. Mme. de Staël, *Germany*.

Kleist, *On the Marionette Theater*. Frédéric Chopin and
Robert Schumann born.

1811 George III of England insane; Prince of Wales becomes Prince Regent. William Henry Harrison defeats Indians under Tecumseh at Tippecanoe, Indiana. Jane Austen, Sense and Sensibility. Kleist, The Prince of Homburg. Théophile Gautier, Franz Liszt, and William Makepeace Thackeray born. Kleist commits suicide.

Napoleon invades Russia, enters Moscow, but retreats with the army greatly diminished. British Prime Minister Spencer Percival assassinated in House of Commons. U.S. declares war on Britain. Byron, *Childe Harold's Pilgrimage*. Brothers Grimm, *Fairy Tales*. Hegel begins *Science of Logic* (completed 1816). Alexander Herzen and Charles Dickens born.

Prussia and Austria declare war on France. "Battle of the Nations," Leipzig: Napoleon defeated. William of Orange reinstated in Holland, French expelled. Mexico declares independence. Jane Austen, *Pride and Prejudice*. Shelley, *Queen Mab.* Saint-Simon, *On the Reorganization of European Society*. Georg Büchner, Søren Kierkegaard, Giuseppe Verdi, and Richard Wagner born.

Allied armies (Britain, Russia, Austria) enter Paris. Napoleon abdicates, banished to Elba. Louis XVIII takes up throne in Paris. End of Anglo–U.S. "War of 1812." Jane Austen, *Mansfield Park*. Scott, *Waverley*. Wordsworth, *The Excursion*. Mikhail Bakunin, Mikhail Lermontov, and Eugène Viollet-le-Duc born. Fichte dies.

1815 Post-Napoleonic creation of Germanic Confederation. Napoleon leaves Elba for France; Louis XVIII flees; "Hundred Days";
Battle of Waterloo; Congress of Vienna marks final defeat of Napoleon. Napoleon is exiled to St. Helena; Louis returns and Bourbon dynasty is reestablished. Elizabeth Cady Stanton and Anthony Trollope born.

1816 Argentina independent. Revival of Luddism in Britain. French naval disaster of the *Medusa*. Saint-Simon edits *L'Industrie* until 1818. Jane Austen, *Emma*. Coleridge, *Kubla Khan* (begun 1797). Benjamin Constant, *Adolphe*. Rossini, *The Barber of Seville*.

1817 Beginning of war against Seminole Indians in Georgia and Florida. Byron, *Manfred*. Keats, "Endymion." Hegel, *Encyclopedia of the Philosophical Sciences* (revised and extended 1827). Henry David Thoreau born.

VISUAL ARTS

Canova, Pauline Borghese as Venus. David, The Coronation of Napoleon. Turner, Sun Rising in a Mist.

Caspar David Friedrich, *The Cross in the Mountains*. Ingres, *La Grande Baigneuse*. Runge, *Morning*.

Friedrich, Monk by the Sea.

Friedrich, Abbey in the Oak Forest. Goya begins The Disasters of War. J. F. Overbeck founds Nazarenes. Karl Friedrich Schinkel, design for a memorial chapel and mausoleum for Queen Luise of Prussia.

Ingres, Jupiter and Thetis. Thorvaldsen, Procession of Alexander the Great.

Canova, Venus Italica. Goya, Portrait of the Duke of Wellington. Turner, Snow Storm: Hannibal and His Army Crossing the Alps. A. W. N. Pugin born.

Turner, Frosty Morning. David Cox, Treatise on Landscape Painting and Effect in Water Colours.

David, Leonidas at Thermopylae. Géricault, The Blacksmith's Signboard. Goya, The Uprising of the Second of May, 1808 and The Executions of the Third of May, 1808. Ingres, Odalisque. J.-F. Millet born.

Goya, The Junta of the Philippines.

Elgin Marbles bought for British Museum. Canova, The Three Graces. Goya, The Duque de Osuna. Nash begins to create Brighton Pavilion

John Constable, *Flatford Mill*. Pasquale Belli begins building Vatican Museum, Rome.

1818 Border between U.S. and Canada agreed. Chile declares independence from Spain. Jane Austen, Northanger Abbey, Persuasion (posthumous). Byron, Don Juan. Thomas Love Peacock, Nightmare Abbey. Mary Shelley, Frankenstein. Mme. de Staël, Thoughts on the Main Events of the French Revolution, Karl Marx and Ivan Turgeney born.

1819 Peterloo Massacre of protestors by British troops in Manchester. U.S. buys Florida from Spain. Keats, "Hyperion" (published 1856). Saint-Simon edits *La Politique*. Schopenhauer, *The World as Will and Idea*. Queen Victoria, Prince Albert, Gottfried Keller, Herman Melville, and Walt Whitman born.

A Spanish revolution leads to constitutional restoration.

Missouri Compromise maintains de jure slavery in U.S. South.

Lamartine, Poetic Meditations. Keats, "Ode to a Nightingale."

Pushkin, Ruslan and Ludmilla. Scott, Ivanhoe, The Monastery, The Abbot.

Shelley, Prometheus Unbound, The Cenci, Ode to the West Wind. Washington Irving, The Sketchbook. Friedrich Engels and Herbert Spencer born.

1821 Greek War of Independence from Ottoman Turks begins. Death of Napoleon. Coronation of George IV of England. Simón Bolívar named President of independent Venezuela. Goethe, Wilhelm Meister (completed 1829). Shelley, Adonais. Hegel, Philosophy of Right. Thomas de Quincey, Confessions of an English Opium Eater. Charles Baudelaire, Fyodor Dostoevsky, Gustave Flaubert, and Nikolai Nekrasov born. Keats dies.

Ottoman massacre of Greeks at Chios (then Scio). Deciphering of Rosetta Stone by J. F. Champollion. William Hazlitt, *Table Talk*. J.-B. Lamarck, *Natural History of Invertebrates*. Gregor Mendel, founder of genetics, born.

1823 Enunciation of Monroe Doctrine. Beethoven, Missa Solemnis.

Simón Bolívar Emperor of Peru. Beethoven completes Ninth Symphony. Alexandre Dumas (fils) born. Byron dies at Missolonghi, Greece; Louis XVIII dies, and brother, Charles X, assumes throne of France.

1825 Ottoman siege of Missolonghi. Czar Alexander I dies, Nicholas I succeeds. Diary of Samuel Pepys published. Hazlitt, The Spirit of the Age. Saint-Simon dies.

1826 James Fenimore Cooper, *The Last of the Mohicans*. Hazlitt, *The Plain Speaker*. Heinrich Heine, *Book of Songs*.

1827 Capitulation of Greek forces on the Acropolis. Manzoni completes

The Betrothed (begun 1821). The Freeman's Journal begins publication
in New York City. Beethoven and Ugo Foscolo die.

Duke of Wellington Prime Minister of Britain. Russo-Turkish war. End of Webster, *An American Dictionary of the English Language*. Schubert, "Unfinished Symphony." Henrik Ibsen, Hippolyte Taine, Leo Tolstoy, and Jules Verne born. Schubert dies.

1829 Greece achieves independence. Fourier, *The New Industrial and Communal World*. Rossini, *William Tell*. Schlegel dies.

July Revolution in France. "Citizen-King" Louis-Philippe becomes limited constitutional monarch. Indian Removal Act signed by President Andrew Jackson. Stendhal, Scarlet and Black. Tennyson, Poems, Chiefly Lyrical. Auguste Comte, Treatise on Positive Philosophy, vol. 1. Emily Dickinson, Frédéric Mistral, and Christina Rossetti born. Bolívar and George IV of England die.

VISUAL ARTS

Géricault, The Bull Market. Prado Museum, Madrid, founded

Géricault, *The Raft of the Medusa*. John Martin, *The Fall of Babylon*. Turner, *Childe Harold's Pilgrimage*. John Ruskin born. Regent Street Quadrant, London, by Nash, begun.

George Cruikshank, *Life in London*. Thorvaldsen, *Christ and the Twelve Apostles*.

Constable, The Hay Wain. Ford Madox Brown born.

Canova, Endymion. Friedrich, Woman By the Window. Eugène Delacroix, The Bark of Dante. Canova dies.

Goya, A Dog and Saturn Devouring His Children.

National Gallery, London, founded. David, Mars Disarmed by Venus and the Three Graces. Delacroix, The Massacre at Scio [Chios]. Ingres, Vow of Louis XIII. Overbeck, Christ's Entry into Jerusalem. Pierre Puvis de Chavannes born. Géricault dies.

Constable, *The Leaping Horse*. Samuel Morse, *Portrait of Lafayette*. Palmer, *Rest on the Flight into Egypt*. David dies.

John James Audubon, *The Birds of America* portfolios. Thomas Cole, *Daniel Boone and His Cabin at Great Osage Lake*. Camille Corot, *The Forum Seen From the Farnese Gardens*. John Martin, *The Deluge*. Gustave Moreau born.

Constable, *The Cornfield*. Delacroix, *The Death of Sardanapalus*. Ingres, *The Apotheosis of Homer*. Ary Scheffer, *The Suliot Women*. William Holman Hunt and Arnold Böcklin born.

Delacroix, Faust. Dante Gabriel Rossetti born. Goya dies.

Turner, *Ulysses Deriding Polyphemus*. John Martin, *The Fall of Ninevah*. John Everett Millais born. P.-L.-F. Fontaine, Galerie d'Orléans, Paris.

End of Nazarene Brotherhood. Corot, Chartres Cathedral. Delacroix, Liberty Leading the People. Palmer, Coming From Evening Church and Cornfield in Moonlight with Evening Star. Camille Pissarro born. Sir Thomas Lawrence dies.

- Nat Turner leads Virginia slave revolt. Insurrection of Lyons silk workers. Heine in exile in Paris until 1856. Balzac, La Peau de chagrin. Hugo, The Hunchback of Notre Dame. Edgar Allan Poe, Poems. Pushkin, Boris Godunov. Vincenzo Bellini, La Sonnambula (The Sleepwalker) and Norma. Karl von Clausewitz and Hegel die.
- Passage of first Reform Act in Britain, doubling eligible voters.

 Blackface minstrel T. D. Rice performs "Jim Crow" in Louisville,
 Kentucky. Goethe, Faust, part II (posthumous). George Sand,
 Indiana and Valentine. Tennyson, The Lady of Shalott.
 Clausewitz, On War (posthumous). Hegel, The Philosophy of
 History (posthumous). Berlioz, Symphonie Fantastique. Goethe,
 Jeremy Bentham, and Scott die.
- 1833 Ferdinand VII of Spain dies, succeeded by a two-year-old daughter, Isabella II. Abolition of slavery in British colonies decreed.

 Balzac, Eugénie Grandet. Pushkin completes Eugene Onegin and first draft of The Bronze Horseman. Johannes Brahms born.
- 1834 English trade unionists from Tolpuddle transported for sedition.

 Balzac, Old Goriot. Alfred de Musset, Lorenzaccio. Pushkin,

 The Queen of Spades. Schleiermacher dies. Büchner publishes

 The Hessian Courier
- 1835 Whites fight Seminole Indians in new war in Florida. Georg Büchner, *Danton's Death*. Théophile Gautier, *Mademoiselle de Maupin*. De Tocqueville, *Democracy in America*, vol. 1 (vol. 2 1840). Donizetti, *Lucia di Lammermoor*. Mark Twain born. Bellini dies.
- Davy Crockett killed at the Alamo. Republic of Texas proclaimed.
 Dickens, *The Pickwick Papers*. Ralph Waldo Emerson, *Nature*.
 Gogol, *The Government Inspector*. Thomas Carlyle,
 Sartor Resartus. Büchner begins Woyzeck.
- 1837 Economic depression in U.S. and Britain. Victoria becomes Queen of England. Capture of Seminole leader Osceola at St. Augustine. Balzac, *Lost Illusions* (parts II and III 1837 and 1839). Carlyle, *The French Revolution*. Algernon Swinburne born. Büchner, Fourier, Leopardi, and Pushkin die.
- 1838 Publication in London of "People's Charter," demanding universal suffrage. "Trail of Tears" in U.S. moves 14,000 Cherokees from homes in South to West during which 4000 die. Dickens, Oliver Twist, Nicholas Nickleby. Rossini, Benvenuto Cellini. Henry Brooke Adams born.
- 1839 Maya culture in Central America examined by John Lloyd.
 Invention of photography. Stendhal, *The Charterhouse of Parma*.
 Louis Blanc, *The Organization of Labor*. Macaulay begins *History of England*.
- 1840 Queen Victoria marries Prince Albert. Lermontov, A Hero of Our Times. Proudhon, "What is Property?" Thomas Hardy and Emile Zola born.
- Britain proclaims sovereignty over Hong Kong in the midst of the Opium War. USS Creole slave-ship seized by slaves, who are subsequently freed. Utopian Brook Farm established in Massachusetts. Ralph Waldo Emerson, Essays: First Series. Gogol, The Overcoat. Poe, The Murders in the Rue Morgue. Ludwig Feuerbach, The Essence of Christianity. Lermontov dies.

VISUAL ARTS

Ando Hiroshige issues his first series of landscape prints, Famous Places in Edo. Constable, Salisbury Cathedral, From the Meadows. John Martin, The Fall of Babylon.

Constable, Waterloo Bridge From Whitehall. Hiroshige publishes series, Fifty-three Stages of the Tokaido. Ingres, M. Louis-François Bertin. Turner, Staffa: Fingal's Cave. Edouard Manet born. Gustave Eiffel born.

Edward Burne-Jones born.

Honoré Daumier, Rue Transnonain, April 15, 1834. Delacroix, Women of Algiers. Paul Delacoche, The Execution of Lady Jane Grey. Ingres, Martyrdom of Saint Symphorian. Edgar Degas, William Morris, and James Abbot McNeill Whistler born.

Constable, *The Valley Farm*. Corot, *Hagar in the Desert*. Sir Charles Barry and Pugin begin Palace of Westminster. Nash dies.

Corot, Diana Surprised by Actaeon. François Rude, The Marseillaise (The Departure of the Volunteers of 1792). Winslow Homer born. Pugin, Contrasts.

David d'Angers, Pantheon pediment, Paris. Constable and Soane die.

National Gallery, London, opens. Christen Købke, View of Lake Sortedam. A. J. Davis designs Knoll, Tarrytown, NY.

M. E. Chevreul, *The Principles of Harmony and Contrast of Colors* and *The Application to the Arts*. Paul Cézanne and Alfred Sisley born.

Corot, Breton Women at the Well. Delacroix, Entry of the Crusaders into Constantinople. Ingres, Odalisque with Slave. John Martin, The Assuaging of the Waters. Claude Monet, Odilon Redon, and Auguste Rodin born. Caspar David Friedrich dies.

Berthe Morisot and Auguste Renoir born. Schinkel dies. Pugin begins St. Giles, Cheadle.

- Fugitive Slave Act of 1793 upheld by U.S. Supreme Court.
 Balzac, A Human Comedy begins to appear. Gogol, Dead Souls,
 part I. Macaulay, Lays of Ancient Rome. Comte, A Study of
 Positive Philosophy. Mendelssohn, A Midsummer Night's Dream.
 Verdi, Nabucco. William James and Stéphane Mallarmé born.
 Stendhal and Luigi Cherubini die.
- 1843 Wordsworth becomes English Poet Laureate. Dickens, A Christmas Carol. Mérimée, Carmen. Tennyson, Morte d'Arthur. Carlyle, Past and Present. Kierkegaard, Either/Or and Fear and Trembling. William Prescott, History of the Conquest of Mexico. Flora Tristan, Union of Workers. Henry lames born. Hölderlin dies.
- Marx and Engels meet in Paris. Morse demonstrates the "electric telegraph." Elizabeth Barrett Browning, *Poems*. Dumas (*père*), *The Three Musketeers*. Gerard Manley Hopkins, Friedrich Nietzsche, and Paul Verlaine born.
- 1845 Irish famine due to potato crop failure. Dumas (père), The Count of Monte Cristo. Poe, The Raven and Other Poems. Engels, The Condition of the Working Class in England. Margaret Fuller, Woman in the Nineteenth Century.
- U.S. declares war on Mexico (to 1848). Free-traders repeal
 English Corn Laws. Proudhon and Marx break relations. Balzac,
 La Cousine Bette. Dostoevsky, Poor Folk. Edward Lear, Book
 of Nonsense. Melville, Typee. Berlioz, Damnation of Faust.
 Comte de Lautréamont born. A.W. Schlegel dies.
- U.S. forces take Mexico City. Alexander Herzen leaves Russia and goes into exile in the West. Charlotte Brontë, Jane Eyre.
 Emily Brontë, Wuthering Heights. Thackeray, Vanity Fair.
 Publication completed of Alfred de Vigny, Complete Works (begun 1839). Lamartine, History of the Girondists.
 Marx, Communist Manifesto. Verdi, Macbeth. Wagner, Tannhäuser.
 Thomas Edison and Georges Sorel born. Mendelssohn dies.
- 1848 Revolution in France, spreads throughout Europe; Louis
 Napoleon III elected president, establishing Second Republic;
 Lamartine minister of foreign affairs in French provisional
 government. Revival of British Chartism. Elizabeth Cady Stanton
 joins in convening the first women's rights meeting in America,
 the Seneca Falls Convention, in which she presents the women's
 "Declaration of Sentiments." Utopian Oneida Community
 established in New York. Dumas (fils), Camille. Elizabeth Gaskell,
 Mary Barton. Chateaubriand, Memoirs From Beyond the Grave.
 Macaulay, History of England (vols. 1 and 2). J. S. Mill, Principles
 of Political Economy. Proudhon writes for and edits Paris newspapers,
 including Le Peuple and La Voix du peuple (until 1850).
 Joris-Karl Huysmans born. Chateaubriand dies.
- 1849 Rome declared a republic under Giuseppe Mazzini with support of Giuseppe Garibaldi. French enter Rome and restore Pope Pius IX. National Assembly fails to unify Germany. Marx moves to London. Kierkegaard, *The Sickness unto Death*. Proudhon, *Confessions of a Revolutionary*. August Strindberg born. Margaret Fuller, Chopin, and Poe die.
- 1850 King Louis-Philippe of France dies. Michael Faraday publishes his general theory of magnetism. Emerson, Nature: Addresses and Lectures. Nathaniel Hawthorne, The Scarlet Letter. Tennyson becomes Poet Laureate; In Memoriam. Turgenev, A Month in the Country. Engels, The Peasant Wars in Germany. Herzen, From the Other Shore. Guy de Maupassant born. Balzac and Wordsworth die.

VISUAL ARTS

David d'Angers, Victor Hugo.

Ruskin, Modern Painters, vol. 1. Théodore Rousseau, Under the Birches. Turner, Shade and Darkness—The Evening of the Deluge.

Turner, *Rain, Steam, and Speed.* Mary Cassatt, Thomas Eakins, and Henri (Douanier) Rousseau born

Portland vase destroyed and restored. Ingres, *Portrait* of Countess Haussonville.

Millet, Oedipus Unbound.

George Caleb Bingham, Raftsmen Playing Cards. Thomas Couture, Romans of the Decadence. Rude, Napoleon Reawakening to Immortality.

Millet, *The Winnower*. Millais, Rossetti, and Holman Hunt found Pre-Raphaelite Brotherhood. Paul Gauguin born.

Ruskin, The Seven Lamps of Architecture. Rosa Bonheur, Plowing in the Nivernais: The Dressing of Vines. Gustave Courbet, The Peasants of Flagey Returning From the Fair, After Dinner at Ornans, and A Burial at Ornans. J.-L.-E. Meissonier, Memory of Civil War (The Barricades).

Courbet, *The Stonebreakers*. Goya, *Proverbios* (posthumous). Millais, *Christ in the House of His Parents*. Millet, *The Sower*.

- Coup d'état of Louis-Napoleon ends French Second Republic.
 Sioux land in Iowa and Minnesota surrendered to Federal
 Government. Hawthorne, House of Seven Gables. Melville, Moby
 Dick. Gérard de Nerval, Journey to the Orient. August Comte, System
 of Positive Politics, (completed 1854). Proudhon, General Theory
 of the Revolution of the Nineteenth Century. Verdi, Rigoletto.
 Wagner, Opera and Drama.
- Proclamation of French Second Empire by Napoleon III. Aristide Boucicault invents department store (Bon Marché) in Paris.

 Dickens, Bleak House. Harriet Beecher Stowe, Uncle Tom's Cabin. Turgeney, Sketches from a Hunter's Album. Gogol dies.
- 1853 U.S.-Mexico boundary settled. Matthew Arnold, *The Scholar Gypsy*. Charlotte Brontë, *Villette*. J. S. Mill, *Principles of Political Economy*. Verdi, *Il Trovatore*, *La Traviata*. Wagner finishes text of *Rine*.
- 1854 Crimean War. Commodore Perry opens Japan to Western trade. Charles Kingsley, Westward Ho! Tennyson, "The Charge of the Light Brigade." Thoreau, Walden. Viollet-le-Duc, Complete Dictionary of French Architecture (Dictionnaire raisonné), vol. 1.

 Oscar Wilde and Arthur Rimbaud born. F. W. J. Schelling dies.
- 1855 Paris Universal Exposition. Hans Christian Andersen, *The Fairy Tale of My Life*. Robert Browning, *Men and Women*. Longfellow, *The Song of Hiamatha*. Nerval, *Aurelia*. Tennyson, *Maud*. Trollope, *The Warden*. Walt Whitman, *Leaves of Grass* (1st edition). Adelbert von Keller, *Green Heinrich*. Kierkegaard and Nerval die.
- 1856 End of Crimean War when Russians capitulate to Austria; Peace Congress in Paris. Nekrasov, *Poet and Citizen*. De Tocqueville, *The Old Regime and the Revolution*. Sigmund Freud born. Heine and Schumann die.
- 1857 Dred Scott decision upholds de jure slavery in U.S. Baudelaire, The Flowers of Evil. Dickens, Little Dorrit. George Eliot, Scenes from Clerical Life. Flaubert, Madame Bovary. Trollope, Barchester Towers. Taine, French Philosophers of the Nineteenth Century. Verdi, Simon Boccanegra. Musset and Comte die.
- 1858 Attempt to assassinate Napoleon III. Marx, Sketches. Proudhon,

 Justice in the Revolution and in the Church. Taine, Essays on

 Criticism and History. Offenbach, Orpheus in the Underworld.

 Giacomo Puccini born.
- France and Austria begin and end war. France acquires
 Indochina. John Brown leads raid on Harper's Ferry, Virginia, in
 hopes of igniting slave revolt; he is hanged. Baudelaire, "Salon de
 1859." Dickens, A Tale of Two Cities. George Eliot, Adam Bede.
 Edward Fitzgerald, Rubáiyát of Omar Khayyám. Ivan Goncharov,
 Oblomov. Tennyson, Idylls of the King. Charles Darwin, On the
 Origin of Species by Natural Selection. Marx, Critique of Political
 Economy. J. S. Mill, On Liberty. Charles Gounod, Faust.
 Verdi, A Masked Ball. Wagner, Tristan and Isolde. Henry Bergson
 born. I. K. Brunel, de Quincey, Macaulay, and de Tocqueville die.
- 1860 Garibaldi proclaims Victor Emmanuel King of Italy. Abraham Lincoln elected President of U.S. Turgenev, First Love and On the Eve. Giuseppe Mazzini, The Duties of Man. Anton Chekhov, Jules Laforgue, Hugo Wolf, Claude Debussy, and Gustav Mahler born. Schopenhauer dies.

VISUAL ARTS

Corot, *The Dance of the Nymphs*. Millais, *Ophelia*. Turner dies. Great Exhibition, Crystal Palace, London.

Ford Madox Brown, *Christ Washing Peter's Feet*. Holman Hunt, *The Light of the World*. Exhibition of "Examples of False Principles in Decoration" opens in London. Pugin dies.

Bonheur, *The Horse Fair*. Holman Hunt, *The Amakening Conscience*. Ruskin, *The Stones of Venice*, vol. 2. Vincent van Gogh born. Fontaine dies.

Courbet, *The Meeting (Bonjour, Monsieur Courbet)*. Millet, *The Reaper*. John Martin dies. Ruskin writes letter to *The Times* defending Hunt's *The Awakening Conscience*.

Courbet, *The Studio of the Painter* exhibited at Pavilion of Realism at Paris Universal Exposition.

Ingres, La Source. John Singer Sargent born. Owen Jones's Grammar of Ornament published.

National Portrait Gallery, London, opens. "Museum of Ornamental Art" opens in London (future Victoria & Albert Museum). Champfleury, *Réalisme*, manifesto of the Realist movement. Courbet, *Young Ladies on the Banks of the Seine*. Millet, *The Gleaners*. Jacques-Ignace Hittorf begins Gare du Nord, Paris. Louis Sullivan born.

William Frith, *Derby Day*. Adolf von Menzel, *Good Evening*, *Gentlemen*.

Manet rejected at the Salon. Corot, *Macbeth*. Millet, *The Angelus*. Whistler, *At the Piano*. Georges Seurat born. Bibliothèque Nationale, Paris, by Henri Labrouste. Red House, Bexleyheath, Kent, by Philip Webb.

Jacob Burckhardt, *The Civilization of the Renaissance in Italy*. Degas, *Young Spartans Exercising*. Holman Hunt, *Finding of the Savior in the Temple*. Manet, *Spanish Guitar Player*. James Ensor and Walter Sickert born. Barry dies.

- 1861 Serfdom abolished in Russia. Italy proclaimed kingdom. Civil War in the U.S. (until 1865). Dostoevsky, Memoirs from the House of the Dead (completed 1862). Herzen, My Past and Thoughts. Harriet Martineau, Health, Husbandry and Handicraft. Sainte-Beuve, Chateaubriand and his Circle under the Empire.
- The Battle of Shiloh ends indecisively after 24,000 are killed.
 Lincoln issues Emancipation Proclamation, freeing slaves.
 Homestead Act greatly increases settlement of U.S. West.
 Flaubert, Salammbô. Hugo, Les Misérables. Christina Rossetti,
 Goblin Market. Turgenev, Fathers and Sons. Spencer, The First
 Principles. Count Maurice Maeterlinck born. Thoreau dies.
- Navaho and Apache Indians forced to relocate to reservation in New Mexico. French capture Mexico City. Baudelaire, *The Painter of Modern Life*. Kingsley, *The Water Babies*. Lincoln, *Gettysburg Address*. J. S. Mill, *Utilitarianism*. Proudhon, *Principle of Federation*. Viollet-le-Duc, *Interviews on Architecture (Entretiens)*. Bizet, *The Pearl Fishers*. D'Annuncio born. Thackeray and Vigny die.
- The International Working Men's Association (the First International) founded in London. Italy renounces claim to Rome. The right to strike becomes legalized in France. Maximilian proclaimed emperor in Mexico. Dostoevsky, *Notes from Underground*. Chevreul, *Notes on Color*.
- U.S. Civil War ends (Confederate States surrender), Lincoln assassinated. Mendel publishes his research on heredity. Matthew Arnold, Essays in Criticism. Lewis Carroll, Alice's Adventures in Wonderland. John Henry Newman, Dream of Gerontius. Francis Parkman, Pioneers of France in the New World. Taine, New Essays. Proudhon and Lord Palmerston die.
- 1866 End of Austro-Italian war; Schleswig-Holstein incorporated into Prussia. Former U.S. slaves granted de jure civil rights. Dostoevsky, Crime and Punishment. Swinburne, Poems and Ballads.
- 1867 The French abandon Mexico. Execution of the Emperor Maximilian. U.S. purchases Alaska from Russia. Nobel patents dynamite in Sweden, America, and Britain. Ibsen, *Peer Gynt.* Marx, *Capital*, vol. 1. Verdi, *Don Carlos*. Madame Curie born. Baudelaire dies.
- 1868 Revolution in Spain. Queen Isabel II flees to France. Gladstone succeeds Disraeli as British Prime Minister. Brahms, *A German Requiem*. Tchaikovsky, Symphony No. 1. Wagner, *The Mastersingers of Nuremberg*. Stefan George and Maxim Gorky born. Rossini dies.
- 1869 Heinrich Schliemann begins excavations to locate Troy. Suez Canal opened. Completion of U.S. transcontinental railway. American Women's Suffrage Association founded by Susan B. Anthony. Henry James goes to England. Louisa May Alcott, Little Women (1868–9). Dostoevsky, The Idiot. Flaubert, A Sentimental Education. Lautréamont, The Songs of Maldoror. Tolstoy, War and Peace. Trollope, Phineas Finn. Mark Twain, The Innocents Abroad. Verlaine, Fêtes galantes. Jules Michelet, History of France, History of the French Revolution. J. S. Mill, The Subjection of Women. Wagner, The Rhinegold. André Gide and Frank Lloyd Wright born.
- Outbreak of Franco-Prussian War and French defeat; Napoleon III capitulates; Third Republic proclaimed in Paris; Prussians begin siege. Italians enter Rome, claiming it as capital city.
 Ratification of 15th Amendment giving voting rights to former slaves. Jules Verne, Twenty Thousand Leagues Under the Sea.
 Wagner, The Valkyrie. Dickens, Mérimée, Dumas père, Herzen, and Lautréamont die.

VISUAL ARTS

Manet successful at the Salon; he meets Charles Baudelaire and Edouard Duranty. Pissarro meets Cézanne. Corot, *Orpheus, The Rest.* William Morris founds Morris, Marshall, Faulkner & Co. (later Morris & Co.).

Frederick Church, Cotopaxi. Daumier, The Third-Class Carriage. Ingres, Turkish Bath. Manet, Lola de Valence and Music in the Tuileries. Gustav Klimt born.

The Salon des Refusés includes works by Cézanne, Guillaumin, Manet, Pissarro, and Whistler. Gustave Doré, *Don Quichotte* illustrations. Manet, *Déjeuner sur l'herbe* and *Olympia*. Rossetti, *Beata Beatrix*. Delacroix dies

Manet rejected at the Salon, while Pissarro and Morisot are included. Manet, *The Dead Toreador*. Whistler, *Symphony in White No. II: The Little White Girl*. Henri de Toulouse-Lautrec born.

Manet exhibits *Olympia* at the Salon. Courbet and Monet meet. Madox Brown, *Work* (begun 1852). Degas, *Woman with Chrysanthemums*. George Innes, *Peace and Plenty*. Moreau, *Orpheus*.

Zola publishes book of Salon reviews. Manet meets Zola and Cézanne. Winslow Homer, *Prisoners From* the Front. Monet, Camille (Woman in a Green Dress).

Courbet and Manet arrange show at Paris Universal Exposition. Cézanne, *The Rape*. Manet, *The Execution of the Emperor Maximilian*. Millais, *Boyhood of Raleigh*. Monet, *Women in the Garden*. Pierre Bonnard born. Ingres dies. Frank Lloyd Wright born.

J.-B. Carpeaux, *The Dance*. Degas, *The Orchestra*. Manet, *Portrait of Emile Zola*. Renoir, *The Skaters*. Edouard Vuillard born. St. Pancras station and hotel, London, by W. H. Barlow and Sir George Gilbert Scott, begun.

Café Guerbois becomes the favorite meeting place of the Impressionists. Manet, *A Balcony*. Monet, *La Grenouillère*. Degas, *The Orchestra of the Paris Opera*. Henri Matisse born.

Manet joins the National Guard when war breaks out. Cézanne, *The Murder*. Fantin-Latour, *A Studio in the Batignolles*. Meissonier, *The Siege of Paris*. Frédéric Bazille is killed in active service.

- A Socialist Commune is established in Paris in March and bloodily repressed in May by government forces; Thiers becomes President; Paris under martial law. King William I of Prussia proclaimed Emperor of United Germany. George Eliot, Middlemarch. Darwin, The Descent of Man. Verdi, Aïda. Marcel Proust and John Millington Synge born. E. B. Tylor, Primitive Culture.
- Civil War in Spain. Feminist Victoria Woodhull runs for U.S.
 Presidency. Lewis Carroll, Through the Looking Glass.
 Dostoevsky, The Possessed. Strindberg, Master Olof. Nietzsche,
 The Birth of Tragedy (revised 1878, 1886). Alexander Scriabin born.
 Gautier and Mazzini die.
- 1873 Financial panic across Europe and North America. Napoleon III dies at Chislehurst, England. Spain proclaimed Republic. Germans leave France. Trollope, *The Eustace Diamonds*. Verne, *Around the World in Eighty Days*. J. S. Mill, *Autobiography* (posthumous). Spencer, *The Study of Sociology*. Alfred Jarry born. Mill dies.
- 1874 Schliemann begins excavating Homeric cities in Greece. Disraeli returns as Prime Minister. Hardy, Far from the Madding Crowd. Verlaine, Songs Without Words. Brahms, Hungarian Dances.

 Mussorgsky, Boris Godunov. Verdi, Requiem. Wagner, The Ring of the Nibelungs completed.
- 1875 Trollope, *The Way We Live Now*. Mark Twain, *The Adventures of Tom Sawyer*. Bizet, *Carmen*. Thomas Mann and Rainer Maria Rilke born. Hans Christian Andersen, Bizet, and Manzoni die.
- 1876 General Custer and his U.S. cavalry force all killed at Battle of the Little Big Horn by Sioux warriors. Telephone invented in U.S. First Socialist International dissolved. Wagner's Festival Theater at Bayreuth opens. George Eliot, Daniel Deronda. Pérez Galdós, Doña Perfecta. Henry James, Roderick Hudson. Mallarmé, The Afternoon of a Faun. Nietzsche, Thoughts out of Season (begun 1873). Wagner, Siegfried. Bakunin and George Sand die.
- Turkey and Russia at war. Queen Victoria Empress of India.
 Capture of Nez Perce braves and Chief Joseph in Montana territory. Edison invents phonograph. Flaubert, *Three Tales*.
 Henry James, *The American*. Tolstoy, *Anna Karenina*. Trollope, *The American Senator*. Turgenev, *Virgin Soil*. Zola, *L'Assommoir*. Nekrasov dies. Society for the Protection of Ancient Buildings founded in England.
- 1878 Russian-Turkish armistice signed. Paris Universal Exposition. Hardy, *The Return of the Native*. Henry James, *The Europeans*. Swinburne, *Poems and Ballads*.
- 1879 British–Zulu War; peace signed. Edison invents electric light bulb in U.S. French Socialist Party formed. Gustave Charpentier,
 Modern Life. Ibsen, A Doll's House. Henry James, Daisy Miller.
 Frege, Conceptual Notation. Tchaikovsky, Eugene Onegin.
 Viollet-le-Duc dies.
- 1880 Transvaal declares its independence. Dostoevsky, *The Brothers Karamazov*. Maupassant, *Boule de suif (Ball of Tallow)* published in Zola's Naturalist collection *Evenings in Medan*. Zola, *Nana*. Henry Brooks Adams, *Democracy*. Nietzsche, *Human*, *All-too-human* (begun 1878). Taine, *The Philosophy of Art*. Guillaume Apollinaire, Alexander Blok, and Robert Musil born.

VISUAL ARTS

Courbet involved in destruction of Napoleon's Column in the Place Vendôme. Rossetti, *The Dream of Dante*.

Manet sells 29 paintings to Durand-Ruel. Böcklin, Battle of the Centaurs. Degas, A Carriage at the Races. Millet, Four Seasons. Monet, Impression, Sunrise and The Basin at Argenteuil. Whistler, The Artist's Mother.

Walter Pater, Studies in the History of the Renaissance. Degas visits New Orleans. Manet meets Mallarmé. Cézanne, A Modern Olympia. Monet, Autumn Effects, Argenteuil. Morisot, The Cradle. Ilya Repin, Barge-Haulers on the Volga.

First Impressionist Exhibition, Paris. Pissarro exhibits in this and all other Impressionist exhibitions (1874–86), which he largely organized; Manet refuses to participate. Manet, *Monet Working on his Boat in Argenteuil.*Monet, *The Seine at Argenteuil.* Renoir, *The Loge.*

Edmond and Jules de Goncourt publish Art of the Eighteenth Century. Caillebotte, The Floorscrapers. Eakins, The Gross Clinic. Menzel, Iron Rolling Mill, completed. Monet The Red Boat, Argenteuil, and Poplars Near Argenteuil. Corot, Millet, and Labrouste die.

Second Impressionist Exhibition. Moreau, *Salome*. Renoir, *Moulin de la Galette*. Bon Marché store, Paris, enlarged by L.-A. Boileau and Eiffel.

Third Impressionist Exhibition. Caillebotte, Paris Street: Rainy Weather. Cézanne, Still Life with Apples. Eakins, William Rush Carving His Allegorical Figure of the Schuylkill River. Winslow Homer, The Cotton Pickers. Monet, Gare St. Lazare, Paris and Argenteuil, the Bank in Flower. Rodin, The Age of Bronze. Wilhelm Leibl, Town Politicians. Courbet dies.

William Morris publishes *The Decorative Arts*. Whistler sues Ruskin for libel. Cassatt, *The Blue Room*. Degas, *The Rehearsal*. Monet, *Rue Montorgueil Decked Out with Flags*. George Cruikshank dies.

Fourth Impressionist Exhibition. Bouguereau, Birth of Venus. Mary Cassatt, The Cup of Tea. Renoir, Mme. Charpentier and Her Children. Rodin, John the Baptist. Daumier and Couture die.

Fifth Impressionist Exhibition. Cézanne, Château de Médan. Pissarro, The Outer Boulevards. Renoir, Place Clichy. Rodin, The Thinker and commission for The Gates of Hell (completed 1917).

- The Boer War begins. Czar Alexander II and U.S. President Garfield assassinated. "Jim Crow" laws passed in Tennessee, furthering segregation. Flaubert, *Bouvard and Pécuchet* (posthumous). Ibsen, *Ghosts*. Henry James, *The Portrait of a Lady*. Maupassant, *La Maison Tellier*. Nietzsche, *The Dawn*. Dostoevsky dies.
- Susan Brownell Anthony (with Elizabeth Cady Stanton and Matilda Joslyn Gage), History of Woman Suffrage, vol. 1
 (completed 1922). Nietzsche, The Gay Science. Tchaikovsky, "1812 Overture." Wagner, Parsifal. Darwin, Disraeli, Emerson, Garibaldi, Longfellow, Trelawny, and Trollope die.
- 1883 Marxist party founded in Russia by Plekhanov and others. Robert Louis Stevenson, *Treasure Island*. Huysmans, *Modern Art*. Nietzsche, *Thus Spake Zarathustra* (completed 1892). Metropolitan Opera House, New York, opens. Léo Delibes, *Lakmé*. Franz Kafka born. Marx, Turgeney, and Wagner die.
- 1884 Huysmans, Against the Grain. Ibsen, The Wild Duck. Mark Twain,
 The Adventures of Huckleberry Finn. Engels, The Origin of the Family,
 Private Property, and the State. Frege, The Foundations of Arithmetic.
- 1885 Leopold II of Belgium declares himself sovereign of the Congo Free State. Pasteur develops vaccine against rabies. Freud studies under Charcot at the Salpêtrière hospital for nervous diseases in Paris and becomes interested in hysteria and hypnosis. Walter Pater, Marius the Epicurean. Zola, Germinal. Kropotkin, Memoirs of a Revolutionist. Marx, Capital, vol. 2 (posthumous). J. S. Mill, Nature, The Utility of Religion, and Theism, 3rd edn. (all posthumous). Victor Hugo dies.
- Apache chief Geronimo captured, ending last major U.S.—Indian war. Orléans and Bonaparte families banished from France. Haymarket Massacre of strikers and police in Chicago. Ibsen, Rosmersholm. Henry James, The Bostonians. Rimbaud, Illuminations. R. L. Stevenson, The Strange Case of Dr. Jekyll and Mr. Hyde. Zola, L'Oeuvre. Engels, Ludwig Feuerbach and the End of Classical German Philosophy. Marx, Capital, published in English. Jean Moréas, manifesto of Symbolism in Le Figaro. Nietzsche, Beyond Good and Evil. Liszt dies.
- 1887 General Boulanger coup d'état fails in Paris. Pérez Galdós, Fortunata and Jacinta. Nietzsche, On the Genealogy of Morals. Verdi, Otello. Laforgue dies.
- Wilhelm II becomes Emperor of Germany. Eastman invents paper photographic films and Kodak box camera. Ibsen, The Lady From the Sea. Rudyard Kipling, Plain Tales from the Hills. Strindberg, Miss Julie. Oscar Wilde, The Happy Prince, and Other Tales. Edward Bellamy, Looking Backward, 2000–1887. Bergson, Time and Free Will. George Moore, Confessions of a Young Man. Nietzsche, Ecce Homo (published 1908), Nietzsche Contra Wagner, The Twilight of the Idols, and completes notes on The Will to Power. Ruskin, Praeteritas. Mahler, Symphony No. 1. Nikolai Rimsky-Korsakov, Scheherazade.
- 1889 More than 30 million people visit the Universal Exposition in Paris. Anatole France, *Thäis*. Tolstoy, *The Kreuzer Sonata*. Mark Twain, *A Connecticut Yankee in King Arthur's Court*. Sir Arthur Evans begins excavating Knossos. Browning and Chevreul die.

VISUAL ARTS

Sixth Impressionist Exhibition. Degas, Little Dancer Aged Fourteen. Monet, Sunshine and Snow. Renoir, Luncheon of the Boating Party. Pablo Picasso born. Samuel Palmer dies.

Seventh Impressionist Exhibition. Cézanne, Self-Portrait. Manet, Bar at the Folies-Bergère. Seurat, Farm Women at Work. Arts and Crafts Exhibition Society founded in England. Rossetti dies.

Monet settles at Giverny. Durand-Ruel arranges series of one-man exhibition of Monet, Pissarro, Renoir, and Sisley. Cézanne, *Rocky Landscape*. Renoir, *Umbrellas*. Manet and Gustave Doré die.

The Société des Vingt holds its first exhibition. Manet memorial exhibition at the Ecole des Beaux-Arts. Redon, Seurat, and Signac become involved in the new Société des Indépendants. Bartholdi, *Statue of Liberty*. Rodin, *The Burghers of Calais* commissioned. Seurat, *A Bathing Place, Asnières*. Whistler exhibits *Portrait of the Artist's Mother* at Salon.

Van Gogh, The Potato Eaters. Redon, Homage to Goya.

Eighth and last Impressionist Exhibition. Félix Fénéon publishes *The Impressionists in 1886*. Cézanne breaks with Zola after publication of *L'Oeuvre*, and marries Hortense Fiquet. Rodin, *The Kiss.* Seurat, *A Sunday Afternoon on the Island of the Grande Jatte*.

Gauguin leaves France for Martinique. Pissarro and Seurat exhibit with Les Vingt in Brussels. Cézanne, Five Bathers. H. H. Richardson, Marshall Field Wholesale Store, Chicago.

Gauguin and Bernard develop principles of Synthetism. Bernard, Buckwheat Harvesters, Pont-Aven. Ensor, The Entry of Christ into Brussels in 1889. Gauguin, The Vision After the Sermon. Van Gogh, The Night Café at Arles, The Sower, and The Yellow Chair. Paul Sérusier, The Talisman. Seurat, The Side Show. Guild and School of Handicrafts founded by Ashbee. Antoni Gaudí, Palau Guell, Barcelona.

Eiffel Tower opened. The Nabis emerge as a group. The Symbolist *La Revue Blanche* starts publication. Eakins, *The Agnew Clinic*. Gauguin, *Yellow Christ*. Van Gogh, *Landscape with Cypress Tree* and *Starry Night*. Monet, *Oatfields* series.

U.S. Congress passes Sherman Anti-Trust Act. Wounded Knee Massacre of 300 Sioux people by troops of 7th Cavalry, South Dakota. First moving picture in New York. Chekhov begins Three Sisters. Knut Hamsun, Hunger. Ibsen, Hedda Gabler. Wilde, The Picture of Dorian Gray. Zola, The Beast in Man. J. G. Frazer, The Golden Bough. William James, Principles of Psychology. Alexander Borodin, Prince Igor (posthumous). Fauré, Requiem. Tchaikovsky, Queen of Spades. Gottfried Keller dies.

- Papal encyclical Rerum novarum highlights employer's responsibility to workers. Arthur Conan Doyle publishes the first Adventures of Sherlock Holmes. Hardy, Tess of the D'Urbervilles. Melville, Billy Budd (posthumous). Wedekind, Spring Awakening: A Tragedy of Childhood. Henry Brook Adams, History of the United States of America During the Administration of Jefferson and Madison. Melville and Rimbaud die.
- 1892 French encounter colonial resistance in Africa. The Dreyfus affair. Homestead, Pennsylvania, steelworks strike. Ibsen, *The Master Builder.* Maeterlinck, *Pelleas and Melisande.* Wilde, *Lady Windermere's Fan.* Leoncavallo, *I Pagliacci* (The Clowns). Tchaikovsky, *The Nutcracker.* Tennyson and Whitman die.
- 1893 Franco-Russian alliance. F. H. Bradley, Appearance and Reality. Engelbert Humperdinck, Hansel and Gretel. Tchaikovsky, Symphony No. 6, "Pathétique." Puccini, Manon Lescaut. Verdi, Falstaff. Maupassant and Taine die.
- Alfred Dreyfus convicted of espionage, increasing antisemitism in France. Nicholas II becomes czar. Pullman strike in Chicago. Anthony Hope, *The Prisoner of Zenda*. Kipling, *The Jungle Book*. George Bernard Shaw, *Arms and the Man*. Debussy, *Afternoon of a Faun*. Christina Rossetti and R. L. Stevenson die.
- Territory in Southern Africa named Rhodesia to honor British imperialist. Theodor Fontane, Effi Briest. Verhaeren, The Tentacular Cities. H. G. Wells, The Time Machine. W. B. Yeats, Poems. Freud and Breuer, Studies on Hysteria. Marx, Capital, vol. 3 (posthumous). Nietzsche, Antichrist. E. C. Stanton, The Woman's Bible. Tchaikovsky, Swan Lake, performed. Engels dies.
- U.S. Supreme Court upholds "Jim Crow" laws. Freud introduces the term "psychoanalysis." Chekhov, *Ivanov* and *The Seagull*.
 Ibsen, *John Gabriel Borkman*. Alfred Jarry, *Ubu Roi*. Bergson, *Matter and Memory*. Puccini, *La Bohème*. Verlaine dies.
- 1897 Freud's self-analysis recognizing infantile sexuality and the Oedipus complex. Joseph Conrad, *The Nigger of the Narcissus*. Henry James, *The Spoils of Poynton* and *What Maisie Knew*. Edmond Rostand, *Cyrano de Bergerac*. H. G. Wells, *The Invisible Man*. Brahms and Burckhardt die.
- U.S. declares war on Spain. Zola publishes "J'Accuse" in L'Aurore, forcing new Dreyfus trial. Henry James, The Turn of the Screw. Wilde, The Ballad of Reading Gaol. Bismarck, Gladstone, and Mallarmé die.
- 1899 Dreyfus exonerated. Right-wing Action Française founded in Paris. Chekhov, *Uncle Vanya*. Kate Chopin, *The Awakening*. Tolstoy, *Resurrection*. Wilde, *The Importance of Being Earnest*. Elgar, *Dream of Gerontius*. Puccini, *Tosca*.
- 1900 Freud, *The Interpretation of Dreams*, published with final chapter giving first full account of dynamic view of mental processes of the unconscious and of the dominance of the "pleasure principle." King Umberto III of Italy assassinated.

VISUAL ARTS

Giovanni Morelli's essays on connoisseurship republished as Kunsthistorische Studien über Italienische Malerei William Morris, News Fram Nowhere. Whistler, The Gentle Art of Making Enemies. Cézanne, The Cardplayers. Monet, Haystacks series. Seurat, Chahut. Van Gogh dies.

Gauguin leaves for Tahiti. Van Gogh exhibition at Salon des Indépendants. William Morris founds Kelmscott Press. Cassatt, *The Bath*. Gauguin, *Ia Orana Maria*. Monet, *Poplars* series. Alfred Ryder, *Siegfried and the Rhine Maidens*. Seurat, *The Circus*. Seurat dies. Wainwright Building, St. Louis, by Sullivan. Haussmann dies.

Monet, Rouen Cathedral series. Toulouse-Lautrec, At the Moulin Rouge. Gauguin, Manao tupapau (The Specter Watches Her). A. J. Davis dies.

Edvard Munch, *The Voice*. Vuillard, *The Workroom*. Ford Madox Brown dies.

Aubrey Beardsley's designs for Wilde's Salome. Degas, Woman at Her Toilette. Ferdinand Hodler, The Chosen One. Rodin, Balzac. First Vienna Secession exhibition. Morris creates "Troy-type" print typeface for his edition of Sir Thomas More's Utopia.

Moreau, Jupiter and Semele. Pissarro, Place du Théâtre Français. Rodin, Burghers of Calais.

Monet, *Mornings of the Seine* series. Millais and William Morris die.

Tolstoy, What is Art? Gauguin, Where Do We Come From? What Are We? Where Are We Going? Max Klinger, Christ in Olympus. Matisse, Dinner Table. Pissarro, Boulevard des Italiens. Rodin, Victor Hugo. Le Douanier Rousseau, The Sleeping Gypsy. Victor Horta, Maison du Peuple, Brussels.

Rodin, *Honoré de Balzac*. Burne-Jones and Moreau die.

Monet, *The Japanese Bridge* series and begins *Waterlilies* series. Sisley dies.

Cézanne, Still Life with Onions. Munch, The Dance of Life. Renoir, The Nude in the Sun. Toulouse-Lautrec, La Modiste.

SELECT BIBLIOGRAPHY

The works listed below are the authors' sources for each chapter, preceded by those titles common to more than one chapter.

Albert Boime, The Art of Exclusion: Representing Blacks in the Nineteenth Century. 1990.

Patricia Condon, In Pursuit of Perfection: The Art of J .- A .- D. Ingres. Louisville, KY: The J. B. Speed Art Museum, 1984.

The Journal of Eugène Delacroix, ed. Hubert Wellington, trans. Lucy Norton. 1951/1980.

Félix Fénéon, Au-delà de l'impressionnisme, ed. Françoise Cachin. 1966.

French Painting 1774-1830: The Age of Revolution. 1985.

Francis Haskell, Past and Present in Art and Taste. 1087.

Dorothy Johnson, Metamorphoses of Jacques-Louis David. 1993.

Patricia Mainardi, Art and Politics of the Second Empire: The Universal Expositions of 1855 and 1867. 1987.

Linda Nochlin, The Politics of Vision: Essays on Nineteenth-Century Art and Society. 1991.

Ellwood C. Parry, The Image of the Indian and the Black Man in American Art, 1590-1900. 1974. John Rewald, The History of Impressionism, 4th rev.

edn., 1973. E. P. Thompson, The Making of the English Working Class. 1963.

Gabriel P. Weisberg (ed.), The European Realist Tradition, 1082.

Raymond Williams, Culture and Society, 1780-1950. 1958/1980.

Introduction

Louis Althusser, For Marx. 1973.

T. H. Aston and C. H. E. Philpin (eds.), The Brenner Debate: Agrarian Class Structure and Economic Development in Pre-Industrial Europe. 1987

Charles Baudelaire, Oeuvres complètes, ed. Claude

Pichois. 1975. Michel Beaud, *A History of Capitalism*, trans. Tom Dickman and Annie Lefebvre. 1983.

Léonce Bénédite, Great Painters of the XIXth Century and Their Paintings. 1910.

Walter Benjamin, Illuminations, ed. Hannah Arendt. 1970/1978.

Albert Boime, A Social History of Modern Art, vol. I.

Richard R. Brettell, Modern Art: 1859-1929. 1999. Norman Bryson, Tradition and Desire: From David to Delacroix. 1984.

T. J. Clark, Farewell to an Idea: Episodes in the History of Modernism. 1999.

Lorenz Eitner, An Outline of 19th Century European Painting, 1087.

David V. Erdman (ed.), Complete Poetry and Prose of William Blake. 1981.

Eric Foner (ed.), The New American History. 1997. Eric J. Hobsbawm, The Age of Capital: 1848-1875. 1979.

—, The Age of Empire: 1875–1914. 1989. —, The Age of Revolution: Europe 1789–1848. 1962. Max Horkheimer, "Traditional and Critical Theory," in Critical Sociology, ed. Paul Connerton. 1978. The Marx-Engels Reader, ed. Robert C. Tucker. 1978.

Richard Muther, The History of Modern Painting, 4 vols. 1907.

Fritz Novotny, Painting and Sculpture in Europe, 1780-1880. 1960, 2nd edn. 1970. Robert Rosenblum and H. W. Janson, 19th-Century

Art. New York, 1984; English edn., Art of the Nineteenth Century, London, 1984.

Jean-Jacques Rousseau, A Discourse on Inequality, trans. with notes by Maurice Cranston. 1984. John Ruskin, The Works of John Ruskin, ed. E. T.

Cook and Alexander Wedderburn. 1903. E. P. Thompson, Witness Against the Beast:

William Blake and the Moral Law. 1995. Raymond Williams, Keywords. 1976. , Marxism and Literature. 1977.

Chapter 1

I want gratefully to acknowledge research by others, published and unpublished, which has informed Chapters 1 and 2: Darcy Grigsby on Gros's Plague House at Jaffa and Delacroix's Liberty; David O'Brien on Gros's Battle of Nazareth; Susan Siegfried likewise on the Nazareth painting and on Ingres's Napoleon on the Imperial Throne; Ewa Lajer-Burchardt on David's Sabines; Stephanie Brown on Girodet and Bruno Chenique on Géricault; Francis Haskell on Sommariva; Nina Athanassoglou-Kallmyer on the imagery of the Greek War of Independence; finally Philippe Bordes and Régis Michel on topics too numerous to mention. Thomas Crow.

Philip Conisbee, Eighteenth-Century French Painting. 1982.

Thomas Crow, Emulation: Making Artists for

Revolutionary France. 1995. -, Painters and Public Life in Eighteenth-Century Paris. 1985.

David Dowd, Jacques-Louis David: Pageant Master of the Republic. 1948.

Robert Herbert, David: Brutus. 1972.

Régis Michel et al., Aux armes et aux arts! Les arts de la Révolution 1789-1799. 1989.

Robert Rosenblum, Transformations in Late Eighteenth-Century Art. 1967.

Mary D. Sheriff, The Exceptional Woman: Elisabeth Vigée-Lebrun and the Cultural Politics of Art. 1995. Elisabeth Vigée-Lebrun, Memoirs, trans. L. Strachev, 1903/1989.

Chapter 2

Les années romantiques: la peinture française de 1815 à 1850. Musée des beaux-arts de Nantes/Grand Palais, Paris/Palazzo Gotico, Piacenza. 1995.

Nina Athanassoglou-Kallmyer, French Images from the Greek War of Independence 1821-1830. 1987. Eugène Delacroix, Selected Letters 1813-1863, ed.

and trans. J. Stewart. 1970.

Philippe Grunchec, Master Drawings by Géricault. 1985

Serge Guilbaut, Maureen Ryan, and Scott Watson (eds.), Théodore Géricault, the Alien Body: Tradition in Chaos. 1997.

Barthélémy Jobert, Delacroix. 1998.

Régis Michel et al., Géricault. 1992.

Todd B. Porterfield, The Allure of Empire: Art in the Service of French Imperialism, 1798-1836. 1008

Frank Anderson Trapp, The Attainment of Delacroix. 1971.

Georges Vigne, Ingres. 1995.

Chapter 3

Nigel Glendinning, Goya and His Critics. 1977. J. Guidol, *Goya*, 4 vols. 1971.

F. D. Klingender, Goya in the Democratic Tradition.

Fred Licht (ed.), Goya in Perspective. 1973. -, Goya: The Origins of the Modern Temper in Art. The Life and Complete Works of Francisco Goya, with a preface by Enrique Lafuente Ferrari. 1981.

André Malraux, Saturn: An Essay on Goya. 1957 Priscilla E. Muller, Goya's "Black" Paintings: Truth and Reason in Light and Liberty. 1984.

Alfonso E. Pérez Sánchez and Eleanor A. Sayre et al., Goya and the Spirit of Enlightenment. 1989. Eleanor A. Sayre et al., The Changing Image: Prints

by Francisco Goya. 1974. Gwyn A. Williams, Goya and the Impossible Revolution. 1976.

Chapter 4

John Barrell, The Political Theory of Painting from Reynolds to Hazlitt. 1986.

David Bindman, Blake as an Artist. 1977.

-, William Blake: His Art and Times. 1982

—, William Blake: The Complete Illuminated Books. 2001.

Jacob Bronowski, William Blake and the Age of Revolution, 1965.

Steve Clark and David Worrall (eds.), Historicizing Blake. 1994.

Stewart Crehan, Blake in Context. 1984.

Morris Eaves, William Blake's Theory of Art. 1982. , The Counter-Arts Conspiracy: Art and Industry

in the Age of Blake. 1992. David V. Erdman, Blake: Prophet against Empire, 3rd edn. 1977.

The Illuminated Blake. 1975.

Richard T. Godfrey, James Gillray, the Art of Caricature. 2001.

David Irwin, English Neoclassical Art. 1966. Geoffrey Keynes (ed.), Blake: Complete Writings. 1072.

Saree Makdasi, William Blake and the Impossible History of the 1790s. 2003.

Eudo C. Mason, The Mind of Henry Fuseli. 1951. Jon Mee, Dangerous Enthusiasm: William Blake and the Culture of Radicalism in the 1790s. 1992.

W. J. T. Mitchell, Blake's Composite Art. 1978. Martin Myrone, Bodybuilding: Reforming Masculinities in British Art, 1750-1810. 2005.

(ed.), Gothic Nightmares: Fuseli, Blake and the Romantic Imagination. 2006.

Morton D. Paley, The Apocalyptic Sublime. 1986. Ronald Paulson, Representations of Revolution. 1983. William L. Pressly, The Life and Art of James Barry. 1981.

Gert Schiff, Johann Heinrich Füssli: Oeuvrekatalog, 2 vols. 1973

David H. Solkin (ed.), Art on the Line: The Royal Academy Exhibition and Somerset House, 1780-1836.

E. P. Thompson, Witness against the Beast: William Blake and the Moral Law. 1993.

Ruthven Todd, Tracks in the Snow: Studies in English Art and Science. 1946.

Joyce H. Townsend (ed.), William Blake: The Painter at Work. 2000.

Chapter 5

Malcolm Andrews, The Search for the Picturesque: Landscape Aesthetics and Tourism in Britain.

John Barrell, The Dark Side of the Landscape: The Rural Poor in English Painting, 1730-1840. 1080.

Ann Bermingham, Landscape and Ideology: The English Rustic Tradition, 1740-1860. 1986.

David Bindman, "Samuel Palmer's 'An Address to the Electors of West Kent, 1832' Rediscovered," Blake Quarterly, 19 (Fall 1985): 56-68.

Albert Boime, "Turner's Slave Ship: The Victims of Empire," Turner Studies, 10 (Summer 1990): 34–43.

 David Blayney Brown, Romanticism. 2001.
 M. Butlin and E. Joll, The Paintings of J. M. W. Turner, 2 vols 1977, rev. 1984.

Stephen Copley and Peter Garside (eds.), The Politics of the Picturesque. 1994.

Stephen Daniels, Humphry Repton: Landscape Gardening and the Geography of Georgian England. 1999.

Renzo Dubbini, Geography of the Gaze, Urban and Rural Vision in Early Modern Europe. 2002.

William Feaver, The Art of John Martin. 1975. John Gage, J. M. W. Turner, "A Wonderful Range of Mind." 1987. Nicholas Green, The Spectacle of Nature. 1990.

Nicholas Green, *The Spectacle of Nature*. 1990. Louis Hawes, *Presence of Nature: British Landscape*, 1780–1830. 1982.

James Heffernan, The Re-Creation of Landscape. 1985.

Elizabeth K. Helsinger, Rural Scenes and National Representation: Britain 1815–1850. 1997.

Andrew Hemingway, Landscape and Urban Culture in Early Nineteenth-Century Britain. 1992.

Humphrey Jennings, Pandaemonium: The Coming of the Machine as Seen by Contemporary Observers, 1660–1886. 1985.

Charlotte Klonk, Science and the Perception of Nature: British Landscape Art in the Late Eighteenth and Early Nineteenth Centuries, 1996. Kw. Din Kriz, The Hea of the English Landscape

Kay Dian Kriz, The Idea of the English Landscape Painter. 1997.

Jack Lindsay, J. M. W. Turner, A Critical Biography. 1966.

Brian Lukacher, "Turner's Ghost in the Machine," Word and Image, 6 (April–June 1990): 119–37.

John McCoubrey, "Time's Railway: Turner and the Great Western," *Turner Studies*, 6 (Summer 1986): 33–9. K. Nicholson, *Turner's Classical Landscape: Myth*

K. Nicholson, Turner's Classical Landscape: Myth and Meaning. 1990.

Ronald Paulson, Literary Landscape: Turner and Constable. 1982.

William S. Rodner, J. M. W. Turner, Romantic Painter of the Industrial Revolution. 1997. Michael Rosenthal, Constable: The Painter and His Landscape. 1983.

Eric Shanes, Turner's Human Landscape. 1990. Sam Smiles, J. M. W. Turner. 2000.

Greg Smith, The Emergence of the Professional Watercolourist. 2002.

Lindsay Stainton, British Landscape Watercolours, 1600–1860. 1985.

William Vaughan, et al., Samuel Palmer: Vision and Landscape. 2006.

Barry Venning, Turner. 2003.

Ian Warrell et al., Ruskin, Turner and the Pre-Raphaelites. 2000.

Raymond Williams, *The Country and the City*. 1973. Andrew Wilton, *Turner in His Time*. 1987.

Chapter 6

Keith Andrews, The Nazarenes. 1964. Rebecca Bedell, The Anatomy of Nature: Geology and American Landscape Painting 1825–75. 2001. Albert Boime, Art in the Age of Bonapartism 1800–1815. 1991.

Helmut Börsch-Supan and Karl Wilhelm Jähnig, Caspar David Friedrich. 1973.

Sarah Burns, Pastoral Inventions. 1989.

—, Painting the Dark Side: Art and the Gothic Imagination in Nineteenth Century America. 2004. Jon Conron, American Picturesque. 2000.

Rachel Ziady DeLue, George Inness and the Science of Landscape. 2004.

Herbert von Einem, Deutsche Malerei des Klassizismus und der Romantik 1760 bis 1840. 1978. Sabine Fastert, Die Entdeckung des Mittelalters: Geschichtsrezeption in der nazarenischen malerei des frühen 19. Jahrhunderts. 2001. Mitchell Benjamin Frank, German Romantic Painting Redefined: Nazarene Tradition and the Narratives of Romanticism. 2001.

Keith Hartley (ed.), The Romantic Spirit in German Art 1790–1990. 1994.

Werner Hofmann, Caspar David Friedrich. 2001.

— (ed.), Runge in seiner Zeit. 1977.

Franklin Kelly, Frederic Edwin Church and the National Landscape. 1988.

— et al., American Paintings of the Nineteenth Century, The Collections of the National Gallery of Art. 1996.

Joseph Leo Koerner, Caspar David Friedrich and the Subject of Landscape. 1990.

David Lubin, Picturing a Nation: Art and Social Change in Nineteenth-Century America. 1994.

Kynaston McShine (ed.), *The Natural Paradise:* Painting in America 1800–1950, with essays by Barbara Novak, Robert Rosenblum, John Wilmerding, et al. 1976.

Kenneth W. Maddox, "Asher B. Durand's *Progress:*The Advance of Civilization and the Vanishing American," in *The Railroad in American Art*, ed. S. Danly and L. Marx. 1988.

Victor Meisel, "Philipp Otto Runge, Caspar David Friedrich, and Romantic Nationalism," Yale University Art Gallery Bulletin, 33 (Oct. 1972): 37–51.

Angela Miller, The Empire of the Eye, Landscape Representation and American Cultural Politics, 1825–1875. Ithaca and London, 1993.

Timothy Mitchell, Art and Science in German Landscape Painting 1770–1840. 1993.

L. Morowitz and W. Vaughan (eds.), Artistic
Brotherhoods in the Nineteenth Century. 2000.

I. Nazaweni a Rama. Galleria pazionale d'arte

I Nazareni a Roma. Galleria nazionale d'arte moderna, Rome. 1981.

Barbara Novak, Nature and Culture: American Landscape and Painting 1825–1875. 1980. Ellwood C. Parry, The Art of Thomas Cole. 1988.

Robert Rosenblum, Modern Painting and the Northern Romantic Tradition, 1975.

Jörg Traeger, Philipp Otto Runge und sein Werk. 1975. William Vaughan, German Romantic Painting. 1980. Alan Wallach et al., Thomas Cole: Landscape into History. 1994.

John Wilmerding (ed.), American Light: The Luminist Movement 1850–1875. 1980.

Chapter 7

Dana Arnold, Re-presenting the Metropolis: architecture, urban experience and social life in London, 1800-1840. 2000.

Paul Atterbury and Clive Wainwright (eds.), Pugin: A Gothic Passion. 1994.

Jeffrey Auerbach, The Great Exhibition of 1851: A Nation on Display. 1999.

Barry Bergdoll, Karl Friedrich Schinkel: An Architecture for Prussia. 1994.

—, European Architecture 1750-1890. 2000. Allan Braham, The Architecture of the French Enlightenment. 1980.

Chris Brooks, *The Gothic Revival*. 1999. J. Mordaunt Crook, *The Dilemma of Style*:

J. Mordaunt Crook, The Dilemma of Style: Architectural Ideas from the Picturesque to the Post-Modern. 1987.

Robin Evans, The Projective Cast. 1995. Kenneth Frampton, Studies in Tectonic Culture: The Poetics of Construction in Nineteenth and Twentieth

Century Architecture. 1995.
Pierre Francastel, Art and Technology in the

Nineteenth and Twentieth Centuries. 1953/2000. J. F. Geist, Arcades: The History of a Building Type.

Georg Germann, Gothic Revival in Europe and Britain: sources, influences, and ideas. 1973. Sigfried Giedion, Space, Time, and Architecture.

1941/1967. Alberto Gómez-Pérez, Architecture and the Crisis

of Modern Science. 1983. Henry Russell-Hitchcock, Architecture: Nineteenth

Henry Russell-Hitchcock, Architecture: Nineteenth and Twentieth Centuries. 1958/1977.

—, Early Victorian Architecture in Britain. 1954. Norman Johnston, Forms of Constraint: A history of prison architecture. 2000.

W. Barksdale Maynard, Architecture in the United States, 1800-1850. 2002.

Robin Middleton and David Watkin, Nevclassical and Nineteenth Century Architecture. 1981.

and Nineteenth Century Architecture. 1981.

Donald J. Olsen, The City as a Work of Art: London,
Paris, Vienna. 1986.

Steven Parissien, Station to Station. 1997.

William H. Pierson, Jr., American Buildings and their Architects, Technology and the Picturesque, the Corporate and Early Gothic Styles. 1980.

Harry Francis Mallgrave, Modern Architectural Theory: A Historical Survey, 1673-1968. 2005.

Nikolaus Pevsner, A History of Building Types. 1976. Margaret Richardson and Mary Ann Stevens (eds.), John Soane, Architect: Master of Space and Light. 1999.

and Light. 1999. Colin Rowe, The Mathematics of the Ideal Villa and other essays. 1976.

Joseph Rykwert, The First Moderns: Architects of the Eighteenth Century. 1980.

Michael Snodin (ed.), Karl Friedrich Schinkel: Universal Man. 1991.

Damie Stillman, English Neo-classical Architecture.

John Summerson, Architecture in Britain, 1530-1830.

Anthony Vidler, The Writing of the Walls: Architectural Theory in the Late Enlightenment. 1987.

—, Claude-Nicolas Ledoux. 1990.

David Watkin, Sir John Soane: Enlightenment Thought and the Royal Academy Lectures. 1996.

Chapter 8

Janet Catherine Berlo (ed.), *Plains Indian Drawings* 1865–1935, *Pages from a Visual History*. 1996. Anna Blume, "In a Place of Writing," in *Plains*

Indian Drawings, ed. J. C. Berlo (see above). George Catlin, Letters and Notes on the Manners, Customs, and Conditions of North American

Indians, 2 vols. 1844/1973.
Brian W. Dippie, Catlin and His Contemporaries: The

Politics of Patronage. 1990.
Tom Hill and Richard W. Hill, Sr. (eds.), Creation's Journey: Native American Identity and Belief, with

Journey: Native American Identity and Belief, wit contributions by Diane Fraher, Ramiro Matos, John C. Ewers, Dorie Reents-Budet, Mari Lynn Salvador, Duane King, Mary Jane Lenz, Eulalie H. Bonar, Nancy Rosoff, and Cécile R. Ganteaume. 1994.

Donal F. Lindsey, *Indians at Hampton Institute*, 1877–1923. 1995. David W. Penney, "The Horse as Symbol: Equine

David W. Penney, "The Horse as Symbol: Equine Representations in Plains Pictographic Art," in Visions of the People, A Pictorial History of Plains Indian Life, ed. Evan M. Maurer. 1992.

Renato Rosaldo, Culture and Truth: The Remaking of Social Analysis. 1989.

Henry R. Schoolcraft, Historical and Statistical Information Respecting the History, Condition, and Prospects of the Indian Tribes of the United States, 6 vols. Philadelphia, 1856.

Joyce M. Szabo, Howling Wolf and the History of Ledger Art. 1994.

Chapter 9

Albert Boime, The Art of Exclusion: Representing Blacks in the Nineteenth Century. 1990.

Kirsten P. Buick, "The Ideal Works of Edmonia Lewis: Invoking and Inverting Autobiography," American Art 9, no. 2 (Summer 1995): 4–19.

Teresa A. Carbone and Patricia Hills, Eastman Johnson Painting America. 1999.

Nicolai Cikovsky, Jr., "Winslow Homer's Prisoners from the Front," Metropolitan Museum Journal, 12, 1977, pp. 155–72.

 and Franklin Kelly, Winslow Homer, with contributions by Judith Walsh and Charles Brock. 1995. Joy S. Kasson, Marble Queens and Captives: Women in Nineteenth-Century American Sculpture. 1990.

Joseph D. Ketner, The Emergence of the African-American Artist: Robert S. Duncanson, 1821-1872.

Mary Panzer, Mathew Brady and the Image of History. 1997. Ellwood Parry, The Image of the Indian and the

Black Man in American Art, 1590–1900. 1974. Frances K. Pohl, "Putting a Face on Difference,"

Art Bulletin 78, (December 1996): 23-28.

Richard J. Powell, "Cinque: Antislavery Portraiture and Patronage in Jacksonian America," American *Art*, 11 (Fall 1997): 48–73.

Kirk Savage, Standing Soldiers, Kneeling Slaves: Race, War, and Monument in Nineteenth-Century America, 1997.

Alan Trachtenberg, "Albums of War, On Reading Civil War Photographs," in Critical Issues in American Art, ed. Mary Ann Calo. 1998, pp. 135-54.

Chapter 10

Jean-Paul Aron, Misérable et glorieuse la femme du xixe siècle. 1980.

Charles Baudelaire, Oeuvres complètes, ed. Claude

Pichois. 1975. Albert Boime, *Thomas Couture and the Eclectic* Vision. 1980.

Hollow Icons: The Politics of Sculpture in

Nineteenth-Century France. 1987. Jacques de Caso, David d'Angers: Sculptural Communication in the Age of Romanticism. 1992.

Thomas Crow, "Modernism and Mass Culture in the Visual Arts," in Pollock and After: The Critical Debate, ed. Francis Frascina. 1985.

Terry Eagleton, The Function of Criticism, 1984. Peter Fusco and H. W. Janson (eds.), The Romantics to Rodin, 1980.

Susan K. Grogan, French Socialism and Sexual Difference. 1992. Jürgen Habermas, "The Public Sphere: An

Encyclopedia Article," New German Critique,

3 (Fall 1974): 49–55. Neil McWilliam, "David d'Angers and the Pantheon Commission: Politics and Public Works under the July Monarchy," Art History, 5: 4 (Dec. 1982): 426-46.

Chapter 11

Walter Benjamin, "The Author as Producer," in Reflections, ed. Peter Demetz, trans. Edmund Jephcott. 1978.

Albert Boime, "Ford Madox Brown, Thomas Carlyle, and Karl Marx: Meaning and the Mystification of Work in the Nineteenth Century," *Arts Magazine* (September 1979):

T. J. Clark, The Absolute Bourgeois: Artists and Politics in France 1848-1851. 1972/1973.

, Image of the People: Gustave Courbet and the 1848 Revolution. 1973. Gerard Curtis, "Ford Madox Brown's Work: An

Iconographic Analysis," Art Bulletin (Dec. 1992): 623-36.

Sarah Faunce and Linda Nochlin, Courbet Reconsi-dered. 1988.

Klaus Herding, Courbet: To Venture Independence.

Timothy Hilton, The Pre-Raphaelites. 1970.

E. D. H. Johnson, "The Making of Ford Madox Brown's Work," in Victorian Artist in the City, ed. I. B. Nadel and F. S. Schwarzbach. 1980. Letters of Gustave Courbet, ed. and trans. Petra

ten-Doesschate Chu. 1992. Linda Nochlin, Realism. 1971.

Gabriel P. Weisberg, The Realist Tradition: French Painting and Drawing, 1830–1900.

Christopher Wood, The Pre-Raphaelites. 2000.

Chapter 12

Carol Armstrong, Scenes in a Library: Reading the Photograph in the Book, 1843-1875. 1998.

Geoffrey Batchen, Burning with Desire: The Conception of Photography. 997.

Walter Benjamin, "A Small History of Photography," in One-Way Street and Other Writings, trans. Edmund Jephcott and Kingsley Shorter, 1992.

Gisele Freund, Photography and Society. 1080. Vicki Goldberg, Photography in Print: Writings from 1816 to the Present. 1981.

Jennifer Green-Lewis, Framing the Victorians: Photography and the Culture of Realism. 1996.

Maria Morris Hambourg, Françoise Heilbrun, and Philippe Néagu, Nadar. 1995.

Ellen Handy, "Art and Science in P. H. Emerson's Naturalistic Vision," in *British Photography in* the Nineteenth Century, ed. Mike Weaver. 1989.

Heinz K. Henisch and Bridget A. Henisch, The Photographic Experience 1839-1914: Images and

Attitudes. 1994. Ulrich Keller, "Nadar as Portraitist: A Photographic Career between Art and Industry," in Gazette des

beaux-arts, 6th series, 107, Apr. 1986. Rosalind Krauss, "Tracing Nadar," October, 5, 1978. Anne McCauley, A. A. E. Disdéri and the Carte de Visite Portrait Photograph. 1985.

, Industrial Madness: Commercial Photography in Paris, 1848-1871. 1994.

Mary Warner Marien, Photography and its Critics: A Cultural History, 1839-1900. 1997.

Patrick Maynard, The Engine of Visualization: Thinking Through Photography. 1997.

Miles Orvell, "Almost Nature: The Typology of Late Nineteenth-Century American Photography," in *Multiple Views*, ed. Daniel P. Younger. 1991.

Mary Panzer, Mathew Brady and the Image of History. 1997.

Shelley Rice, Parisian Views. 1997.

Naomi Rosenblum, A World History of Photography, 3rd edn. 1997

Richard Rudisill, Mirror Image: The Influence of the Daguerreotype on American Society. 1971.

Aaron Scharf, Art and Photography. 1968. Grace Seiberling, Amateurs, Photography and the

Mid-Victorian Imagination. 1986. Allan Sekula, Photography against the Grain: Essays

and Photo Works, 1973–1983. 1984. Lindsay Smith, The Politics of Focus: Women, Children and Nineteenth-Century Photography.

Joel Snyder, "Inventing Photography, 1839-1879," in The Art of Fixing a Shadow, ed. Sarah Greenough et al. 1989.

John Tagg, The Burden of Representation: Essays on Photographies and Histories. 1988.

Alan Trachtenberg, Classic Essays on Photography.

"Photography: The Emergence of a Keyword," in Photography in Nineteenth-Century America, ed. Martha A. Sandweiss. 1991.

John Ward, "The Beginnings of Photography," in The Story of Popular Photography, ed. Colin Ford. 1989.

Chapter 13

Albert Boime, The Art of the Macchia and the Risorgimento. 1993.

Norma Broude, The Macchiaioli: Italian Painters of the Nineteenth Century, 1987.

Peter H. Feist, Geschichte der deutschen Kunst:

1760–1848; 1848–1890. 1986–7. Gobineau: Selected Political Writings, ed. and introduced by Michael D. Biddiss. 1970.

Elizabeth Gilmore Holt, The Art of All Nations, 1850-73: The Emerging Role of Artists and Critics.

The Macchiaioli: Painters of Italian Life, 1850-1900. Frederick S. Wight Art Gallery, Los Angeles, 1986

Linda Nochlin, Realism and Tradition in Art: 1848-1900. 1966.

Irina Tatarinova, "The Pedagogic Power of the Master': The Studio System at the Imperial Academy of Fine Arts in St Petersburg, The Slavonic and East European Review, 83:3, 1 July 2005, pp. 470-89.

Elizabeth K. Valkenier, The Wanderers: Masters of 19th-Century Russian Painting. 1991.

Gabriel P. Weisberg, Beyond Impressionism: The Naturalist Impulse. New York, 1992.

Chapter 14

C. R. Ashbee, Where the Great City Stands-Study in the New Civics, 1917.

Baldersby St. James Conservation Area. Harrogate Borough Council, n.d. http://www.harrogate.gov.uk/pdf/DS-P-ConAreaBaldersby.pdf.

Richard Dennis, English Industrial Cities of the Nineteenth Century, A Social Geography. 1984. Catalogue of the Fourteenth Annual Exhibition of the

Chicago Architectural Club. 1901. Christopher Dresser, Principles of Decorative Design. [1873].

William Hosley, "Herter Brothers," American Heritage Magazine, 46:1, Feb.-March, 1995 (online edition:

http://www.americanheritage.com/articles/ magazine/ah/1995/1/1995_1_74.shtml)

The Illustrated Exhibitor, 1851.

Charles Knight, Knowledge is Power: A View of the Productive Forces of Modern Society. 1855

Thomas More, Utopia, intro. by William Morris.

Hermann Muthesius, "Kunst und Machine," Dekorative Kunst, ix, 1901-2.

Nikolaus Pevsner, Pioneers of Modern Design. 1040/1001.

David Pye, The Nature and Art of Workmanship. 1968.

John Ruskin, The Complete Works of John Ruskin, various edns.

Gottfried Semper, Style in the Technical and Tectonic Arts, or Practical Aesthetics, trans. Harry Mallgrave and Michael Robinson. 1904.

. Wissenschaft, Industrie und Kunst und andere Schriften über Architektur, Kunstshandwerk und Kunstunterricht, ed. Hans M. Wingler. 1966; in Art in Theory, ed. Charles Harrison, Paul Wood and Jason Gaiger. 2001.

Henry van de Velde, Die Renaissance im modernen Kunstgewerbe. 1903.

Suga Yasuko, "Designing the Morality of Consumption: 'Chamber of Horrors' at the Museum of Ornamental Art, 1852-53," Design

Issues, 20:4, Autumn 2004.

Chapter 15

Kathleen Adler and Tamar Garb, Berthe Morisot. 1987.

Carol Armstrong, Odd Man Out: Readings of the Work and Reputation of Edgar Degas. 1991. Art in the Making: Impressionism. National Gallery, London, 1990.

Walter Benjamin, Charles Baudelaire: A Lyric Poet in the Era of High Capitalism, trans. Harry Zohn. 1973.

Norma Broude, Impressionism: A Feminist Reading. 1001.

(ed.), World Impressionism: The International Movement, 1860–1920. 1990.

T. J. Clark, The Painting of Modern Life: Paris in the Art of Manet and His Followers. 1985.

Hollis Clayson, Painted Love: Prostitution in French Art of the Impressionist Era. 1991.

Sander L. Gilman, Difference and Pathology: Stereotypes of Sexuality, Race, and Madness. 1985. George Heard Hamilton, Manet and His Critics.

1954/1969.

Anne Higonnet, Berthe Morisot's Images of Women.

Hugh Honour, The Image of the Black in Western Art, IV. 1989.

Manet: 1832-1883. Metropolitan Museum of Art, New York, 1983.

Manet: The Execution of Maximilian—Painting, Politics and Censorship. London: National Gallery, 1992.

Charles W. Millard, The Sculpture of Edgar Degas. 1976.

The New Painting: Impressionism, 1874-1886. Fine Arts Museums of San Francisco, 1986.

Perspectives on Morisot, ed. and intro. by T. J. Edelstein. 1990.

Daniel Pick, Faces of Degeneration: A European Disorder, ca. 1848–ca. 1918. 1989. Meyer Schapiro, "The Nature of Abstract Art,"

Collected Essays. 1978.

Anne Wagner, Jean-Baptiste Carpeaux: Sculptor of the Second Empire. 1986.

Chapter 16

Adelyn Dohme Breeskin, Mary Cassatt: A Catalogue Raisonné of the Oils, Pastels, Watercolors, and Drawings, 1001.

Michael Fried, Realism, Writing, Disfiguration: On Thomas Eakins and Stephen Crane. 1987. William H. Gerdts, American Impressionism. 1984 Lloyd Goodrich, Thomas Eakins, 2 vols. 1982. Gordon Hendricks, The Life and Work of Thomas

Eakins. 1974.

Patricia Hills (ed.), John Singer Sargent. 1986. Elizabeth Johns, Thomas Eakins: The Heroism of Modern Life. 1983.

T. J. Jackson Lears, No Place of Grace: Antimodernism and the Transformation of American Culture, 1880-1920. 1981.

David M. Lubin, Act of Portrayal: Eakins, Sargent, James. 1985.

Nancy Mowll Mathews, Mary Cassatt. 1989. with B. S. Shapiro, Mary Cassatt: The Color

Prints. 1989. Linda Nochlin, Representing Women. 1999. Stanley Olson, John Singer Sargent, His Portrait.

1986. Richard Ormond, John Singer Sargent: Paintings, Drawings, Watercolors. 1970.

Griselda Pollock, Mary Cassatt. 1980.

, Mary Cassatt: Painter of Modern Women. 1998. Alan Trachtenberg, The Incorporation of America: Culture and Society in the Gilded Age. 1982.

H. Barbara Weinberg, The Lure of Paris: Nineteenth-Century American Painters and Their French Teachers. 1991.

Bryan Jay Wolf, Romantic Re-Vision: Culture and Consciousness in Nineteenth-Century American Painting and Literature. 1982.

Chapter 17

Art Institute of Chicago, "The Grande-Jatte at 100," Museum Studies, 14: 2 (1989), ed. Susan F. Rossen.

Albert Boime, "Georges Seurat's Un Dimanche à la Grande-Jatte and the Scientific Approach to History Painting," Historienmalerei in Europa. 1990, pp. 303-33.

Norma Broude (ed.), Seurat in Perspective, 1978. Henri Dorra and John Rewald, Seurat: L'Oeuvre peint, biographie, et catalogue critique. 1959.

Erich Franz and Bernd Growe, Georges Seurat: Drawings. 1984.

John Gage, "The Technique of Seurat: A Reappraisal," Art Bulletin, 69: 3 (Sept. 1987): 448-54.

Joan Ungersma Halperin, Félix Fénéon: Aesthete and Anarchist in Fin-de-Siècle Paris. 1988.

César de Hauke, Seurat et son œuvre, 2 vols. 1961. Robert Herbert et al., Georges Seurat, 1859-1891.

Alan Lee, "Seurat and Science," Art History,

10: 2 (June 1987): 203-26.

Herbert Marcuse, Negations: Essays in Critical Theory, trans. Jeremy T. Shapiro. 1968.

Camille Pissarro, 1830-1903. Hayward Gallery, London. 1981.

John Rewald, Post-Impressionism: From Van Gogh to Gauguin, 3rd edn. 1978.

Ralph E. Shikes and Paula Harper, Pissarro: His Life and Work. 1980.

Jean Sutter (ed.), The Neo-Impressionists. 1970. Richard Thomson, Seurat. 1985.

Toulouse-Lautrec and His Contemporaries: Posters of the Belle Epoque. Los Angeles County Museum of Art, 1985.

Chapter 18

M.G. Dortu, Toulouse-Lautrec et Son Oeuvre, 6 vols.

Richard von Krafft-Ebing, Psychopathia Sexualis.

Cesare Lombroso and Guglielmo Ferrero, The Female Offender. n.d.

Claire Goldberg Moses, French Feminism in the 19th Century. 1984.

Gale Murray, Toulouse-Lautrec, The Formative Years, 1878-1891. 1991.

Thadée Natanson, Un View de Toulouse-Lautrec.

Max Nordau, Degeneration. 1895.

Herbert Schimmel, The Letters of Henri de Toulouse-Lautrec, 1991

Toulouse-Lautrec. Hayward Gallery, London/Grand Palais, Paris. 1992.

Wolfgang Wittrock, Toulouse-Lautrec, The Complete Prints, 2 vols. 1985.

Chapter 19

Klaus Berger, Japonisme in Western Painting from Whistler to Matisse. 1992.

Albert Boime, "Van Gogh's Starry Night: A History of Matter and A Matter of History," Arts Magazine (Dec. 1984): 86-103.

The Complete Letters of Vincent Van Gogh, 1979. J.-B. de la Faille, The Works of Vincent Van Gogh: His Paintings and Drawings, 4 vols. 1970.

Jan Hulsker, The Complete Van Gogh: Paintings, Drawings, Sketches. 1980.

, Vincent and Theo Van Gogh: A Dual Biography. 1985.

Japonisme in Art: An International Symposium, ed. Society for the Study of Japonisme. 1980.

Tsukasa Kodera, "Japan as Primitivistic Utopia: Van Gogh's Japonisme Portraits," Simiolus, 3: 4 (1984): 189-208.

Griselda Pollock, "Artists, Mythologies and Media: Genius, Madness and Art History," Screen, 21:3 (1980): 57-96.

'Stark Encounters: Modern Life and Urban Work in Van Gogh's Drawings of the Hague 1881–3," *Art History*, 6: 3 (Sept. 1983): 330–58.

-, "Van Gogh and the Poor Slaves: Images of Rural Labour as Modern Art," *Art History*, 11: 3 (Sept. 1988): 408-32.

and Fred Orton, Vincent Van Gogh: Artist of His Time. 1978.

Odilon Redon, To Myself: Notes on Life, Art, and Artists, trans. Mira Jacob and Jeanne L. Wasserman. 1986.

Vincent: Bulletin of the Rijksmuseum Vincent van Gogh, Amsterdam, 1-4 (1970-76).

Chapter 20

The Art of Paul Gauguin, with essays by Richard Brettell et al. 1988. Roland Barthes, Mythologies. 1977. Ruth Butler (ed.), *Rodin in Perspective*. 1980. Jacques de Caso and Patricia B. Sanders, *Rodin's* Sculpture: A Critical Study of the Spreckels Collection. 1977.

Henri le Chartier, Tahiti et les colonies françaises de la Polynésie. 1887.

Stephen F. Eisenman, "Allegory and Anarchism in James Ensor's Vision Preceding Futurism," Record of the Art Museum of Princeton University, 46: 1

, The Temptation of Saint Redon: Biography, Ideology, and Style in the Noirs of Odilon Redon. 1002.

and Oskar Bätschmann, Ferdinand Hodler:

Landscapes. 1987. Albert E. Elsen, The Gates of Hell by Auguste Rodin. 1985.

John David Farmer, Ensor. 1976.

Paul Gauguin: 45 Lettres à Vincent, Theo et Jo Van Gogh, ed. Douglas Cooper. 1983.

Paul Gauguin: Letters to his Wife and Friends, ed. Maurice Malingue, trans. Henry J. Stenning. 1948/1949.

Paul Gauguin, Noa Noa, trans. O. F. Theis. n.d. See also Noa Noa: Gauguin's Tahiti, ed. and with text by N. Wadley. 1985.

Reinhold Heller, Munch: His Life and Work. 1984. Susan Hiller (ed.), The Myths of Primitivism. 1991. E. J. Hobsbawm, The Age of Empire: 1875-1914. 1987/1989.

Elizabeth Gilmore Holt (ed.), The Triumph of Art for the Public: The Emerging Role of Exhibitions and Critics. 1979.

Michel Hoog, Paul Gauguin: Life and Work. 1987. Aline Isdebsky-Pritchard, The Art of Mikhail Vrubel. 1982.

S. Kaplanova, Vrubel. 1975.

Diane Lesko, James Ensor: The Creative Years. 1985. Claude Lévi-Strauss, Myth and Meaning. 1978. Louise Lippincott, Edvard Munch: Starry Night. 1988.

Leo Lowenthal, "Knut Hamsun," in The Essential Frankfurt School Reader, ed. Andrew Arato and Eike Gebhardt. 1977/1978.

Stephen Charles McGough, James Ensor's "The Entry of Christ into Brussels in 1889." 1985.

Monchoisy [Mativet], La Nouvelle Cythère. 1888. Colin Newbury, Tahiti Nui: Change and Survival in French Polynesia, 1767-1945. 1980.

Douglas L. Oliver, Ancient Tahitian Society. 1974. Fred Orton and Griselda Pollock, "Les Données bretonnantes: la prairie de la représentation," Art History, 3: 3 (Sept. 1980): 314–44. Griselda Pollock, Avant-Garde Gambits 1888–1893:

Gender and the Colour of Art History. 1993. Abigail Solomon-Godeau, "Going Native," Art in America (July 1989): 119-28 and 161.

Vienna, 1900: Art, Architecture and Design. Museum of Modern Art, New York, 1986.

Anne M. Wagner, "Rodin's Reputation," in Eroticism and the Body Politic, ed. Lynn Hunt. 1991.

Chapter 21

Theodor W. Adorno, "Commitment," in The Essential Frankfurt School Reader, eds. Andrew Arato and Eike Gebhardt. 1977/1978.

Paul Cézanne: Letters: Revised and Augmented Edition, ed. John Rewald. 1984.

John Elderfield, "The World Whole: Color in Cézanne," Arts Magazine, 52: 8 (Apr. 1978): 148-53.

Lawrence Gowing et al., Cézanne: The Early Years *1859–1872*. 1988.

Mary Louise Krumrine, Paul Cézanne: The Bathers. 1989/1990.

Mary Tompkins Lewis, Cézanne's Early Imagery. 1989.

Jack Lindsay, Cézanne: His Life and Art. 1969. Herbert Marcuse, Reason and Revolution: Hegel and the Rise of Social Theory. 1955/1960.

Maurice Merleau-Ponty, Sense and Non-Sense. 1973. William Rubin (ed.), Cézanne: The Late Work. 1977. J.-P. Sartre, Baudelaire. 1964/1967.

Judith Wechsler (ed.), Cézanne in Perspective. 1975.

LIST OF ILLUSTRATIONS

- ABBATI, Giuseppe 13.8 *Cloister*, 1861–2. Galleria d'Arte Moderna, Palazzo Pitti, Florence.
- ALLSTON, Washington 6.14 Jeremiah Dictating His Prophecy of the Destruction of Jerusalem to Baruch the Scribe, 1820. Gift of S. F. B. Morse, B.A. 1810. Yale University Art Gallery, New Haven, CT.
- BARRY, Sir Charles, and PUGIN, A. W. N. 7.24 Palace of Westminster, London, 1835–56. Photo A. F. Kersting.
- BARRY, James 4.6 King Lear Weeping Over the Body of Cordelia, 1786–7. Tate Gallery, London. 4.7 Satan and His Legions Hurling Defiance Toward the Vault of Heaven, ca. 1792–4. The Trustees of the British Museum. London.
- BARYE, Antoine-Louis 10.6 Lion Crushing a Serpent, 1833. Musée du Louvre, Paris. Photo Bulloz.
- BAUDOT, Anatole de, and Paul Cottancin 14.21 St. Jean de Montmartre, Paris, 1894–1904.
- BAZILLE, Frédéric 15.7 La Toilette, 1870. Musée Fabre, Montpellier.
- BECHER, J. T., and William Nicholson 7.11 Workhouse, Southwell, Notts., 1824–26. Photo © NTPL/Ian Shaw.
- BERMAN, Solon S. 14.17 Arcade Building, Pullman, IL, 1882. Photo Berlin, Ermisch.
- BERNARD, Emile 19.11 Self-Portrait With Portrait of Gauguin, 1888. Rijksmuseum Vincent van Gogh, Amsterdam.
- BILLINGS, Hammatt 9.4 Uncle Tom and Little Eva, 1852.
- BLAKE, William 0.2 Songs of Experience, pl. 46: London, 1794. The Trustees of the British Museum, London. 4.1 Albion Rose, ca. 1794-5. The Trustees of the British Museum, London. 4.2 Visions of the Daughters of Albion, frontispiece, 1793. The Trustees of the British Museum, London. 4.3 "A Negro hung alive by the Ribs to the Gallows," from John G. Stedman, Narrative of a Five Years' Expedition against the Revolted Negroes of Surinam, in Guiana, on the Wild Coast of South America, 1796. 4.5 The Spiritual Form of Nelson Guiding Leviathan, in whose wreathings are infolded the Nations of the Earth, 1809. Tate Gallery, London. 4.13 The Great Red Dragon and the Woman Clothed With the Sun: "The Devil is Come Down," ca. 1805. Rosenwald Collection, Image © 2006 Board of Trustees, National Gallery of Art, Washington, DC. 4.16 Laocoon, ca. 1820. Reproduction by permission of the Syndics of the Fitzwilliam Museum, Cambridge.
- BÖCKLIN, Arnold 20.14 Vita Somnium Breve, 1888. Öffentliche Kunstsammlung, Basel. 20.15 Island of the Dead, 1880. The Metropolitan Museum of Art, New York. Reisinger Fund, 1926.26.90. All rights reserved, The Metropolitan Museum of Art.
- BOILEAU, L.-C., and Gustave Eiffel 14.1 Bon Marché store, Paris, section, from *Encyclopédie* d'architecture et des travaux publics, 1876.
- BONHEUR, Rosa 11.19 Plowing in the Nivernais: The Dressing of the Vines, 1849. Musée National du Château, Versailles. Photo © R.M.N. 13.15 The Horse Fair, 1853. The Metropolitan Museum of Art, New York. Gift of Cornelius Vanderbilt, 1887. All rights reserved, The Metropolitan Museum of Art.
- BORRANI, Odoardo 13.6 The 26th of April, 1859, 1861.Private collection.
- BOUGUEREAU, William-Adolphe 19.9 The Nut Gatherers, 1880. Detroit Institute of Arts. Gift of

- Mrs. William E. Scripps. $\ ^{\circ}$ The Detroit Institute of Arts 1993.
- BOULLÉE, Etienne-Louis 7.4 Design for the interior of a Royal Library, 1784. Bibliothèque Nationale, Paris.
- BRADY, Mathew 12.11 Portrait of Lincoln, 1860. National Portrait Gallery, Smithsonian Institution, Washington, DC.
- BRETON, Jules 13.14 Blessing the Wheat in the Artois, 1857. Musée d'Orsay, Paris. Photo © R.M.N.
- BROC, Jean 1.27 The Death of Hyacinth in the Arms of Apollo, 1801. Musée des Beaux-Arts, Poitiers.
- BROWN, Ford Madox 11.9 Work, 1852–65. © Manchester City Art Galleries.
- CAILLEBOTTE, Gustave 15.12 A Balcony, Boulevard Haussmann, ca. 1880. Private collection.
- CAMERON, Julia Margaret 12.30 The Whisper of the Muse, 1865. Collection of the J. Paul Getty Museum, Los Angeles, CA.
- CAMP, Maxime du 12.17 Thebes: The Eastern Part of the Peristyle of the Temple of Ramases, 1849–51. By courtesy of the Board of the Trustees of the Victoria & Albert Museum, London.
- CANOVA, Antonio 2.3 Perseus, 1801. The Metropolitan Museum of Art, New York. All rights reserved, The Metropolitan Museum of Art. Photo David Finn. 2.4 Pauline Borghese as Venus, 1808. Galleria Borghese, Rome. 2.5 Magdalene, 1796. Palazzo Bianco, Genoa.
- CARJAT, Etienne 12.20 Charles Baudelaire, ca. 1863. Gernsheim Collection. Harry Ransom Humanities Research Center, University of Texas, Austin.
- CAROLUS-DURAN, Charles-Emile-Auguste 18.4 *The Kiss*, 1868. Lille, Musée des Beaux-Arts. © Photo R.M.N. - R. G. Ojeda.
- CARPEAUX, Jean-Baptiste 15.6 The Dance, 1867–9. Musée d'Orsay, Paris. Photo © R.M.N.
- CARROLL, Lewis (Rev. Charles Lutwidge Dodgson) 12.29 Xie Kitchin with Umbrella, ca. 1875.

 Museum purchase. International Museum of Photography at George Eastman House, Rochester, NY.
- CARSTENS, Asmus Jakob 6.1 Night and her Children, 1795. Staatliche Kunstsammlungen, Graphische Sammlung, Weimar.
- CASSATT, Mary 16.2 Self-Portrait, 1878. The Metropolitan Museum of Art, New York. Bequest of Edith H. Proskauer, 1975 (1975.319.1). All rights reserved, The Metropolitan Museum of Art. 16.4 Portrait of Louisine Elder Havemeyer, ca. 1896. Shelburne Museum, Shelburne, VT. 16.6 Five O'Clock Tea, ca. 1880. Courtesy, Museum of Fine Arts, Boston. The Maria Theresa B. Hopkins Fund. 16.8 The Boating Party, 1893-4. © 1993 National Gallery of Art, Washington, DC. Chester Dale Collection. Photo Richard Carafelli. 16.13 Woman in Black at the Opera, 1880. Courtesy, Museum of Fine Arts, Boston. The Hayden Collection. 16.17 Reading Le Figaro, 1883. Private Asset Management Group, New York. Photo Christie's New York. 16.18 Lydia Working at a Tapestry Frame, ca. 1881. Flint Institute of Arts, MI. Gift of the Whiting Foundation. 16.19 The First Caress, ca. 1890. New Britain Museum of American Art, CT. Harriett Russell Stanley Memorial Fund. 16.20 Mother and Child, 1908. © 1993 National Gallery of Art, Washington, DC. Chester Dale Collection. 16.22 The Bath, ca. 1892. The Art Institute of Chicago. The Robert A. Waller Fund. Photo © 1993, The Art Institute of

- Chicago, All Rights Reserved. 16.24 The Mother's Kiss (5th state), 1891. The Art Institute of Chicago. The Mr. and Mrs. Martin A. Ryerson Collection 1932. Photo © 1993, The Art Institute of Chicago, All Rights Reserved. 16.25 The Coiffure (5th state), 1891. The Metropolitan Museum of Art, New York. Gift of Paul J. Sachs. All rights reserved, The Metropolitan Museum of Art. 16.26 The Letter (3rd state), 1891. © 1993 National Gallery of Art, Washington, DC. Chester Dale Collection. 16.27 Afternoon Tea Party (4th state), 1891. © 1993 National Gallery of Art, Washington, DC. Chester Dale Collection. Photo Dean Beasom. 16.28 The Omnibus (4th state), 1891. © 1993 National Gallery of Art, Washington, DC. Chester Dale Collection. 16.30 Young Women Picking Fruit, 1892. Museum of Art, Carnegie Institute, Pittsburgh, PA.
- CATLIN, George 8.6 The Last Race, Okipa Ceremony (Mandan), 1832. National Museum of American Art, Smithsonian Institution, Washington, DC. Gift of Mrs. Joseph Harrison, Jr. Photo Art Resource, New York. 8.7 Clermont, First Chief of the Tribe (Osage), 1823. National Museum of American Art, Smithsonian Institution, Washington, DC. Photo Art Resource, New York. 8.8 Letters and Notes . . ., frontispiece, "The Author painting a Chief at the Base of the Rocky Mountains," 1841. The Huntingdon Library, San Marino, CA. 8.9 Catlin Painting the Portrait of Mah-To-Toh-Pa—Mandan, 1857–69. © 1993 National Gallery of Art, Washington, DC.
- CEZANNE, Paul 21.1 Pastoral Scene, ca. 1870. Musée d'Orsay, Paris. 21.2 A Modern Olympia, ca. 1869-70. Private collection. 21.3 Portrait of Uncle Dominique, 1866. The Provost and Fellows of King's College, Cambridge (Keynes Collection), on loan to the Fitzwilliam Museum, Cambridge, Reproduction by permission of the Syndics of the Fitzwilliam Museum, Cambridge. 21.4 Portrait of the Painter, Achille Emperaire, ca. 1868-70. Musée d'Orsay, Paris. 21.5 The Rape, ca. 1867. The Provost and Fellows of King's College, Cambridge (Keynes Collection), on loan to the Fitzwilliam Museum, Cambridge. Reproduction permission of the Syndics of the Fitzwilliam Museum, Cambridge. 21.6 Portrait of Louis-Auguste Cézanne, Father of the Artist, Reading L'Evénement, 1866. © 1993 National Gallery of Art, Washington, DC. Collection of Mr. and Mrs. Paul Mellon, 1970.5.1. 21.8 House of the Hanged Man, Auvers-sur-Oise, ca. 1873. Musée d'Orsay, Paris. 21.9 L'Estaque, ca. 1876. The Bernhard Foundation, New York. 21.11 Houses in Provence (Vicinity of L'Estaque), 1879-82. © 1993 National Gallery of Art, Washington, DC. Collection of Mr. and Mrs. Paul Mellon. 21.12 Mont Sainte-Victoire Seen From Bibémus, ca. 1898-1900. Baltimore Museum of Art. The Cone Collection, formed by Dr. Claribel Cone and Miss Etta Cone of Baltimore. 21.13 Still Life With Apples, ca. 1895-8. The Museum of Modern Art, New York. Lillie P. Bliss Collection. 21.14 The Large Bathers, 1900-1906. Reproduced by courtesy of the Trustees, The National Gallery, London. Purchased in 1964 with the aid of the Max Rayne Foundation and a special Exchequer Grant. 21.15 Mont Sainte-Victoire, 1902-6. The Art Museum, Princeton University. Lent by the Henry Rose Pearlman Foundation
- CHARPENTIER, Constance 1.25 Melancholy, 1801. Musée de Picardie, Amiens, France. Photo

- Giraudon/The Bridgeman Art Library.
- CHASSERIAU, Théodore 11.12 Portrait Drawing of de Tocqueville, 1844. Musée Carnavalet, Paris.
- CHERET, Jules 17.13 Le Bal du Moulin Rouge, 1889. Bibliothèque Nationale, Paris.
- CHURCH, Frederic Edwin 6.21 Twilight in the Wilderness, 1860. The Cleveland Museum of Art. Mr. and Mrs. William H. Marlatt Fund, 65.233. 6.22 Cotopaxi, 1862. The Detroit Institute of Arts, Detroit, Michigan. Founders Society Purchase, with funds from Mr. and Mrs. Richard A. Manoogian, Robert H. Tannahill Foundation Fund, Gibbs-William Fund, Dexter M. Ferry, Jr., Fund, Merrill Fund, and Beatrice W. Rogers Fund.
- CLAUDEL, Camille 20.41 The Waltz, 1895. Private collection.
- CLESINGER, Jean-Baptiste 10.17 Woman Bitten by a Snake, 1847. Musée d'Orsay, Paris.
- COHOE 8.14 Fort Marion Prisoners Dancing for Tourists, 1875-7. Private collection.
- COLE, Thomas 6.15 View of the Round-Top in the Catskill Mountains, 1827. Courtesy, Museum of Fine Arts, Boston. Mr. and Mrs. Karolik Collection. 6.16 The Course of Empire: Desolation, 1836. Courtesy of The New-York Historical Society, New York City.
- CONSTABLE, John 5.7 Golding Constable's Flower Garden, 1815. Ipswich Museums and Galleries, Ipswich Borough Council. 5.8 Constable's Kitchen Garden, 1815. Museums and Galleries, Ipswich Borough Council. 5.9 The Hay Wain (Landscape: Noon), 1821. Reproduced by courtesy of the Trustees, The National Gallery, London. 5.10 Dedham Vale 1828. National Galleries of Scotland, Edinburgh. 5.11 Hadleigh Castle, Mouth of the Thames-Morning After a Stormy Night, 1829. Yale Center for British Art, New Haven. Paul Mellon Collection. 5.12 Old Sarum, 1832. By courtesy of the Board of the Trustees of the Victoria & Albert Museum, London.
- COURBET, Gustave o.1 Portrait of Baudelaire, ca. 1848 (detail). Musée Fabre, Montpellier, France. Photo The Bridgeman Art Library, 11.11 Man With Leather Belt, ca. 1845. Musée d'Orsay, Paris. 11.14 After Dinner at Ornans, 1849. Musée des Beaux-Arts, Lille. 11.15 The Stonebreakers, 1850. Formerly Gemäldegalerie, Dresden (destroyed in World War II). 11.16 The Meeting, 1854. Musée Fabre, Montpellier. Photo Bulloz. 11.17 A Burial at Ornans, 1849. Musée d'Orsay, Paris. Photo © R.M.N. 11.18 Peasants of Flagey Returning From the Fair, 1849. Musée des Beaux-Arts, Besançon. Photo Bulloz. 11.21 The Studio of the Painter: A Real Allegory Summing Up Seven Years of My Artistic Life, 1854-5. Musée d'Orsay, Paris. Photo © R.M.N. 11.22 The Young Ladies on the Banks of the Seine, 1856-7. Musée du Petit Palais, Paris. 11.23 Sleepers, 1866. Musée du Petit Palais, Paris. 11.24 Seaside, 1866. Wallraf-Richartz Museum, Cologne. 11.24 Grand Panorama of the Alps With the Dents du Midi, 1877. The Cleveland Museum of Art. John L. Severance Fund.
- COUTURE, Thomas 10.13, 10.14 Romans of the Decadence (complete work and detail), 1847. Musée d'Orsay, Paris. Photo © R.M.N.
- DAGUERRE, Louis Jacques Mandé 12.3 Boulevard du Temple, Paris, ca. 1838. Stadtmuseum,
- DANCE, George, the Younger 7.1 Preliminary design for an identified domed building (detail), ca. 1791. By courtesy of the Trustees of Sir John Soane's Museum, London.
- DAUMIER, Honoré 10.2 Rue Transnonain, April 15, 1834, 1834. 11.1 The Third-Class Carriage, ca. 1862. National Gallery of Canada, Ottawa.
- DAVID, Jacques-Louis 1.1 Belisarius Begging Alms, 1781. Musée des Beaux-Arts, Lille. 1.2 The Oath

- of the Horatii Between the Hands of Their Father, 1785. Musée du Louvre, Paris. Photo © R.M.N. 1.7 Socrates at the Moment of Grasping the Hemlock, 1787. The Metropolitan Museum of Art, New York. Catherine Lorillard Wolfe Fund, 1931. All rights reserved, The Metropolitan Museum of Art. 1.10 Lictors Returning to Brutus the Bodies of His Sons, 1789. Musée du Louvre, Paris. Photo © R.M.N. 1.14 The Oath of the Tennis Court, 1791. Musée National du Château, Versailles. Photo © R.M.N. 1.15 Marat at His Last Breath, 1793. Musée Royaux des Beaux-Arts, Brussels. Photo A.C.L. 1.17 The Death of Bara, 1793. Musée Calvet, Avignon. 1.28 The Intervention of the Sabine Women, 1799. Musée du Louvre, Paris. Photo Bulloz. 1.29 Napoleon at the St. Bernard Pass, 1800. Musée National du Château, Versailles. 1.30 Leonidas at Thermopylae, 1814. Musée du Louvre, Paris. Photo © R.M.N.
- DAVID, Jacques-Louis, and François Gérard 1.34 Aeneas Carrying Anchises From the Ruins of Troy, late 1790's. Bibliothèque Nationale, Paris.
- DAVID D'ANGERS, Pierre-Jean 10.8 pediment of the Pantheon, 1830-37. Paris. 10.11 The Motherland Calling Her Children to the Defense of Liberty, 1835. Arc de Triomphe, Aix Gate, Marseille.
- DAVIS, A. J. 7.15 West (rear) façade and two plans for Knoll, Tarrytown, NY, 1838. Metropolitan Museum of Art, New York, Harris Brisbane Dick Fund, 1924 (24.66.795).
- DAVIS, Theodore R., and William S. Soule 8.13 Harper's Weekly, January 16, 1869, p. 41. Photo New York Public Library, New York.
- DEGAS, Edgar 15.14 Little Dancer Aged Fourteen, ca. 1881. Collection of Mr. and Mrs. Paul Mellon, Upperville, VA. 15.15 Portraits at the Stock Exchange, ca. 1879. Musée d'Orsay, Paris. 15.16 The Dance School, 1873. The Corcoran Gallery of Art, Washington, DC. William A. Clark Collection, 1926, 26.74.
- DELACROIX, Eugène 2.25 The Bark of Dante and Virgil, 1822. Musée du Louvre, Paris. Photo Bulloz. 2.26 The Massacre at Scio, 1824. Musée du Louvre, Paris. 2.31 The Death of Sardanapalus, 1827. Musée du Louvre, Paris. Photo © R.M.N. 2.32 Greece on the Ruins of Missolonghi, 1827. Musée des Beaux-Arts, Bordeaux, 2.33 The 28th of July: Liberty Leading the People, 1830. Musée du Louvre, Paris. Photo © R.M.N. 10.16 Women of Algiers, 1834. Musée du Louvre, Paris.
- DELAROCHE, Paul 10.3 Artists of All Ages, 1836-41. Ecole nationale supérieure des Beaux-Arts,
- DENIS, Maurice 20.30 April, 1892. State Museum Kröller-Müller, Otterlo.
- DEVERIA, Eugène 2.29 The Birth of Henri IV, 1827. Musée du Louvre, Paris.
- DEVOSGE, Anatole, after J.-L. David 1.16 The Death of Lepelletier de Saint-Fargeau 1793. Musée des Beaux-Arts de Dijon.
- DISDERI, André Adolphe Eugène 12.18 Portrait of an Unidentified Woman, ca. 1860-65. Gernsheim Collection. Harry Ransom Humanities Research Center, University of Texas, Austin.
- DROUAIS, Jean-Germain 1.8 The Dying Athlete 1785. Musée du Louvre, Paris. Photo © R.M.N 1.9 Marius at Minturnae 1786. Musée du Louvre, Paris. Photo © R.M.N.
- DUNCANSON, Robert Scott 9.3 Uncle Tom and Little Eva, 1853. Detroit Institute of Arts. Gift of Mrs. Jefferson Butler and Miss Grace R. Conover. © The Detroit Institute of Arts 1993.
- DUPRE, Augustin 8.1 The Diplomatic Medal 1790. of Numismatics, Smithsonian Division Institution, Washington, DC.
- DURAND, Asher B. 6.17 Landscape: Progress, 1853. The Warner Collection of Gulf States

- Paper Corporation, Tuscaloosa, AL.
- EAKINS, Thomas 9.23 Will Schuster and Black Man Going Shooting (Rail Shooting), 1876. Yale University Art Gallery, New Haven. Bequest of Stephen Carlton Clark, B.A. 1903. 9.24 Negro Boy Dancing, 1878. The Metropolitan Museum of Art, New York. Fletcher Fund, 1925. All rights reserved, The Metropolitan Museum of Art. 16.1 Self-Portrait, 1902. National Academy of Design, New York City. 16.3 The Swimming Hole, ca. 1883-5. Amon Carter Museum, Fort Worth, TX. 16.5 Portrait of Mrs. Edith Mahon 1904. Smith College Museum of Art, MA. Purchase, Drayton Hillyer Fund. 16.7 Max Schmitt in a Single Scull, 1871. The Metropolitan Museum of Art, New York. Purchase, Alfred N. Punnett Endowment Fund and George D. Pratt Gift, 1934 (34.92). Copyright © 1990 By The Metropolitan Museum of Art. 16.11 Miss Van Buren, 1891. The Phillips Collection, Washington, DC 16.12 Portrait of Benjamin Howard Professor Rand, 1874. Jefferson Medical College of Thomas Jefferson University, Philadelphia, PA. 16.14 The Concert Singer (Weda Cook), 1892. Philadelphia Museum of Art. Given by Mrs. Thomas Eakins and Miss Mary A. Williams. 16.16 The Gross Clinic, 1875. Jefferson Medical College of Thomas Jefferson University, Philadelphia, PA. 16.21 Girl With Cat (Portrait of Kathrin), 1872. Yale University Art Gallery, New Haven. Bequest of Stephen Carlton Clark, B.A. 1903. 16.29 William Rush Carving His Allegorical Figure of the Schuylkill River, 1877. Philadelphia Museum of Art. Given by Mrs. Thomas Fakins and Miss Mary A. Williams.
- EASTERLY, Thomas 8.11 Keokuk, or the Watchful Fox, 1847. National Anthropological Archives, Smithsonian Institution, Washington, DC.
- EMERSON, Peter Henry 12.32 Poling the Marsh Hay, 1886. Platinum print. Gernsheim Collection. Harry Ransom Humanities Research Center, University of Texas, Austin.
- ENSOR, James 20.7 Iston, Pouffamatus, Cracozie, and Transmouff, Famous Persian Physicians Examining the Stools of King Darius after the Battle of Arbela, 1886. Koninklijk Museum voor Schone Kunsten, Antwerp. 20.9 The Entry of Christ into Brussels in 1889, 1888. Collection of the J. Paul Getty Museum, Los Angeles, CA. 20.11 Old Woman With Masks, 1889. Museum voor Schone Kunsten, Ghent. 20.12 The Gendarmes, 1892. Museum voor Schone Kunsten, Ostend. 20.13 My Portrait in 1960, 1888. Bibliothèque Royale de Belgique, Brussels.
- FAVEAU, Félicie de 10.5 Christina of Sweden Refusing to Give Mercy to Her Squire Monaldeschi, ca. 1827. Musée des Beaux-Arts, Louviers.
- FENTON, Roger 12.21 Still Life with Fruit and Decanter, ca. 1856. Royal Photographic Society, Bath. 12.22 Hardships at the Crimea: Portrait of Captain George, Colonel Lowe, and Captain Brown. 4th Light Dragoons, 1855. Gernsheim Collection. Harry Ransom Humanities Research Center, University of Texas, Austin.
- FLANDRIN, Hippolyte-Jean 11.20 Napoleon III, 1860-61. Musée National du Château, Versailles.
- FLAXMAN, John 1.26 "The Fight for the Body of Patroclus," from Illustrations to Homer's "Iliad," 1793. 4.4 Design for a monument to British naval victories with a statue of Britannia, 1799. The Trustees of the British Museum, London
- FRIEDRICH, Caspar David 6.9 Monk by the Sea, 1809–10. Schloss Charlottenburg, 6.10 Abbey in the Oak Forest, 1809-10. Schloss Charlottenburg, Berlin. 6.11 Large Enclosure near Dresden, 1832. Staatliche Kunstsammlungen, Gemäldegalerie Neue Meister, Dresden. 6.12 Hill and Ploughed Field near Dresden, 1824-8. Kunsthalle, Hamburg.

- FUSELI, Henry 4.8 The Nightmare 1790. Goethe Museum, Frankfurt. 4.9 Symplegma (Man and Three Women), ca. 1810. By courtesy of the Board of Trustees of the Victoria & Albert Museum, London. 4.10 Thor Battering the Midguard Serpent 1790. Royal Academy of Arts, London.
- GAERTNER, Eduard 13.1 A View of the Opera and Unter den Linden, Berlin, 1845. Carmen Thyssen-Bornemisza Collection on loan to the Museo Thyssen-Bornemisza, Madrid.
- GANDY, Joseph Michael 7.16 Perspective of a design for the Tivoli Corner, Bank of England, 1803. By courtesy of the Trustees of Sir John Soane's Museum, London.
- GAUDÍ, Antoni 14.19 Palau Guell, Barcelona, 1888. Photo © Andrea Jemolo/Corbis.
- GAUGUIN, Paul 20.2 Green Christ, 1889. Musées Royaux des Beaux-Arts de Belgique, Brussels. 20.3 Yellow Christ, 1889. Albright-Knox Art Gallery, Buffalo, NY. General Purchase Fund. 20.4 The Seaweed Gatherers, 1889. Folkwang Museum, Essen. 20.5 Bonjour Monsieur Gauguin, 1889. Národní Galerie, Prague. 20.6 Jug in the Form of a Head, Self-Portrait, 1889. Museum of Decorative Arts, Copenhagen. 20.8 Christ in the Garden of Olives, 1889. Norton Gallery and School of Art, West Palm Beach, FL. 20.35 The Meal, or The Bananas, 1891. Musée d'Orsay, Paris. Photo © R.M.N. 20.36 Vahine no te vi (Woman of the Mango), 1892. Baltimore Museum of Art. The Cone Collection formed by Dr. Claribel Cone and Miss Etta Cone of Baltimore. 20.37 Manao tupapau (The Specter Watches Her), 1892. Albright-Knox Art Gallery, Buffalo, NY. A. Conger Goodyear Collection. 20.43 Mahana no atua (Day of the God), 1894. The Art Institute of Chicago. Helen Birch Bartlett Collection, 1926.198. Photo © 1993, The Art Institute of Chicago, All Rights Reserved. 20.44 Te faaturuma (Silence, or To Be Dejected), 1891. Worcester Art Museum, Worcester, MA. 20.45 Where Do We Come From? What Are We? Where Are We Going?, 1897. Courtesy, Museum of Fine Arts, Boston. Arthur Gordon Tompkins Residuary Fund.
- GEORGIN, F., and J.-B. Thiébault 10.9 The Apotheosis of Napoleon, 1834. Bibliothèque Nationale, Paris.
- GERARD, François 1.23 Cupid and Psyche 1798. Musée du Louvre, Paris. 1.31 Ossian, 1801. Kunsthalle, Hamburg. Photo © Elke Walford. 2.18 Entry of Henri IV into Paris, 1817.Musée National du Château, Versailles. Photo © R.M.N.
- GERICAULT, Théodore 2.14 The Charging Light Cavalryman (chasseur), 1812. Musée du Louvre, Paris. Photo Bulloz. 2.15 The Wounded Heavy Cavalryman (cuirassier), 1814. Musée du Louvre, Paris 2.20 Severed Limbs, 1818. Musée Fabre, Montpellier. 2.21 Despair and Cannibalism on the Raft of the Medusa, 1818. Private collection. 2.22 The Raft of the Medusa, 1819. Musée du Louvre, Paris. Photo © R.M.N. 2.23 Portrait of an Insane Man, 1822–3. Museum voor Schone Kunsten, Ghent. Photo A.C.L. 2.24 Pity the Sorrows of the Poor Old Man, 1821. Bibliothèque Nationale, Paris.
- GEROME, Jean-Léon 13.11 Reception of the Siamese Ambassadors by Napoleon III and the Empress Engénie at Fontainebleau, June 27, 1861, 1861–4. Musée National du Château, Versailles. Photo © R.M.N.
- GILLRAY, James 4.11 Phaeton Alarm'd!, 1808. The Trustees of the British Museum, London.
- GILLY, Friedrich 7.3 Design for a monument to Frederick II, 1795–9. Staatliche Museen zu Berlin.
- GILPIN, William 5.1, 5.2 Plates from Three Essays: On Picturesque Beauty, On Picturesque Travel, and On Sketching, 1792.

- GIRODET, Anne-Louis 1.12 Pietà 1789. Church of Montesquieu-Volvestre, Haute-Garonne. 1.13 The Sleep of Endymion 1791. Musée du Louvre, Paris. 1.24 Portrait of Jean-Baptiste Belley, 1797. Musée National du Château, Versailles. Photo © R.M.N./Gérard Blot. 1.32 Ossian Receiving the Napoleonic Officers, 1802. Musée National du Château de Malmaison, Rueil-Malmaison. Photo Bulloz. 1.33 The Deluge, 1806. Musée du Louvre, Paris. 2.11 Atala at the Tomb, 1808. Musée du Louvre, Paris. Photo Bulloz. 2.12 Pygmalion and Galatea, 1813–19. Musée du Louvre, Paris. 2.13 The Revolt at Cairo, 1810. Musée National du Château, Versailles. Photo © R.M.N.
- GIRTIN, Thomas 5.5 Kirkstall Abbey, 1800. The Trustees of the British Museum, London. 5.6 The Thames from Westminster to Somerset House, study for the "Eidometropolis," 1802. The Trustees of the British Museum, London.
- GODIN, J.-B.-A. 14.16 The Familistère and associated factory, Guise, from *Solutions sociales*, 1871. Bibliothèque Nationale, Paris.
- GOGH, Vincent van 0.5 Portrait of a Peasant (Patience Escalier), 1888. Norton Simon Art Foundation, Pasadena, CA. 19.1 La Berceuse, 1889. State Museum Kröller-Müller, Otterlo. 19.3 The Artist's Bedroom in Arles, 1888. Rijksmuseum Vincent van Gogh, Amsterdam. 19.4 Carpenter's Workshop and Laundry, 1882. State Museum Kröller-Müller, Otterlo. 19.6 The Bearers of the Burden, 1881. State Museum Kröller-Müller, Otterlo. 19.7 The Potato Eaters, 1885. Rijksmuseum Vincent van Gogh, Amsterdam. 19.10 Portrait of Père Tanguy, 1887-8. Musée Rodin, Paris. Photo © R.M.N. 19.12 Yellow House at Arles, 1888. Rijksmuseum Vincent van Gogh, Amsterdam. 19.14 The Night Café, 1888. Yale University Art Gallery, New Haven. Bequest of Stephen Carlton Clark, B.A. 1903. 19.15 Self-Portrait With Bandaged Ear, 1889. Courtauld Institute Galleries, London. 19.16 Joseph Roulin, 1888. Courtesy, Museum of Fine Arts, Boston. Robert Treat Paine II Bequest. 19.17 Eugène Boch, 1888. Musée d'Orsay, Paris. 19.18 Starry Night, 1889. The Museum of Modern Art, New York. Acquired through the Lillie P. Bliss Bequest. 20.1 Crows in the Wheatfields, 1890. Rijksmuseum Vincent van Gogh, Amsterdam.
- GOYA, Francisco o.3 Caprichos 42, "Tu que no puedes" ("You who cannot"), 1796-7. Davison Art Center, Gift of George W. Davison. 3.1 Caprichos 1, frontispiece, 1799. Biblioteca Nacional, Madrid. 3.2 Caprichos 43, "El sueño de la razón produce monstruos" ("The sleep of reason produces monsters"), 1799. Biblioteca Nacional, Madrid. 3.3 Conde de Floridablanca, 1783. Banco Urquijo, Madrid. 3.4 Charles IV and His Family, 1801. Museo del Prado, Madrid. 3.5 The Family of the Duque de Osuna, 1788. Museo del Prado, Madrid. Photo Mas, Barcelona. 3.6 Queen María Luisa Wearing a Mantilla, 1799. Patrimonio Nacional, Palacio Real, Madrid. Photo Mas, Barcelona. 3.7 Naked Maja, ca. 1798–1805. Museo del Prado, Madrid. 3.8 Clothed Maja, ca. 1798-1805. Museo del Prado, Madrid. 3.9 Courtyard with Lunatics, 1793-4. Meadows Museum, Dallas. 3.10 The Witches Sabbath, 1797-8. Museo Lázaro Galdeano, Madrid. 3.11 Caprichos 68, "Linda maestra!" ("A fine teacher!"), 1799. Biblioteca Nacional, Madrid. Photo Mas, Barcelona. 3.12 Caprichos 50, "Los Chinchillas" ("The Chinchillas"), 1799. Biblioteca Nacional, Madrid. 3.13 Caprichos 10, "El amor y la muerte" ("Love and Death"), 1799. Biblioteca Nacional, Madrid. 3.14 Caprichos 52, "Lo que puede un sastre!" ("What a tailor can achieve!"), 1799. Biblioteca Nacional, Madrid. Photo Mas, Barcelona. 3.15 The Knife Grinder,

- ca. 1808-12. Reproduced by courtesy of the Board of Directors of the Budapest Museum of Fine Arts. 3.16 The Uprising of the Second of May, 1808, 1814. Museo del Prado, Madrid. 3.17 The Executions of the Third of May, 1808, 1814. Museo del Prado, Madrid. Photo Mas, Barcelona. 3.18 The Disasters of War 26, "No se puede mirar" ("One can't look"), ca. 1810–20. Photo Mas, Barcelona. 3.19 The Disasters of War 2, "Con razón o sin ella" ("Whether right or wrong"), ca. 1810-20. 3.20 The Disasters of War 84, seguridad de un reo no exige tormento" ("The custody of a criminal does not call for torture"), ca. 1810-20. Photo Mas, Barcelona. 3.21 The Disasters of War 79, "Murió la verdad" ("Truth is dead"), ca. 1810-20. Photo Mas, Barcelona. 3.22 The Disasters of War 80, "Si resucitaria?" ("If she were to rise again?"), ca. 1810-20. Photo Mas, Barcelona. 3.23 Saturn Devouring His Children, ca. 1820. Museo del Prado, Madrid.
- GRANDVILLE 11.3 "Apple of the Hesperides and rum ice," from *Un Autre Monde*, 1844. Bibliothèque Nationale, Paris.
- GROS, Antoine-Jean 2.1 The Battle of Nazareth, 1801. Musée des Beaux-Arts, Nantes. Photo © Patrick Jean. 2.2 Napoleon in the Plague House at Jaffa, 1804. Musée du Louvre, Paris. Photo © R.M.N.
- GUERIN, Pierre-Narcisse 1.20 The Return of Marcus Sextus 1799. Musée du Louvre, Paris. Photo © R.M.N. 2.10 Aurora and Cephalus, 1811. Musée du Louvre, Paris. Photo © R.M.N. 2.17 Henri de Rochejaquelein, 1817. Musée Municipal, Cholet.
- GUIDOTT, F. 12.1 A Camera Obscura, ca. 1751. International Museum of Photography at George Eastman House, Rochester, NY.
- GUYS, Constantin 15.3 The Champs-Elysées, 1855. Musée du Petit Palais, Paris. Photo Bulloz.
- HARRIET, Fulchran-Jean 1.19 Oedipus at Colonus 1796. Private collection. Photo © R.M.N.
- HAVILAND, John 7.10 Eastern State Penitentiary, Cherry Hill, PA, 1825–36. Photo Historic Buildings Survey.
- HAWARDEN, Lady Clementina 12.31 Photograph of a Model, 1860's. By courtesy of the Board of Trustees of the Victoria & Albert Museum, London
- HENNEQUIN, Philippe-Auguste 1.21 Allegory of 10 August (detail), 1799. Musée des Beaux-Arts, Rouen.
- HERSENT, Louis 2.16 Louis XVI Distributing Alms to the Poor, 1817. Musée National du Château, Versailles. Photo © R.M.N.
- HERTER, Gustave 14.4 Reception room cabinet, ca. 1860. Victoria Mansion (Morse-Libby House), Portland, ME. Photo Melville McLean.
- HILL, David Octavius, and Robert Adamson 12.15 Mrs. Elizabeth (Johnstone) Hall, ca. 1846. Collection of the J. Paul Getty Museum, Los Angeles, CA.
- HODLER, Ferdinand 20.25 The Night, 1891. Kunst-museum, Berne. 20.26 The Beech Forest, 1885. Kunstmuseum, Solothurn. 20.27 Lake Geneva Seen From Chexbres, 1904. Collection du Musée des Beaux-Arts, Lausanne. Photo J. C. Ducret. 20.28 The Mönch With Clouds, 1911. Private collection. 20.31 Valentine in Agony, 1915.Öffentliche Kunstsammlung, Basel.
- HOMER, Winslow 9.11 A Bivouac Fire on the Potomac, 1861. Sterling and Francine Clark Art Institute, Williamstown, MA. 9.12 Our Jolly Cook 1863. Amon Carter Museum, Forth Worth, TX. 9.13 The Bright Side, 1865. The Fine Arts Museum of San Francisco. Gift of Mr. and Mrs. John D. Rockefeller 3rd, 1979-7.56. 9.15 Prisoners From the Front, 1866. The Metropolitan Museum of Art, New York. Gift of Mrs. Frank B. Porter, 1922 (22.207). Copyright © 1884 By The

- Metropolitan Museum of Art. 9.16 A Visit From the Old Mistress, 1876. National Museum of American Art, Smithsonian Institution, Washington, DC. Photo Art Resource, New York.
- HORTA, Victor 14.22 Maison du Peuple, Brussels, 1897–1900. © DACS 2007.
- HOSMER, Harriet 9.17 Beatrice Cenci, 1857. St. Louis Mercantile Library. 9.18 Zenobia in Chains, 1859. Wadsworth Atheneum, Hartford, CT. Gift of Mrs. Josephine M. J. Dodge.
- HOWARD, Ebenezer 14.18 Diagram of a garden city, from Tomorrow: A Peaceful Path to Real Reform, 1898.
- HUNT, William Holman 11.4 Rienzi Vowing to Obtain Justice for the Death of his Young Brother, Slain in a Skirmish between the Colonna and Orsini Factions, 1849. Private Collection. Photo The Bridgeman Art Library. 11.7 The Awakening Conscience, 1853. Tate Gallery, London.
- INGRES, Jean-Auguste-Dominique 1.35 Napoleon on the Imperial Throne, 1806. Musée de l'Armée, Hôtel National des Invalides, Paris. 1.36 The Ambassadors of Agamemnon Visiting Achilles, 1801. Ecole nationale supérieure des Beaux-Arts, Paris. 1.37 Jupiter and Thetis, 1811. Musée Granet, Aixen-Provence. 1.38 The Turkish Bath, 1862. Musée du Louvre, Paris. 2.27 The Vow of Louis XIII, 1824. Montauban Cathedral. Photo Bulloz. 2.28 The Apotheosis of Homer, 1827. Musée du Louvre, Paris. Photo © R.M.N. 2.30 Henri IV Playing With His Children, 1817. Musée du Petit Palais, Paris. Photo Bulloz. 9.7 M. Louis-François Bertin, 1832. Musée du Louvre, Paris. Photo Bulloz. 13.13 Oedipus and the Sphinx, 1808. Musée du Louvre, Paris.
- INNESS, George **6.18** *The Lackawanna Valley*, 1857. National Gallery of Art, Washington, DC.
- ISRAËLS, Jozef 19.8 *The Frugal Meal*, 1876. © Glasgow Museums: Art Gallery and Museum, Kelvingrove.
- JOCELYN, Nathaniel 9.1 Cinque, 1839. New Haven Colony Historical Society. Gift of Dr. Charles B. Purvis, 1898.
- JOHNSON, Eastman 9.6 Old Kentucky Home (Negro Life in the South), 1859. Courtesy of The New-York Historical Society, New York City. 9.7 A Ride for Liberty: The Fugitive Slaves, ca. 1862–3. The Brooklyn Museum. Gift of Miss Gwendolyn O. L. Conkling.
- JOHNSTON, Frances Benjamin 8.16 Class in American History, 1899–1900. The Museum of Modern Art, New York. Gift of Lincoln Kirstein.
- JONES, Owen 7.26 Design for the coloring of the interior of the Crystal Palace, London, 1850. Victoria & Albert Museum, London. Photo Eileen Tweedy. 14.26 "Savage Tribes No. 3," from The Grammar of Ornament, 1856. Ian Sutton Collection
- KAUFMANN, Theodor 9.8 On to Liberty, 1867. The Metropolitan Museum of Art, New York. Gift of Erving and Joyce Wolf, 1982. All rights reserved, The Metropolitan Museum of Art.
- KENSETT, John Frederick **6.20** Lake George, 1869. Bequest of Maria De Witt Jesup, 1915. Metropólitan Museum of Art, New York.
- KING, Charles Bird 8.5 Young Omaham, War Eagle, Little Missouri, and Pawnees, 1822. National Museum of American Art, Smithsonian Institution, Washington, DC. Gift of Miss Helen Barlow. Photo Art Resource, New York. 8.12 Keokuk, Sac (Watchful Fox), 1827. National Museum of Denmark, Copenhagen.
- KISELEV, Alexander 13.19 The Mill , 1890. Norton Simon Art Foundation, Pasadena, CA.
- KLIMT, Gustav 20.32 Poster for the first Secession exhibition, 1894. Historisches Museum der Stadt, Vienna. 20.33 Pallas Athene, 1898. Historisches Museum der Stadt, Vienna.
- KORZUKHIN, Alexsei 13.16 The Day of the

- Parting, 1872. Tretyakov Gallery, Moscow Photo The Bridgeman Art Library.
- KRAMSKOI, Ivan 13.17 Self-Portrait, 1867. Tretvakov Gallery, Moscow.
- KRIMMEL, John Lewis 9.2 Quilting Frolic, 1813. The Henry Francis du Pont Winterthur Museum Courtesy, Winterthur Museum.
- KROHG, Christian **20.17** Sick Girl, 1880–81. © Nasjonalgalleriet, Oslo.
- LABILLE-GUIARD, Adélaïde 1.6 Self-Portrait With Two Pupils, Mademoiselle Marie Gabrielle Capet and Mademoiselle Carreaux de Rosemond, 1785. The Metropolitan Museum of Art, New York, Gift of Julia A. Berwind 1953 (53.225.5). Photo © 1980 Metropolitan Museum of Art.
- LABROUSTÉ, Henri 14.2 Reading room, Bibliothèque Ste. Geneviève, Paris, 1839–50. Photo Courtauld Institute of Art, London. 14.3 Reading room, Bibliothèque Nationale, Paris, 1859–68. Photo Archives Photographiques, Paris.
- LANE, Fitz Hugh 6.19 Brace's Rock, Brace's Cove, 1864. The Lano Collection.
- LAUGIER, Marc-Antoine 7.5 Frontispiece to the second edition of the *Essay on Architecture*, 1755.
- LEDOUX, Claude-Nicolas 7.8 Royal Saltworks at Arc-et-Senans, 1774–8. Photo Gilles Abegg Photothèque Institut Claude-Nicolas Ledoux. 7.9 Design for a cannon manufactory in the ideal city of Chaux, from Architecture considered in relation to art, morals, and legislation, 1, 1804.
- LE GRAY, Gustave 12.26 Seascape with Sailing Ship and Tugboat, ca. 1857. Collection of the J. Paul Getty Museum, Los Angeles, CA.
- LEIBL, Wilhelm 13.4 Town Politicians, 1877. Museum Stiftung Oskar Reinhart, Winterthur.
- LEUTZE, Emmanuel 8.4 study for Westward the Course of Empire Takes its Way (Westward Ho!), 1861. National Museum of American Art, Smithsonian Institution, Washington, DC. Photo Art Resource, New York.
- LEWIS, Edmonia 9.20 Forever Free, 1867. Howard University, James A. Porter Gallery of Afro-American Art, Washington, DC. 9.21 Hagar in the Wilderness, 1868. National Museum of American Art, Smithsonian Institution, Washington, DC. Photo Art Resource, New York. Gift of Delta Sigma Theta Sorority, Inc. 9.22 Old Indian Arrowmaker and His Daughter, 1872. Carver Museum, Tuskegee Institute, AL.
- LOCKWOOD, H. F., and William Mawson 14.15 Saltaire, Yorks., 1851–76. Photo Bradford Metropolitan Libraries.
- MACKMURDO, A. H. 14.10 Cover of Wren's City Churches, 1883.
- MANET, Edouard 15.1 The Barricade, ca. 1871. Reproduced by courtesy of the Board of Directors of the Budapest Museum of Fine Arts. 15.2 Music in the Tuileries, 1862. Reproduced by courtesy of the Trustees, The National Gallery, London.
- 15.4 A Balcony, 1868–9. Musée d'Orsay, Paris. Photo © R.M.N. 15.5 Olympia, 1863. Musée d'Orsay, Paris. Photo © R.M.N. 15.17 A Bar at the Folies-Bergère, ca. 1882. Courtauld Institute Galleries, London.
- MARIS, Jacob 19.5 *The Bleaching Yard*, 1870. © Rijksmuseum-Stichting Amsterdam.
- MARTIN, John 5.14 *The Fall of Ninevah*, 1829. The Trustees of the British Museum, London. 5.15 *The Last Man*, ca. 1832. Laing Art Gallery, Newcastle-upon-Tyne.
- MAURISSET, Théodore 12.10 La Daguerréotypomanie, 1839. Gernsheim Collection. Harry Ransom Humanities Research Center, University of Texas, Austin.
- MENZEL, Adolf von 13.3 The Flute Recital of Frederick the Great at Sanssouci 1852. Nationalgalerie, Staatliche Museen zu Berlin. 13.5 Iron Rolling Mill, 1872–5. Nationalgalerie,

- Staatliche Museen zu Berlin.
- MILLAIS, John Everett 11.8 Christ in the House of His Parents, 1850. Tate Gallery, London. 20.19 Ophelia, 1851. Tate Gallery, London.
- MILLET, Jean-François 11.2 The Gleaners, 1857.
 Musée du Louvre, Paris. Photo Bulloz. 11.10 The
 Sower, 1850. Courtesy, Museum of Fine Arts,
 Boston. Shaw Collection.
- MONET, Claude 15.8 Regatta at Argenteuil, 1872.Musée d'Orsay, Paris. 15.10 Women in the Garden, 1866—7.Musée d'Orsay, Paris. Photo © R.M.N. 20.20 Waterlilies, 1905. Courtesy, Museum of Fine Arts, Boston. Given in memory of Governor Alvan T. Fuller by the Fuller Foundation, 61.959.
- MOREAU, Gustave 13.12 Oedipus and the Sphinx, 1864. The Metropolitan Museum of Art, New York. Bequest of William H. Herriman, 1921. All rights reserved, The Metropolitan Museum of Art
- MORISOT, Berthe 15.18 Laundresses Hanging Out the Wash, 1875. © 1993 National Gallery of Art, Washington, DC. Collection of Mr. and Mrs. Paul Mellon 15.19 The Psyché, 1876. Thyssen-Bornemisza Collection, Lugano, Switzerland.
- MORRIS, William 14.7 Preliminary design for the "Troy" typeface, 1891. The Huntingdon Library, Art Collections, and Botanical Gardens, San Marino, CA. 14.8 "Pimpernel" wallpaper, 1876.
- MUNCH, Edvard 20.16 Sick Child, 1885–6. © Nasjonal-galleriet, Oslo. 20.18 The Voice, 1893.Courtesy, Museum of Fine Arts, Boston. 20.29 Madonna, 1895–7.
- NADAR (Gaspard-Félix Tournachon) 12.19 Sarah Bernhardt, ca. 1860. Musée d'Orsay, Paris.
- NASH, John 7.18 Regent Street Quadrant, London, 1819–20. After T. H. Shepherd, from James Elmes, *Metropolitan Views of London*, 1827. 7.19 Royal Pavilion, Brighton, 1815–22. Photo County Borough of Brighton.
- NAST, Thomas 9.14 Entrance of the Fifty-fifth Massachusetts (Colored) Regiment into Charleston, South Carolina, February 21, 1865, 1865. Courtesy, Museum of Fine Arts, Boston. M. and M. Karolik Collection of American Watercolors and Drawings, 1800–75.
- NEGRE, Charles 12.28 Henri Le Secq at Notre Dame Cathedral, ca. 1851. Collection André Jammes, Paris.
- NIÉPCE, Joseph Nicéphore 12.2 View From the Window at Le Gras, 1827. Gernsheim Collection. Harry Ransom Humanities Research Center, University of Texas, Austin.
- OLBRICH, Joseph 20.34 House of the Secession, Vienna, 1898. Photo Dr. F. Stoedtner.
- O'SULLIVAN, Timothy H. 12.23 A Harvest of Death, Gettysburg, July 4th 1863. Print by Alexander Gardner. Gernsheim Collection. Harry Ransom Humanities Research Center, University of Texas, Austin.
- OVERBECK, Friedrich 6.7 Portrait of Franz Pforr, 1810. Nationalgalerie, Staatliche Museen zu Berlin.
- PALMER, Samuel 5.13 A Hilly Scene, ca. 1826. Tate Gallery, London.
- PAPETY, Dominique 10.15 The Dream of Happiness, 1843. Musée de Compiègne. Photo © R.M.N.
- PAXTON, Joseph 7.27 Crystal Palace, London, 1850–51. Photo R. B. Fleming.
- PEYRON, Pierre 1.3 The Death of Alcestis, 1785. Musée du Louvre, Paris. Photo © R.M.N.
- PFORR, Franz 6.6 The Virgin and the Demon, 1810. 6.8 Count Rudolph of Hapsburg and the Priest, 1809–10. Städelsches Kunstinstitut, Frankfurt.
- PILOTY, Karl von 13.2 Seni Before Wallenstein's Corpse, 1855. Neue Pinakothek, Munich.
- PILS, Isidore 11.13 The Death of a Sister of Charity, 1850. Musée d'Orsay, Paris. Photo © R.M.N.

PISSARRO, Camille 15.9 Hoarfrost, 1873.Musée d'Orsay, Paris. 15.13 Edge of the Woods, or Undergrowth in Summer, 1879. The Cleveland Museum of Art. Gift of Hanna Fund. 17.7 L'Isle Lacroix, Rouen, Mist, 1888. Pennsylvania Museum of Art. Courtesy of the John G. Johnson Collection, Philadelphia. 21.7 Village Near Pontoise, 1873. Sammlung Oskar Reinhart "Am Römerholz," Winterthur. 21.10 The Côte des Boeus at L'Hermitage, Near Pontoise, ca. 1873. Reproduced by courtesy of the Trustees, The National Gallery, London.

POWERS, Hiram 9.19 The Greek Slave, 1846. The Corcoran Gallery of Art, Washington, DC.

POYET, Bernard 7.7 Design for the Hôtel-Dieu on the Ile des Cygnes, Paris, from Mémoire sur la necessité de transférer et réconstruire l'Hôtel-Dieu à Paris 1785. Bibliothèque Nationale, Paris.

PREAULT, Antoine-Augustin 10.10 Slaughter, 1833–4. Musée des Beaux-Arts, Chartres.

PRUD'HON, Pierre-Paul 2.6 Crime Pursued by Vengeance and Justice, 1808. Musée du Louvre, Paris. 2.8 Psyche Carried by Zephyrs to Cupid's Domain, 1808. Musée du Louvre, Paris. 2.9 Portrait of Empress Josephine, 1805. Musée du Louvre, Paris.

PUGIN, Å. W. N. 7.21 The same town in 1840 and 1440, from the second edition of *Contrasts*, 1841. 7.22 St. Giles, Cheadle, Derbys., 1841–7. Photo McQuillan and Brown. 7.23 Throne and canopy in the House of Lords, Palace of Westminster, London, first used in 1847.

PUGIN, A. W. N., and Sir Charles Barry 7.24 Palace of Westminster, London, 1835–56. Photo

A. F. Kersting.

- PUVIS DE CHAVANNES, Pierre 17.4 The Sacred Grove, 1884. The Art Institute of Chicago. Mr. and Mrs. Potter Palmer Collection, 1922.445. Photo © 1993, The Art Institute of Chicago, All Rights Reserved.
- REDON, Odilon 20.10 Ophelia Among the Flowers 1905. Reproduced by courtesy of the Trustees, The National Gallery, London. 20.21 Roger and Angelica, ca. 1908. The Museum of Modern Art, New York. Lillie P. Bliss Collection. 20.22 The Smiling Spider, 1885. Musée du Louvre, Paris. Photo Bulloz. 20.24 The Cyclops 1905. State Museum Kröller-Müller, Otterlo. 20.38 "Death: My Irony Exceeds All Others," from To Gustave Flaubert, 1889. Bibliothèque Nationale, Paris.
- REGNAULT, Jean-Baptiste 1.11 Lamentation of Christ 1789. Musée du Louvre, Paris. Photo © R.M.N. 2.7 Liberty or Death 1795. Kunsthalle, Hamburg. Photo © Elke Walford.
- REJLANDER, Oscar Gustav 12.24 The Two Ways of Life, 1857. Gernsheim Collection. Harry Ransom Humanities Research Center, University of Texas, Austin.
- REJLANDER, O. G., and Guillaume-Benjamin Duchenne de Boulogne 12.25 Illustration from Charles Darwin, *The Expression of Emotion in Man* and Animals, pl. VII, 1872. International Museum of Photography at George Eastman House, Rochester, NY
- RENOIR, Auguste 15.11 Bal du Moulin de la Galette, 1876. Musée d'Orsay, Paris. Bequest of Gustave Caillebotte, 1894. 16.15 The Loge, 1874. Courtauld Institute Galleries, London.

REPIN, Ilya 13.18 Barge-Haulers on the Volga (detail), 1873. Russian Museum, St. Petersburg.

REPTON, Humphry 5.3, 5.4 "View from my own cottage, in Essex," before and after, from Fragments on the Theory and Practice of Landscape Gardening, 1816.

RICHARDSON, H. H. 14.25 Marshall Field Whole-sale Store, Chicago, 1885–7. Chicago Architectural Photographing Company.

ROBINSON, Henry Peach 12.27 Fading Away,

1858. International Museum of Photography at George Eastman House, Rochester, NY.

RODIN, Auguste 20.39 The Gates of Hell, 1880–1917. Musée Rodin, Paris. Photo Bulloz. 20.40 Iris, Messenger of the Gods, ca. 1890. Musée Rodin, Paris. 20.42 Fugit Amor, ca. 1887. Musée Rodin, Paris.

ROGERS, John 9.5 Slave Auction, 1859. Courtesy of The New-York Historical Society, New York City

ROSSETTI, Dante Gabriel 11.5 Beata Beatrix, 1867–70. Tate Gallery, London. 11.6 Ecce Ancilla Domini!, 1848. Tate Gallery, London.

RUDE, François 10.12 The Marseillaise (The Departure of the Volunteers of 1792), 1833–6. Arc de Triomphe, Paris.

RUNGE, Philipp Otto 6.2 Fingal with Raised Spear, 1804. Kunsthalle, Hamburg. 6.3 Night, 1805. Kunsthalle, Hamburg. 6.4 Morning (small version), 1808. Kunsthalle, Hamburg. 6.5 The Downfall of the Fatherland, 1809. Kunsthalle, Hamburg.

RUTHERFORD, Lewis M. 12.8 Moon, March 4, 1865. International Museum of Photography at George Eastman House, Rochester, NY.

SARGENT, John Singer 16.9 Lady Agnew of Lochnaw, ca. 1892–3. National Galleries of Scotland, Edinburgh. 16.10 Ena and Betty, Daughters of Mr. and Mrs. Asher Wertheimer, 1901. Tate Gallery, London.

SCHEFFER, Ary 10.4 Saint Augustine and Saint Monica, 1854. Reproduced by courtesy of the Trustees, The National Gallery, London.

SCHINKEL, Karl Friedrich 7.12 Design for a mausoleum and memorial chapel for Queen Luise of Prussia, 1810. Nationalgalerie, Staatliche Museen zu Berlin.

SCOTT, George Gilbert, and W. H. Barlow 7.25 Midland Grand Hotel and St. Pancras station, London, 1868–76. National Monuments Record.

SERNESI, Raffaello 13.9 Roofs in Sunlight, 1860–61. Galleria Nazionale d'Arte Moderna, Rome.

SEURAT, Georges 17.1 Aman-Jean, 1882-3. The Metropolitan Museum of Art, New York. Bequest of Stephen Carlton Clark, B.A. 1960. All rights reserved, The Metropolitan Museum of Art. 17.2 The Echo, 1883. Yale University Art Gallery, New Haven. Bequest of Edith Malvina K. Wetmore. 17.3 A Bathing Place, Asnières, 1883-4. Reproduced by courtesy of the Trustees, The National Gallery, London. 17.5 A Sunday Afternoon on the Island of the Grande Jatte, 1884-6. The Art Institute of Chicago. Helen Birch Bartlett Memorial Collection, 1926.224. Photo © 1993, The Art Institute of Chicago, All Rights Reserved. 17.8 Le Crotoy, Upstream, 1889. Detroit Institute of Arts. Bequest of Robert H. Tannahill. © The Detroit Institute of Arts 1993. 17.9 The Models, 1886–8. The Barnes Foundation, Merion Station, PA. 17.10 Final study for Chahut, 1889. Albright-Knox Art Gallery, Buffalo, NY. General Purchase Fund 1943. 17.11 Chahut, 1889-90. State Museum Kröller-Müller, Otterlo. 17.14 The Circus, 1890-91. Musée d'Orsay, Paris. Bequest of John Quinn, 1924. Photo Bulloz. 19.2 Young Woman Powdering Herself, 1889-90. Courtauld Institute Galleries, London.

SIGNAC, Paul 17.6 The Dining Room, Breakfast, 1886–7. State Museum Kröller-Müller, Otterlo.

SOANE, Sir John 7.2 Unexecuted design for alterations to the conservatory on the garden front at Pitzhanger Manor (detail), 1806–10. By courtesy of the Trustees of Sir John Soane's Museum, London. 7.17 Consols Transfer Office, Bank of England, London 1798–9. From H. Rookby Steele and F. R. Yerbury, The Old Bank of England, 1930. SOUFFLOT, Jacques-Germain 7.6 Interior of Ste. Geneviève (the Pantheon), Paris, 1756–90. Photo A. F. Kersting

SOUTHWORTH, Albert Sands, and Josiah Johnson Hawes 12.7 Postmortem photograph of an unidentified child, ca. 1850's. International Museum of Photography at George Eastman House, Rochester, NY. 12.14 Portrait of Albert Sands Southworth, ca. 1848. International Museum of Photography at George Eastman House, Rochester, NY.

STEVENS, Alfred 19.13 The Japanese Dress, ca. 1880. Musée d'art moderne et d'art contemporain, Liège.

STICKLEY, Gustav 14.9 "Chalet table" 1900. Dilliof Collection.

SULLIVAN, Louis 14.28 Wainwright Building, St. Louis, MO, 1890–91. Photo Hedrich Blessing. 14.29 Carson, Pirie, Scott and Company department store, Chicago (detail), 1898–9. Photo Emily Lane.

TALBOT, William Henry Fox 12.4 Latticed Window at Lacock Abbey, 1835. Trustees of the Science Museum, London. 12.5 The Open Door (The Pencil of Nature, pl. VI), 1843. The Fox Talbot Museum, Lacock, England.

TANNER, Henry Ossawa 9.25 The Banjo Lesson, 1893. Hampton University Museum, Hampton, VA.

THONET, Michael 14.5 Bentwood "café chair" no. 14, 1859. Photo Gebrüder Thonet GmbH.

TIFFANY, Louis Comfort 14.20 "Cobweb" library lamp, ca. 1900. Charles Hosmer Morse Museum of American Art, Winter Park, FL.

TOULOUSE-LAUTREC, Henri de 17.12 Le Divan Japonais, 1892–3. 18.1 Poudre de Riz, 1887. Stedelijk Museum, Amsterdam. 18.2 Au Cirque Fernando: Equestrienne, 1887–8. Art Institute of Chicago, Joseph Winterbotham Collection. 18.3 In Bed, 1893. Musée du Louvre, Paris. 18.5 Two Friends, 1895. Private collection. 18.6 Jane Avril, 1893. Guardsmark, Inc., Collection, Memphis. 18.7 Ambassadeurs, Aristide Bruant, 1892. Musée Toulouse-Lautrec, Albi.

TURNER, Joseph Mallord William 0.4, 5.20 Rain, Steam, and Speed—The Great Western Railway, 1844. Reproduced by courtesy of the Trustees, The National Gallery, London. 5.16 London, 1809. The Turner Collection, Tate Gallery, London. 5.17 Snow Storm: Hannibal and His Army Crossing the Alps, 1812. The Turner Collection, Tate Gallery, London. 5.18 Dudley, Worcestershire, ca. 1831–2. The Board of the Trustees of the National Museums & Galleries on Merseyside (Lady Lever Art Gallery, Port Sunlight). 5.19 Slavers Throwing Overboard the Dead and Dying—Typhoon Coming On, 1840. Courtesy, Museum of Fine Arts, Boston.

USSI, Stefano 13.7 The Expulsion of the Duke of Athens From Florence, 1861. Galleria d'Arte Moderna, Palazzo Pitti, Florence.

UTAMARO, Kitagawa 16.23 A Mother Bathing Her Son Edo period, eighteenth century. The Metropolitan Museum of Art, New York. The H. O. Havemeyer Collection, Bequest of Mrs. H. O. Havemeyer. All rights reserved, The Metropolitan Museum of Art.

VANDERLYN, John 6.13 Marius Amidst the Ruins of Carthage, 1807. De Young Museum. Fine Arts Museums of San Francisco. 8.3 The Death of Jane McCrea, 1804. Wadsworth Atheneum, Hartford, CT.

VAN DE VELDE, Henry 14.11 Poster for "Tropon," 1897. Victoria & Albert Museum, London. 14.23 Desk for Julius Meier-Graefe 1899. Germanisches Nationalmuseum, Nuremberg.

VERNET, Horace 2.19 City Gate at Clichy, 1822. Musée du Louvre, Paris. Photo © R.M.N. 10.1 The Duc d'Orléans Proceeds to the Hôtel-de-Ville,

- July 31, 1830, 1833. Musée National du Château, Versailles.
- VIGEE-LEBRUN, Elisabeth-Louise 1.4 Portrait of the Artist With Her Daughter, 1789. Musée du Louvre, Paris. Photo © R.M.N. 1.5 Marie-Antoinette With Her Children, 1784. Musée National du Château, Versailles. Photo © R.M.N.

VOYSEY, C. F. A. 14.13 Moorcrag, near Gillhead, Cumbria, 1898–9.

VRUBEL, Mikhail 20.23 Pan, 1899. Tretyakov Gallery, Moscow.

WATKINS, Carleton E. 12.16 Cape Horn near Celilo, 1867. Gilman Paper Company Collection.

WEBB, Philip 14.6 Red House, Bexleyheath, Kent, ca. 1860. National Monuments Record. 14.12 Standen, near East Grinstead, Sussex, ca. 1892–4. Photo Emily Lane

WEST, Benjamin 4.12 The Destruction of the Old Beast and False Prophet, 1804. Minneapolis Institute of Arts. The William Hood Dunwoody Fund. 4.14 Design for The Apotheosis of Nelson, 1807. Yale Center for British Art, New Haven. Paul Mellon Collection.

WHISTLER, James Abbot McNeill 13.10 The White Girl, 1862. © 1993 National Gallery of Art, Washington, DC. Harris Whittemore Collection.

WIERTZ, Antoine 10.18 Two Young Girls or The Beautiful Rosine, 1847. Musée Wiertz, Brussels. Photo A.C.L.

WILD, Charles 7.13 Fonthill Abbey, Wiltshire, ca.

1799. Victoria & Albert Museum, London.

WRIGHT, Frank Lloyd 14.24 Ward W. Willits House, Highland Park, IL, 1900–1902. © ARS, N.Y. and DACS, London 2007.

WO-HAW 8.15 Reading Class at Fort Marion, 1875 7. Missouri Historical Society. Negative. Indians 117.

Other illustrations

- 1.18 After François Gérard, Belisarius, 1795. Bibliothèque Nationale, Paris.
- 1.22 After Philippe-Auguste Hennequin, *The Remorse of Orestes*, 1800. Bibliothèque Nationale, Paris.
- 4.15 Baron d'Hancarville, Researches on the Origin, Spirit and Progress of the Arts of Greece, 1785, I,
- 7.14 Fonthill Abbey, Wiltshire, after Charles Wild, from John Rutter, *Delineations of Fonthill and its* Abbey, 1823.
- 7.20 Galerie d'Orléans, Paris, by P.-E.-L. Fontaine, after J.-B. Arnout, from Paris et ses souvenirs, 1829. Lithograph.
- 8.2 "America," from *The Four Continents*, 1804. The Henry Francis du Pont Winterthur Museum. Courtesy, Winterthur Museum.
- 8.10 Mandan buffalo robe, collected in 1837. Historical Museum, Berne.

- 9.9 War Photograph and Exhibition Company, A Group of "Contrabands", ca. 1861–5. George Eastman House Collection, Rochester, NY.
- 9.10 Taylor and Huntington Publishers, Execution of a Colored Soldier, 1864. Courtesy of The New-York Historical Society, New York City.
- 12.6 Unidentified photographer (American), Spirit Photograph—Woman's Spirit behind Table with Photograph, ca. 1865. Museum purchase. International Museum of Photography at George Eastman House, Rochester, NY.
- 12.9 Unidentified photographer (French?)
 Odalisque, ca. 1840's. International Museum of
 Photography at George Eastman House,
 Rochester, NY.
- 12.12 Unidentified artist after a woodburytype by Mathew Brady, Abraham Lincoln, from *Harper's Weekly*, 1860. Library of the National Portrait Gallery and the National Museum of American Art, Smithsonian Institution, Washington, DC.
- 12.13 Unidentified photographer (American), Woman Seated, Holding Daguerreotype, ca. 1850. Gift of Ueda L. Burker. International Museum of Photography at George Eastman House, Rochester, NY.
- 14.14 View of Bedford Park, London, 1882. Photo Private Collection/The Stapleton Collection/ The Bridgeman Art Library.
- 14.27 Eiffel Tower, Paris, 1889. Contemporary photograph.

INDEX

Page numbers in italic refer to illustrations.

Abbati, Giuseppe, 298-9; Cloister, 299 Academic Painting, 266 Académie des Beaux-Arts, 226, 303, Académie Julian, 222 Academy of Fine Arts, Antwerp, 397 Academy of Fine Arts, Brussels, 412 Academy of Science, Paris, 265, 267 Adamson, Robert, 227, 280, 288; Disruption Picture, 277; Mrs. Elizabeth (Johnstone) Hall, 277 Adorno, Theodor, 141, 442 Alba, Duquesa de, 87, 95 Algardi, Alessandro, 235 All-German Historical Exhibition (1858), 295Allston, Washington, 152; Jeremiah Dictating His Prophecy of the Destruction of Jerusalem to Baruch the Scribe, 152, 152 Althusser, Louis, 14 Aman-Jean, Edmond-François, 368, American Art Students' Club, Paris, American Society of Painters of Water Color Exhibition (1878), 221 d'Ancona, Vito, 298 Angrand, Charles, 372, 375 Anguetin, Louis, 383, 412 Anseele, Edouard, 417, 418 Antigna, Alexandre, 305 Anti-Slavery League, 201 Anti-Slavery Society, 200 Arago, François, 265, 267, 271-4, 283, 292 Arc-et-Senans, Royal Salt Works, 164, 165 Art moderne, 417 Art Nouveau, 311, 318, 323 Artel'Khudoznikov, 307-8 Ashbee, C. R., 316, 323 Athenaeum, 271 Atlantic Monthly, 275 Aurier, Albert, 408, 409 Austen, Jane, 120 Autre Monde, Un, 244, 244 d'Avignon, François, 275 Avril, Jane, 387, 388, 388 Babeuf, Gracchus, 41 Balzac, Honoré de, 63, 173, 243, 270-71, 275, 281, 333 Banti, Cristiano, Brush Gatherers, 299 Barbizon school, 156, 304, 305, 340, Barcelona: Palau Guell, 323, 324 Barlow, W. H., 176, 310; St. Pancras railway station, London, 176, 177, Barlow, General Francis Channing, 212 Barlow, Joel, 184 Barnum, P. T., 276

Barrell, John, 127

Barry, Sir Charles, 175; Palace of

Barry, James, 110-11; King Lear

Weeping Over the Body of Cordelia,

109, 110; Satan and His Legions

Hurling Defiance Toward the Vault

Westminster, 175-6, 176

of Heaven, 110, 110 Barthes, Roland, 412 Barye, Antoine-Louis, 230; Lion Crushing a Serpent, 230, 231 Bastien-Lepage, Jules, 291 Batchen, Geoffrey, 269 Baudelaire, Charles, 12, 14, 238, 242–4, 250, 251, 253, 261, 272 279, 280, 282-3, 287, 292, 300, 333, 335, 338, 382, 386, 406, 416, 434; portrait by Carjat, 282; portrait by Courbet, 6 Baudot, Anatole de, 323; church at Rambouillet, 323; St. Jean de Montmartre, Paris, 323, 324 Baudry, Paul, 336 Bauer, Bruno, 345 Bayard, Hippolyte, 265 Bazille, Frédéric, Toilette, 337, 337 Beard, Richard, 272 Becher, Rev. J. T., 167; workhouse, Southwell, Notts., 167 Beckford, William, 168–70; Fonthill Abbey, 168, 169 Bedford Park, London, 319, 320 Belgian Workers' Party, 417 Bénédite, Léonce, 15 Benjamin, Walter, 125, 252, 274, 277, Benjamin-Constant, Jean-Joseph, 222 Bennett, Lerone, Jr., 199, 215 Benson, Eugene, 213 Bentham, Jeremy, 166 Benvenuti, Pietro, 296 Berkeley, Bishop, 185 Berlo, Janet, 195 Bernard, Emile, 383, 400, 401, 403, 412, 441, 446, 448, 450; Self-Portrait With Portrait of Gauguin, 399, 401 Bernhardt, Sarah, 281, 281 Bernini, Gian Lorenzo, 336 Bertall (Charles Albert d'Arnoux), 340 Bezzuoli, Giuseppe, 296 Biedermeier, 293, 295 Billaud, Jacques, 173; Galerie Colbert. Paris, 173 Billings, Hammatt, Uncle Tom and Little Eva, 201-2, 203 Bing, Samuel, 400 Bingham, R. J., 278 Bisson brothers, 281 Blake, Catherine (Boucher), 102, 103 Blake, William, 9–10, 12, 81, 101, 102–18, 131, 142–3, 224, 225, 226; Albion Rose, 103, 104, 105, 143; America, 9, 103, 105; Ancient Britons, 118; Europe, 9, 103; French Revolution, 9; Great Red Dragon and the Woman Clothed With the Sun: "The Devil is Come Down," 116, 117; Jerusalem, the Emanation of the Great Albion, 106; Laocoon, 117-18, 118; Milton, 106; Narrative of a Five Years' Expedition against the Revolted Negroes of Surinam, in Guiana, on the Wild Coast of South America (Stedman/Blake), 106, 106; 'Poetical and Historical Inventions, 102, 107; Songs of Experience, 9, 9; Spiritual Form of Nelson Guiding Leviathan, in whose Wreathings are Infolded the Nations of the Earth, 107, 108, 109, 114, 117, 118; Spiritual Form . . . (of Pitt), 114; Visions of the Daughters of Albion, 105, 105

Blanc, Charles, 370 Blanc, Louis, 251 Blanquart-Evrard, Louis-Désiré, 277-8 Blanqui, Auguste, 227, 233, 251 Böcklin, Arnold, 408, 420, 423; Island of the Dead, 419, 420; Vita Somnium Breve, 419, 420 Böhme, Jakob, 144 Boileau, L. A., 310; Bon Marché store, Paris, 310, 311 Boime, Albert, 16, 208, 219, 230, 236, 298 Bonaparte, Joseph, 230, 232 Bonheur, Rosa, 251, 305; Horse Fair, 306, 306; Plowing in the Nivernais: the Dressing of the Vines, 257, 258, 306 Bonnard, Pierre, 383, 408 Bonnat, Léon, 304, 422 Boone, Daniel, 184, 186 Borghese, Princess Pauline, 59 Borrani, Odoardo, 26th of April, 1859, 296, 298 Bouchardon, Edmé, 233 Boucher, François, 61, 90 Boudin, Eugène, 340 Bouguereau, William-Adolphe, 303, 304, 336; Nut Gatherers, 396, 397 Boullée, Etienne-Louis, 160-61; design for a Royal Library, 160-61, 162 Boulogne, Guillaume-Benjamin Duchenne de, 285, 285 Bourgoing, J. F. de, 87-8 Bouton, Charles-Marie, 265 Boydell, John, 110 Brackett, Edward, 217 Brady, Mathew, 194, 221, 275–6; portraits of Abraham Lincoln, 274 Breitner, George, 393 Breton, André, 438 Breton, Jules, 251; Blessing the Wheat in the Artois, 305, 306, 397; Gleaners, Brettell, Richard R., 16 Breugel, Pieter, 101, 233, 406, 412; Battle Between Carnival and Lent, 416; Blind Leading the Blind, 396 Brewster, Sir David, 270, 271, 277, 279 Brighton: Royal Pavilion, 172, 173 Briullov, Karl, 307; Last Day of Pompeii, 307 Broc, Jean, 71; Death of Hyacinth in the Arms of Apollo, 44-5, 45 Bronowski, Jacob, 107 Brooklyn Art Association, 209 Brothers, Richard, 106 Brown, Ford Madox, 250, 314-5; Work, 249, 250 Brown, John, 203 Bruant, Aristide, 386–8; Ambassadeurs, Aristide Bruant, 387, 389 Bruni, Fedor, 305 Brussels: Maison du Peuple, 324, 325 Bryant, William Cullen, 152 Bryson, Norman, 11-12 Buchon, Max, 442 Buffalo, NY: Larkin Building, 326; Guaranty Building, 324 Bullard, Laura Curtis, 219 Burke, Edmund, 110-11, 120 Burne-Jones, Edward, 314-5 Burns, Robert, 277

Burr, Aaron, 152

Butts, Thomas, 117 Byron, Lord, 73, 74, 79, 80, 134 Cabanal, Alexandre, 303, 304, 336 Cabat, Louis, 305 Cabinet d'Anatomie Comparée, Paris, Cachin, Françoise, 303 Cafiero, Carlo, 418 Caillebotte, Gustave, Balcony, Boulevard Haussmann, 343, 344 Cameron, Julia Margaret, 288, 290, 292; Illustrations to Tennyson's "Idylls of the King" and Other Poems, 288; Whisper of the Muse, 289 Cameron, Simon, 199 Camp, Maxime du, Thebes: The Eastern Part of the Peristyle of the Temple of Ramases, 278, 278 Campbell, Thomas, 134 Campin, Robert, Mérode Altarpiece, Canaletto, 135 Cañizares, José de, 94 Canning, George, 114 Canova, Antonio, 58–9, 60, 61: Magdalene, 58, 60, 63; Pauline Borghese as Venus, 58, 59, 81; Perseus, Caravaggio, Ecstasy of Saint Francis, Carjat, Etienne, 282; portrait of Baudelaire, 282 Carlyle, Thomas, 138, 177, 179, 250, 314, 400; Past and Present, 250 Carnot, Lazare, 260 Carolus-Duran, Charles-Emile-Auguste, 355; The Kiss, 385, 387 Carpeaux, Jean-Baptiste, 336; Dance, 336, 337 Carroll, Lewis, 288, 361; Xie Kitchin with Umbrella, 289 Carstens, Asmus Jakob, 143-4, 293; Night and Her Children, 143, 143 Carus, Carl Gustav, 236 Cassatt, Mary, 15, 349, 353-5, 357-8, 360-66, 387; Afternoon Tea Party, 363, 364; Baby Reaching for an Apple, 365; Bath, 361, 362; Boating Party, 352, 354; Caress, 361; Coiffure, 362, 363; Emmie and her Child, 360; First Caress, 360, 361; Fitting, 362; Five O'Clock Tea, 351, 353, 354; Lady at her Tea Table (Mrs. Robert Riddle), 360; Lamp, 361; Letter, 363, 364; Lydia Crocheting in the Garden at Marly, 360; Lydia Working at a Tapestry Frame, 359, 360; Maternal Caress, 362; Modern Woman, 363-5; Mother and Child, 361, 361; Mother's Kiss, 362, 363; Omnibus, 363, 364; Portrait of Louisine Elder Havemeyer, 349-353, 351; Reading Le Figaro, 359, 360; Self-Portrait, 349, 350; Woman in Black at the Opera, 357, 357, 358, 387; Young Women Picking Fruit, 365, 367 Castagnary, Jules, 302, 303, 304, 305, 307, 340 Castille, Hippolyte, 302 Catlin, George, 187, 188–90, 191, 192, 303; Catlin Painting the Portrait of Mah-To-Toh-Pa-Mandan, 191, 192; Clermont, First Chief of the

Tribe, 189, 190, 192; Last Race, Part

of Okipa Ceremony, 187, 189, 190; Letters and Notes . . . , 189, 190 Cenci, Beatrice, 216, 217 Cézanne, Louis-Auguste, 442, 443, Cézanne, Paul. 15, 90, 303, 362, 426. 438, 440-51, House of the Hunged Man, Auvers-sur-Oise, 446, 447; Houses in Provence (Vicinity of L'Estaque), 449, 450; Large Bathers, 451, 452; L'Estaque, 446, 448; Modern Olympia, 442, 443; Montagne Sainte-Victoire, 426: Mont Sainte-Victoire, 451, 453; Mont Sainte-Victoire Seen From Bibémus, 449, 450; Pastoral Scene, 441, 442; Portrait of L. A., 450; Portrait of Louis-Auguste Cézanne, Father of the Artist, Reading L'Evénement, 442-3, 445; Portrait of the Painter, Achille Emperaire, 443, 444; Portrait of Uncle Dominique 443, 444; Rape, 442, 443, 444; Self-Portrait, 442; Sorrow, or Mary Magdalene, 442; Still Life With Apples, 450, 452; Temptation of Saint Antony, 442 Chadwick, Whitney, 217 Champfleury (Jules Husson), 251, 253, 258, 261, 264 Chapman, John Gadsby, Baptism of Pocahontas, 184 Chapman, Maria Weston, 217 Charcot, Jean-Martin, 387 Charivari, Le, 244, 251, 280 Charles III, King of Spain, 86 Charles IV, King of Spain, 86, 90, 95 Charles X, King of France, 11, 74, 76, 80, 227 Charpentier, Constance, 44-5; Melancholy, 43, 44, 53, 62 Chartier, Henri le, 434, 435 Chassériau, Théodore, 252, 304; Portrait Drawing of de Tocqueville, 252, 252 Chaumelin, Marius, 343 Chéret, Jules, 383; Bal du Moulin Rouge, 379, 380, 386, 387 Chevreul, Michel-Eugène, 281, 372 Chicago: Carson, Pirie, Scott and Company department store, 331, 331; Marshall Field Wholesale Store, 327, 327; World's Columbian Exposition (1893), 222, 363 Chrysalide group, 414 Church, Frederick, 157; Cotopaxi, 158, 159; Twilight in the Wilderness, 157, 159 Claretie, Jules, 336 Clark, T. J., 16, 255, 258, 259, 336, 345 Clark, William, 186, 190 Classicism, 10-12, 13-14, 18-23, 32-50, 55-72, 76-8, 81, 107, 180-84, 230, 233, 236, 238, 295, 296, 304, 375 Claude Lorrain, 120, 135, 201, 419 Claudel, Camille, Waltz, 435, 437 Clésinger, Jean-Baptiste, Woman Bitten by a Snake, 239, 241 Cohoe, 195; Fort Marion Prisoners Dancing for Tourists, 195, 196 Cole, Thomas, 153-7, 201; Course of Empire: Desolation, 154, 154; View of the Round-Top in the Catskill Mountains, 153, 153 Coleridge, Samuel Taylor, 114, 152 Constable, John, 126-7, 130-31, 133, 135, 136, 224-6, 419, 451; Dedham Vale, 127, 128, 130; Golding Constable's Flower Garden, 124, 126;

124, 126; Hadleigh Castle, Mouth of the Thames-Morning After a Stormy Night, 129, 130, 224; Hay Wain (Landscape: Noon), 125, 127; Old Sarum, 129, 130-31 Cooper, James Fenimore, 151-2 Corday, Charlotte, 36 Corneille, Pierre, 20-21, 27 Cornelius, Peter, 246, 293, 296 Corot, Camille, 340, 397 Cottancin, Paul, 323; St. Jean de Montmartre, Paris, 323, 324 Courbet, Gustave, 14-15, 17, 90, 96, 226, 242, 250-64 passim, 295, 300, 304, 305, 307, 314, 336, 337, 361, 362, 375, 386, 391, 404, 416, 440, 451; After Dinner at Ornans, 253, 254; Burial at Ornans, 256, 257, 258, 280, 323-5, 366; Château d'Ornans, 264; Grand Panorama of the Alps With the Dents du Midi, 263, 264; Man With Leather Belt, 252, 252 Meeting (Bonjour Monsieur Courbet), 255, 258, 412; Peasants of Flage) Returning From the Fair, 256, 258, 261; Portrait of Baudelaire, 6; Seaside, 262, 264; Sleepers, 262, 264, 335; Stonebreakers, 254, 255, 258, 314; Studio of the Painter, 260, 260, 261, 263, 264; Toilette of the Bride, 337; Wounded Man, 252; Young Ladies on the Banks of the Seine, 261, 264 Courrier français, Le, 383, 386 Cousin, Victor, 230 Couture, Thomas, 228, 236, 238, 239, 252; Romans of the Decadence, 236, 236, 237, 238, 239, 240, 286, 336 Crayon, The 188 Crow, Thomas, 259 Cruz, Ramón de la, 86 Cubism, 408, 451 Curtis, Edward, 180, 197 Curtis, Gerard, 250 Custer, General George, 193-4, 196 Cuvier, Georges, 230, 232, 233 Dagnan-Bouveret, Pascal, 411 Daguerre, Louis Jacques Mandé 265-7, 268, 271, 274, 282; Boulevard du Temple, 266, 267 Dance, George, the Younger, 160-61, 170, 179; design for an identified domed building, 160, 161 Danhauser, Josef, 293; Eye Doctor, Dante, 10, 11, 57, 73, 106, 434-5 Darwin, Charles, 285; Expression of Emotion in Man and Animals, 285 Daumier, Honoré, 227, 242, 244, 251, 300, 391, 413; "Abduction of Helen," 244; Ratapoil, 300; Rue Transnonain, April 15, 1834, 227, 228; Third-Class Carriage, 242, 243; You have the floor, explain yourself, 227 David, Jacques-Louis, 9, 18–54 passim, 57, 61, 72, 79, 96, 102, 110, 232, 252, 293, 303, 370, 397; Aeneas Carrying Anchises From the Ruins of Troy (with F. Gérard), 49, 51; Belisarius Begging Alms, 9, 19-20, 20; Coronation of Napoleon, 303; Death of Bara, 36-8, 37; Death of Lepelletier de Saint-Fargeau, 36, 36; Hector, 36; Intervention of the Sabine

Women, 46, 46, 48, 52, 98; Leonidas

at Thermopylae, 28, 47-8, 47, 50-51;

Bodies of His Sons, 29, 30, 32, 34, 38,

46, 57, 78; Marat at his Last Breath,

35-6, 35, 41; Napoleon at the St.

Lictors Returning to Brutus the

Horatii Between the Hands of Their Father, 20, 21-23, 26-30, 46, 53, 80; Oath of the Tennis Court, 34, 34-5; Socrates at the Moment of Grasping the Hemlock, 26-7, 26, 29, 32, 34, 45 David d'Angers, l'ierre-Jean, 151, 227, 230, 232, 233, 235, 236; Monument to Emancipation, 236: Motherland Calling Her Children to the Defense of Liberty, 233, 235; Pantheon pediment, 232, 233, 233 Davis, A. J., 169-70; Knoll, Tarrytown, NY, 169, 170 Davis, Theodore R., 193-4, 194, 195, 208 Davy, Humphry, 267 Defregger, Franz von, 295 Degas, Edgar, 304, 342-5, 349, 362, 379, 386, 390, 422; Criminal Physiognomies, 345; Dance School, 343, 346; Little Dancer Aged Fourteen, 345, 345; Miss Lola at the Cirque Fernando, 379; Portraits at the Stock Exchange, 343, 345, 346 Delacroix, Eugène, 68, 72, 73, 77 101, , 227, 230, 232, 238, 240, 281, 304, 404, 441, 304, 370, 397, 404; Bark of Dante and Virgil, 73-4, 74; Death of Sardanapalus, 78, 79-80; Greece on the Ruins of Missolonghi, 79, 80; Massacre at Scio (Chios), 73-6, 75, 79; 28th of July: Liberty Leading the People, 81, 80–81, 226, 232, 233, 238; Women of Algiers, 238, 240, 336 Delaroche, Paul, 226, 227, 233, 238, 277, 295; Artists of All Ages, 228-9, 227, 233 Delécluze, Etienne, 11, 14 Demolder, Eugène, 417 Denis, Maurice, 408, 429, 442; April, 429, 429 Descamps, Guillaume 259, 304 Descartes, René, 15 Devéria, Eugène, 78, 79; Birth of Henri IV, 77, 77 Devosge, Anatole, 36 Diaz, Narcisse, 304 Dickens, Charles, 103, 250, 281, 400 Dictionnaire Véron, 450 Diderot, Denis, 27 Disdéri, André Adolphe-Eugène, 279-80, 281, 282; Art of Photography, 280; portrait of unidentified woman, 280 Downing, A. J., 169-70 Dreyfus Affair, 366, 450 Driffield, Vero Charles, 291 Droit de Femmes, Le, 383 Drouais, Jean-Germain, 20, 29, 30, 32, 33, 34, 35, 38, 41, 64, 65; Dying Athlete, 27, 29-30, 33, 38; Marius at Minturnae, 28, 30, 33 Drumont, Edouard, 345 Dryden, John, 189 DuBois, W. E. B., 211 Dubois-Pillet, Albert, 372; Portrait of Mlle. M. D., 390 Dujardin, Edouard, 379, 406 Duncanson, Robert Scott, 201, 216; Falls of Minnehaha, 201; Landscape With a View of Vesuvius and Pompeii, 201; Uncle Tom and Little Eva. 201-2, 203; Valley Pasture, 201 Dupont, Pierre, 253 Dupré, Augustin, Diplomatic Medal, 181–3, 182 Dupré, Jules, 304 Durand, Asher B., 155, 156; Landscape, Progress, 155, 155

Bernard Pass, 47, 48, 52; Oath of the

Durand-Ruel, Paul, 342 Duranty, Edmond, 302 Dürer, Albrecht, 145, 146 Duret, Théodore, 340 Eakins, Thomas, 15, 220-22, 349, 353 9, 361, 363, 366; Concert Singer (Weda Cook), 357, 357; Coral Necklace, 357; Girl With Cat, 361, 361; Gross Clinic, 358, 358; Home Scene, 361; Max Schmitt in a Single Scull, 352, 354; Miss Van Buren, 356, 356, 357; Negro Boy Dancing, 221, 221; Old-Fashioned Dress (Portrait of Helen Parker), 357; Portrait of Mrs. Edith Mahon, 351. 353, 357; Portrait of Professor Rand, 356, 356; Self-Portrait, 349, 350; Swimming Hole, 350, 353; William Rush Carving His Allegorical Figure of the Schuylkill River, 363, 365; Will Schuster and Black Man Going Shooting (Rail Shooting), 220, 220-21 Easterly, Thomas, 192-3; Keokuk, or the Watchful Fox, 192-3, 193 Eastlake, Sir Charles, 283 Eastlake, Lady Elizabeth, 283, 284, 288, 290 Ecole des Beaux-Arts, Paris, 227, 368, Eiffel, Gustave, 310, 328; Bon Marché store, Paris, 310, 311; Eiffel Tower, Paris, 328, 329, 330 Eiffel Tower Exposition, Paris (1889), 327-8, 450 Eitner, Lorenz, 15 Elderfield, John, 446, 450 Eliot, George, 314 Emerson, Peter Henry, 290-92; Death of Naturalistic Photography, 291; Life and Landscape on the Norfolk Broads, 290–91; Poling the Marsh Hay, 290-91, 291 Emerson, Ralph Waldo, 157, 275, 276 Enfantin, Prosper, 238 Engels, Friedrich, 14 Ensor, James, 324, 412-414, 416-418; Belgium in the Nineteenth Century, 418; Entry of Christ into Brussels in 1889, 415, 416, 418; Gendarmes, 417, 418; Iston, Pouffamatus, Cracozie, and Transmouff, Famous Persian Physicians . . . Battle of Arbela, 413, 413; My Portrait in 1960, 418, 419; Old Woman With Masks, 416, 417; Skeletons Fighting for the Body of a Hanged Man, 416; Tribulations of Saint Antony, 413 Erdman, David, 107 Escaramouche, L', 383 Esposizione Nazionale, Florence (1861), 296Esquilache, Marquis of, 86 Essor group, 414 Etienne, Louis, 303 Evening Post, 213 Examiner, 136 "Examples of False Principles in Decoration," exhibition at the Museum of Ornamental Art (later

Fantin-Latour, Théodore, 304, 406 Fatherland Museum, 145 Fattori, Giovanni, 298 Fauves, 450 Faux, William, 188

Eytinge, Sol, Jr., 215; Virginia One

Hundred Years Ago, 215

the Victoria & Albert Museum, see

below), 313

Eyck, Jan Van, 412

Golding Constable's Kitchen Garden,

182, 212, 230, 233, 244, 443; 47, Napoleon III, Emperor of France, 250, 258, 260, 279, 303, 313, 336, 443; 257, 304 Nash, John, 170, 172-3; Quadrant, Regent Street, London, 172, 172-3; Royal Pavilion, Brighton, 172, 173 Nasmyth, James, 138 Nast, Thomas, 210–11, Entrance of the Fifty-fifth Massachusetts (Colored) Regiment into Charleston, South Carolina, February 21, 1865, 211, 211 Natanson, Thadée, 386 National Academy of Design, 204, 208, 211; Annual Exhibitions, (1865), 209; (1866), 209, 212 Naturalism, 15, 277, 282, 290, 293, 296, 300, 304 Nazarenes, 146, 246, 293, 296 Nègre, Charles, 288; Henri Le Secq at Notre-Dame Cathedral, 288 Nelson, Lord, 107, 108, 109 Neoclassicism see Classicism Neoimpressionism, 368-81, 390, 409, 414 Nerval, Gérard de, 280 New York Illustrated News, 211 Newton, Sir William, 287–8, 290 Nicholson, William, 167; workhouse, Southwell, Notts., 167 Niépce, Claude, 266 Niépce, Isidore, 266, 267 Niépce, Joseph Nicéphore, 265, 266, 267, 268, 271; View From the Window at Le Gras, 266 Nieuwerkerke, Comte de, 260, 303, 443 Nochlin, Linda, 260, 344 Nouguier, Emile, 328 Novak, Barbara, 157 Novotny, Fritz, 15 Oberlin College, 216 Offenbach, Jacques, 333

(Bonaparte), 48, 49, 52, 57, 58, 60,

65, 82, 96, 100, 103, 114, 149, 152,

Official Painting, 226 Ogden, Robert C., 223 Olbrich, Josef, 430; House of the Secession, Vienna, 430, 431 Oliver, Douglas, 435 Orton, Fred, 400 Orvell, Miles, 292 Ossian, 50, 110, 142, 150; 48 O'Sullivan, Timothy, 275, 276; 284 Osuna, Duque and Duquesa de, 85, 86,94 Overbeck, Johann Friedrich, 146-8, 246; Portrait of Franz Pforr, 147, Paine, Thomas, 9, 103, 104 Pajou, Augustin, 26, 233 Palmer, Bertha Potter, 365, 366 Palmer, Samuel, 131, 133; Hilly Scene, 130, 132 Papety, Dominique, Dream of Happiness, 238, 239 Paris: Rue de Rivoli, 172; Bon Marché store, 310, 311; Ecole des Beaux-Arts, 227, 368, 397; Eiffel Tower, 328, 329, 330; Galerie Colbert, 173; Galerie d'Orléans, 173, 173; Gare du Nord, 176; Louvre, 10, 11; Opera House, 330; Pantheon, 162-3, 163; St. Jean de Montmartre, 323, 324 Paulet, Alfred, 371 Paxton, Joseph, 279 Pennell, Joseph, 177, 222, 327; Crystal Palace, 176-179, 178,

179, 314, 327-8 Pennsylvania Academy of Design, Pennsylvania Academy of Fine Arts, 220, 349 Percier, Charles, 330 Perov, Vasily, 308 Perthes, Friedrich, 145 Perugino, 288 Peskelechaco, Chief, 188 Petalesharro, Chief, 188 Peyron, Pierre, 22; Death of Alcestis, 22, 22 Pforr, Franz, 146-8, 246; Count Rudolph of Hapsburg and the Priest, 146, 148; Virgin and Demon, 146, Phidias, 10, 11, 52, 371 Philadelphia Centennial Exposition (1876), 219 Photographic Journal, 283 Picard, Edmond, 414, 417 Picasso, Pablo, 235; Guernica, 235 Picot, F. E., 303 Pictorialism, 276, 286 Pieneman, Jan Willem, 397 Pigalle, Jean-Baptiste, 233 Piloty, Karl von, 295; Seni Before Wallenstein's Corpse, 294, 295 Pils, Isidore, 251; Death of a Sister of Charity, 253, 257 Piranesi, Giovanni Battista, Carceri, Pissarro, Camille, 302, 340, 341, 362, 440, 446; Corner of a Village in Winter, 341; Côte des Boeufs at L'Hermitage, Near Pontoise, 446, 448; Edge of the Woods, or Undergrowth in Summer, 344, 344; Hoarfrost, 339, 340, 341; L'Isle Lacroix, Rouen, Mist, 373, 375; Village Near Pontoise, 446, 447 Pissarro, Lucien, 362 Pitt, William, 103, 114 Plato, 27, 28, 144 Plint, Edward, 250 Plumbe Jnr, John, 275 Plutarch, 31, 413 Pocahontas, 184 Poe, Edgar Allan, 274 Pointillism see Neoimpressionism Pollaiuolo, Antonio, Battle of Nudes, 295 Pollastrini, Enrico, 296 Pollock, Griselda, 349, 397, 400 Postimpressionist style, 366 Poussin, Nicholas, 10, 46, 135, 419 Powers, Hiram, Greek Slave, 217, 217 Poyet, Bernard, 164; design for the Hôtel-Dieu on the Ile des Cygnes, Paris, 164, 164 Pratt, Richard H., 195 Préault, Antoine-Augustin, Slaughter, 234, 235 Pre-Raphaelite Brotherhood, 246, 247, 288, 314, 401, 408, 430 Price, Martin, 120 Proudhon, Pierre-Joseph, 251, 253, 300, 302, 361 Prud'hon, Pierre-Paul, 60; Crime Pursued by Vengeance and Justice, 59, 60; Portrait of Empress Josephine, 60, 61; Psyche Carried by Zephyrs to Cupid's Domain, 60, 61; Zephyr, 61, Puget, Pierre, 227, 235 Pugin, A. W. N., 138, 174-176, 179, 321; Contrasts, 174, 174; Palace of Westminster, London, 175-6, 175, 176; St. Giles, Cheadle, Derbys.,

174, 175 Pullman, IL, 319, 322

Puvis de Chavannes, Pierre, 264, 371, 246-250, 430; Beata Beatrix, 245, 430; Ecce Ancilla Domini!, 247, 247 408; Peace, 264; Sacred Grove, 371, 372; War, 264 Roulin, Augustine, 390 Rousseau, Ernest, 416, 417 Rousseau, Jean-Jacques, 9, 86, 111, 161, 189, 232, 321 Quarterly Review, 283, 290 Rousseau, Théodore, 304, 305 Racine, Jean, 10, 73 Raphael, 10, 76, 146, 238, 246, 286, Rowlandson, Thomas, 120 Royal Academy of Arts (Britain), 102–3, 110, 112, 114, 125, 127 131, 136, 188, 225, 246, 250, 283 Raynal, Abbé, 43 Realism, 242–64, 296, 393, 402, 420 Récamier, Madame, 41 Royal Academy of Fine Arts of San Reclus, Elisée, 417, 418 Carlos (Spain), 86 Redon, Odilon, 304, 371, 397, 406, 411, 416, 417, 419, 422, 423, 431, Royal Academy of Painting and Sculpture (France), 19 435, 451; Cyclops, 423, 425; "Death: Royal Photographic Society, London, My Irony Exceeds all Others," 434, 283, 287, 288 434; Eye, 422; Ophelia Among the Rubens, Peter Paul, 46, 68, 117, 341, Flowers, 415, 422; Roger and Angelica, 422, 424; Smiling Spider, 397, 412 Rude, François, 233–5; Marseillaise 422, 425; To Gustave Flaubert, 434 The Departure of the Volunteers of Reed, Luman 154 1792), 233–5, 235 Reekie, John, 275 Rudisill, Richard, 275 Regnault, Jean-Baptiste, 51; Runge, Philipp Otto, 142-6, 150, 246; Downfall of the Fatherland, 145, 145; Lamentation of Christ, 31, 33, 51; Fingal with Raised Spear, 142, 143; Morning, 144, 144, 145; Night, 143, Liberty or Death, 59, 60 Rejlander, Oscar Gustav, 284-5, 286; 143; "Times of Day," 143–5 Ruskin, John, 12, 13, 119, 135, 139, Expression of Emotion in Man and Animals, 285, 285; Two Ways of Life, 285-6, 285 141, 176, 179, 224, 247, 272, 282, Rembrandt, 135, 222, 288, 341, 397, 306, 312-14, 321, 325 406, 412, 413; Anatomy Lesson of Dr. Rutherford, Lewis M., Moon, 272 Tulp, 358 Renan, Ernest, 302 Saint-Simon, Henri de, Nouveau Renoir, Pierre-Auguste, 340, 342, 345, 400, 406, 450; Bal du Moulin de la Christianisme, 400 St. Louis, MO: Wainwright Building, Galette, 341, 342; First Evening, 330, 330 358; The Loge, 358, 358; Swing, 341 St. Petersburg: Imperial Academy of Repin, Ilya, 308; Barge-Haulers on the Art, 307 Salon, Paris, 11, 14, 225, 250, 295–300, 306, 340, 383, 440; (1806), Volga, 308, 309 Repton, Humphry, 121-2; "View 50; (1808), 63; (1810), 64; (1812), from my own cottage, in Essex," 64; (1814), 65; (1818), 67; (1819), before and after, 122 71; (1822), 73; (1824), 73, 76, 127; Revue comique, 280 Revue Wagnérienne, 406 (1827), 77, 228; (1831), 227; (1834), Rewald, John, 15 236; (1843), 238; (1845), 14; (1847), Reynolds, Sir Joshua, 110, 111 230, 238, 239; (1848), 252; (1849), Ribot, Théodule, 251, 252 Richardson, H. H., 327; Marshall Field Wholesale Store, Chicago, 252; (1850), 252, 255; (1851), 252, 253; (1853), 306; (1857), 302; (1859), 282; (1861), 302; (1864), (1867), 262, (1867), 302, (1867), 302; (1865), 305; (1869), 304; (1882), 345, 414, 450; (1884), 414; 327, 327 Ricoeur, Paul, 411 (1894), 223 Ripa, Cesare, Iconologia, 94 Robespierre, Maximilien de, 26, 37, Salon d'Automne, 450 38, 40, 41, 224 Salon des Indépendants see Société des Artistes Indépendants Salon des Refusés, 302, 303, 307, 443 Robinson, Henry Peach, 286-7, 290, 292; Fading Away, 286–7, 287; She Never Told Her Love, 286 Saltaire, Yorks., 319, 320 Rodenbach, Georges, 414 San Francisco Art Association, 219 Rodin, Auguste, 407, 416, 434-5; De Sargent, John Singer, 355; Ena and Profundis Clamavi, 435; Fugit Amor, Betty, Daughters of Mr. and Mrs. 435, 437; Gates of Hell, 434, 436; Asher Wertheimer, 355, 355; Lady Iris, Messenger of the Gods, 435, 437 Rogers, John, 203-4; Slave Auction, Agnew of Lochnaw, 353, 355; Mr. and Mrs. I. N. Phelps Stokes, 355 Sartre, Jean-Paul, 443 Sauvestre, Stephen, 328 203, *204* Rolfe, John, 184 Romano, Giulio, 112 Schapiro, Meyer, 165, 258, 338, 375 Romantic style (Romanticism), 55, Scheffer, Ary, 68, 228, 230, 233, 304; 72-6, 78-81, 82-101, 102-18, St. Augustine and St. Monica, 228, 142-59, 266, 270, 300-302; Schelling, F. W., 225 Schiller, Friedrich, 146 landscape painting, 119-41, 142-59, 224-5 Rome Prize, 20, 33, 52, 66, 73 Schimmel, Julie, 188 Romney, George, 91 Rood, Ogden, 372, 375 Schinkel, Karl Friedrich, 168; design for a mausoleum and memorial Root, Marcus Aurelius, 275 chapel for Queen Luise of Prussia, Rops, Félicien, 417 Rosa, Salvator, 120, 153 Schoolcraft, Henry Rowe, 192 Schuffenecker, Emile, 407, 412 Scott Archer, Frederick, 278 Rosaldo, Renato, 189 Roscoe, William, 111 Rosenblum, Robert, 15-16 Scott, George Gilbert, 176, 310; Rossetti, Dante Gabriel, 244, Midland Grand Hotel, St. Pancras,

London, 176, 177 Scott, Dred, 205 Scott, Sir Walter, 277 Seele, Johann Baptist, 200 Sekula, Allan, 271, 292 Selvatico, Pietro, 146, 298, 300 Semper, Gottfried, 314, 331; Der Stil. 314; Naturhistorisches Museum, Vienna, 314 Sernesi, Raffaelo, 298–9; Roofs in Sunlight, 298-9, 300 Sérusier, Paul, 408, 412 Seurat, Georges, 15, 17, 226, 259, 368–80, 390, 403, 404, 406, 450; Aman-Jean, 369, 368–71; Bathing Place, Asnières, 369, 370-71; Chahut final study 376; Chahut, 377, 377-9; Circus, 377-9, 381; Echo, 368, 369, 370; Le Crotoy, Upstream, 374, 375; Models, 374, 375; Sideshow, 377; Sunday Afternoon on the Island of the Grande Jatte, 371, 372, 372, 375, 377; Young Woman Powdering Herself, 390, 391, 392 Shadbolt, George, 288 Shakespeare, William, 10, 11, 73, 110, 112, 422 Shaw, Colonel Robert Gould, 217 Shelley, Mary, *The Last Man*, 134 Shiff, Richard, 340 Siddal, Elizabeth, 315 Sieyès, Abbé 9 Signac, Paul, 371, 375, 378, 379; Dining Room, Breakfast, 373, 375; Gasometer at Clichy, 375 Signorini, Telemaco, 298 Simpson, Marc, 210 Sisley, Alfred, 341 Slotkin, Richard, 181, 198 Smith, John, 184 Smith, Lindsay, 290 Snyder, Joel, 278, 292 Soane, Sir John, 152, 160-61, 170; Bank of England, London, 170, 171, 171; Pitzhanger Manor, 160, 161 Société Anonyme, 340, 343, 408 Société des Artistes Indépendants, 371, 375, 408, 414 Society of Friends of the Fine Arts (Freiburg), 426 Society of the Rights of Man, 227 Socrates, 26, 26, 27, 28 Sommariva, Giovanni Battista, 58, 59, 60, 61, 62, 63, 64 Sommer, Ferdinand, 425 Sophocles, 38 Soufflot, Jacques-Germain, 162-3, Ste. Geneviève (the Pantheon), Paris, 162-3, 163 Soule, William, 194 Southwell, Notts.: workhouse, 167, Southworth, Albert Sands, 276-7; postmortem photograph of unidentified child, 270; selfportrait, 276, 276 Springer, Anton, 295 Steinlen, Théophile-Alexandre, 383 Stendhal (Marie Henri Beyle), 60 Stevens, Alfred, Japanese Dress, 400, Steward, S. S., The Black Hercules, or the Adventures of a Banjo Player, 222 Stickley, Gustav, 316; "chalet table", Stieglitz, Alfred, 276 Stone, John Augustus, 187 Stowe, Harriet Beecher, 201-2, 215 Strong, Pauline Turner, 184 Sullivan, Louis, 317, 327, 330-31; Carson, Pirie, Scott and Company

store, Chicago, 331, 331; Guaranty Building, Buffalo, 324; Wainwright Building, St. Louis, 330, 330 Sumner, Charles, 217 Surrealists, 408, 438, 439 Swedenborg, Emmanuel, 106 Symbolists, 145, 361, 366, 404, 406–39, 440, 450 Synthetists, 412 Tagg, John, 277 Taine, Hippolyte, 135, 139 Talbot, William Henry Fox, 267-8, 269, 270, 271, 278, 283; Latticed Window at Lacock Abbey, 268, 268; Pencil of Nature (The Open Door), 268, 269 Tanguy, Père, 400 Tanner, Bishop, 219 Tanner, Henry Ossawa, 219-23; Banjo Lesson, 223, 221-3 Tassaert, Octave, 251, 252 Taylor, Thomas, 106 Taylor and Huntington Publishers, Execution of a Colored Soldier, 207, Thackeray, W. M., 141 Thiébault, J.-B., and F. Georgin, Apotheosis of Napoleon, 233, 234 Thiers, Adolphe, 227 Thompson, Charles Thurston, 283 Thompson, E. P., 106 Thomson, James, 136 Thonet Brothers, 311; "café chair", 312, 313 Thoré, Théophile, 303 Tieck, Ludwig, 143 Tiffany, Louis Comfort, 323; "Cobweb" library lamp, 323, 324 Tintoretto, Last Supper, 295; Ascent to Calvary, 308 Tocqueville, Alexis de, 166, 251 Toorop, Jan, 324 Toulouse-Lautrec, Henri de, 12, 15, 17, 382-88; Ambassadeurs, Aristide Bruant, 12, 387, 389; Au Cirque Fernando: Equestrienne, 384, 386; Bal du Moulin de la Galette, 386; Divan Japonais, 378, 380, 388; Dressage des nouvelles, 386; In Bed, 385, 387; Jane Avril, 387, 388, 388; Kiss, 387; Poudre de Riz, 384, 386; Two Friends, 385, 386, 387 Tournachon, Adrien, 280 Tournachon, Paul, 281 Trachtenberg, Alan, 272 Tristan, Flora, 238; Méphis 238 Troyon, Constant, 304 Trudaine de la Sablière, 26-7 Trumbull, John, Surrender of General Burgoyne at Saratoga, October 16, 1777, 213 Tuke, Samuel, 91 Turner, Frederick Jackson, 181 Turner, Joseph Mallord William, 13. 119, 135–6, 138–41, 154, 177, 201, 224, 413, 419, 423; Dudley, Worcestershire, 136–8, 138; The Fighting Téméraire, 13; London, 136, 137; 'Picturesque Views in England and Wales," 136; Rain, Steam, and Speed—the Great Western Railway, 13, 13, 139, 140-41, 141; Slavers Throwing Overboard the Dead and Dying-Typhoon Coming On, 139, 140; Snow Storm: Hannibal and His Army Crossing the Alps, 136, 137 Turner, Nat, 202

Ukiyoe, 362 Union, 272 Universal Exposition, Paris, (1855), 259, 260, 279, 293, 302, 306, 328; (1867), 328, 400; (1889), 327–8, 409, 412; (1900), 197
Ussi, Stefano, 296; Expulsion of the Duke of Athens From Florence, 296, 298
Utamaro, Kitagawa, 362; Mother Bathing Her Son, 362, 362
Vallé, Jules, 417, 443
Vanderlyn, John, 152; Death of Jane McCrae, 182, 184, 185; Marius

Amidst the Ruins of Carthage, 152,

152 van de Velde, Henry, 317, 323-5; desk for Julius Meier-Graefe, 324–5, 326; poster for "Tropon", 317, 317 Van Dyck, Sir Anthony, 355 Van Gogh, C. M., 393 Van Gogh, Theo, 386, 391, 393, 397, 401-4, 406, 411 Van Gogh, Vincent, 14, 17, 226, 259, 380, 383, 386, 388, 390-407 passim, 412; Artist's Bedroom in Arles, 391, 392, 401-2; Bearers of the Burden, 395, 396; Berceuse (La Mère Roulin), 390, 391, 392, 403; Carpenter's Workshop and Laundry, 393-4, 394; Crows In the Wheatfields, 406, 407; Eugène Boch, 403, 403; Joseph Roulin, 402, 403; Night Café, 401, 402; Portrait of a Peasant (Patience Escalier), 17, 386; Portrait of Père Tanguy, 398, 400, 401; Potato Eaters, 395, 396-7, 403; Roots and Trunks of Trees, 404; Self-Portrait With Bandaged Ear, 402, 403; Starry Night, 404, 405; Yellow House at Arles, 399, 401 Van Rysselberghe, Théo, 414 Velázquez, Diego, 84-6, 355; Triumph of Bacchus, 295 Verhaeren, Emile, 375, 379

Vernet, Carle, 64
Vernet, Carle, 64
Vernet, Horace, 68, 70, 227, 261, 304;
Battle of Jemappes, 68; City Gate at
Clichy, 68, 68; Duc d'Orléans
Proceeds to the Hôtel-de-Ville, July
31, 1830, 227, 228
Vie Moderne, La, 383
Vie Parisienne, La, 388
Vien, Joseph-Marie, 19
Vienna: House of the Secession,

430, 431; Lukasbund, 146-8;

Naturhistorisches Museum, 314

Vienna Secession, 430–31 Vigée, Louis, 22 Vigée-Lebrun, Elizabeth-Louise, 22–3; Marie-Antoinette With Her Children, 23, 24; Portrait of the Artist With Her Daughter, 23, 23 Vincent, F.-A., 23

Vingt, Les, 414–6 Viollet-le-Duc, Eugène-Emmanuel, 323–4

Virgil, 11, 131, 419, 450 Volney, Comte de, *The Ruins of Empire*, 154

Voltaire (François Marie Arouet), 12, 73, 86, 91, 161, 189, 232 Voysey, C. F. A., 318, 323; Moorcrag, 318, 320

Vrubel, Mikhail, 407, 411, 423, 451; *Pan*, 423, 425 Vuillard, Edouard, 408

Wackenroder, Wilhelm, The Heartfelt Effusions of an Art Loving Monk, 146 Wagner, Anne, 435

Wagner, Richard, 145, 375, 406, 435 Wallis, Captain Samuel, 435 Wanderers, The, 308 War Photograph and Exhibition Company, Group of "Contrabands," 207, 208 Ward, John, 269 Washington, George, 199, 200 Watkins, Carleton E. 276; Cape Horn Near Celilo, 277 Watteau, Jean-Antoine, 135, 413 Watts, G. F., 288 Webb, Philip, 314-15; Red House, 314-15, 315; Standen, 318, 319 Weber, Eugen, 388 Wedgwood, Thomas, 267 West, Benjamin, 114–17, 151, 188; Apotheosis of Nelson, 117, 117; Destruction of the Old Beast and False Prophet, 114-17, 115 Wheatley, Francis, 91 Whistler, James Abbott McNeill, 291, 416, 423; White Girl, 301, 302 Whitney, Anne, 217 Whittier, John Greenleaf, 201 Wiertz, Antoine, Two Young Girls or the Beautiful Rosine, 239, 241 Wilde, Oscar, 387 Wilkie, David, 246 Wilkins, Charles, 118 Willette, Adolphe, *Danseuse*, 386 Williams, Eunice, 185 Williams, Gwyn, 101 Williams, John, 185 Williams, Raymond, 14, 333 Winckelmann, Johann, 111, 118, 293 Wo-Haw, 196; Reading Class at Fort Marion, 196, 197–8, 197 Wolf, Eric, 180 Wollstonecraft, Mary, 103, 111, 112 World Exposition see Universal Exposition World's Columbian Exposition, Chicago (1893), 222, 363

World's Congress on Africa, Chicago (1893), 222, 223 Wright, Frank Lloyd, 323, 325–6; Larkin Building, Buffalo, NY, 326; Ward W. Willits House, Highland Park, IL, 325, 326

Park, IL, 325, 326 Wright of Derby, Joseph, 138 Wyatt, James, 168–9; Fonthill Abbey, 168, 169

Wynfield, David Wilkie, 288 Wyzewa, Théodore de, 406

Yeats, William Butler, 354 Yusupoff, Prince, 62

Zapater, Martin, 86, 90, 95 Zola, Emile, 290, 302, 408, 330, 442, 450 Zorilla, Leocadia, 95 Zuccaro, Federico, 370

Faveau, Félicie de, 228; Christina of Sweden Refusing to Give Mercy to Her Squire Monaldeschi, 228, 231 Fénéon, Félix, 371, 372, 375, 409, 412 Fenton, Roger, 283; Hardships at the Crimea, 283, 284; Still Life with Fruit and Decanter, 283 Ferdinand VII, King of Spain, 96, 97, 98, 100 Fèvre, Henri, 371 Figaro, Le, 280 Figaro Littéraire, Le, 408 Fildes, Luke, 394 Figuet, Hortense, 446, 450 Flandrin, Hippolyte-Jean, 252, 303; Napoleon III, 257, 258 Flaubert, Gustave, 242, 278, 300 Flaxman, John, 44, 45, 47, 52, 58–9, 60, 107, 142, 190; "Design for the Monument to British Naval Victories, with a Statue of Britannia," 107, 107; "Fight for the Body of Patroclus," 44, 44
Fontaine, P.-F.-L., 172–3; Galerie d'Orléans, Paris, 173, 173 Fonthill Abbey, Wilts., 168-9, 168, 169 Foster, Stephen, 204 Foucault, Michel, 91, 164 Fould, Achille, 261 Fourier, Charles, 238, 401 Fragonard, Jean-Honoré, 90 France, Anatole, 423 Frank Leslie's Illustrated Weekly, 211 Frank Leslie's Popular Monthly, 196-7 Franque brothers, 50 Frederick II (the Great), King of Prussia, 293 Free African Society, 200 French Academy, Rome, 19, 38, 53, 73 Freud, Sigmund, 439 Fried, Michael, 359 Friedrich, Caspar David, 150-51, 224, 246, 419, 420, 423; Abbey in the Oak Forest, 149, 150; Hill and Ploughed Field near Dresden, 151, 151; Large Enclosure near Dresden, 149, 151; Monk by the Sea, 148, 150 Friedrich Wilhelm III, King of Prussia, 168, 293 Friends of the Indians, 196-7 Fromentin, Eugène, 336 Fry, Roger, 368 Fuseli, Henry, 111-14; Nightmare, 111, 111, 112, 117; Symplegma (Man and Three Women), 112; Thor Battering the Midguard Serpent, 112, Fustel de Coulanges, Numa-Denis, Gadd, Mette (Mme. Gauguin), 432 Gaertner, Eduard, 295; View of the Opera and Unter den Linden, Berlin, 294, 295 Gainsborough, Thomas, Road from the Market, 258 Gardner, Alexander, 194, 275 Garibaldi, Giuseppe, 261 Garnier, Charles, 330; Opera House, Paris, 330 Garrison, William Lloyd, 216 Gaudí, Antoni, 323; Palau Guell, Barcelona, 323, 324 Gauguin, Mette, 432 Gauguin, Paul, 226, 238, 407, 409,

411, 412, 431–440, 446, 450; Be in

Love and You Will Be Happy, 409;

412, 414; Faaturuma (Reverie), 438;

Fatata te miti (Near the Sea), 438;

Bonjour Monsieur Gauguin, 411, 412; Christ in the Garden of Olives,

Green Christ, 407, 409; Jug in the Form of a Head, Self-Portrait, 412, 413; Mahana no atua (Day of the God), 437, 438, 438; Manao tupapau (The Specter Watches Her), 433, 432-5; Meal, or the Bananas, 431, 432; Seaweed Gatherers, 411, 412; Te faaturuma (Silence, or To Be Dejected), 438, 439; Tiare farani (Flowers of France), 431; Vahine no te vi (Woman of the Mango), 432, 432; Vision After the Sermon (Jacob Wrestling With the Angel), 409; Where Do We Come From? What Are We? Where Are We Going?, 438, 439; Yellow Christ, 409, 410, 412 Gaulois, Le, 383 Gautier, Théophile, 176, 239, 280 Gay-Lussac, Joseph Louis, 265 Ge, Nikolai, 308 Geffroy, Gustave, 388 General Coloured Association, 200 George III, King of England, 103, 114 Georget, E. J., 91 Georgin, F., and J.-B. Thiébault, Apotheosis of Napoleon, 233, 234 Gérard, François, 32, 35, 38, 41, 43, 46, 50, 57, 60, 73; Aeneas Carrying Anchises From the Ruins of Troy (with J.-L. David), 49, 51; Belisarius, 38, 38; Cupid and Psyche, 41, 43, 44, 45; Entry of Henri IV into Paris, 67, 67-8, 76; Ossian, 48, 50; portrait of Madame Récamier, 41 Géricault, Théodore, 64-8, 70, 74, 79, 91, 101, 226, 238, 252, 304; Charging Light Cavalryman (chasseur), 63, 64-5, 73; Despair and Cannibalism on the Raft of the Medusa, 68-70, 69; Pity the Sorrows of the Poor Old Man, 72; Portrait of an Insane Man, 72, 71–2; Raft of the Medusa, 70, 70–74, 80; Severed Limbs, 69; Wounded Heavy Cavalryman (cuirassier), 65, 65 Germ, The, 246 Gérôme, Jean-Léon, 228, 233, 303, 303, 305, 397; Cockfight, 228; Reception of the Siamese Ambassadors by Napoleon III and the Empress Eugénie at Fontainebleau, June 27, 1861, 303, 304, 304, 305; Slave Market, 278 Gide, André, 422 Gillray, James, 114; Phaeton Alarm'd!, Gilly, Friedrich, 160-61; design for a monument to Frederick II, 160, 161 Gilpin, William, 120; Three Essays: On Picturesque Beauty, On Picturesque Travel, and On Sketching, 120, 121 Girodet (-Trioson), Anne-Louis, 29, 32-8, 40, 41, 50, 52, 54, 55, 60, 64, 68, 79, 80; Atala at the Tomb, 61, 63; Deluge, 49, 50, 52; Ossian Receiving the Napoleonic Officers, 48, 50, 64, 307; Pietà, 31, 33, 36; Portrait of Jean-Baptiste Belley, 42, 43; Pygmalion and Galatea, 62, 63, 64; Revolt at Cairo, 62, 64, 80; Sleep of Endymion, 32, 32-3, 34, 37, 38, 40, 41, 43, 54, 60, 61, 63 Girtin, Thomas, 122–4, 135; Adelphi Terrace, 125; "Eidometropolis," 124; Kirkstall Abbey, 123, 123; Somerset House, 123, 124

Glaize, Auguste-Barthélemy, Misery

Godin, J.-B.-A., 319, Familistère,

the Procuress, 302

Gobineau, Arthur de, 303

Guise, 319, 321 Godov, Emmanuel, 87, 90, 94, 96 Goethe, Johann von, 73, 145, 147, 150, 304 Goncourt, Edmond de, 279, 387, 400 Goodall, Thomas F., Life and Landscape on the Norfolk Broads, Gould, Charles, 155 Goupil & Co., 401 Gowing, Lawrence, 443 Goya y Lucientes, Francisco José de, 9-10, 12, 13, 17, 81, 82-101, 102, 226, 404, 413; Album G, 101; "Black Paintings," 95, 100–101; Bordeaux Milkmaid, 100, 101; Caprichos, 9–10, 10, 82–3, 83, 90, 91, 92, 94–5, 100; Charles IV and His Family, 84, 86, 90, 96; Clothed Maja, 87, 88, 90, 97; Conde de Floridablanca, 84-6, 84; Courtyard With Lunatics, 89, 90-91, 94, 100; Disasters of War, 90, 95, 98-100, 98, 99, 101; Executions of the Third of May, 1808, 90, 95–8, 97, 100; Family of the Duque de Osuna, 85, 86; Family of the Infanta Don Luis, 84-6; Knife Grinder, 93. 95; Madrid Album B, 90; Naked Maja, 87, 88, 90, 97; Picnic, 90; Queen María Luisa Wearing a Mantilla, 87, 87; Sanlúcar Album A, 90; Saturn Devouring His Children, 100, 101; Uprising of the Second of May, 1808, 96–7, 96; Water Carrier, 95; Witches' Sabbath, 90, 90, 91, 94, 100 Grandville, 139; Autre Monde, 244, 244 Granet, François-Marius, 442 Grant, General Ulysses S., 212 Grasset, Eugène, 383 Great Exhibition of Works of Industry of All Nations (Crystal Palace, London, 1851), 16, 176-7, 179, 275, 313, 327 Greuze, J. B., 295 Gros, Antoine-Jean, 55, 78, 304; Battle of Nazareth, 55-7, 56; Capitulation of Madrid, December 4, 1808, 212; Napoleon in the Plague House at Jaffa, 56, 56-7, 64, 70 Groseclose, Barbara, 183 Gross, Dr. Samuel D., 356, 359 Groupe Synthétiste, 409 Groux, Charles de, 397 Growe, Bernd, 370 Guérin, Pierre-Narcisse, 39, 64, 70, 73; Aurora and Cephalus, 61, 62; Henri de Rochejaquelein, 66, 67; Return of Marcus Sextus, 38-40, 39 Guidott, F., 266 Guilbert, Yvette, 379, 388 Guillaumin, Armand, 383 Guillemet, Antoine, 450 Guimard, Hector, 323; Maison Colliot, Lille, 323 Guise: Familistère, 319, 321 Guizot, François, 227, 233 Guys, Constantin, 335, 382; *Champs*-Elysées, 334, 335 Habermas, Jürgen, 225 Hague School Realism, 393 Hall, Mrs. Elizabeth (Johnstone), 277, Hals, Frans, 355 Hampton Institute, 197, 223 Hamsun, Knut, 420,422 Hancarville, Baron d', Researches on the Origin, Spirit, and Progress of the Arts of Greece . . . on the Antique Monuments of India, Persia, the Rest

of Asia, and Egypt, 117, 118 Harper's Weekly, 193, 194, 194, 195, 208, 210, 215, 274 Harriet, Fulchran-Jean, 38; Oedipus at Colonus, 38, 39, 48 Haussmann, Baron Georges, 313, 332 Havemeyer, Louisine Elder, 349-353, 351, 366 Haviland, John, 166; Eastern State Penitentiary, Cherry Hill, PA, 166 Hawarden, Lady Clementina, 288; Photograph of a Model, 289 Hawes, Josiah Johnson, 276-7; portrait of Albert Sands Southworth, 276, 276; postmortem photograph of unidentified child, 270 Hayes, Rutherford B., 212, 215 Hazlitt, William, 133, 136 Hegel, Georg, 12, 147, 150, 244 Heim, François-Joseph, 76 Heine, Heinrich, 240 Hennequin, Emile, 375 Hennequin, Philippe-Auguste, 41, 50, 60; Allegory of 10 August, 40, 41; Remorse of Orestes, 40, 41 Henner, J.-J., 303 Henri IV, King of France, 67, 77, 77, Henry, Charles, 372 Herbert, Robert, 379 Herder, J. G., 112, 142 Herding, Klaus, 264 Herkomer, Hubert van, 394 Hermel, Maurice, 371 Herschel, Sir John, 268, 271, 288 Hersent, Louis, 67; Louis XVI Distributing Alms to the Poor, 66, 67 Herter Brothers, 311; reception room cabinet, 311, 313 Hight, Kathryn, 192 Hill, David Octavius, 277, 280, 288; Disruption Picture, 277; Mrs. Elizabeth (Johnstone) Hall, 277 Historicism, 27-33, 108-11, 227-33, 293-306 Hittorf, Jacques-Ignace, 176; Gare du Nord, Paris, 176 Hobbes, Thomas, 109 Hobsbawm, Eric, 8 Hodler, Ferdinand, 407, 411, 417, 419, 425-6, 451; Beech Forest, 426, 427; Chosen One, 426; Eiger, Mönch, and Jungfrau Above the Fog, 426; Lake Geneva Seen From Chexbres, 426, 427; Mönch With Clouds, 426, 428, 429; Night, 426, 426, 429; Valentine in Agony, 429, 429 Hogarth, William, 84, 295; "Madhouse," 91; Rake's Progress, Holl, Frank, 394 Holmes, Oliver Wendell, 275 Holt, Elizabeth Gilmore, 408 Homer, 10-11, 44, 50, 74, 76, Homer, Winslow, 208-10; Bivouac Fire on the Potomac, 208, 209; Bright Side, 209, 210, 210; Inviting a Shot before Petersburg, Virginia, 209; Our Jolly Cook, 209, 209; Prisoners From the Front, 214, 214, 215; Visit From the Old Mistress, 214, 215, 215 Horkheimer, Max, 15 Horta, Victor, 323-4; Maison du Peuple, Brussels, 324, 325 Hosmer, Harriet, 217; Beatrice Cenci, 216, 217; Zenobia in Chains, 216, 217 Howard, Ebenezer, 166, 321-2, 322 Howard, John, 166 Howling Wolf, 195 Hudson River school, 156-7

Hugo, Victor, 304, 333 Humboldt, Alexander, Cosmos, 157 Hunt, William Holman, 246–250 passim: Amakening Conscience, 247, 248, 250, 312–13; Rienzi Vowing to Obtain Justice for the Death of hls Young Brother, Slain in a Skirmish between the Colonna and Orsini Faction, 244, 246–7 Hurter, Ferdinand, 291

Imperial Academy of Art, St.

Petersburg, 307 Impressionists, 15, 224, 259, 264, 293, 303, 307, 336, 338, 340, 341, 342, 343, 400, 404, 442, 443, 446, 450; exhibitions, (1874), 281, 288, 293; (1877), 343, 343; (1879), 341; (1880), 341; (1881), 341; (1886), 341, 450 Ingres, Jean-Auguste-Dominique, 10–12, 17, 54, 55, 67, 79, 230, 232, 238, 261, 303, 304, 336, 356, 370, 419; Ambassadors of Agamemnon Visiting Achilles, 51, 52; Apotheosis of Homer, 10-12, 76, 77, 209; Henri IV Playing With His Children, 77, 78; Jupiter and Thetis, 53, 53; M. Louis-François Bertin, 230, 232; M. Rivière and Mme. Rivière, 356; Napoleon on the Imperial Throne, 51-3, 50; Oedipus and the Sphinx, 304, 305; Source, La, 264; Turkish Bath, 54, 54; Vapinçon Bather, 54; Vow of Louis XIII, 76, 76 Inness, George, 155–6; *Lackawanna Valley*, 155–6, *156* Israels, Isaac, 393 Israëls, Jozef, 397; Frugal Meal, 396,

Jackson, Andrew, 154, 188 Jackson, William H., 276 Jaeger, Hans, 422 James, Henry, 219, 355 Jameson, Anna, 120 Janson, H. W., 15–16 Jefferson, Thomas, 30, 153, 184, 185, 187, 190 Jocelyn, Nathaniel, 200-201; Cinque, 200, 202 Johns, Elizabeth, 356, 357, 359 Johnson, Eastman, 221; Old Kentucky Home, 204, 205, 205, 221; Ride for Liberty: the Fugitive Slaves, 205, 206, 206 Johnson, Joseph, 103 Johnston, Frances Benjamin, 197-8; Class in American History, 197-8, 198, 222 Jones, Owen, 311, 317, 327; design for Crystal Palace, 178; Grammar of Ornament, 328, 328 Jongkind, J.-B., 340 Journal illustré, 281 Journet, Jean, 258

Kahn, Gustave, 371, 375, 378, 379, 408, 418, 440
Kandinsky, Wassily, 442
Kant, Immanuel, 15
Kaufmann, Theodor, 211; On to Liberty, 206, 207
Kaulbach, Wilhelm von, 293
Keller, Ulrich, 282
Kensett, John Frederick, 156, 157; Lake George, 157, 158
Keokuk, Chief, 192–3
nopff, Fernand, 324, 414

Jovellanos, Gaspar Melchor de, 86, 95

Justice, La, 388

Juvenal, 238

King, Charles Bird, 187, 188; Keokuk Sac (Watchful Fox), 192-3, 193; Young Omahaw, War Eagle, Little Missouri, and Pawnees, 186, 188 Kiselev, Alexander, 308-9; The Mill, 308, 309 Kitchin, Xie, 289 Kleist, Heinrich von, 150 Klimt, Gustav, 430-31; Pallas Athene, 430; poster for the first Secession exhibition, 430 Klingender, Francis, 88-9, 90 Knickerbocker, 152 Knoll, Tarrytown, NY, 169, 170 Kodera, Tsukasa, 401 Koechlin, Maurice, 328 Korzukhin, Aleksei, 307; Day of the Parting, 307, 308 Kosciuszko, Thaddeusz, 260 Kosegarten, G. L., 150 Kossuth, Lajos, 260 Krafft-Ebing, Richard von, Psychopathia- Sexualis, 386 Kramskoi, Ivan, 307-8; Portrait of a Peasant, 307; Self-Portrait, 307-8,

Silos Krimmel, John Lewis, 200–201, 222; Quilting Frolic, 200, 202 Krohg, Christian, 422; Sick Girl, 420, 422 Kropotkin, Peter, 325, 417 Ku Klux Klan, 212

Labille-Guiard, Adélaïde, 23, 24-6; Self-Portrait With Two Pupils, 24-6, 25

Labrouste, Henri, 310–11, 326; Bibliothèque Nationale, Paris, 311, 312; Bibliothèque Ste. Geneviève, Paris, 311, 311 Laforgue, Jules, 341, 406 Lane, Fitz Hugh, 156, 157; Brace's

Rock, Brace's Cove, 157, 158 Langston, John Mercer, 216 Lanterne magique, 280 Latrobe, Benjamin, 152 Laugier, Marc-Antoine, 161–3, 174;

Laugier, Marc-Antoine, 161–3, 174; Essay on Architecture, 161–2, 163, 311

Laurens, Jean-Paul, 222 Lavater, J. C., 111 Lawrence, Thomas, 78, 131 Lears, Jackson, 354 Lebrun, J.-B.-P., 22 Ledoux, Claude-Nicolas, 164–6;

Architecture considered in relation to art, morals, and legislation, 164–5, 165; Chaux, 164–5, 165; Royal Salt Works at Arc-et-Senans, 164, 165 Lee, General Robert E., 212

Lega, Silvestro, 298 Le Gray, Gustave, 277, 278, 280, 285; Seascape with Sailing Ship and

Tugboat, 286 Lehmann, Henri, 368, 370 Leibl, Wilhelm, 295–6; Town Politicians, 295–6, 297

Leopold, King of Belgium, 418 Leroux, Pierre, 230 Le Secq, Henri, 288

Lessing, Gotthold, 118
Leutze, Emmanuel, Westward the
Course of Empire Takes its Way
(Westward Ho!), 183, 185–6

Lévi-Strauss, Claude, 180, 197, 439 Lewis, Edmonia, 216–19; Death of Cleopatra, 219; Forever Free, 217, 218, 218, 219; Freed Woman and Her Child, 217; Hagar in the Wilderness, 218, 218; Old Indian Arrowmaker and His Daughter, 219, 219

Lewis, Meriwether, 190

Libre Esthétique group, 414 Lille: Maison Coilliot, 323 Lincoln, Abraham, 205, 211, 212, 217, 221, 274, 275 Lindsay, Jack, 135 Linked Ring, 286 Linn, Karen S., 222 Little, John, 204 Littré, Emile, 340 Lockwood and Mawson, 319; Saltaire, Yorks., 319, 321 London: Bedford Park, 319, 320; Crystal Palace, 176–9, 178, 179, 314, 327–8; St. Pancras station and hotel, 176, 177, 310; Palace of Westminster, 175-6, 175, 176; Regent Street Quadrant, 172 172-3; Victoria & Albert Museum, 313 Lora, Léon de, 341 Louis XIV, King of France, 11, 18, 19,76

Louis XVI, King of France, 80, 232 Louis XVIII, King of France, 67 Louis Napoleon see Napoleon III, Emperor Louis-Philippe, King of France, 80,

226, 227, 230, 232, 253 Loutherburg, Philippe de, 138 Louvre, Paris, 10, 11 Lowenthal, Leo, 420, 422, 423 Luce, Maximilien, 372 Lucid, Robert F, 209 Luddism, 313 Ludwig I, King of Bavaria, 293

Lukacs, Georg, 12 Lukasbund, 146–8 Lumière, La, 283

Macchiaioli, 226, 296–9, 299, 306 MacMonies, Mary Fairchild, 365 Macpherson, James, Ossian, 50 Mackmurdo, A. H., 316, 318; cover of Wren's City Churches, 317, 318 Madison, James, 27 Mah-To-Toh-Pa, Chief, 189, 190,

Man-10-10n-Pa, Chief, 189, 190, 191, 191, 192 Mainardi, Patricia, 302

Mallarmé, Stéphane, 12, 14, 341, 343, 345,406 Malraux, André, 191

Mandan art, 189, 190, 191, 192
Manet, Edouard, 90, 226, 227, 259, 264, 280, 302, 303, 307, 332, 333–45, 349, 354, 441; Argenteuil, 345; Balcony, 333–4, 335; Bar at the Folies-Bergère, 345, 347, 382; Barricade, 332, 333; Boating, 354; Christ Mocked, 336; Déjeuner sur l'herbe, 303, 336, 371, 442; Masked

Ball at the Opéra, 345; Music in the Tuileries, 333, 334; Olympia, 264, 337–8, 335, 335–6, 337 Manet, Eugène, 333 Marat, Jean-Paul, 36–7 Marcuse, Herbert, 379, 440

Marcuse, Herbert, 379, 440
María Luisa, Queen of Spain, 86, 87, 87, 94
Marie-Antoinette, Queen of France,

23, 24, 89 Marien, Mary Warner, 272 Marion, A. F., 446 Maris, Jacob, *Bleaching Yard*, 393, 394

Marmontel, Jean-François, 19, 39 Martin, John, 133–4, 154, 158; Fall of Ninevah, 133, 133; Last Man, 134, 134, 135

Marx, Karl, 7, 12–13, 14, 102, 125, 244, 275, 300, 308, 314, 341, 383; Capital, 263, 274, 341; Economic and Philosophic Manuscripts of 1844, 12; Eighteenth Brumaire, 308; Manifesto of the Communist Party, 7, 242
Mathews, Nancy Mowll, 349
Mativet, 435
Maupassant, Guy de, "La Chevelure,"
388
Maurice, Frederick Denison, 250

Maurics, Frederick Denison, 250
Maurics, Théodore, La Daguerréotypomanie, 2/3
Maus Octave, 375, 414

Maus, Octave, 375, 414 Mauve, Anton, 393 Max, Gabriel von, 295 May, Ernest, 344 Mayer and Pierson, 281, 282 McCauley, Anne, 279, 281

McElroy, Guy, 200 McGough, Stephen C., 418 Meier-Graefe, Julius, 15, 325

Meissonier, Ernest, 330 Mendes, Catulle, 386 Mengs, Anton Raphaël, 84, 293 Menzel, Adolf von, 295, 296; *Flute*

Recital, 295, 296; Iron Rolling Mill, 295, 297, 308; Roundtable of Frederick II at Sanssouci, 295 Merleau-Ponty, Maurice, 441, 451

Meyer de Haan, Jacob, 412 Michelangelo, 11, 79, 112, 336; tomb of Giuliano de' Medici, 10 Michelet, Jules, 133, 227, 400 Millais, John Everett, 246, 247, 430;

Christ in the House of His Parents, 247, 249, 250; Ophelia, 421, 422
Millet, Jean-François, 240, 242, 291, 304, 305, 391, 397; Gleaners, 242,

304, 305, 391, 397; Gleaners, 242, 243, 251; Sower, 251, 251 Milton, John, 106, 110, 111, 112, 133

Mirbeau, Octave, 409 Mir Iskusstva, 423 Mistral, Frédéric, 442

Modernism, 250, 259, 264, 406 Mondrian, Piet, 368, 401, 438 Monet, Claude, 336, 340, 341, 400,

408; Grenouillère, 345; Poplars, 429; Regatta at Argenteuil, 338, 340; Waterlilies, 423, 423; Women in the Garden, 336, 339, 340, 365

Monro, Dr. Thomas, 122–3, 125, 135 Moratín, Leandro Fernandez, 86, 94 Moréas, Jan, 408

Moreau, Gustave, 304, 406, 423; Hercules and the Hydra of Lerna, 304; Oedipus and the Sphinx, 304, 305; Salome, 304

Morel, Bénédict Augustin, 337 Morisot, Berthe, 334, 340, 343, 345, 391; Laundresses Hanging Out the Wash, 343, 347, 383; Psyché, 345, 348

Morris, William, 12, 13, 14, 314–18, 321–5, 331; "Troy-type" typeface, 315, 316, 317; wallpapers, 316, 317–8

Morrison, Ralph, 194
Morse, Samuel, 271, 274
Mucha, Alphonse, 383
Munch, Edvard, 407, 411, 417, 419,
422, 426, 451; "Frieze of Life," 422;
Jealousy, 422; Kiss, 434; Madonna,
428; Sick Child, 420; Voice, 421
Murray, Freeman Henry Morris, 218
Museum of Ornamental Art see
London: Victoria & Albert Museum

London: Victoria & Albert Muss Mussini, Luigi, 296 Muther, Richard, 15

Nabis, 408

Nadar (Gaspard-Félix Tournachon), 269, 270, 271, 280–81, 340; Panthéon Naddar, 280; Sarah Bernhardt, 281, 281; When I Was a Photographer, 280 Napoleon I, Emperor of France